# RITES OF LIFE

## LES RITES DE LA VIE · LEBENSRITUALE

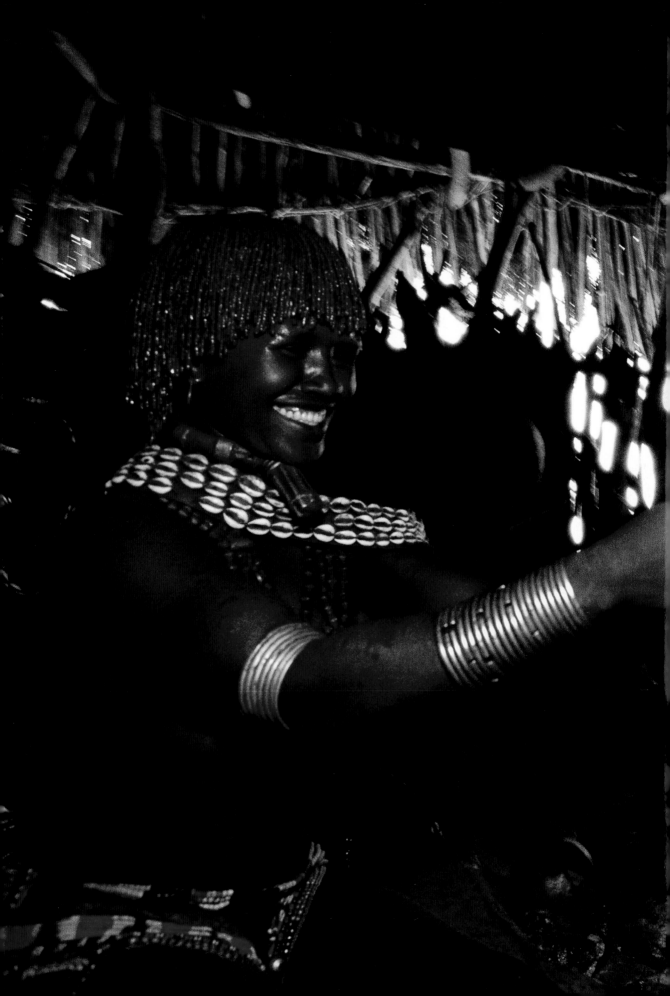

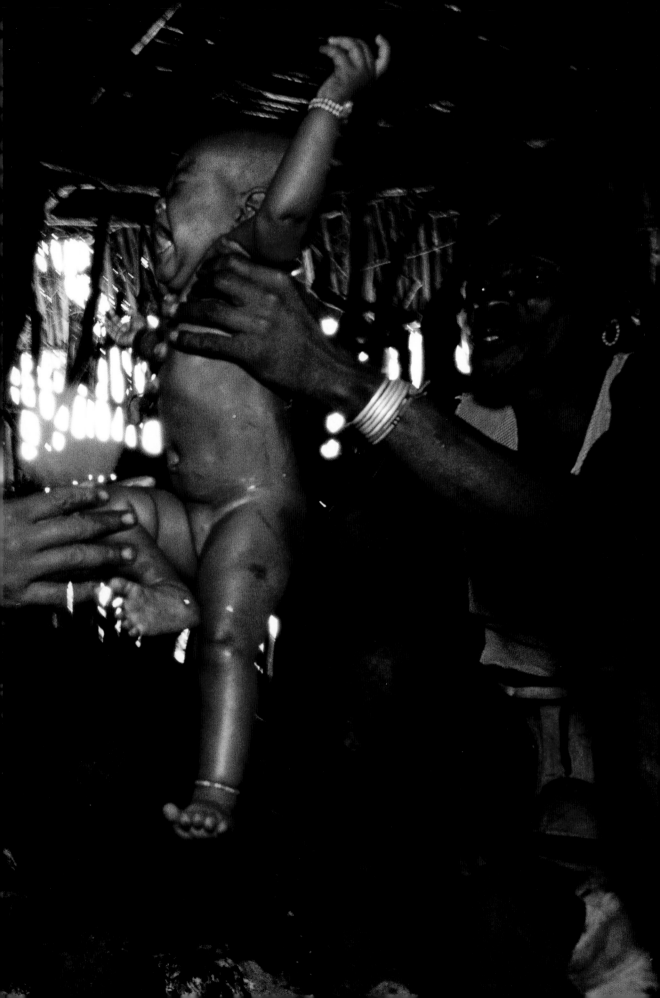

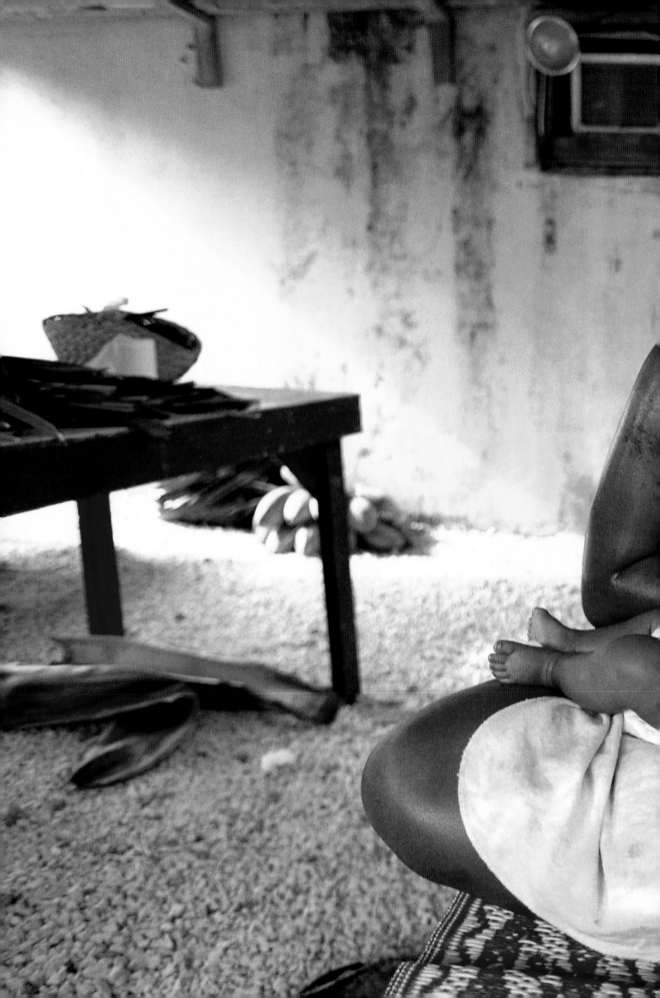

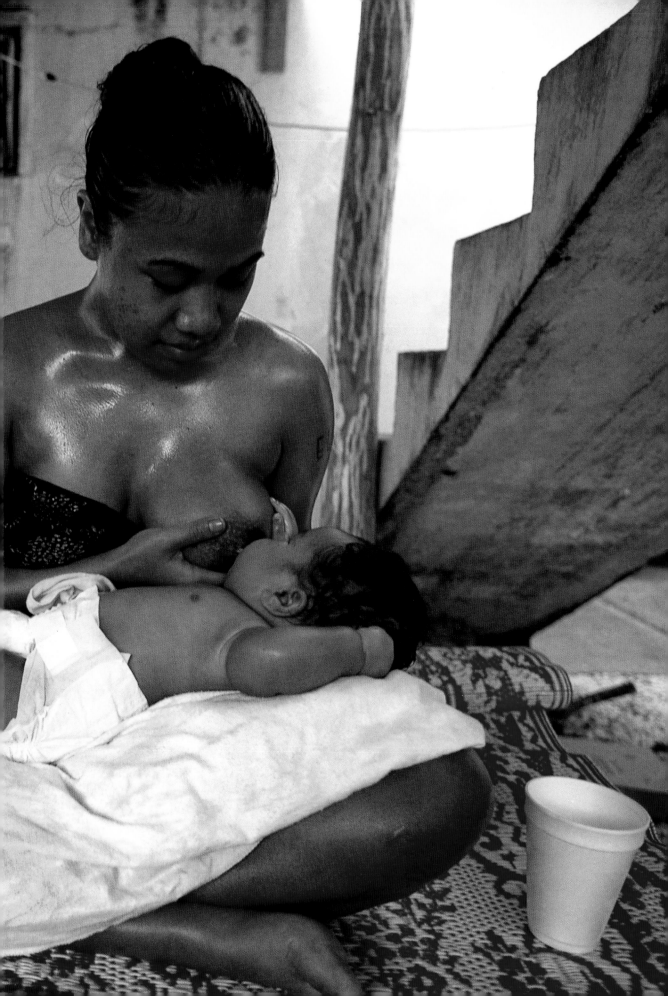

**Pages 2–3:** An infant belonging to the Hamar people of south-west Ethiopia is blessed by being sprayed with a mouthful of coffee.
**Pages 4–5:** In Palau, Micronesia, a mother gives her little baby the breast after having endured one of the many hot baths that are part of the special ceremony that all women go through after their first childbirth.

**Pages 2–3 :** Des femmes Hamar, peuple du sud-ouest de l'Éthiopie, bénissent un nouveau-né en l'aspergeant d'une gorgée de café.
**Pages 4–5 :** Palau en Micronésie : une jeune mère donne le sein à son nouveau-né après avoir dû endurer plusieurs bains bouillants, un des rituels obligatoires de la cérémonie célébrant une première naissance.

**Seiten 2–3:** Ein Hamar-Kind in Südwestäthiopien wird mit einem Mundvoll Kaffee gesegnet.
**Seiten 4–5:** Im mikronesischen Palau stillt eine Mutter ihr Kind, nachdem sie eines von vielen heißen Bädern hat über sich ergehen lassen, die Teil einer besonderen Zeremonie für alle erstgebärenden Frauen sind.

© 2010 for this edition:
EVERGREEN GmbH, Köln

Original title: Rites of Life
© Bokförlaget Max Ström 2008
© Photographs and text: Anders Ryman
Creative Director: Mark Holborn
Original design and Art direction: Patric Leo
English translation: Greg McIvor
French translation: Valerie Carreno and France Varry
(Introduction, captions, epilogue and background)
German translation: Petra Frese
Final art production: Petra Ahston Inkapööl

Printed in China

ISBN 978-3-8365-1867-3

ANDERS RYMAN

# RITES OF LIFE

## LES RITES DE LA VIE · LEBENSRITUALE

evergreen

# Contents
# Sommaire
# Inhalt

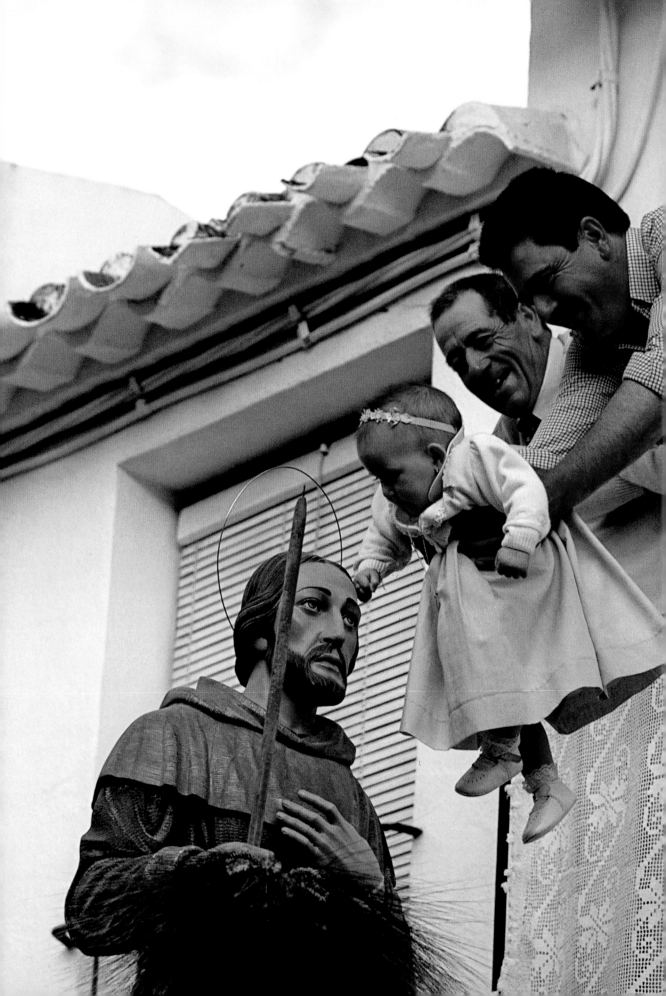

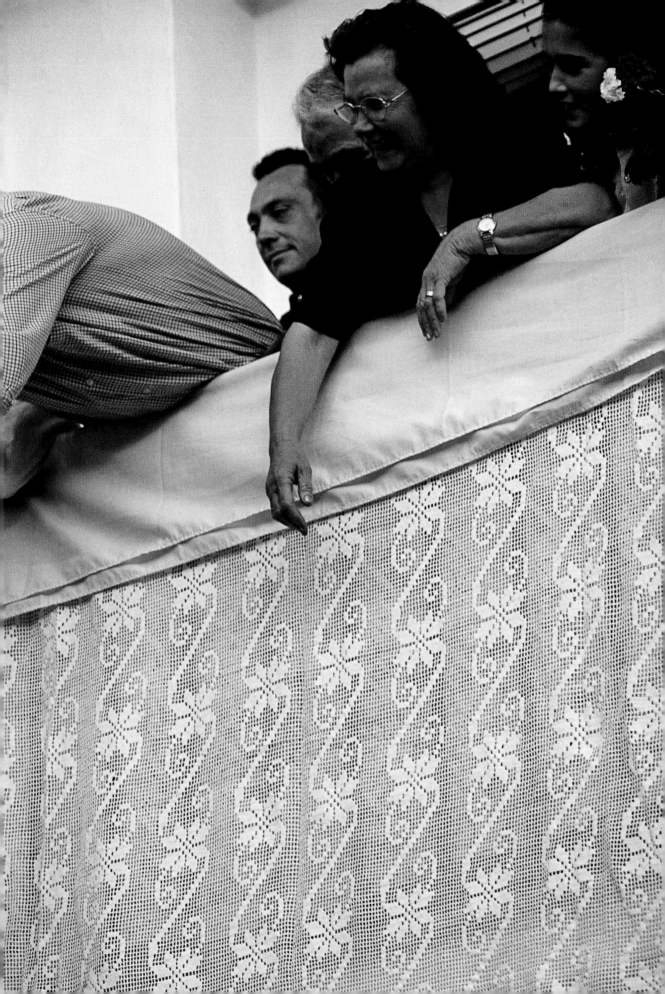

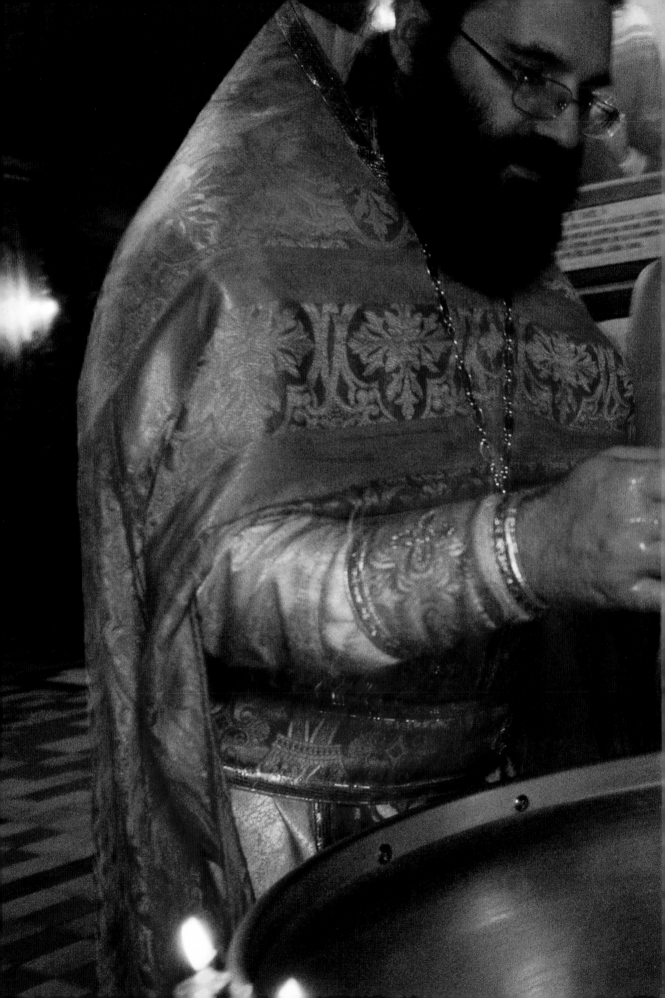

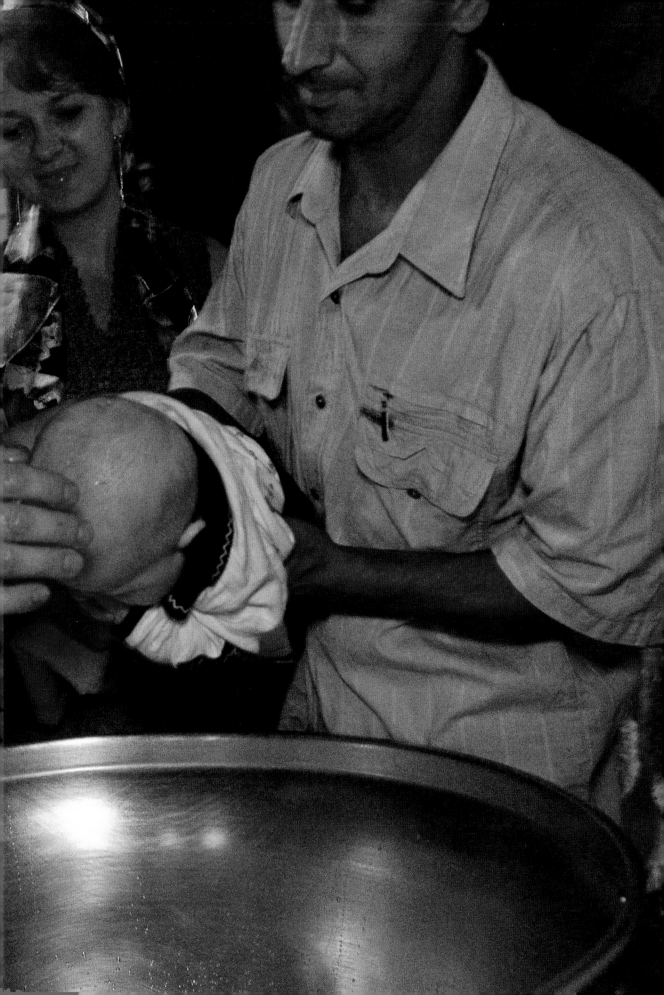

# Introduction

Is there anything more fascinating than meeting other people? Humans are among the planet's most social beings, with an almost insatiable need to relate to others and themselves.

As a child I used to dream about faraway places and people. I vividly remember a Swedish television series about a cheeky little boy called Villervalle who travelled to the South Pacific and had all sorts of adventures. The stories captivated me and I have often wondered whether Villervalle was the reason I specialised in Oceania when I went on to study cultural anthropology at Uppsala University.

Eventually I found my way to the South Pacific, spending a year in Samoa doing anthropological fieldwork. It was a trip that changed my life. A local family adopted me and invited me to live with them in their village by the sea. We became very close. Lamusitele, my sentimental Samoan father, used to say it was as if I had been born from his own body.

I studied the organisation of the village and its oral history. It was absorbing work. Like doing a jigsaw, it was a thrill every time I found a new piece that fitted. Seeing a culture from the inside in this way was a rich and rewarding experience that has stood me in good stead down the years, not least in my work on this book.

When I arrived in Samoa my initial fascination was with the cultural differences. But, more than anything else, what I learnt is that people are basically the same wherever you are. I found warmth, generosity, humour, sorrow and a comforting hand in times of sadness. Naturally, I saw the unattractive sides of human nature too: envy, intrigue, power struggles and, on occasion, violence. But overriding these were people's empathy and willingness to cooperate, two of our greatest human characteristics.

As a complement to the amassment of field notes and tape recordings, still photography proved an invaluable tool. On returning to Sweden I had planned to pursue a Ph. D. but instead found myself travelling the country giving lectures and showing my photos. Photography eventually took over completely and I left academia. But my interest in different cultures and how societies transcend the cultural divide has continued to burn strong.

The human need for rituals and ceremonies is one of our most fundamental forms of cultural expression. Perhaps the most important and universal are the rites of passage that mark our steps along life's path. People in all cultures and societies, no matter where their geographic location or what their level of access to the "necessities" of modern life, share the need to celebrate these moments when we pass from one phase of life to the next.

By focusing on these defining moments in life I have sought to highlight the great cultural diversity in the world while showing how intrinsically similar we are as human beings. After more than seven years of work, including journeys to cultures in all the inhabited continents of the world, this book has come to describe some thirty rites of passage spanning the full cycle of life, from birth to death.

Arnold van Gennep coined the term "rite of passage" in his 1909 book *Les rites de passage*, and it is today a familiar concept among anthropologists. My anthropology background certainly helped me in preparing the book, though my approach to the subject has been somewhat looser than an anthropologist's might have been. My ambition is to tell stories, to communicate with the non-expert and above all, through photography, to get closer to our humanity, the feelings we all have in common.

**Pages 10–11:** During a fiesta in the village of Periana, Spain, a family member lowers an infant down to a statue of San Isidro for health and prosperity.
**Pages 12–13:** In the Russian Orthodox cathedral in Peterhof outside St Petersburg a child is baptised by the priest and thereby received into the church community.

**Pages 10–11:** Lors d'une fête au village de Periana, en Espagne, un parent tend une fillette vers la statue de saint Isidro, pour qu'elle reçoive santé et prospérité.
**Pages 12–13:** Dans la cathédrale orthodoxe de Peterhof, en banlieue de Saint-Pétersbourg, un prêtre célèbre le baptême d'un bébé, le recevant ainsi au sein de l'Église.

**Seiten 10–11:** Bei einer Fiesta im Dorf Periana in Spanien wird ein Kind zur Statue des Heiligen Isidro hinuntergehalten, damit es gesund und wohlhabend wird.
**Seiten 12–13:** In der russisch-orthodoxen Kathedrale in Peterhof bei St. Petersburg tauft ein Priester ein Kind und nimmt es so in die Gemeinschaft der Kirche auf.

During the course of my work I have been privileged to meet people in many different parts of the world, and the rites that they have allowed me to document have left a strong imprint. They have been joyful, sad, poignant, uplifting, at times unsettling. Now I hope that this book will bring to life some of these profound emotions – and that you, like me, will be fascinated by our cultural diversity while at the same time seeing that as human beings we have far more in common with each other than not.

*Anders Ryman*

# Introduction

Quoi de plus fascinant que de rencontrer des gens inconnus ? Les humains font partie des êtres les plus sociaux de la planète, pourvus d'un besoin quasi insatiable de savoir qui ils sont et de communiquer avec leurs semblables.

Enfant, je rêvais de contrées lointaines et de leurs habitants. Je me souviens encore, comme si c'était hier, d'une série télévisée suédoise dont le héros était un gamin hardi prénommé Villervalle qui partit dans le Sud-Pacifique, où il vécut d'innombrables aventures. Ses histoires me captivaient et je me suis souvent demandé si c'était à cause de Villervalle que j'ai choisi de me spécialiser dans l'Océanie lors de mes études d'anthropologie culturelle à l'université d'Uppsala.

Quoi qu'il en soit, moi aussi, je me suis retrouvé dans le Pacifique Sud, à Samoa, où j'ai passé un an à faire des recherches anthropologiques sur le terrain. Un voyage qui a changé ma vie. Une famille locale m'a adopté et invité à partager sa vie dans son village au bord de la mer. Nous sommes devenus très proches. Grand sentimental, Lamusitele, mon père samoan, affirmait que j'étais comme un fils qui serait né de ses entrailles.

J'ai étudié l'organisation du village et sa tradition orale. C'était un travail très absorbant, comme reconstituer un puzzle, avec à chaque fois l'excitation de trouver une nouvelle pièce qui s'assemblait aux autres. Découvrir une culture de cette façon, à la source, a été une expérience riche, qui m'a beaucoup apporté et m'a rendu grand service au long des années, notamment dans la réalisation de ce livre.

Au départ, à Samoa, j'ai d'abord été fasciné par les différences culturelles. Mais, plus que tout autre chose, j'ai appris que les gens sont partout fondamentalement les mêmes. J'ai rencontré la chaleur humaine, la générosité, l'humour, la détresse et le réconfort dans les temps d'épreuves. J'ai été certes également confronté aux mauvais côtés de la nature humaine : jalousies, intrigues, luttes de pouvoir et parfois violence. Mais l'empathie et la bonne volonté à mon égard l'ont toujours emporté sur le négatif. Empathie et bienveillance sont deux des plus belles qualités de l'homme.

Pour compléter mes innombrables notes et enregistrements, la photographie m'a été un précieux outil. De retour en Suède, au lieu de préparer un doctorat, comme j'en avais eu l'intention, j'ai commencé à parcourir le pays pour y donner des conférences et montrer mes photos. Finalement, la photographie a pris la première place, et j'ai laissé tomber mon cursus universitaire. Mais les diverses civilisations et le désir d'apprendre comment les sociétés transcendent les divisions culturelles me passionnent toujours autant.

Le besoin de rituels et cérémonies constitue une des expressions culturelles

fondamentales de l'être humain. Les rites de passage qui marquent le cours de notre existence sont sans doute les plus importants et les plus universels. Dans toutes les cultures et sociétés, quels que soient la situation géographique ou le niveau d'accès d'un peuple aux « nécessités » de la vie moderne, les hommes partagent le besoin de célébrer les étapes majeures de la vie.

En me concentrant sur ces moments cruciaux de l'existence, j'ai cherché à mettre en relief l'immense diversité culturelle dans le monde, mais à montrer en même temps combien les hommes sont intrinsèquement semblables. Ce livre est le résultat de sept années de travail qui ont compris des voyages à travers les continents, à la découverte de maintes cultures ; j'y décris quelque trente rites de passage, embrassant le cycle entier de la vie, de la naissance à la mort.

Arnold van Gennep a été le premier à utiliser le terme « rites de passage » dans son livre éponyme écrit en 1909. Ce terme est aujourd'hui un concept courant parmi les anthropologues. Mes études d'anthropologie m'ont sans aucun doute aidé dans la réalisation de *Rites de la vie*, bien que j'aie abordé la matière avec moins de rigueur que ne l'aurait fait un anthropologue. Mon objectif est de raconter des histoires, de communiquer avec le grand public, et surtout, par le biais de la photographie, de me rapprocher de notre humanité, des sentiments communs à tous les hommes.

Au cours de mon travail, j'ai eu le grand privilège de rencontrer divers peuples dans bien des parties du monde ; les rites qu'ils m'ont permis de documenter ont laissé une empreinte profonde. J'ai participé à des instants joyeux, tristes, poignants, spirituels et parfois perturbants. J'espère que ce livre fait un peu revivre ces moments d'émotions intenses et que, comme moi, vous serez fasciné par la diversité culturelle sur notre planète, mais aussi par le fait que tous les habitants de la Terre partagent bien davantage de traits communs que de différences.

*Anders Ryman*

# Einleitung

Gibt es etwas Faszinierenderes, als andere Menschen kennenzulernen? Menschen gehören zu den geselligsten Lebewesen unseres Planeten. Ständig versuchen sie, mit sich selbst und anderen in Kontakt zu treten.

Als Kind träumte ich von weit entfernten Orten und Menschen. Ich erinnere mich lebhaft an eine schwedische Fernsehserie über einen aufmüpfigen kleinen Jungen, der Villervalle hieß und in die Südsee reiste, wo er alle möglichen Abenteuer erlebte. Die Geschichte fesselte mich, und ich habe mich oft gefragt, ob Villervalle der Grund dafür war, dass ich mich auf Ozeanien spezialisiert habe, als ich mein Studium der Kulturanthropologie an der Universität Uppsala aufnahm.

Irgendwann fand ich dann auch den Weg in die Südsee, wo ich ein Jahr in Samoa mit anthropologischer Feldforschung zubrachte. Diese Reise hat mein Leben verändert. Eine samoische Familie adoptierte mich und lud mich ein, in ihrem Haus in einem Dorf am Meer zu wohnen. Wir standen uns sehr nahe, und Lamusitele, mein emotionaler Adoptivvater, pflegte zu sagen, es sei, als ob ich direkt von ihm abstamme. Ich erforschte die Organisation des Dorfes und seine mündlich überlieferte Geschichte. Die Arbeit schlug mich in ihren Bann. Es war jedes Mal aufs Neue aufregend, ein passendes Teil in dem Puzzle zu finden. Eine Kultur so von innen

zu erleben, war eine wunderbare und bereichernde Erfahrung, die mir im Lauf der Jahre immer wieder zugute gekommen ist, nicht zuletzt bei der Arbeit an diesem Buch.

Als ich in Samoa ankam, faszinierten mich zunächst die kulturellen Unterschiede. Aber was sich mir mehr als alles andere einprägte, war, dass Menschen im Grunde überall gleich sind. Ich traf auf Wärme, Großzügigkeit, Humor, Kummer und tröstende Worte, wenn ich einmal traurig war. Natürlich habe ich auch die unattraktiven Seiten der menschlichen Natur gesehen: Neid, Intrigen, Machtkämpfe und gelegentlich Gewalt. Trotzdem werden sie jedes Mal wieder übertroffen von Mitgefühl und der Bereitschaft zur Kooperation, zwei der großartigsten menschlichen Eigenschaften überhaupt.

Als Ergänzung zu meinen Notizen und Tonaufnahmen erwiesen sich Fotos als unschätzbares Hilfsmittel. Eigentlich wollte ich nach meiner Rückkehr nach Schweden meine Doktorarbeit schreiben. Stattdessen war ich im ganzen Land unterwegs, hielt Vorträge und zeigte meine Bilder. Die Fotografie gewann schließlich die Überhand, und ich ließ das akademische Leben hinter mir. Aber mein Interesse an unterschiedlichen Kulturen und daran, wie Gesellschaften die kulturellen Unterschiede überwinden, ist nie erloschen.

Menschen brauchen Rituale und Zeremonien, sie gehören zu den grundlegenden Formen unseres kulturellen Ausdrucks. Die Übergangsriten, die die Stationen unseres Lebens markieren, sind dabei wahrscheinlich die wichtigsten und am häufigsten vertretenen. In allen Kulturen und Gesellschaften, unabhängig vom geografischen Standort und dem Zugang zu den „Notwendigkeiten" des modernen Lebens, teilen wir Menschen das Bedürfnis, die Momente zu feiern, in denen wir von einer Phase des Lebens in die nächste wechseln.

Indem ich mich auf diese entscheidenden Augenblicke des Lebens konzentrierte, wollte ich hervorheben, wie groß die kulturelle Vielfalt der Welt ist, und zugleich zeigen, wie ähnlich wir uns als Menschen eigentlich sind. Nach mehr als sieben Jahren Arbeit, zu der Reisen auf alle bewohnten Kontinente der Erde gehörten, beschreibt dieses Buch nun etwa 30 Übergangsriten, die das gesamte Leben, von der Geburt bis zum Tod, umfassen.

Den Begriff Übergangsritus prägte Arnold van Gennep 1909 in seinem Buch *Les rites de passage* (deutsch: *Übergangsriten*). Heute ist er unter Anthropologen ein geläufiges Konzept. Mein anthropologischer Hintergrund war bei der Vorbereitung dieses Buchs bestimmt hilfreich, obwohl ich das Unternehmen etwas lockerer angegangen bin, als ein Anthropologe es getan hätte. Ich möchte Geschichten erzählen, mit dem Laien ins Gespräch kommen, und vor allem möchte ich mithilfe der Fotografie unserem Menschsein, den Gefühlen, die wir alle gemeinsam haben, näherkommen.

Im Verlauf meiner Arbeit hatte ich das Glück, Menschen in verschiedenen Teilen der Welt kennenzulernen, und die Riten, die zu dokumentieren sie mir erlaubt haben, haben einen tiefen Eindruck hinterlassen. Sie waren freudvoll, traurig, schmerzlich, erhebend, manchmal beunruhigend. Ich hoffe nun, dass dieses Buch einige dieser grundlegenden Emotionen lebendig werden lässt – und dass Sie, so wie ich, von unserer kulturellen Vielfalt fasziniert sein werden und zugleich erkennen, dass wir als menschliche Wesen viel mehr gemeinsam haben als uns unterscheidet.

*Anders Ryman*

# Blessings for the newborn
## *Castrillo de Murcia, Spain*

Swish. A whip whistles through the air and snaps against my backside. Ouch! Dressed in red and yellow, his face hidden behind a mask, El Colacho dashes past and up the narrow streets of Castrillo de Murcia in hot pursuit of a group of youngsters. Most are agile enough to evade his oxtail whip. Most, but not all. I, the Swedish photographer, thought myself immune, but no.

There is a carnival mood and much jollity and laughter. Smiling faces gaze down from the windows and balconies in this usually sleepy village west of Burgos in northern Spain. For the annual *Fiesta del Colacho*, Castrillo de Murcia's population of two hundred swells to many times that number.

Behind El Colacho walk two lines of austere-looking men dressed in black. And behind them comes the drummer, *el atabalero*, his drum thumping like a sonorous heartbeat. He is wearing a top hat and tails; the others are in Castilian felt hats and cloaks. Unlike the gaudy El Colacho, they have a serious, almost ominous air about them, standing for order and god-fearing values in contrast to the chaotic and diabolical El Colacho.

Castrillo de Murcia's Fiesta del Colacho has a long history. It is organised by a Catholic fellowship, *La Cofradia del Santisimo Sacramento*, and is held yearly at the time of the feast of Corpus Christi.

There are two main protagonists: the church, which from its hilltop position commands a panoramic view of the village's grey stone houses, and El Colacho. The two represent the struggle between good and evil, order and chaos.

El Colacho interrupts the religious ceremonies by beating a pair of giant castanets with a stick in tune to the drumbeats. As he clacks away, he does his best to swipe onlookers – especially the local youngsters – with the oxtail whip on the end of his stick.

For their part, the youngsters goad him and make him chase them through the narrow streets. In bygone days, young women were tempted not to dodge the whip too earnestly because being touched by it was believed to bring fertility. It is therefore not surprising that El Colacho's castanets are shaped like a giant scrotum and his wooden stick is seen to symbolise a phallus.

After several days of celebrations, church masses and religious processions, interspersed with El Colacho running up and down the streets, the festival highlight is at hand. All babies born during the year are laid on mattresses in the streets for El Colacho to jump over them. Vaulting over the helpless infants is meant to protect them against illness, because when El Colacho passes over them he simultaneously removes the evil he represents.

Ninety-five children are to be leapt over today, though only one of them actually lives in Castrillo de Murcia. The village has suffered from an exodus of people to the cities in recent decades. Nevertheless, many former inhabitants and their descendants have preserved their local connections, returning at weekends and for holidays. Attending the fiesta is for many an annual highlight that is not to be missed.

All of them have once lain here as an infant on a mattress, gazing innocently skywards as El Colacho has soared over them. Today they have returned, bringing the children born during the year to repeat the experience and join La Cofradia. The fellowship has male and female members, although only the men actually perform

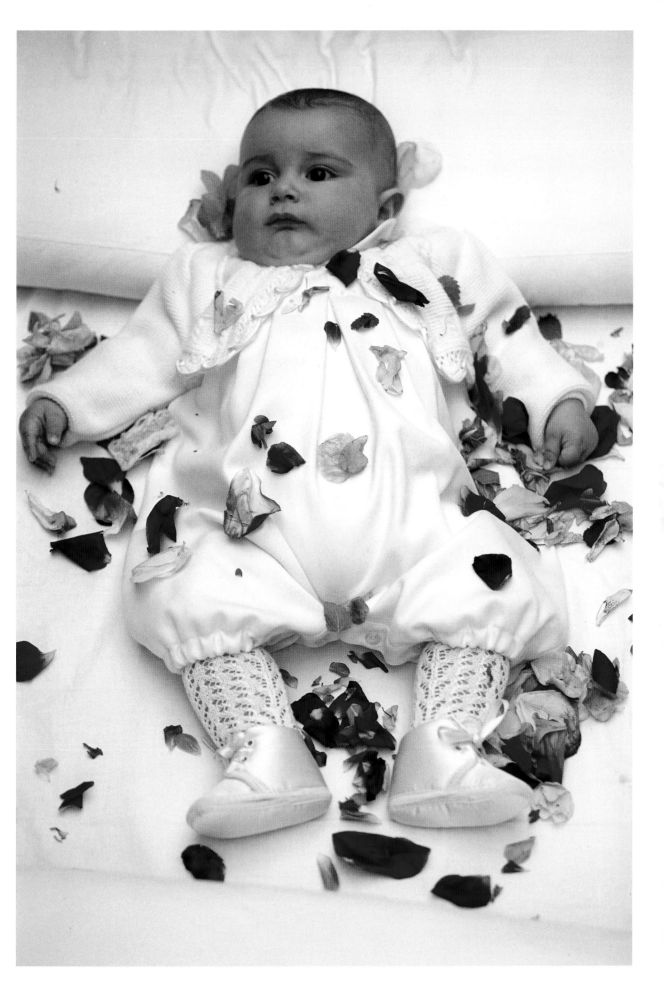

at the festival, either as drummers, black-clad men who walk through the village or as El Colacho himself.

The ceremony is near. White crocheted blankets are hung from the windows and temporary altars erected at the jumping points, where mattresses complete with sheets and two rows of pillows are laid out for the infants.

After mass and communion in the church, the villagers form a procession outside. Six men hold a canopy for the priest, who carries a monstrance – a round ornament embellished in gold and silver – and holding the consecrated host, or Eucharist. Alongside him stand young boys in white naval uniforms and girls in white bridal dresses who have recently made their first holy communion.

The drumbeats begin and the long procession commences its journey from the church steps to the square below. Standard bearers lead the way, followed by dancers in traditional dress and then the men in black representing La Cofradia.

Among them walks El Colacho, disturber of the peace, and another man who next year will play his role and who now is about to be inducted into the child-jumping art. They both wear the red and yellow garb of El Colacho, but without masks. This is for safety reasons: leaping over the infants could be a risky business if El Colacho did not see clearly where to put down his feet.

At the square, scene of the first jump, three mattresses have been arranged in a Y-shape. On them lies a huddle of infants, placed there by their mothers. The standard bearers march past, and then El Colacho appears at a sprint. Hurtling towards the first mattress like an Olympic sprinter, he takes off and leaps over the babies. Next year's El Colacho follows him, repeating the jump. The two then separate and each jumps over one of the other mattresses.

Symbolically it is the body of Christ, in the shape of the host, that has driven away the evil El Colacho, and through the jumps the children are liberated from the evil forces he represents.

Now the priest prays at the makeshift altar in the square. Afterwards, as he blesses the babies, the little girls in their white dresses scatter rose petals over them.

The square is packed. Many people have come from other places to be here. Jostling among them are camera crews, photographers and journalists, here to report on the occasion.

The first jumping station is complete. Another six remain and the procession moves on. An hour and a half later it reaches the final jumping station, where Laura Villaverde, the only mother who lives in the village, has laid her little Marcos on a mattress.

The two El Colachos safely negotiate their jumps, and as Marcos is sprinkled in rose petals the tears flow down his proud mother's cheeks. She once lay here, too, and has now passed the tradition on to the next generation. A tradition she firmly believes will give her son protection during the life that lies ahead of him.

# Bénédiction des nouveau-nés
## *Castrillo de Murcia, Espagne*

**Pages 24–25:** Behind El Colacho walk the austerely dressed *La Cofradia* through the narrow streets. The drumbeats are meant to urge the villagers to remain god-fearing, but El Colacho distracts the crowd's attention by clicking his outsized castanets.

**Pages 26–27:** El Colacho's lurid mask symbolises his dual role of jester and devil. He bangs his castanets with an oxtail-topped stick that also serves as a whip.

**Pages 24–25:** En tenue sombre, *La Cofradia* suit El Colacho dans les ruelles du village. Le son des tambours rappelle aux villageois qu'ils doivent craindre Dieu, mais El Colacho détourne leur attention en faisant claquer ses énormes castagnettes.

**Pages 26–27:** Le masque effrayant d'El Colacho symbolise son double rôle de bouffon et de démon. Il frappe ses castagnettes avec un bâton pourvu d'une queue de bœuf qui lui sert également de fouet.

**Seiten 24–25:** Hinter El Colacho gehen die streng gekleideten Mitglieder von La Cofradía durch die engen Straßen. Die Trommelschläge sollen die Dorfbewohner ermahnen, gottesfürchtig zu bleiben, aber El Colacho lenkt die Menge ab, indem er mit seinen übergroßen Kastagnetten klappert.

**Seiten 26–27:** El Colachos grelle Maske symbolisiert seine Doppelrolle als Spaßmacher und Teufel. Er schlägt die Kastagnetten mit einem Stock, an dem ein Ochsenschwanz befestigt ist und der als Peitsche dient.

Slatch… Un fouet cingle l'air et vient s'abattre sur mes fesses. Aïe ! Vêtu de rouge et jaune, le visage dissimulé derrière un masque, El Colacho se lance à la poursuite d'un groupe de jeunes gens dans les rues étroites de Castrillo de Murcia. La plupart sont suffisamment agiles pour éviter son terrible fouet, mais pas moi, le photographe suédois, qui me croyais à l'abri. Il règne ici une humeur joyeuse de carnaval. Des visages souriants s'affichent aux fenêtres et aux balcons de ce village habituellement endormi, situé à l'ouest de Burgos au nord de l'Espagne. À l'occasion de la *Fiesta del Colacho*, les deux cents habitants de Castrillo de Murcia voient leur village soudainement envahi.

Derrière El Colacho, deux files d'hommes austères vêtus de noir sont suivies par *el atabalero* qui fait résonner son tambour dans les rues. Il porte un chapeau haut-de-forme et une queue de pie ; les hommes en noir sont coiffés de chapeaux de feutre et de capes castillanes. Si l'allure du Colacho tend vers le burlesque, ces hommes, eux, ont l'air sérieux, presque sinistres. Ils représentent l'ordre et les valeurs pieuses, contrastant ainsi avec El Colacho, le diabolique.

La Fiesta del Colacho de Castrillo de Murcia est organisée par une confrérie catholique, *La Cofradia del Santisimo Sacramento*, et se tient tous les ans lors de la Fête-Dieu.

L'église surplombe les maisons en pierres grises et offre une vue panoramique sur le village. L'église et El Colacho représentent la lutte entre le bien et le mal, l'ordre et le chaos. El Colacho interrompt les cérémonies religieuses en frappant un bâton sur des castagnettes géantes au rythme des battements de tambour. Ce faisant, il fouette au passage les spectateurs à la volée – et tout particulièrement les jeunes du pays – avec une queue de bœuf accrochée au bout de son bâton.

Autrefois, les jeunes femmes se laissaient toucher par le fouet, symbole de fertilité. Ce n'est pas pour rien si les castagnettes du Colacho font penser à de grosses bourses, et son bâton de bois à un phallus.

Après plusieurs jours de célébration, de messes et de nombreuses processions religieuses, El Colacho a parcouru toutes les rues du village et aujourd'hui le festival bat son plein. Dans les rues, des bébés nés dans l'année sont installés sur des matelas pour que El Colacho puisse sauter par-dessus, éloignant ainsi l'esprit malin qu'il représente.

Quatre-vingt-quinze enfants sont présents aujourd'hui, un seul étant issu de Castrillo de Murcia. Le village a en effet connu un fort exode vers les villes, ces dernières années, mais beaucoup d'émigrés ont préservé des liens étroits avec les locaux. Chaque année la fête demeure une occasion de se retrouver. Tous ont déjà été couchés sur ces matelas, comme les nouveau-nés d'aujourd'hui, leur regard innocent tourné vers le ciel lorsque El Colacho effectue son grand saut. Ils reviennent maintenant avec leurs enfants nés dans l'année et répètent l'expérience en rejoignant la Confrérie. Ses membres comptent des hommes et des femmes, mais seuls les hommes prennent part au festival, en tant que batteurs ou vêtus de noir lorsqu'ils arpentent le village, parfois dans la peau du Colacho lui-même.

La cérémonie approche. Des couvertures blanches crochetées sont suspendues aux fenêtres et des autels provisoires sont installés à côté des matelas recouverts de draps et d'oreillers destinés aux bébés.

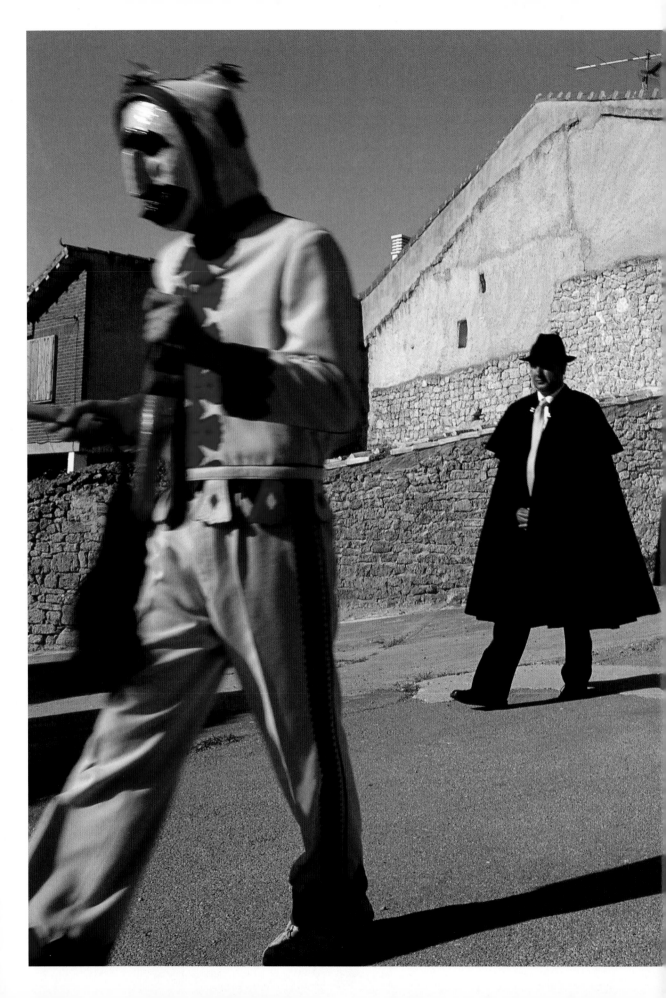

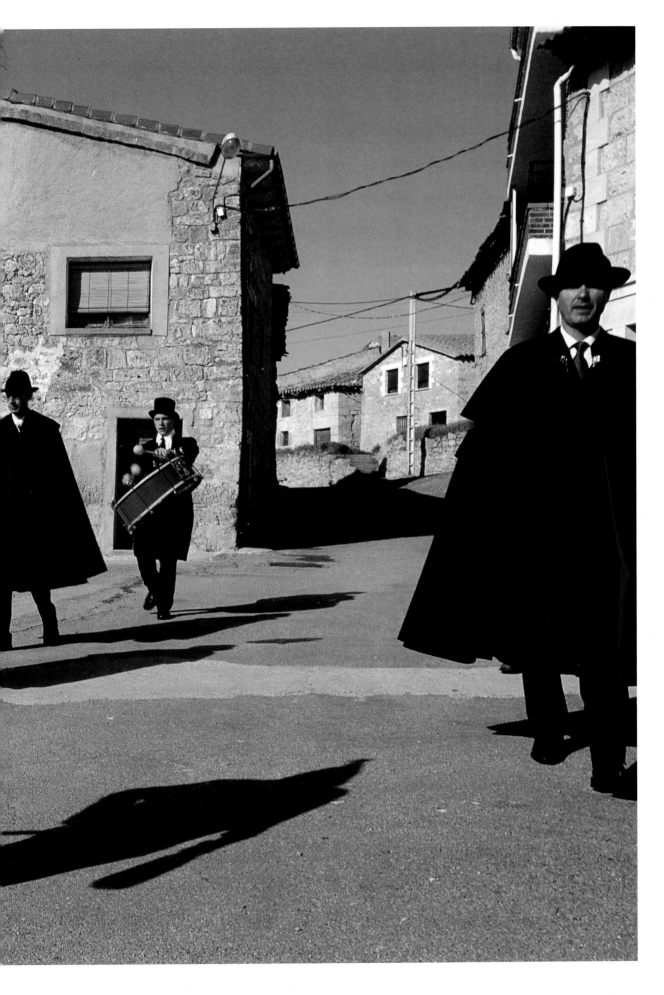

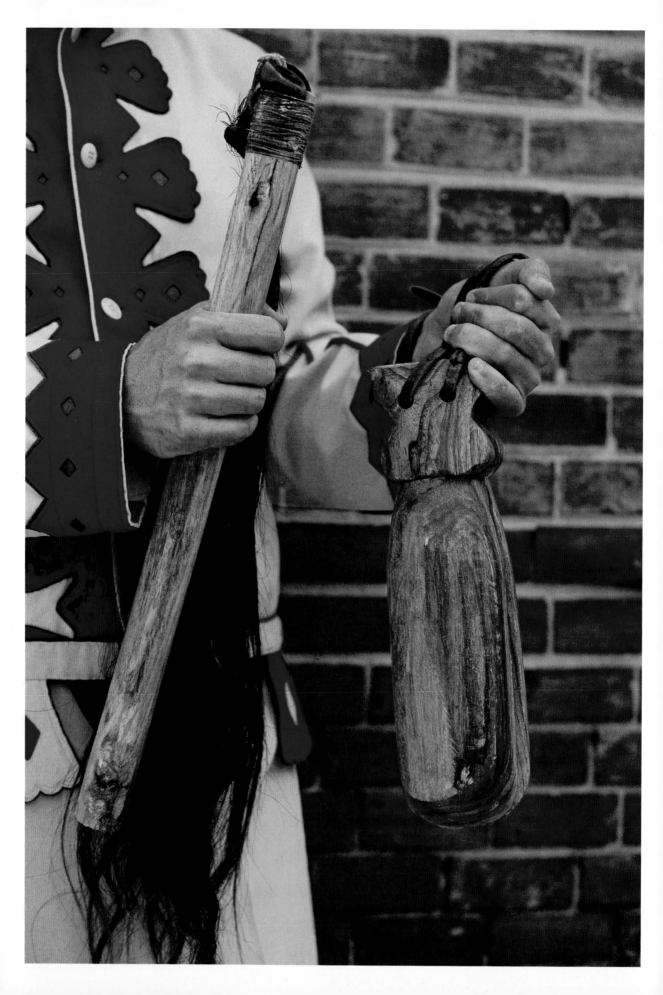

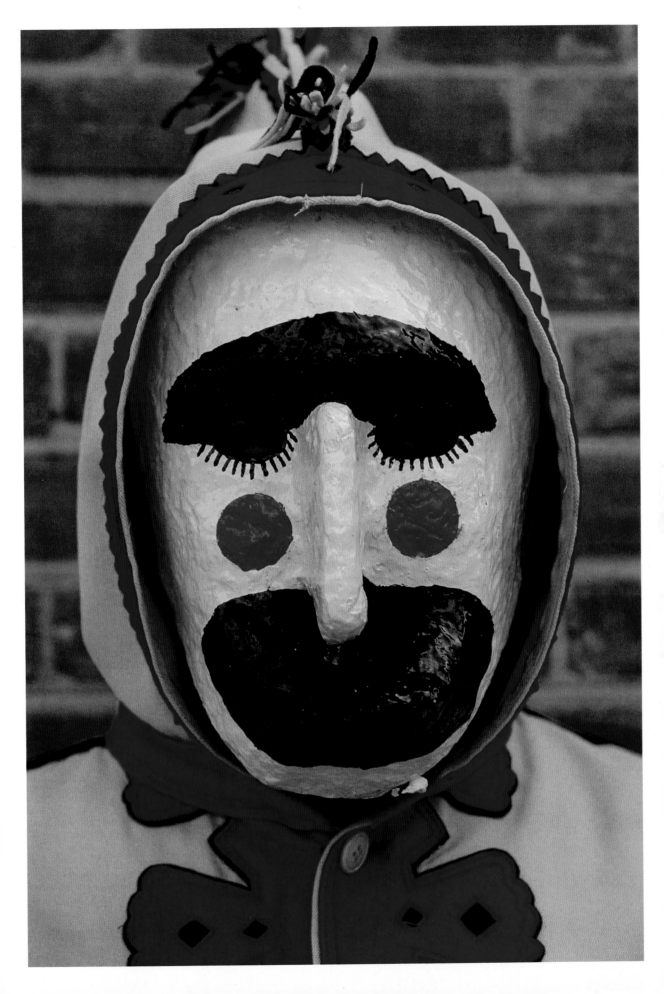

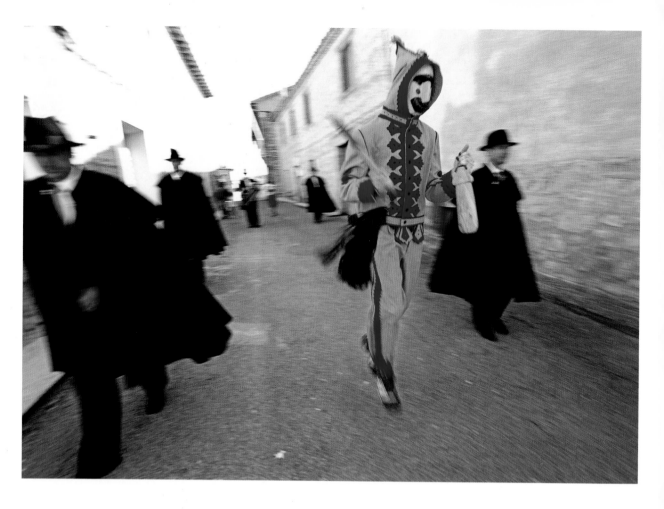
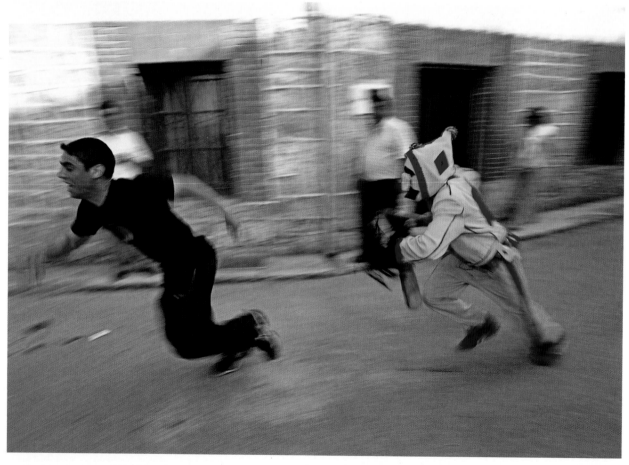

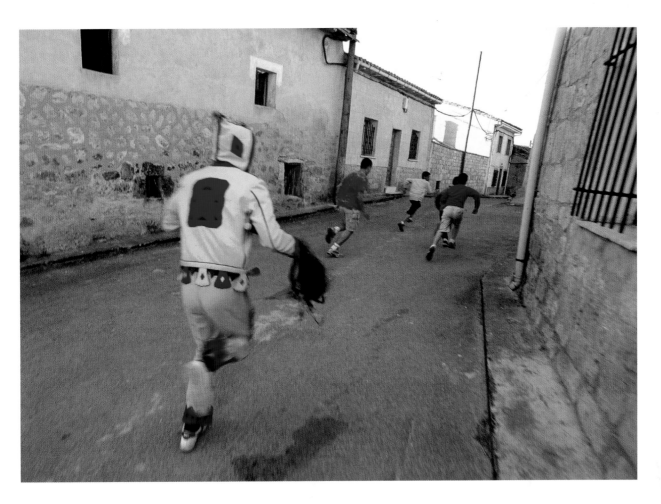
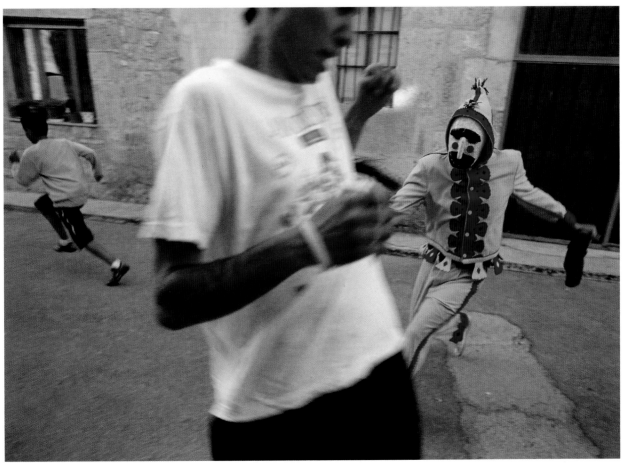

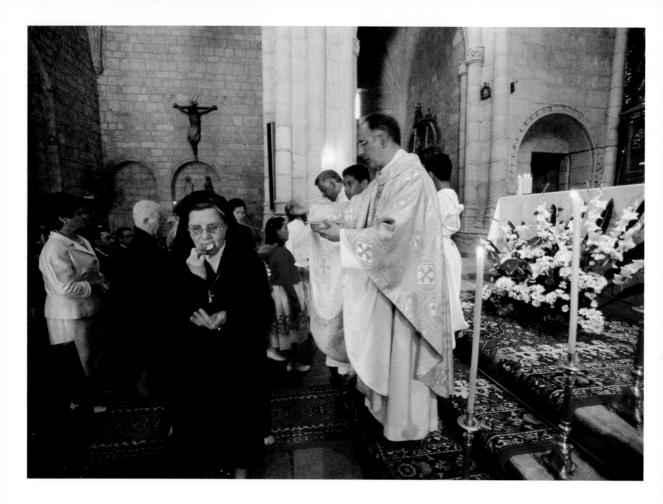

**Above:** Worshippers at Castrillo de Murcia's Catholic church receive the consecrated bread known as the Eucharist.

**Ci-dessus:** Des fidèles à l'église Murcia de Castrillo reçoivent l'Eucharistie.

**Oben:** Gläubige empfangen in der katholischen Kirche von Castrillo de Murcia die Eucharistie, das geweihte Brot.

**Pages 28–29:** Playing El Colacho and dashing around pursuing trouble-some youngsters with a whip can be energy-sapping, so the main El Colacho always has a few stand-ins.

**Pages 28–29:** El Colacho joue un rôle épuisant; il a toujours quelques doubles pour le remplacer quand il est fatigué de poursuivre les jeunes qui le provoquent.

**Seiten 28–29:** El Colacho zu spielen und ständig herumzulaufen und lästige Jugendliche zu jagen, kostet Kraft. Deshalb hat der eigentliche El Colacho immer ein paar Doppel-gänger.

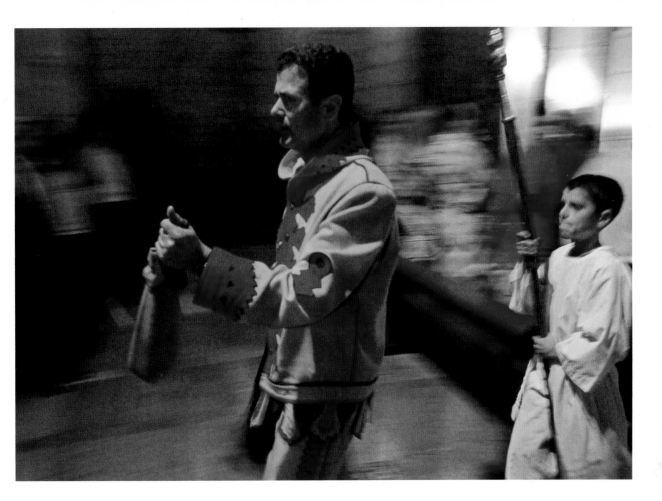

**Above:** El Colacho also disturbs the church services by clacking his castanets, though he does so discreetly and minus his mask.

**Ci-dessus :** El Colacho dérange aussi les offices religieux en faisant claquer ses castagnettes discrètement, et a enlevé son masque.

**Oben:** El Colacho stört mit dem Klappern seiner Kastagnetten auch den Gottesdienst, allerdings sehr zurückhaltend und ohne seine Maske.

Après la messe et la communion à l'église, les villageois forment une procession. Six hommes soutiennent un dais protégeant le prêtre qui porte un ostensoir – une pièce d'orfèvrerie ronde ornée d'or et d'argent contenant l'hostie consacrée, ou Eucharistie. De jeunes garçons en costume marin blanc et des fillettes habillées de leur plus belle robe cousue pour leur première communion suivent le cortège.

Les battements de tambour grondent et la foule s'éloigne des marches de l'église en direction de la place du village. Les porteurs du dais ouvrent la voie, suivis par des danseurs vêtus du costume traditionnel, puis viennent les hommes en noir représentant la Confrérie. El Colacho marche parmi eux, perturbant la paix de la procession, directement suivi d'un autre homme qui, l'année prochaine, jouera son rôle et sera initié au grand saut. Ils portent tous deux le même costume rouge et jaune du Colacho, sans masque pour des raisons de sécurité : sauter par-dessus les enfants pourrait être risqué si El Colacho n'était pas en mesure de voir ses pieds lors du saut.

Sur la place, lieu du premier saut, trois matelas ont été déposés en Y. Les mères y ont soigneusement installé leur enfant. Le cortège apparaît alors, immédiatement suivi par El Colacho au pas de course. Lancé à toute vitesse vers les matelas tel un athlète olympique, il prend son élan et saute par-dessus les bébés. L'apprenti El Colacho, qui lui succédera l'année prochaine, fait de même, répétant le grand saut. Les deux se séparent alors pour franchir les autres matelas. Symboliquement, c'est l'Eucharistie, le corps et le sang du Christ, qui chasse le mauvais esprit représenté par El Colacho, le saut libérant ainsi les enfants des forces du mal.

Le prêtre prie maintenant devant l'autel de fortune dressé sur la place. Tandis qu'il bénit les bébés, les fillettes vêtues de blanc dispersent des pétales de rose sur les nouveau-nés. La place est en pleine euphorie. Dans la bousculade, des photographes et des journalistes tentent de se frayer un chemin. La première session de saut est terminée. Il en reste six à exécuter et la procession continue d'avancer. Une heure et demie plus tard, elle atteint le dernier site, où Laura Villaverde, la seule mère issue du village, a déposé son petit Marcos sur un matelas.

Les deux Colachos négocient avec succès leur saut, et au moment où Marcos est recouvert de pétales de rose, les larmes coulent sur les joues de sa mère emplie de fierté. Elle a vécu cet instant en tant que bébé et, aujourd'hui, elle transmet cette tradition à la nouvelle génération, assurant ainsi la protection de son fils tout au long de sa vie.

**Right:** Holding the monstrance with the host, the priest leads the congregation in a procession through the village streets. The Fiesta del Colacho is held on Corpus Christi, a Catholic feast to celebrate the body and blood of Christ.

**À droite :** Brandissant l'ostensoir, le prêtre conduit le procession des fidèles à travers les rues du village. La Fiesta d'El Colacho se déroule le jour de la Fête-Dieu qui commémore le corps et le sang de Jésus-Christ.

**Rechts:** Der Priester, der die Monstranz mit der Hostie hält, führt die Gemeinde in einer Prozession durch die Straßen des Dorfs. Die Fiesta del Colacho wird an Fronleichnam gefeiert, einem katholischen Feiertag, der dem Leib und Blut Christi gewidmet ist.

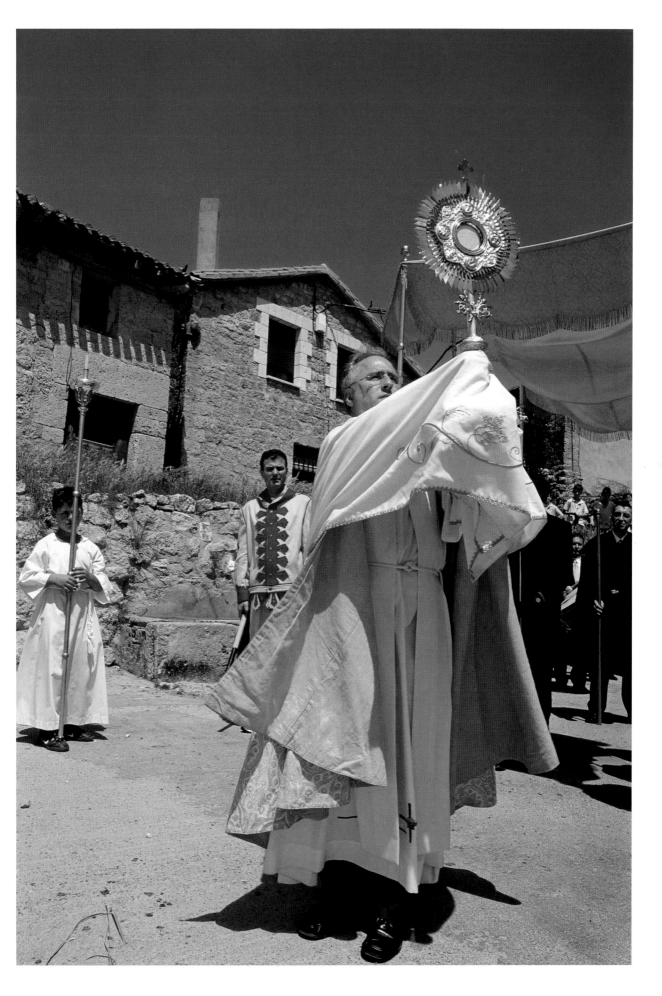

# Segen für das Neugeborene
## Castrillo de Murcia, Spanien

Zisch. Eine Peitsche saust durch die Luft und knallt auf mein Hinterteil. Autsch! El Colacho, in Rot und Gelb gekleidet und mit einer Maske, die sein Gesicht versteckt, flitzt vorbei und rennt die schmalen Gassen von Castrillo de Murcia hinauf, einer Gruppe Jugendlicher dicht auf den Fersen. Die meisten sind flink genug, um seiner Peitsche auszuweichen. Die meisten, aber nicht alle. Ich, der schwedische Fotograf, dachte, ich sei immun – falsch gedacht!

Es herrschen Karnevalsstimmung, Gelächter und große Ausgelassenheit. Lächelnde Gesichter blicken von oben aus den Fenstern und von Balkonen in diesem sonst eher verschlafenen Dorf westlich von Burgos in Nordspanien. Während der jährlichen Fiesta del Colacho wächst die 200-köpfige Bevölkerung von Castrillo de Murcia auf ein Vielfaches an.

Hinter El Colacho gehen in zwei Reihen streng aussehende Männer in Schwarz. Und ihnen folgt der Trommler, El Atabalero, dessen Instrument wie ein volltönender Herzschlag klingt. Er trägt Zylinder und Frack, die anderen sind mit kastilischen Filzhüten und Umhängen bekleidet. Anders als der schrille El Colacho haben sie eine ernste, fast schon bedrohliche Ausstrahlung. Sie vertreten im Gegensatz zum chaotischen und teuflischen El Colacho Ordnung und gottesfürchtige Werte. Die Fiesta del Colacho in Castrillo de Murcia hat eine lange Geschichte. Sie wird von der katholischen Bruderschaft La Cofradía del Santísimo Sacramento organisiert und findet einmal im Jahr, an Fronleichnam, statt.

Es gibt zwei Hauptdarsteller: Die Kirche, die von der Spitze des Hügels aus einen Panoramablick über die grauen Steinhäuser des Dorfs bietet, und El Colacho. Die beiden stehen für den Kampf von Gut und Böse, Ordnung und Chaos.

El Colacho unterbricht die religiösen Zeremonien, indem er mit einem Stock im Rhythmus der Trommel auf ein Paar riesige Kastagnetten schlägt. Während er das tut, gibt er sich alle Mühe, die Zuschauer mit seiner Peitsche, einem Ochsenziemer am Ende des Stocks, zu erwischen – vor allem die Jugendlichen aus dem Dorf.

Die Jugendlichen wiederum stacheln ihn an und lassen sich von ihm durch die engen Straßen jagen. In früheren Tagen waren vor allem junge Frauen versucht, der Peitsche nicht wirklich auszuweichen, denn es hieß, sich von ihr berühren zu lassen, mache fruchtbar. Es kommt also nicht von ungefähr, dass El Colachos Kastagnetten wie riesige Hoden geformt sind und der Stock als Symbol für einen Phallus betrachtet wird.

Nach einigen Tagen mit Festen, Messen und Prozessionen, die von dem die Straßen auf und ab laufenden El Colacho immer wieder unterbrochen wurden, steht der Höhepunkt bevor. Alle Kinder, die im Verlauf des Jahres geboren wurden, werden auf Matratzen auf die Straße gelegt, damit El Colacho sie überspringen kann. Der Sprung über die hilflosen Säuglinge soll diese vor Krankheit schützen, denn während El Colacho sich über sie hinwegbewegt, nimmt er das Böse, das er repräsentiert, mit.

Heute müssen 95 Kinder übersprungen werden, von denen aber nur eines tatsächlich in Castrillo de Murcia lebt. In den letzten Jahren hat das Dorf einen regelrechten Exodus erlebt; die Menschen sind in die Stadt gezogen. Trotzdem haben viele ehemalige Dorfbewohner ihre Verbindung zur Heimat aufrechterhalten und kommen an Wochenenden und zu Feiertagen zurück. An der Fiesta teilzunehmen ist für viele ein Highlight, das man nicht verpassen darf.

**Right:** El Colacho jumps over the children born during the year, removing the evil he represents, while parents hold their babies still. Then it is on to the next jumping station, where a fresh set of mattresses and children are waiting.

**À droite :** Pour contrer le démon qu'il représente, El Colacho bondit au-dessus d'enfants nés dans l'année, pendant que les parents les tiennent. D'autres bébés couchés sur des matelas l'attendent un peu partout dans le village.

**Rechts:** Während die Eltern ihre im Lauf des Jahres geborenen Kinder ruhig halten, springt El Colacho über sie und befreit sie von dem Bösen, das er repräsentiert. Dann geht es weiter zur nächsten Station, wo weitere Matratzen und Kinder warten.

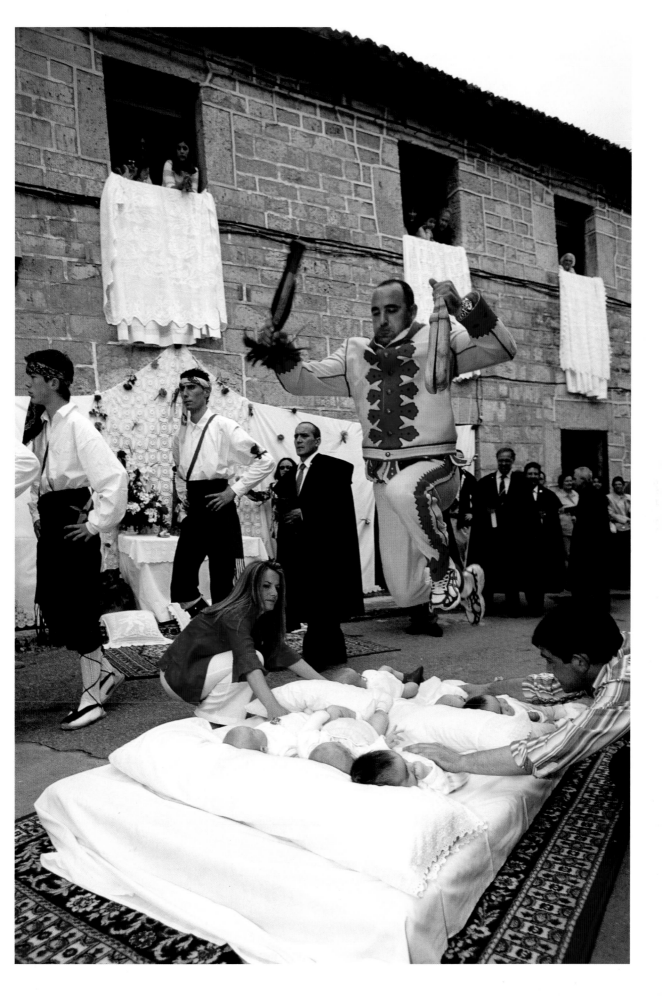

Alle haben sie hier einmal auf einer Matratze gelegen und unschuldig himmelwärts geblickt, als El Colacho plötzlich über sie hinwegschoss. Heute bringen sie ihre im letzten Jahr geborenen Kinder her, damit auch sie diese Erfahrung machen und Mitglieder der Cofradía werden. Die Bruderschaft hat männliche und weibliche Mitglieder, aber nur die Männer treten beim Festival auf, entweder als Trommler, als schwarz gekleidete Männer, die durch das Dorf ziehen, oder als El Colacho selbst.

Die Zeremonie steht unmittelbar bevor. Weiße, gehäkelte Decken werden aus den Fenstern gehängt und provisorische Altäre an den Orten aufgestellt, an denen El Colacho springen wird. Dort werden die Matratzen komplett mit Bettlaken und zwei Reihen Kissen für die Kinder hergerichtet.

Nach Messe und Kommunion in der Kirche formieren sich die Dorfbewohner draußen zu einer Prozession. Sechs Männer halten einen Baldachin über den Priester, der eine Monstranz trägt – ein rundes, in Gold und Silber verziertes Gefäß, in dem sich die geweihte Hostie, das Allerheiligste, befindet. Neben ihm reihen sich kleine Jungen in weißen Marineuniformen und Mädchen in weißen Brautkleidern auf, die erst kürzlich zur Erstkommunion gegangen sind.

Die Trommelschläge beginnen, und die lange Prozession macht sich auf den Weg von den Stufen der Kirche zum Platz unten im Dorf. Standartenträger gehen voran, gefolgt von Tänzern in Trachten und dann den Männern in Schwarz, die La Cofradía repräsentieren.

Unter ihnen sind El Colacho, der Ruhestörer, und ein anderer Mann, der im nächsten Jahr diese Rolle spielen wird und der nun kurz davor steht, in die Kunst des Kinderüberspringens eingeweiht zu werden. Beide tragen die gelb-roten Kleider El Colachos, aber keine Masken. Das dient der Sicherheit: Über Kinder zu springen wäre eine riskante Angelegenheit, wenn El Colacho nicht genau sähe, wo er hintritt.

Auf dem Platz, wo der erste Sprung stattfindet, bilden drei Matratzen die Form eines Ypsilons. Auf ihnen befindet sich ein Gewirr von Säuglingen, die dort von ihren Müttern hingelegt wurden. Die Standartenträger marschieren vorbei, und dann taucht rennend El Colacho auf. Wie ein olympischer Sprinter schießt er auf die erste Matratze zu, hebt ab und springt über die Babys. Sein Nachfolger kommt gleich hinterher und wiederholt den Sprung. Dann trennen sich die beiden, und jeder von ihnen springt über eine der anderen Matratzen.

Der Körper Christi in Form der Hostie hat den bösen El Colacho symbolisch vertrieben, und durch seine Sprünge werden die Kinder von den bösen Kräften befreit, die er repräsentiert.

Nun betet der Priester an dem provisorischen Altar auf dem Platz. Dann segnet er die Babys, über die die kleinen Mädchen Rosenblätter streuen.

Der Platz ist brechend voll. Viele Leute haben einen weiten Weg auf sich genommen, um heute hier sein zu können. Zwischen ihnen drängen sich Kamerateams, Fotografen und Journalisten durch, die von dem Ereignis berichten.

Die erste Station des Zugs ist geschafft, sechs Männer bleiben zurück, während sich die Prozession weiterbewegt. Eineinhalb Stunden später erreicht sie den letzten Ort, an dem El Colacho seinen Sprung vollführt. Dort hat Laura Villaverde, die einzige Mutter, die hier im Dorf wohnt, ihren kleinen Marcos auf eine Matratze gelegt.

Die beiden El Colachos absolvieren sicher ihre Sprünge, und als Marcos mit Rosenblättern bestreut wird, rollen der stolzen Mutter Tränen über die Wangen. Auch sie hat einmal hier gelegen, und nun hat sie den Brauch an die nächste Generation weitergereicht. Ein Brauch, von dem sie fest glaubt, dass er ihrem Sohn im Lauf seines vor ihm liegenden Lebens Schutz gewähren wird.

**Right:** The devil incarnate, El Colacho, has fled and the priest holds up the monstrance to symbolise the triumph of good over evil. Young girls who have recently celebrated their first holy communion scatter petals over the infants.

**À droite :** Le diable El Colacho s'est enfui ; le prêtre brandit l'ostensoir, symbole du triomphe du bien sur le mal. Des fillettes qui ont récemment célébré leur première communion parsèment des pétales de roses sur les bébés.

**Rechts:** Der leibhaftige Teufel, El Colacho, ist geflohen, und der Priester hält die Monstranz hoch, um den Triumph des Guten über das Böse darzustellen. Junge Mädchen, die erst kurz zuvor ihre Erstkommunion gefeiert haben, streuen Blütenblätter über die Säuglinge.

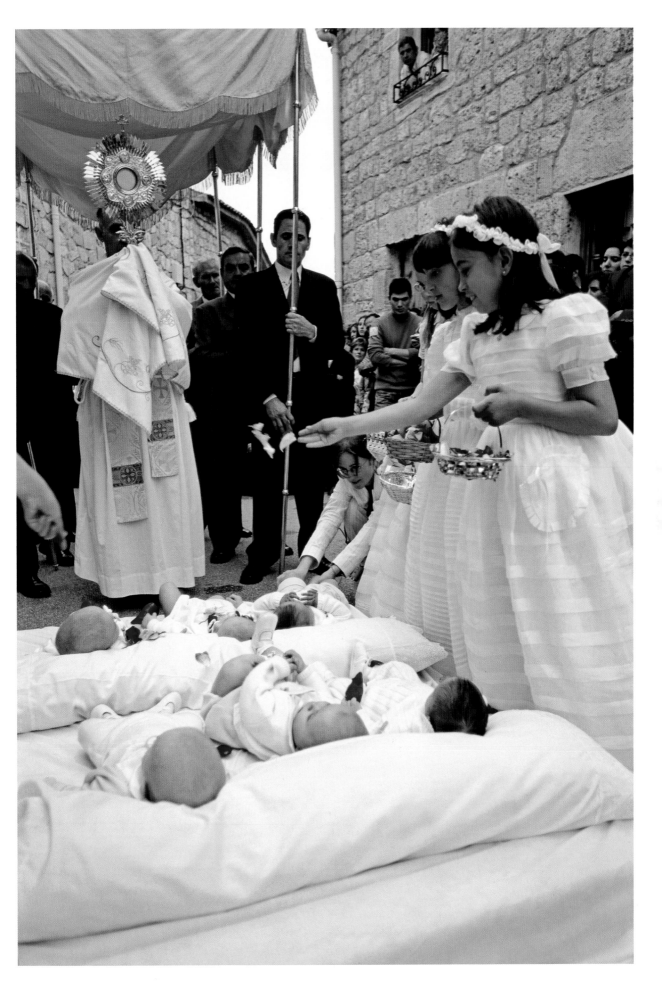

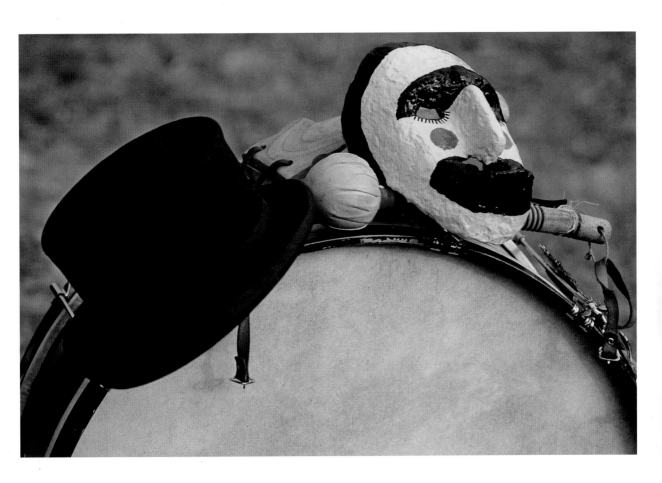

**Above:** The fiesta culminates in a folkdance, for which El Colacho and the drumer lay down their gear.

**Ci-dessus:** La fête se termine par une danse folklorique au cours de laquelle El Colacho et le tambour retirent leurs attributs.

**Oben:** Das Fest findet seinen Höhepunkt in einem Volkstanz, für den El Colacho und der Trommler ihre Ausrüstung ablegen.

株式会社大晋実業殿　和公ス工業株式会社京都支店殿　十村九右衛門殿　山田和彦殿　田興殿　北脇保蔵殿　木本藤三殿　栄原秀夫殿　飛地定男殿

有限会社ハットリ　安馬公男殿　狩野光市殿　桐山新次殿　村田益男殿　木村國廣殿　織田久子殿　上田進殿　前田辰夫殿　野口龍夫殿　前川務殿　駒崎珠工有限会社殿　都スクリーン株式会社殿　三木哲殿　林野総合高等学校殿　光映工業株式会社殿　織作忠男殿　株式会社保科金物殿　株式会社北尾商事殿　木村照男殿　中崎善造殿　西崎徹殿　今西正和殿

株式会社小巻電設工業所　大杉茂吉殿　和泉屋旅館殿　太田栄一殿　木村哲雄殿　森村哲雄殿　原田水太郎殿　小笹高史殿　神田照夫殿　林照雄殿　岩田嘉郎殿　佐々木龍夫殿　三菱東骨瀧上川田丁啓　西小路光喜殿　竹田清殿　高塚勝巳殿　中原利一殿　中川原利光殿　中川敏逸殿　村上一男殿　藤岡守殿　村井一生殿　柴田勇殿

アヴァカス東　北村茂夫殿　岡本茂章殿　野村善彦殿　五十川敏男殿　竹内一郎殿　井内優一郎殿　小路好明殿　福本萬生殿　比叡山観光タクシー株式会社殿　二股陸夫殿　有限会社山川製材所　井口秋子殿　井口石材店殿　五十川豊彦殿　山本文一殿　袖　森岡清殿　樺澤源蔵殿　蘆田ひろみ殿　株式会社光楽堂殿　竹口ひろ殿　中塚昭三殿　近藤忠義殿

野安男殿　下部義寛殿　村喜久男殿　村芳延殿　山寬殿　野諄二殿　田清一殿　藤善三殿　﨑良一殿

株式会社環高事殿　奧井好昭殿　奧谷晟殿　京都建装株式会社殿　田附正男殿　株式会社京都紋付殿　㈱アークホテル京都殿　株式会社白井長豊堂殿　河村一男殿　蔵立義也殿　玉井金装店殿　堀江義一殿　佐竹加代子殿　青木誠一殿　山崎千寿子殿　田中哲夫殿　上門義紀殿　犬山良雄殿　中西功一殿　大野木要殿　伊藤寛一殿　高坂峯弘殿　伊藤一子殿

豆川信三　外川信三狸　天野隼也殿　天野殿　津島勝二殿　西島三雄殿　天野瑠美殿　天野悠樹殿　木村寛次殿　岡本恵子殿　中村吉郎殿　乾雅也殿　岡部幸也殿　佐藤ひろゆき殿　垣貫敏文殿　坂部秀彦殿　芝田造園殿　松井隆史殿　株式会社マルイ美術殿　有限会社ヤマニ測器殿　中村悦子殿　西浦木工所殿　林勤殿　メンズショップタケハラ殿　株式会社美也古商会殿　中原勲殿

磯貝　今井幸一郎　外川信三　豆狸　金井健　株式会社アサヒ屋　大薮善興治　清水龍興　鍵田芳昭　石田伊三男　石村久男　下村久男　北村久太郎　千成餅食堂　西村亀太郎　福永忠　有限会社山本石材　上田ふみよ　藤堂喜代子　塚本昌雄　山本建治　吉村百合子　太田八十一　片岡敬太郎

# Shichi-go-san
## *Tokyo and Kyoto, Japan*

There is a faint rustle as the tall Shinto priest leans forward and waves his *harai-gushi*, a wand of white zig-zag paper, back and forth. Standing there in bright kimonos, seven-year-old Nanako and her three-year-old sister Momoko bow their heads respectfully.

The wand's movements are intended to cleanse them from evil. The priest then turns to the most sacred part of the sanctuary in order to present the girls to the god of the shrine, thank him for looking after them and ask him to give them a long and happy life.

Flanking the girls are their parents: mother Emiko in a moss-green kimono and father Naoyuki, wearing a dark, Western suit. The atmosphere inside the low-ceilinged shrine is quiet and intimate. Square rice-paper windows open on to the garden.

Autumn is late this year and the colours of the trees outside are less vibrant than usual during *shichi-go-san*, the ceremony that Nanako and Momoko are now celebrating and which is held on November 15 every year.

During shichi-go-san (literally "seven-five-three"), parents dress their daughters aged three and seven and sons aged five in traditional costume and take them to a Shinto shrine to be blessed. Three, five and seven years are important milestones for Japanese children. In ancient times, children were allowed to grow their hair once they reached the age of three; prior to that age their heads were shaven. At the age of five, boys could wear *hakama* – wide, creased trousers – for the first time, while girls who turned seven were permitted to tie their kimonos with a wide sash known as an *obi*.

The contemporary version of shichi-go-san originated in the Kanto region and is said to have been held by shogun Tokugawa Tsunayoshi for his son, Tokumatsu, at the end of the seventeenth century. The ritual later spread from aristocratic circles to the wider population.

Today we are at the Aoto Jinja shrine on the outskirts of Tokyo, where Nanako's and Momoko's father once participated in shichi-go-san himself, like his ancestors before him. This is the shrine of Sarutahiko-no-Okami, the god who guards the gateway between heaven and earth.

"We're not very religious," confides Emiko, the girls' mother, "but we want our children to have good lives."

**Pages 40–41:** Heian Jingu is Kyoto's most popular shrine for *shichi-go-san* ceremonies. Letters inscribed on wooden slabs show the names of people who have made donations.
**Right:** Girls have their hair set in the traditional style before the ceremony.
**Pages 44–45:** This seven-year-old girl is wearing the wide sash, or *obi*, with her kimono for the very first time.

**Pages 40–41:** Heian Jingu à Kyoto est un temple très populaire pour les cérémonies de Shichi-Go-San. Sur les plaquettes en bois sont gravés les noms des donateurs du temple.
**À droite:** Les fillettes sont coiffées dans le style traditionnel avant la cérémonie.
**Pages 44–45:** Cette petite fille de sept ans porte pour la première fois la large ceinture, appelée *obi*, sur son kimono.

**Seiten 40–41:** Heian-jingu ist Kiotos beliebtester Schrein für Shichi-go-san-Zeremonien. Auf Holztafeln stehen die Namen derer, die dem Schrein Geld gespendet haben.
**Rechts:** Das Haar der Mädchen wird vor der Zeremonie traditionell frisiert.
**Seiten 44–45:** Diese Siebenjährige trägt zum allerersten Mal ihren Kimono mit der breiten Schärpe, dem Obi.

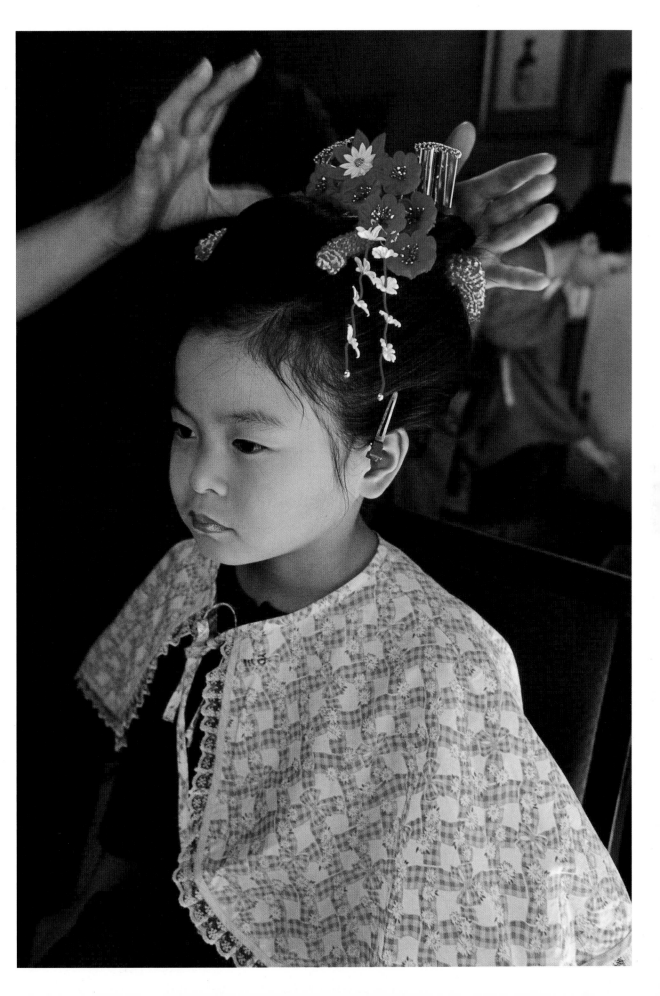

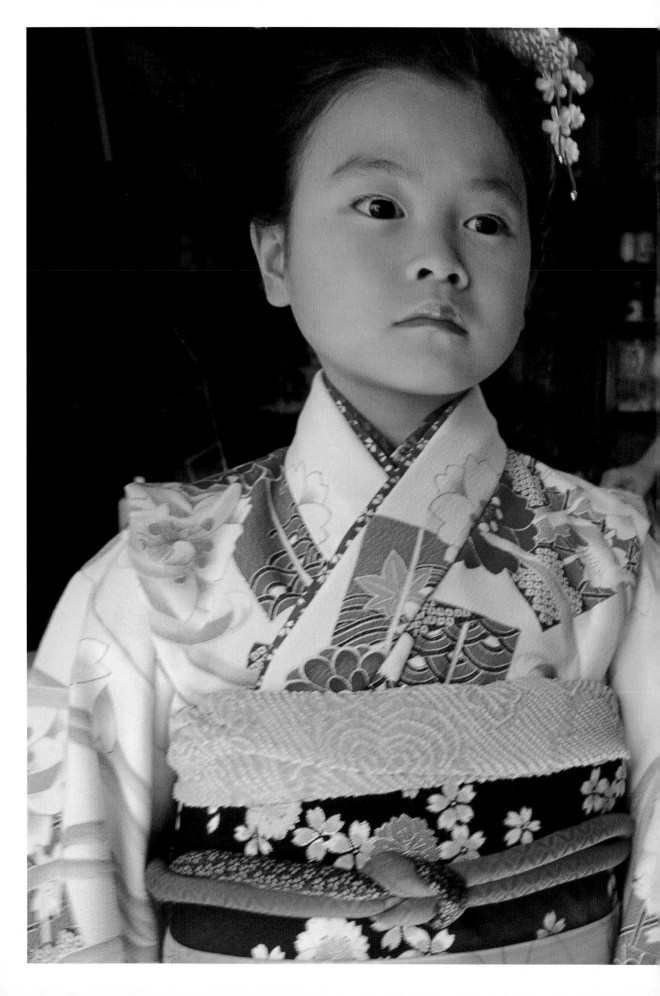

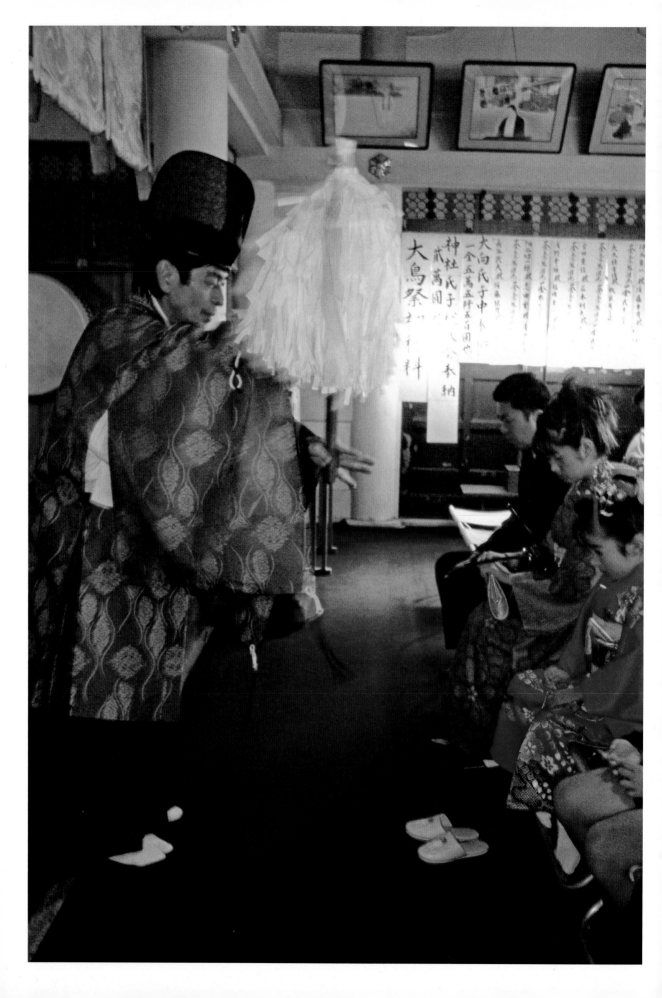

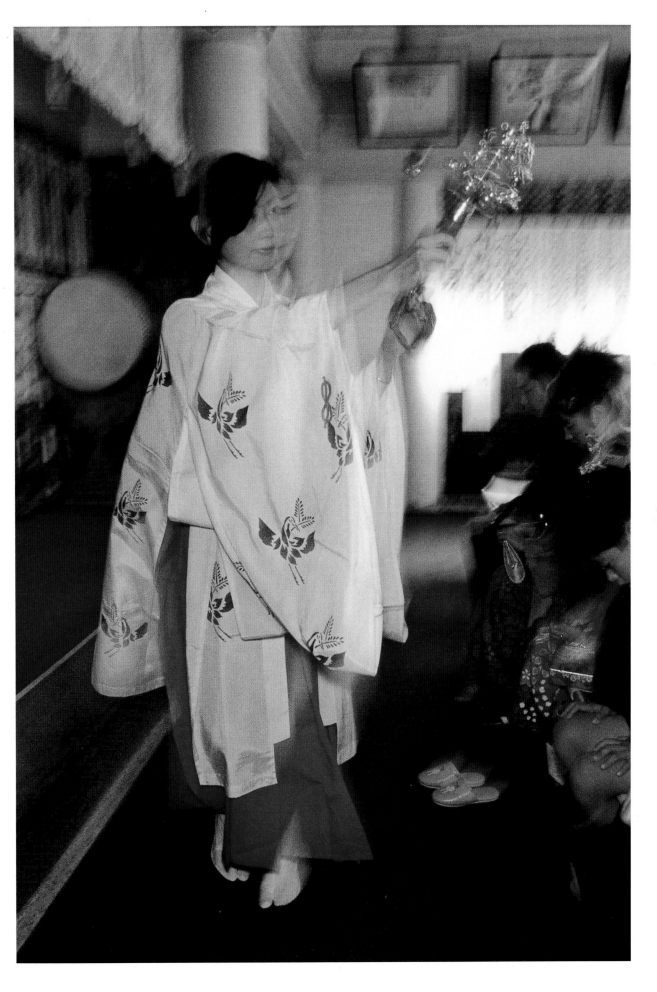

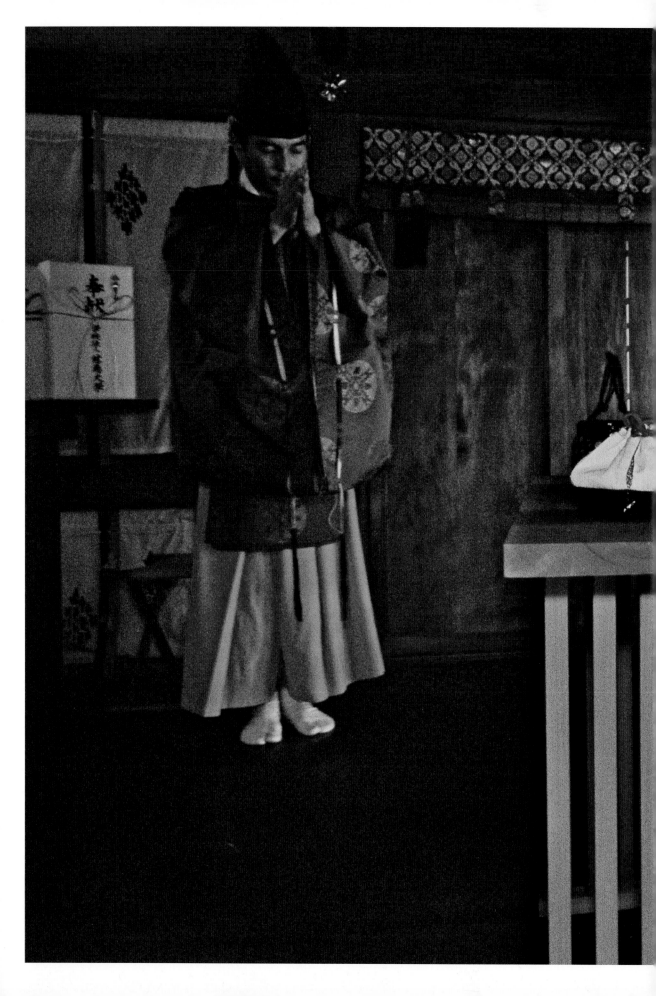

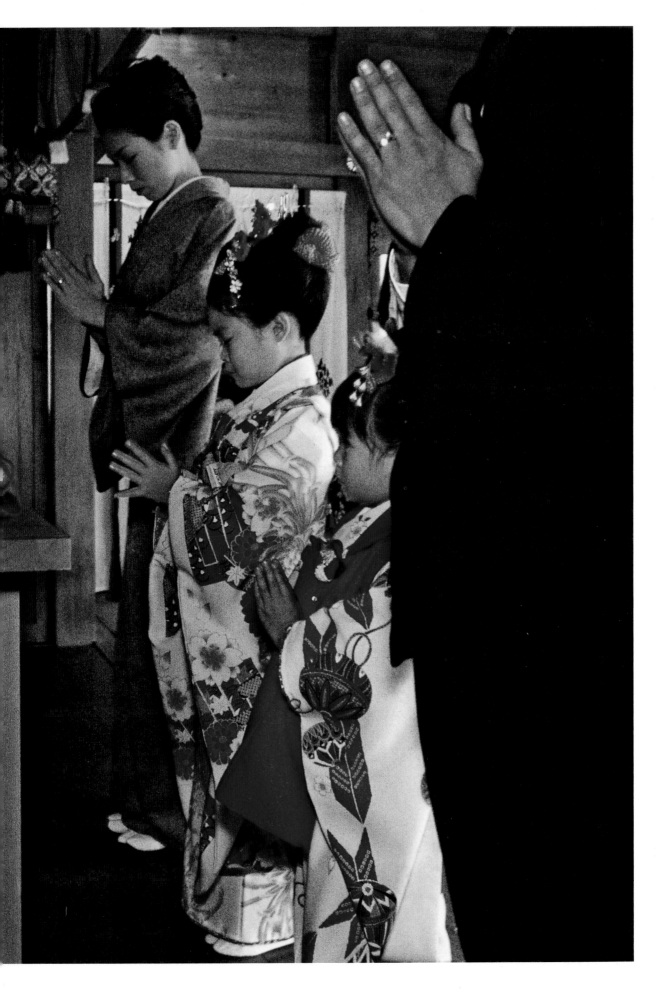

# Shichi-Go-San
## *Tokyo et Kyoto, Japon*

Dans un faible bruissement, le grand prêtre shintoïste se penche en avant et agite son *harai-gushi*, une baguette dotée de bandes de papier blanc froissé. Devant lui, vêtus de kimonos lumineux, Nanako âgé de sept ans et sa sœur de trois ans, Momoko, inclinent la tête avec respect. Les mouvements de la baguette « magiques » sont destinés à les purifier. Le prêtre présente ensuite les fillettes au dieu du sanctuaire, le remercie, puis lui demande de leur accorder une longue et belle vie. À côté des fillettes, leur mère Emiko est vêtue d'un kimono vert tandis que leur père, Naoyuki, porte un costume occidental noir. L'atmosphère qui règne est calme et intime. Des fenêtres en papier de riz s'ouvrent sur le jardin. L'automne est tardif cette année et les couleurs des arbres sont moins vibrantes que d'habitude lors de *Shichi-Go-San*, la cérémonie à laquelle assistent Nanako et Momoko, qui a lieu tous les ans, le 15 novembre.

Pendant Shichi-Go-San (« sept-cinq-trois »), les parents de fillettes âgées de trois et sept ans et de garçons de cinq ans, les habillent en costumes traditionnels et les emmènent dans un sanctuaire shintoïste afin d'être bénis. Trois, cinq et sept sont des repères importants pour les enfants japonais. Autrefois, ils n'avaient le droit de laisser pousser leurs cheveux qu'après l'âge de trois ans ; avant cet âge, leur tête était rasée. À l'âge de cinq ans, les garçons pouvaient porter le *hakama* – un large pantalon plissé – pour la première fois, tandis que les fillettes de sept ans étaient autorisées à nouer leurs kimonos avec une ceinture large nommée *obi*.

La version contemporaine du Shichi-Go-San est apparue dans la région de Kanto et aurait été organisée par le shogun Tokugawa Tsunayoshi pour son fils, Tokumatsu, à la fin du XVIIᵉ siècle. Le rituel s'est ensuite étendu aux cercles aristocratiques, puis à la population entière. Aujourd'hui, nous sommes au sanctuaire d'Aoto Jinja à la périphérie de Tokyo, où le père de Nanako et Momoko a fait lui-même Shichi-Go-San, comme ses ancêtres avant lui. Il s'agit du sanctuaire de Sarutahiko-no-Okami, le dieu gardien de la passerelle entre le ciel et la terre.

« Nous ne sommes pas très religieux », confie Emiko, la mère des fillettes, « mais nous voulons que nos enfants aient une belle vie. »

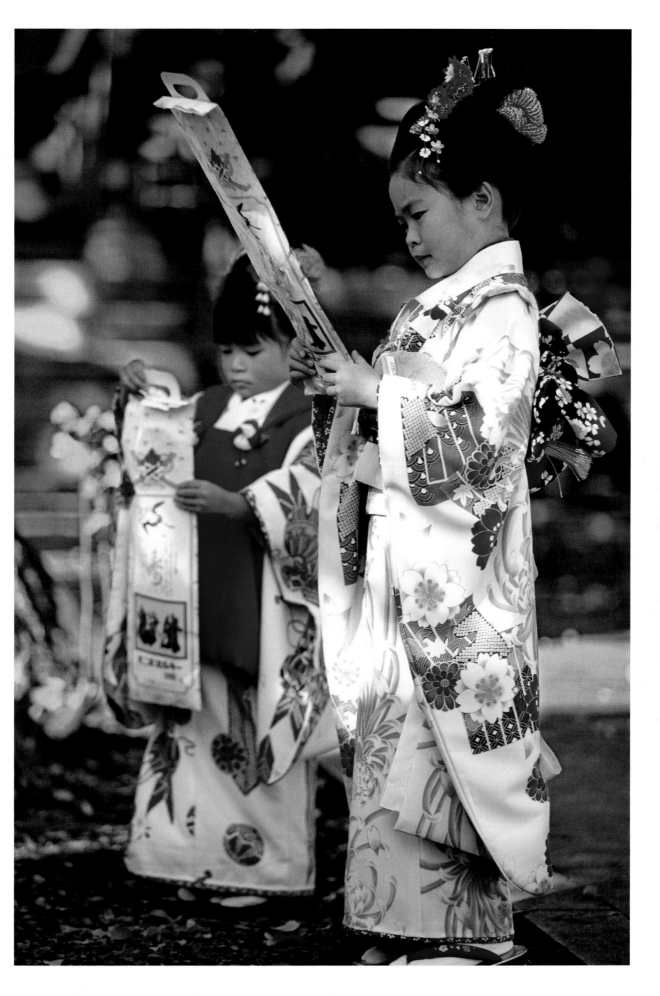

**Right:** In the photographer's studio: the family get ready to pose for the camera.
**Pages 54–55:** A seven-year-old girl and her five-year-old brother hold plastic imitations of bamboo shoots to symbolise growing up with a strong and upright body.
**Pages 56–57:** Some boys have the family emblem embroidered on their clothes. Girls tie their *obis* with a large knot at the back.
**Pages 58–59:** A mother at the Heian Jingu shrine captures the moment for posterity.

**À droite :** La famille prend la pose dans le studio du photographe.
**Pages 54–55 :** Une fillette de sept ans et son frère de cinq ans tiennent des pousses de bambou en plastique, emblèmes d'une croissance dans un corps droit et sain.
**Pages 56–57 :** L'emblème de la famille est parfois brodé sur la tenue des garçons. La ceinture des fillettes s'attache avec un large nœud dans le dos.
**Pages 58–59 :** Au temple Heian Jingu, une maman capte le grand événement pour la postérité.

**Rechts:** Beim Fotografen. Die Familie macht sich bereit, um für das Foto zu posieren.
**Seiten 54–55:** Eine Siebenjährige und ihr fünfjähriger Bruder haben Bambussprossen aus Plastik dabei. Der Bambus symbolisiert das Erwachsenwerden in einem starken, aufrechten Körper.
**Seiten 56–57:** Manche Jungen tragen das Familienemblem auf ihrer Kleidung. Die Mädchen binden ihren Obi zu einer großen Schleife auf dem Rücken.
**Seiten 58–59:** Am Heianjingu-Schrein hält eine Mutter den Augenblick für die Nachwelt fest.

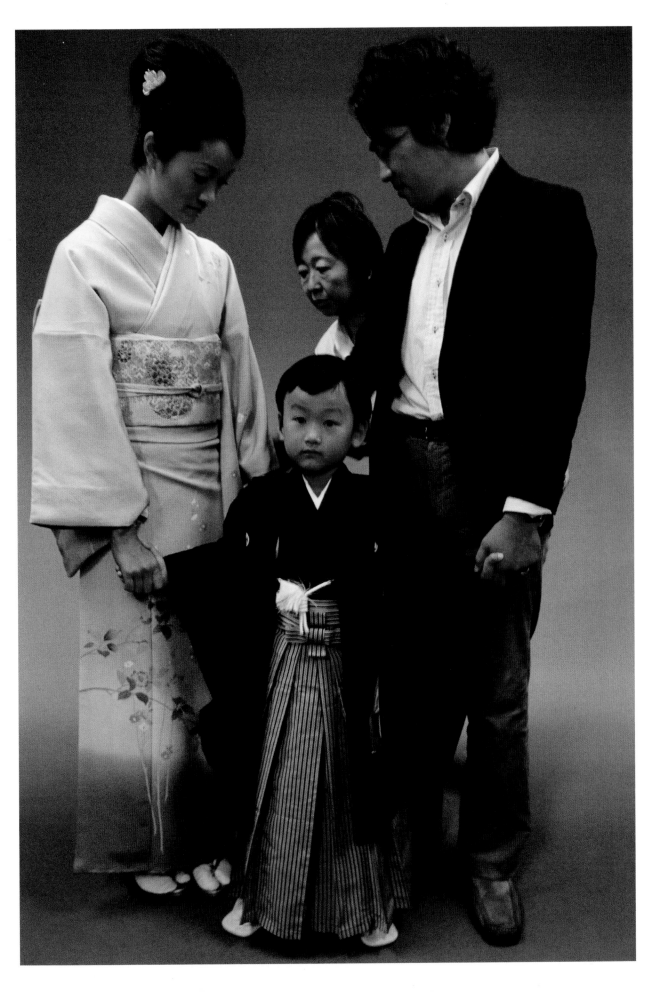

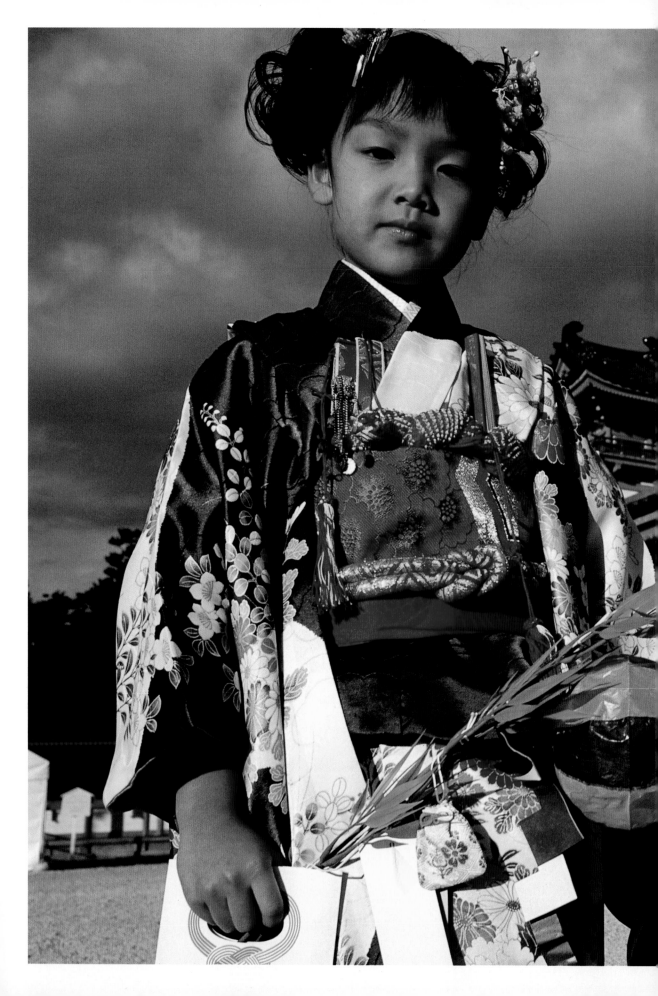

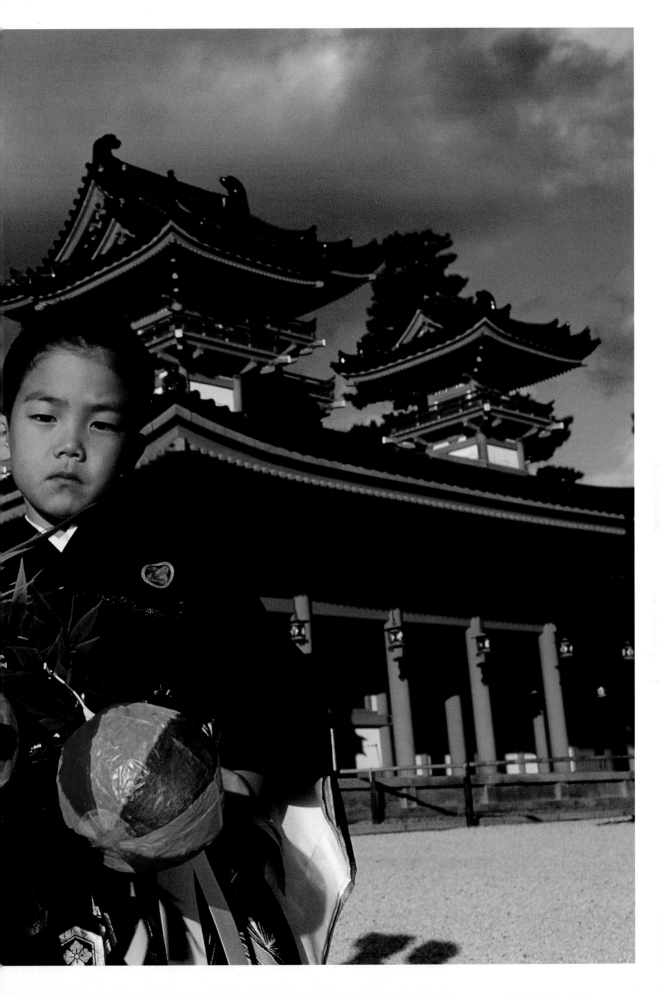

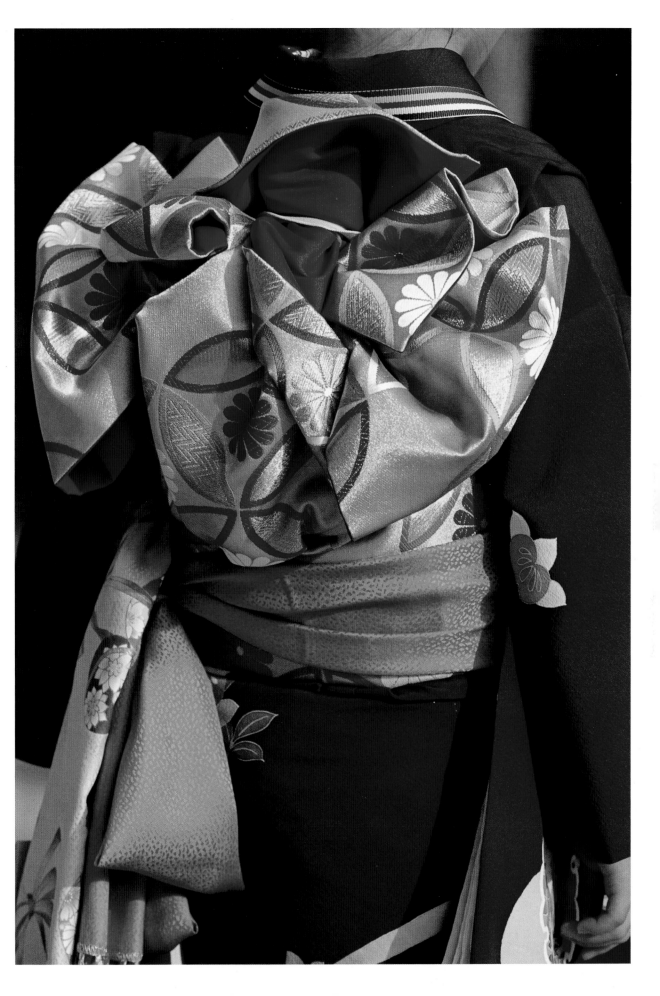

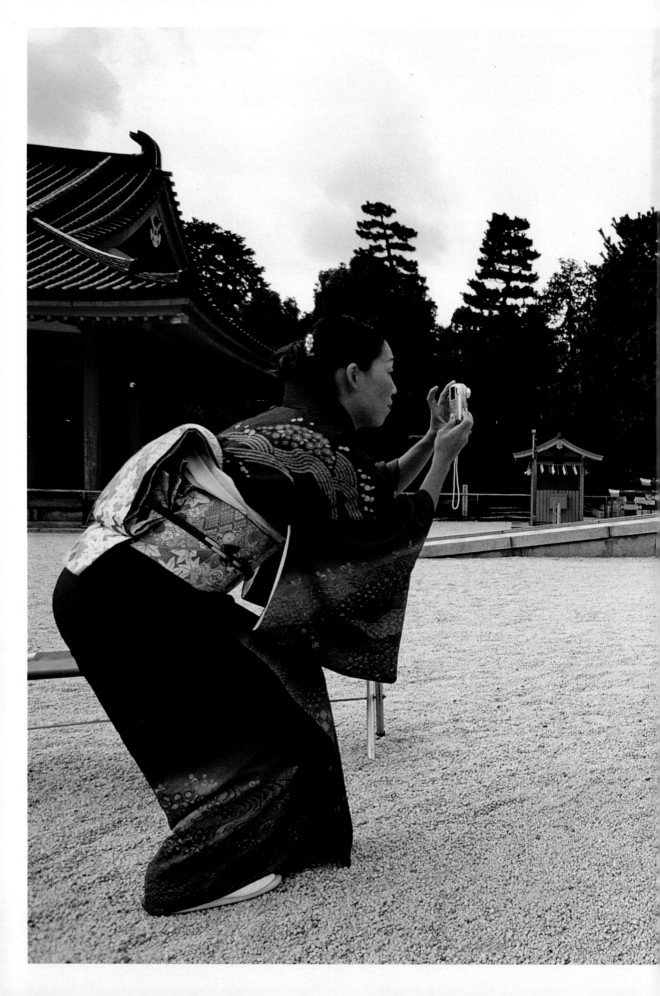

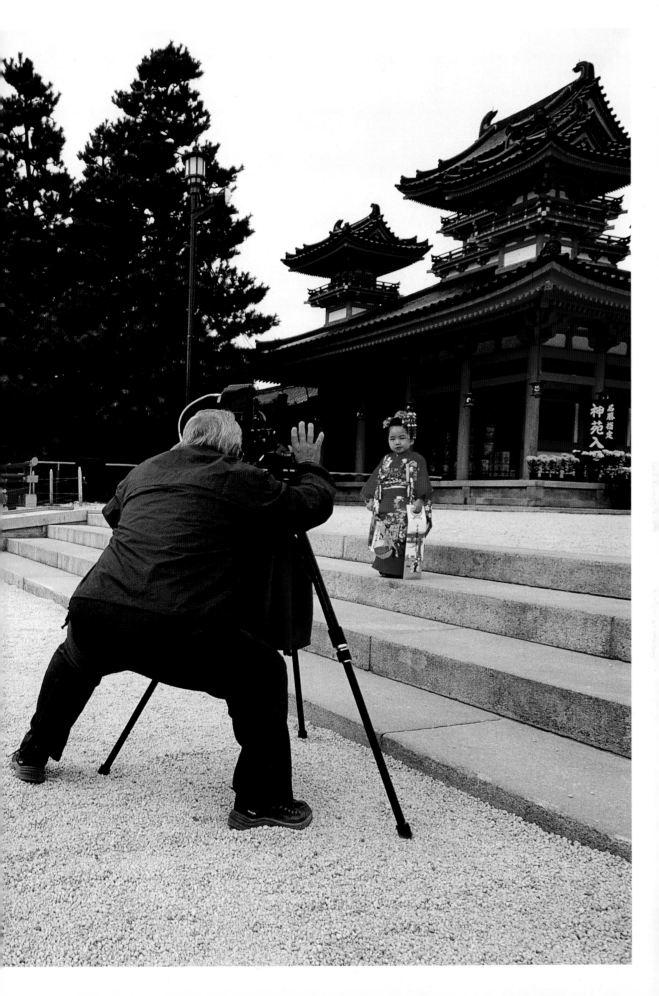

# Shichi-go-san
*Tokio und Kioto, Japan*

Es raschelt leise, als sich der große Schintopriester vorbeugt und seinen Harai-gushi, einen Stab, an dem gefaltete Papierstreifen hängen, hin und her schwingt. Die siebenjährige Nanako und ihre dreijährige Schwester Momoko stehen vor ihm und verneigen sich respektvoll.

Die Bewegungen des Stabs sollen die Mädchen vom Bösen reinigen. Der Priester wendet sich dann dem heiligsten Teil des Altars zu, um die Mädchen dem Gott dieses Schreins anzuvertrauen und ihn zu bitten, ihnen ein langes und glückliches Leben zu schenken.

Den Mädchen zur Seite stehen ihre Eltern: Mutter Emiko in einem moosgrünen Kimono und Vater Naoyuki, der einen dunklen Anzug im Stil westlicher Geschäftsleute trägt. In dem Schrein mit niedriger Decke herrscht eine ruhige und intime Atmosphäre. Quadratische Reispapierfenster öffnen sich zum Garten hin.

Der Herbst ist in diesem Jahr spät dran, die Farben der Bäume sind nicht so lebhaft wie sonst zu Shichi-go-san, der Zeremonie, die Nanako und Momoko gerade feiern und die jedes Jahr am 15. November abgehalten wird.

Während Shichi-go-san (wörtlich: Sieben-fünf-drei) ziehen Eltern ihren drei- und siebenjährigen Töchtern und ihren fünfjährigen Söhnen traditionelle Kleidung an und bringen sie zu einem schintoistischen Schrein, um sie segnen zu lassen. Drei, fünf und sieben Jahre sind wichtige Meilensteine für japanische Kinder. Früher durften Kinder ab drei Jahren ihre Haare wachsen lassen, bis dahin wurden ihre Köpfe rasiert. Mit fünf Jahren war es Jungen zum ersten Mal erlaubt, den Hakama – weite Hosen mit breiten Falten – zu tragen, während Mädchen mit sieben Jahren erstmals ihren Kimono mit einem Obi, einer breiten Schärpe, binden durften.

Die heutige Version von Shichi-go-san entstand in der Region Kanto und soll Ende des 17. Jahrhunderts von dem Schogun Tokugawa Tsunayoshi für seinen Sohn Tokumatsu abgehalten worden sein. Später verbreitete sich das Ritual von Adelskreisen aus auf weitere Bevölkerungsschichten.

Heute sind wir im Schrein Aoto-jinja am Stadtrand von Tokio, wo bereits Nanakos und Momokos Vater wie auch seine Vorfahren Shichi-go-san feierten. Dieser Schrein ist Sarutahiko-no-Okami geweiht, dem Gott, der das Tor zwischen Himmel und Erde bewacht.

„Wir sind nicht sehr religiös", bekennt Emiko, die Mutter der Mädchen, „aber wir wünschen uns für unsere Kinder ein gutes Leben."

**Right:** Accompanied by their older brother, two young boys before their shichi-go-san. Boys sometimes wear *hakama* trousers and perform the ceremony at the age of three, though in bygone days they were not supposed to wear these trousers until they were older.

**À droite :** Accompagné de leur grand frère, deux garçonnets s'apprêtent à célébrer Shichi-Go-San. Les garçons accomplissent parfois ce rituel à l'âge de trois ans, revêtus du *hakama*, le pantalon traditionnel. Par le passé, seuls les enfants plus âgés avaient le droit de le porter.

**Rechts:** Zwei Jungen vor ihrem Shichi-go-san in Begleitung des älteren Bruders. Manchmal wird die Zeremonie schon für dreijährige Jungen abgehalten, die dazu ihre Hakama-Hosen tragen. In früheren Tagen durften sie sie erst anziehen, wenn sie älter waren.

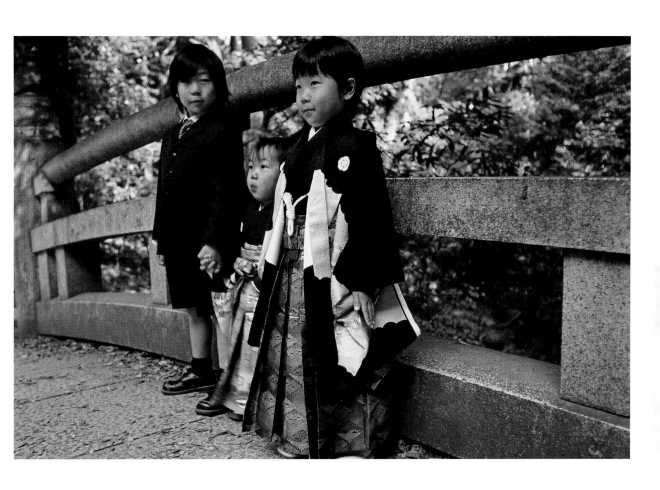

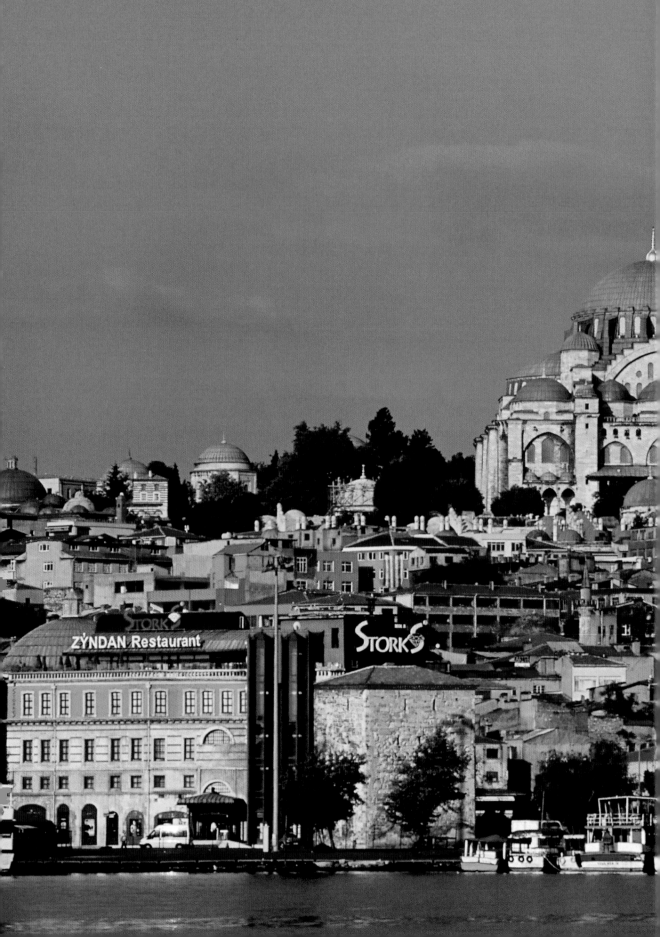

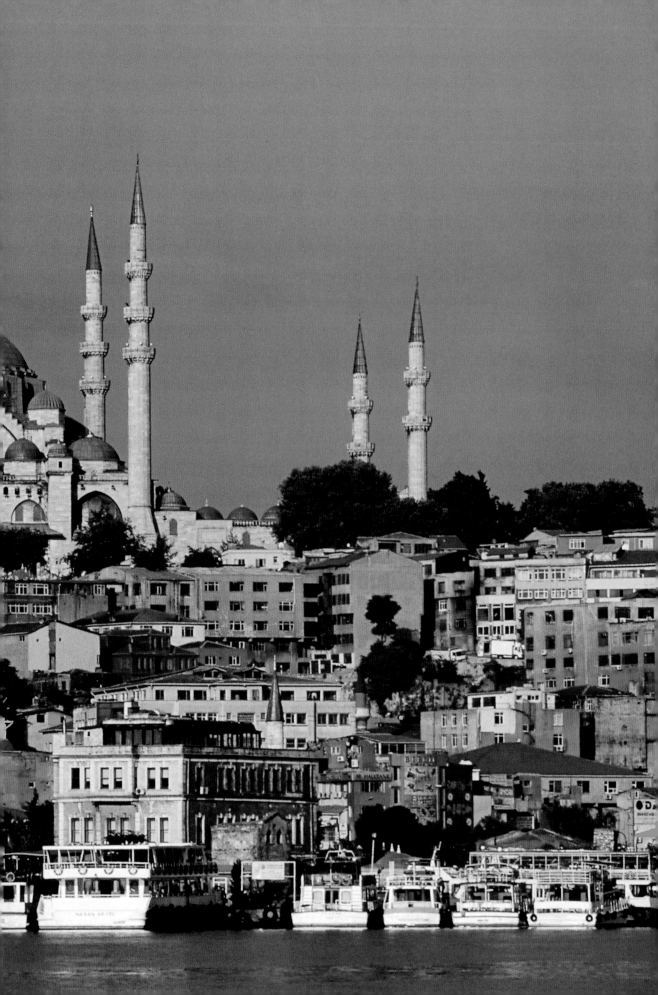

# Circumcision
## Istanbul, Turkey

"Don't worry lads, it doesn't hurt."

Yighit has just received his second painkilling jab and returns to his place on the couch. On hearing his reassuring words, the other boys heave a collective sigh of relief. Then the loudspeaker calls out another name and the next boy, dressed in white and wearing a plumed headdress, approaches the large chair on the platform opposite the circumciser.

It is June and the school holidays have just begun: high season for Turkey's circumcision industry. And an industry it certainly is. When he is done for the day Kemal Özkan and his assistants at *Sünnet Sarayı* ("Circumcision Palace") in Istanbul will have circumcised 114,343 boys since he started out in the profession forty-four years ago.

Circumcision is not compulsory according to the Koran, but the practice is part of the *sunnah* that the Prophet Muhammad decreed as proper observance of Islam. In Turkish, it is known as *sünnet* and is also the name used for ritual circumcision.

Here at the junction of Asia and Europe, the custom is for boys to be circumcised between the ages of five and ten, though these days many doctors advise earlier circumcision in the interest of the patient's psychological welfare.

Kemal Özkan disagrees and instead urges parents to stick to tradition and not allow their sons to be circumcised too early. "The boy must be at least five, otherwise he doesn't understand why the adults are hurting him," he insists.

Özkan tries to make circumcision as positive an experience as possible for the boys. The ceremonies start with games and activities led by a clown. The boys, generally a group of ten to fifteen, then have a quiz, during which they are asked for their name and the name of their favourite football team. Each time the boy is called up to the platform – twice to receive a local anaesthetic and finally for the circumcision itself – his team's song is played.

The circumcisions take place on a raised platform, with the boys' families and relatives a short distance away, clapping the boys to encourage them. Özkan holds up his palm in a "high five" as each boy walks up for his turn. Turkey's most famous circumciser still likes to be involved, but age is catching up with him and as of this year it is his son, Murat, who now performs the procedures.

In 1582 the people of Constantinople celebrated the circumcision of Crown Prince Mehmet, son of Sultan Murad III, for fifty-two days. Circumcision celebrations have never quite reached the same heights since, but every Turkish boy is still treated like a sultan at his circumcision.

Certainly the initiates look the part in their regal outfits, complete with creased trousers, waistcoat, cape, plumed headdress and sceptre. Boys wear this attire in the weeks leading up to circumcision, during which their parents take them to visit mosques and other well-known places in their local area. In Istanbul, these include world-famous attractions such as Hagia Sophia, the Blue Mosque and Eyüp Sultan Mosque, one of Turkey's holiest sites. Boys also wear their sultan outfits while recovering after circumcision.

The boy recovers in a canopy bed. Not just physically weak but also vulnerable to the evil that visitors may bring with them, he is protected by the word *Masallah* ("What God has willed") emblazoned on the bed in big letters.

**Pages 62–63:** Suleiman Mosque in the heart of Istanbul rises up above the Golden Horn.
**Right:** Newly circumcised, this nine-year-old boy, who lives in a suburb of Istanbul, proudly poses in his sultan outfit. As is the custom, his parents have worked hard to make his bed fit for a sultan.

**Pages 62–63:** La mosquée de Suliman au cœur d'Istanbul domine une rive de la Corne d'Or.
**À droite:** Après sa circoncision, ce garçonnet de neuf ans pose fièrement dans son costume de sultan. Selon la coutume, ses parents se sont dépensés pour lui préparer un divan digne d'un sultan.

**Seiten 62–63:** Die Süleymaniye-Moschee im Herzen Istanbuls liegt über dem Goldenen Horn.
**Rechts:** Ein gerade beschnittener neunjähriger Junge, der in einem Vorort von Istanbul lebt, führt stolz sein Sultanskostüm vor. Wie es der Brauch will, haben seine Eltern sich alle Mühe gegeben, sein Bett eines Sultans würdig zu gestalten.

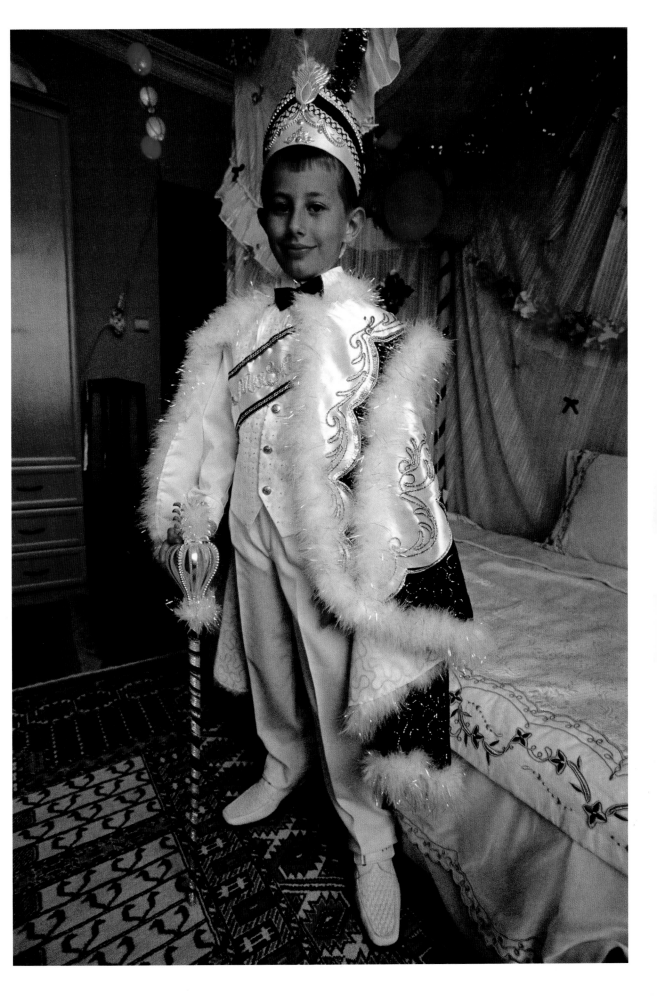

Before or after the circumcision the family invite relatives and friends to a henna party. Henna is associated with joy and happiness. During the party the boy's fingers are daubed, colouring them red. The boy also receives presents in the form of money and small gold coins to ward off the evil eye. If he is lucky, and his parents can afford it, he may get a bicycle, computer or other major gift.

Nowadays many families also hold a party at a local hotel, where the boy sits like a sultan on a throne and receives congratulations from the guests. More traditional families hold a religious ceremony at home with an imam reading passages from the Koran.

Prince Mehmet's circumcision, in 1582 at the age of thirteen, marked his coming of age. Although circumcisions are performed at a younger age nowadays, they are still associated with the transition from boy to man. For this reason the boy is encouraged to be strong and take the circumcision "like a man". Many worry about the procedure beforehand, their anxiety fed by jokes about how circumcisions are done with an axe and saw.

Traditionally, it was the job of a barber to wield the knife, but these days circumcisions are carried out by a licensed circumciser or doctor. They are performed at home, in hospital or in special centres like those of Kemal Özkan, and using local anaesthetic.

Yighit takes his seat again on the sofa, relieved at not feeling any pain after the second painkilling jab. The first one hurt but he feels less nervous about the proceedings now. Eventually his name is called again and he sits down in the plush red velvet chair opposite Murat.

Murat unzips Yighit's trousers and the turban-clad prayer leader chants "*Allahu akbar, Allahu akbar!*" Under the watchful gaze of Yighit's family, Murat gets to work, extending the foreskin with one pair of forceps and clamping it in place with another. He cuts the skin not with a knife but with a hot wire attached to a solder. Yighit stares raptly as the glowing solder traces a line along the forceps, trailing a puff of smoke. He feels no pain and in a few seconds his foreskin is off. Murat applies a sterile gauze dressing and pulls up Yighit's pants and trousers.

"It's done, it's over," cries the clown as music plays from the loudspeakers. Yighit receives a medal to hang round his neck and is swept away onto the dance floor, where his family dances round him. Yighit grins as he sways in time to the music.

His wound needs to be stitched, and after the dance he goes into a nearby room where men in white coats and rubber glove s apply the sutures. When it is over, ten-year-old Yighit returns to the hall, now a man.

# La circoncision
## *Istanbul, Turquie*

« Ne vous inquiétez pas, ça ne fait pas mal. » Yighit vient tout juste de recevoir sa deuxième piqure analgésique et retourne à sa place sur le divan. En entendant ces mots rassurants, les autres garçons poussent un soupir collectif de soulagement. Le haut-parleur appelle le garçon suivant, vêtu de blanc et arborant une coiffe ornée d'une plume. L'enfant s'approche du fauteuil sur la scène en face du circonciseur. Nous sommes en juin, au début des grandes vacances, et c'est le moment fort de l'industrie de la circoncision en Turquie. Le terme industrie est à peine exagéré. À ce jour, au *Sünnet Saray* (« le Palais de la circoncision ») à Istanbul, Kemal Özkan, aidé de ses assistants, a circoncis 114 343 garçons depuis qu'il a commencé dans la profession quarante-quatre ans plus tôt. La circoncision n'est pas obligatoire d'après le Coran, mais elle est inscrite dans la Sunna, compilation de règles à suivre selon le prophète Mahomet pour une juste pratique de l'Islam. En Turquie, la Sunna est appelée Sünnet, de même que le rituel de la circoncision.

Ici, à la frontière entre l'Asie et l'Europe, la coutume veut que les garçons soient circoncis entre cinq et dix ans, bien qu'aujourd'hui certains médecins recommandent de pratiquer la circoncision plus tôt dans l'intérêt psychologique du patient.

Kemal Özkan désapprouve cette volonté et insiste au contraire auprès des parents pour préserver la tradition en leur conseillant de ne pas la pratiquer trop tôt. « Les garçons doivent être âgés d'au moins cinq ans, sinon ils ne comprennent pas pourquoi les adultes leur font mal », insiste-t-il. Özkan tente de faire de la circoncision une expérience positive. Les cérémonies commencent par des activités menées par un clown. Les garçons, généralement en groupe de dix à quinze, répondent ensuite à un questionnaire qui leur demande leur nom ainsi que celui de leur équipe de football favorite. Chaque fois qu'un garçon est appelé – deux fois pour recevoir l'anesthésie locale et enfin pour la circoncision – il entend l'hymne de son équipe favorite.

Les circoncisions ont lieu sur une scène, les parents et les amis de l'enfant restant à proximité, l'encourageant par des applaudissements. Özkan, le plus célèbre circonciseur de Turquie, est présent et participe autant que possible à l'événement, mais il se fait vieux et, cette année, c'est son fils Murat qui pratique la circoncision à sa place.

En 1582, la population de Constantinople célébra la circoncision du prince Mehmet, le fils du sultan Murad III, pendant cinquante-deux jours. Les célébrations des circoncisions n'ont jamais plus été aussi démesurées, mais chaque garçon turc est toujours traité comme un fils de sultan lors de sa circoncision. Les garçonnets arborent une parure somptueuse composée d'un pantalon blanc, d'un gilet, d'une cape, d'une coiffe à plumes et d'un sceptre. Les garçons le portent lors des semaines précédant la circoncision, lorsque leurs parents les emmènent visiter les mosquées ainsi que tous les sites célèbres de la ville. À Istanbul, il s'agit de la mosquée Sainte-Sophie, de la mosquée Bleue et de la mosquée du sultan Eyüp, l'un des lieux les plus sacrés de Turquie. Les garçons portent également leur costume de sultan pendant quelques jours après la circoncision.

Le temps que la plaie guérisse, l'enfant reste à la maison sur un lit à baldaquin. Physiquement affaibli, il est plus vulnérable à l'esprit malin que les visiteurs risquent d'amener avec eux. Le mot *Masallah* (« Selon la volonté de Dieu ») est inscrit

**Pages 68–69:** Sultan outfits for boys on sale in Istanbul's commercial district.

**Pages 68–69:** Costumes de sultan pour garçonnets en vente dans un centre commercial d'Istanbul.

**Seiten 68–69:** Sultan-Outfits in einer Istanbuler Einkaufsstraße.

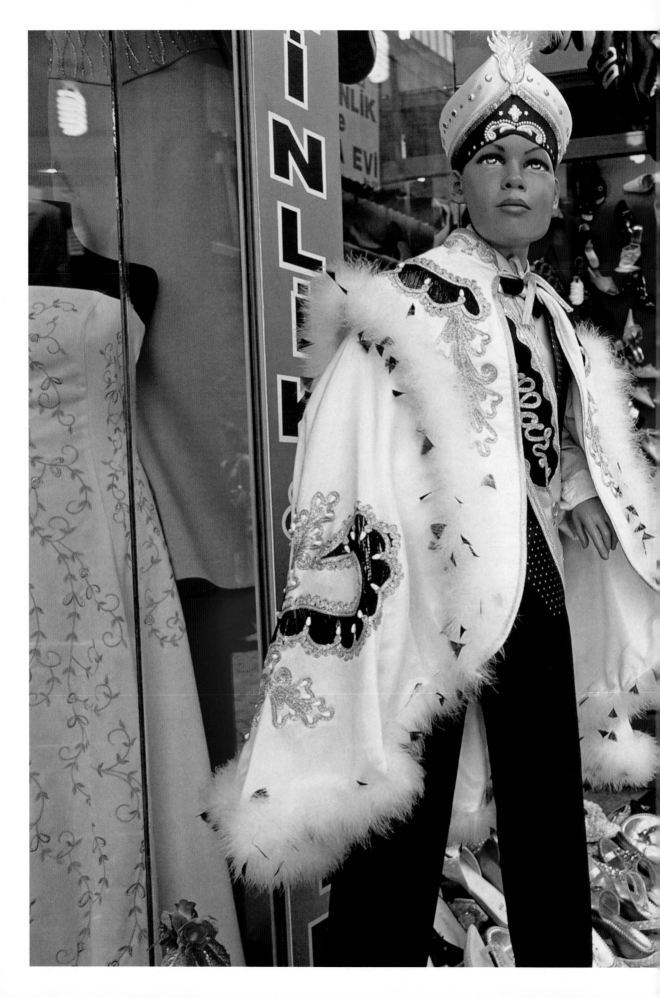

en grosses lettres sur son lit. Avant et après la circoncision, les parents invitent la famille et les amis à la fête du henné. Les doigts de l'enfant sont enduits de henné, symbole de joie et de bonheur. Il reçoit aussi des cadeaux, de l'argent ou de petites pièces d'or pour éloigner le « mauvais œil ». Si ses parents peuvent se le permettre, il recevra une bicyclette, un ordinateur ou un autre gros cadeau. De nos jours, beaucoup de familles organisent une fête dans un hôtel où l'enfant trône tel un sultan et reçoit les félicitations des invités. Les familles plus traditionnelles organisent une cérémonie religieuse à la maison, un imam lisant des passages du Coran.

La circoncision du prince Mehmet, en 1582 à l'âge de treize ans, a ainsi marqué sa majorité. Bien que la circoncision soit de nos jours pratiquée plus tôt, elle reste associée au passage d'enfant à homme ; c'est pourquoi le garçon se doit d'être fort en vivant la circoncision « comme un homme ». Beaucoup d'enfants s'inquiètent à propos de l'acte en lui-même, leur anxiété étant alimentée par des plaisanteries selon lesquelles les circoncisions seraient pratiquées avec une hache ou une scie. Traditionnellement, il s'agissait d'une tâche confiée au barbier qui maniait bien la lame mais, de nos jours, l'opération a lieu systématiquement sous anesthésie locale par des circonciseurs autorisés ou par des médecins, à la maison, à l'hôpital ou dans des centres spécialisés comme celui de Kemal Özkan. Yighit retourne sur le sofa, soulagé de ne pas avoir éprouvé de douleur après la deuxième piqûre analgésique. Finalement son nom est appelé, et il se dirige vers le grand fauteuil rouge en velours devant Murat.

Murat fait glisser la fermeture éclair du pantalon de Yighit tandis que retentissent les chants scandés par des prieurs enturbannés « Allahu akbar, Allahu akbar! » Sous le regard vigilant de la famille de Yighit, Murat tire sur le prépuce avec une paire de forceps tout en le retenant avec une autre. Il sectionne la peau avec un fil chaud relié à un fer à souder. Yighit regarde fixement l'inquiétant fer à souder qui s'approche accompagné d'une légère fumée. Il n'a rien senti et en quelques secondes son prépuce a disparu. Murat applique alors une compresse stérile et remonte le pantalon de Yighit. « Voilà, c'est fini ! » crie le clown, alors que la musique retentit dans les haut-parleurs. Yighit reçoit une médaille et se dirige vers la piste de danse où sa famille l'entoure tendrement. Il sourit en se balançant au rythme de la musique. Sa blessure doit être soignée et, après une danse, il se rend dans une petite pièce où l'attendent des hommes en blouses blanches, munis de gants stériles, pour suturer la plaie. Lorsque c'est terminé, Yighit, âgé de dix ans est devenu un homme.

**Right:** A pre-circumcision visit to the Golden Horn. This lookout point is not far from the Eyüp Sultan Mosque, which welcomes a steady flow of sultan-clad boys and their families during the circumcision season.
**Pages 72–73:** At three-and-a-half, this boy is younger than the usual circumcision age because his parents want him to undergo the ritual with his older brother. The ceremony will be performed at home by a licensed circumciser.

**À droite :** Excursion sur la Corne d'Or avant la circoncision. Cet endroit est proche de la mosquée Eyüp qui accueille nombre de garçonnets costumés en sultan et leurs familles durant la saison de la circoncision.
**Pages 72–73 :** N'ayant que trois ans et demi, ce garçonnet n'a pas encore atteint l'âge d'être circoncis, mais il le sera en même temps que son frère aîné, selon le vœu de ses parents. Le rituel est effectué à la maison par un circonciseur autorisé.

**Rechts:** Ausflug zum Goldenen Horn vor der Beschneidung. Der Aussichtspunkt liegt nahe der Eyüp-Moschee, durch die sich in der Beschneidungssaison ein stetiger Strom als Sultan gekleideter Jungen und ihrer Familien zieht.
**Seiten 72–73:** Mit dreieinhalb Jahren ist dieser Junge jünger als üblich, aber seine Eltern möchten, dass er sich dem Ritual zusammen mit seinem älteren Bruder unterzieht. Die Zeremonie wird zu Hause von einem lizenzierten Beschneider durchgeführt.

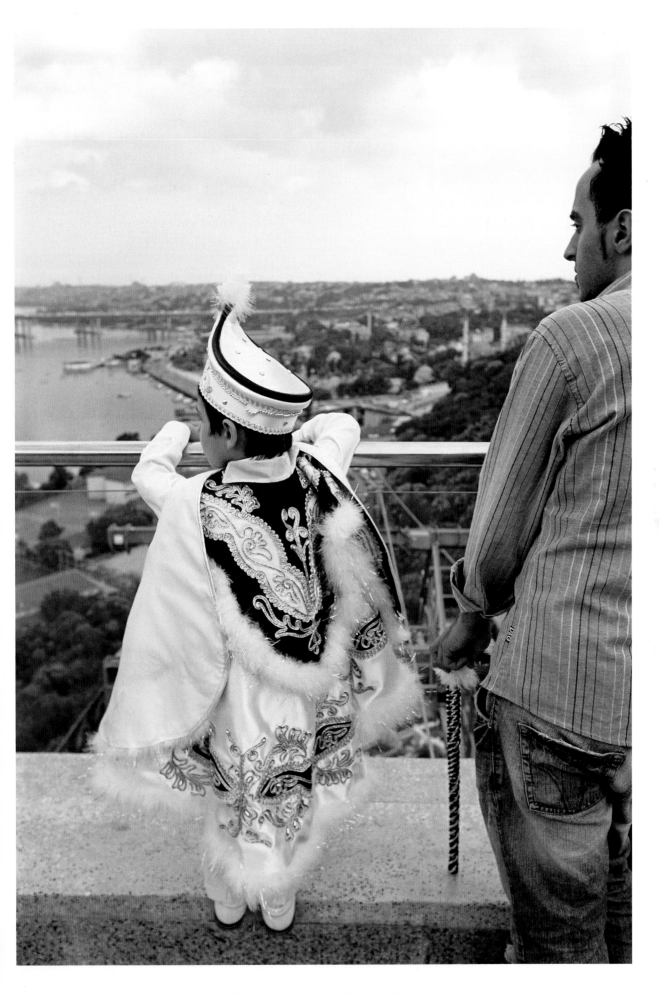

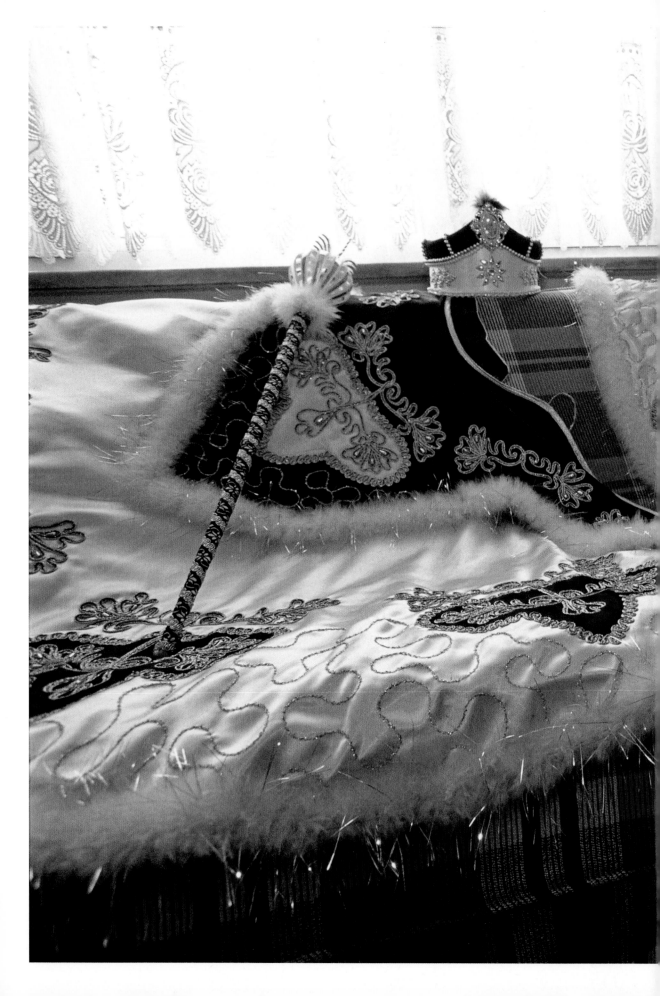

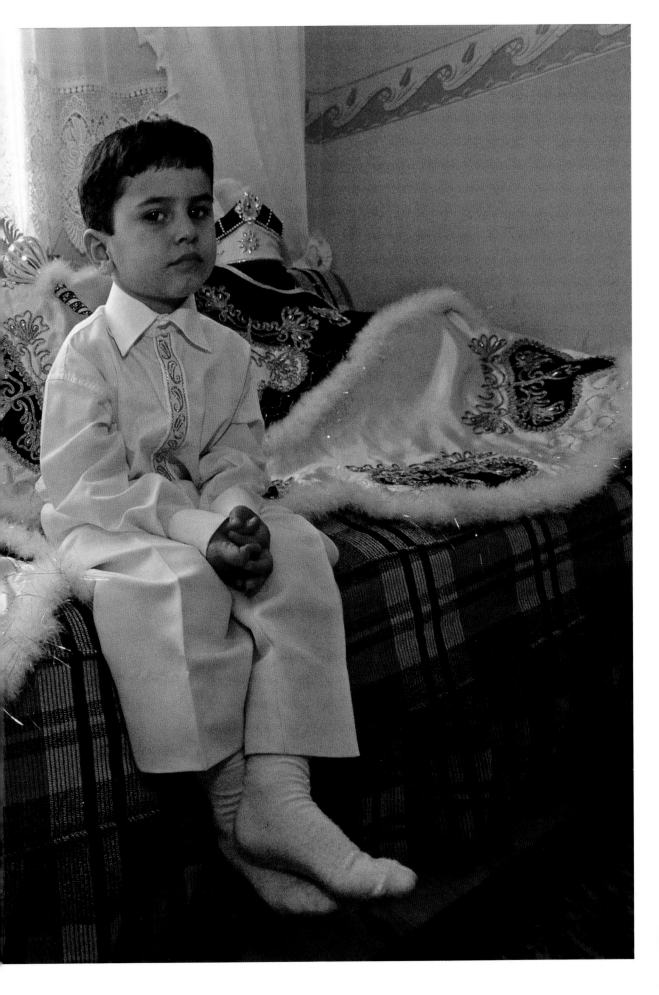

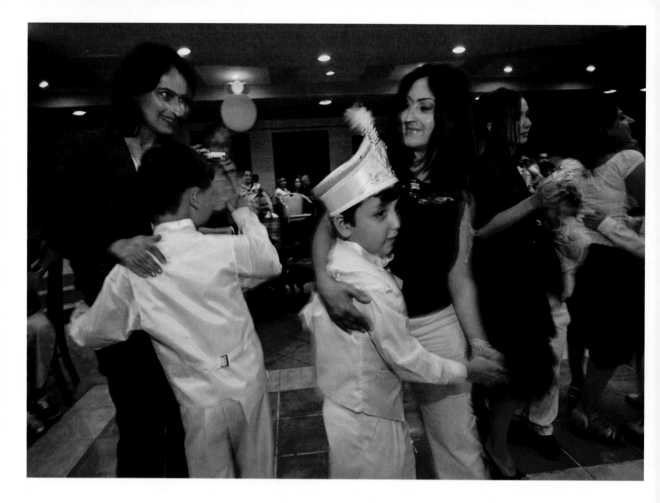

**Above and right:** Kemal Özkan, Turkey's best-known circumciser, works hard to put the boys at ease, organising games and dancing – the boys here dance with their mothers – before the main event. Özkan gives each boy a "high five" as he approaches the circumcision chair.

**Ci-dessus et à droite :** Avant le moment crucial, Kemal Özkan, circonciseur renommé de Turquie, organise des jeux et des danses – ici, les garçons dansent avec leurs mères – pour mettre les enfants en confiance. Özkan encourage chaque garçon avant qu'il ne monte sur le fauteuil de circoncision.

**Oben und rechts:** Kemal Özkan, der bekannteste Beschneider der Türkei, gibt sich viel Mühe, damit die Jungen sich wohlfühlen. Vor dem eigentlichen Ereignis gibt es Spiele und Tanz – hier tanzen die Jungen mit ihren Müttern. Özkan klatscht jeden Jungen auf dem Weg zum Beschneidungsstuhl ab.

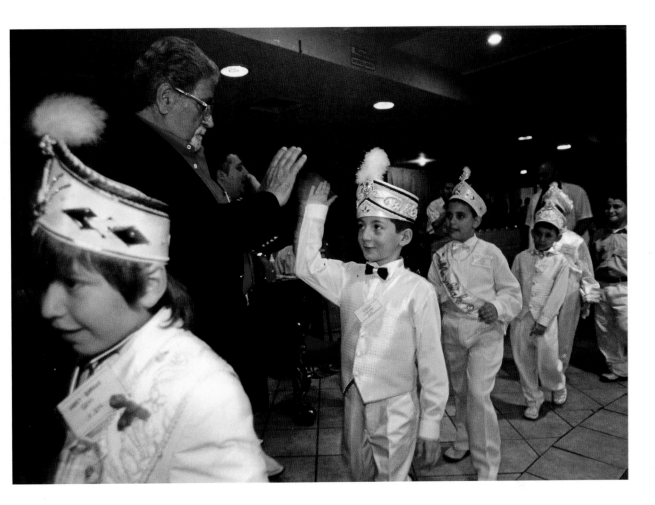

Pages 76–79: Tradition dictates that a close relative holds the boy down during circumcision, but Kemal Özkan and his son Murat insist the boy is alone for the painkilling jabs. No more than a supportive hand on the shoulder is allowed during the actual procedure.

Pages 76–79 : Traditionnellement, un parent proche tient le garçon durant l'intervention, mais Kemal Özkan et son fils Murat préfèrent que l'enfant subisse la coupure douloureuse seul, comme « un grand ». Une main rassurante posée sur l'épaule est toutefois autorisée.

Seiten 76–79: Der Brauch schreibt vor, dass ein naher Verwandter den Jungen während der Beschneidung festhält, aber Kemal Özkan und sein Sohn Murat bestehen darauf, dass der Junge seine Betäubungsspritzen allein bekommt. Während der eigentlichen Prozedur ist nicht mehr als eine tröstende Hand auf der Schulter erlaubt.

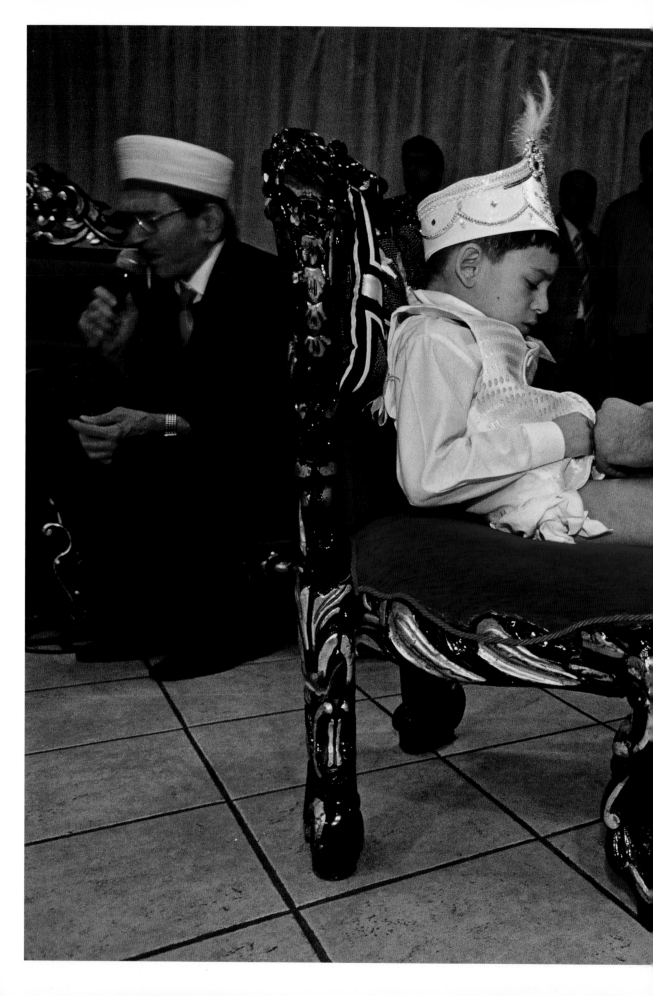

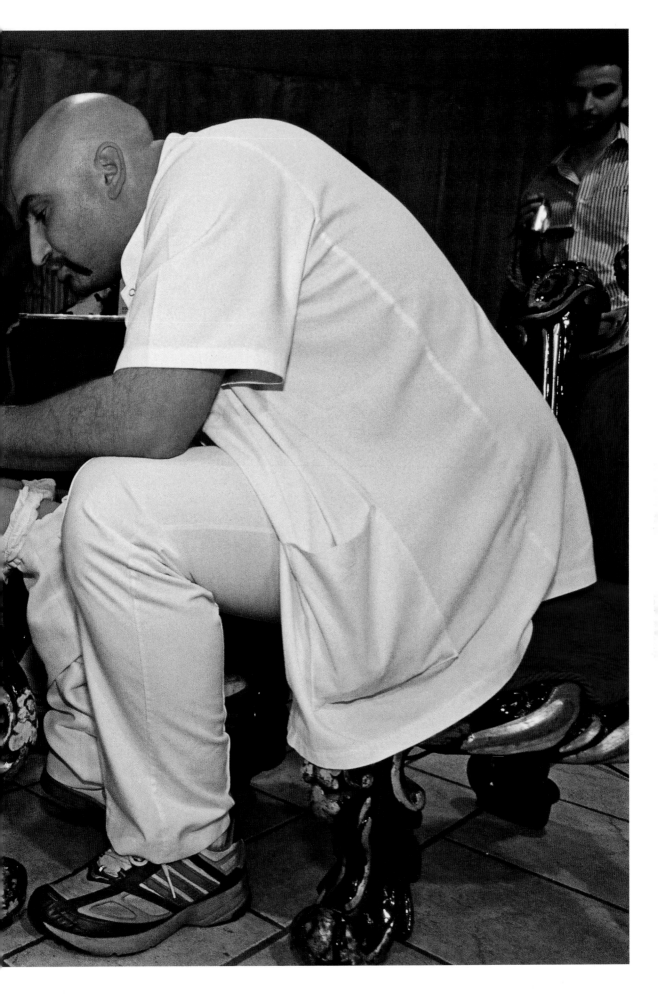

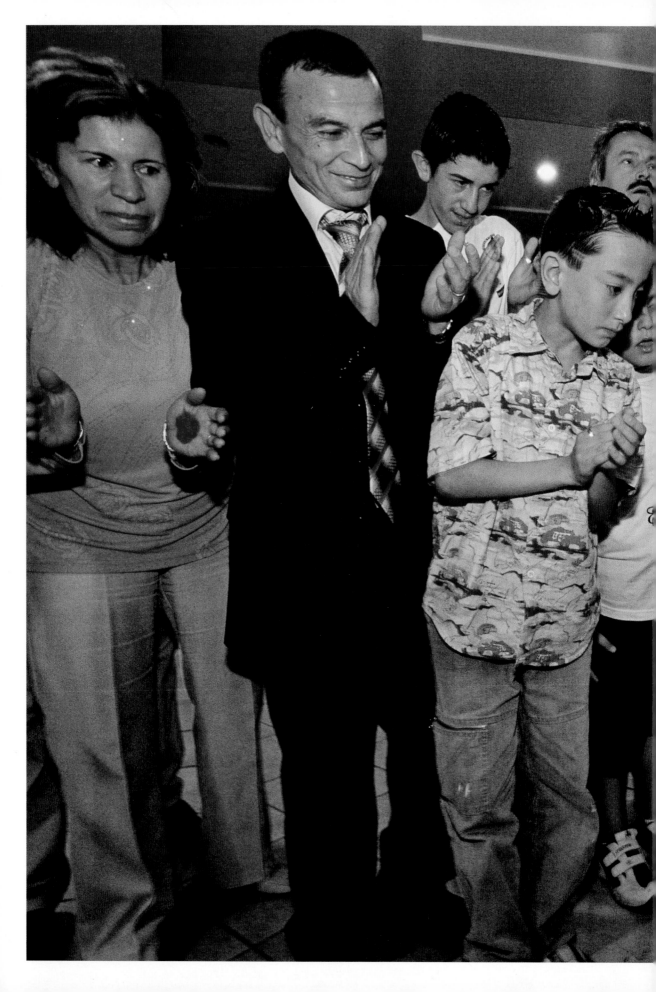

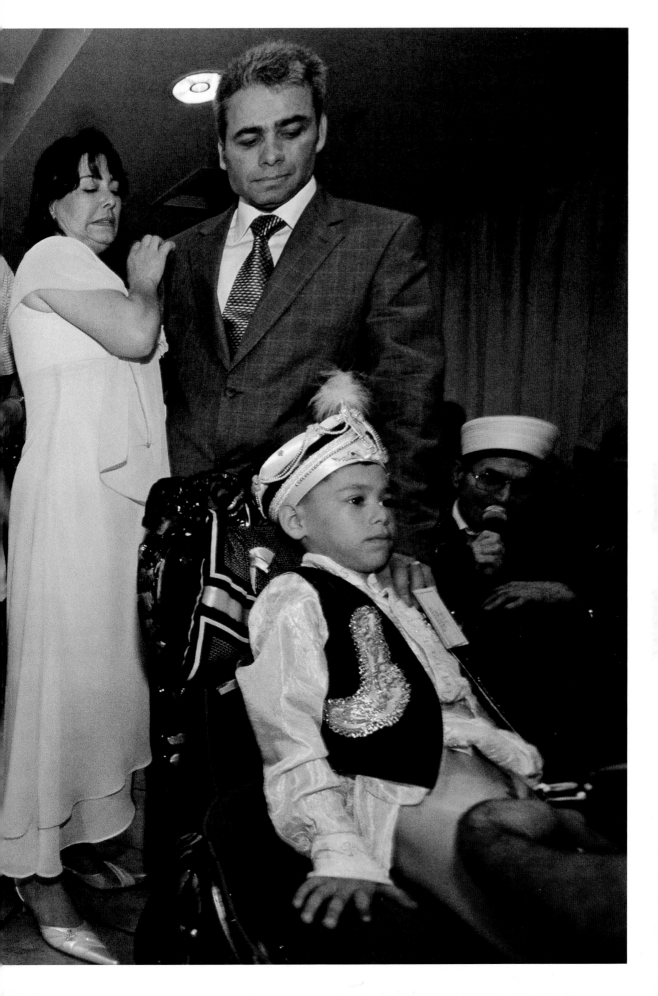

**Right:** The newly circumcised little sultan sits proudly in his ceremonial bed. The word *Masallah* ("What God has willed") is emblazoned on both the canopy and the boy's chest to protect him from malign influences.

**À droite :** Le petit sultan qui vient d'être circoncis, trône fièrement sur son lit d'apparat. Appliqué sur le baldaquin et la chemise du garçonnet, le terme *Masallah* (« Selon la volonté de Dieu ») est censé le protéger des influences malfaisantes.

**Rechts:** Der gerade beschnittene, kleine Sultan sitzt stolz auf seinem zeremoniellen Bett. Das Wort „Masallah" (Was Gott befiehlt) schmückt sowohl den Baldachin als auch die Brust des Jungen, um ihn vor bösen Einflüssen zu schützen.

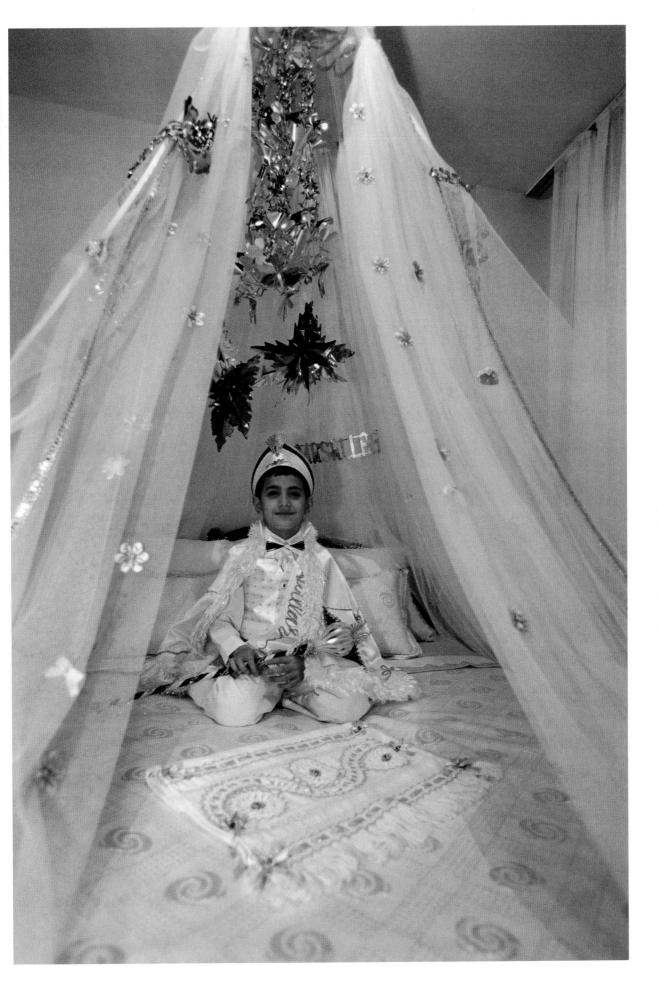

# Beschneidung
## *Istanbul, Türkei*

„Keine Sorge, Jungs, es tut nicht weh." Yighit hat gerade seine zweite Spritze gegen die Schmerzen bekommen und setzt sich wieder auf die Couch. Als sie seine beruhigenden Worte hören, atmen die anderen Jungen gemeinsam auf. Dann erklingt ein anderer Name durch den Lautsprecher, und der nächste Junge, ganz in Weiß und mit einem gefiederten Kopfschmuck, geht auf den großen Stuhl zu, der auf einem Podest gegenüber dem Beschneider steht.

Es ist Juni, und die Ferien haben gerade angefangen: Hochsaison für die Beschneidungsindustrie in der Türkei. Und es ist wirklich eine Industrie. Am Ende dieses Tages wird Kemal Özkan mit seinen Assistenten im Sünnet Sarayı, dem „Beschneidungspalast", den 114 343. Jungen beschnitten haben, seit er vor 44 Jahren seinen Beruf aufnahm.

Der Koran schreibt die Beschneidung nicht vor, aber sie ist Teil der Sunna, in der Mohammed die Verhaltensregeln für Muslime festgelegt hat. Auf Türkisch heißt die Beschneidung Sünnet, und das ist auch der Name für das Ritual.

Hier, wo Asien und Europa aufeinandertreffen, ist es üblich, Jungen im Alter zwischen fünf und zehn Jahren zu beschneiden, obwohl viele Ärzte heute mit Blick auf das psychische Wohlergehen der kleinen Patienten einen früheren Eingriff empfehlen.

Dem stimmt Kemal Özkan nicht zu und drängt die Eltern dazu, sich an die Tradition zu halten und ihren Söhnen keine zu frühe Beschneidung zu gestatten. Er ist sich sicher: „Die Jungen müssen mindestens fünf sein, sonst verstehen sie nicht, warum die Erwachsenen ihnen wehtun."

Özkan versucht, die Beschneidung für die Jungen zu einem so positiven Erlebnis wie möglich zu machen. Die Zeremonien beginnen mit Spielen und Aktivitäten, die von einem Clown angeführt werden. Die Jungen, gewöhnlich eine zehn- bis 15-köpfige Gruppe, werden dann nach ihrem Namen und ihrer Lieblingsfußballmannschaft gefragt. Jedes Mal, wenn ein Junge danach zum Podest gerufen wird – zweimal, um sich eine örtliche Betäubung geben zu lassen, und schließlich zur Beschneidung selbst – wird dann das Lied ihrer Mannschaft gespielt.

Die Beschneidung findet auf einem Podest statt, um das herum die Familie steht und klatscht, um die Jungen zu ermutigen. Özkan hält jedem Jungen, der dran ist, seine Hand zum Abklatschen hin. Aber mittlerweile spürt er sein Alter, und ab diesem Jahr wird sein Sohn Murat die Prozedur durchführen.

1582 feierten die Bürger von Konstantinopel 52 Tage lang die Beschneidung von Kronprinz Mehmet, Sohn des Sultans Murad III. Solche Ausmaße haben Beschneidungsfeiern seither nicht mehr erreicht, aber aus Anlass seiner Beschneidung wird jeder türkische Junge wie ein Sultan behandelt.

Und die Initianden sehen in ihrer fürstlichen Ausstattung inklusive Hosen mit Bügelfalten, Weste, Cape, mit Federn geschmücktem Kopfputz und Zepter wirklich wie kleine Sultane aus. Schon in den Wochen vor der Beschneidung tragen sie diese Montur. Mit ihren Eltern besuchen sie dann Moscheen und bekannte Orte in der Umgebung. In Istanbul gehören dazu weltberühmte Sehenswürdigkeiten wie die Hagia Sophia, die Blaue Moschee und die Eyüp-Sultan-Moschee, einer der heiligsten Orte in der Türkei. Auch in der Zeit, in der die Jungen sich von ihrer Beschneidung erholen, tragen sie ihr Outfit.

**Right:** The sultan's outfit of this circumcised boy includes bow-tie, sceptre and an embroidered cape adorned with a couple of gold coins to ward off the evil eye.

**À droite :** La tenue de sultan du garçonnet circoncis comprend un nœud papillon et une cape brodée à laquelle sont attachées quelques pièces d'or pour éloigner le mauvais œil.

**Rechts:** Zum Sultanskostüm dieses beschnittenen Jungen gehören Fliege, Zepter und ein besticktes Cape. Goldmünzen am Cape sollen den bösen Blick abwenden.

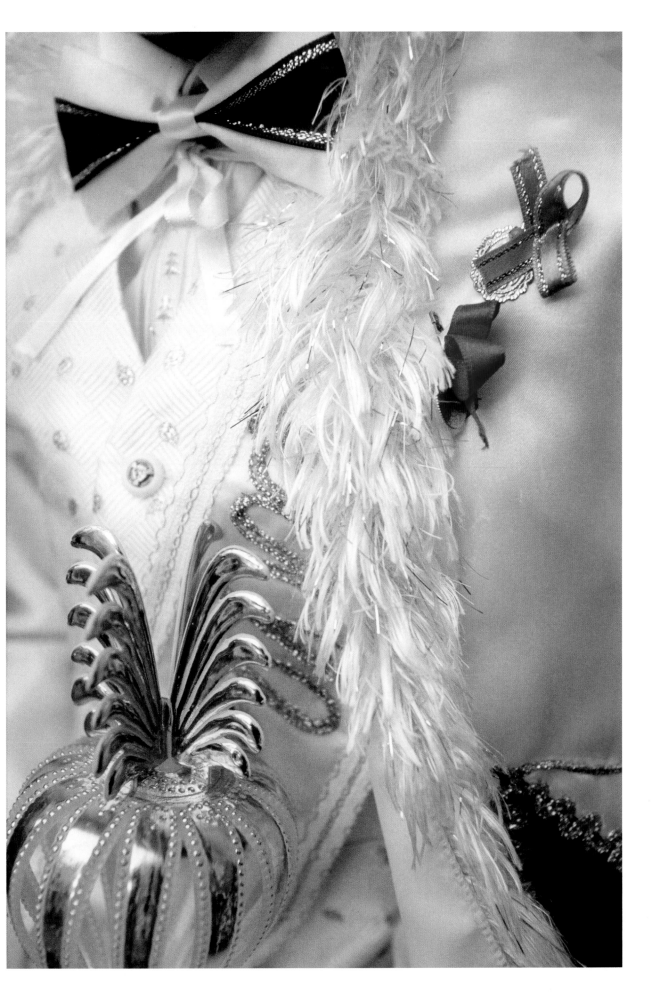

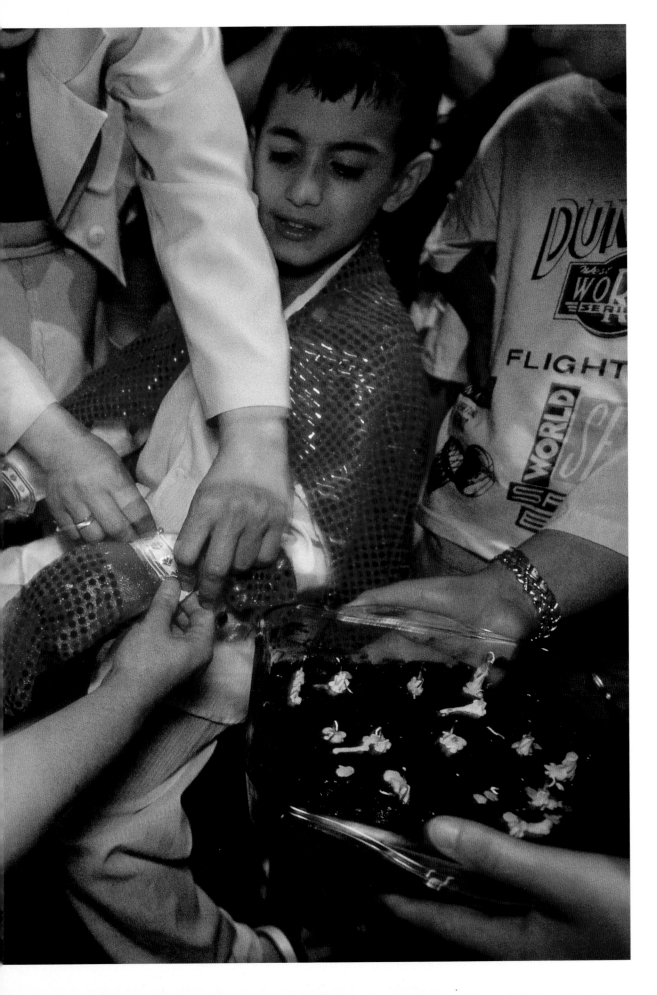

Während die Wunden heilen, liegt der Junge zu Hause auf einem Himmelbett. Da er in dieser Zeit nicht nur körperlich geschwächt ist, sondern auch besonders anfällig für alles Böse, das Besucher mitbringen könnten, wird er von dem Wort „Masallah" (Was Gott befiehlt) beschützt, das in großen Buchstaben das Bett schmückt.

Vor oder nach der Beschneidung lädt die Familie Verwandte und Freunde zu einer Hennaparty ein. Henna wird mit Freude und Glück assoziiert. Im Lauf der Party werden die Hände des Jungen mit Henna bestrichen, bis sie rot sind. Er wird auch mit Geld und kleinen Goldmünzen zur Abwehr des bösen Blicks beschenkt. Wenn er Glück hat und seine Eltern es sich leisten können, bekommt er vielleicht auch noch ein Fahrrad, einen Computer oder ein anderes großes Geschenk.

Heutzutage feiern viele Familien das Fest in einem Hotel, wo der Junge wie ein Sultan auf einem Thron sitzt und die Glückwünsche der Gäste entgegennimmt. Traditionellere Familien halten zu Hause eine religiöse Zeremonie ab, bei der der Imam Verse aus dem Koran liest.

Für den 13-jährigen Prinzen Mehmet markierte die Beschneidung im Jahr 1582 den Übergang zum Erwachsensein. Obwohl heute die Beschneidungen in jüngeren Jahren vollzogen werden, gelten sie immer noch als Übergang vom Kind zum Mann. Aus diesem Grund wird der Junge aufgefordert, stark zu sein und die Zeremonie „wie ein Mann" über sich ergehen zu lassen. Viele machen sich zuvor Sorgen, wobei ihre Ängste noch durch Witze bestärkt werden, in denen es um Beschneidungen mit Axt und Säge geht.

Früher war es Aufgabe des Barbiers, das Messer zu schwingen, aber heute übernehmen das lizenzierte Beschneider oder Ärzte. Der Eingriff wird mit örtlicher Betäubung zu Hause, im Krankenhaus oder in speziellen Zentren wie dem von Kemal Özkan durchgeführt.

Erleichtert darüber, dass er nach der zweiten Spritze keinen Schmerz spürt, setzt sich Yighit wieder auf das Sofa. Die erste hatte noch wehgetan, aber jetzt sieht er der Prozedur gelassener entgegen. Schließlich wird sein Name aufgerufen, und er setzt sich Murat gegenüber auf den vornehmen roten Samtstuhl.

Murat öffnet den Reißverschluss von Yighits Hose, und der Vorbeter im Turban singt: „Allahu akbar, Allahu akbar!" Unter den aufmerksamen Blicken von Yighits Familie macht sich Murat an die Arbeit. Er weitet die Vorhaut mit einer Zange und hält sie mir einer anderen in der richtigen Position fest. Statt mit einem Messer schneidet er die Haut mir einem heißen Draht ab, der mit einem Lötkolben verbunden ist. Yighit starrt ergeben vor sich hin, als der glühende Lötkolben eine Linie entlang der Zange zieht und dabei eine Rauchwolke erzeugt. Er fühlt keinen Schmerz, und in ein paar Sekunden ist seine Vorhaut ab. Murat legt einen sterilen Verband an und zieht Yighits Unterhose und Hose hoch.

„Es ist geschafft, es ist vorbei", ruft der Clown, während Musik aus den Lautsprechern tönt. Yighit bekommt eine Medaille, die er sich umhängt, und wird auf die Tanzfläche mitgerissen, wo seine Familie um ihn herumtanzt. Yighit grinst und wiegt sich im Takt.

Seine Wunde muss versorgt werden, und nach dem Tanz geht er in einen Raum nebenan, wo Männer in weißen Kitteln und Gummihandschuhen sie vernähen. Danach kehrt der Zehnjährige als Mann in den Saal zurück.

**Pages 84–87 and right:**
A henna party is held after the circumcision ceremony. Music and dancing are followed by the boy's fingers being daubed in henna and his hands then wrapped in red bags, while a red cloth bearing the emblem of the Turkish flag is draped over his shoulders to protect his clothes from stains.

**Pages 84–87 et à droite:**
Après le rituel de la circoncision, la fête se poursuit avec musique, danse et applications de henné. Les doigts du garçon sont trempés dans du henné et ses mains enveloppées dans des sacs en toile rouge. On le drape ensuite d'une cape rouge portant l'emblème du drapeau turc, destinée à protéger ses vêtements blancs des taches.

**Seiten 84–87 und rechts:**
Eine Hennaparty nach der Beschneidungszeremonie: Nach Musik und Tanz werden die Finger des Jungen mit Henna bestrichen und seine Hände dann in rote Säckchen gesteckt. Dazu trägt er einen roten Umhang mit den Emblemen der türkischen Nationalflagge, um seine Kleidung vor Flecken zu schützen.

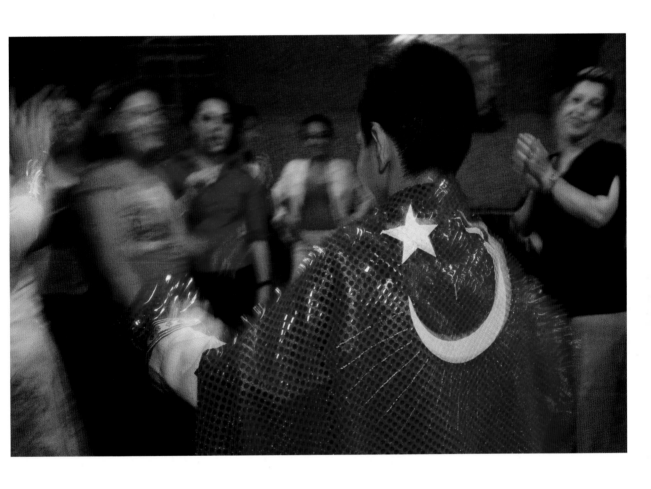

# In the footsteps of Buddha
## Mae Hong Son, Thailand

Locks of hair tumble to the ground in the Wat Hua Wiang Temple courtyard. It is early April – the dry, hot season – and the air in the small town of Mae Hong Son is hazy with the smoke of forest fires burning in the mountains nearby.

A group of boys aged from eight to fourteen are having their hair cut by monks and novices in orange robes. Behind them their families are waiting, holding towels and small metal buckets of water.

The boys are Shan, a people who come mainly from Burma but who also live on the Thai side of the border. Many of them are refugees from the fighting between Shan guerrillas and the Burmese army, though some have lived in Thailand for generations and can trace their roots back to Shan, who moved to Thailand in the early nineteenth century to capture and train elephants for the king of Chiang Mai.

The haircuts mark the start of the annual, three-day *Poy Sang Long* festival, during which Shan boys become novice monks and embark on a month of monastic life to learn about Buddha and his philosophy.

As Buddhists, Shan must earn merit before the next stage in the eternal cycle of death and rebirth. One way of doing so is to become a novice or monk.

But this is a male path not open to women. They earn merit when their sons become novices. Thus, Poy Sang Long is seen as a boy's repayment to his parents, especially to his mother who bore and nursed him. Custom dictates that becoming a novice repays the milk from one of his mother's breasts. If the boy later becomes a monk he repays the milk from the other breast.

By the time the afternoon sun sets behind the temple walls all the boys have had their heads shaved, washed and anointed with a soothing cream-coloured balm. A three-day ceremony now awaits to prepare them for monastic life.

Next morning everyone gets together before sunrise inside the temple, under the watchful gaze of several huge Buddha statues. The polished wooden floor is full of relatives gathered around the boys to help them dress up as princes. This part of the ritual is to commemorate Buddha himself, who was a prince in northern India before starting his journey in search of enlightenment, and his son, Rahula, who was also born a prince but who left the royal household at the age of seven to become a novice and follow in his father's footsteps.

Around twenty boys are dressed as Shan princes in brightly coloured trousers, jackets and headdresses garlanded with flowers. Their imitation gold bracelets, rings and amulets glitter as if made of the real variety.

Neighbours and friends wait outside in the courtyard with small orchestras playing traditional Shan music. The sound of gongs and cymbals fills the air, with rhythmic beats from the drums suspended from the musicians' shoulders.

As princes, the boys are no longer allowed to touch the ground with their feet. When they have put on their outfits their male relatives pick them up and carry them, shielded by golden parasols, on their shoulders down the stairs and outside into the courtyard.

The men dance an energetic jig with the boys still on their shoulders. It is a sea of happy faces, though every now and then one of the boys grimaces in fright as his carrier narrowly avoids doing the splits.

Eventually everyone forms a procession, leaving the temple grounds and mov-

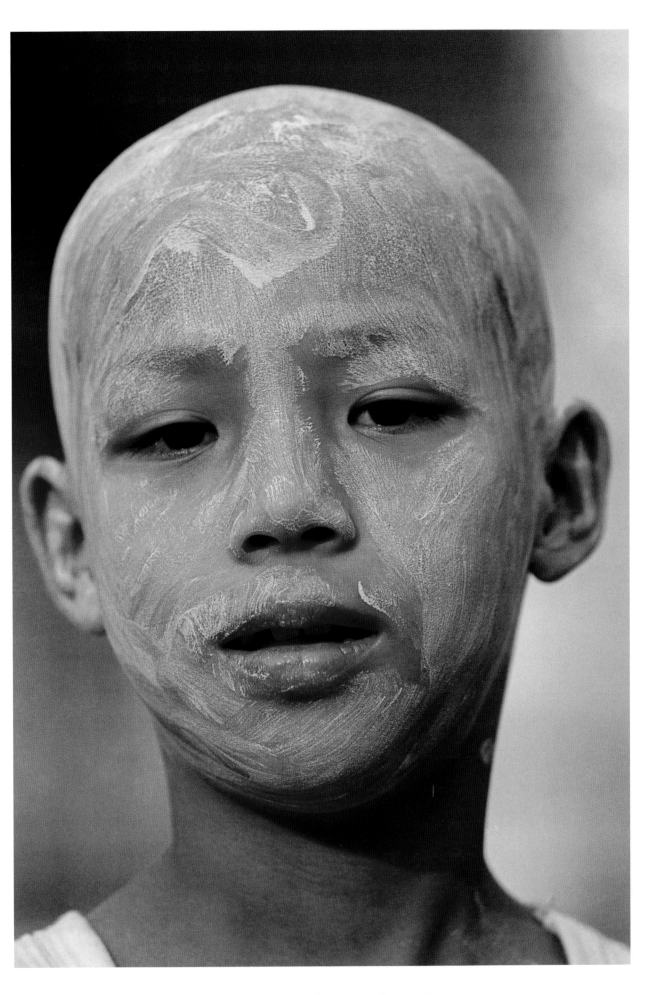

ing out into the streets of Mae Hong Son. A man at the front leads a horse on which the city's guardian spirit is said to ride, and it is the shrine of this spirit that is the pageant's first stop. Here, the boys will pray for happiness and well-being and beg forgiveness for the bad deeds they have committed during their short lives.

Forgiveness is a key theme of the three-day festivities. As well as praying to their guardian spirit for absolution, the boys also ask forgiveness from the monks in the town's various temples, their elderly relatives and others close to the family.

The next two days involve a succession of processions and visits to temples and family members' homes. When darkness falls, the boys and their families return to watch traditional Shan theatre in the temple grounds.

At dawn on the third day everyone gathers again at the temple. On a platform in the packed hall the monks sit in front of the statues of Buddha. The boys sit on the floor below the podium, still wearing their colourful prince's outfits and each of them facing towards a particular monk.

After readings of holy writings and much reverent bowing, the monks unroll the orange novice robes for the boys to put on. This is the moment at which the boys formally become novices.

The robes are identical to those of the monks, consisting of a waistcloth held up by a sash, a thin sleeveless top, which leaves the right shoulder bare, and a piece of cloth tied or wound round the upper body. Apart from his robe, a novice's only possessions are an alms bowl, a razor, a strainer (to prevent him from swallowing insects when drinking) and a needle and thread to mend his robe if it tears.

Once the parents have helped their sons to make sure the right pieces of cloth are in the right places the three-day ceremony is complete, and the relatives and friends file out of Wat Hua Wiang Temple, leaving the boys behind with the monks to embark on their month of novice life.

Life in the temple requires observance of certain rules, such as not injuring or killing any living organism. This is not as easy as it might sound: Wat Hua Wiang is a haven for the town's mosquitoes and at sunset the boys have to flee to their dormitory to avoid being bitten.

The rule permits only two meals a day, the last being just before noon. The boys must find the food themselves, leaving the temple grounds early each morning and walking barefoot on Mae Hong Son's streets with their alms bowls in search of donations.

They do not beg, however, and their walks through town simply invite people to do a good deed by putting food in their bowls and thereby earn merit for their next life in the eternal cycle of existence.

# Sur les traces du Bouddha
## *Mae Hong Son, Thaïlande*

**Pages 96–97:** Head-shaving marks a new stage in a boy's life, in which he puts aside material things to learn the teachings of Buddha.
**Pages 98–99:** A boy's five prince's jackets worn during the Poy Sang Long ceremonies.

**Pages 96–97:** Le rasage du crâne marque une nouvelle phase dans la vie du garçon; il renonce aux choses matérielles pour apprendre les enseignements du Bouddha.
**Pages 98–99:** Les cinq tuniques princières revêtues par les garçons durant les cérémonies de Poy Sang Long.

**Seiten 96–97:** Die Rasur des Kopfes markiert den Beginn eines neuen Abschnitts im Leben eines Jungen, in dem er sich von den materiellen Dingen löst, um die Lehren Buddhas zu studieren.
**Seiten 98–99:** Die fünf Prinzenjacken eines Jungen, die während der Poy-Sang-Long-Zeremonien zum Einsatz kommen.

Les cheveux tombent par milliers dans la cour du temple de Wat Hua Wiang. Nous sommes début avril – la saison sèche et chaude – et l'air dans la petite ville de Mae Hong Son est saturé par les fumées des feux de forêt qui brûlent dans les montagnes alentour. Un groupe de jeunes garçons, âgés de huit à quatorze ans, se voit raser la tête par des moines en robes orange. Derrière eux, leurs familles attendent avec des serviettes et de petits seaux remplis d'eau.

Les garçons sont des Chan, une population qui vient principalement de Birmanie, mais qui vit aussi aux frontières de la Thaïlande. Bon nombre sont des réfugiés, suite aux guérillas entre les Chan et l'armée birmane. Ainsi, certains vivent en Thaïlande depuis des générations et retrouvent leurs racines avec les Chan qui se sont installés en Thaïlande au cours du XIX<sup>e</sup> siècle pour élever des éléphants destinés au roi de Chiang Mai.

La tonte des cheveux marque le début du festival annuel de *Poi Sang Long*. Après trois jours, les garçons Chan deviendront des moines novices, qui vont se livrer à un mois de vie monastique afin d'apprendre qui est Bouddha et quelle est sa philosophie. En tant que bouddhistes, les Chan doivent mériter d'atteindre l'étape suivante dans le cycle éternel de la mort et de la renaissance. Une des voies possible consiste à devenir un novice ou un moine.

Il s'agit là d'un chemin réservé aux hommes. Les femmes acquièrent leur mérite lorsque leurs fils deviennent novices. Poi Sang Long est très attendu par les parents, surtout par les mères qui ont donné la vie aux enfants et les élèvent. Selon la croyance, devenir novice compense le don de lait offert par l'un des seins de la mère. Si l'enfant devient plus tard un moine, il aura rendu le don de lait fourni par l'autre sein.

Au moment où les rayons du soleil tombent derrière le mur du temple, tous les garçons doivent avoir la tête rasée, lavée et recouverte d'un baume apaisant. Une cérémonie de trois jours les attend maintenant afin de les préparer à la vie monastique. Le lendemain matin, ils se réuniront dans le temple avant le lever du soleil, sous le regard vigilant de plusieurs statues du grand Bouddha. Tous les parents sont déjà là, entourant les enfants pour les aider à s'habiller comme des princes. Cette partie du rituel est censée commémorer la quête de l'illumination entreprise par Bouddha, prince du nord de l'Inde, et de son fils Rahula, qui quitta la maison royale à l'âge de sept ans pour devenir novice et suivre les traces de son père. Une vingtaine de jeunes garçons sont ainsi vêtus comme des princes Chan, avec des pantalons aux couleurs chatoyantes, des vestes et des coiffes décorées de fleurs. Leurs bracelets, leurs anneaux et leurs amulettes dorés brillent comme de l'or véritable. Voisins et amis attendent dans la cour, accompagnés par un petit orchestre de musique traditionnelle Chan. Le son des gongs et des cymbales remplit l'air, tandis que résonnent les battements rythmés des percussions accrochées aux épaules des musiciens.

En tant que princes, les garçons ne sont plus autorisés à toucher le sol avec leurs pieds. Une fois parés de leurs costumes, les hommes de leur famille les portent sur les épaules, et protégés sous des ombrelles dorées, ils descendent les marches jusqu'à la cour. Les hommes se mettent alors à danser frénétiquement au sein d'une mer de visages heureux, même si l'un ou l'autre des garçons cahotés ne peut retenir une grimace de frayeur, de peur de tomber. Finalement, tout le monde forme un cortège, quittant le temple pour remplir les rues de Mae Hong Son. Un homme accom-

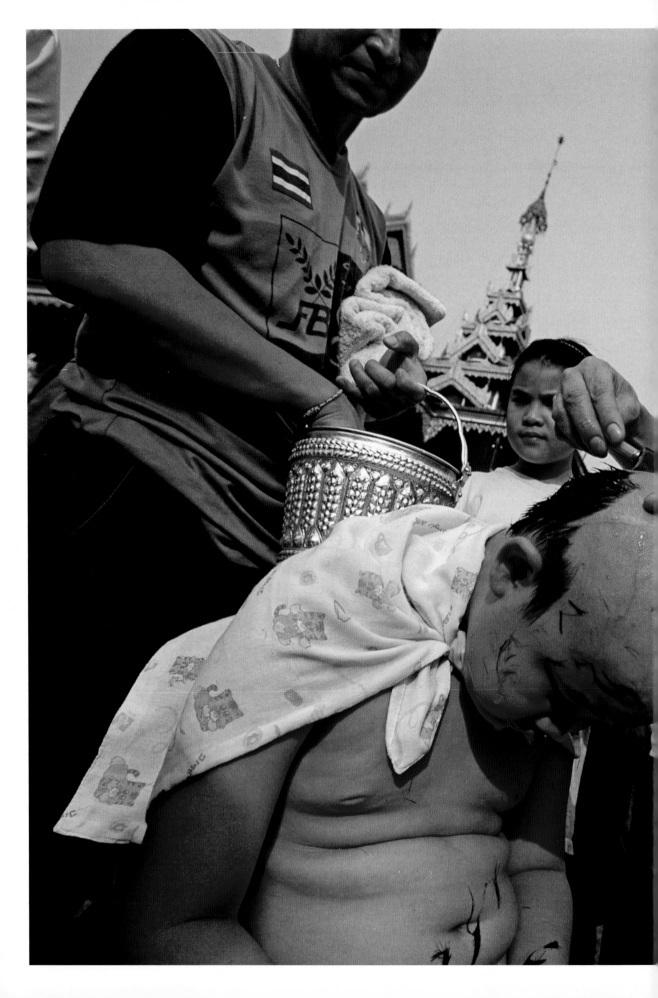

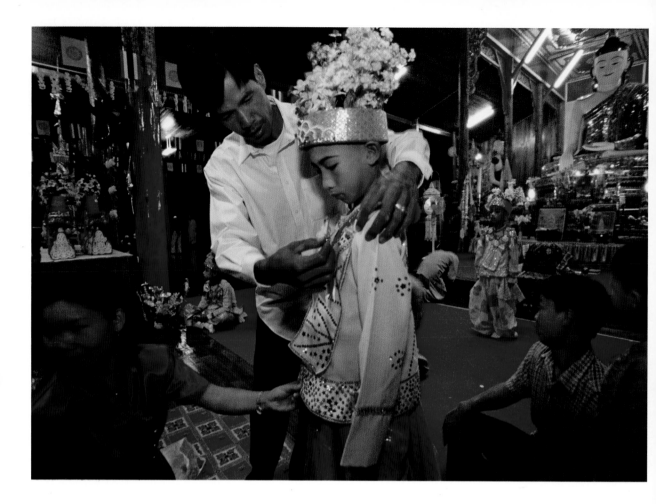

pagné d'un cheval chevauché par « l'esprit gardien de la ville » ouvre la marche. Les jeunes garçons prient ensuite pour le bonheur et le bien-être et demandent pardon pour les mauvais actes qu'ils ont commis depuis leur naissance.

Le pardon est la clé de voûte de ces trois jours de festivités. Les garçons ne prient pas seulement pour obtenir l'absolution de leurs gardiens spirituels, mais demandent aussi pardon aux moines des différents temples de la ville, à leur famille et à leurs proches. Les deux jours suivants donnent lieu à de nombreuses processions et à des visites aux temples, ainsi qu'aux maisons familiales. Lorsque la nuit tombe, les enfants et leurs familles rentrent pour assister au spectacle de théâtre traditionnel Chan dans la cour du temple.

À l'aube du troisième jour, tout le monde se réunit au temple. Là, sur une scène décorée, les moines sont assis devant les statues du Bouddha. Les jeunes garçons, toujours parés de leur costume princier, font chacun face à un moine. Après une lecture des écrits sacrés et de nombreux saluts respectueux, les moines déroulent les robes orange destinées aux novices. C'est à ce moment même que chaque garçon devient véritablement novice.

Les robes sont identiques à celles des moines, constituées d'un drapé retenu par une ceinture, d'un haut sans manche qui laisse l'épaule droite à découvert, et enfin d'une pièce de tissu nouée autour du buste. Hormis cette robe, un novice ne possède qu'un bol d'aumône, un rasoir, une passoire (pour éviter qu'il avale des insectes lorsqu'il boit) et une aiguille avec du fil pour recoudre sa robe si elle se déchire.

Une fois que les parents ont aidé leur fils à s'habiller, les trois jours de cérémonie s'achèvent et la famille quitte le temple de Wat Hua Wiang, laissant les enfants avec les moines qui les emmènent pour un mois de vie de novice.

**Above and right:** The day after the head-shaving, the boys dress up as princes to commemorate Buddha, who was born a prince in northern India. These days, most parents buy headdresses with paper flowers, but some still follow the tradition of using the braided hair of a female relative and real flowers.

**Ci-dessus et à droite :** Le lendemain de la cérémonie de rasage du crâne, les garçons revêtent leurs tenues somptueuses pour commémorer le Bouddha, né prince dans le nord de l'Inde. Aujourd'hui, la plupart des parents achètent des coiffes de fleurs en papier, mais certains perpétuent la tradition consistant utiliser des fleurs fraîches et la natte d'une parente proche.

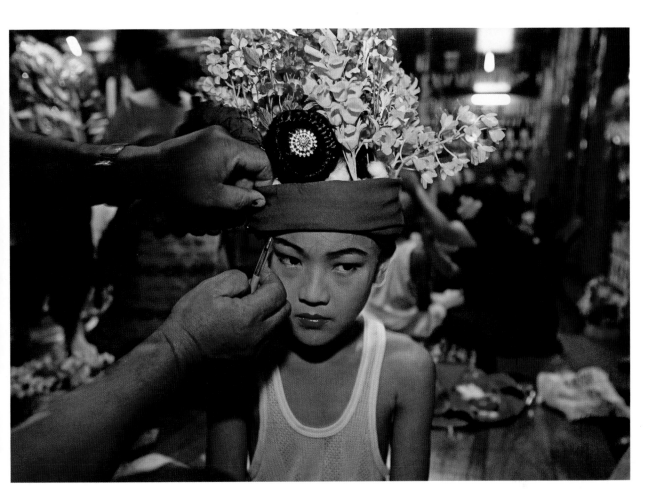

**Oben und links:** Am Tag nach der Kopfrasur kleiden sich die Jungen wie Prinzen, um an Buddha zu erinnern, der als Prinz im nördlichen Indien geboren wurde. Heutzutage kaufen die meisten Eltern Kopfbedeckungen mit Papierblumen, aber manche bleiben der Tradition treu und benutzen das geflochtene Haar einer Verwandten und echte Blumen.

La vie dans le temple requiert le respect de certaines règles, comme de ne blesser ou tuer aucun organisme vivant. Ce qui s'avère plus difficile qu'il n'y paraît, puisque Wat Hua Wiang est un paradis pour les moustiques et, au coucher du soleil, les enfants doivent se réfugier dans leur dortoir pour éviter de se faire piquer. Les règles permettent uniquement deux repas par jour, le dernier étant juste avant midi.

Les jeunes garçons doivent trouver la nourriture eux-mêmes, en quittant le temple tôt le matin pour arpenter, pieds nus, les rues de Mae Hong Son avec leur bol d'aumône en quête de donations. Toutefois, ils ne mendient pas, leur présence dans les rues incite la population à faire une bonne action en déposant de la nourriture dans leur bol, leur fournissant ainsi une occasion de gagner en mérite pour leur prochaine vie dans le cycle éternel de l'existence.

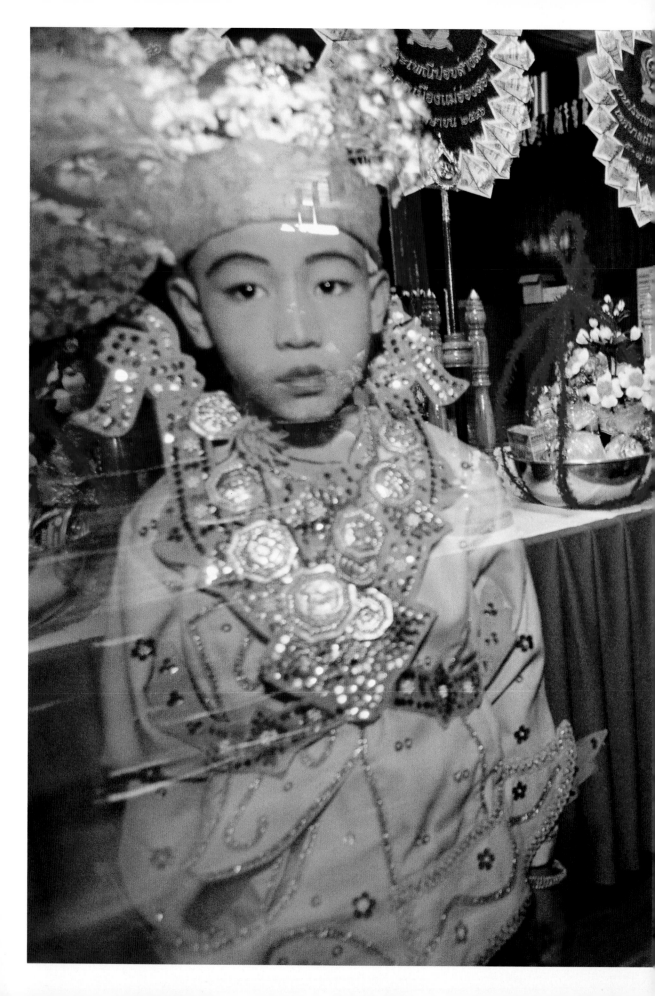

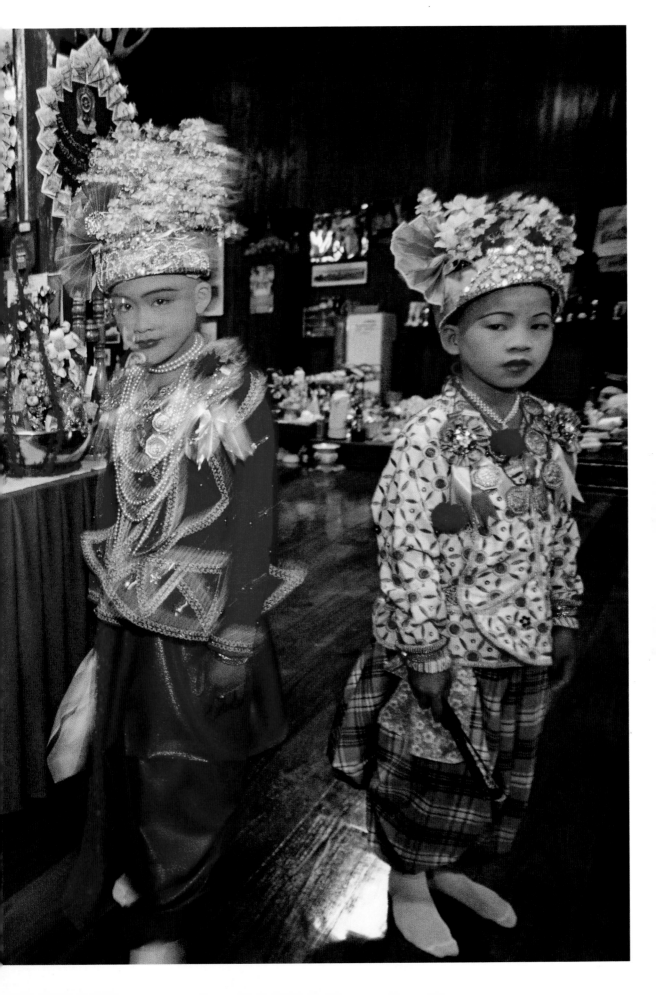

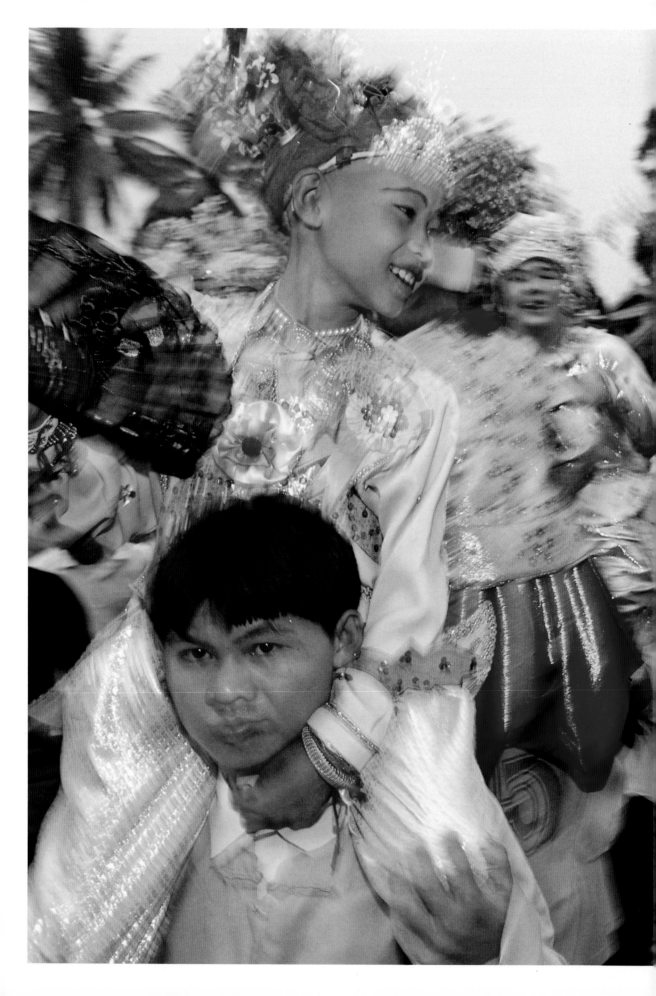

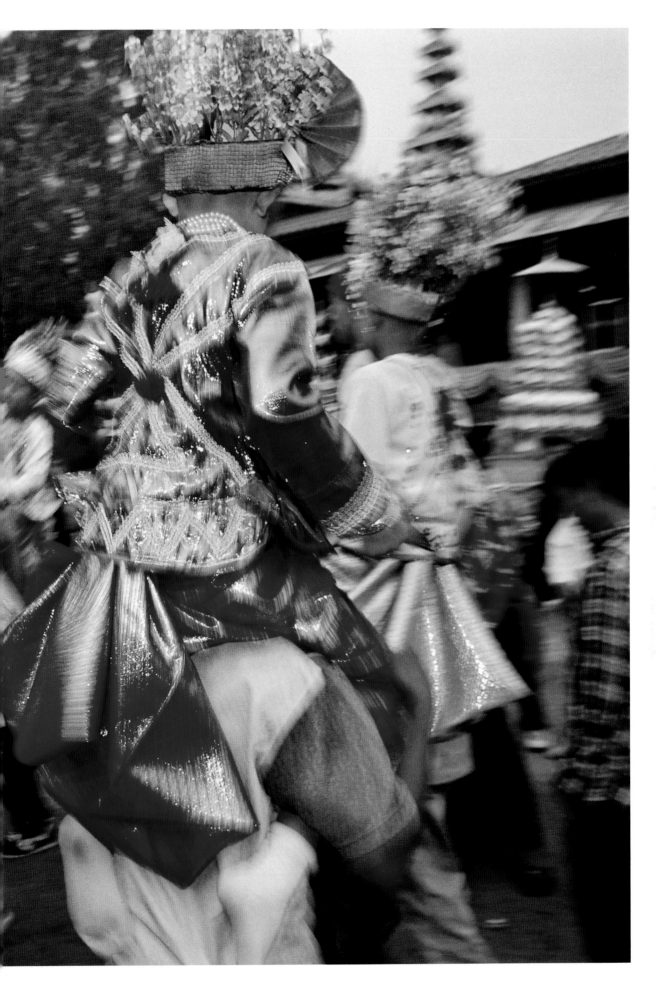

**Pages 102–103:** Inside the temple, boys dressed as princes await the next ritual.
**Pages 104–105:** When the boys emerge from the temple their male relatives dance with them on their shoulders. As princes, their feet are not allowed to touch the ground.
**Right:** Princely regalia includes imitation jewellery and medallions, along with red lipstick, mascara and rouge.
**Pages 108–109:** A horse, said to be ridden by Mae Hong Son's guardian spirit, leads the day's first procession.

**Pages 102–103 :** Dans le temple, des garçonnets en costumes de prince attendent le prochain rite.
**Pages 104–105 :** Quand les garçons sortent du temple, ils sont portés sur les épaules de parents proches pendant les danses traditionnelles. Des pieds princiers ne peuvent fouler le sol !
**À droite :** Joyaux et médailles factices, rouge à lèvres, mascara et rouge à joues font partie des attributs princiers.
**Pages 108–109 :** Un cheval monté par l'esprit gardien invisible de Mae Hong Son mène la première procession de la journée.

**Seiten 102–103:** Im Prinzengewand warten Jungen im Tempel auf das nächste Ritual.
**Seiten 104–105:** Wenn die Jungen in den Tempelhof kommen, tanzen ihre männlichen Verwandten mit ihnen auf den Schultern. Als Prinzen dürfen ihre Füße den Boden nicht berühren.
**Rechts:** Zum prinzlichen Ornat gehören Modeschmuck und Medaillons sowie roter Lippenstift, Mascara und Rouge.
**Seiten 108–109:** Ein Pferd, auf dem der Schutzgeist von Mae Hong Son reiten soll, führt die erste Prozession des Tages an.

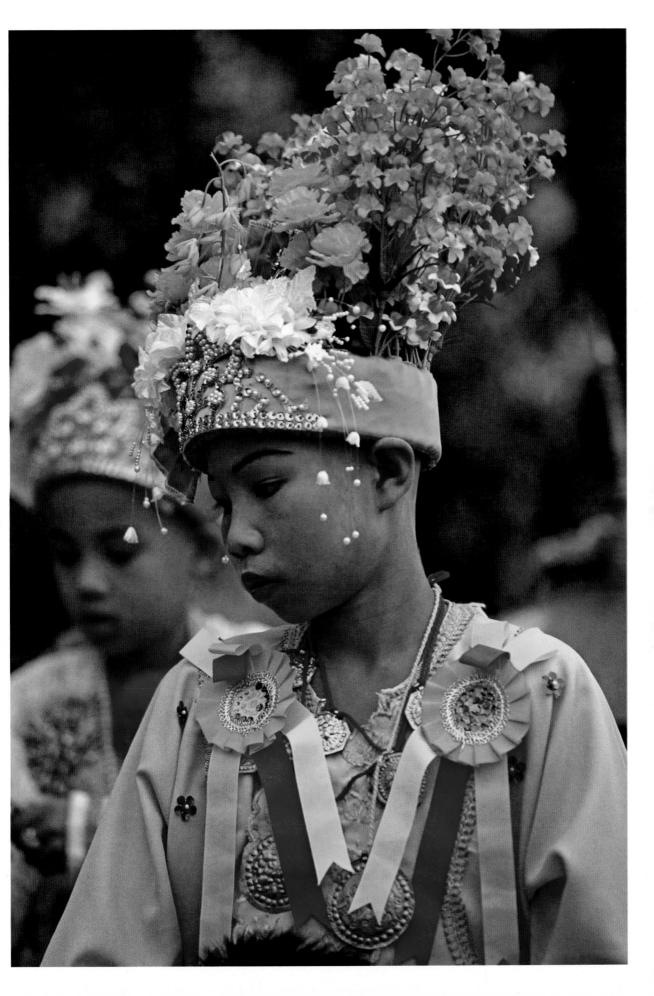

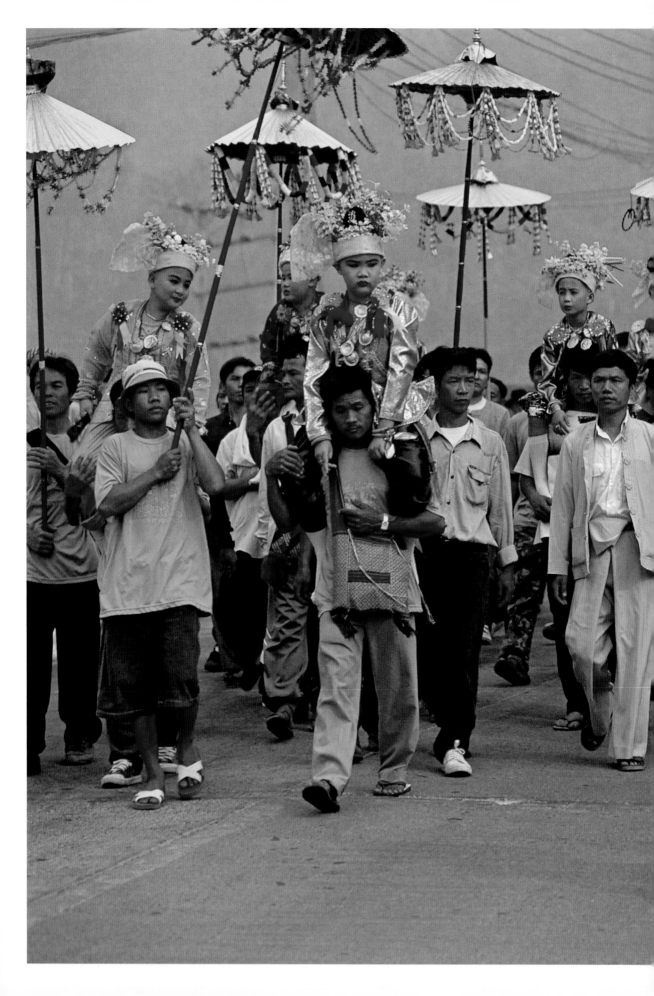

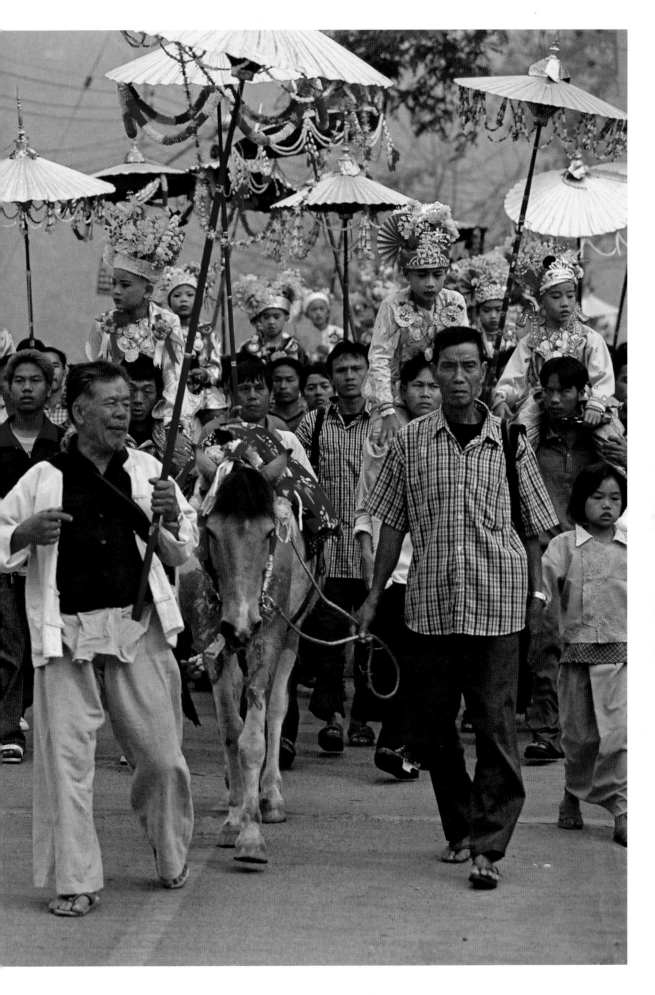

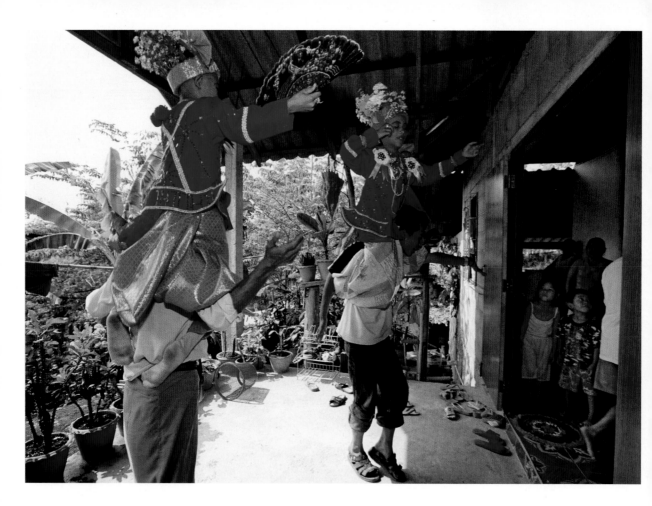

# In Buddhas Fußstapfen
## Mae Hong Son, Thailand

Im Hof des Tempels Wat Hua Wiang fallen Haarbüschel auf den Boden. Es ist Anfang April, die trockene, heiße Jahreszeit, und in der Luft in der kleinen Stadt Mae Hong Son hängt der Rauch von Waldbränden in den nahe gelegenen Bergen.

Mönche und Novizen in orangefarbenen Gewändern schneiden einer Gruppe von Jungen zwischen acht und 14 Jahren die Haare. Hinter ihnen stehen die Familien der Jungen mit Handtüchern und kleinen metallenen Wassereimern und warten.

Die Jungen gehören zu den Shan, einem Volk, das vor allem in Birma, aber auch auf der thailändischen Seite der Grenze lebt. Viele von ihnen sind vor den Kämpfen zwischen Shan-Guerillas und der birmanischen Armee geflohen, andere dagegen leben schon seit Generationen in Thailand und können ihren Familienstammbaum bis ins frühe 19. Jahrhundert zurückverfolgen. Ihre Vorfahren kamen damals hierher, um für den König von Chiang Mai Elefanten zu fangen und abzurichten.

Das Haareschneiden läutet das jährliche, drei Tage während Fest *Poy Sang Long* ein, an dem die Shan-Jungen Novizen werden und sich einen Monat lang dem klösterlichen Leben widmen, um etwas über Buddha und seine Philosophie zu lernen. Als Buddhisten müssen sie Verdienste erwerben, um im ewigen Kreislauf von Tod und Wiedergeburt die nächste Stufe erreichen zu können. Das kann man tun, indem man Novize oder Mönch wird.

Dieser Weg steht Frauen allerdings nicht offen. Für sie ist es ein Verdienst, wenn ihre Söhne Mönche werden. Daher gilt Poy Sang Long als Fest, bei dem die Schuld der

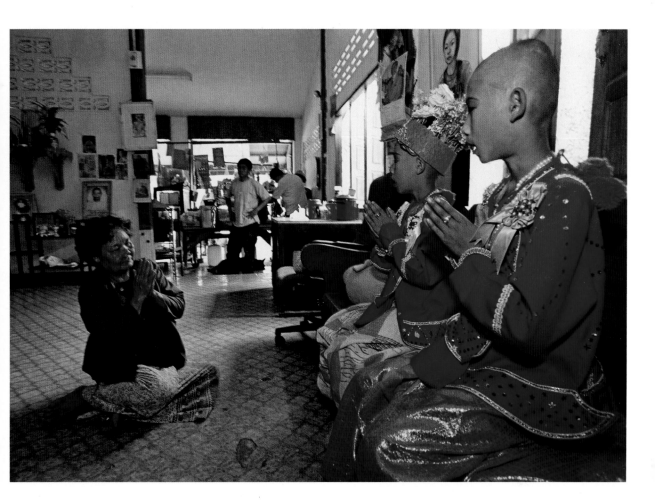

Eltern, besonders die der Mutter, die einen Jungen zur Welt gebracht und genährt hat, beglichen wird. Man sagt, als Novize begleiche ein Junge seine Schuld für die Milch aus einer Brust, wird er später Mönch, bezahle er auch die aus der anderen Brust.

Als die Nachmittagssonne hinter den Tempelmauern verschwindet, sind die Köpfe aller Jungen rasiert, gewaschen und mit einem wohltuenden, cremefarbenen Balsam gesalbt. Nun wartet eine dreitägige Zeremonie auf die Jungen, die sie auf ihr Leben im Kloster vorbereitet.

Am nächsten Morgen treffen sich vor Sonnenaufgang alle unter den wachsamen Augen mehrerer riesiger Buddhastatuen im Tempel. Auf dem glänzenden Holzboden haben sich zahlreiche Verwandte versammelt, die den Jungen helfen, sich wie Prinzen zu kleiden. Dieser Teil des Rituals soll daran erinnern, dass auch Buddha im nördlichen Indien ein Prinz war, bevor er seine Reise auf der Suche nach Erleuchtung begann, ebenso wie sein Sohn Rahula, der als Prinz geboren wurde, mit sieben Jahren aber ebenfalls den fürstlichen Haushalt verließ und Novize wurde, um in die Fußstapfen seines Vaters zu treten.

Ungefähr 20 Jungen sind mit farbenfrohen Hosen, Jacken und Kopfbedeckungen mit Blumenschmuck als Shan-Prinzen gekleidet. Ihre goldenen Armbänder, Ringe und Amulette sind Modeschmuck, glänzen aber, als wären sie echt. Nachbarn und Freunde warten draußen im Hof mit einem kleinen Orchester, das traditionelle Shan-Musik spielt. Der Klang der Gongs und Zimbeln erfüllt die Luft, und die Trommel, die an der Schulter eines Musikers hängt, gibt den Rhythmus an.

Als Prinzen dürfen die Jungen den Boden nicht mehr mit den Füßen berühren. Nachdem sie ihr Kostüm angelegt haben, tragen männliche Verwandte sie im Schutz goldener Sonnenschirme auf ihren Schultern die Treppe hinunter in den Hof.

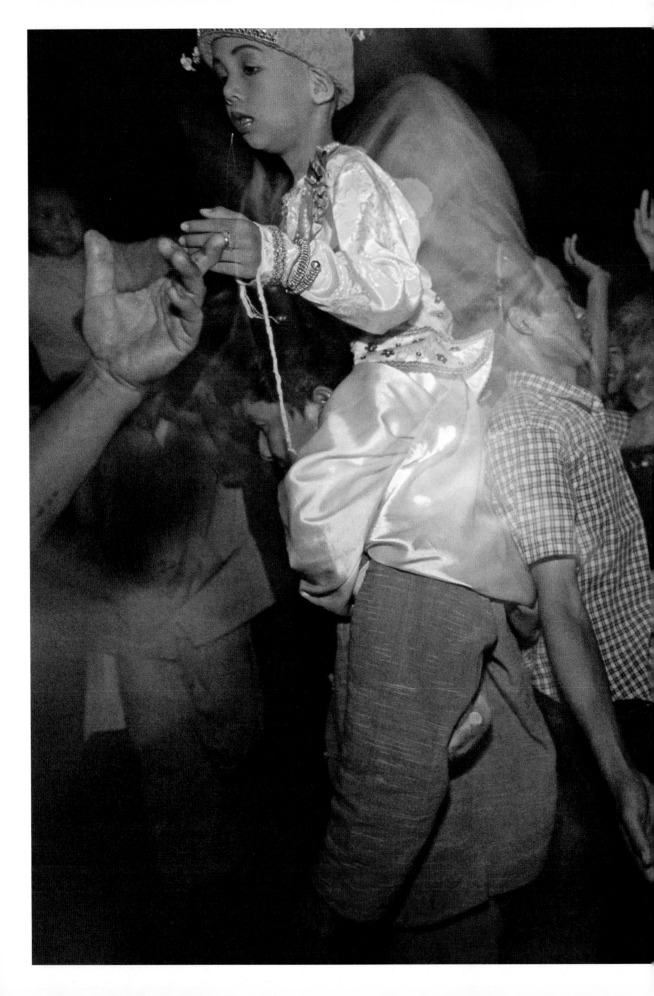

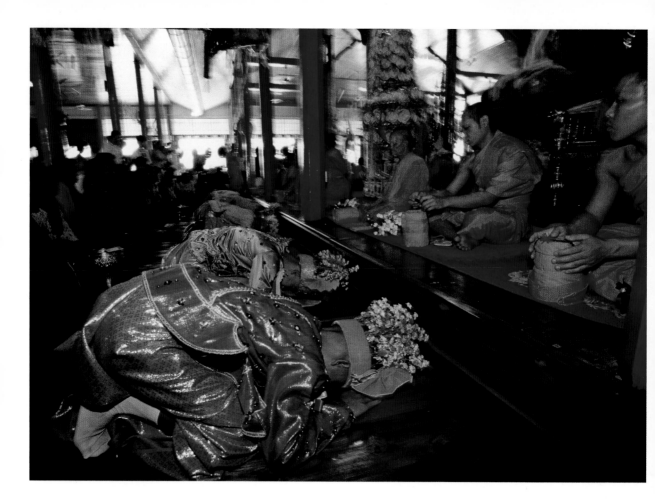

**Pages 112–113:** When the
boys visit their own home
their family members dance
with them.
**Pages 114–115:** During the
penultimate day's proces-
sions, mothers show off their
sons' novice robes, rolled up
and garlanded with flowers.

**Pages 112–113:** Quand les
garçons arrivent chez eux,
la famille réunie célèbre leur
entrée en noviciat par de
joyeuses danses.
**Pages 114–115:** Lors de
l'avant-dernière proces-
sion du festival, les mères
portent avec fierté le sac
orné de fleurs et rubans qui
renferme la robe de novice
de leur fils.

**Seiten 112–113:** Wenn die
Jungen ihr eigenes Zuhause
besuchen, tanzen die Fa-
milienmitglieder mit ihnen.
**Seiten 114–115:** Während
der Prozession am vorletzten
Tag präsentieren die Mütter
die aufgerollten und mit
Blumen geschmückten
Novizengewänder ihrer
Söhne.

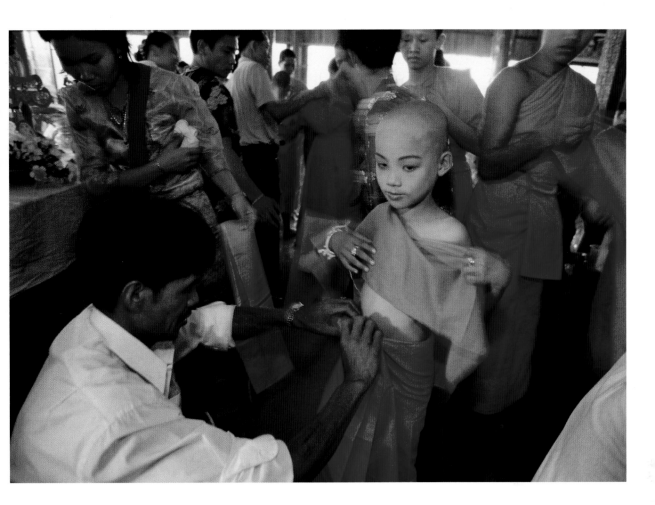

**Above and left:** Everyone gathers in the temple on the third and last day for the ordination ceremony, which culminates with the monks handing the boys their novice robes. Parents help their sons to put on their new garments.

**Ci-dessus et à gauche:** Le troisième jour du festival, tout le monde se rassemble au temple pour le dernier rite d'ordination au cours duquel les moines remettent leurs robes de novices aux garçons. Les parents aident les enfants à revêtir leur nouvelle tenue.

**Oben und links:** Am dritten und letzten Tag versammeln sich alle für die Ordinationszeremonie im Tempel, die ihren Höhepunkt hat, wenn die Mönche den Jungen ihre Novizengewänder überreichen. Die Eltern helfen ihren Söhnen, die neuen Kleider anzulegen.

**Page 118:** The boys gather for prayers after the end of the ceremonies, some still with traces of princely make-up on their faces.
**Page 119:** Novices wear the same orange garments as the monks – a waistcloth and a thin sleeveless shirt. Whenever the boys leave the temple grounds a piece of cloth is also tied or wrapped round their upper body.

**Page 118:** À la fin de la cérémonie, les garçons se rassemblent pour des prières communes. Quelques-uns portent encore des traces du maquillage princier sur leur visage.
**Page 119:** Les novices portent le même vêtement orange que les moines; il consiste en une sorte de long pagne et une chemise fine sans manche. Quand ils sortent du temple, ils drapent une pièce d'étoffe autour de leurs épaules.

**Seite 118:** Am Ende der Zeremonien kommen die Jungen zum Gebet zusammen. Manche haben noch Spuren ihres prinzlichen Make-ups im Gesicht.
**Seite 119:** Novizen tragen dieselben orangefarbenen Gewänder wie die Mönche – ein Hüfttuch und ein dünnes, ärmelloses Hemd. Wenn ein Junge das Tempelgelände verlässt, wird noch ein Stück Stoff um seinen Oberkörper gebunden oder gewickelt.

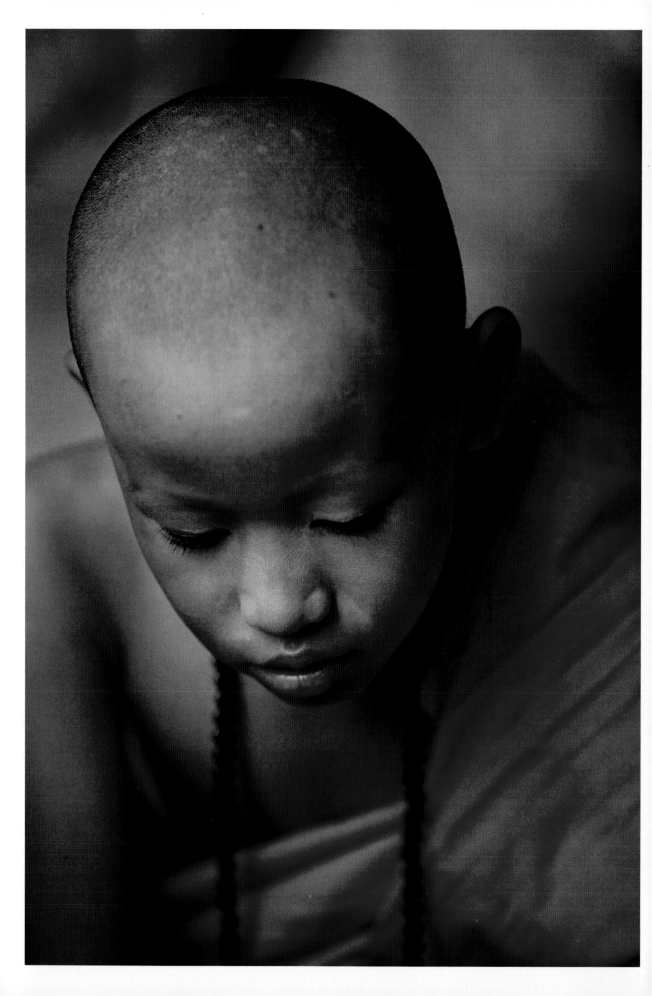

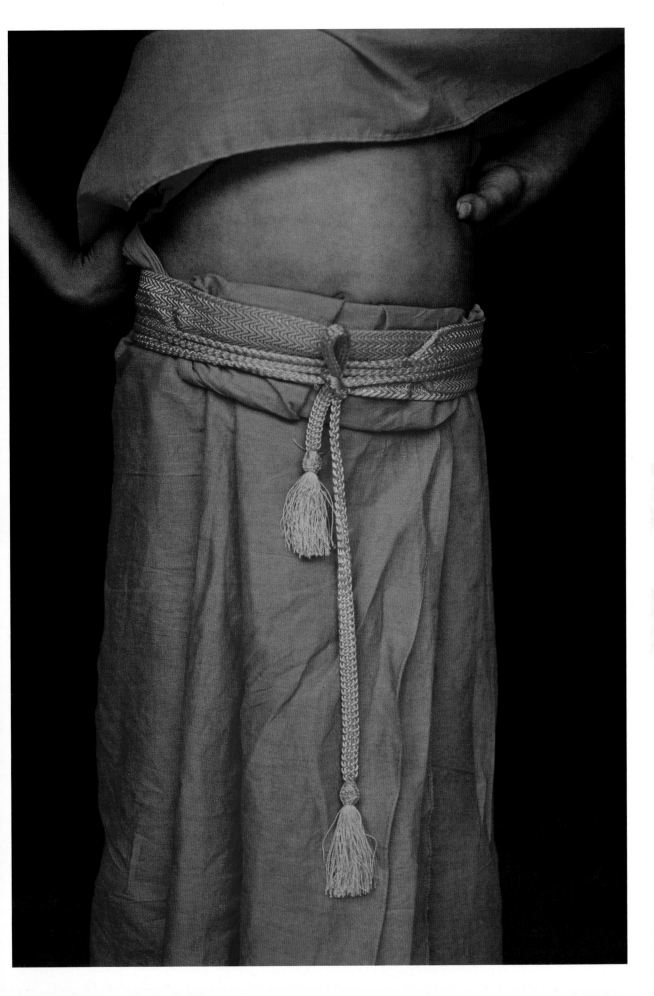

Die Männer tanzen wild umher, während die Jungen noch auf ihren Schultern sitzen. Alle sehen glücklich aus, doch ab und zu verzieht ein Junge sein Gesicht vor Schreck, wenn sein Träger nur knapp einem Sturz entgeht. Schließlich bilden alle eine Prozession, die das Tempelgelände verlässt und hinaus in die Straßen von Mae Hong Son zieht. Ganz vorn führt ein Mann ein Pferd, von dem man glaubt, der Schutzgeist der Stadt reite auf ihm. Und so ist auch der Schrein gerade dieses Schutzgeistes der erste Halt des Festzugs. Hier beten die Jungen um Glück und Wohlbefinden und bitten um Vergebung für die bösen Taten, die sie in ihrem kurzen Leben begangen haben.

Vergebung ist ein wesentlicher Aspekt der dreitägigen Feier. Die Jungen ersuchen nicht nur ihren Schutzgeist um Vergebung, sondern auch die Mönche in den verschiedenen Tempeln der Stadt, ihre älteren Verwandten und andere, die der Familie nahe stehen.

Die nächsten beiden Tage bestehen aus einer Abfolge von Prozessionen und Besuchen in Tempeln und bei Verwandten. Wenn es dunkel wird, kehren die Jungen und ihre Familien zum Tempelgelände zurück, um traditionelle Theaterstücke der Shan anzusehen.

In der Dämmerung des dritten Tages treffen sich alle im Tempel. Auf einem Podest in der vollen Halle sitzen die Mönche vor den Buddhastatuen. Die Jungen hocken in ihren Prinzenkostümen vor dem Podest auf dem Boden, jeder von ihnen einem bestimmten Mönch gegenüber.

Nachdem aus heiligen Schriften gelesen wurde und nach vielen ehrfürchtigen Verbeugungen, wickeln die Mönche die orangefarbenen Gewänder aus, die die Jungen nun anlegen. In diesem Augenblick werden die Jungen ganz formell Novizen.

Die Gewänder, die denen der Mönche gleichen, bestehen aus einem Hüfttuch, das von einem Gürtel gehalten wird, einem dünnen, ärmellosen Oberteil, das die rechte Schulter frei lässt, und einem Stück Stoff, das um den Oberkörper geschlungen oder gebunden wird. Abgesehen davon besitzt der Novize nur eine Almosenschale, ein Sieb (das ihn davor schützen soll, beim Trinken Insekten zu verschlucken) sowie Nadel und Faden, damit er gegebenenfalls sein Gewand flicken kann.

Sobald die Eltern ihren Söhnen geholfen haben, alles richtig anzuziehen, ist die dreitägige Zeremonie beendet, und die Verwandten und Freunde verlassen nacheinander den Tempel Wat Hua Wiang. Die Jungen bleiben bei den Mönchen zurück, um nun einen Monat als Novizen zu leben.

Das Leben im Kloster erfordert die Einhaltung bestimmter Regeln, zum Beispiel darf kein lebendes Wesen verletzt oder getötet werden. Das ist schwieriger, als es klingt. Wat Hua Wiang ist ein Paradies für die Mücken der Stadt, und bei Sonnenuntergang müssen die Jungen in ihren Schlafsaal fliehen, wenn sie nicht vollkommen zerstochen werden wollen.

Die Regel sieht nur zwei Mahlzeiten am Tag vor, die letzte kurz vor Mittag. Die Jungen müssen sich selbst um Speisen kümmern. Daher machen sie sich jeden Morgen barfuß vom Kloster aus auf in die Straßen von Mae Hong Son, um mit ihren Schalen Almosen zu sammeln.

Sie betteln aber nicht – indem sie einfach durch die Stadt gehen, laden sie die Leute dazu ein, eine gute Tat zu tun und ihnen etwas zu essen in ihre Schalen zu füllen, denn damit erwerben die Spender Verdienste für ihr nächstes Leben im ewigen Kreislauf des Daseins.

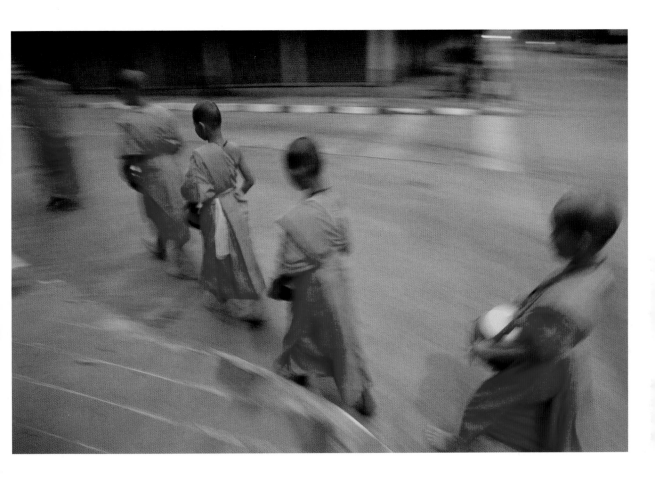

**Above:** Temple life includes a daily alms round to collect charity food from the people of Mae Hong Son.

**Ci-dessus :** La vie au temple inclut une sortie quotidienne pour collecter de la nourriture auprès des habitants de Mae Hong Son.

**Oben:** Zum Leben im Tempel gehört die tägliche Runde, um Almosen der Bewohner von Mae Hong Son zu sammeln.

# Bar and bat mitzvah
## *New Jersey, USA*

It is Saturday morning, the Jewish Sabbath, and the rows of chairs at the Fair Lawn Jewish Center are filled with people listening to the words of a thirteen-year-old boy.

Dressed in a dark suit, a red *kippah* (skullcap) and with a white *tallith*, or prayer shawl, across his shoulders, Shachar Avraham reads from the Torah, the five holy books of Moses.

The words are written on a half-metre-long parchment scroll held between two wooden rollers resting on the pulpit in front of him. Several male relatives in kippahs and prayer shawls stand beside Shachar to assist him as he reads.

The rabbi stands behind the other pulpit on the *bimah*, a raised podium, from where he passes occasional comment on the words Shachar reads. Between them are the open doors of the ark, the cupboard that houses the scrolls.

The synagogue has no shortage of Torah scrolls. The ark contains another eight, all covered in protective cloth mantles and embellished with silver decorations, some of them with symbols representing the stone tablets that God gave Moses after he led the Jews out of Egypt.

In Judaism, a boy comes of age at thirteen. He becomes a *bar mitzvah* ("son of the commandments"), meaning that he must follow the commandments of Judaism, of which the Torah has six hundred and thirteen, and thereby assumes responsibility for his own actions. His bar-mitzvah day is also the first time he reads from the ancient scriptures in front of the synagogue congregation.

For girls, the tradition varies. In Orthodox Judaism, only men are generally allowed to recite prayers and read from the Torah. However, Reform and Conservative Jews celebrate a girl's *bat mitzvah*, when she becomes a "daughter of the commandments" and is called to the podium to read from the scriptures.

And so the week after Shachar's bar mitzvah, it is Nicky Swain's turn to read from the Torah at Temple Avoda, Fair Lawn's Reform Jewish congregation.

Though similar, the rituals differ slightly among the synagogues. This is not only due to differences between Conservative and Reform liturgies but also because of the individual traditions of each synagogue.

During Shachar's recitation all male congregation members wear prayer shawls, but when Nicky stands in the Temple Avoda pulpit only a few have shawls. Nicky herself wears a white prayer shawl over her slender shoulders, presented to her by the rabbi during a private blessing in his office before the ceremony.

Shachar's ceremony at Fair Lawn Conservative Jewish Center lasted for three hours; at Temple Avoda the proceedings are over in an hour and a half. Shachar had to wait until the next day for his bar-mitzvah party because his family wanted to respect Conservative Judaism's strict rules on not playing musical instruments, driving a car or switching on or off electric lights on the Sabbath. Nicky's party, by contrast, starts straight after the synagogue rituals are over.

Nicky is a forthright girl and confesses that the party was the main reason she wanted to do her bat mitzvah. Food, music, dancing and presents for Nicky's friends are all on the agenda.

Bar- and bat-mitzvah parties are notorious for their extravagance, and more than one wealthy Jewish family has found itself in the gossip columns for hosting lavish

**Pages 122–123:** Radburn, a district in Fair Lawn, New Jersey, is one of America's first planned communities. Of the 35,000 people in Fair Lawn about one third are Jewish.
**Right:** Jewish tradition dictates that a girl comes of age at twelve, though in Reform and Conservative Jewish congregations they usually become *bat mitzvahs* at thirteen, the same age as boys. Here, the girl carries the holy Torah scrolls through the synagogue after reading extracts to the congregation.

**Pages 122–123:** Radburn, un quartier de Fair Lawn, New Jersey, abrite une des premières communautés planifiées des États-Unis. Environ un tiers des 35000 habitants de Fair Lawn est juif.
**À droite:** Dans la tradition juive, une fille atteint sa majorité religieuse à douze ans; dans les communautés de mouvements conservateur ou réformé, elles font toutefois leur bat mitzvah treize ans, comme les garçons. Ici, la jeune fille porte les rouleaux sacrés de la Torah, après en avoir lu des extraits devant l'assemblée de la synagogue.

**Seiten 122–123:** Radburn, ein Stadtteil von Fair Lawn in New Jersey, ist einer der ersten geplanten Orte der USA. Von den 35 000 Menschen in Fair Lawn sind etwa ein Drittel Juden.
**Rechts:** Die jüdische Tradition schreibt vor, dass Mädchen mit 12 volljährig werden, in reformierten und konservativen Gemeinden haben sie aber in der Regel mit 13 die Bat-Mizwa, genau wie Jungen. Hier trägt ein Mädchen die heiligen Thorarollen durch die Synagoge, nachdem sie vor der Gemeinde aus ihnen vorgelesen hat.

banquets or parties with luxurious presents for all the guests and paying astronomical fees to rock stars to provide live music.

This type of profligacy has brought bar and bat mitzvahs into disrepute in some quarters, but at Fair Lawn the celebrations are altogether more modest. Which is not to say that Nicky's family has skimped. Like Shachar's parents, Nicky's have hired three professional "party enablers" – two young African-Americans and a young white woman – to keep the atmosphere bubbling nicely and show the youngsters a few cool moves on the dance floor.

Live entertainment is courtesy of Nicky's father and a group of musician friends. A lawyer by profession, he is a keen bass guitarist and plays in a band at weekends. The family picture is complete when Nicky joins her mother and sister on stage for a song.

# Bar et bat mitzvah
## *New Jersey, États-Unis d'Amérique*

Ce samedi matin, jour de sabbat pour les Juifs, le centre juif de Fair Lawn est bondé de gens écoutant attentivement les paroles d'un jeune garçon de treize ans. Vêtu d'un costume sombre, portant une *kippa* rouge et un *tallit* blanc, un châle de prière jeté sur ses épaules, Shachar Avraham lit la Torah, les cinq livres sacrés de Moïse. Les mots sont inscrits sur un parchemin d'un demi-mètre de long, enroulé entre deux rouleaux de bois reposant sur le pupitre devant lui. Plusieurs parents portant la kippa et le châle de prière assistent Shachar dans sa lecture.

Le rabbin se tient debout derrière l'autre pupitre sur la *bimah*, une estrade surélevée d'où il émet parfois des commentaires lors de la lecture de Shachar. Entre eux, on voit les portes ouvertes de l'arche sainte, le meuble dans lequel sont rangés les rouleaux. L'arche en contient huit autres, tous recouverts d'un tissu protecteur orné d'argent, certains étant décorés avec des symboles représentant les tables de pierre que Dieu donna à Moïse après qu'il eut mené les Juifs hors d'Égypte. Le judaïsme veut qu'un garçon atteigne la majorité religieuse à l'âge de treize ans. Il devient alors un *bar mitzvah* (« fils des commandements »), ce qui signifie qu'il doit suivre les commandements du judaïsme, soit les six cent treize lois contenues dans la Torah, et ainsi assumer la responsabilité de ses actes. Le jour de sa bar mitzvah est également l'occasion de sa première lecture des anciennes écritures saintes devant la congrégation de la synagogue. Pour les filles, la tradition est différente. Dans le judaïsme orthodoxe, seuls les hommes sont généralement autorisés à réciter les prières et à lire la Torah. Cependant, les Juifs réformés et conservateurs célèbrent une *bat mitzvah* pour les filles, qui deviennent alors « fille des commandements », et sont donc également appelées sur l'estrade pour lire les Écritures saintes.

C'est ainsi que la semaine qui suit la bar mitzvah de Shachar, c'est au tour de Nicky Swain de lire la Torah au temple Avoda, au sein de la congrégation juive réformée de Fair Lawn. Quoique similaires, les rituels diffèrent légèrement entre les liturgies des conservateurs et des réformés, mais aussi selon les traditions propres à chaque synagogue. Pendant la lecture de Shachar, tous les hommes de la congrégation portaient des châles de prières alors que, lorsque Nicky se tient debout devant le pupitre dans le temple Avoda, seuls quelques-uns en portent. Mais un châle de

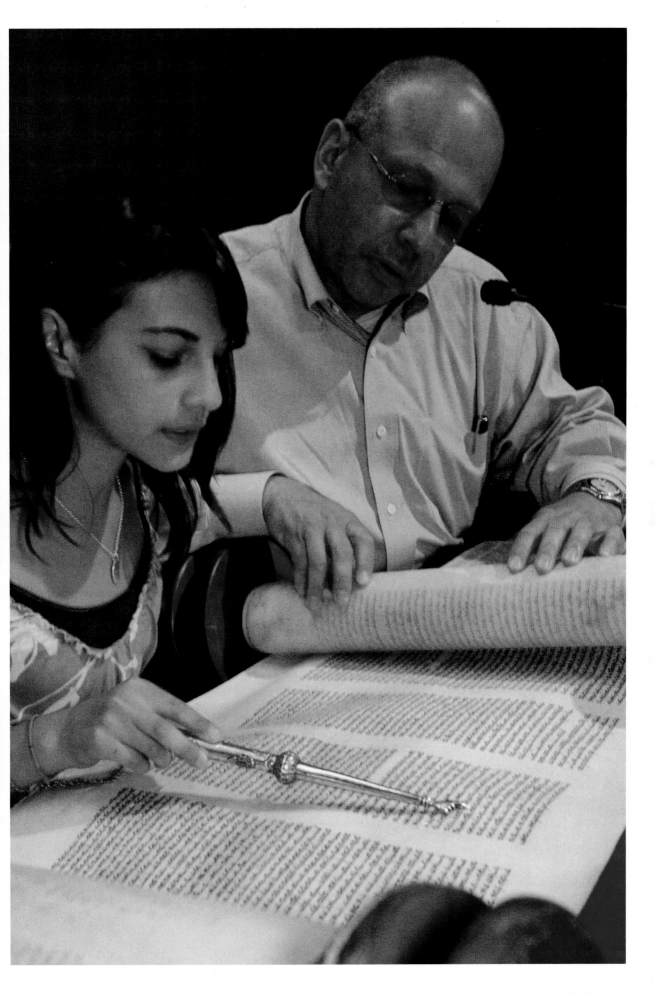

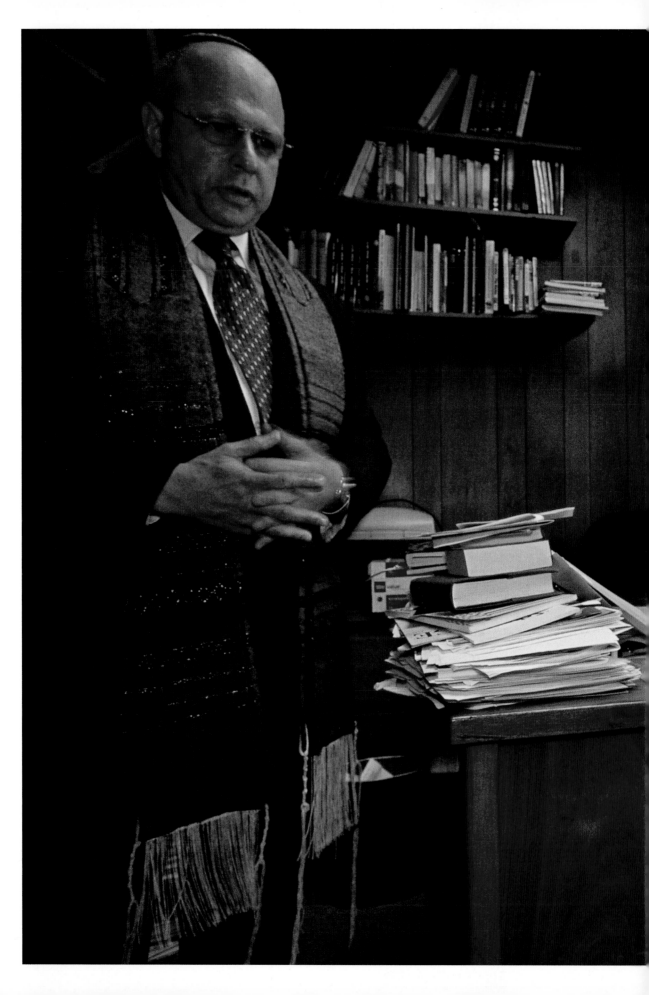

prière blanc entoure les épaules de Nicky ; il lui a été remis par le rabbin lors d'une bénédiction privée dans son bureau, juste avant la cérémonie.

La cérémonie de Shachar au centre des juifs conservateurs de Fair Lawn a duré trois heures ; dans le temple Avoda, la séance s'achève en une heure et demie. Shachar a dû attendre le jour suivant pour fêter sa bar mitzvah, car sa famille souhaitait respecter les règles plus strictes du judaïsme conservateur qui consistent à ne pas jouer d'instrument de musique, ne pas conduire de voiture ou allumer et éteindre l'électricité lors du sabbat. En revanche, la fête de Nicky a commencé juste après la fin des rituels à la synagogue. Nicky est une fille franche et elle avoue qu'elle a voulu faire sa bat mitzvah pour inviter tous ses amis à profiter du festin, de la musique et de la fête. Les fêtes de bar et bat mitzvah sont célèbres pour leur extravagance, et plus d'une riche famille juive a fait les titres de revues « people » après avoir organisé des banquets spectaculaires avec cadeaux luxueux pour tous les invités, payant parfois royalement des stars du rock pour des concerts particuliers.

Ce type d'excès a contribué à discréditer les fêtes de bar et bat mitzvah dans certaines couches de la société. Mais les célébrations de Fair Lawn demeurent plus modestes. Ce qui ne veut pas dire que la famille de Nicky a lésiné sur l'organisation de la fête. Tout comme les parents de Shachar, ceux de Nicky ont loué les services de trois « animateurs » professionnels – deux jeunes Afro-Américains et une jeune femme blanche – pour s'assurer que la fête sera réussie et montrer aux jeunes quelques danses originales pour que la piste soit en feu.

Le concert est assuré par le père de Nicky accompagné d'amis musiciens. Avocat dans la vie, il est bassiste par passion et joue dans un groupe, le week-end. La famille est au complet lorsque Nicky, sa mère et sa sœur montent sur scène pour chanter.

# Bar- und Bat-Mizwa
## *New Jersey, USA*

Es ist Samstagmorgen, der jüdische Sabbat, und die Leute in den gut besetzten Stuhlreihen im jüdischen Zentrum in Fair Lawn lauschen den Worten eines 13-jährigen Jungen.

Er trägt einen dunklen Anzug und eine rote *Kippa* (die rituelle Kopfbedeckung jüdischer Männer), über seinen Schultern liegt der weiße *Tallit*, der Gebetsmantel. Shachar Avraham liest aus der Thora, den heiligen fünf Büchern Mose.

Die Worte stehen auf einer 50 cm hohen Pergamentrolle, die an zwei hölzernen Stangen auf dem Pult vor ihm befestigt ist. Mehrere männliche Verwandte in Kippa und Tallit stehen neben Shachar und unterstützen ihn, während er liest. Der Rabbi steht hinter dem anderen Pult auf der Bima, einem Podest, von wo aus er hin und wieder kommentiert, was Shachar vorliest. Zwischen ihnen befinden sich die geöffneten Türen des Thoraschreins, in dem die Schriftrollen aufbewahrt werden.

In der Synagoge herrscht kein Mangel an Thorarollen. Der Schrein enthält noch acht weitere, die von schützenden Stoffhüllen bedeckt und mit silbernen Verzierungen geschmückt sind. Einige tragen Symbole, die für die Steintafeln stehen, die Gott Moses gab, nachdem er die Juden aus Ägypten geführt hatte.

Im Judentum erreicht ein Junge mit 13 Jahren die Volljährigkeit. Er wird Bar-Mizwa (Sohn der Gebote) und muss nun die Gebote des Judentums befolgen, von denen es in der Thora 613 gibt. Von da an ist er für seine Taten selbst verantwortlich.

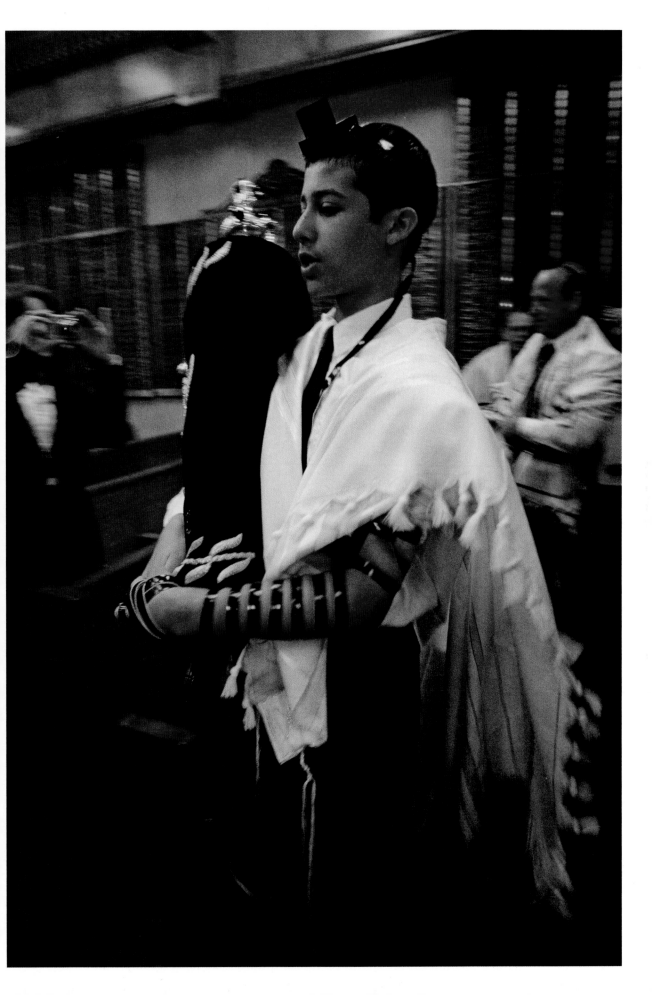

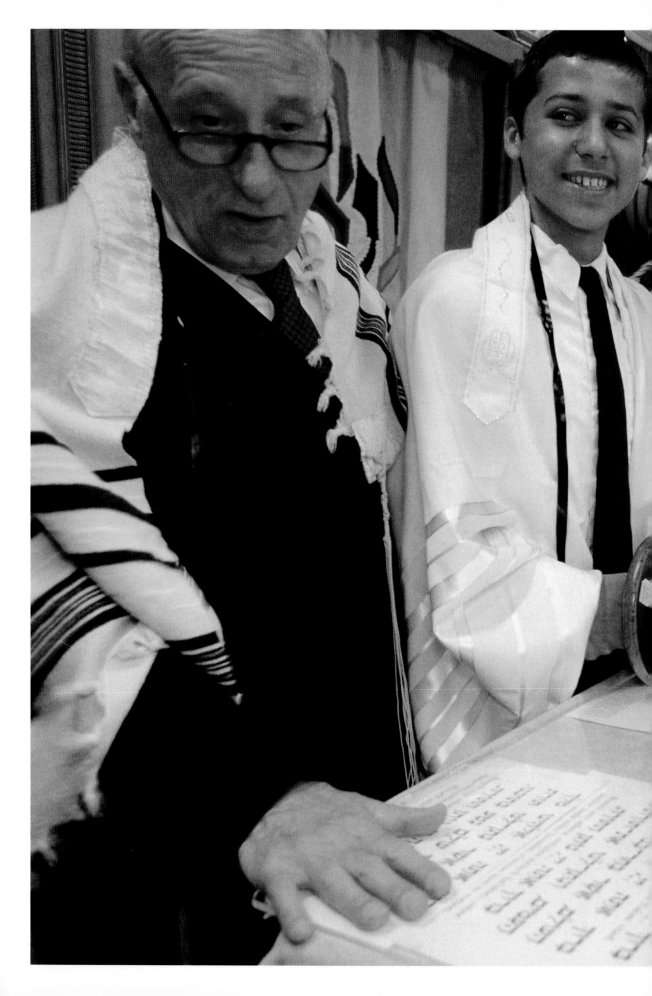

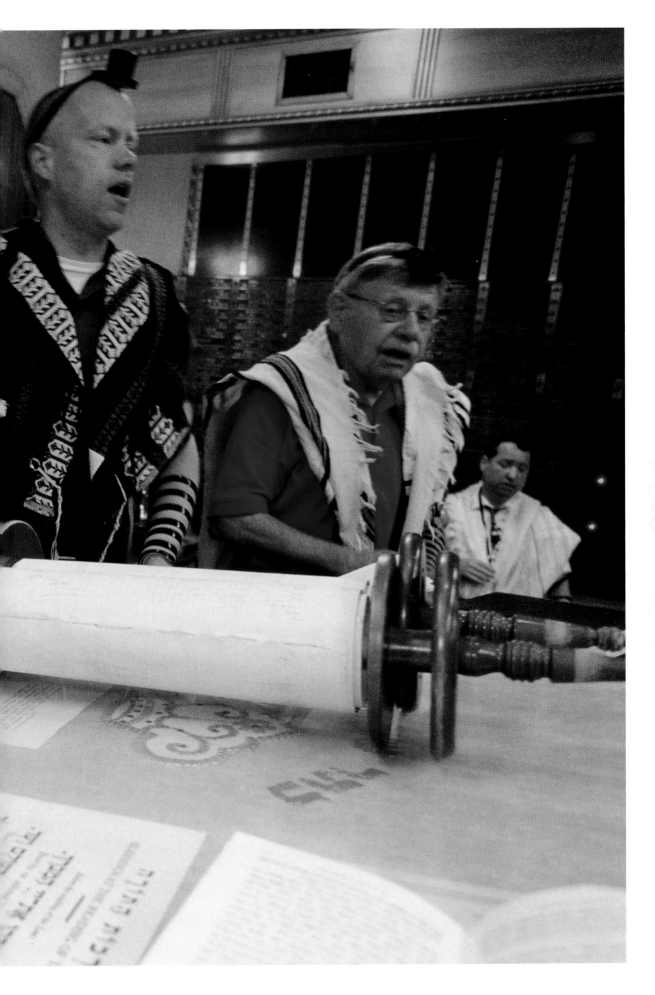

**Pages 132–133:** Male family members assist the boy during his reading, after which the cantor (standing to his left) leads the congregation in singing a hymn.

**Pages 132–133:** Des membres masculins de sa famille l'entourent et l'aident dans sa lecture. Le cantor, qui se tient à sa gauche, entame ensuite un hymne repris par l'assemblée.

**Seiten 132–133:** Männliche Familienangehörige unterstützen den Jungen, während er liest. Danach führt der links von ihm stehende Kantor die Gemeinde beim Gesang an.

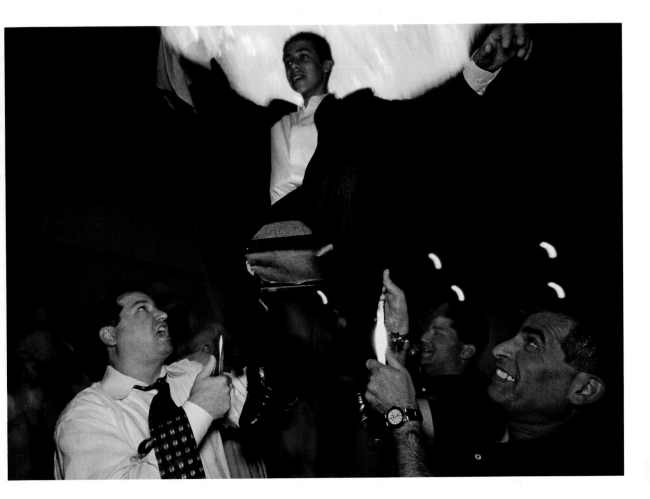

**Above and left:** Once the religious rituals are over the party can begin. This Conservative Jewish bar mitzvah reception is being held the day after the Sabbath, which means photography and electric music are permitted. Party enablers lead the guests in modern dancing and the boy then performs the traditional *horah*, where everyone dances in a circle and holds him aloft in a chair.

**Ci-dessus et à gauche :** La fête commence, une fois les rituels religieux terminés. Chez les Juifs conservateurs, la réception a lieu un autre jour que celui du sabbat durant lequel des instruments électriques de musique ne seraient, par exemple, pas autorisés. La soirée se déroule comme n'importe quelle autre, avec banquet et danses modernes, mais aussi avec la traditionnelle *horah*, où les hommes dansent en cercle autour du garçon porté sur une chaise.

**Oben und links:** Sind die religiösen Rituale erstmal zu Ende, kann die Party losgehen. Diese konservativen Juden feiern die Bar-Mizwa-Party am Tag nach dem Sabbat, weil dann Fotografieren und Musik mit Verstärkern erlaubt sind. Partyorganisatoren bringen den Gästen moderne Tänze bei, und der Junge wird in der traditionellen Hora auf einem Stuhl hochgehoben und von den Gästen umtanzt.

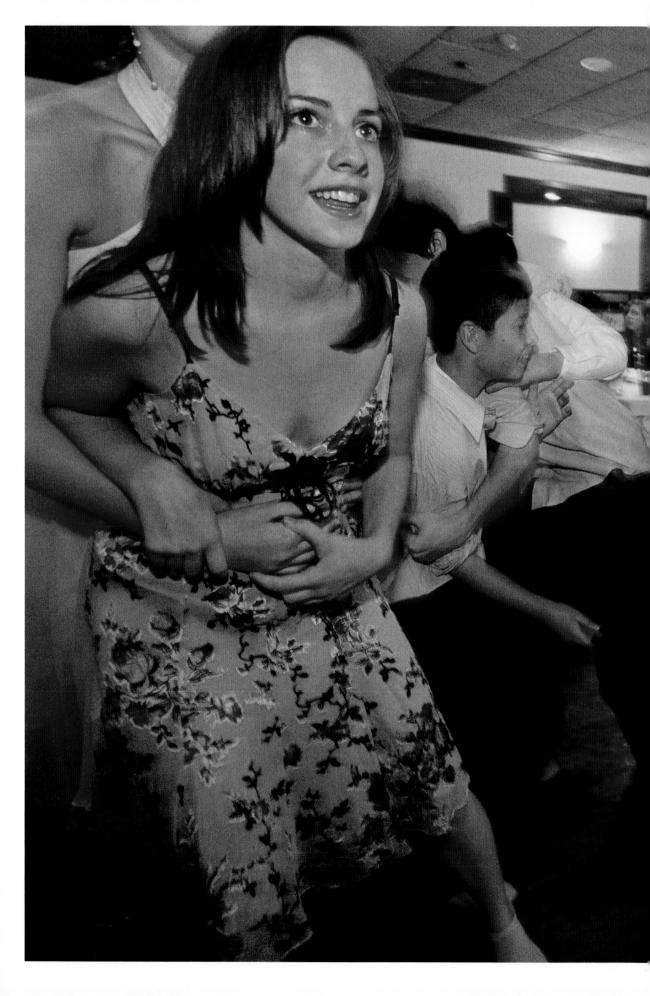

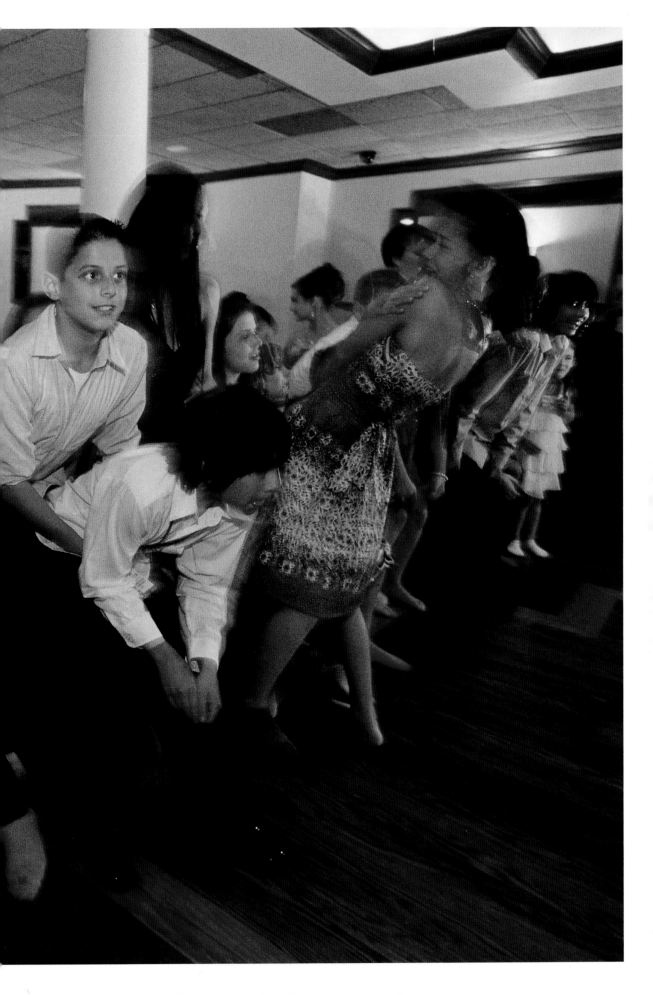

An seinem Bar-Mizwa-Tag liest er auch zum ersten Mal vor der Synagogengemeinde aus der Thora vor.

Bei den Mädchen gibt es unterschiedliche Bräuche. Im orthodoxen Judentum ist es grundsätzlich nur Männern gestattet, Gebete zu sprechen und aus der Thora zu lesen. Anhänger des konservativen und Reformjudentums feiern aber die Bat-Mizwa der Mädchen, mit der sie „Töchter der Gebote" werden. Dann werden auch sie nach vorne gerufen, um aus der Thora zu lesen.

Und so ist eine Woche nach Shachars Bar-Mizwa Nicky Swain an der Reihe, um im Tempel Avoda vor der reformierten jüdischen Gemeinde in Fair Lawn aus der Thora zu lesen.

Obwohl sie sich ähneln, gibt es von Synagoge zu Synagoge kleine Unterschiede zwischen den Ritualen. Das liegt nicht nur an den Unterschieden zwischen konservativen und reformierten Liturgien, sondern auch an den individuellen Gepflogenheiten der jeweiligen Synagogen.

Während Shachar liest, tragen alle männlichen Gemeindemitglieder Gebetsmäntel. Als Nicky dagegen am Pult des Tempels Avoda steht, haben nur wenige den Tallit angelegt. Nicky selbst trägt einen Gebetsmantel über ihren schmalen Schultern, ein Geschenk des Rabbis, der sie vor der Zeremonie in seinem Büro gesegnet hat.

Shachars Zeremonie im konservativen jüdischen Zentrum von Fair Lawn hat drei Stunden gedauert, im Tempel Avoda ist sie in eineinhalb Stunden vorüber. Shachar musste mit seiner Bar-Mizwa-Party bis zum nächsten Tag warten, weil seine Familie die strengen Regeln des konservativen Judentums beachten wollte, nach denen man am Sabbat kein Musikinstrument spielen, nicht Auto fahren und kein Licht an- oder ausschalten darf. Nickys Party schließt sich dagegen direkt an die Rituale in der Synagoge an.

Nicky ist geradeheraus und gesteht, dass es ihr vor allem um die Party ging, als sie sich zu ihrer Bat-Mizwa entschloss. Essen, Musik, Tanz und Geschenke für Nickys Freunde gehören dazu.

Bar- und Bat-Mizwa-Partys sind berüchtigt wegen ihrer Extravaganz, und immer wieder finden sich wohlhabende jüdische Familien in den Klatschspalten wieder, wo über ihre üppigen Bankette oder Partys mit luxuriösen Geschenken für die Gäste und die astronomischen Summen berichtet wird, die sie Rockstars zahlen, damit sie auf dem Fest live auftreten.

Diese Art von Verschwendung hat Bar- und Bat-Mizwas einen schlechten Ruf eingebracht, aber in Fair Lawn sind die Feiern im Allgemeinen bescheidener. Was nicht heißen soll, dass Nickys Familie geknausert hätte. Wie Shachars Eltern haben auch sie drei junge professionelle Partyorganisatoren engagiert (zwei Afroamerikaner und ein weiße Frau), die das Fest schön spritzig halten und den Jugendlichen die neuesten coolen Schritte auf der Tanzfläche beibringen sollen.

Für die Livemusik sorgt Nickys Vater mit einer Gruppe von befreundeten Musikern. Er ist Anwalt, spielt aber als begeisterter Bassist am Wochenende in einer Band. Und so ist das Familienbild vollständig, als auch Nicky mit Mutter und Schwester auf der Bühne steht und singt.

**Pages 136–137:** Friends join a bat-mitzvah girl in party games. She belongs to a Reform Jewish synagogue, where Sabbath observance rules are less strict than among Conservative or Orthodox congregations, and her reception is held straight after the synagogue ceremony.

**Pages 136–137:** Cette adolescente appartient au mouvement réformé dont l'observation des règles est moins stricte que chez les Juifs conservateurs et orthodoxes. Sa fête de bat mitzvah a lieu juste après la cérémonie à la synagogue, avec des divertissements typiques de jeunes.

**Seiten 136–137:** Ein Bat-Mizwa-Mädchen und seine Freunde bei einem Partyspiel. Es gehört einer reformierten Gemeinde an, die die Sabbatregeln nicht so streng befolgt wie Konservative oder Orthodoxe. Das Fest findet gleich nach der Zeremonie in der Synagoge statt.

**Above:** Boys and men always wear the traditional *kippah*, or skullcap, during religious rituals such as Torah readings.

**Ci-dessus :** Garçons et hommes portent toujours la kippa lors des rites religieux célébrés en privé ou à la synagogue.

**Oben:** Jungen und Männer tragen während religiöser Rituale, wie dem Lesen aus der Thora, immer die traditionelle Kippa, die Scheitelkappe.

# The Sunrise dance of the Apache
## Arizona, USA

The fringes of Kayla Kitcheyan's buckskin sarape bob and sway as she kicks puffs of desert dust into the air with her moccasins. The bells on her wooden walking stick jangle as she hits the ground with every step.

Her sunrise dance began half an hour or so ago in the weak pre-dawn light and now the sun has emerged from behind Mount Triplet's sacred peaks and gently warms the air. Kayla faces the glowing red orb at all times as she dances. Although the temperature is rising, she has more than five hours of dancing ahead of her before she can rest.

*Na-ih-es*, the sunrise dance, is an ancient rite held by Apache Indians to celebrate a girl's first menstrual period. It is a test of physical endurance and mental strength, vital attributes in former times when the Apache roamed the south-west of America and north-west Mexico in hunter-gatherer communities.

According to the Apache creation story, a Great Flood once covered the land. When the waters receded, a girl was washed ashore, having survived the flood by floating in an abalone shell. She was known as Changing Woman, or alternatively as White Shell Woman from the abalone shell, and White Painted Woman from the white clay she was caked in when she reached the shore.

She built a tipi and went to sleep inside. When the rays of the sun entered the tipi and shone between her legs she began to menstruate for the first time. She was impregnated by the sun, giving birth to a son called Slayer-of-Monsters. Later, when she lay under a rock from which water dropped she became pregnant again and gave birth to a second child, Son-of-Water. Together, the brothers killed many monsters and liberated the earth from much evil.

The sunrise dance partly re-enacts this creation story. As a sign that the girl actually becomes Changing Woman during the dance and inherits her magical, healing powers, she wears mother-of-pearl on her forehead. It symbolises the abalone shell in which Changing Woman survived the Great Flood.

As soon as a girl tells her family she has had her first period the preparations for the dance begin – provided, that is, that her family can afford to host the event, which can cost anything from two to ten thousand dollars. Another proviso is that the girl and her family are not members of any Christian revivalist faiths that prohibit observance of the ritual.

First the family finds the girl a godmother to act as her mentor and assist her during the dance. The two will have a special, lifelong bond. A godmother must also have financial means, because the dance involves considerable expense for her and her family.

The family then contact a medicine man and sew moccasins and a buckskin dress for the girl. A large number of presents are purchased to be exchanged between the families of the girl and her godmother. Sufficient food for the four-day ceremony must also be bought.

A week or two beforehand, the family builds two camps by the dance site, one for the girl's relatives and one for the godmother's. A traditional *wickiup* is also built for the girl to live in during the ceremony.

For Kayla's family, the preparations are finally over. It is the second day of Kayla's sunrise dance and the day on which she must wake before dawn to begin her

**Pages 140–141:** San Carlos Lake, formed by the completion of the Coolidge Dam on Arizona's Gila River in 1928. Selling fishing permits is one of the primary sources of income for the San Carlos Apache Indian Reservation. However, a prolonged drought when this photograph was taken had left water levels so low that sales were under threat.
**Right:** After an Apache girl has her first menstrual period she performs the four-day sunrise dance. A girl who has already completed the ritual accompanies her to provide help and support.

**Pages 140–141:** Le lac de San Carlos, né de la construction du barrage Coolidge sur l'Arizona's Gila River en 1928. La vente de permis de pêche est une des sources majeures de revenus de la réserve apache de San Carlos. Cependant, quand la photo a été prise, une longue sécheresse avait fait baisser le niveau de l'eau au point de menacer cette source de revenus.
**À droite:** Après sa première menstruation, une adolescente apache exécute la danse du lever du soleil. Une jeune fille, qui a déjà accompli les rituels, l'accompagne et l'encourage durant la cérémonie de quatre jours.

**Seiten 140–141:** Der San Carlos Lake entstand durch den Coolidge-Damm, der seit 1928 den Gila-Fluss in Arizona staut. Eine der wichtigsten Einkommensquellen für das Apachenreservat San Carlos ist der Verkauf von Angelgenehmigungen. Als dieses Foto aufgenommen wurde, gefährdete allerdings eine lange Dürre das Geschäft.
**Rechts:** Nachdem ein Apachen-Mädchen zum ersten Mal menstruiert hat, tanzt es den vier Tage dauernden Sunrise Dance. Ein Mädchen, das das Ritual bereits hinter sich hat, begleitet und unterstützt es dabei.

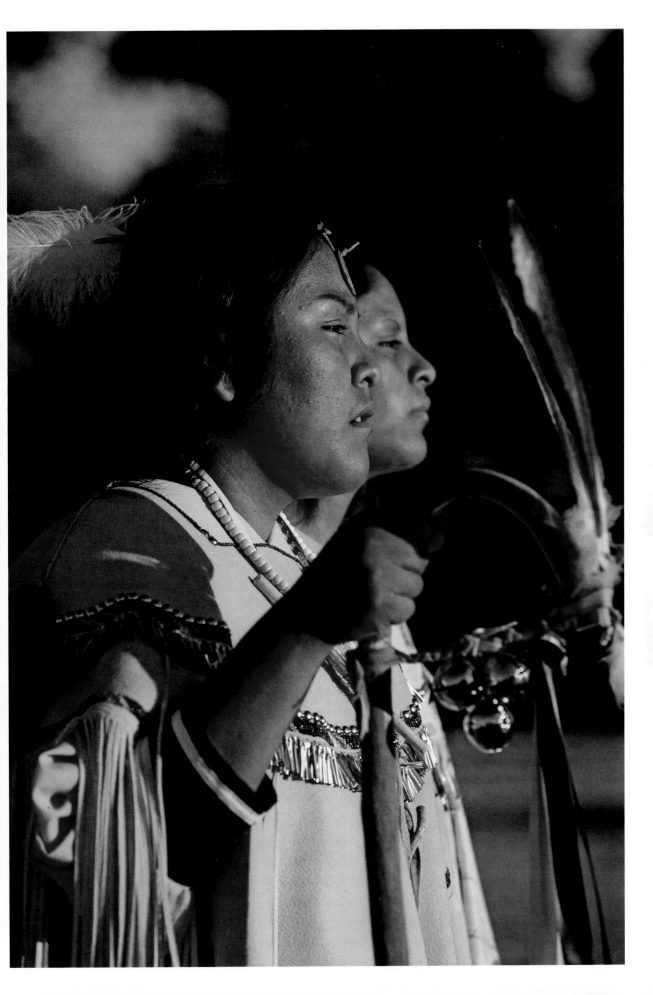

dance. Alongside her dances Bria, a girl who has already had her sunrise ceremony and is there to support her. Like Kayla, she is also dressed in buckskin. Behind them stands the medicine man with his assistants, chanting and beating their hand drums.

Kayla and Bria dance behind a buckskin hide laid out on blankets. Facing east is a long, straight row of boxes filled with soft drinks, sweets and other goodies – symbols of a life of plenty.

One purpose of the dance is to guarantee the girl a long and healthy life until she is old and grey. The walking stick that Kayla holds during the dance is a symbol of this longevity, and she will keep it until she needs it one day.

It is becoming hotter now and Kayla begins dancing on her knees on the buckskin hide, raising her hands and swaying from side to side as she faces the sun. This was the moment, according to Apache legend, that the sun entered Changing Woman and made her pregnant.

The next phase involves Kayla lying face down on the buckskin while her godmother kneads and pummels her body to form her into a strong, adult woman with a healthy physique.

And so the dance continues through its eight phases, each laden with symbolism and magical powers. The most solemn moment comes when Kayla and her two godparents are blessed with holy cattail pollen, leaving them caked in yellow. So sacred is this ritual that no photographs are allowed.

After six hours the dance is over and Kayla, visibly tired, retires to her camp to rest before the ceremonies resume in the evening with dancing round the campfire. Masked mountain spirits, or *gaan*, join the dance. They are divine beings who live in the mountains and sometimes visit people to purify them from illness and evil.

Kayla's partners are four girls also dressed in buckskin clothes. After first dancing by themselves in a line, the four girls are each accosted by a mountain spirit and do a follow-the-leader dance, which involves imitating each step the spirit takes.

The mountain spirits are still there the next morning and have a key role to play in the ceremonies. An open tipi of four poles is erected to symbolise the tipi that Changing Woman built before being impregnated by the sun. Kayla dances inside, surrounded by the mountain spirits.

The highlight comes when the spirits paint her with a mixture of white clay and sacred corn flour, a blessing in memory of when Changing Woman stepped out of her abalone shell and onto the shore, covered from head to toe in white clay. The viscous mixture spatters into the air and runs down Kayla's face and buckskin dress.

Kayla and her godfather then join the mountain spirits in a dance. Kayla holds the white clay in a basket for her godfather, who flicks it over everyone present. That way they all share Kayla's blessing. When the dance is over it is time for the great gift exchange between Kayla's family and her god-family.

On day four the ceremony concludes. Kayla is undressed and washed, ready to return to her everyday life. Her sunrise dance is over and she is no longer a girl but an Apache woman.

# La danse du soleil levant des Apaches
## *Arizona, États-Unis d'Amérique*

**Pages 146–147:** On the first morning the girl bakes four types of corn bread and then visits the medicine man with her family. When she arrives with the bread in a basket on her back the medicine man is in a steam tent where he sings sacred chants.

**Pages 148–149:** On the second day the dance begins just before sunrise. Facing the sun at all times, the girl dances while the medicine man and his helpers sing and beat their drums.

**Pages 146–147 :** Le premier matin, la fille cuit quatre sortes de pain de blé, puis se rend avec sa famille chez le guérisseur. Quand elle arrive, avec sa corbeille de pains dans le dos, le guérisseur chante des mélopées sacrées dans la tente à sudation.

**Pages 148–149 :** Le deuxième jour, la danse commence juste avant le lever du soleil. Visage tourné vers l'astre, la jeune fille danse tandis que le guérisseur et ses assistants chantent et frappent sur les tambours.

**Seiten 146–147:** Am ersten Morgen backt das Mädchen vier Arten Maisbrot und sucht dann mit seiner Familie den Medizinmann auf. Als es mit dem Brot in einem Korb auf seinem Rücken ankommt, ist er gerade in einem Schwitzzelt und singt heilige Lieder.

**Seiten 148–149:** Am zweiten Tag beginnt der Tanz kurz vor Sonnenaufgang. Während des Tanzes ist das Mädchen immer der Sonne zugewandt. Der Medizinmann und seine Helfer singen und schlagen ihre Trommeln.

Les franges du poncho en daim de Kayla Kitcheyan brassent la poussière du désert remuée par ses mocassins à chacun de ses pas, les cloches accrochées à son bâton de bois résonnant de plus belle. Elle a débuté la danse du soleil levant il y a environ une demi-heure, alors que l'aube naissait. Les premiers rayons de soleil sont apparus derrière les sommets sacrés de Mount Triplet, réchauffant lentement l'air. Kayla se tient face à l'astre rougeoyant tandis qu'elle danse. Bien que la température augmente, il lui reste pas moins de cinq heures à danser avant de penser à se reposer. *Na-ih-es*, la danse du soleil levant, est un ancien rite apache qui célèbre la puberté des filles. Il s'agit de tester leur endurance physique et leur force mentale, des qualités essentielles du temps où les Apaches parcouraient le sud-ouest de l'Amérique et le nord-ouest du Mexique, réunis en communautés de chasseurs-cueilleurs.

Selon l'histoire de la Création chez les Apaches, le Grand Raz-de-Marée aurait recouvert la Terre. Lorsque les eaux sont redescendues, une femme aurait survécu au déluge en flottant dans une coquille d'ormeau. Connue sous le nom de Femme-qui-Change, ou bien Femme-Coquillage-Blanc, ou encore Femme-Peinte-d'Argile-Blanche-Quand-Elle-Atteignit-Le-Rivage, elle construisit un tipi et s'y endormit. Lorsque les premiers rayons du soleil pénétrèrent dans le tipi et passèrent entre ses jambes, elle eut ses règles pour la première fois. Imprégnée par le soleil, elle donna naissance à un fils nommé Tueur-de-Monstres. Plus tard, alors qu'elle était couchée sous une roche, l'eau coula sur elle entraînant ainsi une nouvelle grossesse. Elle donna naissance à un deuxième fils, Fils-Né-des-Eaux. Ensemble, ils tuèrent de nombreux monstres et libérèrent la Terre de tous les mauvais esprits.

La danse du soleil levant s'inspire du thème de cette histoire de la Création. Lors de la danse, la jeune fille, comme Femme-qui-Change, hérite de sa magie, de ses pouvoirs divins, symbolisés par un collier de nacre qu'elle porte autour du cou, rappelant le coquillage dans lequel Femme-qui-Change a réchappé au Grand Raz-de-Marée. Dès que la jeune fille annonce à sa famille qu'elle a eu ses premières règles, les préparatifs pour la danse commencent. Pour certaines familles, le coût de cet événement est parfois difficile à assumer, sachant qu'il peut s'agir de deux à dix mille dollars. Il convient, de plus, que la jeune fille et sa famille ne fassent pas partie d'une communauté chrétienne interdisant ce type de rituel.

La famille doit d'abord choisir une marraine qui assistera la jeune fille lors de la danse. Elles partageront toutes deux une relation très forte tout au long de leur vie. Une marraine doit également disposer de quelques moyens financiers, car l'événement sera très coûteux pour elle et sa famille. La famille contacte ensuite un homme-médecine, puis fait confectionner des mocassins et une robe en daim pour la jeune fille. De nombreux cadeaux seront également échangés entre les familles de la jeune fille et celle de la marraine. Reste à prévoir suffisamment de nourriture pour quatre jours de cérémonie.

Une semaine ou deux auparavant, la famille construit deux camps sur le site prévu pour la danse, un pour les proches de la jeune fille, et l'autre pour ceux de la marraine. De même, un *wickiup* traditionnel sera construit pour la jeune fille, lui servant d'habitat durant la cérémonie. Du côté de la famille de Kayla, les préparatifs sont enfin terminés. Il s'agit du deuxième jour de la danse du soleil levant pour Kayla et, par conséquent, elle doit se réveiller avant l'aube pour danser. Bria, une jeune

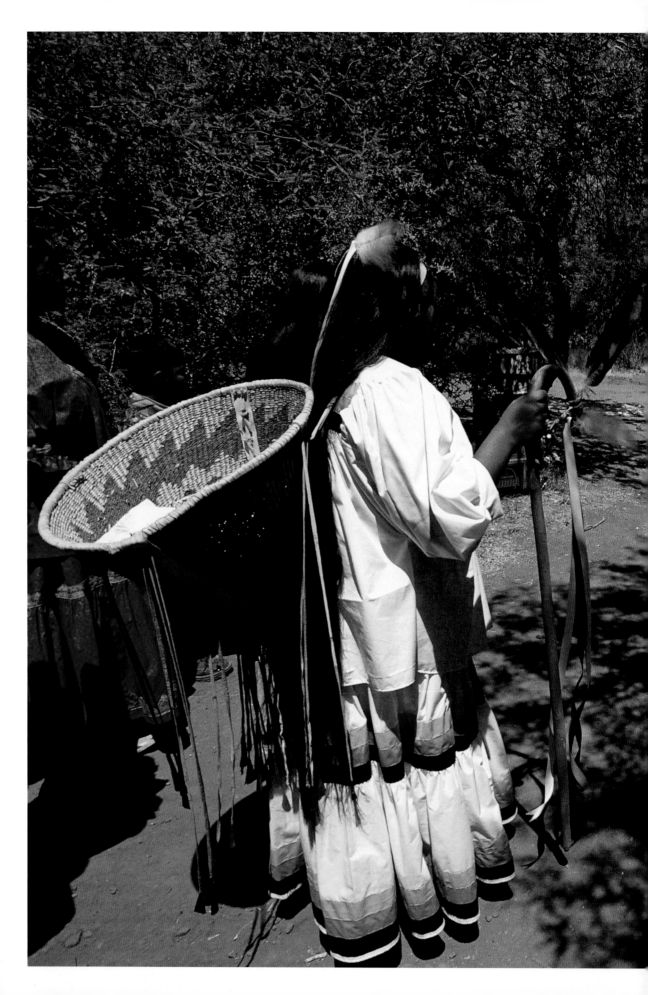

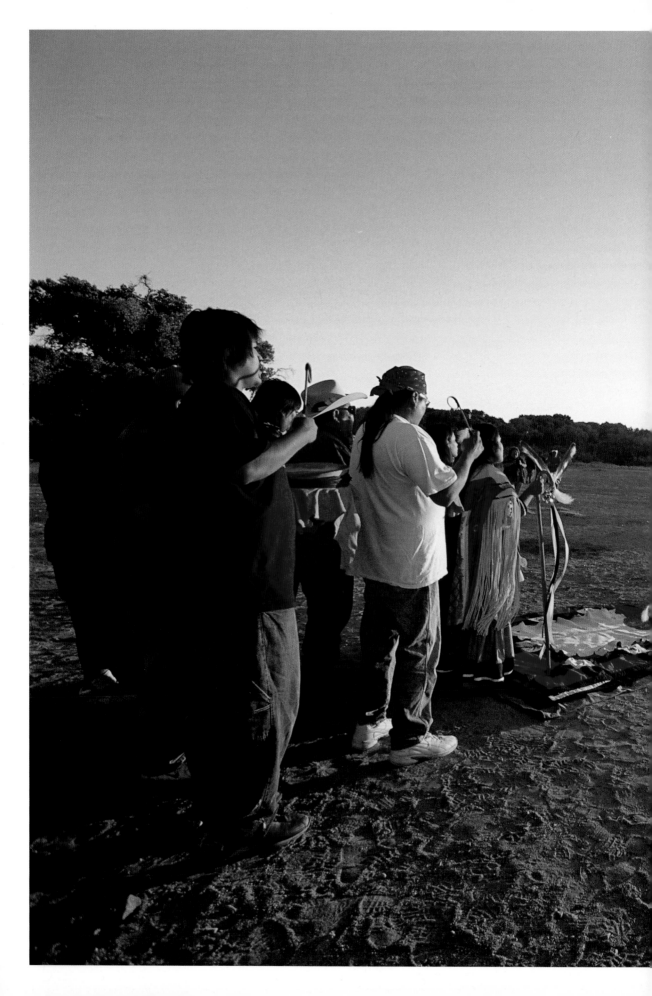

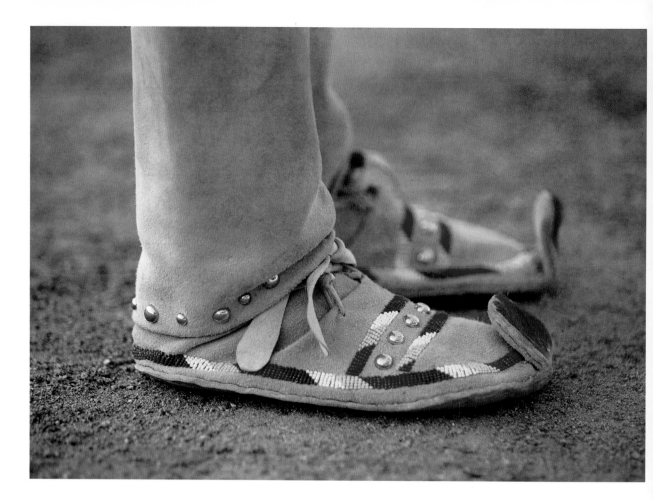

**Above:** Women who join the dance wear traditional moccasins. The long, thick leather toe-guards protect their feet from the stony ground.

**Ci-dessus :** Les femmes qui se joignent à la danse portent des mocassins renforcés par une languette de cuir épais aux orteils pour protéger les pieds sur le sol rocheux.

**Oben:** Die Frauen, die mittanzen, tragen traditionelle Mokassins. Die langen, dicken Spitzen schützen die Zehen auf steinigem Untergrund.

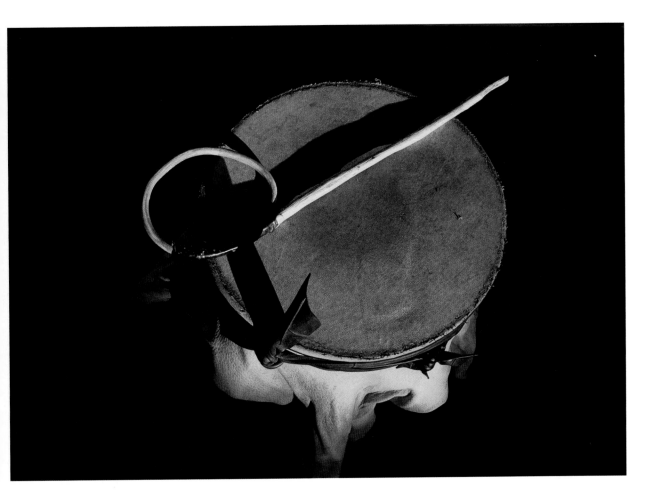

**Above:** The drums used by the medicine man and his helpers comprise a piece of buckskin hide stretched over an air-conditioner compressor.

**Ci-dessus :** Les tambours du guérisseur et de ses aides sont faits d'une peau de daim tendue sur un fût rempli d'air.

**Oben:** Der Medizinmann und seine Helfer spielen auf Trommeln aus Hirschhaut, die über den Kompressor einer Klimaanlage gespannt ist.

**Pages 152–153:** During the dance the girl becomes Changing Woman, mother of all Apache. She drops to her knees and does a swaying dance to symbolise Changing Woman's impregnation by the sun. Her godmother stands behind, offering guidance and support.

**Pages 152–153 :** Au cours de la danse, la jeune fille devient la « Femme-qui Change », mère de tous les Apaches. Elle tombe à genoux et son corps oscille jusqu'à terre, pour symboliser que le soleil est entré en elle. Derrière elle, sa marraine la guide et lui prodigue encouragements et réconfort.

**Seiten 152–153:** Im Verlauf des Tanzes wird aus dem Mädchen Changing Woman, die Mutter aller Apachen. Es fällt auf die Knie und wiegt sich tanzend hin und her, womit es darstellt, wie Changing Woman von der Sonne ein Kind empfängt. Seine Patin steht hinter ihm und bietet Rat und Unterstützung.

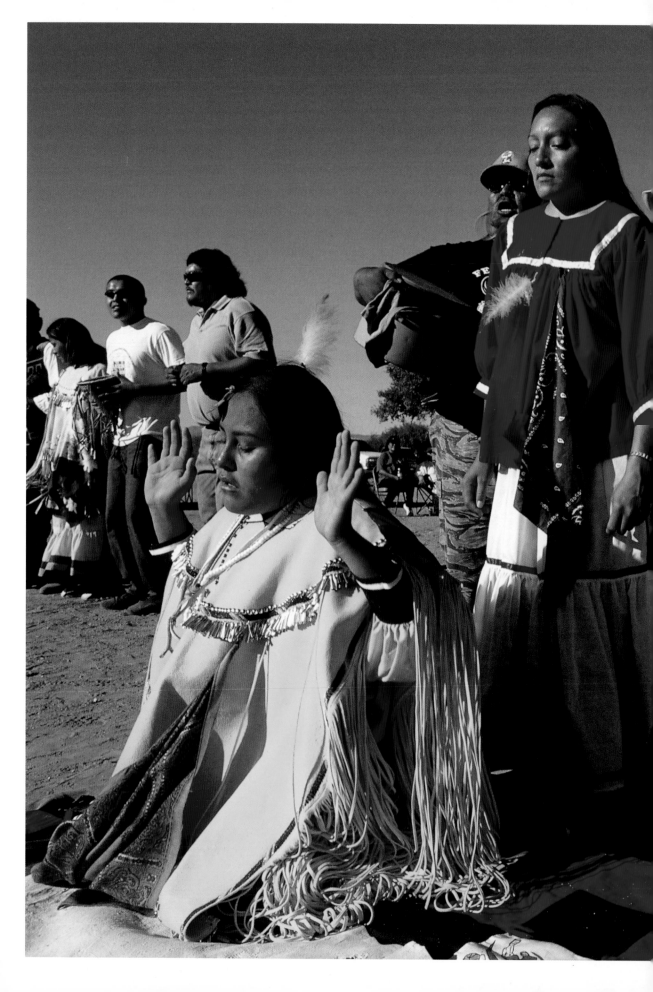

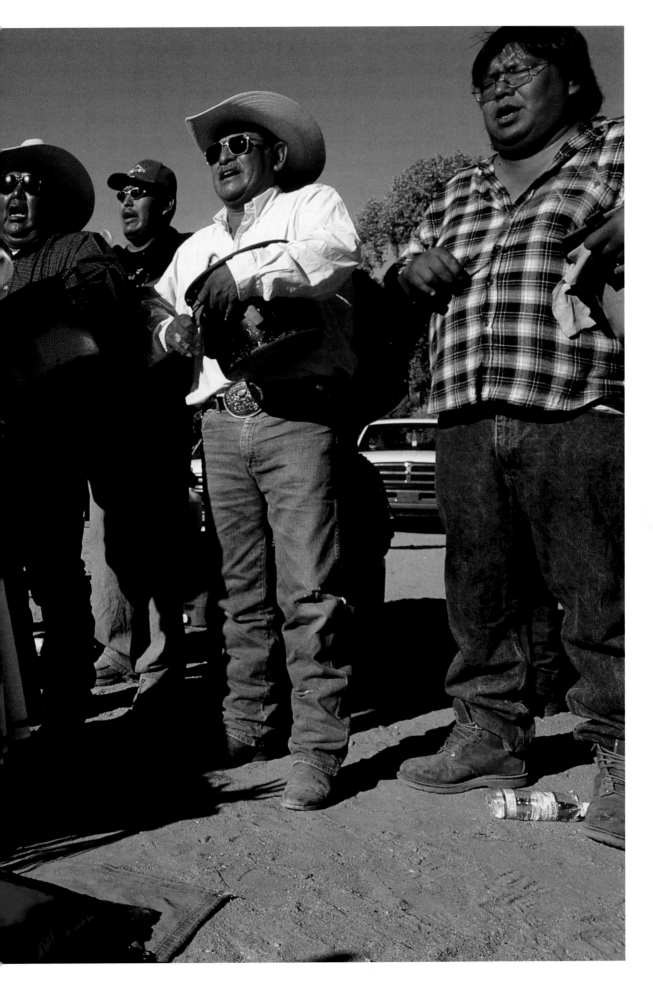

fille ayant déjà vécu sa cérémonie du soleil levant, l'encourage en dansant à ses côtés. Comme Kayla, elle est vêtue d'une robe en daim. Derrière elles se tiennent le guérisseur et ses assistants, chantant et frappant sur des percussions. Kayla et Bria dansent devant un tapis en daim étendu sur des couvertures. Face à l'est s'aligne une longue rangée de récipients remplis de boissons, de sucreries et de cadeaux, symboles d'une vie d'abondance.

En effet, cette danse devra assurer une longue et saine vie à la jeune fille pour qu'elle vieillisse en paix. Le bâton de marche que tient Kayla lors de la danse est un symbole de longévité, et elle le conservera pour ses vieux jours. La température monte maintenant et Kayla commence à danser à genoux sur le tapis, levant les mains et se balançant de part et d'autre face au soleil. Il s'agit, selon la légende apache, du moment où le soleil pénétra la Femme-qui-Change afin qu'elle tombe enceinte.

Peu après, Kayla s'allonge sur le ventre sur le tapis, tandis que sa marraine pétrit et masse son corps pour faire d'elle une femme adulte, forte et en bonne santé. Puis, la danse continue selon huit phases, chacune riche de symbolisme et de pouvoirs magiques. Le moment le plus solennel reste celui où Kayla, son parrain et sa marraine sont bénis avec du pollen de jonc sacré qui les couvre de jaune. Ce rituel étant sacré, il n'est pas permis de le photographier.

Après six heures de danse, Kayla est visiblement fatiguée et se retire dans son campement afin de se reposer avant les cérémonies du soir autour du feu. Les esprits masqués des montagnes, ou *gaan*, rejoignent la danse. Il s'agit d'êtres divins qui vivent dans les montagnes et qui rendent parfois visite aux gens pour les purifier des maladies et des mauvais esprits. Les partenaires de Kayla sont quatre jeunes filles également vêtues de robes en daim. Après une danse qu'elles exécutent alignées, les quatre jeunes filles sont chacune accostées par un esprit de la montagne et pratiquent alors une danse l'une derrière l'autre, imitant chaque pas de l'esprit devant elles.

Les esprits des montagnes restent jusqu'au matin et jouent un rôle fondamental dans le déroulement des cérémonies. Un tipi ouvert à quatre sommets est érigé pour symboliser le tipi que construisit la Femme-qui-Change avant d'être envahie par le soleil. Kayla danse à l'intérieur, entourée par les esprits des montagnes. Le soleil s'est enfin levé lorsque les esprits la recouvrent d'un mélange d'argile blanche et de farine de maïs sacrée, en mémoire du moment où Femme-qui-Change quitta le coquillage et arriva sur le rivage, couverte de la tête aux pieds d'argile blanche. La mixture visqueuse se répand dans l'air et coule sur le visage de Kayla et sur sa robe en daim. Kayla et sa marraine rejoignent alors les esprits de la montagne dans la danse. Kayla porte un panier rempli d'argile blanche destinée à sa marraine, qui la projette sur tous les invités afin que tous partagent la bénédiction de Kayla. Lorsque la danse s'achève, arrive le moment des échanges de cadeaux entre la famille de Kayla et celle de sa marraine.

La cérémonie prend fin le quatrième jour. Kayla s'est changée et lavée, prête à retourner à sa vie quotidienne. Sa danse du soleil levant accomplie, dorénavant elle n'est plus une jeune fille, mais une femme apache.

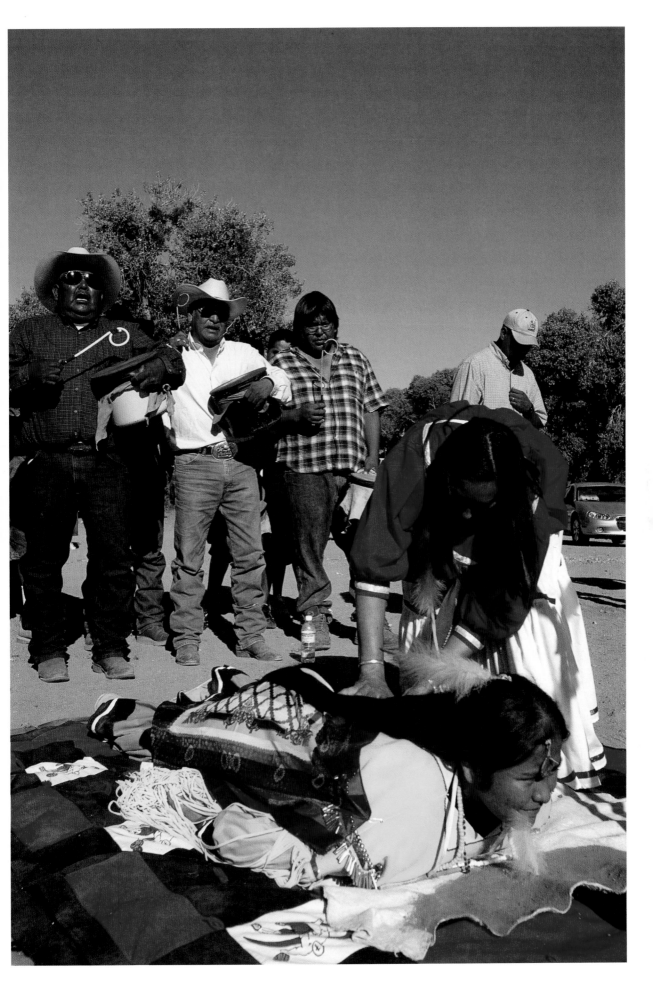

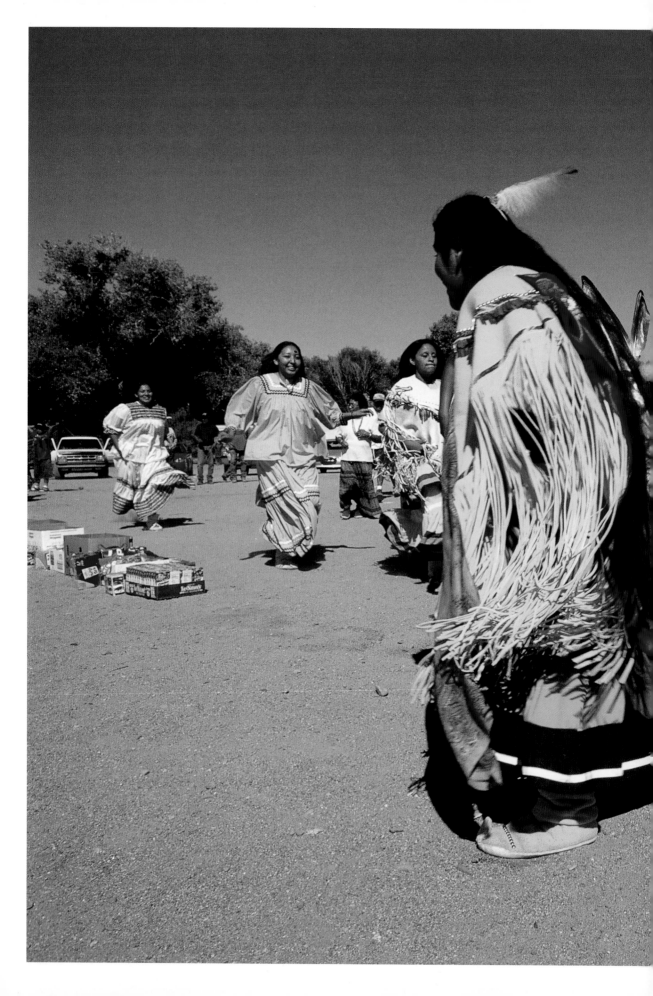

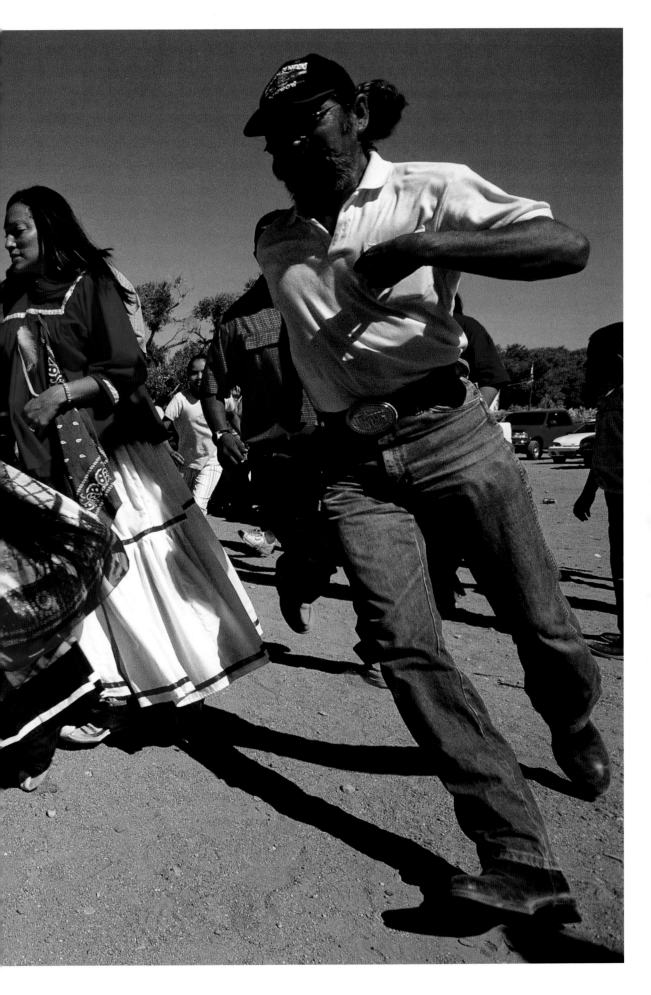

# Der Sunrise Dance der Apachen
## *Arizona, USA*

Die Fransen von Kayla Kitcheyans Sarape, einer Art Poncho, schwingen hin und her, während sie mit ihren Mokassins den Wüstenstaub in kleinen Wolken aufwirbelt. Bei jedem Schritt stößt sie ihren Gehstock mit rasselnden Schellen auf den Boden.

Ihr Sunrise Dance hat vor etwa einer halben Stunde im schwachen Licht der frühen Dämmerung begonnen, und nun ist die Sonne hinter den heiligen Gipfeln von Mount Triplet aufgetaucht und wärmt sanft die Luft. Die ganze Zeit über sieht Kayla beim Tanzen in Richtung des glühenden, roten Balls. Obwohl es immer wärmer wird, liegen noch mehr als fünf Stunden vor ihr, bevor sie sich ausruhen kann.

*Na-ih-es*, der Tanz des Sonnenaufgangs, ist ein uraltes Ritual der Apachen, das die erste Menstruation eines Mädchens feiert. Es testet seine körperliche Ausdauer und die geistige Stärke – in früheren Zeiten, als die Apachen noch als Sammler und Jäger durch den Südwesten der heutigen USA und den Nordwesten Mexikos zogen, waren das lebenswichtige Eigenschaften.

Der Schöpfungsmythos der Apachen besagt, dass einst eine große Flut das Land überschwemmte. Als sich das Wasser zurückzog, wurde ein Mädchen an Land gespült, das in der Schale einer Abalone überlebt hatte. Es wurde Changing Woman (Frau, die sich verändert), White Shell Woman (Frau aus der weißen Muschel) oder White Painted Woman (weiß angemalte Frau) genannt, denn als es das Ufer erreichte, war es mit weißem Ton bedeckt.

Das Mädchen baute ein Tipi und legte sich schlafen. Als die Sonnenstrahlen in sein Tipi fielen und zwischen seine Beine trafen, begann es zum ersten Mal zu menstruieren. Es bekam das Kind der Sonne, einen Sohn namens Slayer of Monsters (Bezwinger der Ungeheuer). Als es später unter einem Felsen lag, von dem Wasser tropfte, wurde es wieder schwanger und gebar ein zweites Kind, Son of Water (Sohn des Wassers). Gemeinsam befreiten die Brüder die Erde von einigem Übel.

Der Sunrise Dance spielt diese Schöpfungsgeschichte nach. Als Zeichen dafür, dass das Mädchen während des Tanzes wirklich Changing Woman wird und deren magische, heilende Kräfte erbt, trägt es Perlmutt auf der Stirn. Es symbolisiert die Abalone, in der Changing Woman die Überschwemmung überlebte.

Sobald das Mädchen seiner Familie mitteilt, dass es seine erste Periode hatte, beginnen die Vorbereitungen für den Tanz, immer vorausgesetzt, dass die Familie sich erlauben kann, das Ritual abzuhalten, das zwischen 2000 und 10 000 Dollar kosten kann. Außerdem dürfen das Mädchen und seine Familie keiner christlichen Erweckungsgemeinde angehören, die das Ritual verbietet.

Zunächst sucht die Familie eine Patin für das Mädchen, die seine Mentorin wird und es beim Tanz unterstützt. Zwischen den beiden entsteht eine besondere, lebenslange Bindung. Die Patin muss auch über finanzielle Mittel verfügen, denn der Tanz bringt für sie und ihre Familie beträchtliche Ausgaben mit sich.

Dann benachrichtigt die Familie den Medizinmann und näht Mokassins und ein Hirschlederkleid für das Mädchen. Geschenke, die zwischen den Familien des Mädchens und der Patin ausgetauscht werden, müssen gekauft werden, ebenso wie ausreichend viel Verpflegung für eine viertägige Zeremonie.

Ein oder zwei Wochen vorher errichtet die Familie zwei Lager an der Stelle des Tanzes, eins für die eigene und eins für die Familie der Patin. Das Mädchen lebt während der Zeremonie in einem traditionellen Wickiup (Wigwam).

Pages 158–159: On a sign, everyone makes for the soft drinks and sweets laid out on the ground. The ceremony symbolises the granting of a happy life, with plenty of food for both the girl and all the guests.
Right: The morning's rituals end with the participants blessing the girl and her godparents with cattail pollen, after which the girl accompanies her godparents in a dance.

Pages 158–159: Sur un signe, l'assemblée se précipite sur les limonades et les douceurs posées au sol. Ce rite symbolise l'assurance d'une vie heureuse, avec une abondance de nourriture pour la jeune fille et les participants.
À droite: Les rites du matin s'achèvent par l'offrande de pollen de jonc à la jeune fille, à son parrain et sa marraine. Tous trois exécutent ensuite une danse.

Seiten 158–159: Auf ein Zeichen hin machen sich alle über die Getränke und Süßigkeiten auf dem Boden her. Die Zeremonie steht für ein glückliches Leben, in dem das Mädchen und seine Gäste immer ausreichend zu essen haben.
Rechts: Die morgendlichen Rituale enden mit der Segnung des Mädchens und seiner Pateneltern mit Rohrkolbenpollen. Danach tanzt das Mädchen gemeinsam mit den Paten.

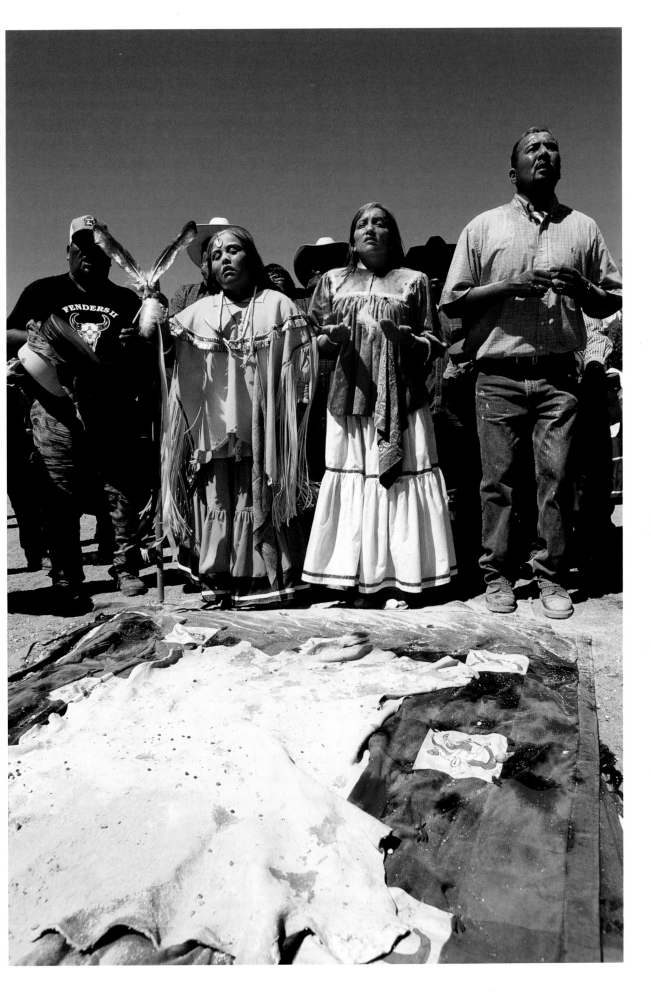

Kaylas Familie hat die Vorbereitungen endlich hinter sich gebracht. Es ist der zweite Tag von Kaylas Sunrise Dance, der Tag, an dem sie vor der Dämmerung aufwachen und ihren Tanz beginnen muss. Mit ihr tanzt Bria, die ihre Sunrise-Zeremonie schon geschafft hat und hier ist, um Kayla beizustehen. Wie sie ist sie in Hirschleder gekleidet. Hinter ihnen stehen der Medizinmann und seine Helfer, die singen und ihre Handtrommeln schlagen.

Kayla und Bria tanzen hinter einer Hirschhaut, die auf Decken ausgebreitet ist. Nach Osten hin ist eine lange Reihe von Getränken, Süßigkeiten und anderen guten Dingen aufgestellt – Symbole für ein Leben im Überfluss.

Ein Anlass für den Tanz ist es, dem Mädchen bis ins hohe Alter ein gesundes Leben zu sichern. Der Stock, den Kayla beim Tanzen in der Hand hält, symbolisiert ein langes Leben, und sie wird ihn behalten, bis sie ihn eines Tages braucht.

Es ist mittlerweile heißer geworden, und Kayla beginnt, auf den Knien auf der Hirschhaut zu tanzen. Sie hebt die Hände und wiegt sich hin und her, während sie in Richtung Sonne blickt. Dies ist der Legende nach der Augenblick, in dem die Sonne in Changing Woman eindrang und ein Kind mit ihr zeugte.

In der nächsten Phase liegt Kayla bäuchlings auf der Hirschhaut. Ihre Patin massiert und knetet ihren Körper, um sie zu einer starken, erwachsenen Frau mit einem gesunden Körper zu formen.

So setzt sich der Tanz über seine acht Phasen hinweg fort, jede von ihnen voller Symbolik und magischer Kraft. Der feierlichste Moment ist erreicht, als Kayla und ihre Pateneltern mit einer dicken Schicht von Rohrkolbenpollen gesegnet werden. Dieses Ritual ist den Apachen so heilig, dass es nicht fotografiert werden darf.

Sechs Stunden des Tanzens sind vorüber und die sichtlich ermüdete Kayla zieht sich in ihre Hütte zurück, um sich auszuruhen, bevor die Zeremonie am Abend mit einem Tanz um das Lagerfeuer weitergeht. Maskierte Berggeister, die Gaan, nehmen daran teil. Sie sind göttliche Wesen, die in den Bergen leben und die Menschen manchmal besuchen, um sie von Krankheit und dem Bösen zu heilen.

Kaylas Mittänzerinnen sind vier Mädchen, die ebenfalls Hirschlederkleider tragen. Zuerst tanzen sie allein in einer Reihe, dann wird jedes von ihnen von einem Berggeist angesprochen und folgt ihm, indem es jeden seiner Schritte imitiert.

Die Berggeister sind am nächsten Morgen immer noch da, denn ihnen kommt eine wichtige Rolle in der Zeremonie zu. Mit vier Stangen wird ein offenes Tipi aufgebaut, so wie das, das Changing Woman baute, bevor sie von der Sonne schwanger wurde. Darin tanzt Kayla nun, umgeben von den Berggeistern.

Der Höhepunkt ist erreicht: Die Berggeister bemalen sie mit einer Mischung aus weißem Ton und Maismehl, eine Segnung, die daran erinnert, wie Changing Woman von Kopf bis Fuß mit weißem Ton bedeckt aus ihrer Abalone ans Ufer trat. Die zähflüssige Mischung spritzt herum und läuft Kayla über Gesicht und Kleid.

Anschließend tanzen Kayla und ihr Pate gemeinsam mit den Geistern. Kayla hält ihrem Paten den weißen Ton in einem Korb hin, damit er die Gäste damit bespritzen kann. So haben sie alle an Kaylas Segen teil. Nach dem Tanz ist es Zeit, die Geschenke zwischen den Familien Kaylas und der Paten auszutauschen.

Am vierten Tag geht die Zeremonie zu Ende. Kayla wird ausgezogen und gewaschen und ist nun bereit, ihr alltägliches Leben wieder aufzunehmen. Der Sunrise Dance ist vorüber, und sie ist kein Mädchen mehr, sondern eine erwachsene Apachin.

**Right:** It is midday, the heat is rising and the girl is exhausted. Apart from short breaks to drink, she has been dancing almost non-stop for six hours.
**Pages 164–165:** Following an afternoon rest, the ceremony resumes again towards nightfall. *Gaan*, men dressed as mountain spirits, join the dancing. Their heads are covered by hoods topped with wooden horns.

**À droite:** Il est midi, la chaleur augmente et la jeune fille est épuisée. Hormis quelques courtes pauses pour boire, elle a déjà dansé six heures, sans interruption.
**Pages 164–165:** Après un repos dans l'après-midi, la cérémonie reprend au crépuscule. Les *Gaan*, hommes costumés en esprits des montagnes, se joignent à la danse. Ils portent des cagoules surmontées de cornes en bois.

**Rechts:** Es ist Mittag, es wird heißer und das Mädchen ist erschöpft. Abgesehen von kurzen Trinkpausen tanzt es fast ununterbrochen seit sechs Stunden.
**Seiten 164–165:** Nach einer kurzen Pause am Nachmittag wird die Zeremonie bis Sonnenuntergang weitergehen. Gaan, als Berggeister verkleidete Männer, tanzen dann mit. Sie tragen Kapuzen mit hölzernen Hörnern.

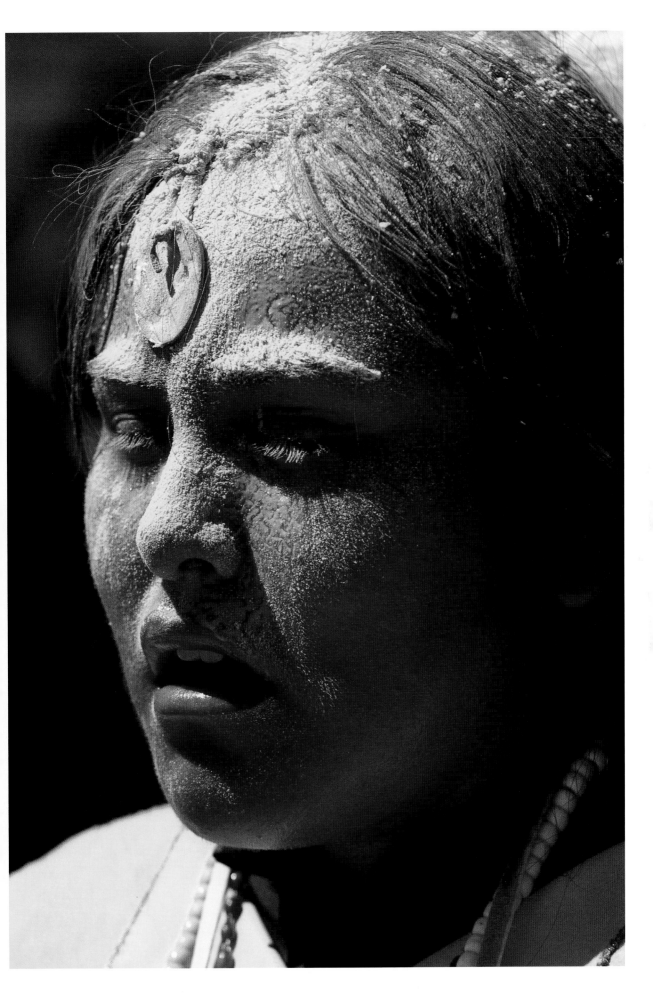

**Above:** The clown wears
a white headdress and
swishes a bullroarer that
cuts through the air with a
whooshing noise.

**Ci-dessus :** Arborant une
coiffe blanche, le bouffon
fend l'air avec un rhombe
vrombissant.

**Oben:** Der Clown trägt einen
weißen Kopfschmuck und
lässt sein Schwirrholz mit
einem zischenden Geräusch
durch die Luft sausen.

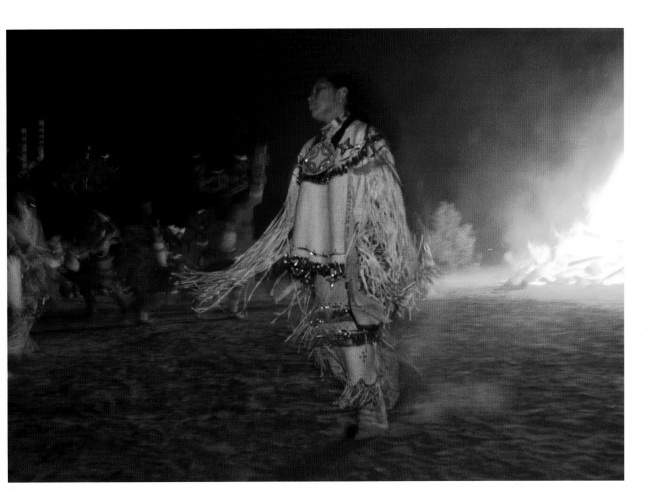

**Above:** The sunrise dancer is accompanied by four other girls, also dressed in buckskin clothes.

**Ci-dessus :** Quatre filles également habillées de peaux de daim se sont jointes à la danseuse du lever du soleil.

**Oben:** Die Sunrise-Tänzerin wird von vier Mädchen begleitet, die ebenfalls Hirschlederkleider tragen.

**Right:** The third morning starts with the girl and her helpers dancing behind an open tipi while the mountain spirits dance in and out of it.
**Pages 170–173:** Later, the girl dances with her godfather inside the tipi. The mountain spirits daub her with white clay as a blessing and to commemorate Changing Woman, who was caked in clay when she stepped ashore after surviving the Great Flood.

**À droite :** Au troisième matin, la jeune fille et ses aides dansent derrière un tipi ouvert, tandis que les esprits de la montagne entrent et sortent du tipi en dansant.
**Pages 170–173 :** Plus tard, la fille danse avec son parrain dans le tipi. Les esprits de la montagne enduisent ensuite sa tête d'argile blanche, un rite de bénédiction ; il commémore la Femme-qui-Change, recouverte d'argile lorsqu'elle mit pied sur le rivage après avoir survécu au Grand Raz-de-Marée.

**Rechts:** Der dritte Tag beginnt mit einem Tanz des Mädchens und seiner Helfer hinter einem offenen Tipi, während die Berggeister in und vor dem Tipi tanzen.
**Seiten 170–173:** Später tanzt das Mädchen mit seinem Paten im Tipi. Die Berggeister bedecken es mit weißem Ton, der es segnet und an Changing Woman erinnert, die nach der großen Flut tonbedeckt ans Ufer kam.

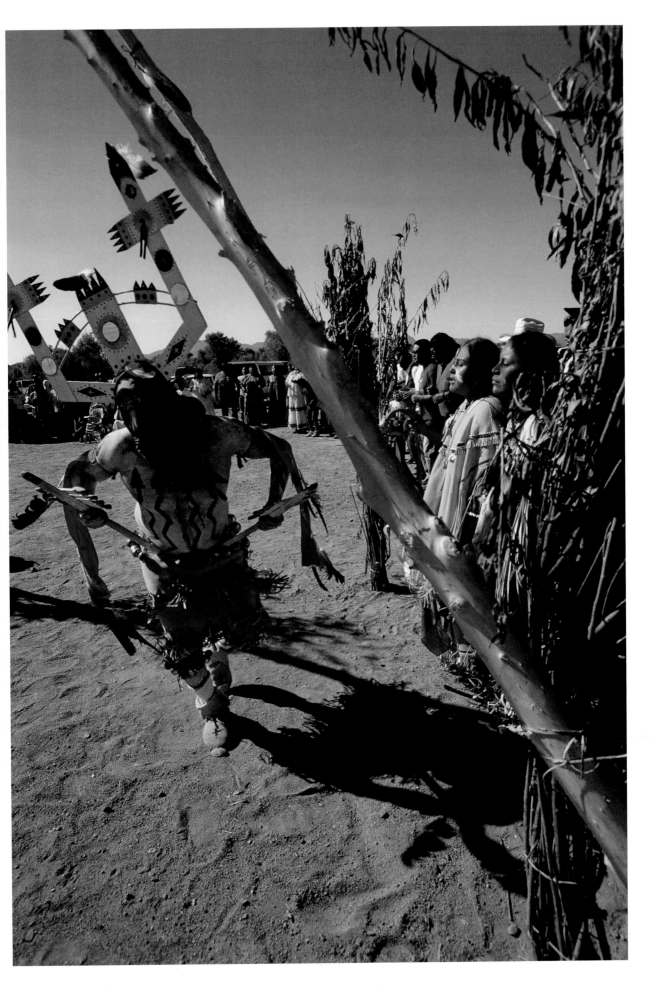

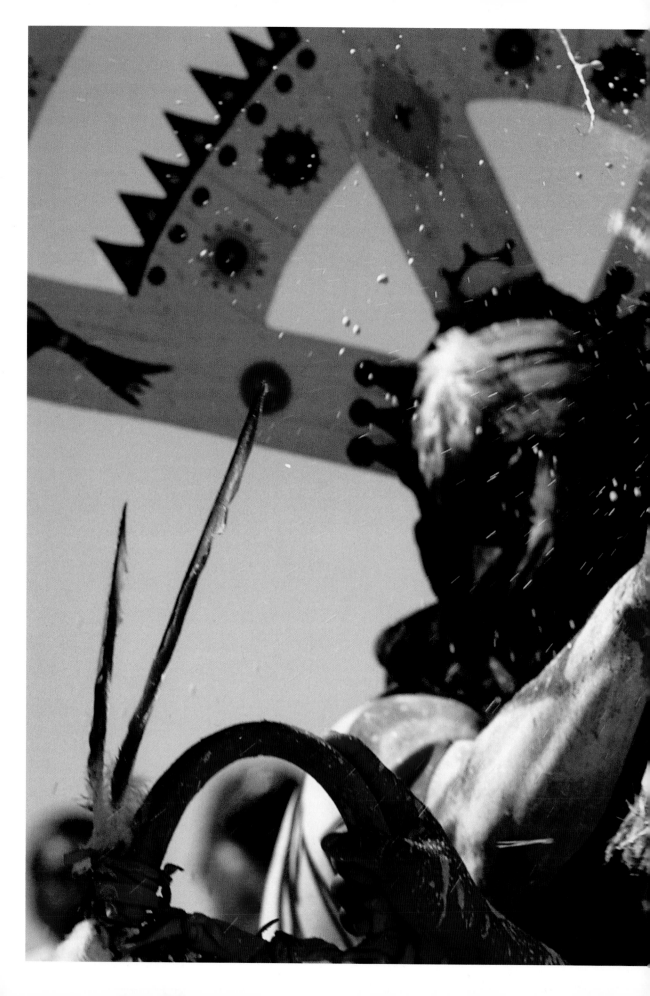

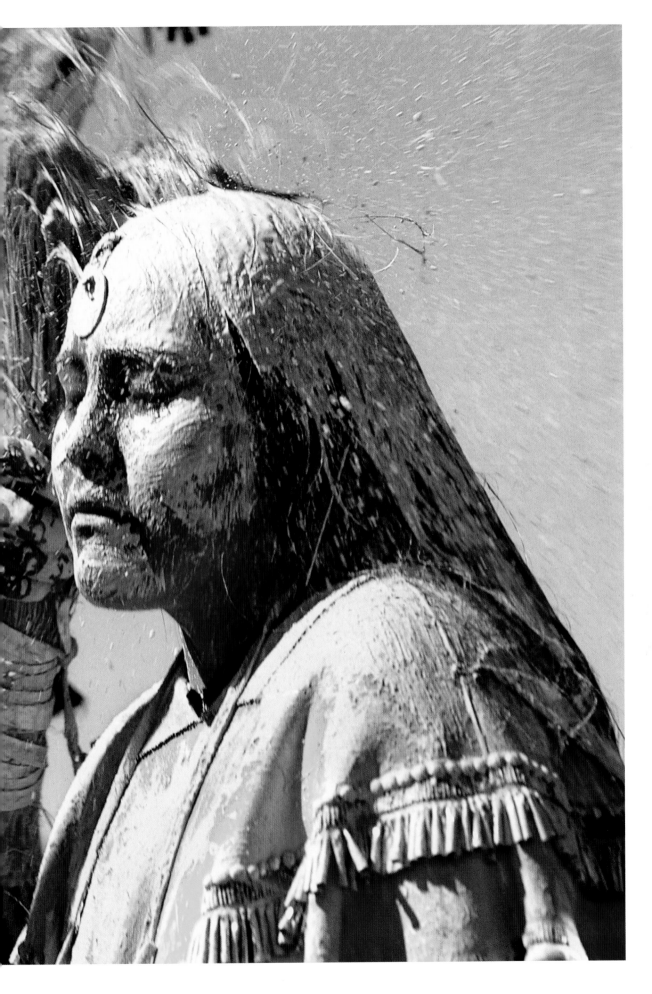

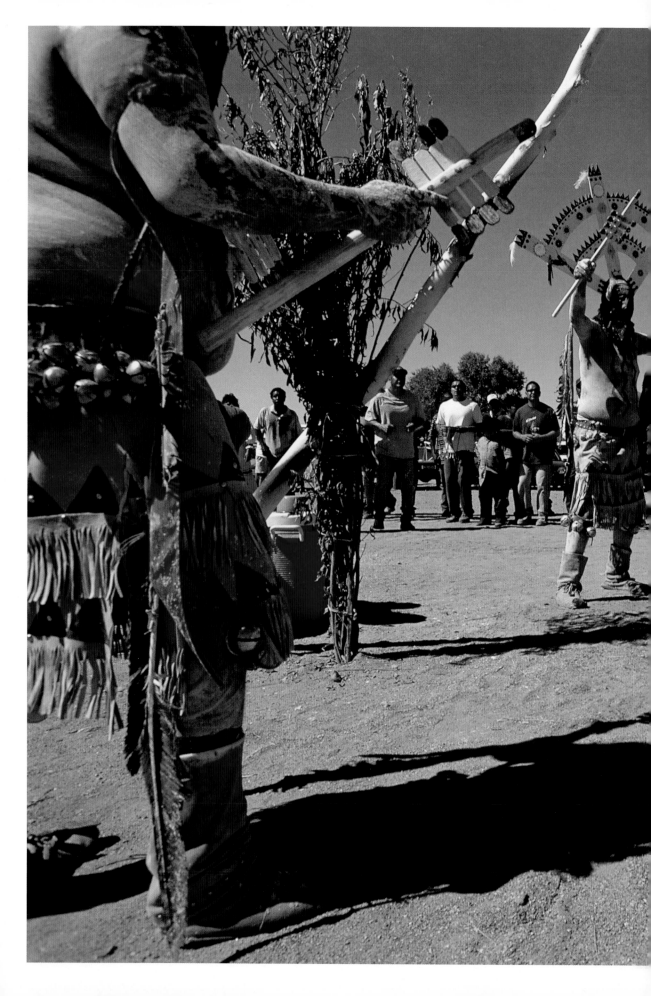

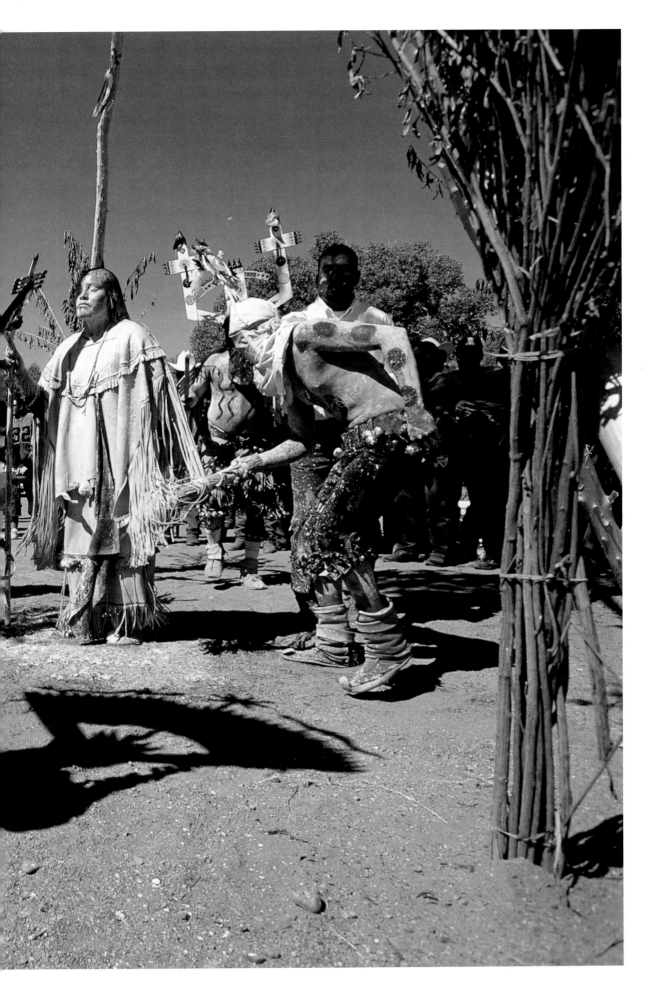

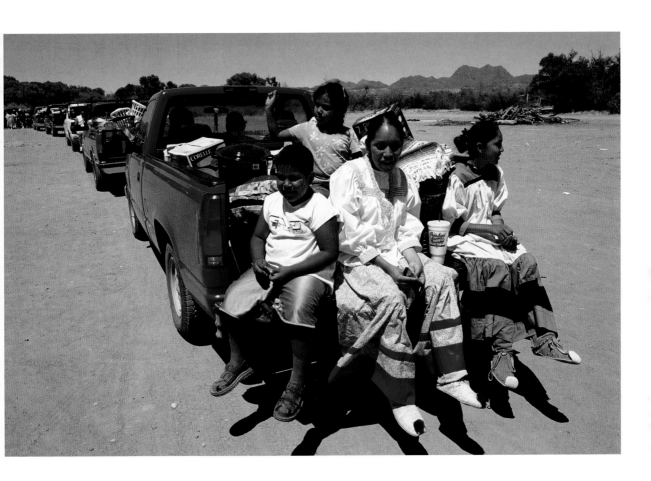

**Above:** When the third day's dances are over it is time for the gift exchange. The girl's family presents gifts to the godparents' camp, and then the godparents' family responds by giving gifts of similar value to the girl's family.

**Ci-dessus :** Des cadeaux sont échangés à la fin du troisième jour de danses. La famille de la jeune fille offre des présents au camp du parrain et de la marraine. Ceux-ci font à leur tour des cadeaux de valeur similaire à la famille de la fille.

**Oben:** Wenn die Tänze des dritten Tages vorbei sind, ist es Zeit, Geschenke auszutauschen. Die Familie des Mädchens bringt Geschenke ins Lager der Paten, die daraufhin der Familie des Mädchens Geschenke von vergleichbarem Wert macht.

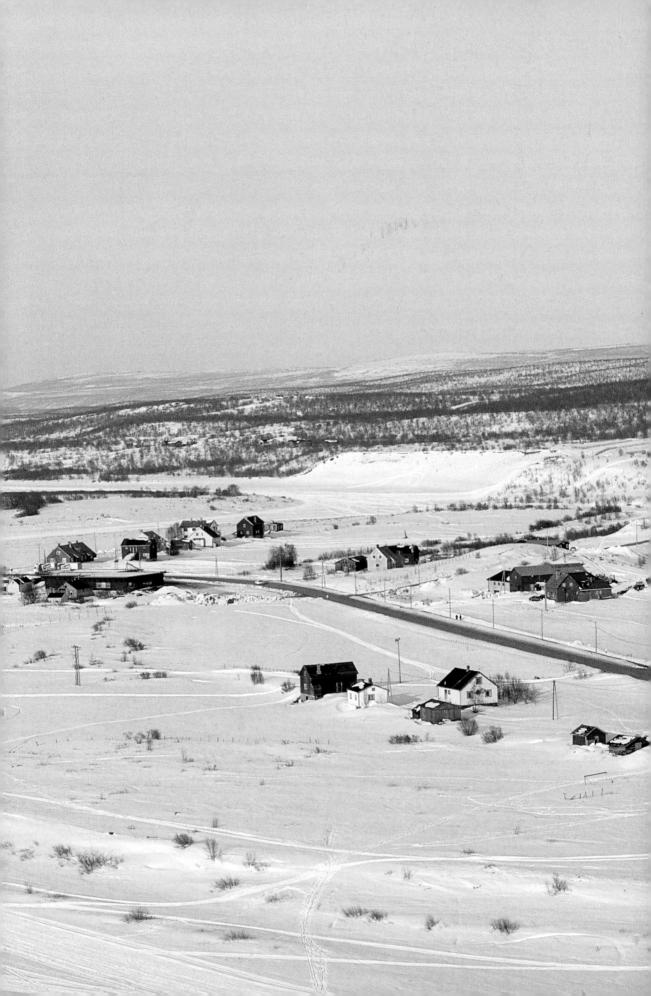

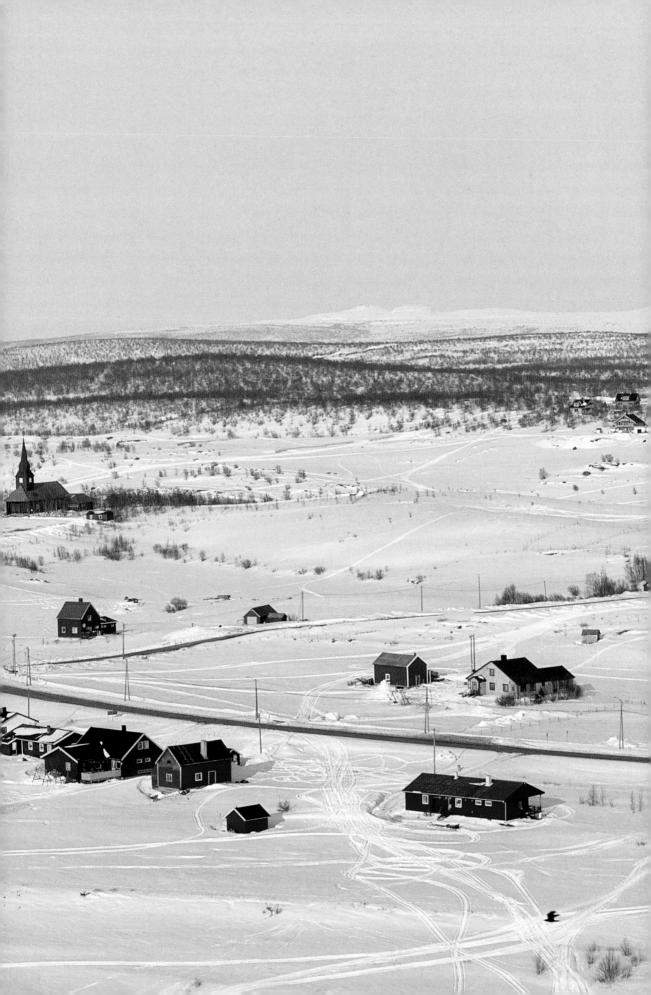

# Saami confirmation
## *Kautokeino, Norway*

Kautokeino Church is packed to the rafters, the pale faces of the several hundred-strong congregation standing out amid a sea of red and blue traditional Saami outfits.

The confirmees kneel at the altar rails, the soles of their reindeer-skin shoes turned up towards the congregation. They are about to receive Holy Communion for the first time and the priest walks along the rails laying his hand on each confirmee's head in a blessing.

Outside the sun shines over the winter landscape, the reflected light from the snow bathing the church interior in light. In two weeks it will be Easter, the traditional time for weddings, baptisms and confirmations in Kautokeino and also the date for a major Saami festival, featuring reindeer racing, concerts and plays. Afterwards, the Saami reindeer herders will leave in small groups to follow their animals on the springtime migration to the summer grazing pastures on the Atlantic coast.

Traditional shamanist Saami beliefs have all but given way to Christianity and the Norwegian Saami have been Lutherans for generations now. Confirmation in the Lutheran Church is an affirmation of the baptism, when the child was cleansed of sin and welcomed into the Christian fellowship. It also marks the confirmee's entry into the adult world.

Among the young people kneeling at the altar rails is fifteen-year-old Inga Anne Marit Hætta Juuso. Shining brightly on her chest are two silver broaches, one a confirmation present and the other borrowed from her mother. Like most of her fellow confirmees, she is dressed in a new Saami outfit. Putting it on that morning took two hours, despite help from her mother and two aunts.

The minister gives the confirmees the bread and wine, symbolising the body and blood of Christ, after which the congregation files up to the altar to share in the sacrament.

When the service is over the families head off for a reception at home with presents, cake and coffee.

Inga Anne Marit's relatives on her father's side have come all the way from Finland, where her uncles herd her reindeer. But reindeer-herding holds little appeal for Inga Anne Marit. She wants to be a veterinary surgeon or footballer.

**Pages 176–177:** Kautokeino, on the Finnmark Plateau in northern Norway, is a centre of Saami culture.
**Right:** Wearing the traditional high Saami bonnet and silk shawl pinned by two silver broaches, a Saami girl is confirmed at Kautokeino Church. Confirmations are held every year shortly before Easter.
**Pages 180–181:** Easter coincides with a major Saami cultural festival where the attractions include reindeer racing.

**Pages 176–177:** Kautokeino, sur le plateau du Finnmark dans le nord de la Norvège, est un centre de la culture sami.
**À droite:** Parée du châle de soie attaché par deux broches en argent et de la coiffe sami traditionnels, une adolescente fait sa confirmation dans l'église de Kautokeino. Les confirmations ont lieu chaque année, juste avant Pâques.
**Pages 180–181:** À Pâques, se déroule également un grand festival culturel sami qui inclut des courses de rennes.

**Seiten 176–177:** Kautokeino liegt in der Finnmark im nördlichen Norwegen und ist ein Zentrum der samischen Kultur.
**Rechts:** Ein samisches Mädchen mit traditioneller hoher Haube und einem Seidenschal, der von zwei Silberbroschen gehalten wird, wird in der Kirche von Kautokeino konfirmiert. Konfirmationen finden jedes Jahr kurz vor Ostern statt.
**Seiten 180–181:** An Ostern findet auch ein samisches Kulturfestival statt. Zu seinen Attraktionen gehören auch Rentierrennen.

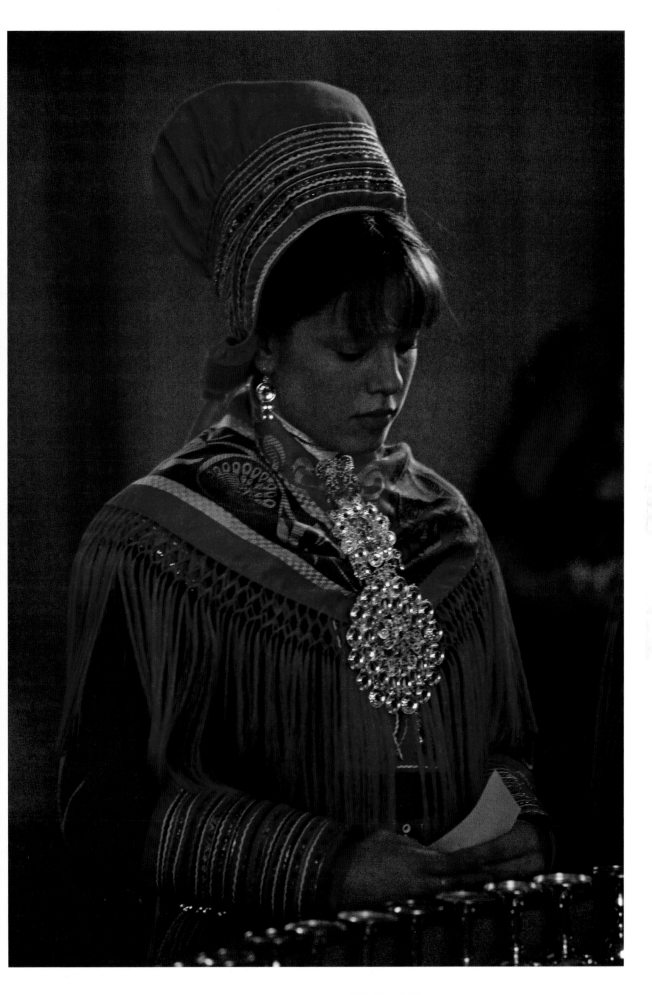

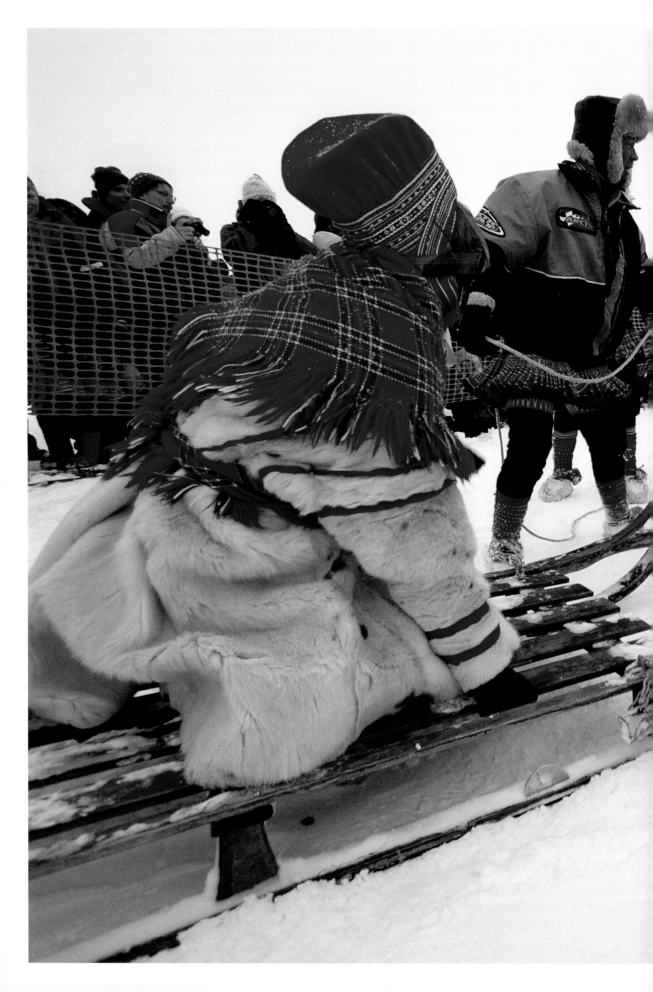

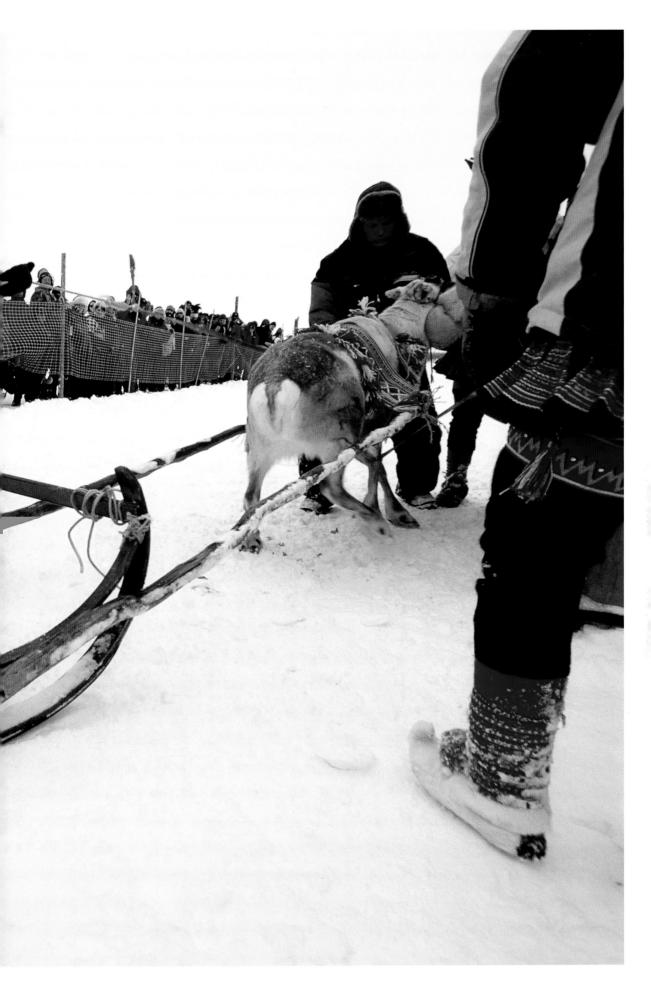

# La confirmation chez les Sami
## *Kautokeino, Norvège*

L'église de Kautokeino est bondée ; les visages pâles de plusieurs centaines de membres de la congrégation se détachent dans la mer des costumes traditionnels rouges et bleus des Sami. Les confirmands sont agenouillés devant l'autel, les semelles de leurs chaussures en peau de renne tournées vers la congrégation. Ils sont sur le point de recevoir la Sainte Communion pour la première fois, le prêtre posant alors sa main sur la tête de chacun d'eux pour les bénir.

Dehors, le soleil brille sur le paysage hivernal et la lumière qui se reflète dans la neige inonde l'intérieur de l'église. Dans deux semaines ce sera Pâques, la période traditionnelle à Kautokeino pour les mariages, les baptêmes et les confirmations, mais aussi l'époque du plus grand festival sami proposant une course de rennes, des concerts et des jeux. Après quoi, les gardiens des troupeaux se rassembleront en petits groupes afin de suivre les rennes pour la migration de printemps, vers les riches pâturages de la côte Atlantique.

Les croyances chamaniques traditionnelles des Sami ont été remplacées par le christianisme, les Norvégiens sami étant luthériens depuis des générations. La confirmation dans une église luthérienne est un prolongement naturel du baptême, lorsque l'enfant lavé du péché fut accueilli au sein de la communauté chrétienne. Elle marque également l'entrée du confirmand dans le monde des adultes.

Parmi les jeunes gens agenouillés devant l'autel se trouve Inga Anne Marit Hætta Juuso, âgée de quinze ans. Deux broches en argent scintillent sur sa poitrine, l'une étant un cadeau pour sa confirmation, tandis que l'autre a été empruntée à sa mère. Comme la plupart des confirmands présents, elle porte une nouvelle parure sami. Ce matin, elle a mis deux heures à se préparer avec l'aide de sa mère et de ses deux tantes.

Les confirmands reçoivent le pain et le vin du pasteur, symboles du corps et du sang du Christ ; la congrégation s'aligne ensuite devant l'autel pour partager le sacrement. Lorsque l'office est terminé, les familles se rendent à une réception à la maison, où sont offerts les cadeaux et un goûter. Du côté paternel, la famille d'Inga Anne Marit est venue de Finlande, où ses oncles élèvent pour elle des rennes. Mais Inga Anne Marit ne souhaite pas continuer à élever des rennes. Elle veut être vétérinaire ou footballeuse.

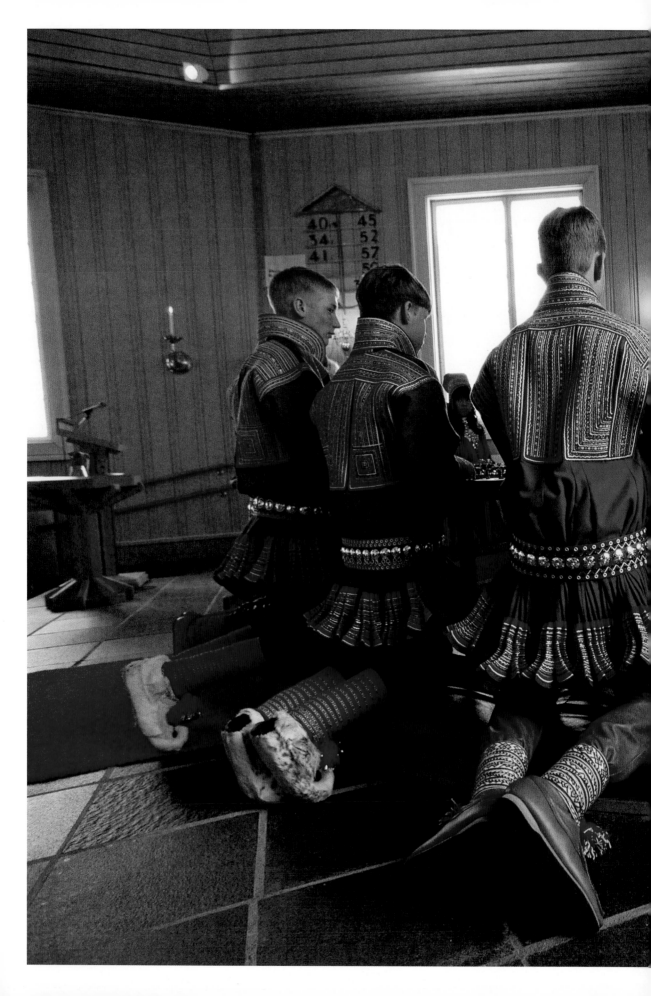

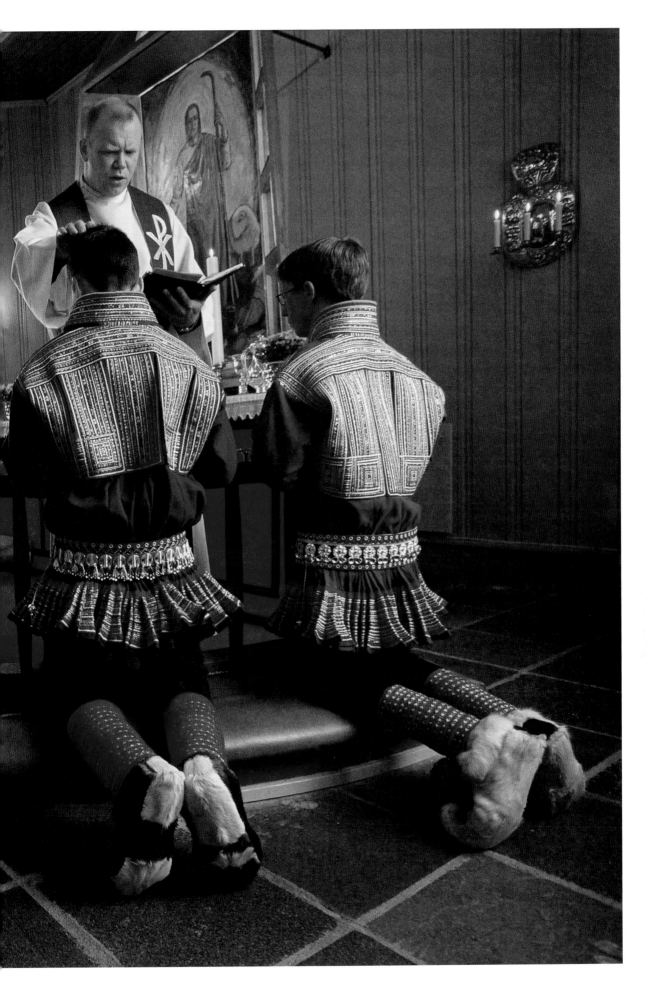

# Konfirmation bei den Samen
## *Kautokeino, Norwegen*

Die Kirche von Kautokeino ist brechend voll, die blassen Gesichter der mehrere Hundert Mitglieder zählenden Gemeinde stechen aus dem Meer von roten und blauen samischen Trachten hervor.

Die Konfirmanden knien vor dem Altar, sodass die Sohlen ihrer Rentierlederschuhe zur Gemeinde zeigen. Sie werden gleich zum ersten Mal an der heiligen Kommunion teilnehmen, und der Priester geht an ihnen entlang und legt allen Konfirmanden der Reihe nach segnend die Hand auf den Kopf.

Draußen scheint die Sonne über der Winterlandschaft. Ihr Licht wird vom Schnee reflektiert und erleuchtet das Kircheninnere. In zwei Wochen ist Ostern, die Zeit der Hochzeiten, Taufen und Konfirmationen in Kautokeino. Und auch ein großes Festival findet zu dieser Zeit statt, für das Rentierrennen, Konzerte und Theateraufführungen veranstaltet werden. Danach machen sich die samischen Hirten in kleinen Gruppen auf, um den Tieren auf ihrer Frühjahrswanderung zu den Weideplätzen an der Atlantikküste zu folgen.

Der traditionelle Schamanenglaube der Samen wurde fast vollständig vom Christentum verdrängt. Die norwegischen Samen sind schon seit Generationen Lutheraner. In ihrer Kirche ist die Konfirmation eine Bestätigung der Taufe, mit der das Kind von seinen Sünden befreit und in die Gemeinschaft der Christen aufgenommen wurde. Zugleich markiert die Konfirmation den Übergang in das Erwachsenenalter.

Unter den Jugendlichen, die vor dem Altar knien, ist die 15-jährige Inga Anne Marit Hætta Juuso. Auf ihrer Brust strahlen zwei silberne Broschen; die eine ist ein Konfirmationsgeschenk und die andere eine Leihgabe der Mutter. Wie die meisten ihrer Mitkonfirmanden hat sie eine neue Samentracht an. Sie am Morgen anzulegen, hat zwei Stunden gedauert, und das obwohl ihre Mutter und zwei Tanten ihr geholfen haben.

Der Pastor verteilt Brot und Wein an die Konfirmanden, die den Leib und das Blut Christi symbolisieren, wonach sich auch die Gemeinde zum Altar bewegt, um am Sakrament teilzuhaben.

Nach dem Gottesdienst gehen die Familien nach Hause zurück und feiern bei Kaffee, Kuchen und Geschenken.

Inga Anne Marits Verwandte väterlicherseits sind den ganzen Weg aus Finnland gekommen, wo ihre Onkel ihre Rentiere hüten. Aber die Rentierzucht erscheint Inga Anne Marit nicht besonders attraktiv: Sie möchte lieber Tierärztin oder Fußballspielerin werden.

**Right:** Traditional Saami dress includes reindeer-skin boots with straw linings for maximum insulation. The uppers are tied to the base of the trousers with colourful binding to keep out snow and ice.

**À droite :** La tenue traditionnelle sami comprend des bottillons en peau de renne fourrés de paille ; ils sont attachés au bas de la culotte par une bande colorée pour une protection maximale contre la neige et la glace.

**Rechts:** Zur samischen Tracht gehören Stiefel aus Rentierleder, die zum Wärmen mit Stroh gefüttert sind. Der Schaft ist mit bunten Bändern über das Hosenbein gebunden, damit kein Schnee in die Stiefel rutschen kann.

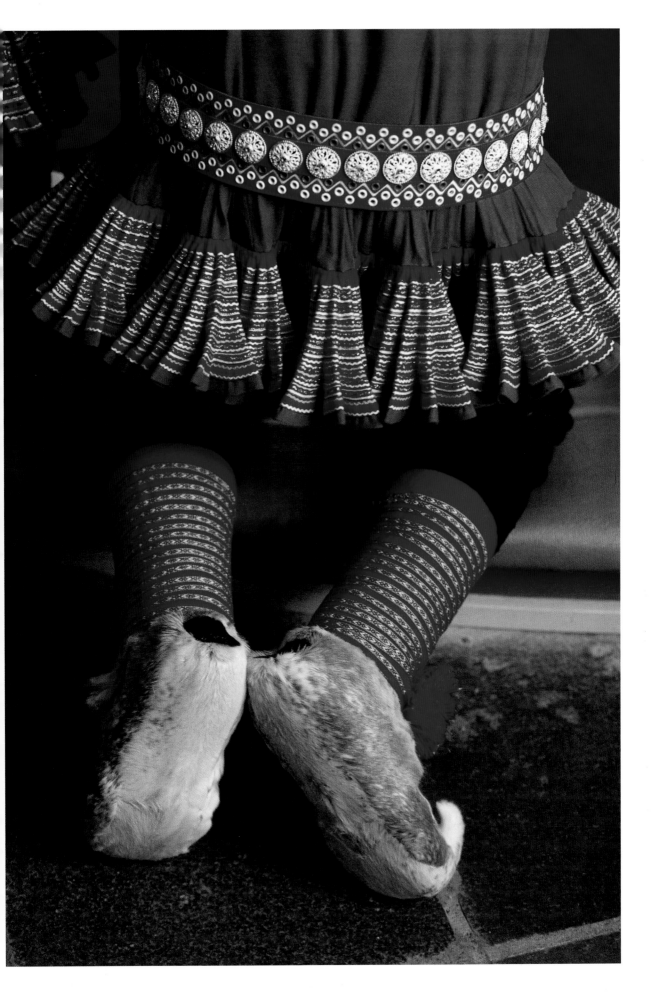

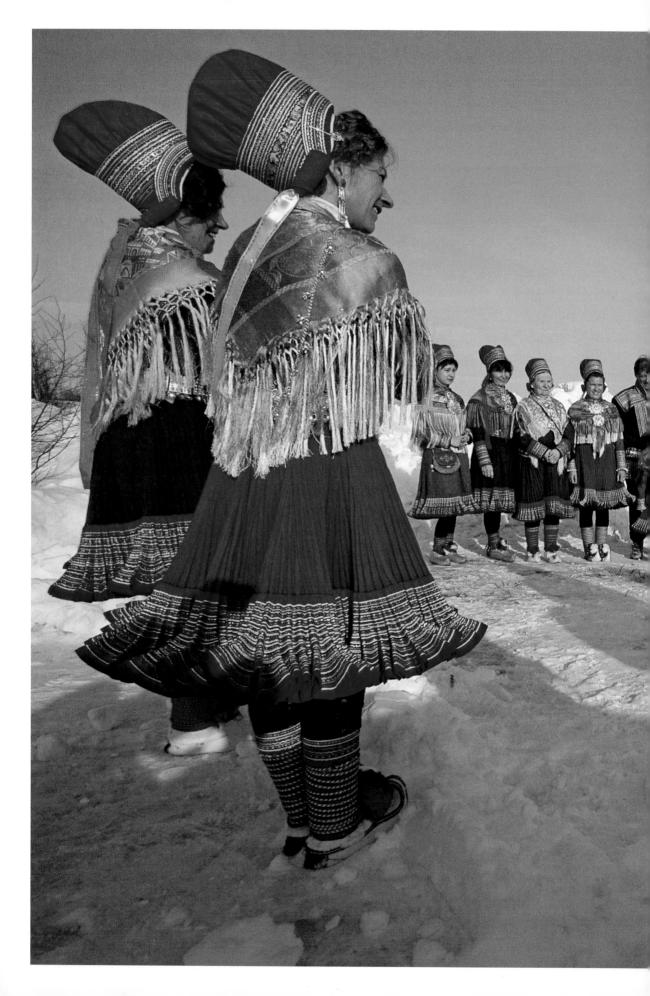

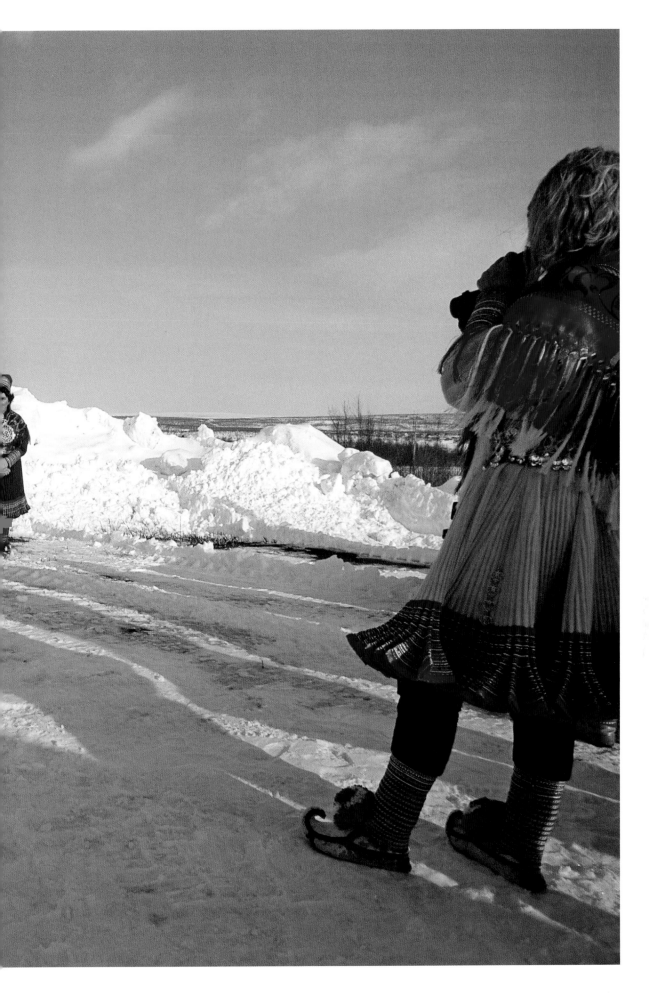

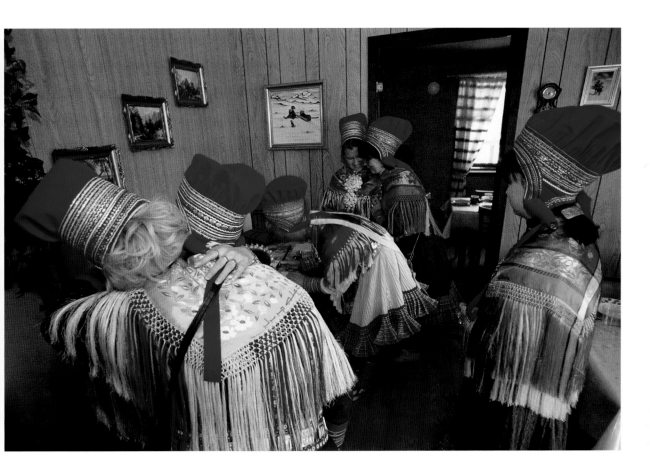

**Pages 190–191 and above:**
After the church ceremony
relatives and friends go to
the confirmee's home. Pho-
tographs are taken outside
in the snow and a reception
is held indoors.

**Pages 190–191 et ci-
dessus:** Après la cérémonie
à l'église, les obligatoires
séances de photos sont
prises dehors, dans la neige,
mais la réception qui réunit
parents et amis se tient au
chaud, à l'intérieur.

**Seiten 190–191 und oben:**
Nach der Kirche gehen die
Verwandten und Freunde
mit den Konfirmanden nach
Hause. Draußen im Schnee
werden Fotos gemacht und
drinnen wird gefeiert.

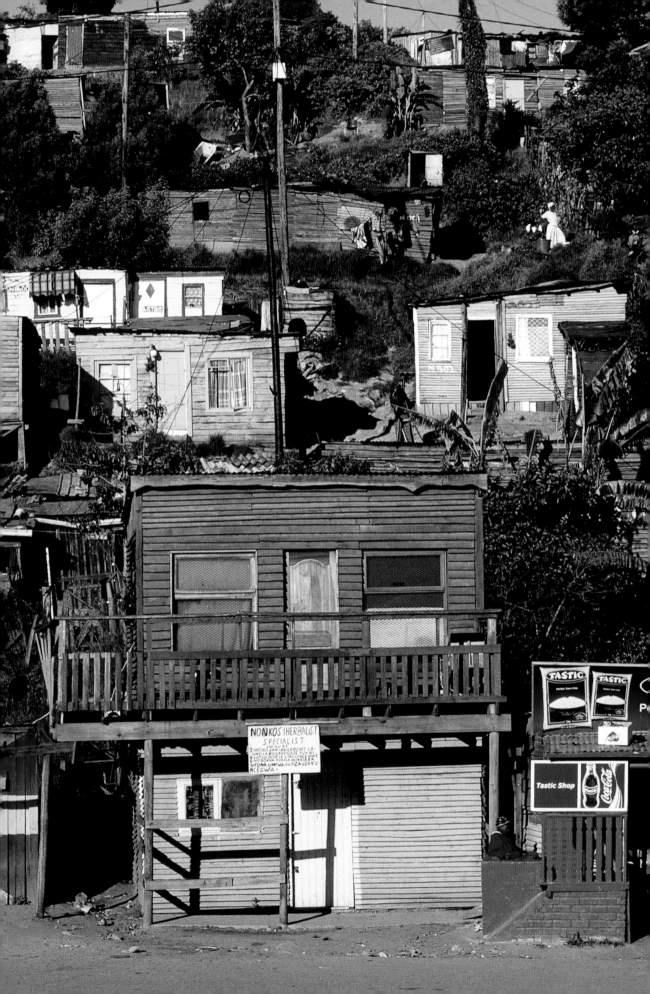

# Xhosa male initiation
## Eastern and Western Cape, South Africa

Things are different this year. It is 19 December 2006 and the usual news stories about young men dying after undergoing the traditional Xhosa circumcision ritual are conspicuous by their absence.

"By this time of year we've usually heard of ten dying here and fifteen dying there. But so far this year there's been nothing yet," Patric says, with an air of satisfaction.

A Xhosa himself, he is part of a group that has worked hard to reduce deaths during male initiation ceremonies. Right now he is on his way to visit a group of young initiates who were circumcised a few weeks ago and are living together in a small group of trees and bushes just fifty metres from the buildings of the black township on the outskirts of Knysna in Western Cape Province, where their families live.

Before reaching the wood, Patric calls out so the initiates know a grown man is approaching. "I can't see my way, where's the path?"

In response come a collection of strong, deep sounds that continue until he has made his way through the first row of bushes.

A group of young men are lounging beneath the trees. They are dressed in felt loincloths and all the visible parts of their bodies – apart from their hair, lips and eyes – are caked in white mud. Two of their domed huts stand close by, with a third just visible between the trees. All three are covered in black plastic. Litter and rubbish lie everywhere.

The Xhosa are the southernmost of Africa's Bantu-speaking people and have their ancestral homeland between the umThamvuna and Fish rivers in Eastern Cape Province. Traditionally, Xhosa undergo the male initiation rite during the cooler winter months. The timing is deliberate and intended to minimise the risk of developing an infection afterwards.

In his book *Long Walk to Freedom*, Nelson Mandela, the best known of all Xhosa, recalled being circumcised with the short spear, or *assegai*, still favoured by many circumcisers. "The pain was so intense that I buried my chin against my chest," he wrote.

Mandela was sixteen then. Today the minimum age for circumcision is eighteen; most of those who undergo the ritual are aged between eighteen and twenty.

Before the ritual, the initiate has his head shaved and gives away his worldly possessions. He is then guided to a prearranged, uninhabited place where the ceremony begins with circumcision. In the old days, initiates would spend six months living in seclusion and learning how to be a Xhosa man before being allowed to return home. The rules were strict, with initiates receiving instruction in self-discipline and being required to hunt for food once their circumcision wounds had healed.

These days, the ritual lasts for three to six weeks and many young men are initiated during the summer, when they are on holiday from school or work. They may travel to the former Transkei and Ciskei homelands in Eastern Cape if they still have family living there, though nowadays it is common to undergo initiation in the townships of big cities like Cape Town and Port Elizabeth, where many Xhosa have moved. Here the young men spend their initiations in cardboard and plastic

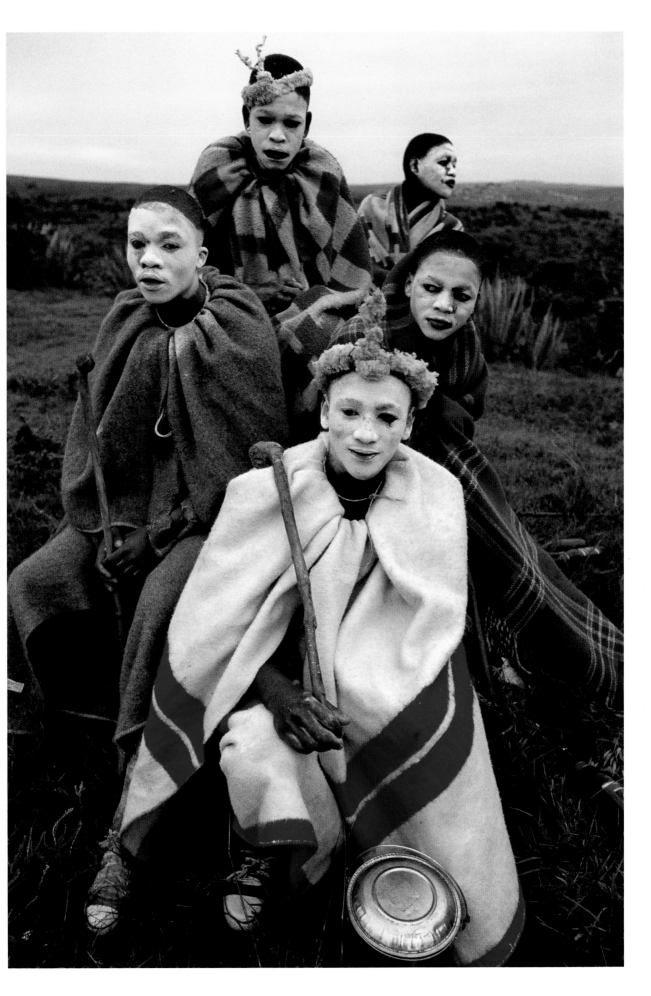

shelters, in fields assigned to them by the local authorities or in a wood on the edge of a town, as at Knysna.

In the camp that Patric visits, sunlight filters through the foliage, illuminating patches of white on the young men's bodies. For four of the initiates the ritual will soon be over and in two days they will return home. They are visibly proud at having completed their month-long manhood test.

Hardest, they say, was the week after circumcision. Those seven days were filled with pain, they were not allowed to leave their shelter, could only drink minimal amount of water and were forbidden to eat anything containing salt. Their wounds were continually redressed, as often as once every five minutes straight after circumcision, with green leaves for bandages.

The pain eased after the first week but the rules remained strict. Western clothes, mobile phones and use of modern medicines were all banned, as was leaving the wood to visit the township or see a doctor or nurse. Had they sought medical help it would have nullified the circumcision and they would never have been viewed as men. This, in turn, would have disqualified them from ever being able to speak at meetings or to enter cattle pens during Xhosa ceremonies.

To guard against cheating, preventing them from passing only parts of the initiation, leaders disclose their secret knowledge to initiates in dribs and drabs. Only someone who has passed all parts of the initiation can answer all the questions. The scar on a man's penis also reveals whether his circumcision was performed by an *ingcibi* (traditional circumciser) or in a medical centre.

Numerous cases of botched circumcisions, some even involving deaths and amputations, have heaped controversy on male initiation. Patric insists the problem is due not to tradition but to the breakdown of Xhosa society, where elders no longer play an active role and young men are left to make their own decisions. This, he says, puts them at the mercy of untrained circumcisers and men who harass and sometimes injure them.

The government has responded by introducing new guidelines and requirements: a minimum age for circumcision of eighteen; mandatory certification of circumcisers; compulsory pre-initiation medical check-ups for all initiates to determine, for instance, whether they are HIV-positive; and the establishment of guardian committees in all Xhosa communities to look after and keep an eye on initiates.

Patric, a local health authority AIDS adviser and counsellor, has helped to introduce the new rules in Knysna, where they have been highly successful. One positive effect is that local leaders now accept the need for initiates to seek medical treatment (though only if both the circumciser and the initiate's father agree it is essential).

The following evening, the initiates dance round a bonfire of car tyres as a plume of acrid, black smoke spews into the air. The heat is so intense that the plastic on one of the shelters starts to melt. Patric joins in the dance along with Andrew, one of the *khankatha* (guardians) who have helped the young men during their initiation.

On the morning after, the initiates bathe in a nearby watercourse at dawn and are then rubbed in butter before leaving the camp and heading back to their homes. Barefoot, wrapped in blankets and without so much as a glance back at the camp where their shelters have been set on fire, they begin their long walk through the township. A group of men follow them, play-fighting with sticks and singing a hymn to the mythical Somagwaza, the first Xhosa to be circumcised and attain true manhood.

# L'initiation des jeunes Xhosa
## *Cap-Ouest et Cap-Est, Afrique du Sud*

**Pages 200–201:** This initiation camp has been built in a grove of trees just fifty metres from Khayalethu South township at Knysna, Western Cape. Here the initiates are circumcised and then spend weeks being inducted into adulthood before eventually being allowed to return home.

**Pages 202–203:** Initiates are vulnerable to evil forces during the initiation process. They thwart attacks by daubing themselves in white clay, making it impossible for witches to tell them apart.

**Pages 200–201:** Le camp d'initiation a été bâti dans un bosquet, à quelque 50 mètres à peine de la township de Khayalethu à Knysna, Cap-Ouest. C'est ici que les garçons subissent la circoncision et un apprentissage de la vie d'adulte pendant des semaines, avant d'être autorisés de rentrer dans leurs foyers.

**Pages 202–203:** Les jeunes sont vulnérables aux forces du mal durant le processus d'initiation. Ils s'enduisent d'argile blanche pour se protéger des attaques des esprits malfaisants qui, ainsi, ne peuvent pas les différencier.

**Seiten 200–201:** Das Lager für die Initiation wurde in einem kleinen Wald nur 50 Meter vom Township Khayalethu South bei Knysna in der Provinz Westkap errichtet. Hier werden die jungen Männer beschnitten, um danach mehrere Wochen in das Erwachsenenleben eingeführt zu werden. Dann erst dürfen sie nach Hause zurück.

**Seiten 202–203:** Initianden sind, während sie an dem Ritual teilnehmen, anfällig für die Kräfte des Bösen. Davor schützen sie sich mit einer Schicht weißem Lehm – so können Hexen sie nicht mehr auseinanderhalten.

Les choses sont bien différentes cette année. Nous sommes le 19 décembre 2006 et les faits divers qui d'habitude relatent la mort de jeunes hommes à la suite des rituels traditionnels de circoncision xhosa, brillent par leur absence. « Normalement, à cette saison, on entend souvent parler d'une dizaine de morts par ci et d'une quinzaine par là. Mais cette année, il ne s'est encore rien passé de fâcheux », nous dit Patric avec satisfaction.

Lui-même Xhosa, il fait partie de ceux qui agissent pour réduire le nombre de morts lors des cérémonies d'initiation des jeunes hommes. Il est justement sur le point de rendre visite à un groupe de jeunes initiés circoncis il y a quelques semaines qui vivent ensemble dans un bosquet, à environ cinquante mètres des maisons du township où résident leurs familles, à la périphérie de Knysna dans la province du Cap-Ouest.

Avant d'atteindre le bois, Patric lance un appel afin de leur signaler qu'un adulte approche. « Je ne trouve pas mon chemin, par où dois-je passer ? » Comme réponse, il obtient des sons forts qui le guident vers la première rangée de buissons. Un groupe de jeunes hommes est allongé derrière les arbres. Ils sont vêtus de pagnes courts, et toutes les parties visibles de leur corps – sauf leurs cheveux, leurs lèvres et leurs yeux – sont recouvertes d'argile blanche. Deux huttes se trouvent non loin d'eux, une troisième est à peine visible derrière les arbres. Toutes trois sont recouvertes de plastique noir. Ordures et détritus jonchent le sol.

La population xhosa vit à l'extrême sud de l'Afrique bantoue, leurs terres ancestrales se situant entre la umThamvuna river et la Fish River, dans la province du Cap-Est. Traditionnellement, les Xhosa procèdent au rituel de l'initiation des jeunes hommes lors des mois les plus frais, en hiver. Ainsi, ils limitent les risques de développer une infection suite à l'intervention. Dans son livre *Un long chemin vers la liberté*, Nelson Mandela, le plus célèbre de tous les Xhosa, rappelle avoir été circoncis avec une courte lance, ou *assegai*, très prisée des circonciseurs. « La douleur fut si intense que j'ai dû bloquer mon menton contre ma poitrine », écrit-il.

Mandela était alors âgé de seize ans. Aujourd'hui, l'âge minimum pour la circoncision est de dix-huit ans ; la plupart des jeunes gens qui la subissent sont âgés de dix-huit à vingt ans. Avant le rituel, les initiés doivent se raser la tête et abandonner leurs moindres possessions. Ils sont ensuite conduits dans un lieu particulier et inhabité, où la cérémonie débute par la circoncision. Auparavant, les initiés devaient vivre reclus durant six mois afin d'apprendre à devenir un Xhosa, avant d'être autorisés à rentrer chez eux. Les règles étaient strictes et les initiés recevant une instruction d'autodiscipline devaient chasser pour se nourrir, une fois leurs blessures dues à la circoncision cicatrisées.

De nos jours, le rituel dure trois à six semaines et beaucoup de jeunes hommes sont initiés en été, pendant les grandes vacances scolaires. Ils peuvent se rendre dans leur patrie ancestrale – Transkei et Ciskei au Cap-Est – s'ils possèdent encore de la famille là-bas, mais il est plus fréquent aujourd'hui qu'ils effectuent l'initiation dans les townships des grandes villes comme Cape Town et Port Elizabeth, où beaucoup de Xhosa se sont installés. Là, les jeunes hommes passent la période d'initiation dans des abris en carton et plastique, dans des champs assignés par les autorités locales ou dans une forêt aux alentours d'une ville, comme ici à Knysna.

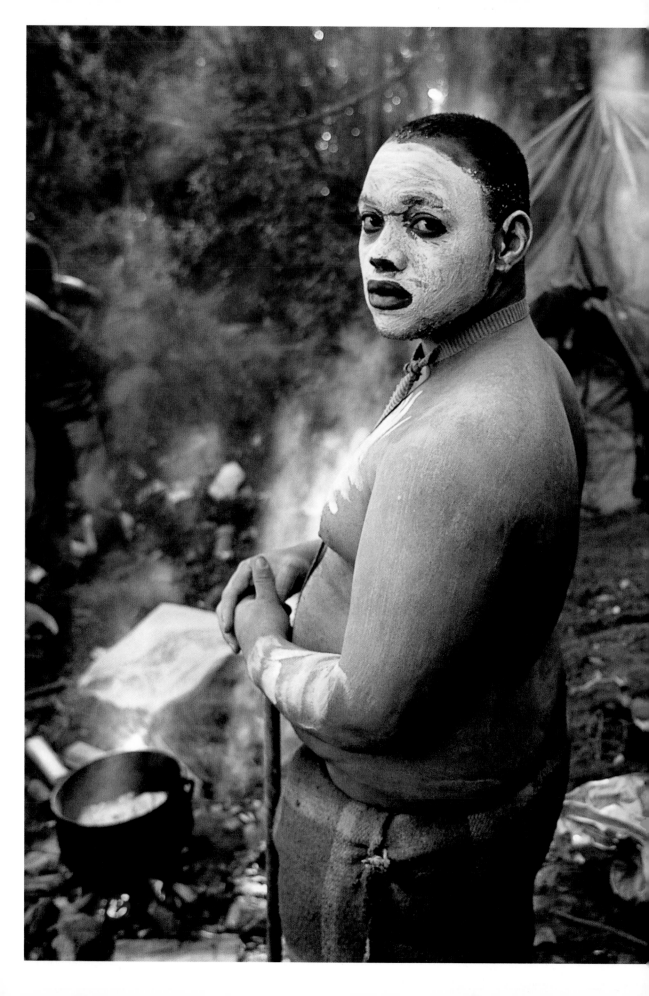

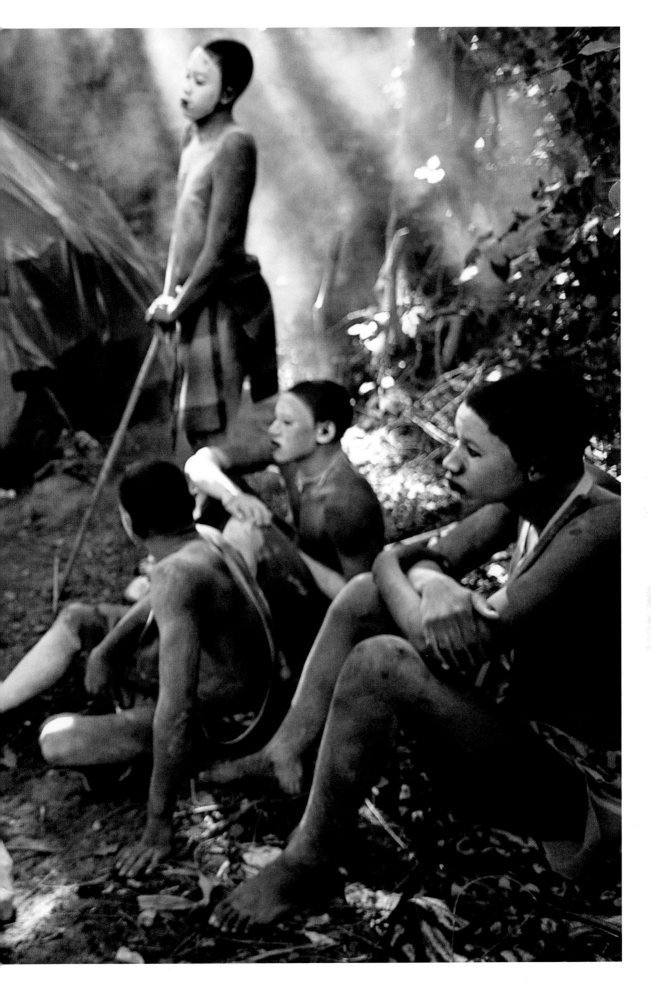

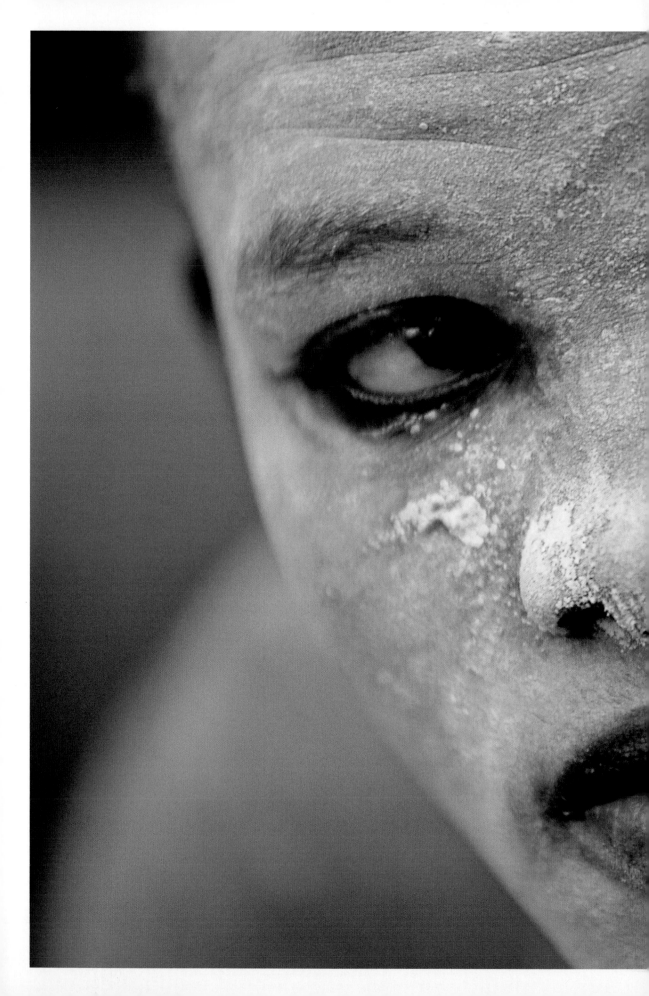

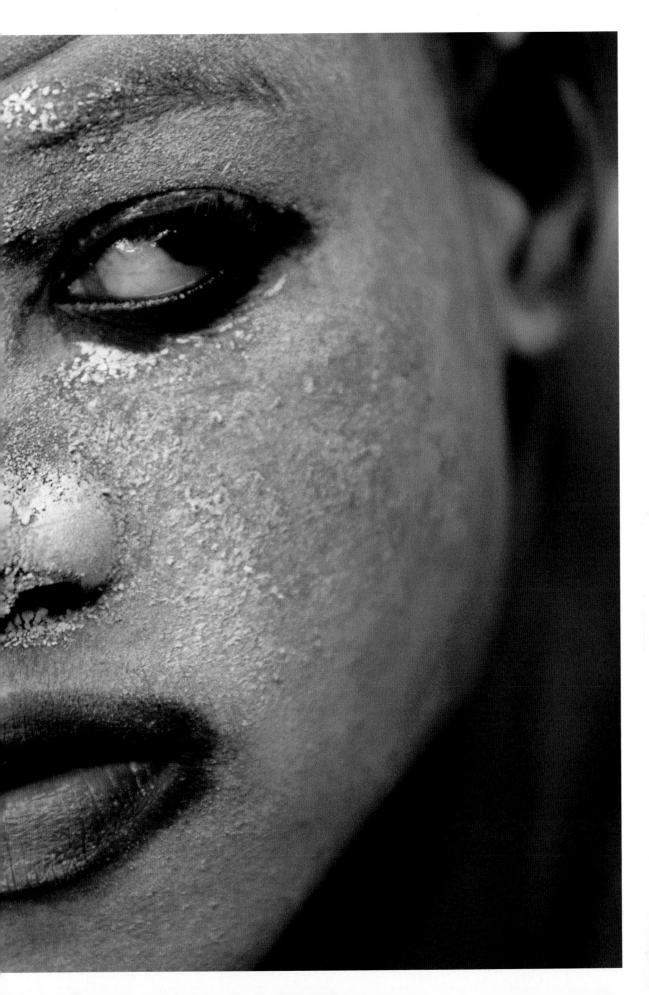

Dans le camp que visite Patric, les rayons du soleil filtrent à travers le feuillage, illuminant les traces blanches sur le corps des jeunes hommes. Pour quatre d'entre eux, le rituel s'achève bientôt, et dans deux jours, ils pourront rentrer chez eux. Ils ont l'air fiers d'avoir passé avec succès leur test de virilité pendant un mois.

Le plus difficile, nous disent-ils, ce fut la semaine après la circoncision. Sept jours de douleur, sans être autorisés à quitter leur abri, buvant de petites quantités d'eau avec l'interdiction de manger quoi que ce soit contenant du sel. Leurs blessures étaient continuellement pansées, parfois même toutes les cinq minutes après la circoncision, avec des feuilles vertes en guise de bandages.

La douleur s'atténue après la première semaine, mais les règles restent strictes. Les vêtements occidentaux, les téléphones portables et les médicaments modernes sont interdits, de même que quitter la forêt pour voir leur famille, un médecin ou une infirmière. S'ils allaient chercher une aide médicale, leur circoncision serait annulée et ils ne seraient jamais considérés comme des hommes. Ils ne seraient donc pas autorisés à s'exprimer aux réunions ou à entrer dans les parcs à bestiaux lors des cérémonies xhosa.

Pour éviter les tromperies et la tentation de partir avant la fin de l'initiation, les chefs révèlent les connaissances secrètes au fur et à mesure. Seul celui qui est resté tout au long de l'initiation est capable de répondre à toutes les questions. La cicatrice sur le pénis révèle également si la circoncision a été pratiquée par un *ingcibi* (circonciseur traditionnel) ou dans un centre médical.

Les nombreux cas de circoncisions qui se sont mal déroulées, certaines provoquant la mort ou des amputations, ont attisé la controverse concernant l'initiation des jeunes hommes. Patric insiste sur le fait que le problème n'est pas lié à la tradition, mais à la répartition de la société xhosa au sein de laquelle les plus âgés ne jouent plus un rôle actif, laissant les jeunes hommes prendre leurs décisions seuls. Ainsi livrés à eux-mêmes, ils sont à la merci de circonciseurs inexpérimentés qui les harcèlent et parfois les blessent.

Le gouvernement agit en introduisant de nouvelles directives et d'autres exigences : un âge minimum de dix-huit ans pour la circoncision ; un certificat obligatoire pour les circonciseurs ; des contrôles médicaux pour tous les initiés afin de dépister, par exemple, les cas de séropositivité, et la mise en place de comités de tuteurs dans toutes les communautés xhosa pour surveiller et protéger les initiés. Patric, un agent local des autorités sanitaires en matière de SIDA est aussi un conseiller. Il a ainsi aidé à introduire les nouvelles règles à Knysna qui, depuis lors, donnent de très bons résultats. Un des effets positifs est que les chefs locaux autorisent dorénavant les initiés à recevoir une aide médicale (mais uniquement si le circonciseur et le père de l'initié estiment que c'est nécessaire).

Le soir suivant, les initiés dansent autour d'un feu de pneus de voiture dans une fumée âcre et noire qui se répand dans l'air. La chaleur est si intense que le plastique de l'un des abris commence à fondre. Patric rejoint la danse avec Andrew, un des *khankatha* (gardiens) qui a aidé les jeunes hommes lors de leur initiation. Au matin, les initiés se baignent dans un cours d'eau aux alentours et se frictionnent avec du beurre avant de quitter le camp pour regagner leur maison. Pieds nus, enveloppés dans des couvertures et sans plus s'attarder dans le camp où leurs tentes ont été réduites en cendres, ils commencent leur longue marche à travers la township. Un groupe d'hommes les suit, jouant à se battre avec des bâtons et chantant l'hymne mythique de Somagwaza, le premier Xhosa à avoir été circoncis et à être devenu un homme.

**Right:** A vial of magic potion is worn around the neck to provide extra protection.
**Pages 206–207:** Initiates at Ciskei play traditional games with their guardian. Shelters were originally made of straw, but in the absence of the right kind of straw more modern materials can be used.

**À droite :** La fiole de potion magique portée autour du cou assure davantage de protection.
**Pages 206–207 :** Au Ciskei, les garçons et leur gardien se livrent à des jeux traditionnels. Les cases étaient autrefois faites de paille, mais, à défaut, on utilise aujourd'hui des matériaux modernes pour construire les abris.

**Rechts:** Als zusätzlicher Schutz dient ein Fläschchen Zaubertrank, das um den Hals getragen wird.
**Seiten 206–207:** Initianden in der Ciskei spielen mit ihrem Begleiter traditionelle Spiele. Die Hütten wurden ursprünglich aus Stroh gebaut, das aber nicht mehr verfügbar ist und daher durch modernere Materialien ersetzt werden darf.

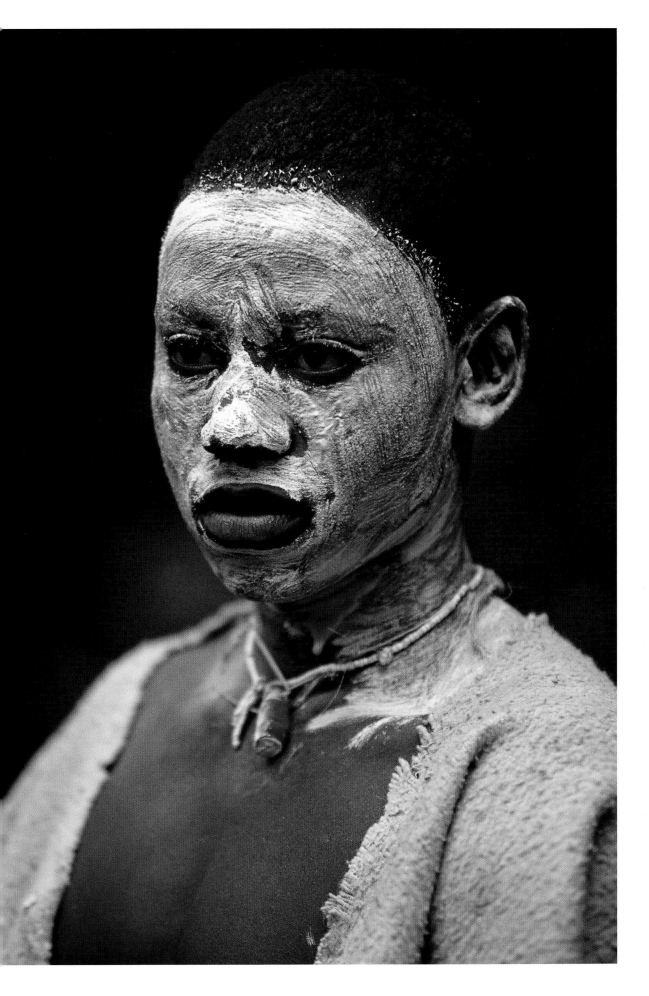

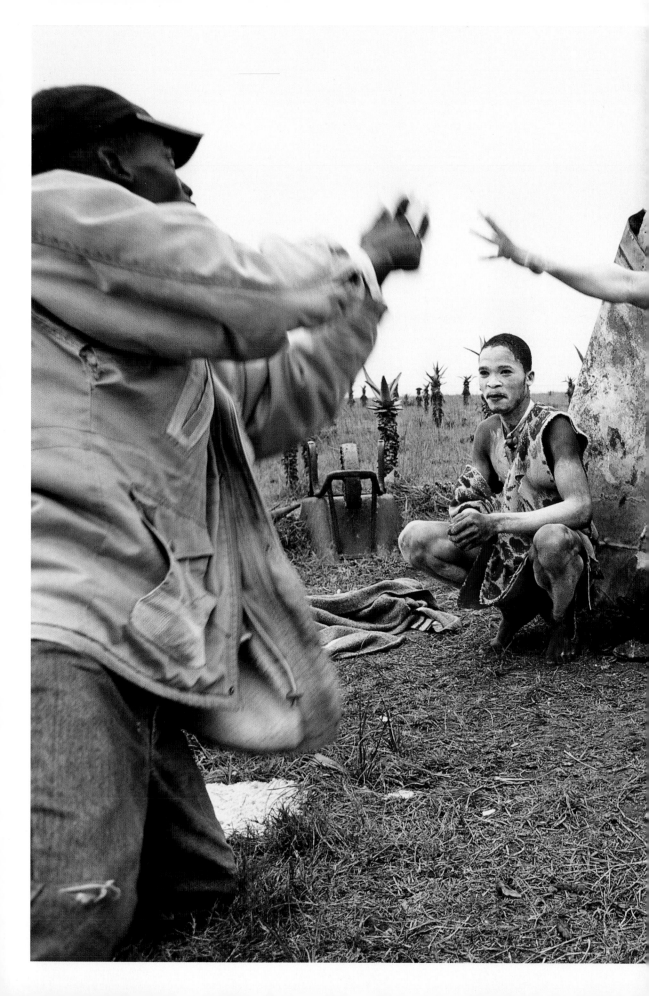

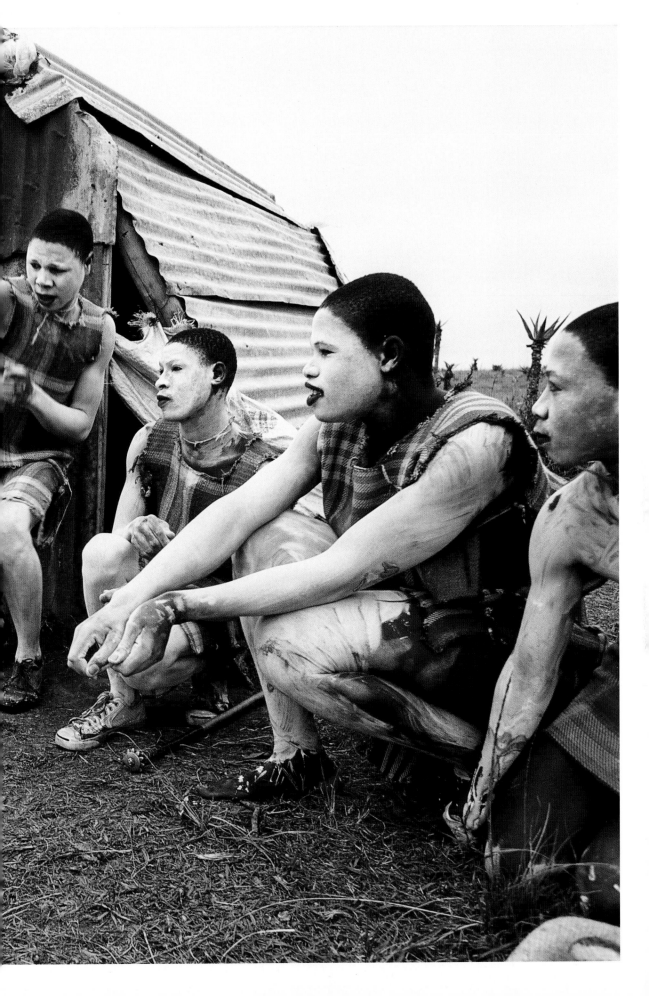

**Right:** The night before they return home the initiates have their heads shaved.
**Pages 210–213:** A bonfire of car tyres is lit and the initiates dance around it singing and chanting.
**Pages 214–215:** Before leaving the camp at the end of the initiation, the young men wash in a nearby stream and then smear themselves in butter. The three boys without penis sheathes are uncircumcised and have been staying with the initiates as helpers. They, too, must perform the homecoming ritual.

**À droite :** Les initiés ont le crâne rasé, la veille de leur retour à la maison.
**Pages 210–213 :** Les initiés allument un feu avec des pneus de voiture autour duquel ils dansent et chantent.
**Pages 214–215 :** À la fin de la période d'initiation, les jeunes hommes se lavent dans un ruisseau proche et s'enduisent de beurre avant de quitter le camp. Les trois garçons sans étui pénien ne sont pas circoncis ; ils ont assisté leurs aînés durant l'initiation. Eux aussi doivent exécuter le rituel du retour dans la communauté.

**Rechts:** Am Abend, bevor sie nach Hause zurückkehren, lassen sich die Initianden den Kopf rasieren.
**Seiten 210–213:** Autoreifen werden angezündet, und die Initianden tanzen um das Feuer herum und singen.
**Seiten 214–215:** Bevor sie am Ende des Initiationsritus das Camp verlassen, waschen sich die jungen Männer in einem Fluss und reiben sich mit Butter ein. Die drei Jungen ohne Penishüllen sind noch nicht beschnitten und halten sich als Helfer im Lager auf. Auch sie müssen das Heimkehrritual durchführen.

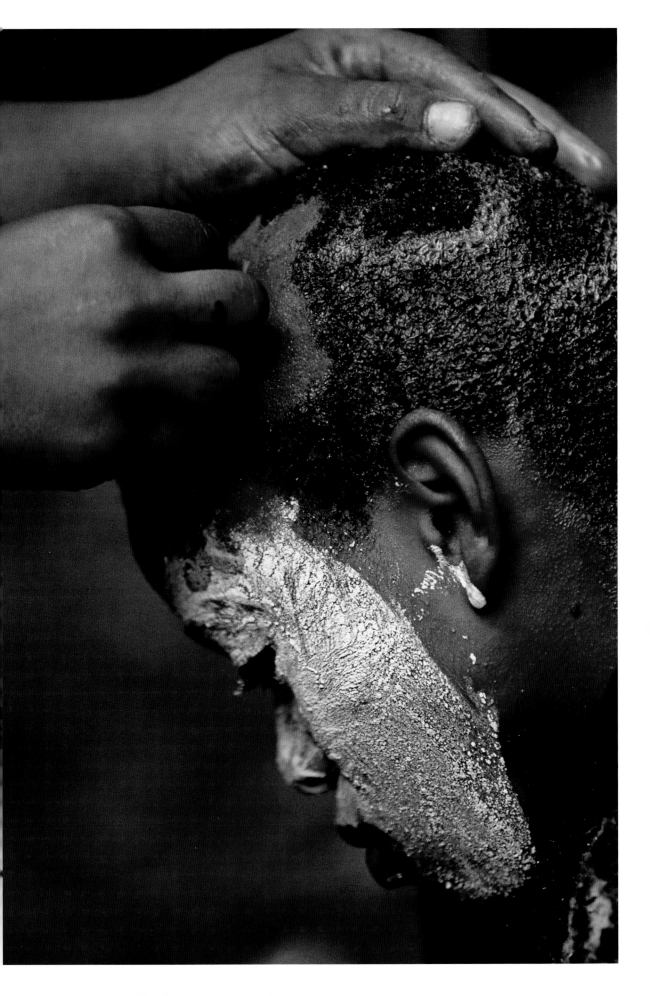

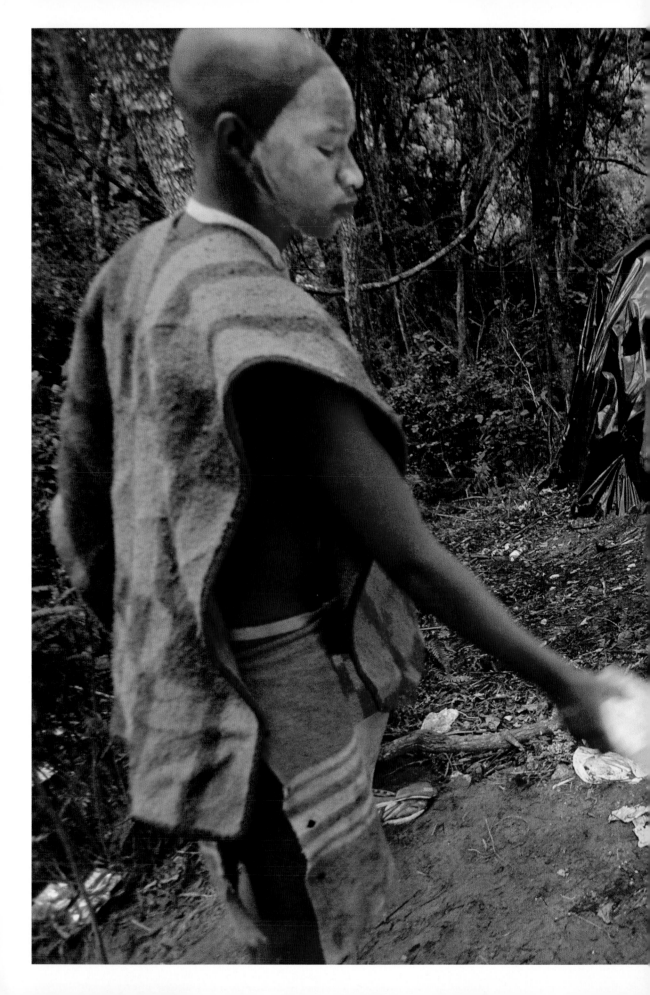

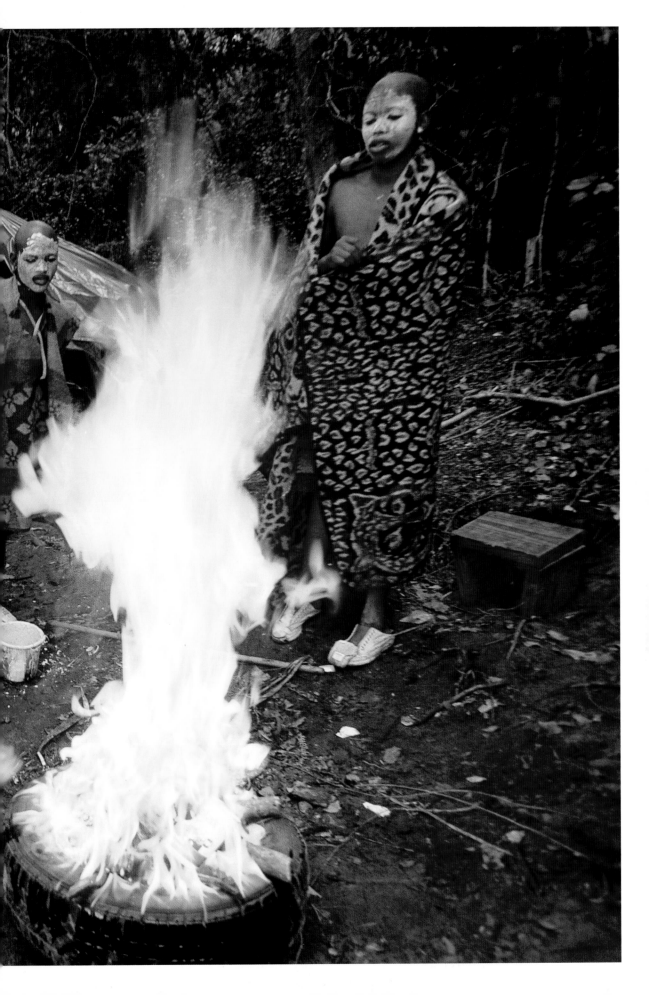

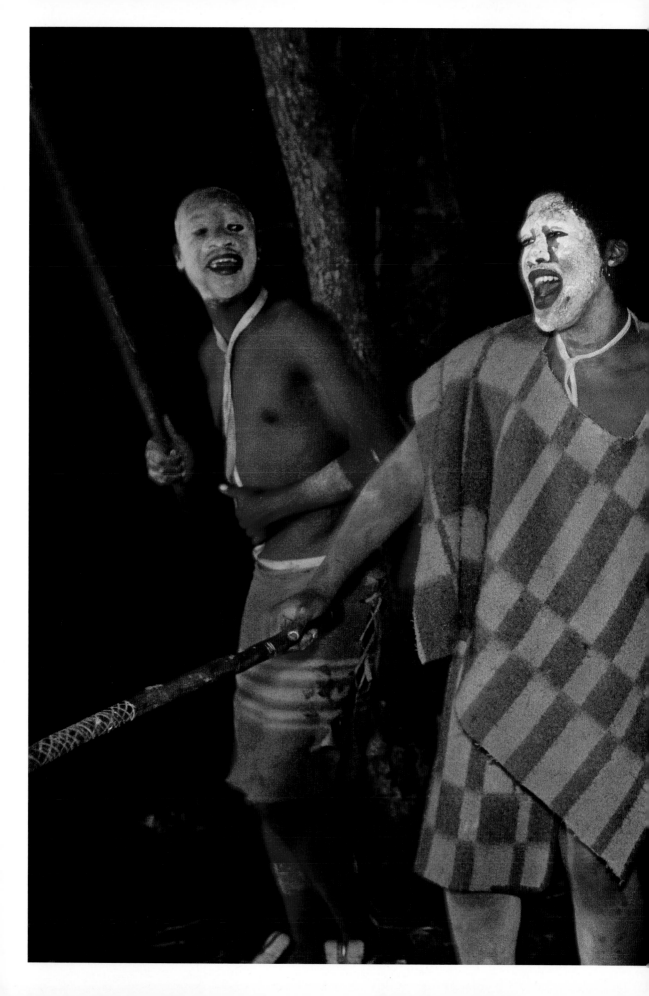

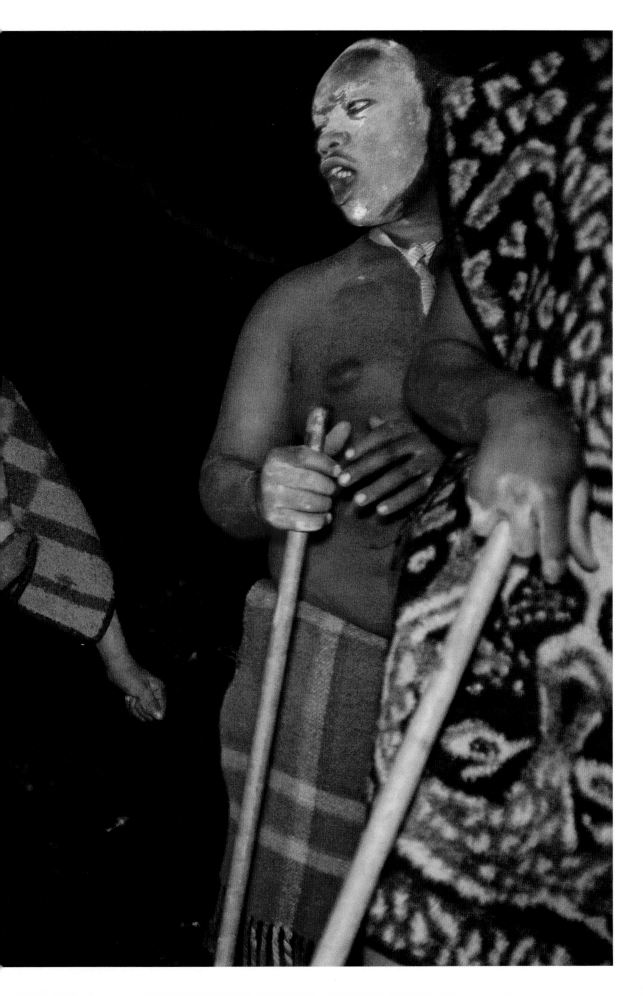

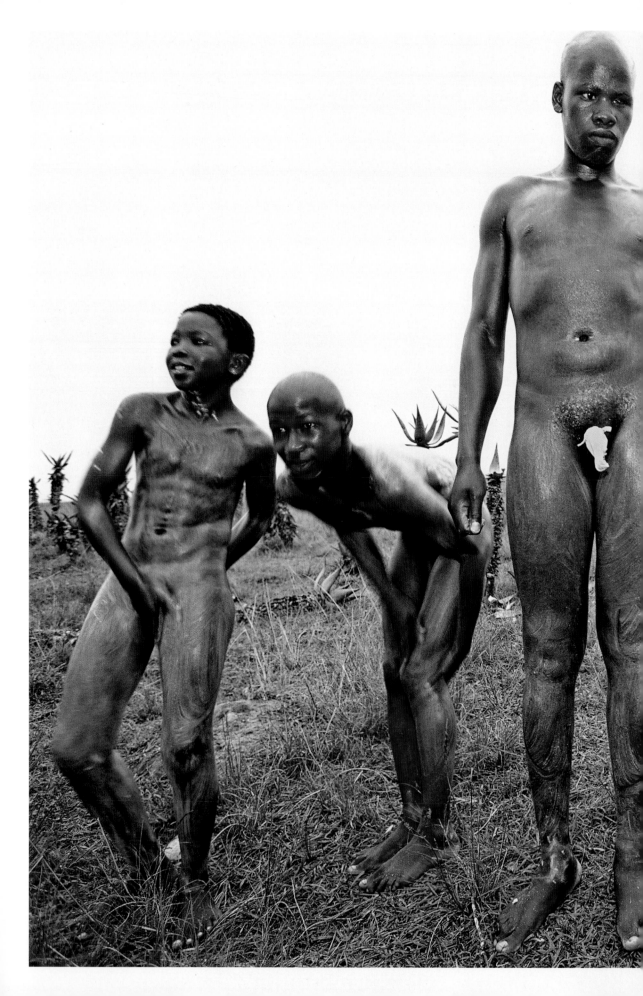

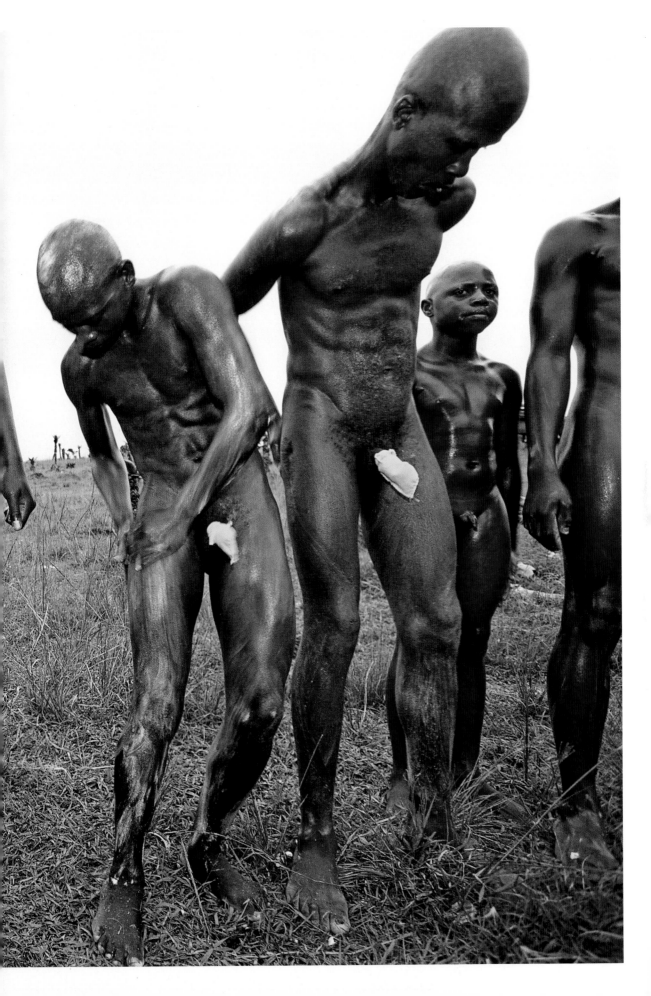

# Initiation der Xhosa-Jungen
## Ost- und Westkap, Südafrika

In diesem Jahr ist es anders. Es ist der 19. Dezember 2006, und es fällt auf, dass es keine Nachrichten über junge Männer gibt, die nach der traditionellen Beschneidungszeremonie der Xhosa gestorben sind.

„Um diese Zeit des Jahres haben wir normalerweise schon gehört, dass hier zehn und da 15 gestorben sind. Aber bisher gab es noch keine Meldungen", sagt Patric und macht einen zufriedenen Eindruck.

Er ist selbst ein Xhosa und gehört einer Gruppe an, die viel dafür getan hat, die Todesfälle bei den Initiationszeremonien der Jungen zu reduzieren. Jetzt ist er gerade auf dem Weg, um eine Gruppe von Jungen zu besuchen, die vor ein paar Wochen beschnitten wurden und die nun in einem kleinen Wald zusammenleben, nur 50 Meter entfernt von der Häusern des schwarzen Townships am Rand von Knysna in der Provinz Westkap. Im Township leben ihre Familien.

Bevor er das Wäldchen erreicht, ruft Patric den Jungen zu: „Ich kann nicht sehen, wo ich hin muss. Wo ist der Weg?", damit die Jungen wissen, dass sich ein erwachsener Mann nähert.

Sein Ruf wird von kräftigen, dunklen Klängen beantwortet, die man hört, bis er sich durch die ersten Reihen der Büsche vorgearbeitet hat.

Einige junge Männer liegen unter den Bäumen. Sie tragen Lendenschürze aus Filz, und alle sichtbaren Teile des Körpers, mit Ausnahme von Haaren, Lippen und Augen, sind mit einer dicken Schicht weißen Schlamms bedeckt. Gleich nebenan stehen zwei von ihren kuppelförmigen Hütten, eine dritte kann man gerade noch durch die Bäume erkennen. Alle drei sind mit schwarzem Plastik abgedeckt, und überall liegt Abfall herum.

Die Xhosa sind das am weitesten im Süden lebende bantusprachige Volk Afrikas. Ihr angestammtes Gebiet liegt zwischen dem Thamvuna-Fluss und dem Fish River in der Provinz Ostkap. Traditionell unterziehen sich die Xhosa dem Initiationsritus der Männer in den kühleren Wintermonaten. Das hat seinen Grund, denn so sollen Infektionen vermieden werden. In seinem Buch *Der lange Weg zur Freiheit* erinnert sich der wohl bekannteste Xhosa, Nelson Mandela, daran, wie er mit einem kurzen Speer, einem *Assegai*, beschnitten wurde, den viele Beschneider noch heute bevorzugt benutzen. „Der Schmerz war so intensiv, dass ich mein Kinn gegen die Brust presste [um nicht zu schreien]", schrieb er.

Damals war Mandela 16 Jahre alt. Heute liegt das Mindestalter für Beschneidungen bei 18; die meisten, die sich dem Ritual unterziehen, sind zwischen 18 und 20 Jahre alt.

Vor dem Ritual wird der Kopf des Initianden rasiert, und er verschenkt seine weltlichen Besitztümer. Dann wird er an einen vorbereiteten, unbewohnten Ort geführt, wo die Zeremonie mit der Beschneidung beginnt. Früher lebten die jungen Männer sechs Monate lang zurückgezogen und lernten, als Xhosa-Mann zu leben, bevor sie wieder nach Hause zurückkehren durften. Die Regeln waren streng, die Initianden übten Selbstdisziplin und mussten, wenn ihre Wunden erst einmal verheilt waren, ihre Nahrung selbst jagen.

Heutzutage dauert das Ritual drei bis sechs Wochen, und viele junge Männer werden im Sommer initiiert, wenn sie Schulferien oder Urlaub haben. Manche reisen in die früheren Homelands Transkei oder Ciskei in der Provinz Ostkap, wenn sie

**Right:** This initiate is swathed in a blanket and given a stick that has been blackened by the smoke in the initiation hut. He keeps it for the rest of his life as proof that he has attained manhood.
**Pages 218–219:** Without looking back, the initiates leave the camp. The camp is set on fire after their departure as a symbolic farewell to childhood.

**À droite:** Engoncé dans une couverture, l'initié reçoit un bâton qui a été noirci à la fumée dans la hutte d'initiation. Il le gardera toute sa vie, preuve qu'il a atteint l'âge adulte.
**Pages 218–219:** Les initiés quittent le camp sans jeter un regard en arrière. Après leur départ, le feu est mis au camp, un rite qui symbolise l'adieu à l'enfance.

**Rechts:** Der Initiand ist in eine Decke gehüllt und hat einen Stock bekommen, der über dem Feuer in der Initiationshütte geschwärzt wurde. Er behält ihn sein Leben lang als Beweis dafür, dass er ein Mann geworden ist.
**Seiten 218–219:** Ohne zurückzublicken verlassen die Initianden das Camp. Das Lager wird nach ihrem Aufbruch abgebrannt – ein symbolischer Abschied von der Kindheit.

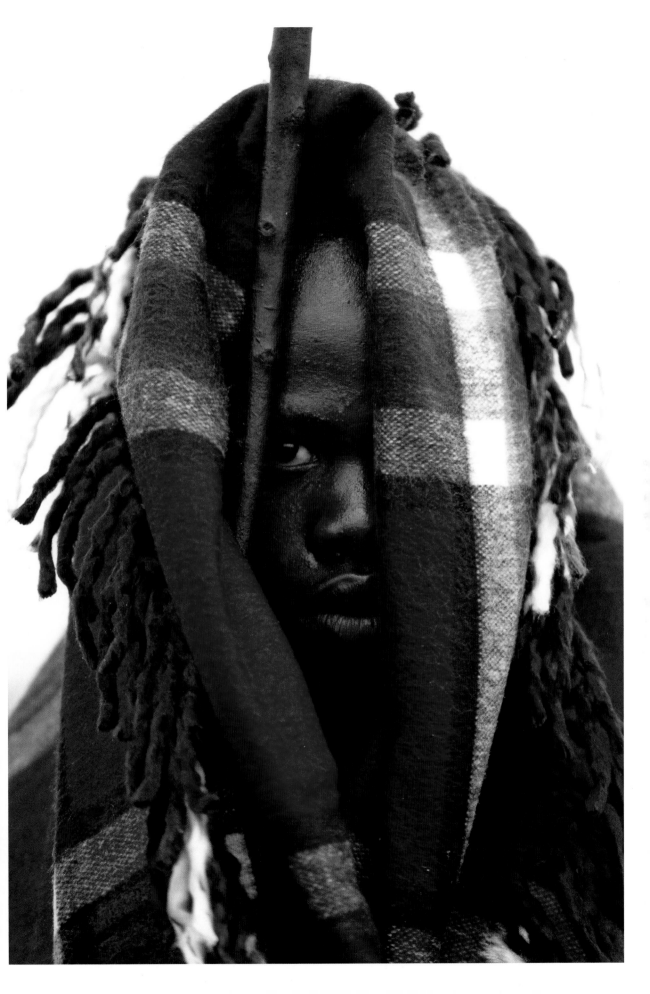

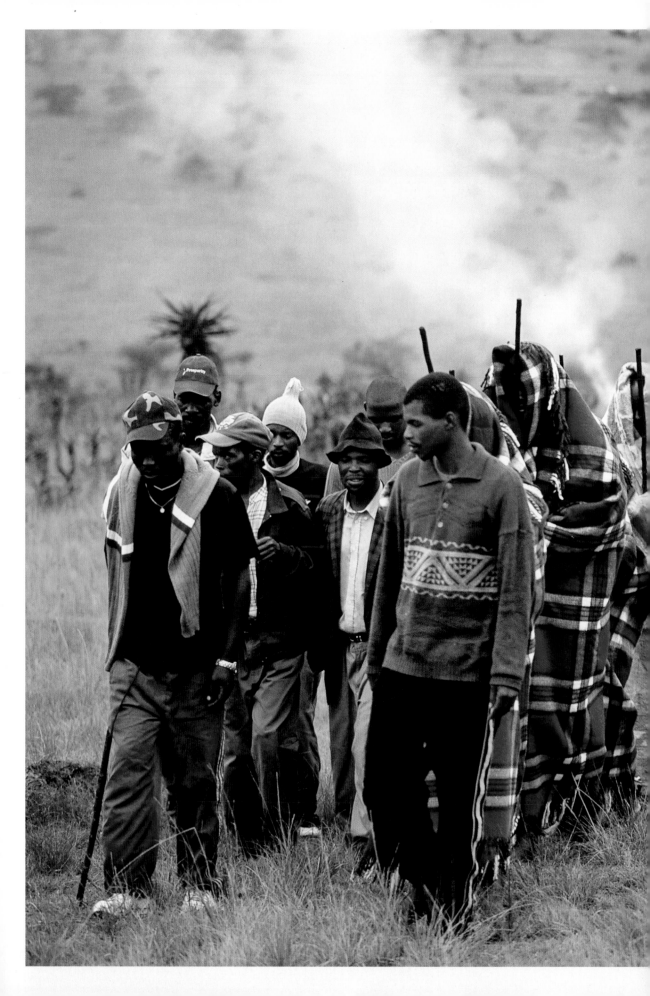

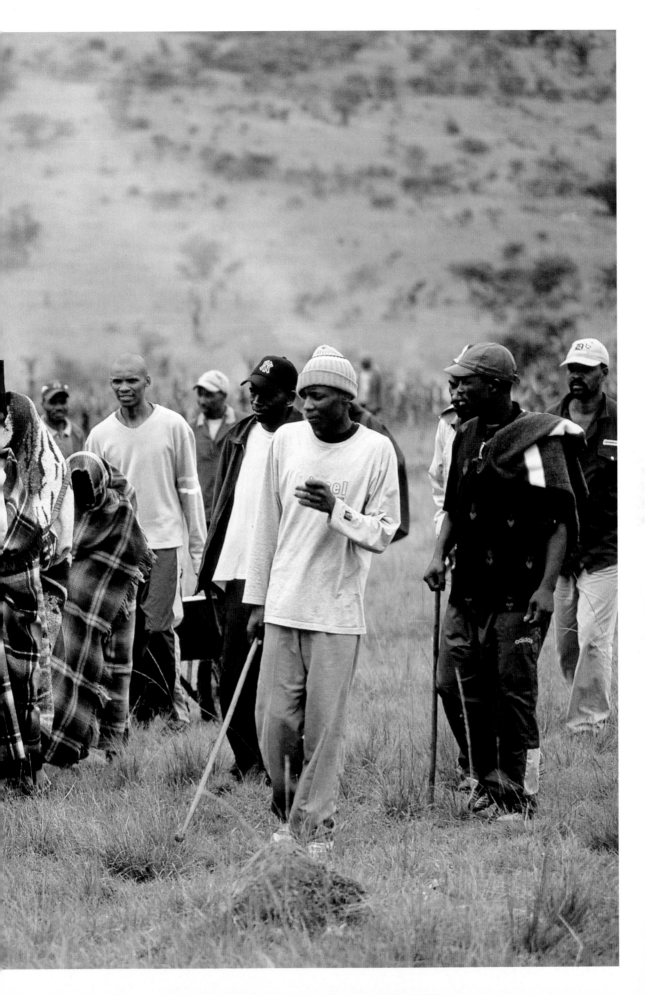

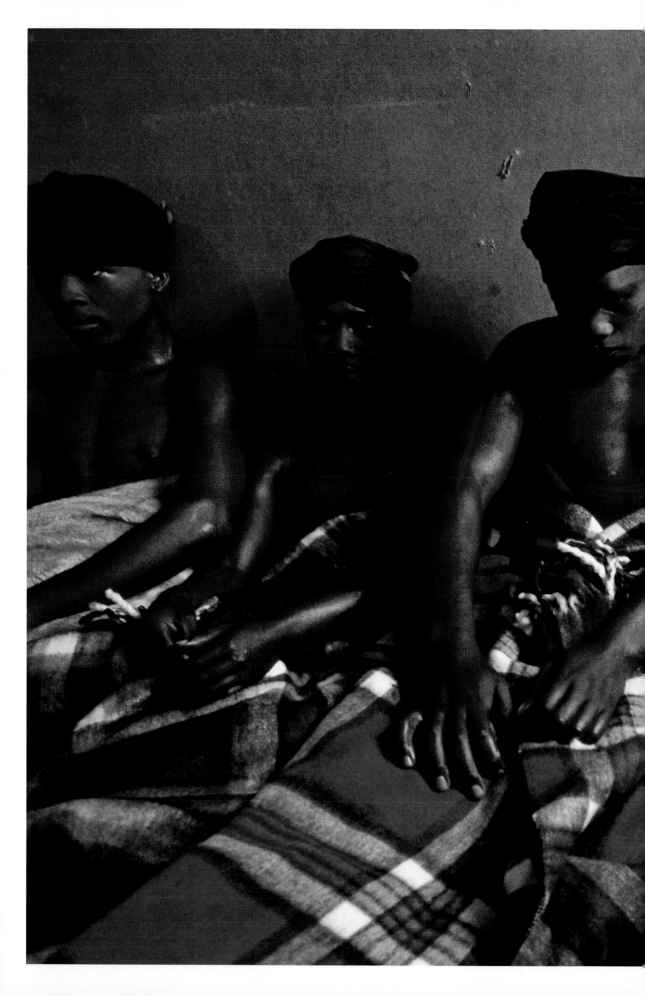

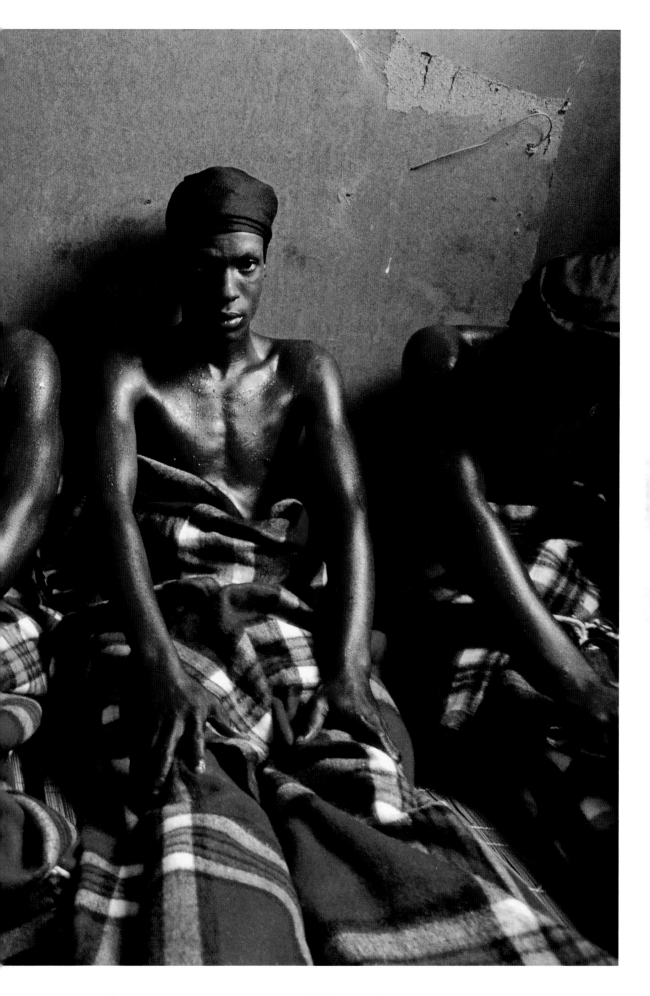

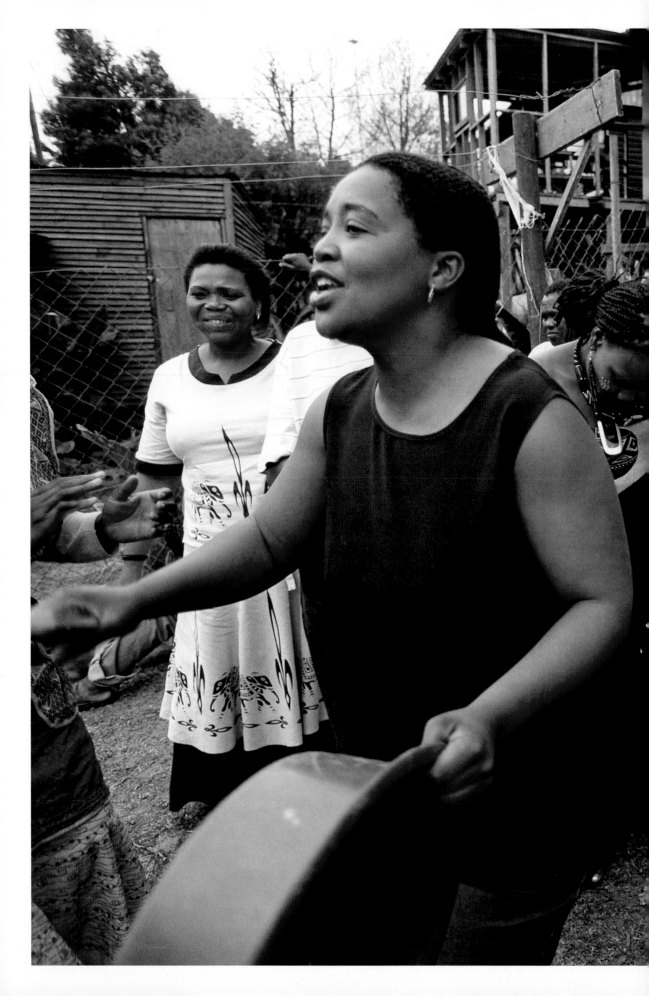

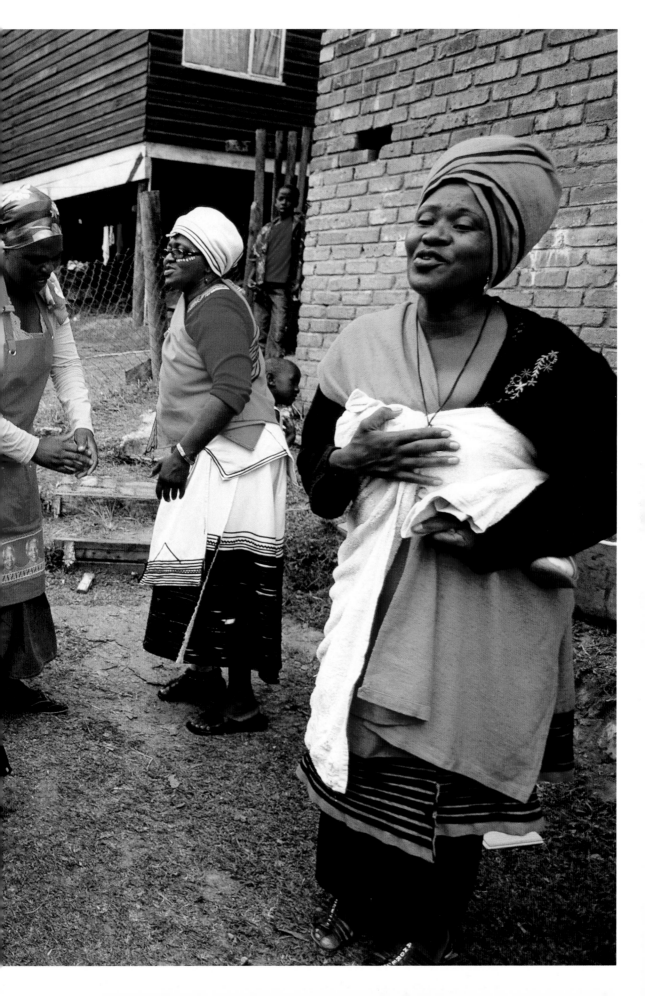

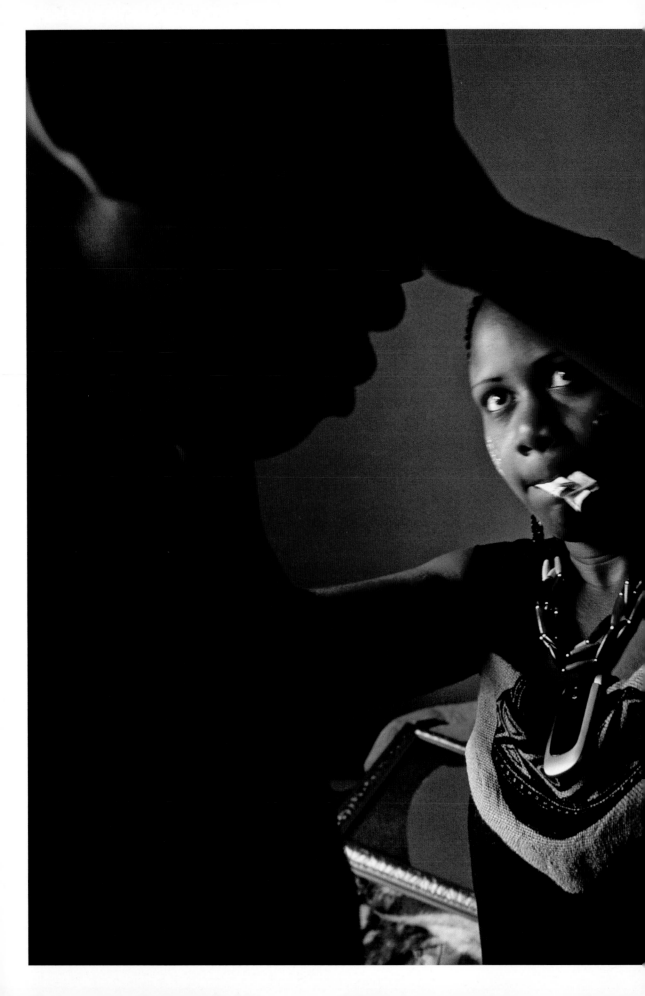

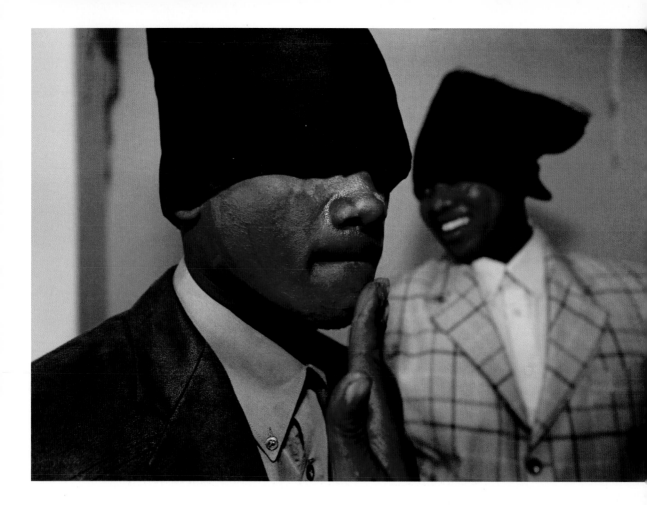

**Pages 220–221:** On returning home to their villages the initiates receive turbans to cover their shaven heads and have red ochre mixed with butter – a symbol of masculinity – applied to their skin.
**Pages 222–223:** Women in Khayalethu South, in Knysna, celebrate the return of three cousins from initiation.
**Pages 224–225:** A female relative adjusts a turban after the initiates have dressed in suits.

**Pages 220–221:** De retour dans leur communauté, les initiés reçoivent des turbans pour couvrir leur crâne rasé. On leur applique un mélange d'ocre rouge et de beurre sur la peau, un symbole de leur virilité.
**Pages 222–223:** Des femmes de la township Khayalethu, à Knysna, accueillent dans la liesse trois cousins qui ont accompli l'initiation.
**Pages 224–225:** Une parente redresse le turban d'un initié revêtu de son costume neuf.

**Seiten 220–221:** Zu Hause angekommen, erhalten die jungen Männer Turbane, mit denen sie ihre kahlen Schädel bedecken. Auf ihre Haut wird ein Gemisch aus Butter und rotem Ocker, ein Symbol der Männlichkeit, aufgetragen.
**Seiten 222–223:** Frauen in Khayalethu South in Knysna feiern die Rückkehr von drei Cousins nach deren Initiationsritus.
**Seiten 224–225:** Eine Verwandte rückt die Turbane zurecht, nachdem die jungen Männer Anzüge angezogen haben.

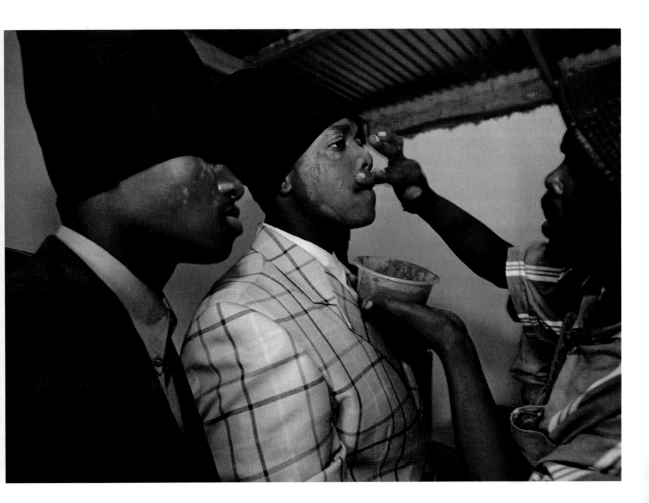

**Above and left:** On the second day of the home-coming the initiates dress in new suits and receive a fresh coating of red ochre and butter. They are now at liberty to go out in the neighbourhood, provided they are accompanied by their guardians.

**Ci-dessus et à gauche :** Le lendemain de leur retour, les initiés sont de nouveau enduits d'ocre et de beurre, et revêtent un costume neuf. Ils ont maintenant le droit de sortir dans le voisinage, à condition d'être accompagnés de leurs gardiens.

**Oben und links:** Am zweiten Tag ihrer Rückkehr kleiden sich die Initiierten in neue Anzüge und werden noch einmal mit Butter und rotem Ocker eingerieben. Jetzt dürfen sie sich in der näheren Umgebung frei bewegen, solange ihre Betreuer sie begleiten.

dort noch Familie haben, aber es ist mittlerweile üblich, sich der Zeremonie in den Townships der großen Städte wie Kapstadt und Port Elizabeth zu unterziehen, in die viele Xhosa gezogen sind. Hier verbringen die jungen Männer die Initiationszeit in Papp- oder Plastikbehausungen auf Feldern, die ihnen von den Behörden zugewiesen werden, oder in einem Wald am Stadtrand, wie in Knysna.

In dem Camp, das Patric besucht, fällt das Sonnenlicht durch das Blätterdach und bildet helle Flecken auf den weißen Körpern der jungen Männer. Für vier von ihnen wird das Ritual bald beendet sein; in zwei Tagen kehren sie nach Hause zurück. Sie sind offensichtlich stolz darauf, ihre einen Monat während Prüfung bestanden zu haben und nun Männer zu sein.

Die schwierigste Zeit sei die Woche nach der Beschneidung gewesen, sagen sie. Diese sieben Tage waren voller Schmerzen. Sie durften ihre Hütte nicht verlassen, durften nur sehr wenig trinken und nichts Salzhaltiges essen. Ihre Wunden waren mit grünen Blättern verbunden, und die Verbände wurden ständig erneuert, direkt nach der Beschneidung sogar alle fünf Minuten.

Der Schmerz ließ nach der ersten Woche nach, aber die strengen Regeln blieben. Westliche Kleidung, Handys und der Einsatz moderner Medikamente waren verboten. Auch war es nicht erlaubt, den Wald zu verlassen und im Township einen Arzt oder eine Krankenschwester aufzusuchen. Hätten sie sich medizinische Hilfe gesucht, wäre ihre Beschneidung null und nichtig gewesen, und sie wären nie als Männer anerkannt worden. Damit wäre es ihnen verwehrt geblieben, bei Versammlungen zu sprechen oder bei Xhosa-Zeremonien einen Viehpferch zu betreten.

Um die jungen Männer davon abzuhalten, zu schummeln oder nur Teile des Rituals über sich ergehen zu lassen, geben die Führer ihr Wissen nur portionsweise an die Gruppe weiter. Nur wer die gesamte Initiation mitgemacht hat, kann alle Fragen beantworten. Die Narbe auf dem Penis eines Mannes zeigt auch, ob er von einem *Ingcibi*, einem traditionellen Beschneider, oder in einer Krankenstation beschnitten wurde.

Die vielen Fälle, in denen Beschneidungen verpfuscht wurden und manchmal sogar zu Amputationen oder zum Tod führten, haben Kontroversen um die männliche Initiation aufkommen lassen. Patric besteht darauf, dass das Problem nicht von den Traditionen herrührt, sondern vom Zusammenbruch der Xhosa-Gesellschaft, in der die Alten keine aktive Rolle mehr spielen und es den jungen Männern selbst überlassen bleibt, ihre Entscheidungen zu treffen. Das, so sagt er, liefere sie der Gnade nicht ausgebildeter Beschneider aus, die sie bedrängten und manchmal verletzten. Die Regierung hat darauf mit neuen Richtlinien und Anforderungen reagiert: ein Mindestalter von 18 Jahren für die Beschneidung, eine medizinische Pflichtuntersuchung vor der Initiation, um beispielsweise festzustellen, ob die jungen Männer HIV-positiv sind, und die Einrichtung von Betreuungskomitees in allen Xhosa-Gemeinden, die sich um die Initianden kümmern.

Patric, ein AIDS-Berater der örtlichen Gesundheitsbehörde, war an der Einführung der neuen Regeln in Knysna beteiligt, wo sie äußerst erfolgreich waren. Ein positiver Effekt ist, dass lokale Führer nun akzeptieren, dass die gerade Beschnittenen medizinisch versorgt werden (allerdings nur, wenn sowohl der Beschneider als auch der Vater des Initianden es für notwendig halten).

Am folgenden Abend wird um ein Feuer aus Autoreifen getanzt, von dem eine Wolke beißenden schwarzen Qualms in die Luft steigt. Die Hitze lässt das Plastik auf einer der Hütten schmelzen. Patric tanzt mit, ebenso wie Andrew, einer der Betreuer, die den jungen Männern während ihrer Initiation beigestanden haben.

**Right:** After a week, a cap replaces the turban and the young men can move freely in the neighbourhood. They wear their caps for six months, along with a jacket or suit.

**À droite :** Au bout d'une semaine, ils échangent le turban pour une casquette et peuvent se déplacer librement. Ils porteront la casquette, un costume ou une veste durant six mois.

**Rechts:** Nach einer Woche tritt eine Kappe an die Stelle des Turbans, und die jungen Männer dürfen jetzt allein in der Nachbarschaft unterwegs sein. Sie tragen noch ein halbes Jahr lang ihre Kappen sowie Jackett oder Anzug.

Am Morgen danach baden die jungen Männer bei Sonnenaufgang in dem nahe gelegenen Flusslauf und werden dann mit Butter eingerieben, bevor sie sich auf den Weg nach Hause begeben. Barfuß, in Decken gewickelt und ohne auch nur einen Blick zurück auf das Camp zu werfen, in dem ihre Hütten angesteckt wurden, machen sie sich auf ihren langen Marsch durch das Township. Eine Gruppe Männer folgt ihnen, sie führen Schaukämpfe mit Stöcken aus und preisen in einem Lied den mythischen Somagwaza, den ersten Xhosa, der beschnitten und so zum wahren Mann wurde.

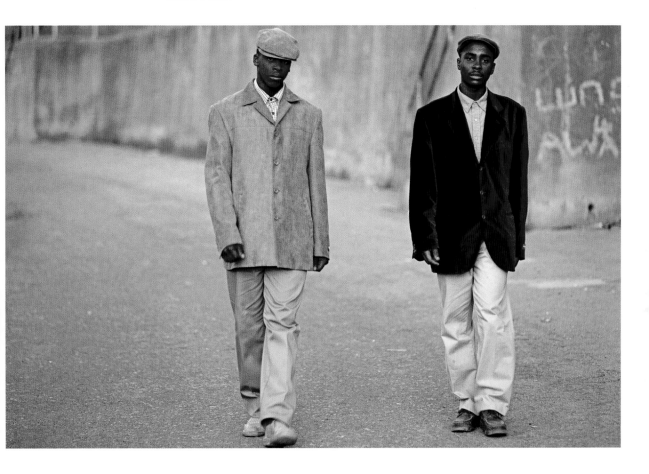

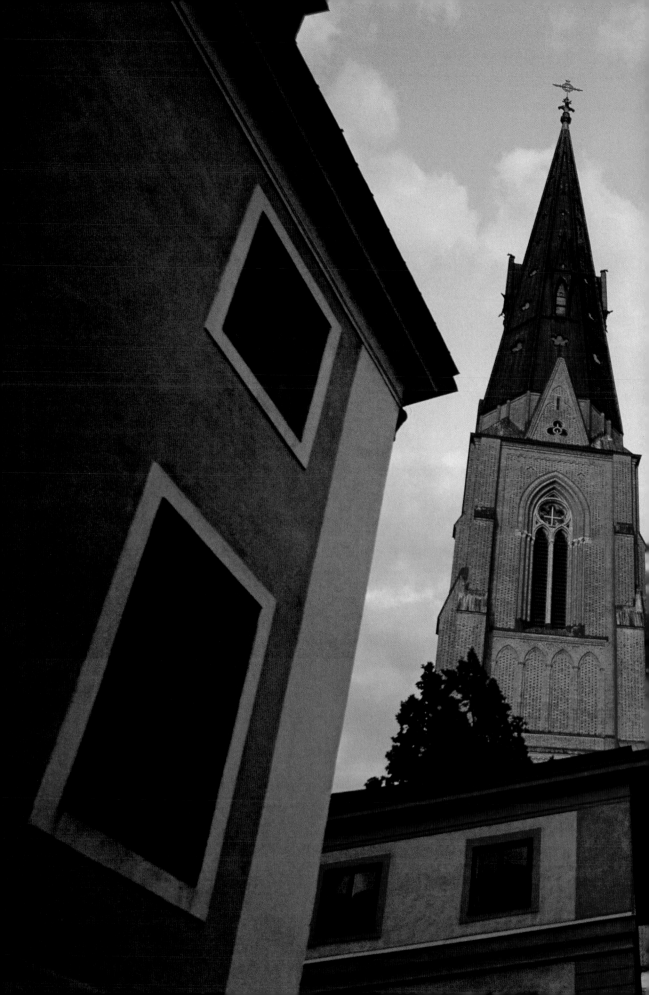

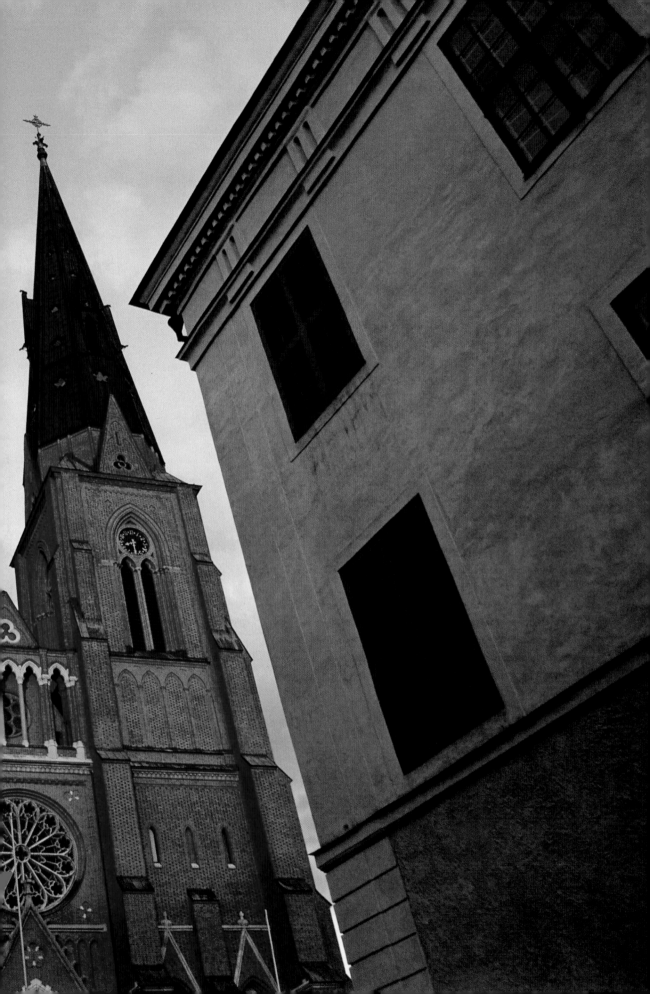

# High-school graduation
## *Uppsala, Sweden*

Lisa Norén and her classmates wait expectantly in the hallway for the heavy oak doors of Katedralskolan school to swing open. The young faces beneath the white student caps brim with excitement and anticipation. Twelve years of school are over and they cannot wait to get out to embrace their families and the lives and opportunities that await them.

The head teacher rings a bell and the doors swing open onto the yard outside. Shrieking with joy, the students rush into the June sunshine clutching brown paper envelopes containing their final grades. There to greet them is a large crowd of relatives and friends holding up posters and placards with photographs of the students when they were little.

Lisa spots a photograph of herself aged four on a placard emblazoned "Lisa". A few moments later she is hugging her family and friends who have come to celebrate her big day.

When Lisa's father was young, only a minority of students went on to a further three years of *gymnasium* (senior high school). Fewer still passed their examinations and earned the right to wear a white cap.

End-of-term examinations have long since been replaced by continuous assessment, and these days the vast majority of students go on to senior high school and graduate three years later with at least a pass grade. The emphasis has swung away from the academic aspect, and high-school graduation has now become a rite of passage marking an eighteen- or nineteen-year-old's entry into adulthood. As such it has eclipsed church confirmation, the traditional rite of passage for Swedish youth.

After hugs, congratulations and bouquets of flowers in the schoolyard, the students are driven through Uppsala in an eclectic motorcade of cars, trucks, sports cars and other vehicles. Lisa and her friend Beata ride in a 1957 Ford Thunderbird driven by Beata's father.

The pageant wends its way through the streets as the students sing "We have graduated, we have graduated…" to the tune of "For he's a jolly good fellow".

Eventually the procession disperses and everyone heads home for refreshments and the giving of presents. The students then say goodbye to their relatives and head out for a night of celebration.

**Pages 230–231:** Uppsala's medieval cathedral dominates the city's skyline.
**Right:** Dating back to the 1840s, the white graduation cap features blue and yellow, the colours of the Swedish flag.
**Pages 234–235:** Graduating students sign each other's caps during a champagne breakfast prior to the day's events.

**Pages 230–231:** La cathédrale médiévale d'Uppsala domine la ligne d'horizon de la ville.
**À droite:** L'origine de la casquette blanche remonte aux années 1840. Elle est décorée d'un motif bleu et jaune, les couleurs du drapeau suédois.
**Pages 234–235:** Avant la remise des diplômes, les lycéens signent les casquettes de leurs camarades lors d'un petit déjeuner au champagne.

**Seiten 230–231:** Uppsalas mittelalterlicher Dom dominiert die Skyline der Stadt.
**Rechts:** Seit den 1840er-Jahren tragen Abiturienten die Mütze mit der Kokarde in den Farben der schwedischen Fahne, Gelb und Blau.
**Seiten 234–235:** Die Abiturienten signieren bei einem Sektfrühstück vor den anstehenden Feierlichkeiten des Tages gegenseitig ihre Mützen.

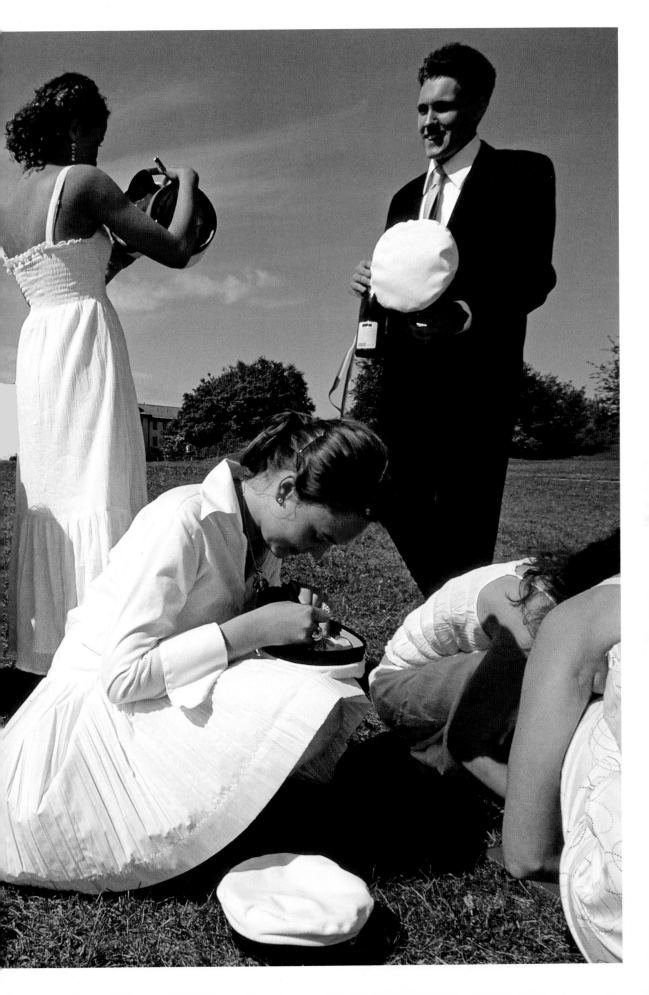

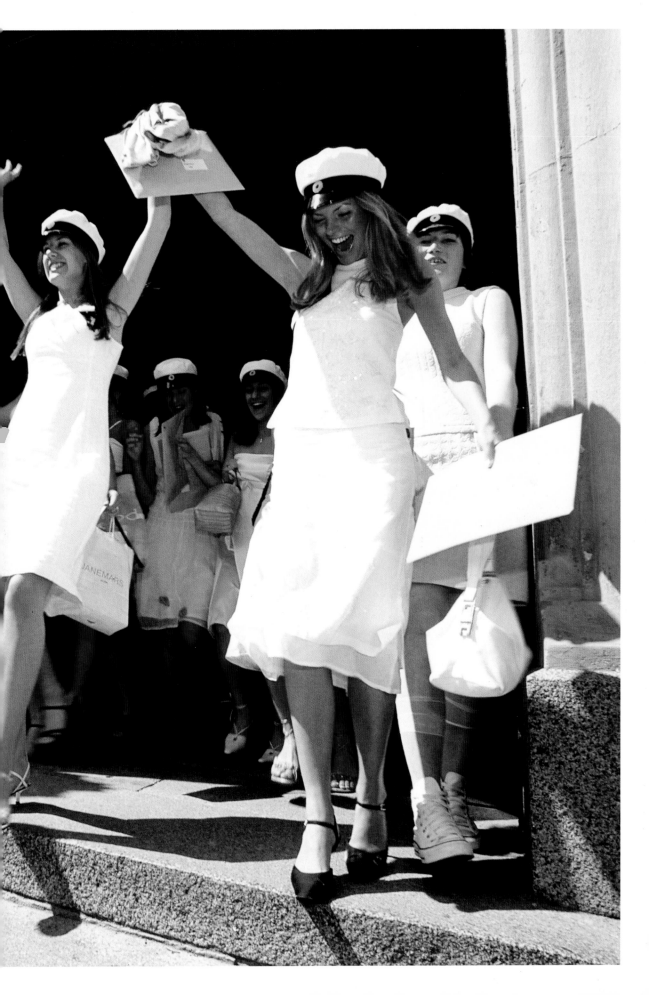

# Remise des diplômes
## *Uppsala, Suède*

Lisa Norén et ses camarades attendent avec impatience dans le hall que les lourdes portes en chêne de l'école de Katedralskolan s'ouvrent enfin. Les jeunes visages sous les casquettes blanches sont pétris d'excitation et d'attente. Après douze ans d'école, ils ne peuvent plus attendre davantage pour sortir embrasser leur famille, la vie et les opportunités futures. Le professeur principal fait retentir une cloche et les portes s'ouvrent enfin sur la cour. Hurlant de joie, les étudiants se précipitent sous le soleil de juin, munis de leur enveloppe de papier brun contenant leur diplôme de fin d'études. Une foule de parents et d'amis croulent sous des affiches illustrées avec les photographies des étudiants lorsqu'ils étaient enfants.

Lisa remarque une affiche à son nom avec une photographie d'elle quand elle avait quatre ans. Quelques instants plus tard, elle a réussi à rejoindre sa famille et tous ceux qui sont venus célébrer ce grand jour. Lorsque le père de Lisa était jeune, seule une minorité d'écoliers continuait les études pour trois années supplémentaires au gymnasium (lycée). Encore moins nombreux étaient ceux qui réussissaient leur examen et gagnaient le droit de porter une casquette blanche. Les examens trimestriels ont depuis été remplacés par des contrôles continus et, de nos jours, la grande majorité des jeunes fréquente le lycée, se présente à l'examen de fin d'études et obtient au moins un certificat. L'aspect académique a perdu de l'importance et les trois années d'études représentent davantage aujourd'hui un rite de passage marquant l'entrée dans l'âge adulte d'un jeune de dix-huit ou dix-neuf ans. Cette cérémonie a plus ou moins remplacé la confirmation à l'église, rite traditionnel de passage de la jeunesse suédoise.

Après un flot d'étreintes, de félicitations et de bouquets de fleurs dans la cour de l'école, les étudiants sont conduits à travers Uppsala dans un cortège d'automobiles éclectiques, de camionnettes ou de voitures de sport. Lisa et son amie Beata sont montées dans une Ford Thunderbird de 1957, conduite par le père de Beata.

Le cortège parcourt les rues sous les chants des étudiants « Nous sommes diplômés, nous sommes diplômés… » sur l'air de « Car c'est un bon camarade ». Finalement, le cortège se disperse et chacun regagne sa maison pour profiter de quelques rafraîchissements et pour ouvrir ses cadeaux. Les étudiants abandonnent enfin leur famille et retrouvent leurs amis pour une nuit de fête ininterrompue.

**Pages 236–239:** Clutching their graduation certificates, the students wait inside the school before the doors open and they rush outside to greet their families.
**Pages 240–241:** Where are you? Some find it difficult to locate family members amid the throng in the schoolyard.
**Right:** After being congratulated by their families the students take their place on the motorcade for a tour of the city. This farm trailer has enough room for an entire class.

**Pages 236–239:** Diplôme en main, les lycéens attendent à l'intérieur que les portes s'ouvrent pour se précipiter dehors et rejoindre leurs familles.
**Pages 240–241:** Où êtes-vous ? La foule est si nombreuse dans la cour du lycée qu'on ne retrouve pas tout de suite ses proches.
**À droite:** Après avoir reçu les félicitations des familles, les lycéens rejoignent le cortège de voitures qui va parcourir les rues de la ville. Cette remorque de ferme peut recevoir une classe entière.

**Seiten 236–239:** Das Abiturzeugnis fest in der Hand, warten die Abiturienten in der Schule darauf, dass sich die Türen öffnen. Dann stürmen sie nach draußen zu ihren Familien.
**Seiten 240–241:** Wo seid ihr? Manchmal sind die Familienangehörigen im Gewimmel auf dem Schulhof schwer zu finden.
**Rechts:** Nach den Glückwünschen der Familie steigen die Schüler in ihre Wagen, um eine Tour durch die Stadt zu machen. Auf diesem Anhänger hat eine ganze Klasse Platz.

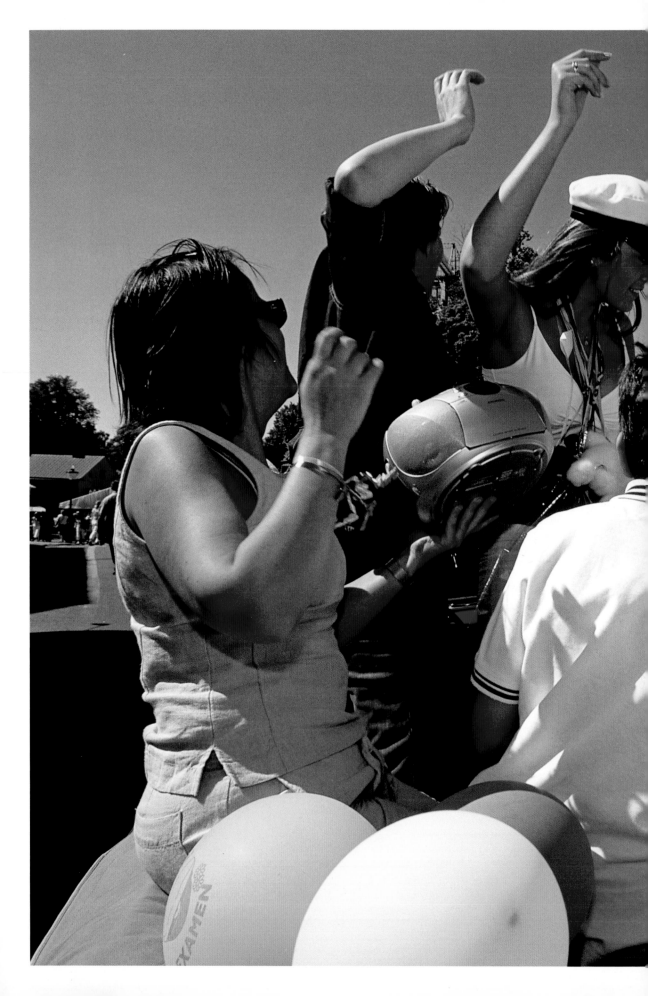

# Abitur
## *Uppsala, Schweden*

Lisa Norén und ihre Mitschüler warten gespannt im Flur darauf, dass sich die schweren Eichentüren der Katedralskolan (Domschule) öffnen. Die jungen Gesichter unter den weißen Schülermützen leuchten vor Aufregung und Spannung. Sie haben zwölf Jahre Schule hinter sich gebracht und können es kaum erwarten, hinauszustürmen, ihre Familien zu umarmen und sich dem Leben und den Möglichkeiten zu stellen, die sie erwarten.

Der Direktor läutet eine Glocke, und die Türen zum Hof gehen auf. Mit Freudenschreien rennen die Schüler in die Junisonne, in den Händen die braunen Umschläge mit ihren Abschlusszeugnissen. Draußen werden sie von einer Menge Verwandter und Freunden begrüßt, die Plakate mit Bildern der Schüler als kleine Kinder hochhalten.

Auf einem Plakat mit ihrem Namen erkennt Lisa ein Foto von sich selbst als Vierjährige. Kurz darauf umarmt sie Familienangehörige und Freunde, die gekommen sind, um ihren großen Tag mit ihr zu feiern.

Als Lisas Vater noch jung war, gingen nur die wenigsten Schüler auf das Gymnasium. Noch weniger bestanden ihre Prüfungen und erwarben sich das Recht, die weiße Mütze zu tragen.

Solche Abschlussprüfungen sind schon längst von Arbeiten und Tests im Lauf der Schuljahre abgelöst worden, und heute besuchen die meisten Schüler das Gymnasium, das sie drei Jahre später, zumindest mit einem „bestanden" auf dem Zeugnis, abschließen. Der Schwerpunkt liegt nicht mehr auf dem akademischen Aspekt. Aus dem Fest „Studenten" ist ein Übergangsritus geworden, der den Schritt der 18- und 19-Jährigen ins Erwachsenenalter markiert und mittlerweile die Konfirmation als typisch schwedischen Ritus zum Eintritt in die Erwachsenenwelt ersetzt hat.

Nach Umarmungen, Gratulationen und Blumensträußen im Schulhof werden die Schüler in einem bunt zusammen gewürfelten Autokorso mit Trucks, Sportwagen und anderen Fahrzeugen durch Uppsala gefahren: Lisa und ihre Freundin Beata fahren in einem 1957er Ford Thunderbird, den Beatas Vater lenkt.

Der Zug schlängelt sich durch die Straßen, und zur Melodie von „For he's a jolly good fellow" singen die Abiturienten: „Wir haben das Abitur, wir haben das Abitur …"

Irgendwann löst sich die Prozession auf, und alle gehen nach Hause, wo Erfrischungen und Geschenke warten. Dann verabschieden sich die Schüler von den Verwandten und werfen sich ins Nachtleben, um zu feiern.

**Pages 244–245 and right:** Spirits are high as the procession makes its way through town. Relatives participate by dancing and waving flags.

**Pages 244–245 et à droite:** La liesse règne dans le cortège qui traverse la ville. Les familles dansent et agitent des drapeaux.

**Seiten 244–245 und rechts:** Die Stimmung ist prächtig, als sich der Korso durch die Stadt zieht. Die Verwandtschaft am Straßenrand hat auch ihren Spaß und tanzt und schwenkt Fähnchen.

# A Dani girl comes of age
## *New Guinea, Indonesia*

Smoke rises from the fires inside the long kitchen house, stinging the eyes, as the women's voices swell in song. In the middle, next to the long wall, sits Doraleke, a young Dani girl who is having her first menstrual period.

Doraleke belongs to the Dugum Dani, a sub-group of the Dani immortalised by the Harvard-Peabody anthropological expedition in 1961 and the subsequent film *Dead Birds*. Though much has changed since then, the Dani remain conservative people and uphold *hotaly* as an important ritual when a girl has her first menstruation.

This is a dangerous time for a young girl; she is vulnerable to evil spirits as if she were sick or in mourning. Thus the singing and dancing continue through the night until dawn to protect the girl and keep the spirits at bay.

For her part, Doraleke is required to remain awake throughout the night while sitting on a patch of grass to absorb her menstrual blood. She may leave this spot only to relieve herself, accompanied by her mother.

When the new day finally dawns outside the house, Doraleke and the women walk down to the river, where they engage in a wild mud fight that leaves them caked in grey-brown sludge from head to toe.

The women then bathe in the water to clean off and light a fire around which they dry off. The grass on which Doraleke sat during the night is thrown onto the flames, creating a pall of smoke.

Each woman presents Doraleke with a grass skirt as a gift. They dress her in layers, one on top of the other. The womenfolk cover her head with a string bag filled with grass to make her invisible to the evil spirits. Then they sing and dance round the fire.

The men stand some distance away on a rock, observing the ritual. They wear feathered headdresses and sport long sheathes on their penises, most of them more than half a metre in length.

Their curiosity intensifies when the women lay the blood-stained grass on the fire. Tradition dictates that Doraleke must search for her future husband in the direction that the smoke drifts, and the men watch eagerly to see the outcome.

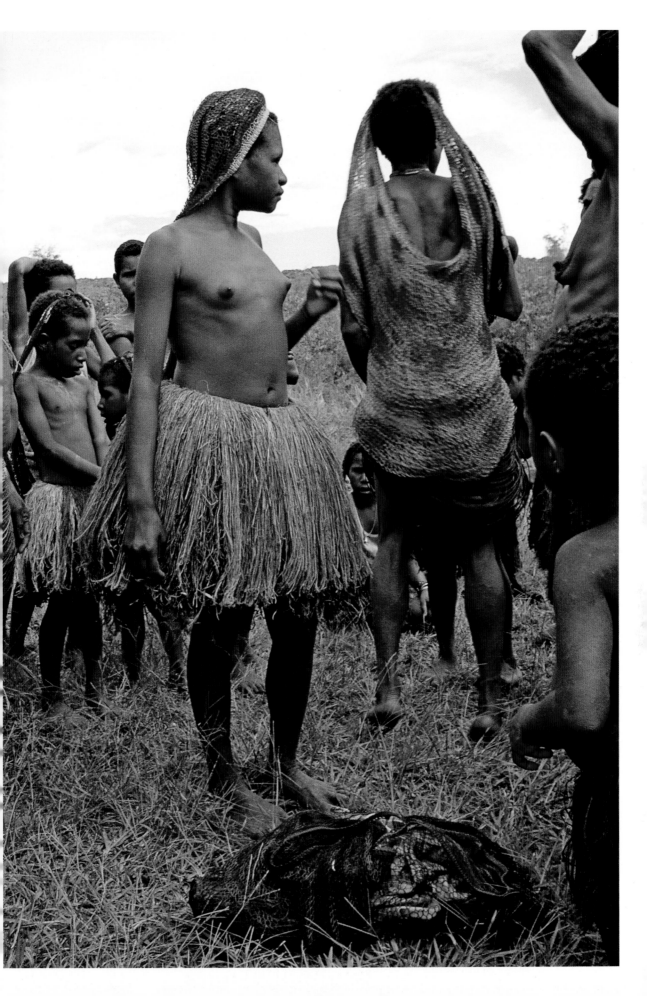

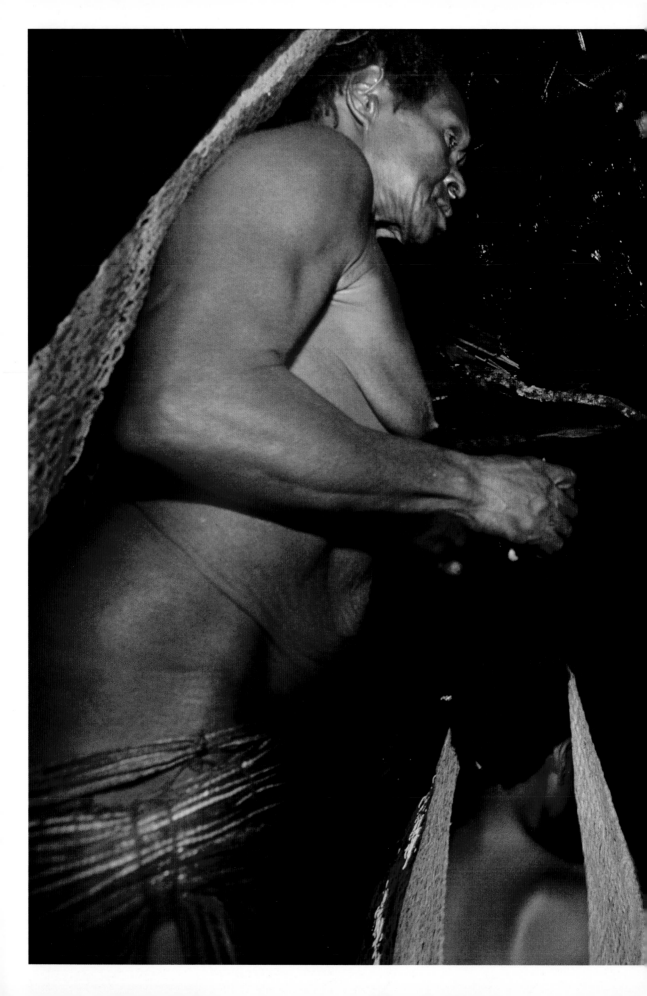

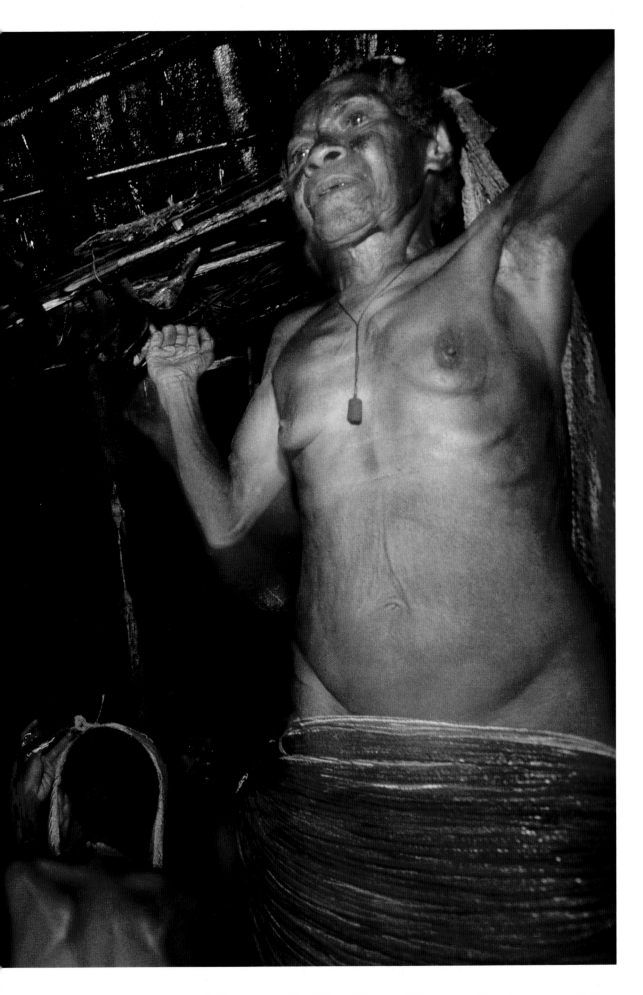

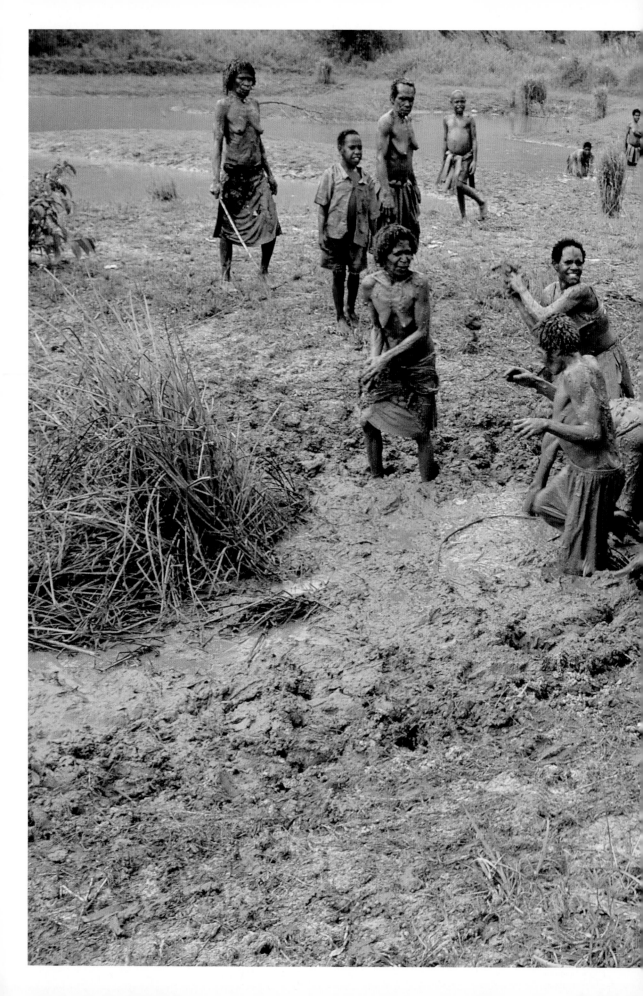

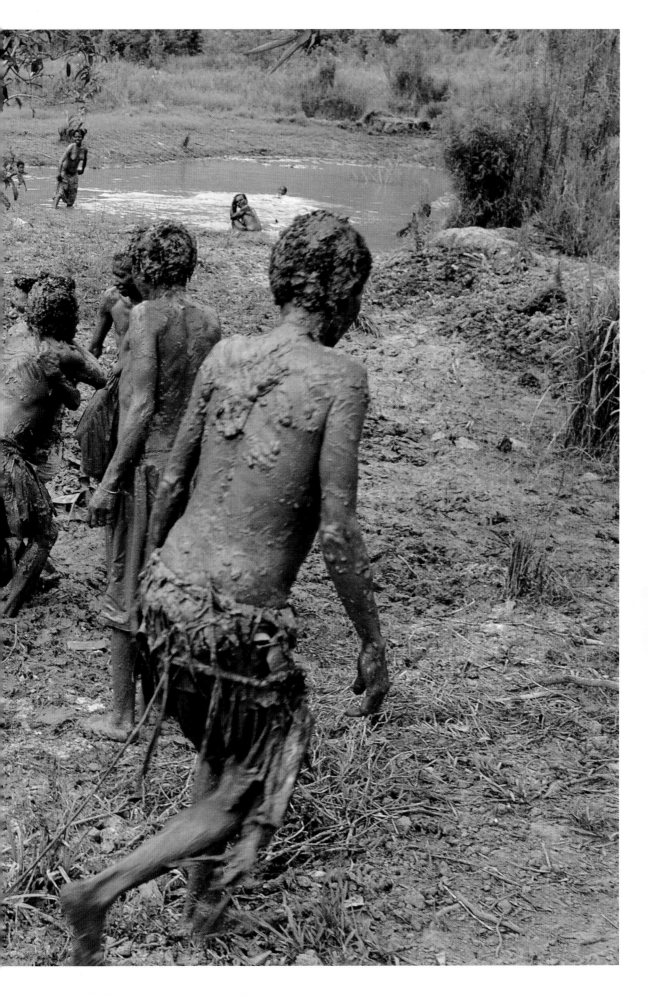

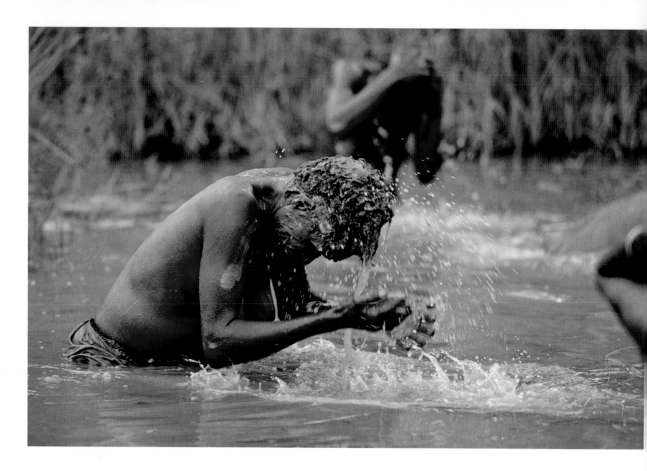

# Une jeune fille dani atteint la majorité
## *Nouvelle-Guinée, Indonésie*

La fumée monte, irritant les yeux après de longues cuissons dans les maisons, en même temps que la voix d'une femme qui chante. À côté du long mur, Doraleke, une jeune femme dani qui vient d'avoir ses premières règles, est assise au centre.

Doraleke appartient au Dugum Dani, un sous-groupe des Dani, immortalisé par l'expédition anthropologique de Harvard-Peabody en 1961 et par le film *Dead Birds*. Bien que les temps aient changé depuis, les Dani demeurent un peuple conservateur qui maintient le *hotaly* comme un rituel important lorsqu'une jeune fille atteint la puberté.

Il s'agit d'une période dangereuse pour la jeune fille ; elle est vulnérable face aux esprits malins comme lorsqu'elle est malade ou en deuil. Ainsi, le chant et la danse se poursuivent toute la nuit jusqu'à l'aube, afin de la protéger et d'écarter les esprits. Doraleke doit donc rester éveillée tout au long de la nuit, assise sur un tas d'herbe qui absorbe le sang de sa menstruation. Elle ne quittera cet endroit que pour se rendre aux toilettes, accompagnée par sa mère.

Lorsque, le lendemain, les lumières de l'aube envahissent la maison, Doraleke et les femmes descendent à la rivière. Là, elles se livrent à un sauvage combat de boue qui les laisse recouvertes d'une croûte gris-brun de la tête aux pieds. Les femmes se baignent ensuite dans l'eau pour se laver et allument un feu autour duquel elles se sèchent. L'herbe sur laquelle était assise Doraleke toute la nuit est ensuite jetée dans les flammes, créant un épais voile de fumée.

Chaque femme se présente à Doraleke avec une jupe d'herbe en cadeau. Elles la parent de ces jupes, les unes par-dessus les autres. La meneuse du groupe des fem-

**Above and left:** The mud fight and subsequent washing in the river symbolise death and rebirth, two common themes in life-cycle rituals around the world. After the washing ceremony the girl has a new social role, that of a marriageable woman.

**Ci-dessus et à gauche :** La bataille de boue, puis la baignade dans la rivière sont deux rituels symbolisant la mort et la renaissance, deux thèmes communs dans le cycle de la vie, célébrés partout dans le monde. Après le rituel de la baignade, la jeune fille a un nouveau statut social : elle est en âge de se marier.

**Oben und links:** Die Schlammschlacht und das folgende Bad symbolisieren Tod und Wiedergeburt, zwei Rituale im Lebenszyklus, die auf der ganzen Welt verbreitet sind. Nach der Waschungszeremonie bekleidet das Mädchen eine neue soziale Rolle: die der heiratsfähigen Frau.

mes lui couvre la tête d'un filet rempli d'herbe pour la rendre invisible aux esprits malins. Ensuite, elles chantent et dansent autour du feu. Les hommes restent à distance sur un rocher, observant le rituel de loin. Ils portent des coiffes à plumes ; une longue gaine, de plus d'un demi-mètre de long, recouvre leur pénis. Leur curiosité est au comble lorsque les femmes jettent l'herbe souillée dans le feu. La tradition veut que Doraleke cherche son futur époux dans la direction que prend la fumée, ce qui incite les hommes à rester très attentifs au moindre souffle d'air.

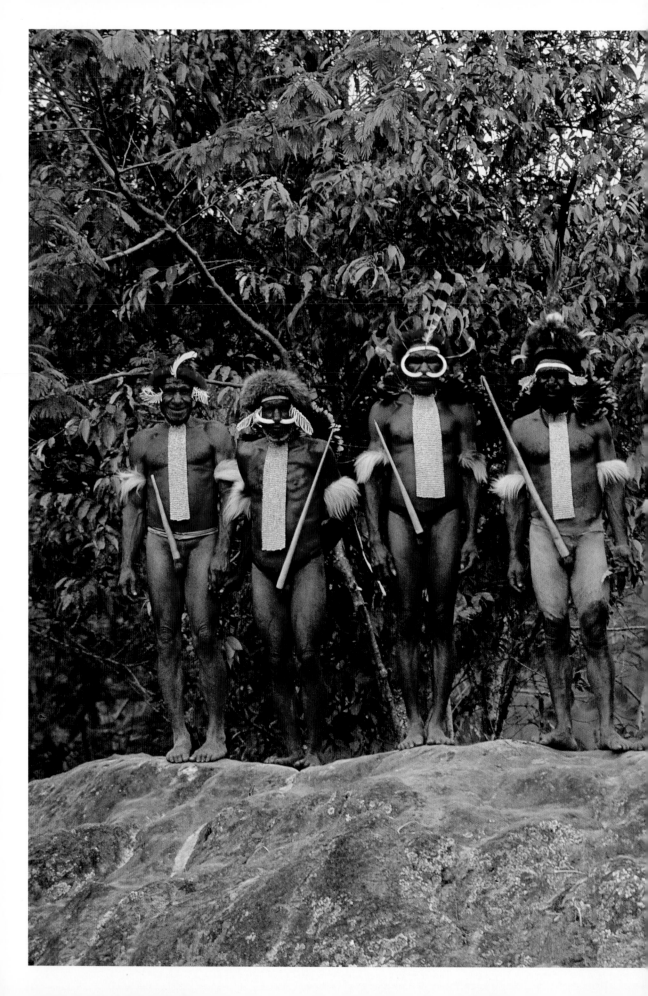

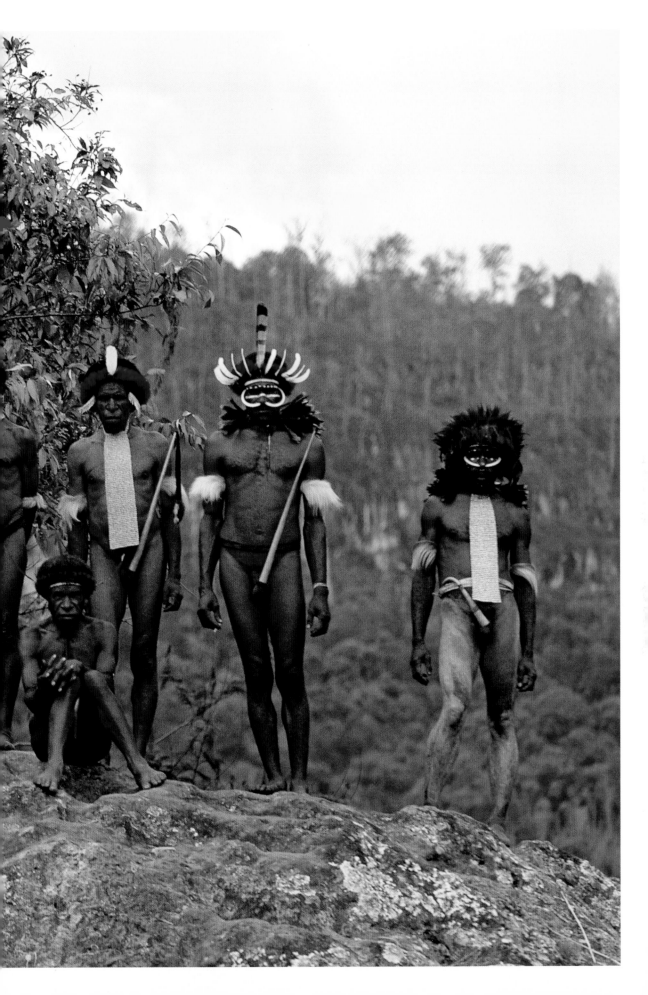

# Ein Dani-Mädchen wird volljährig
## *Neuguinea, Indonesien*

Rauch steigt von den Feuern neben dem Küchenhaus auf und brennt in den Augen. Die Stimmen der Frauen erheben sich zum Gesang. Mittendrin, an der langen Wand, sitzt Doraleke, eine junge Dani, die ihre erste Menstruation hat.

Doraleke gehört zu den Dugum Dani, einer Untergruppe der Dani, die durch die Harvard-Peabody-Expedition 1961 und den daraus entstandenen Film *Dead Birds* bekannt wurden. Obwohl sich seither viel verändert hat, sind die Dani ein konservatives Volk geblieben und begehen noch immer das *Hotaly* genannte Ritual anlässlich der ersten Periode eines Mädchens.

Für das Mädchen ist das eine gefährliche Zeit, ist es doch für böse Geister nun eine leichte Beute, genauso als wäre es krank oder in Trauer. Deshalb dauern Gesang und Tanz die ganze Nacht über an, denn sie schützen das Mädchen und halten die Geister in Schach.

Doraleke selbst muss die ganze Nacht über wach bleiben und sitzt auf Gras, das ihr Menstruationsblut auffängt. Sie darf nur aufstehen, um in Begleitung ihrer Mutter zur Toilette zu gehen.

Als draußen endlich der neue Tag anbricht, gehen Doraleke und die Frauen zum Fluss, wo sie eine wilde Schlammschlacht veranstalten, nach der sie von Kopf bis Fuß mit grau-braunem Matsch bedeckt sind.

Anschließend baden die Frauen im Wasser, waschen den Schlamm ab und zünden ein Feuer an, an dem sie sich trocknen. Das Gras, auf dem Doraleke in der Nacht gesessen hat, wird ins Feuer geworfen und geht in Rauch auf.

Jede der Frauen beschenkt Doraleke mit einem Grasrock. Sie ziehen sie ihr in Schichten an, einen über den anderen. Ihren Kopf bedecken die Frauen mit einer Tragetasche voller Gras, damit die Geister sie nicht sehen können. Dann singen sie und tanzen ums Feuer.

Die Männer stehen in einigem Abstand auf einem Felsen und beobachten das Ritual. Sie tragen gefiederten Kopfschmuck und Futterale auf ihren Penissen, die meist mehr als einen halben Meter lang sind.

Ihre Neugier wird noch größer, als die Frauen das blutgetränkte Gras ins Feuer werfen. Die Tradition will es, dass sich Doraleke in der Richtung, in die der Rauch zieht, nach ihrem zukünftigen Ehemann umsieht, und die Männer warten gespannt darauf, was dabei wohl herauskommen mag.

**Pages 260–261:** When the women have washed after the mud fight they dress the girl in grass skirts.
**Pages 262–263:** The men monitor the proceedings from a nearby rock.

**Pages 260–261:** Après s'être à leur tour lavées, les femmes ceignent la jeune fille de pagnes d'herbe.
**Pages 262–263:** Les hommes observent les rituels depuis le haut d'un rocher.

**Seiten 260–261:** Ist das Bad nach der Schlammschlacht beendet, kleiden die Frauen das Mädchen in Grasröcke.
**Seiten 262–263:** Die Männer beobachten das Geschehen von einem nahe gelegenen Felsen aus.

**Above:** Most of the men
wear ornate headdresses,
including caps made of
plant fibres.

**Ci-dessus :** La plupart des
hommes arborent des
coiffes ouvragées, dont des
bonnets en fibres végétales.

**Oben:** Die meisten Männer
tragen kunstvolle Kopfbe-
deckungen, darunter Müt-
zen aus Pflanzenfasern.

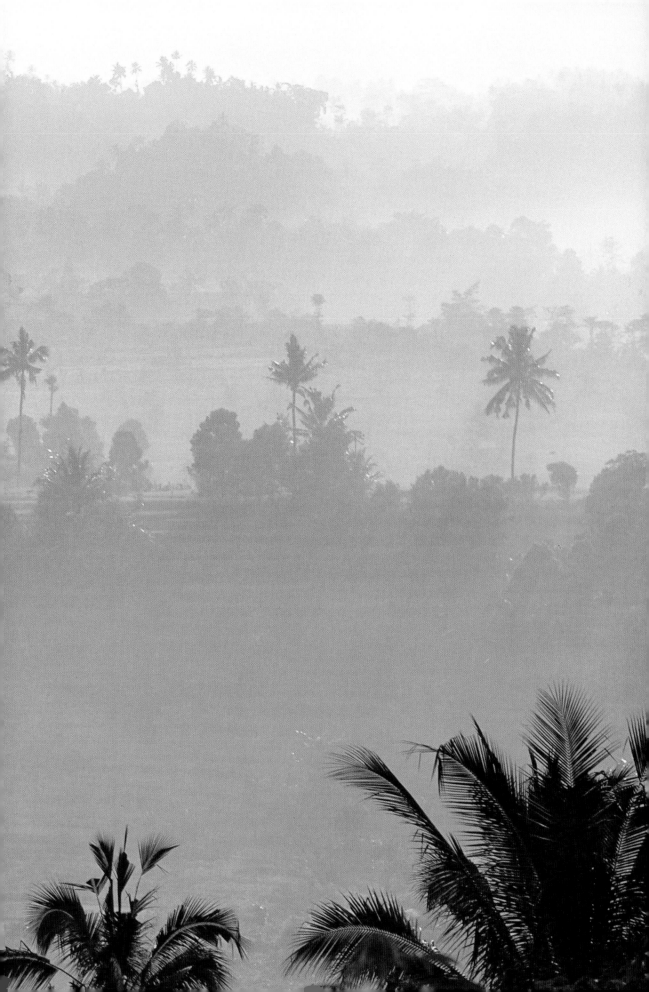

# Tooth filing
## *Bali, Indonesia*

Putu spits the enamel shavings into the coconut shell, pulls back his lips and examines his teeth in the hand mirror. Are his teeth even enough now? "No, not yet!" chorus his relatives gathered round the ceremonial bed.

Putu lies down again and the tooth filer grips his chin as he resumes work on the six upper front teeth. His female relatives rest their hands on Putu's arms in silent encouragement.

People who have had their teeth filed say it is highly uncomfortable rather than painful. It is a ritual that boys undergo when their voices have broken and girls when they have had their first period. But it is an expensive event and many families save money by waiting until a later occasion, such as marriage, so they can combine two ceremonies in one.

Putu's family have not waited. Aged fifteen, he is having his teeth filed together with three cousins. They wear lavish brocade outfits, and Sri, Putu's female cousin, sports numerous pieces of gold jewellery in her hair.

We are in the Balinese capital, Denpasar. As the guests arrive they are served cups of strong Balinese coffee and biscuits. All wear ceremonial clothes: the women in *kebaya*, a thin blouse with long sleeves, and a tightly wrapped sarong that forces them to take short, mincing steps, and the men in looser sarongs, shirt and *udeng*, a head-cloth tied in a flowery knot at the front.

An ensemble plays metallic gamelan music, and the verandahs are crowded with family and friends. Close relatives gather round the ceremonial bed, which stands in an open pavilion in the courtyard. Tarpaulins have been strung up between the houses to keep the sun off, creating the sense of a room outdoors.

The purpose of tooth filing is to control six desires and bad traits – lust, anger, greed, confusion, intoxication and jealously – while also helping the person to become more humane. Demons have long fangs, while humans have to have a straight row of teeth, otherwise they are not let into the realm of the dead when they die and cannot be reborn.

**Pages 266–267:** An early morning mist hangs over the lush agricultural terraces that typify Bali's rural landscape.
**Right:** For his tooth-filing ceremony, this boy has donned make-up and wears a ceremonial head-covering adorned with gold.
**Pages 270–271:** An expert from the Brahmin caste performs the tooth filing as close relatives gather round the ceremonial bed to offer encouragement and support.

**Pages 266–267:** Une brume matinale enveloppe les luxuriantes cultures en terrasses, typiques des paysages de Bali.
**À droite:** Pour le rituel du limage des dents, ce garçon s'est maquillé et porte la coiffe cérémonielle ornée d'un motif doré.
**Pages 270–271:** Un praticien, membre de la caste brahmane, effectue le limage tandis que les proches rassemblés autour de la couche de cérémonie encouragent le garçon.

**Seiten 266–267:** Morgendlicher Nebel hängt über den für die balinesische Landschaft typischen Terrassenfeldern.
**Rechts:** Der Junge hat sich für die Zahnfeilzeremonie geschminkt und trägt eine festliche Kopfbedeckung mit goldenen Verzierungen.
**Seiten 270–271:** Ein brahmanischer Spezialist feilt die Zähne, während sich nahe Verwandte um das zeremonielle Bett gruppieren und dem Jungen Mut und Trost zusprechen.

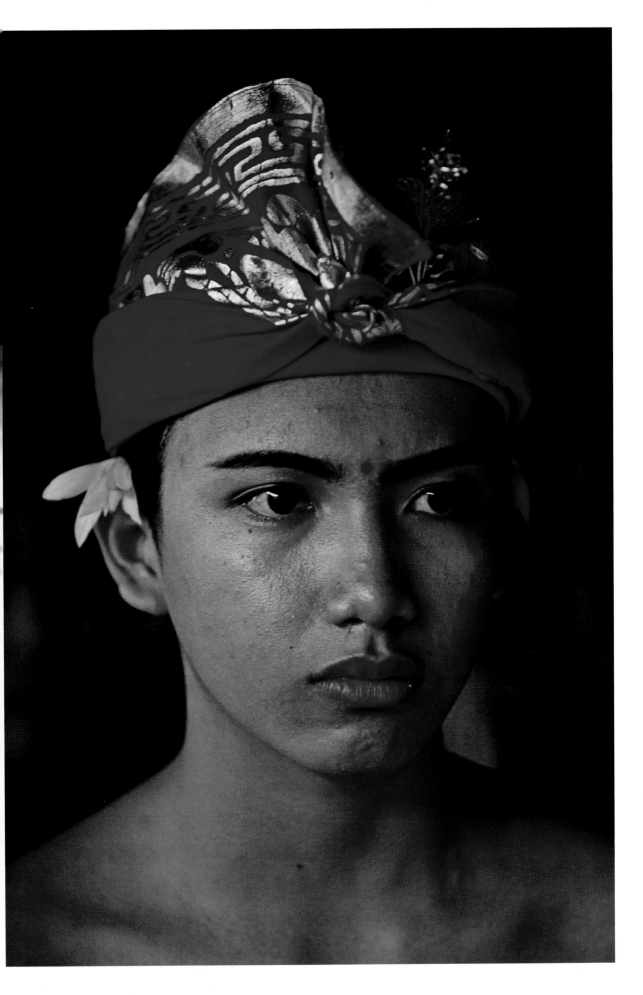

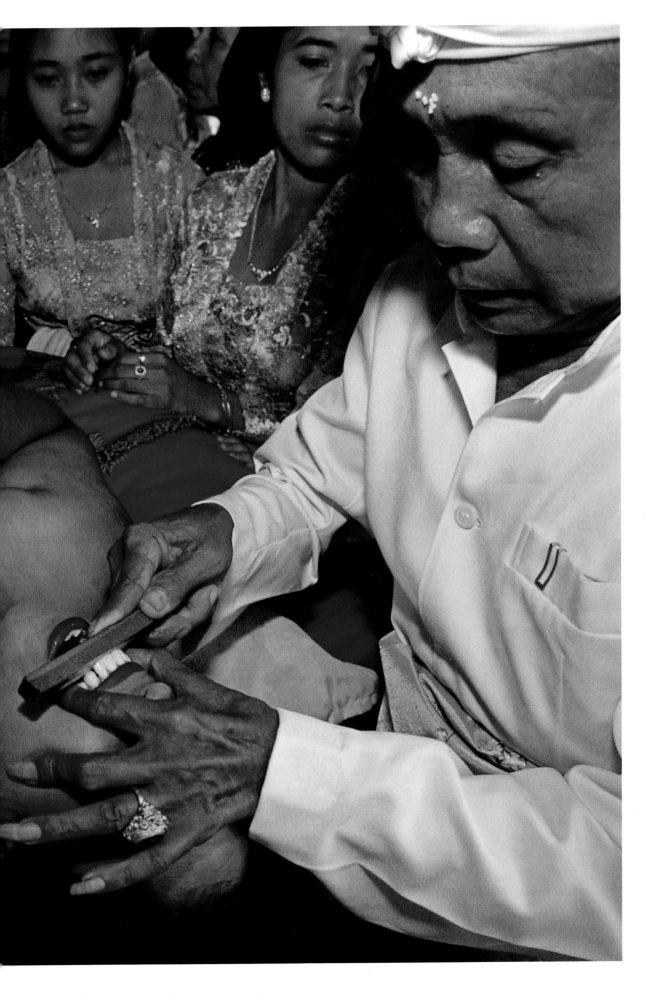

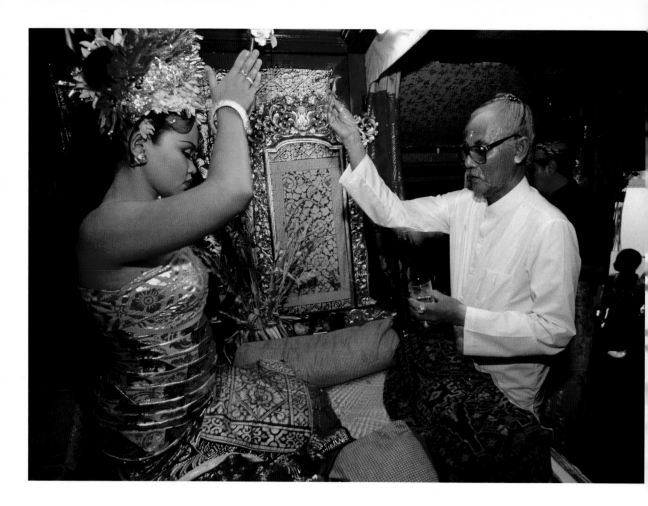

# Limage des dents
## *Bali, Indonésie*

Putu crache la limaille d'émail dans une noix de coco, relève les lèvres et examine ses dents dans un miroir. Sont-elles bien droites maintenant ? « Non, non pas encore ! » crie en chœur sa famille qui l'entoure autour du lit cérémonial. Putu s'allonge à nouveau sur le lit et le limeur de dent saisit son menton, tandis qu'il se remet au travail sur les six dents supérieures de devant. Les femmes autour de lui posent leurs mains sur les bras de Putu dans un encouragement silencieux.

Ceux qui ont déjà fait limer leurs dents prétendent que c'est plus désagréable que douloureux. Il s'agit d'un rituel que les garçons subissent traditionnellement au moment où leur voix mue et les filles, après leurs premières règles. Mais l'événement est fort coûteux et beaucoup de familles épargnent jusqu'à une occasion ultérieure, comme un mariage, de façon à combiner les deux cérémonies.

La famille de Putu ne souhaitait pas patienter. Âgé de quinze ans, il se fait limer les dents en même temps que trois de ses cousins. Ils portent un costume orné de magnifiques brocarts ; Sri, la cousine de Putu, a accroché de nombreux bijoux dorés dans ses cheveux. Nous sommes dans la capitale balinaise, Denpasar. Lorsque les invités arrivent, on leur sert des tasses de café fort balinais et des biscuits. Tous sont vêtus de costumes de cérémonie : les femmes en *kebaya*, une fine tunique à manches longues, et un sarong fermement drapé autour de leurs jambes les contraignant à faire de tout petits pas ; les hommes sont habillés de sarongs plus amples, d'une chemise et d'un *udeng*, un foulard noué en forme de fleur sur le front.

**Above and right:** Before the tooth filer gets to work, the Brahmin high priest purifies the initiates by sprinkling them with holy water and inscribing magical signs on their teeth with a ruby set in a gold ring.

**Ci-dessus et à droite :** Avant que le praticien ne commence à limer les dents, un prêtre brahmane purifie le garçon en l'aspergeant d'eau sacrée, puis il inscrit des signes magiques sur ses dents avec un rubis serti dans une bague en or.

**Oben und rechts:** Bevor das Feilen der Zähne beginnt, reinigt der brahmanische Hohepriester die Initianden, indem er sie mit heiligem Wasser benetzt und mit einem Rubin in seinem Ring magische Zeichen auf ihre Zähne schreibt.

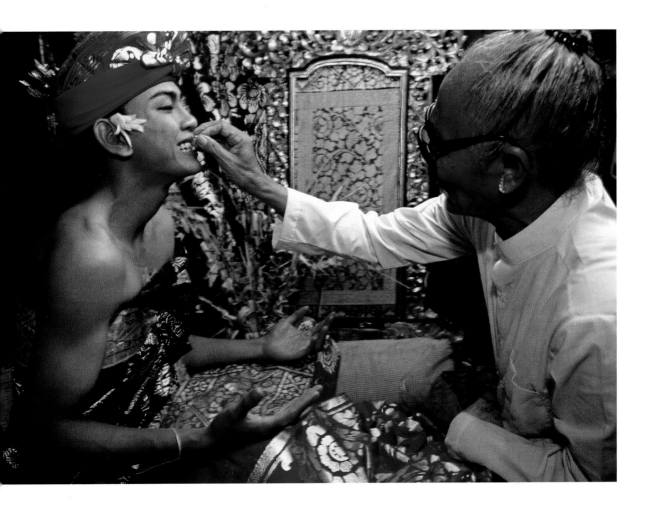

**Pages 274–275:** How do I look? An initiate checks his teeth in the mirror during an interlude in the ritual.

**Pages 274–275 :** Ça me va ? Le garçon profite d'un bref répit pendant la session de limage pour examiner ses dents.

**Seiten 274–275:** Wie sehe ich aus? Ein Initiand nutzt eine Pause, um seine Zähne im Spiegel zu begutachten.

Un orchestre joue une musique métallique de gamelan, tandis que les vérandas sont bondées d'amis et de membres de la famille. Les parents proches sont réunis autour du lit cérémonial situé dans un pavillon ouvert dans la cour. Des bâches ont été tendues entre les maisons pour empêcher le soleil d'entrer, donnant la sensation d'une pièce en plein air. Le but du limage de dent est de maîtriser six désirs et défauts – la soif, l'avidité, la colère, la confusion, l'intoxication et la jalousie – tout en aidant la personne à devenir plus humaine. Les démons possèdent de longues canines, et les êtres humains doivent donc se distinguer par une rangée de dents bien droites, risquant sinon de ne pas être autorisés à pénétrer dans le royaume des morts et donc ne pas être réincarnés.

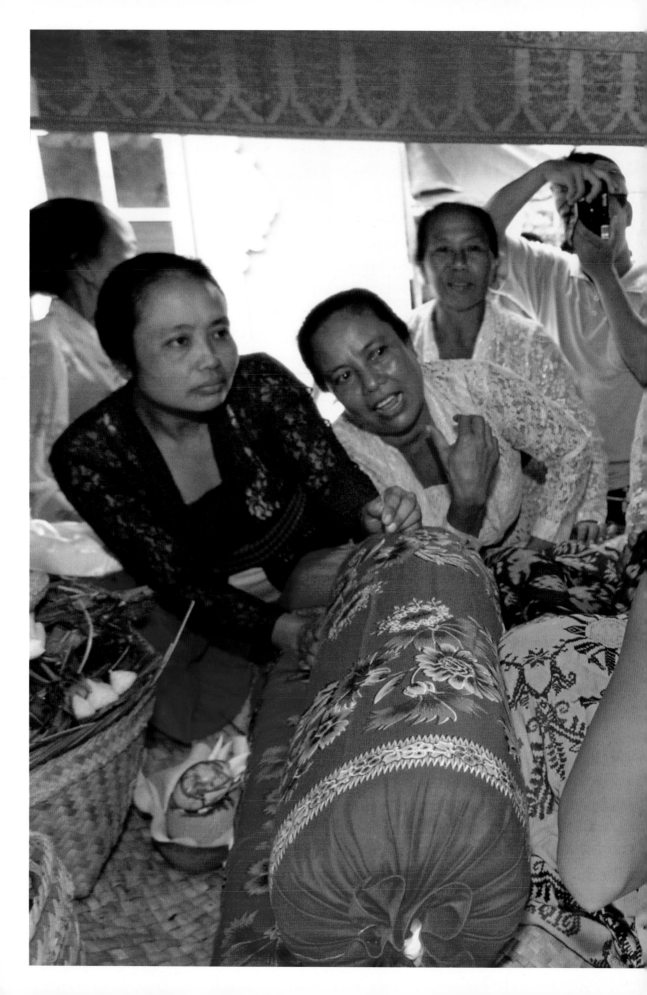

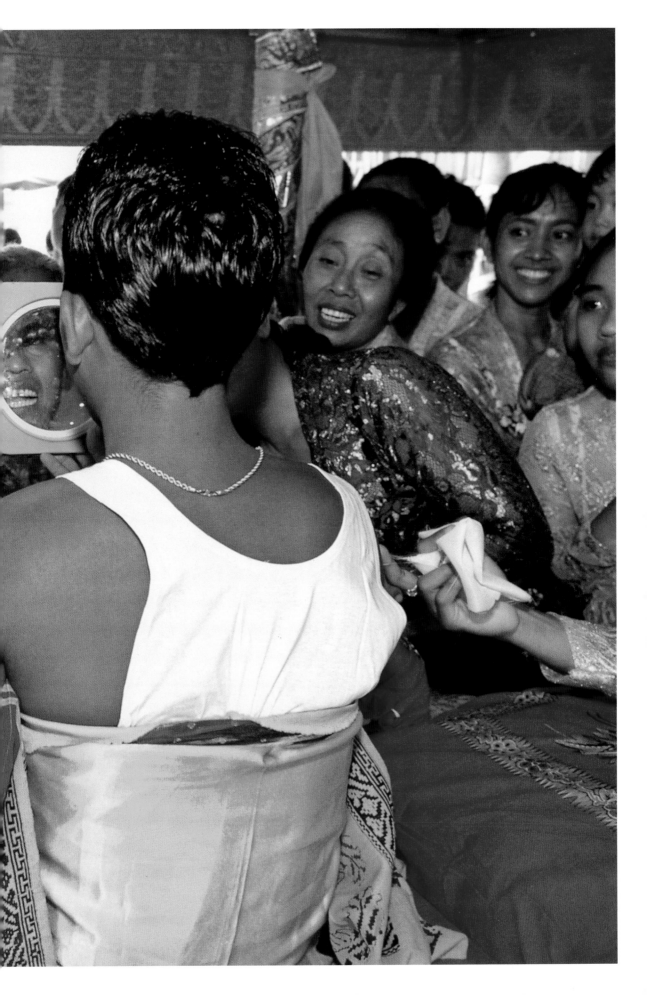

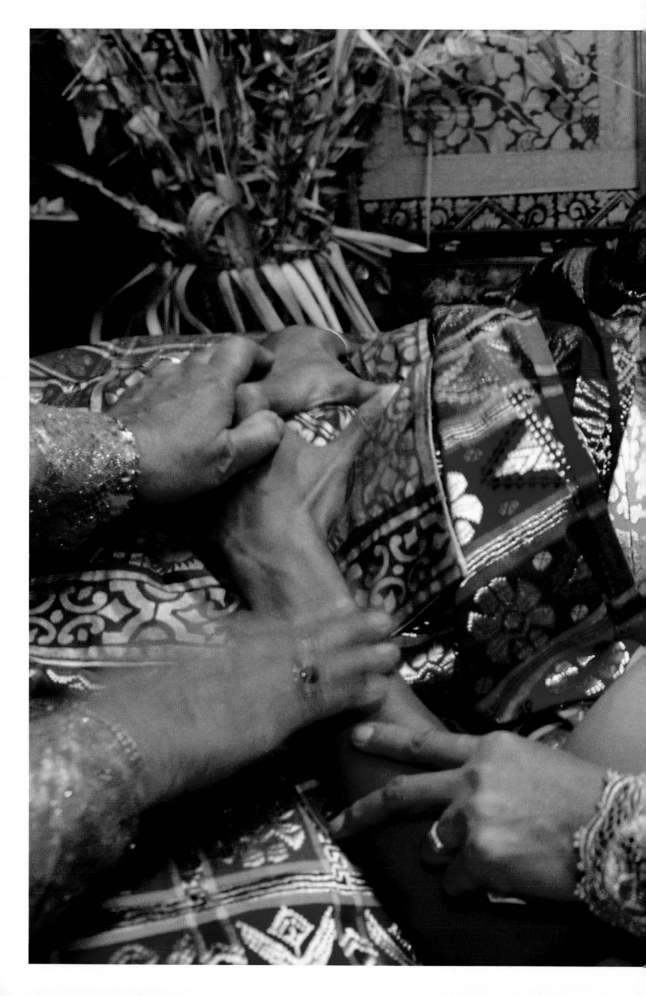

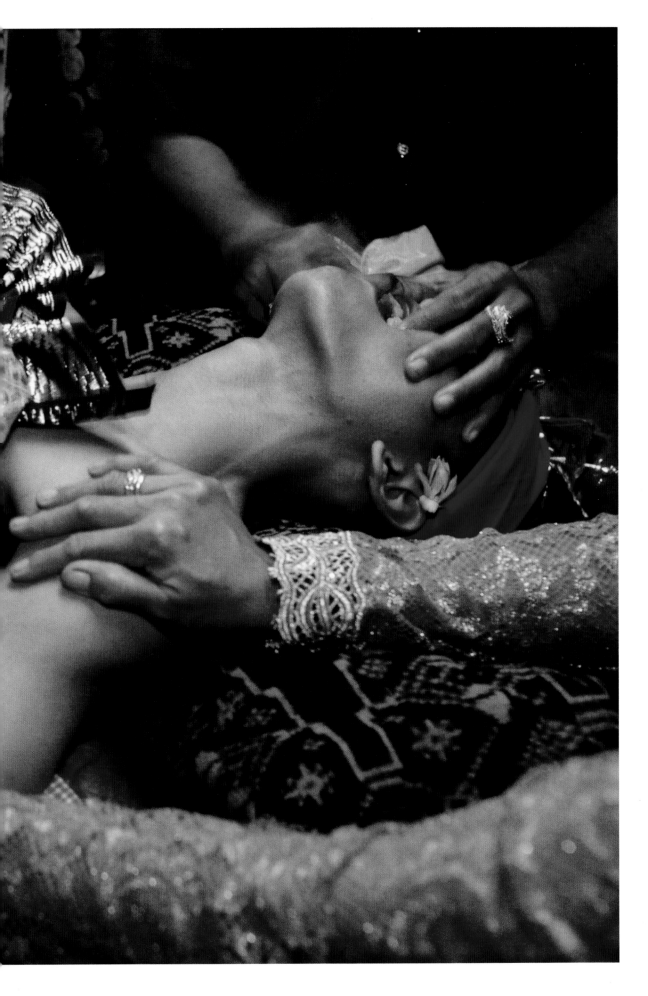

# Zähnefeilen
## *Bali, Indonesien*

Putu spuckt die Zahnschmelzspäne in die Kokosnussschale, fletscht die Zähne und betrachtet sie im Spiegel. Sind sie jetzt gleichmäßig genug? „Nein, noch nicht!", finden seine Verwandten, die sich um das zeremonielle Bett versammelt haben.

Putu legt sich wieder hin, und der Zahnfeiler packt sein Kinn, während er seine Arbeit an den sechs Frontzähnen wieder aufnimmt. Seine weiblichen Familienangehörigen legen ihre Hände in schweigender Ermutigung auf seine Arme.

Leute, die sich die Zähne haben abfeilen lassen, berichten, dass die Prozedur eher sehr unangenehm als schmerzvoll ist. Diesem Ritual unterziehen sich Jungen nach dem Stimmbruch und Mädchen, nachdem sie ihre erste Menstruation hatten. Aber es ist ein teures Fest, und viele Familien sparen Geld, indem sie es auf einen späteren Termin verschieben und es zum Beispiel gemeinsam mit der Hochzeit feiern.

Putus Familie hat nicht gewartet. Er ist 15, als seine Zähne wie die zweier Cousins und einer Cousine gefeilt werden. Sie tragen üppige Brokatkleidung und das Haar von Sri, Putus Cousine, ist mit viel Gold geschmückt.

Wir befinden uns in der Hauptstadt Balis, Denpasar. Die Gäste werden bei der Ankunft mit starkem balinesischem Kaffee und Keksen bewirtet. Alle haben ihre Festtagskleidung angelegt, die Frauen die Kebaya, eine dünne Bluse mit langen Ärmeln, und einen eng gewickelten Sarong, in dem sie nur kurze Trippelschritte machen können. Die Männer tragen lockere Sarongs, Hemd und den Udeng, ein Kopftuch, das mit einem aufwendigen Knoten vorn gebunden wird.

Ein Gamelan-Ensemble lässt metallische Klänge hören und auf den Veranden tummeln sich Freunde und Verwandte. Enge Familienmitglieder versammeln sich um das zeremonielle Bett, das in einem offenen Pavillon im Hof steht. Die Planen, die zwischen den Häusern gespannt sind, um Schutz vor der Sonne zu bieten, schaffen die Atmosphäre eines Außenraums.

Die Zähne werden gefeilt, um sechs Begierden und schlechte Eigenschaften im Zaum zu halten: Wollust, Zorn, Gier, Verwirrung, Rausch und Eifersucht. Außerdem soll die Person menschlicher werden, denn während Dämonen an ihren langen Fangzähnen zu erkennen sind, haben Menschen eine gerade Zahnreihe. Fehlt die, werden sie nach ihrem Tod nicht in das Reich der Toten gelassen und können nicht wiedergeboren werden.

Pages 276–277: Female relatives lay comforting hands on the boy as the tooth filer resumes work on his upper row of teeth.
Right: When the filing is complete, the family temple is visited. Led by a temple priest, the initiates pray and present offerings to their ancestors and the gods.

Pages 276–277: Des parentes posent des mains réconfortantes sur le garçon tandis que le praticien reprend le limage sur la mâchoire supérieure.
À droite: La famille se rend au temple après le rite du limage. Guidés par un prêtre, l'initié et ses proches prient et font des offrandes aux ancêtres et aux divinités.

Seiten 276–277: Die weiblichen Familienmitglieder legen ihre Hände tröstend auf den Jungen, während der Zahnfeiler seine Arbeit an der oberen Zahnreihe wieder aufnimmt.
Rechts: Ist das Feilen abgeschlossen, besucht die Familie den Tempel. Unter der Anleitung des Tempelpriesters beten die Jugendlichen und bringen ihren Vorfahren und den Göttern Opfer dar.

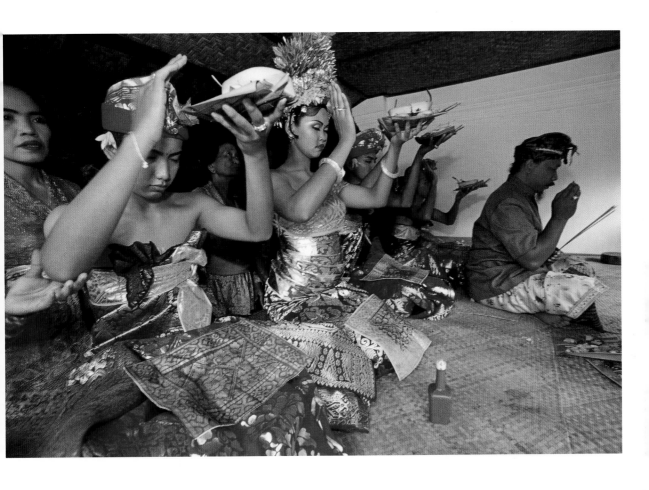

# Hamar bull jumping
## South Omo, Ethiopia

Against a sonic backdrop of shrill female singing, tooting bugles and metallic rattles, a herd of cattle stands on a dancing ground near the sandy banks of the Kaske River, the animals huddled tightly together as if seeking refuge from the din.

It is early October and a month has passed since the annual harvest. The Hamar people now have enough food and energy for their ceremonial traditions. This is the season for the young men to join the adult world and become marriageable. This they do by undergoing *ukuli bula*, a ritual that involves running over a line of bullocks.

The Kaske River in south-west Ethiopia once formed the western border of Hamar territory. The Hamar who still live to the east of the river hold their bull jumps in the vicinity of their own homes, but those who now live on the western side must travel back to the traditional side for the ritual. The crossing point at Turmi is a popular venue and hosts numerous gatherings in a special ukuli bula area during the high season.

Here, amid thorny acacia bushes, it is time for Wale to come of age and become a man. The process began several weeks ago with an older relative, as a substitute for his deceased father, giving him a *boko*, a carved phallus-shaped stick. This was the first in a series of rituals that eventually will culminate in Wale becoming a *donza* (married man). It was followed by Wale giving away all his worldly possessions and starting to wear only a tatty old loincloth. His forehead was shaved and his remaining hair tightly plaited to show his status as an *ukuli* ("one who is due to jump").

Twice a day since the initiation process began, Wale's sisters and female cousins have tied metal rattles to their legs and then sung and danced in the cattle pen outside the family's mud hut. His mother and sisters have prepared for the big day by grinding wheat and millet, making porridge and brewing beer. For his part, Wale has walked for miles visiting relatives to request their support and tell them the date of his bull jump.

The cattle arrived this morning, herded in the savannah grazing grounds far to the west by Wale's uncle and older brothers. The Hamar have ongoing feuds with various neighbouring tribes, and Wale's uncle, wearing a blue jacket and bright orange hat, never goes anywhere without his Kalashnikov.

Earlier, Wale visited a ceremonial expert who threaded a sheath made of antelope skin, another phallic symbol, over his index finger. He then had cow dung smeared on his chest in a crossed pattern.

Wale's *mansange* (helper) has now tied strips of bark onto his chest over the cow dung and unknotted his plaits, leaving a bush-like tangle of matted hair on his head.

Meanwhile Wale's sisters and female cousins are begging for chastisement by the *maz*, young men with faces painted white and red, shaved heads and bark headbands. They recently went through the ceremony themselves but have yet to marry. The ritual involves the women cajoling the maz to whip them, thereby demonstrating the strength of their devotion to Wale and their own physical fitness. The women pester the maz incessantly, grabbing them by the wrists, honking on bugles and flicking their hair, smeared in butter and red ochre, into the men's faces.

Eventually one of the women will make a maz relent and agree to administer chastisement with one of the whipping wands that he carries. According to tradition, the maz gives the woman a single stroke, striking the upper arm first and letting the whipping wand recoil to hit the woman on the back. It is then dropped to the ground.

Not all the women are satisfied and some request more strokes to show the depth of their devotion to Wale. Some maz are forced to retreat to escape these importunate demands, though they return for the bull jumping, which cannot be held without their presence.

Together with some of the married men they now form a tight circle, facing inwards, with Wale sitting on the ground in the middle. Hidden from view by others, they carry out a series of ritual acts, including spilling milk on Wale's legs, all symbolising his rebirth as a grown man, ready to marry.

Then Wale runs out naked among the cattle.

Hamar associate cattle with women, and in Wale's present social position they represent his mother and sisters, who up until now have lived under the same roof as himself. Later, by leaping over the backs of the bullocks, he becomes a marriageable man who will soon attain a higher social status than the women in his household, becoming a family head with authority over wife and children.

This is how anthropologists interpret the jump, though the Hamar themselves do not always have precise explanations for their ceremonies.

The maz grip the bullocks by their horns and tails and line them up, some taking up positions by the animals' heads and others by their hindquarters to hold them steady.

Seven bullocks and a calf are now lined up. Still naked, Wale waits behind his helper. When his helper steps aside Wale sprints towards the line of cattle, his relatives singing and holding wooden sticks horizontally in a bid to help him complete the jump safely.

Like all initiates, Wale must run over the backs of the cattle four times. If he fails a jump he must retake it, and if he makes too many mistakes he may find himself physically attacked by his affronted sisters.

Using the calf as a step up, Wale hops onto the back of the first bullock. He wavers slightly on reaching the second animal but regains his balance and neatly skips over the rest of the cattle. Dismounting with a jump, he promptly turns round and repeats the procedure from the other direction.

After weeks of training at home, Wale is a confident jumper and completes his quartet of jumps with aplomb. For the finale everybody lines up, with Wale at the front, and sings. They imitate the sound made when blessing a person by sipping and spraying a mouthful of coffee.

Wale is no longer a boy; he is old enough to marry, with the blessing of his family. But the path to marriage is still a long one.

First he becomes a *maz*, who leaves home to roam with other *maz*. His head is shaved, he has a band of bark tied round his forehead and he assumes the name of the calf he stepped on during the jump. From this moment he is not allowed to sleep indoors and must exist on a diet of meat, milk and honey. Whenever a bull jump is held he attends, along with his fellow maz, and administers lashes to the young women who ask for chastisement.

Young men spend several months, sometimes more than a year, waiting while their families finalise marriage terms. The relations between the two families have

to be of the right traditional kind and they must agree on the number of sheep, goats and cattle to be given to the bride's family.

When the arrangements have been made the young man returns home for good. His family receives a visit for a few days from the bride-to-be. The young couple then go through betrothal ceremonies in which the bride removes her fiancé's bark headband and hangs it from a tree to show that he is no longer a maz.

A necklace of antelope hide is placed round the bride's neck to indicate she is engaged. Before she is taken home, the womenfolk of the groom's family rub butter and red ochre into her hair, forehead and chest to make her look her best.

From this point it may take a year or two before the woman's parents finally let their daughter go. If she has an older sister who is also engaged, then the older sister must marry first. The payments from the groom's family also have to be made, and the bride's family frequently demands additional contributions over and above those originally agreed. In such cases it is considered acceptable for the young man to tire of the procrastination and abduct his bride.

Even then the groom's patience continues to be tested. After the bride has moved into the groom's home, she spends three months living in the loft, which she enters via a tiny hole in the ceiling.

There she is attended by her mother-in-law, who rubs her with butter and red ochre every day and feeds her nutritious food. She does no work, and by the time she finally descends to consummate the marriage she has been fattened up and her skin has a glistening reddish hue.

The happy couple spend their wedding night sleeping on animal hides in the open air. The couple prepare by eating millet pancakes, which give the man a strong erection, and the morning after the whole family celebrates with a ritual drink of coffee. Everyone now knows that the deed has been done. The man cannot hide it even if he wants to, for the butter and red ochre have now rubbed off on him.

# Le saut de bœufs chez les Hamar
## Sud-Omo, Éthiopie

Le chant des femmes mêlé aux clairons dans un puissant fracas métallique surprend un troupeau de bétail retenu sur la piste de danse près des bancs sablonneux de la rivière Kaské. Les animaux se serrent les uns contre les autres comme s'ils cherchaient refuge face à un tel vacarme. C'est début octobre et un mois s'est écoulé depuis la moisson annuelle. Les Hamar possèdent dorénavant assez de nourriture et d'énergie pour profiter de leurs traditions cérémonielles. C'est également la saison où les jeunes hommes deviennent adultes et peuvent se marier. Ils doivent donc se soumettre à *ukuli bula*, un rituel qui implique de sauter sur une lignée de bœufs. La rivière Kaské, dans le sud-ouest de l'Éthiopie, constituait la frontière occidentale du territoire Hamar. Les Hamar qui vivent encore à l'est de la rivière pratiquent le saut à proximité de leurs maisons, tandis que ceux qui vivent maintenant du côté ouest font le voyage pour retourner sur le site traditionnel du rituel. Le point de rencontre à Turmi est un lieu populaire qui, en haute saison, héberge de nombreuses réunions dans une zone dédiée à l'*ukuli bula*. C'est ici, parmi les buissons d'acacias épineux, que Wale va devenir un homme. Le processus a déjà commencé plusieurs semaines auparavant, avec un parent plus âgé qui s'est substitué à son père décédé en lui fournissant un *boko*, un bâton taillé en forme de phallus. Il s'agit du premier rituel d'une longue série qui atteindra son comble lorsque Wale deviendra un *donza* (homme marié). Wale a déjà abandonné toutes ses possessions et ne porte plus qu'un vieux pagne. Son front a été rasé et ses cheveux restants fermement tressés pour le désigner en tant qu'*ukuli* (« celui qui doit sauter »).

Deux fois par jour, avant que le processus ne commence, les sœurs et les cousines de Wale attachent des clochettes à leurs jambes et dansent en chantant dans le parc à bétail à l'extérieur de la hutte en terre familiale. Sa mère et ses sœurs ont préparé du blé et du millet pilé pour le grand jour, afin de confectionner du gruau d'avoine et de la bière. Wale, de son côté, marche de longues heures pour rendre visite aux membres de sa famille afin de leur demander leur soutien et de les informer de la date du grand saut.

Le bétail est arrivé ce matin, élevé par l'oncle et les frères plus âgés de Wale dans les terres fertiles de la savane plus à l'ouest. Les Hamar sont en conflit permanent avec des tribus voisines, et l'oncle de Wale, vêtu d'une veste bleue et d'un chapeau orange vif, ne sort jamais sans sa Kalashnikov.

Plus tôt, Wale a rendu visite à un spécialiste en cérémonie qui lui a confectionné une gaine en peau d'antilope qu'il porte à l'index, un autre symbole phallique. Il s'est également enduit d'excréments de vache en formant des croix sur sa poitrine. Son *mansange* (parrain) lui a ensuite attaché des bandes d'écorce sur la poitrine, par-dessus les excréments de vache, et a dénoué ses tresses, laissant ses cheveux emmêlés.

Pendant ce temps, les sœurs et les cousines de Wale demandent aux *maz* de les châtier. Les jeunes hommes aux visages peints en blanc et rouge, le crâne rasé et bardés de bandes d'écorce, ont récemment vécu la cérémonie et doivent maintenant se marier. Le rituel veut que les femmes se fassent fouetter par les *maz* de façon à démontrer la force de leur dévotion ainsi que leur résistance physique. Les femmes les harcèlent sans relâche, leur saisissant les poignets afin qu'ils les fouettent. Elles jouent également du clairon et agitent leurs cheveux enduits de beurre et d'ocre rouge devant le visage des hommes.

**Right:** Today is the big day and the plaits of the initiate have been untied. The calabash in his hand will be useful in the months ahead, as he is only allowed to drink milk and eat meat and honey until he is engaged to be married.
**Pages 288–289:** Sisters and female cousins show their devotion to the initiate in many ways. For weeks leading up to the ceremony they dance every morning and afternoon, singing about their excitement about his bull jump.

**À droite:** Le grand jour est arrivé. Le garçon a dénoué ses cheveux. Sa calebasse lui sera précieuse dans les mois à venir où il aura le droit de ne boire que du lait et se nourrir de viande et miel jusqu'à ses fiançailles.
**Pages 288–289:** Dans les semaines précédant la cérémonie, les sœurs et cousines des futurs initiés les entourent de nombreuses marques d'affection. Deux fois par jour, elles dansent et chantent dans l'attente du saut de bœufs.

**Rechts:** Heute ist der große Tag, und das geflochtene Haar ist wieder gelöst worden. Die Kalebasse in seiner Hand wird er in den folgenden Monaten gut gebrauchen können – bis er verlobt ist, darf er nur von Milch, Fleisch und Honig leben.
**Seiten 288–289:** Schwestern und Cousinen zeigen dem Initianden ihre Zuneigung auf vielerlei Art. Vor der Zeremonie tanzen sie wochenlang jeden Morgen und Nachmittag für ihn und singen davon, wie gespannt sie auf seinen Sprung über die Rinder sind.

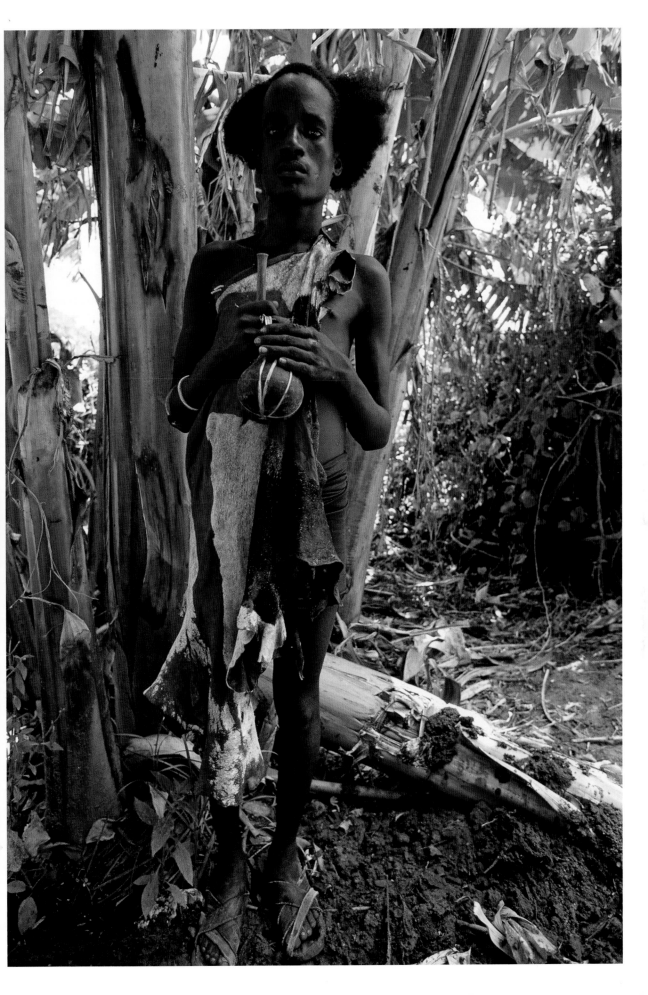

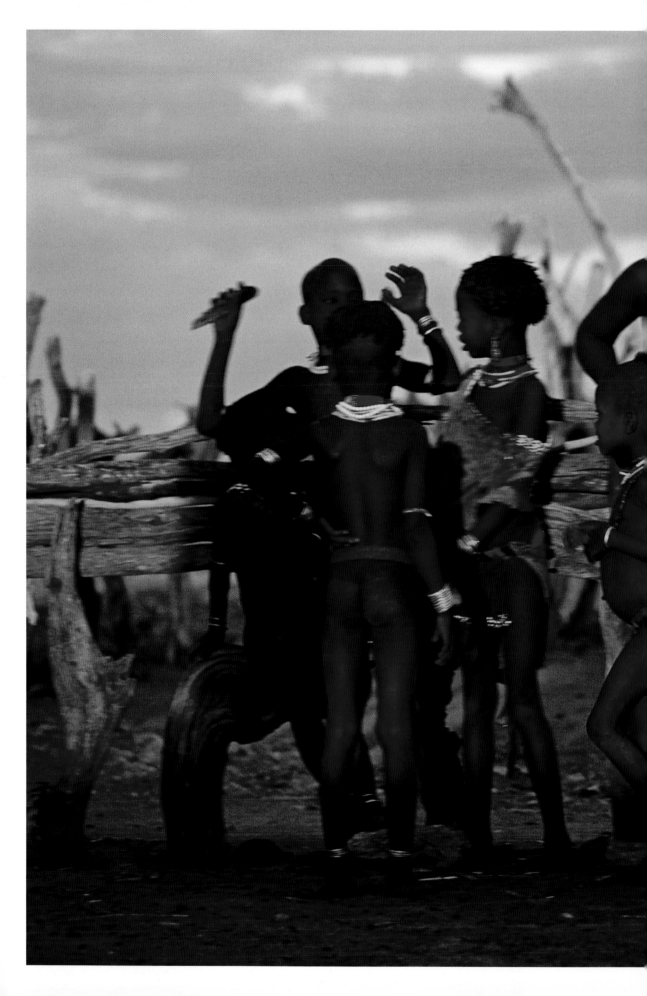

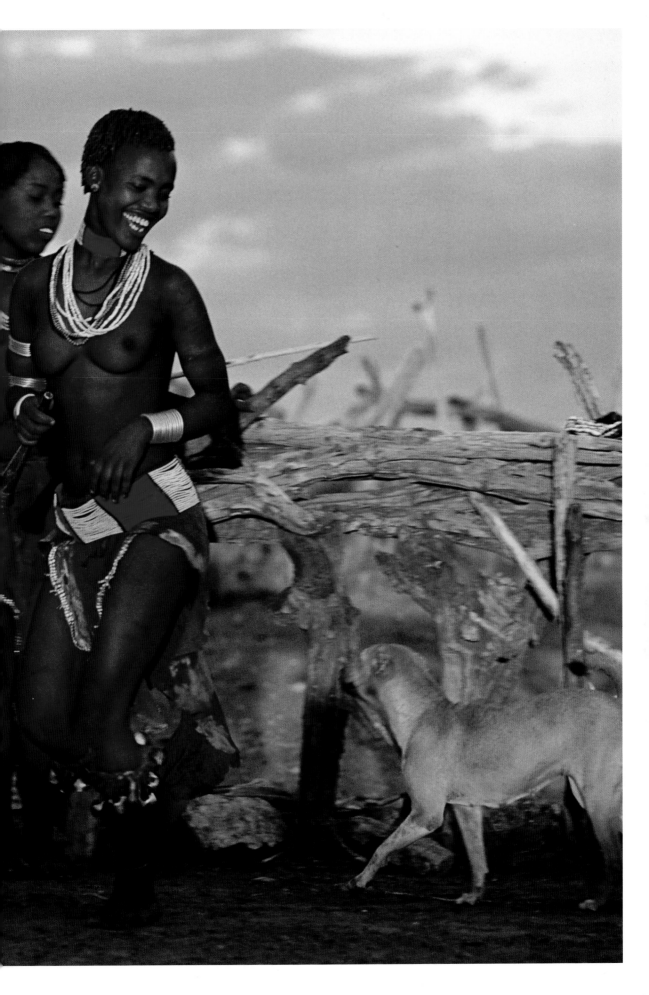

Pour finir, une des femmes s'apprête à recevoir le châtiment d'un *maz* muni d'une badine magique. Selon la tradition, le jeune homme lui donne un seul coup, frappant le haut du bras en premier et laissant reculer la baguette sur le dos de la femme, avant de la lâcher à terre.

Toutes les femmes ne sont pas satisfaites et réclament davantage de coups afin de démontrer leur profonde dévotion à Wale. Certains *maz* sont contraints de reculer pour échapper à des requêtes importunes, mais reviennent sur les lieux pour assister au saut qui ne peut être exécuté sans leur présence. Ensemble, avec d'autres hommes mariés, ils forment alors un cercle étroit les uns en face des autres, Wale assis à terre au milieu. Ils entament ensuite une série de rituels et badigeonnent de lait les jambes de Wale. Ces rites symbolisent la renaissance en tant qu'adulte prêt pour le mariage. C'est alors que Wale court nu au cœur du troupeau. Les Hamar associent le bétail aux femmes, et dans la position sociale actuelle de Wale, les bœufs représentent sa mère et ses sœurs qui, jusqu'à présent, ont vécu sous le même toit que lui. Plus tard, en sautant sur le dos des bœufs, il deviendra un homme susceptible de se marier qui atteindra bientôt un statut social plus élevé que les femmes de son foyer, devenant ainsi un chef de famille ayant autorité sur sa femme et ses enfants.

C'est ainsi que les anthropologues interprètent le saut, bien que les Hamar eux-mêmes ne fournissent pas vraiment d'explications précises concernant leur cérémonie. Les *maz* agrippent les bœufs par les cornes et la queue pour les aligner, certains retenant les animaux par la tête ou par l'arrière-train pour qu'ils restent en place.

Sept bœufs et un veau sont maintenant alignés. Toujours nu, Wale attend derrière son parrain. Au moment où ce dernier se déplace sur le côté, Wale commence sa course vers la ligne de bœufs, ses proches chantant et posant des bâtons de bois à l'horizontal pour l'aider à franchir l'obstacle plus facilement. Comme tous les initiés, Wale doit franchir la ligne de bœufs quatre fois.

S'il rate un saut, il doit recommencer, et s'il fait trop de fautes, il se verra attaqué physiquement et verbalement par ses propres sœurs. Prenant le veau comme tremplin, Wale saute sur le dos du premier bœuf. Il vacille légèrement lorsqu'il atteint le deuxième animal, mais rétablit son équilibre et saute d'un seul coup par-dessus les autres bœufs. Terminant par un petit saut, il se retourne promptement et répète ses gestes dans l'autre direction.

Après des semaines d'entraînement chez lui, Wale est confiant et effectue ses sauts avec aplomb. Pour le saut final, tout le monde s'aligne, et Wale se place devant. Ils imitent alors le son de quelqu'un qui bénirait une personne, en buvant et recrachant de petites gorgées de café. Wale n'est plus un jeune garçon ; il est maintenant assez âgé pour se marier, avec la bénédiction de sa famille. Mais le chemin jusqu'au mariage est encore très long. D'abord il devient *maz* et quitte la maison pour errer avec d'autres *maz*. Sa tête est rasée et il porte une bande d'écorce nouée autour du front, puis il prend le nom du veau qu'il a chevauché lors du saut. À partir de ce moment, il n'est plus autorisé à dormir à l'intérieur et n'a plus le droit que de boire du lait et manger de la viande et du miel. Lors de chaque nouvelle cérémonie du saut, il se tient prêt avec les autres *maz*, à administrer des coups de fouet aux jeunes femmes qui demandent le châtiment.

Les jeunes hommes attendent parfois plusieurs mois, voire même plus d'une année, que leurs familles arrangent leur mariage. Les relations entre les deux familles doivent rester dans la droite lignée de la tradition et elles sont censées s'accorder sur le nombre de moutons, de chèvres et de bœufs qui doit être offert à la famille de la future mariée.

**Right:** A female dancer on the day of the ceremony. The antelope skin and metal necklace indicate that she is married, while her belt studded with cowry shells shows she is a mother. Her hair and neck are coated in butter and red ochre and she has scarifications on her arms and shoulders.
**Pages 292–293:** A blue cotton singlet and safety-pin necklace add a touch of modernity to this woman's dress.
**Pages 294–295:** Women bugling and dancing.

**À droite :** Une danseuse le jour de la cérémonie. La peau d'antilope et le collier en métal indiquent qu'elle est mariée et la ceinture ornée de caudis qu'elle a des enfants. Ses cheveux et son cou sont enduits de beurre et ocre ; des scarifications ornent ses bras et épaules.
**Pages 292–293 :** Le tee-shirt de coton bleu et un collier d'épingles à nourrice ajoutent une touche de modernité à la tenue de cette femme.
**Pages 294–295 :** Les femmes dansent et sonnent du clairon.

**Rechts:** Eine Tänzerin am Tag der Zeremonie. Die Antilopenhaut und der metallene Halsschmuck zeigen an, dass sie verheiratet ist, ihr mit Kaurischneckenhäusern besetzter Gürtel weist sie als Mutter aus. Ihr Haar und ihr Hals sind mit Butter und rotem Ocker bestrichen, an Armen und Schultern hat sie Ziernarben.
**Seiten 292–293:** Ein blaues Baumwollunterhemd und eine Halskette aus Sicherheitsnadeln geben der Erscheinung dieser Frau einen modernen Touch.
**Seiten 294–295:** Frauen blasen Hörner und tanzen.

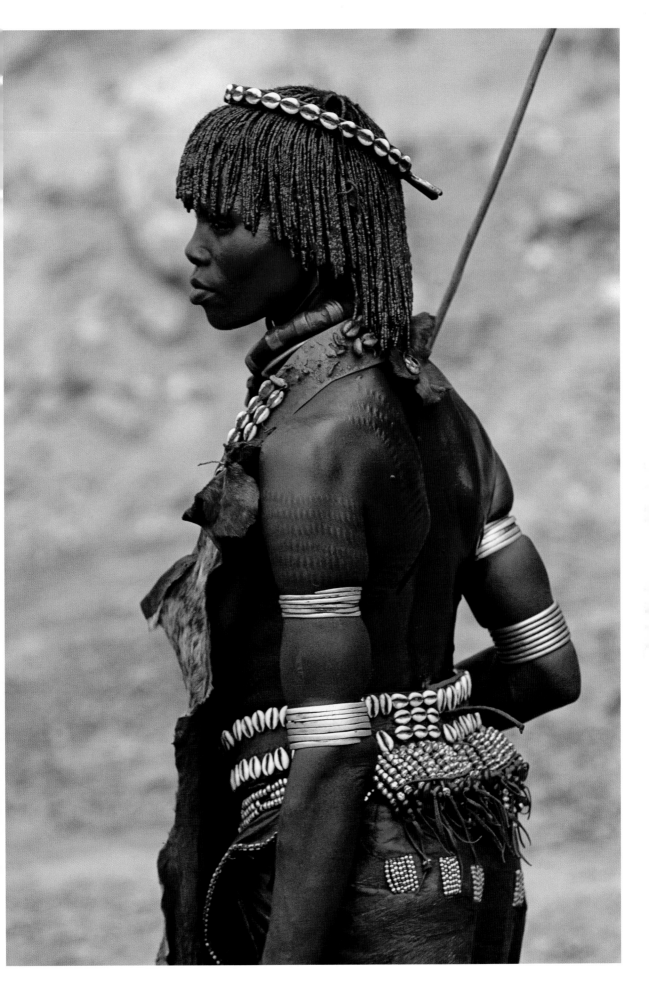

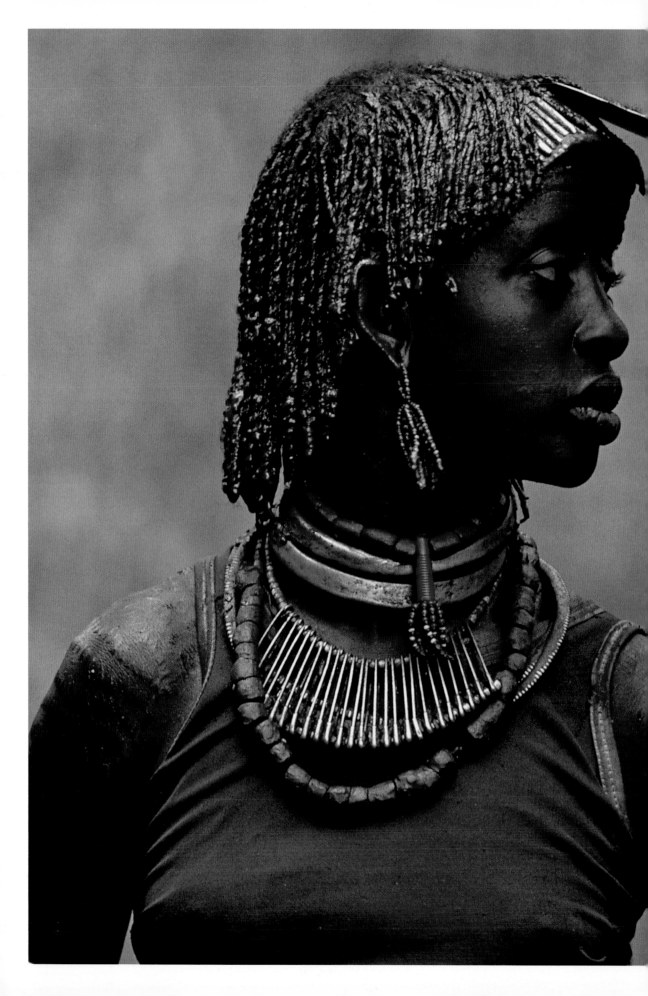

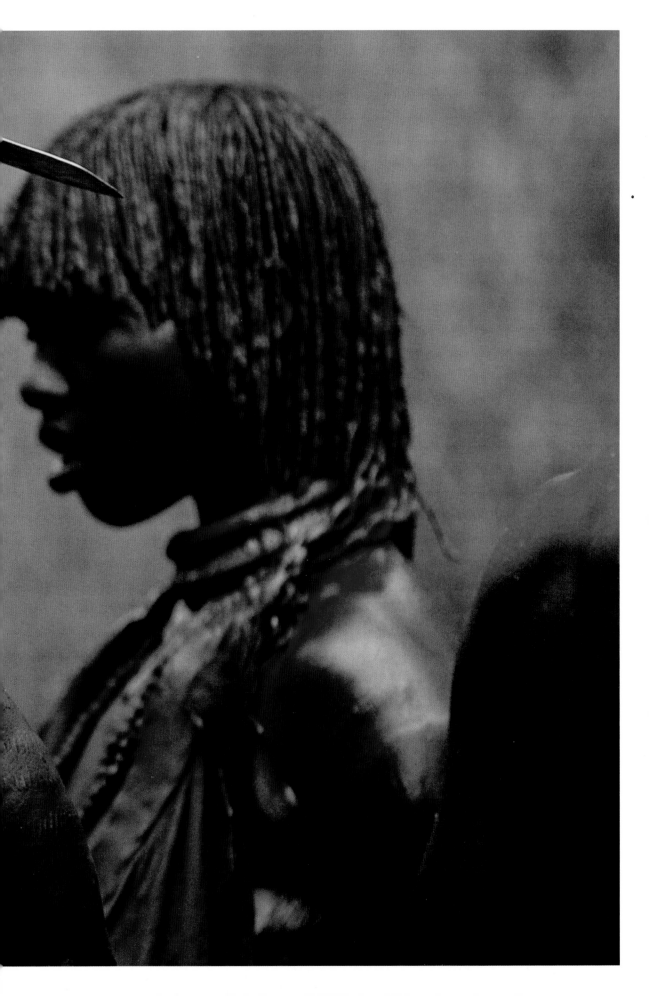

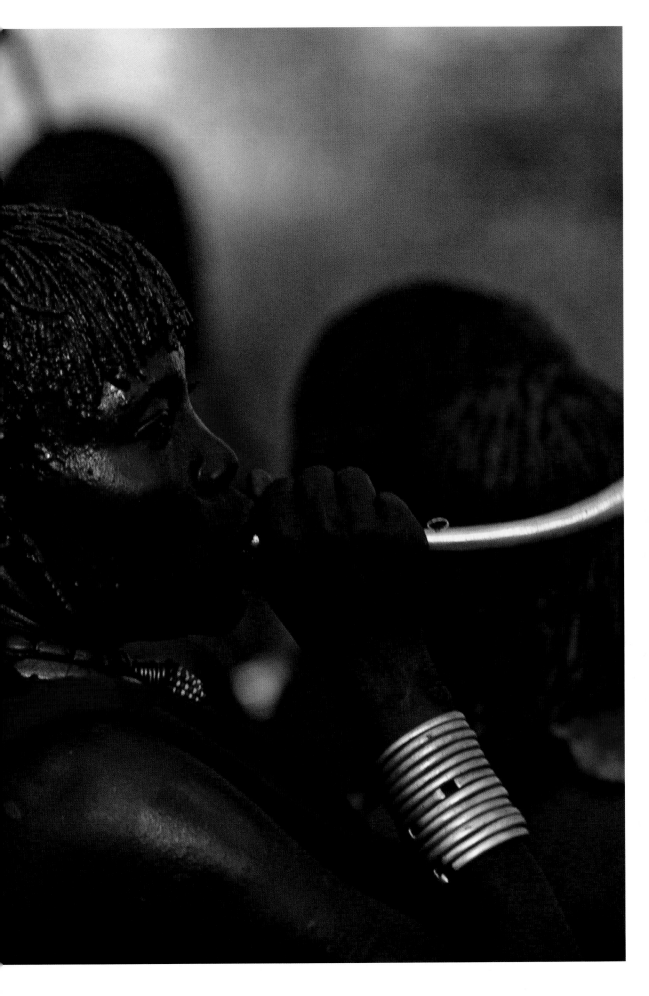

Lorsque toutes les dispositions ont été prises, le jeune homme retourne définitivement chez lui. Sa famille reçoit alors la jeune fille pendant quelques jours. Le jeune couple entre ensuite dans la période de fiançailles, lors de laquelle la jeune fille enlève la bande d'écorce de son fiancé pour l'accrocher à un arbre et montrer ainsi qu'il n'est plus un *maz*. Un collier en peau d'antilope est attaché autour du cou de la fiancée pour indiquer qu'elle n'est plus libre. Avant de rentrer chez elle, les femmes de la famille du fiancé enduisent de beurre et d'ocre rouge sa chevelure, son front et sa poitrine pour l'embellir.

Dès lors, il peut se passer une année ou deux avant que la famille de la jeune fille la laisse partir. Si elle a une sœur plus âgée déjà fiancée, elle devra attendre que celle-ci se marie. La dette envers la famille de la jeune fille doit être également assumée, sachant que la famille exige souvent des compensations supplémentaires par rapport à l'engagement initial. Dans ce cas, il est considéré comme acceptable que le jeune homme enlève sa fiancée pour tester la patience de sa famille. Après que la jeune fiancée a déménagé dans la maison du fiancé, elle passe trois mois à vivre dans le grenier, dans lequel elle entre par un trou percé dans le plafond. Sa future belle-mère s'occupe d'elle tous les jours en l'enduisant de beurre et d'ocre rouge et lui fournit des vivres nourrissants. Elle ne travaille pas, et au moment où elle redescend finalement pour consommer son mariage, elle a été engraissée et sa peau brille d'un rouge vif. Le couple heureux passe sa nuit de noces en dormant sur des peaux de bêtes en plein air. Le couple se prépare en mangeant des galettes de millet, ce qui assure une forte érection à l'homme. Au petit matin, toute la famille célèbre ce grand jour autour d'un café. Chacun sait maintenant que l'acte s'est réalisé. L'homme ne peut plus le cacher, même s'il le souhaitait, couvert comme il est de beurre et d'ocre rouge.

**Right:** *Maz* are men who have performed a bull jump but have yet to marry, recognised as such by a strip of bark tied round their heads. This maz is sitting on his stool, waiting for the day's ceremonies to begin.
**Pages 298–299:** The tasks of the maz include obliging the initiate's sisters and female cousins when they ask to be chastised with the whipping wand. Women nowadays wear cotton singlets to protect their breasts from stray strokes.

**À droite :** On reconnaît les *maz*, les hommes qui ont accompli le saut des bœufs, mais sont encore célibataires, à la bande d'écorce qui ceint leur tête. Assis sur un tabouret, ce maz attend le début des cérémonies.
**Pages 298–299 :** Une des fonctions d'un maz est de « châtier » à la baguette les sœurs et cousines du futur initié, si elles l'invitent à le faire. Aujourd'hui, les femmes portent des hauts en coton pour protéger leur buste des coups de baguette qui pourraient dévier.

**Rechts:** Männer, die den Sprung über die Rinder hinter sich haben, aber noch nicht verheiratet sind, heißen Maz. Sie sind an einem Rindestreifen zu erkennen, den sie um den Kopf gebunden tragen. Dieser Maz sitzt auf einem Hocker und wartet darauf, dass die heutige Zeremonie beginnt.
**Seiten 298–299:** Zu den Aufgaben der Maz gehört es, den Wünschen der Schwestern und Cousinen der Initianden nachzukommen und sie mit einer Rute zu schlagen. Heute tragen Frauen Baumwollunterhemden, um ihre Brüste vor eventuell fehlgehenden Schlägen zu schützen.

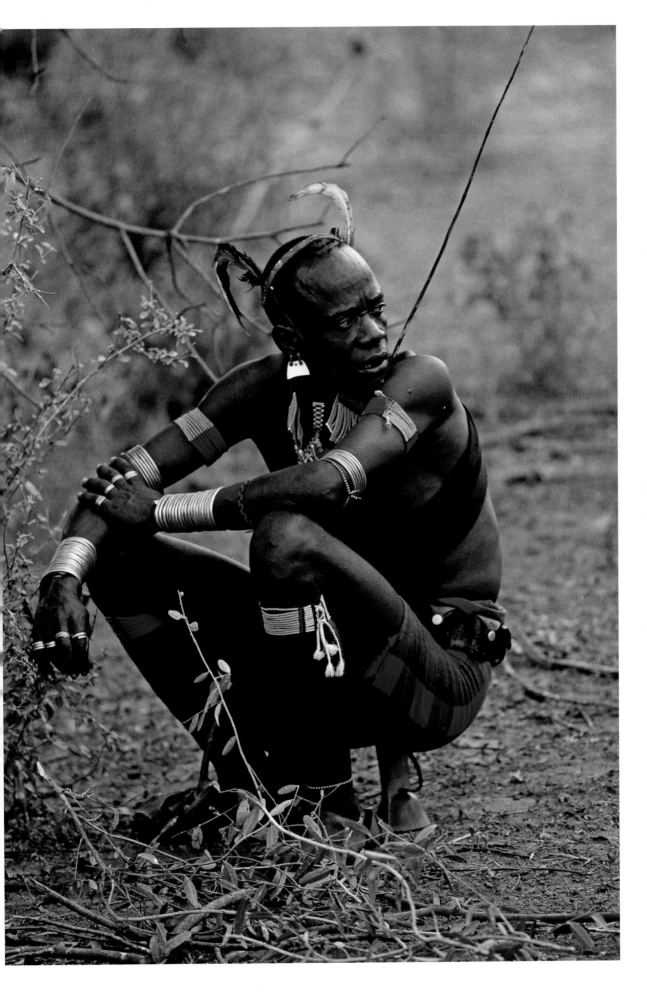

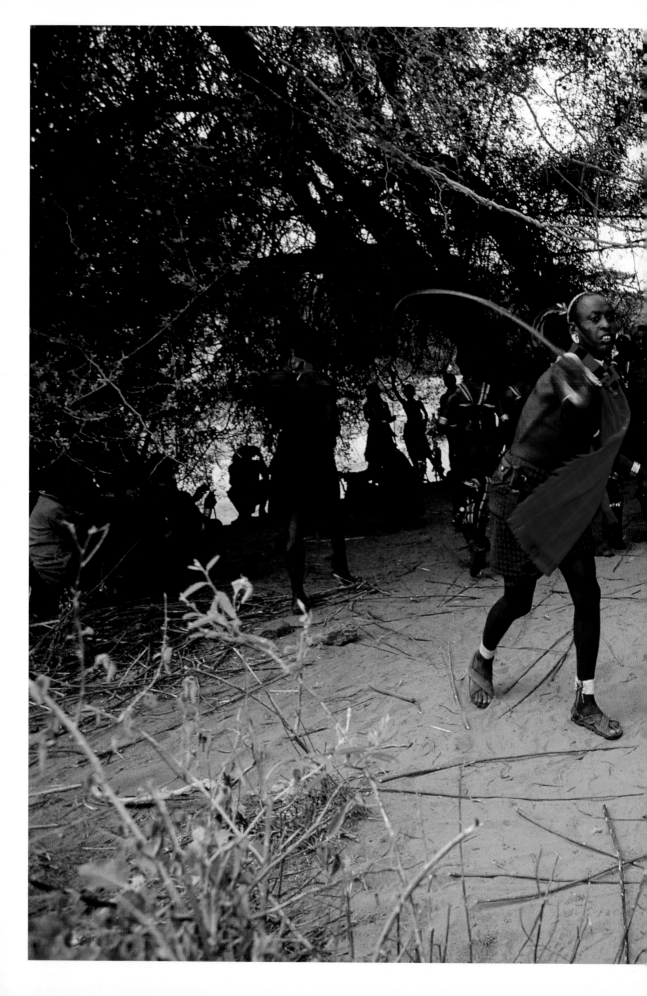

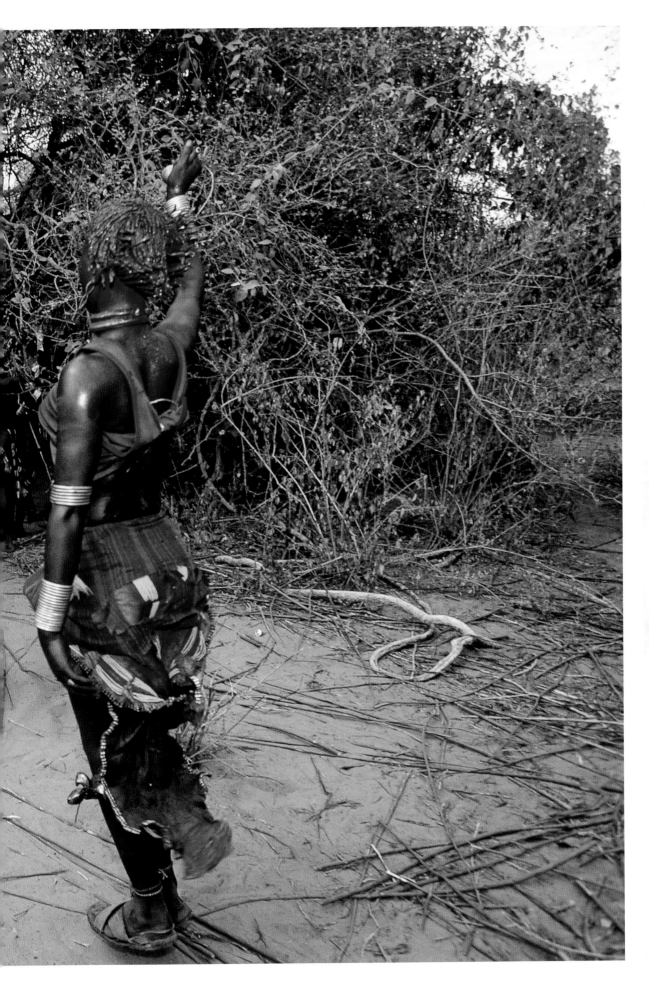

# Sprung über die Rinder
## Süd-Omo, Äthiopien

Vor dem akustischen Hintergrund schriller Frauengesänge, tutender Hörner und Metallrasseln steht auf dem Tanzplatz nahe dem sandigen Ufer des Flusses Kaske eine Rinderherde. Die Tiere drängen sich dicht aneinander, als suchten sie Schutz vor dem Lärm.

Es ist Anfang Oktober, seit der Ernte ist ein Monat vergangen. Nun haben die Hamar genug zu essen und können sich ihren zeremoniellen Bräuchen widmen. Das ist die Zeit, in der die jungen Männer in die Welt der Erwachsenen aufgenommen und heiratsfähig werden. Dazu unterziehen sie sich dem Ritual Ukuli Bula, zu dem es gehört, über eine Reihe von Ochsen zu laufen.

Der Fluss Kaske im südwestlichen Äthiopien bildete einmal die westliche Grenze des Hamar-Gebiets. Diejenigen Hamar, die immer noch östlich des Flusses leben, halten ihre Rindersprünge heute in der Gegend ab, in der sie leben. Wer aber westlich des Flusses lebt, muss dorthin reisen, wo das Ritual ursprünglich stattfand. Turmi, wo der Fluss überquert wird, ist ein beliebter Veranstaltungsort und in der Hochsaison Mittelpunkt für viele Zusammenkünfte in einem speziellen Ukuli-Bula-Bereich.

Hier, inmitten stacheliger Akazienbüsche, ist es für Wale an der Zeit, volljährig und ein Mann zu werden. Dieser Prozess hat schon vor ein paar Wochen begonnen, als ein älterer Verwandter, der die Stelle von Wales verstorbenem Vater einnahm, ihm einen Boko, einen phallusförmig geschnitzten Stock gegeben hat. Das war das erste einer Reihe von Ritualen, die schließlich ihren Höhepunkt finden werden, wenn aus Wale ein Donza, ein verheirateter Mann, wird. Als Nächstes verschenkte Wale all seine Besitztümer und trug von da an nur noch einen schäbigen Lendenschurz. Seine Stirn wurde ausrasiert und das übrige Haar stramm geflochten. Daran ist sein Status als Ukuli, als „einer, der springen wird", zu erkennen.

Seit der Initiationsprozess begonnen hat, binden sich Wales Schwestern und Cousinen zweimal täglich metallene Rasseln an die Beine und singen und tanzen im Rinderpferch vor der Lehmhütte der Familie. Seine Mutter und Schwestern haben sich auf den großen Tag vorbereitet, indem sie Weizen und Hirse gemahlen und daraus Brei gemacht und Bier gebraut haben. Wale seinerseits hat kilometerlange Märsche unternommen, um Verwandte zu besuchen. Er informiert sie über den Tag des Sprungs und bittet sie um ihren Beistand.

Die Rinder sind heute Morgen angekommen. Wales Onkel und ältere Brüder hatten sie in den Weidegründen der Savanne weit im Westen gehütet. Die Hamar liegen im dauernden Streit mit verschiedenen benachbarten Stämmen, und Wales Onkel, der eine blaue Jacke und einen leuchtend orangefarbigen Hut trägt, geht nirgendwo ohne seine Kalaschnikow hin.

Zuvor hat Wale einen Zeremonienexperten aufgesucht, der eine Hülle aus Antilopenhaut über seinen Zeigefinger genäht hat, ein weiteres phallisches Symbol. Dann wurde ihm Kuhdung in einem Kreuzmuster auf die Brust geschmiert. Wales Mansange, sein Helfer, hat daraufhin Rindenstreifen über den Kuhdung auf seiner Brust gebunden und seine Flechten gelöst. Das verfilzte Haar steht nun wie ein buschiges Dreieck von seinem Kopf ab.

In der Zwischenzeit betteln Wales Schwestern und Cousinen darum, von den Maz, jungen Männern, deren Gesichter weiß und rot bemalt sind und die um die

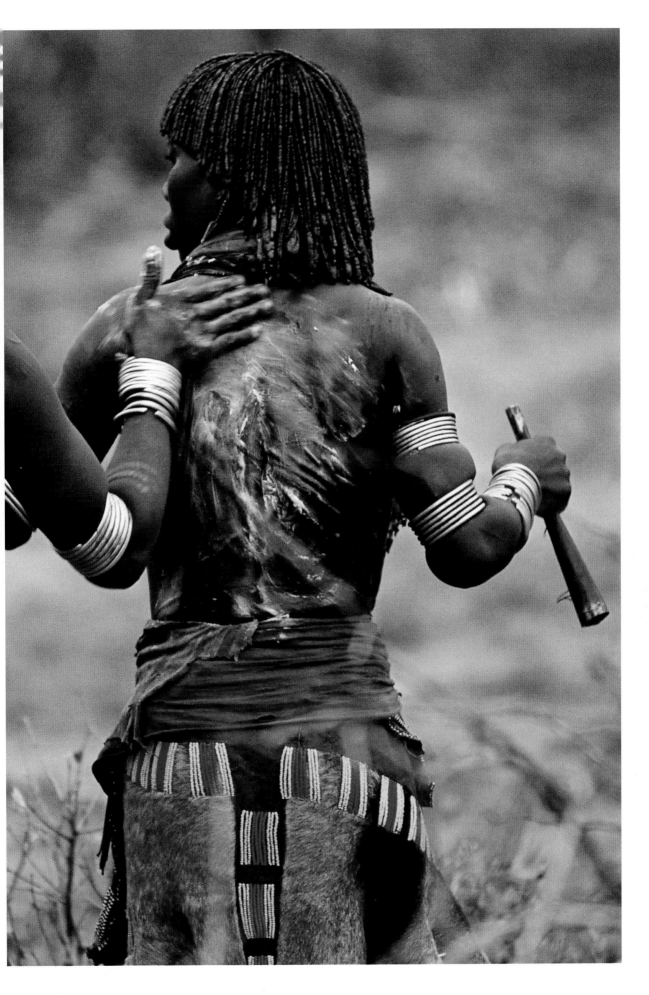

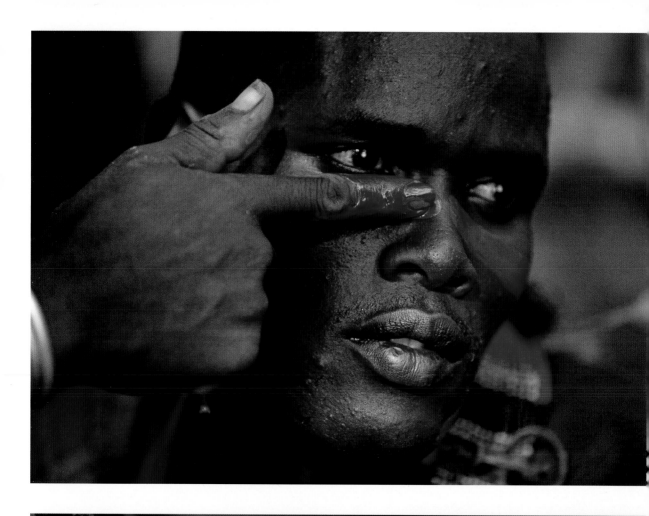

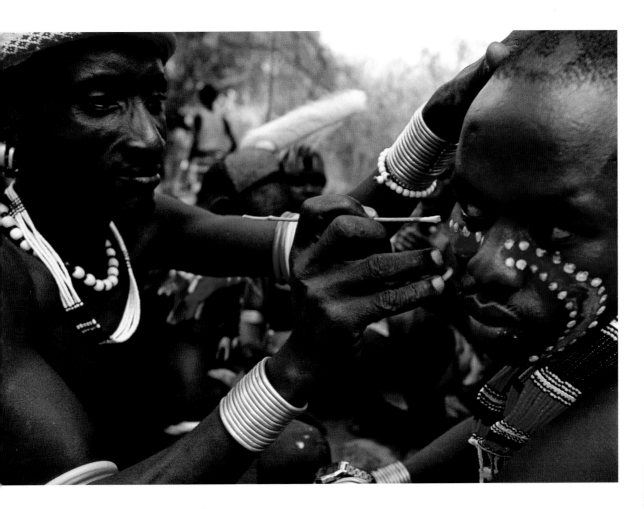
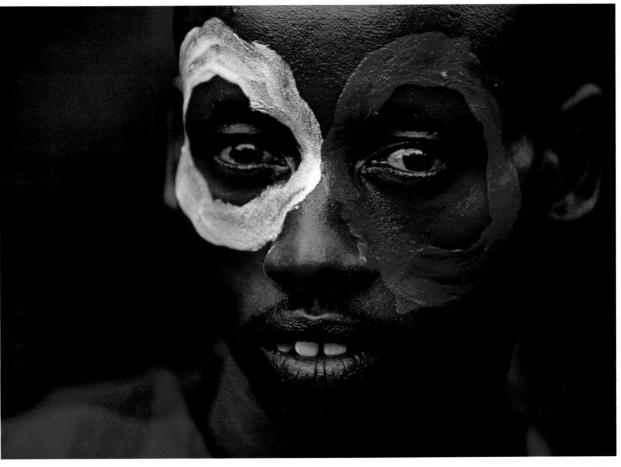

kahl rasierten Köpfe Bänder aus Rinde tragen, ausgepeitscht zu werden. Diese jungen Männer haben das Ritual erst kürzlich selbst durchlaufen, aber noch nicht geheiratet. Zum Ritual gehört, dass die Frauen einen Maz darum bitten, sie zu schlagen. Damit beweisen sie neben ihrer körperlichen Fitness auch, wie sehr sie Wale ergeben sind. Die Frauen bedrängen den Maz ununterbrochen, fassen ihn an den Handgelenken, blasen auf Hörnern, schleudern ihm ihr Haar, das mit Butter und rotem Ocker bestrichen ist, ins Gesicht.

Wenn ein Maz bereit ist, eine Frau mit einer der Ruten, die er bei sich hat, zu schlagen, dann versetzt der Maz der Frau zuerst einen einzelnen Schlag auf den Oberarm. Wenn die Rute zurückgeschnellt ist, hiebt er der Frau auf den Rücken. Dann lässt er die Rute fallen.

Das reicht nicht allen Frauen, und manche verlangen nach mehr Schlägen, um ihre Ergebenheit Wale gegenüber zu beweisen. Manche Maz fühlen sich angesichts so aufdringlicher Forderungen bisweilen genötigt, das Weite zu suchen. Sie kehren aber zum Sprung über die Rinder zurück, denn der kann ohne sie nicht stattfinden.

Gemeinsam mit den verheirateten Männern bilden sie nun einen engen Kreis, in dessen Mitte Wale auf dem Boden sitzt. Die Augen auf Wale gerichtet und geschützt vor den Blicken anderer, führen sie eine Reihe ritueller Handlungen durch, die alle symbolisch für seine Wiedergeburt als erwachsener Mann stehen, der bereit ist, zu heiraten. Anschließend rennt Wale nackt zwischen den Rindern hindurch.

Die Hamar stellen eine Verbindung zwischen Rindern und Frauen her, und in Wales derzeitiger sozialer Stellung repräsentieren sie Mutter und Schwestern, mit denen er bis jetzt unter einem Dach gelebt hat. Später, wenn er über die Rücken der Rinder gesprungen ist, wird er einen höheren Status haben als die Frauen in seinem Haushalt. Er wird dann ein Familienoberhaupt sein, das über Frau und Kinder herrscht.

So interpretieren Anthropologen den Sprung. Die Hamar selbst haben aber nicht immer so genaue Begründungen für ihre Zeremonien.

Die Maz packen die Ochsen an Hörnern und Schwänzen und reihen einen nach dem anderen auf. Um sie ruhig zu halten, stehen einige bei den Köpfen der Tiere, andere an den Hinterteilen.

Sieben Ochsen und ein Kalb sind nun aufgestellt. Immer noch nackt, wartet Wale hinter seinem Helfer. Als der zur Seite tritt, sprintet Wale auf die Rinderreihe zu, während seine Verwandten singen und Holzstöcke quer halten, damit er seinen Sprung sicher absolvieren kann.

Wie alle Initianden muss Wale viermal über die Rücken der Rinder laufen. Misslingt ein Sprung, muss er ihn wiederholen, und wenn er sich zu viele Fehler leistet, könnte es passieren, dass seine gekränkten Schwestern ihn angreifen.

Wale benutzt den Rücken des Kalbs als Tritt und springt auf den ersten Ochsen. Er schwankt etwas, als er das zweite Tier erreicht, fängt sich aber wieder und hüpft sauber über die restlichen Rinder. Er springt am Ende hinunter und dreht sich auf der Stelle um, um die Prozedur in die andere Richtung zu wiederholen.

Wale hat zu Hause wochenlang trainiert und ist jetzt ein sicherer Springer, der seine Sprünge alle mit Bravour meistert. Zum letzten Sprung stellen sich alle in einer Reihe auf und singen. Sie imitieren das Geräusch, das entsteht, wenn jemand mit einen Schluck Kaffee besprüht und gesegnet wird. Wale ist jetzt kein Junge mehr, er ist alt genug, um mit dem Segen seiner Familie zu heiraten. Aber bis zur Hochzeit ist es noch ein langer Weg.

**Right:** Before the jump, the men who participate in the ceremony often ask a friend to paint their legs white. The pattern is made by having the friend run his index finger through the wet paint.

**À droite:** Avant d'accomplir le saut, les jeunes hommes demandent souvent à un ami de leur peindre les jambes en blanc. Le motif est réalisé en faisant glisser l'index sur la couche de peinture fraîche.

**Rechts:** Vor dem Sprung bitten die an der Zeremonie teilnehmenden Männer oft jemanden, ihre Beine weiß anzumalen. Mit dem Zeigefinger werden dann Muster in die weiße Farbe gezogen.

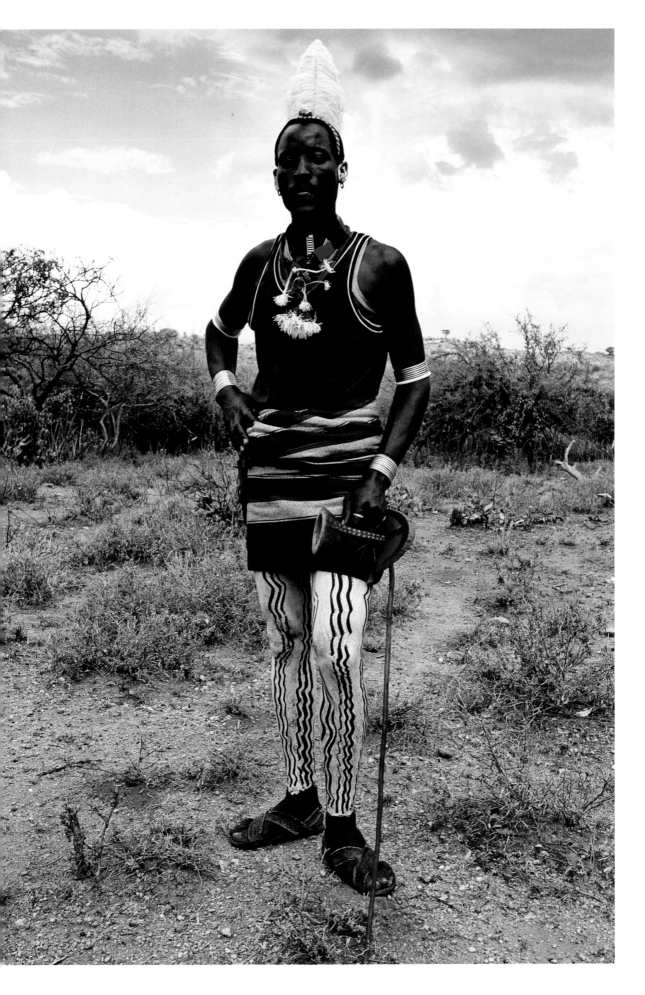

Zunächst einmal ist er jetzt ein Maz, der sein Zuhause verlässt und sich mit den anderen Maz herumtreibt. Sein Kopf ist rasiert, ein Stück Rinde über seine Stirn gebunden, und er hat den Namen des Kalbs angenommen, das ihm als Tritt gedient hat. Von nun an darf er nicht mehr in einem Haus schlafen und muss sich von Fleisch, Milch und Honig ernähren. Wenn irgendwo ein Sprung über die Rinder stattfindet, gehen er und die anderen Maz dorthin und verteilen Schläge an die jungen Frauen, die sie darum bitten.

Junge Männer warten mehrere Monate, manchmal mehr als ein Jahr, bis sich ihre Familien über die Bedingungen einer Eheschließung einigen. Die Beziehung zwischen den beiden Familien muss den traditionellen Vorgaben entsprechen, und die Zahl der Schafe, Ziegen und Rinder, die die Familie der Braut erhält, muss ausgehandelt werden.

Wenn diese Arrangements abgeschlossen sind, kehrt der junge Mann endgültig nach Hause zurück. Die Familie empfängt die zukünftige Braut für ein paar Tage in ihrem Haus. Dann durchläuft das Paar die Verlobungszeremonien, während derer die Braut ihrem Verlobten auch das Kopfband aus Rinde abnimmt und an einen Baum hängt, damit alle sehen können, dass er kein Maz mehr ist.

Die Braut bekommt einen Halsschmuck aus Antilopenleder, der anzeigt, dass sie verlobt ist. Bevor sie nach Hause zurückgebracht wird, reiben die Frauen aus der Familie des Bräutigams ihr Haar, ihre Stirn und Brust mit Butter und rotem Ocker ein, um sie besonders gut aussehen zu lassen.

Von da an können noch ein oder zwei Jahre vergehen, bevor die Brauteltern ihre Tochter endlich gehen lassen. Wenn sie eine ältere Schwester hat, die auch verlobt ist, muss zuerst die ältere verheiratet werden. Außerdem muss die Familie des Bräutigams den Brautpreis entrichten. Über das Vereinbarte hinaus verlangt die Brautfamilie oft noch weitere Zuwendungen. In solchen Fällen ist es allgemein akzeptiert, dass der Bräutigam die Verzögerungen zum Anlass nimmt, die Braut zu entführen.

Aber selbst dann muss sich der Bräutigam noch in Geduld üben. Nachdem die Braut in das Haus seiner Familie eingezogen ist, lebt sie drei Monate lang auf dem Dachboden, auf den sie durch ein winziges Loch in der Decke gelangt.

Ihre Schwiegermutter kümmert sich dort um sie. Sie reibt sie jeden Tag mit Butter und rotem Ocker ein und bringt ihr nahrhafte Mahlzeiten. Sie arbeitet nicht, und wenn sie schließlich herunterkommt, um die Ehe zu vollziehen, ist sie wohlgenährt und ihre Haut glänzt in einem rötlichen Ton.

Das glückliche Paar verbringt seine Hochzeitsnacht auf Tierhäuten unter freiem Himmel. Zur Vorbereitung essen sie Hirsepfannkuchen, die dem Mann eine starke Erektion geben sollen. Am Morgen danach feiert die ganze Familie bei einem rituellen Schluck Kaffee. Jeder weiß, dass es passiert ist. Selbst wenn es der Mann wollte, es ließe sich nicht geheim halten, denn die Butter und der rote Ocker haben nun auch Spuren auf seiner Haut hinterlassen.

**Right:** An initiate's older brother wears an ostrich plume in his clay hairdo. Male relatives often have a new hairdo arranged before the jump and then hire an expert to handle the expensive clay, imported from enemy territory in the south.

**À droite:** Le frère aîné d'un futur initié a décoré sa coiffure façonnée à l'argile d'une plume d'autruche. La cérémonie du saut est souvent l'occasion pour les hommes de porter de nouvelles coiffures. Ils achètent l'argile onéreuse à des intermédiaires qui l'importent des régions ennemies du sud.

**Rechts:** Der ältere Bruder eines Initianden trägt eine Straußenfeder in seiner Tonfrisur. Männliche Verwandte legen sich vor dem Sprung häufig eine neue Frisur zu und engagieren Fachleute, die mit dem teuren Ton, der aus Feindesland im Süden importiert wird, umzugehen verstehen.

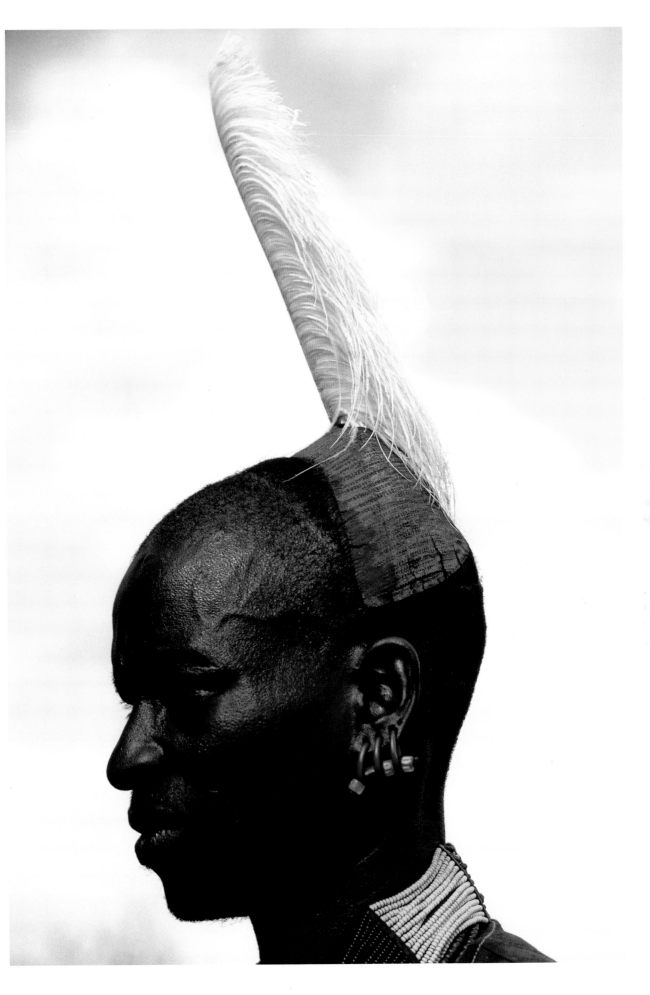

**Pages 308–309:** Before his jump, the initiate wanders naked among the herd. Nudity represents his death and rebirth, as he is about to assume a new social role, while the strips of bark over his chest symbolise that he is still tied to boyhood. When he has jumped and become a man the strips are immediately cut off.

**Pages 308–309 :** Avant le saut, les garçons nus traversent le troupeau. La nudité figure la mort et le renaissance dans un nouveau rôle social ; les lanières d'écorce sur le torse symbolisent le rattachement à l'enfance. Elles seront coupées dès que le garçon a accompli le saut de boeufs qui fait de lui un homme.

**Seiten 308–309:** Vor seinem Sprung bewegt sich der Initiand nackt durch die Herde. Seine Nacktheit repräsentiert Tod und Wiedergeburt, denn er steht kurz davor, eine neue soziale Rolle anzunehmen. Die Rindenstreifen über seiner Brust zeigen, dass er noch immer an die Kindheit gebunden ist. Sobald er gesprungen und zum Mann geworden ist, werden die Streifen abgeschnitten.

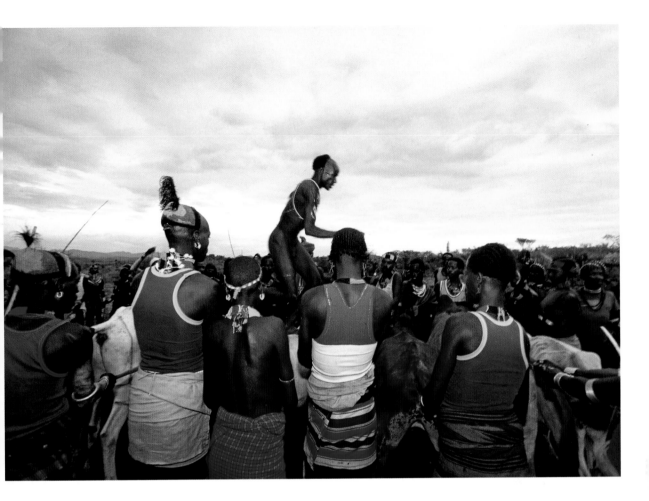

**Above, left and pages 312–313:** The men hold the bullocks still while the initiate runs over their backs twice, in both directions. By successfully completing his jump the young man becomes a maz and is ready to marry.

**Ci-dessus, à gauche et pages 312–313 :** Les hommes maintiennent les boeufs pendant que le garçon bondit par-dessus, dans une direction et dans l'autre. S'il accomplit avec succès le rituel, il devient un *maz,* un homme qui peut prendre femme.

**Oben, links und Seiten 312–313:** Die Männer halten die Ochsen fest, während der Initiand zweimal in beide Richtungen über ihre Rücken läuft. Wenn er den Sprung erfolgreich absolviert hat, ist der junge Mann ein Maz und bereit zu heiraten.

**Pages 314–317:** After the jump the initiate's family holds a feast, serving beer and millet porridge to the guests. The festivities include erotic dances between the men and women and continue all night long and into the following afternoon.

**Pages 314–317 :** Après la cérémonie du saut, la famille de l'initié invite à un festin de bouillie de millet, accompagnée de bière. Les festivités comprennent des danses érotiques entre les hommes et les femmes, qui dureront toute la nuit et jusque dans l'après-midi du lendemain.

**Seiten 314–317:** Nach dem Sprung gibt die Familie des jungen Mannes ein Fest mit Bier und Hirsebrei. Zum Fest gehört es, dass Männer und Frauen aufreizend miteinander tanzen. Das Fest kann die ganze Nacht und bis zum nächsten Nachmittag dauern.

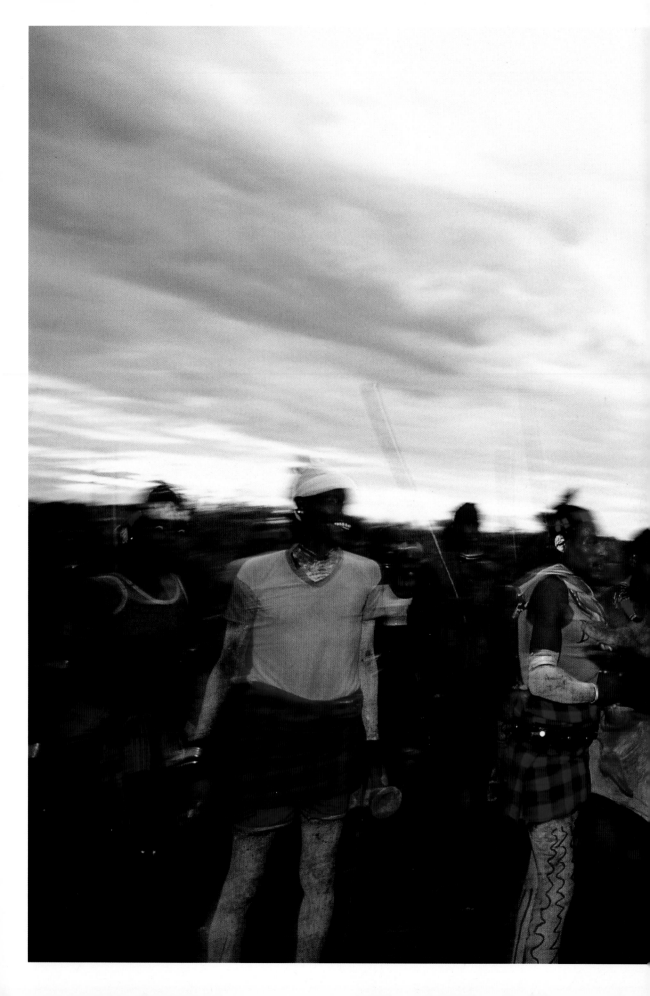

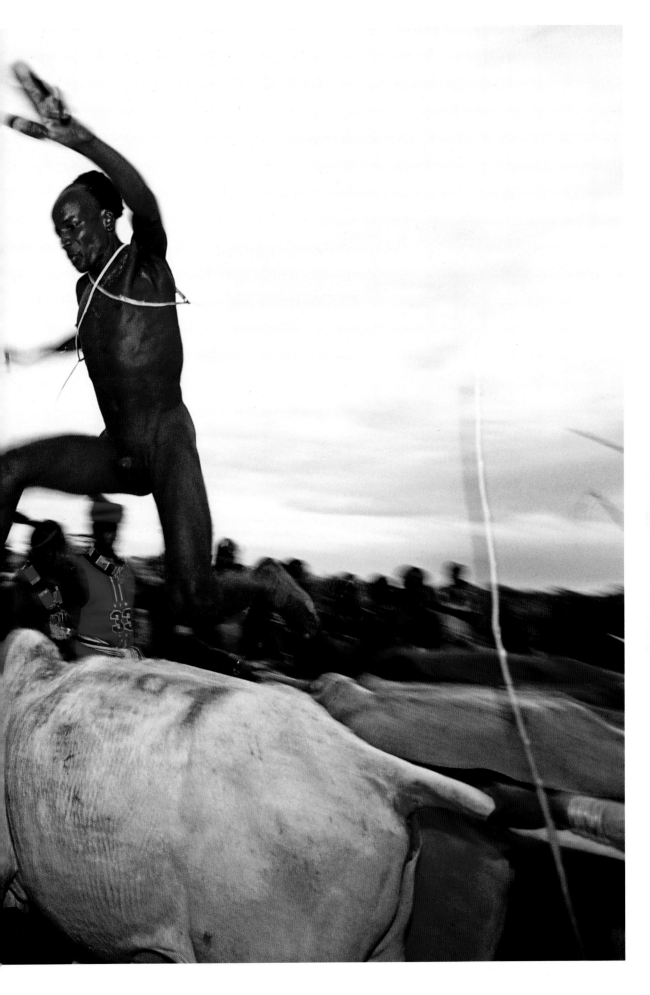

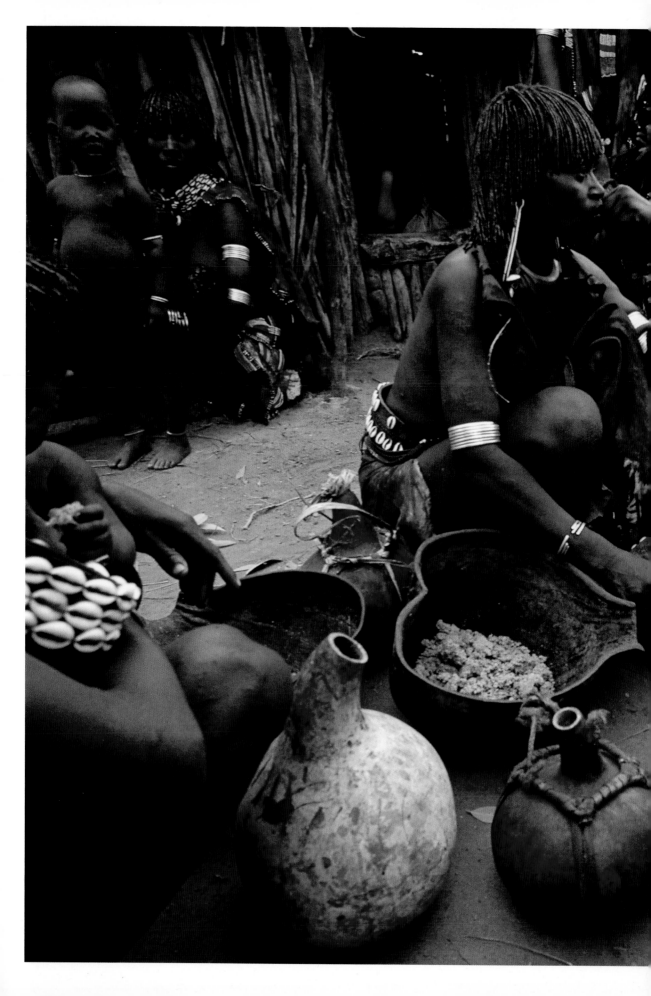

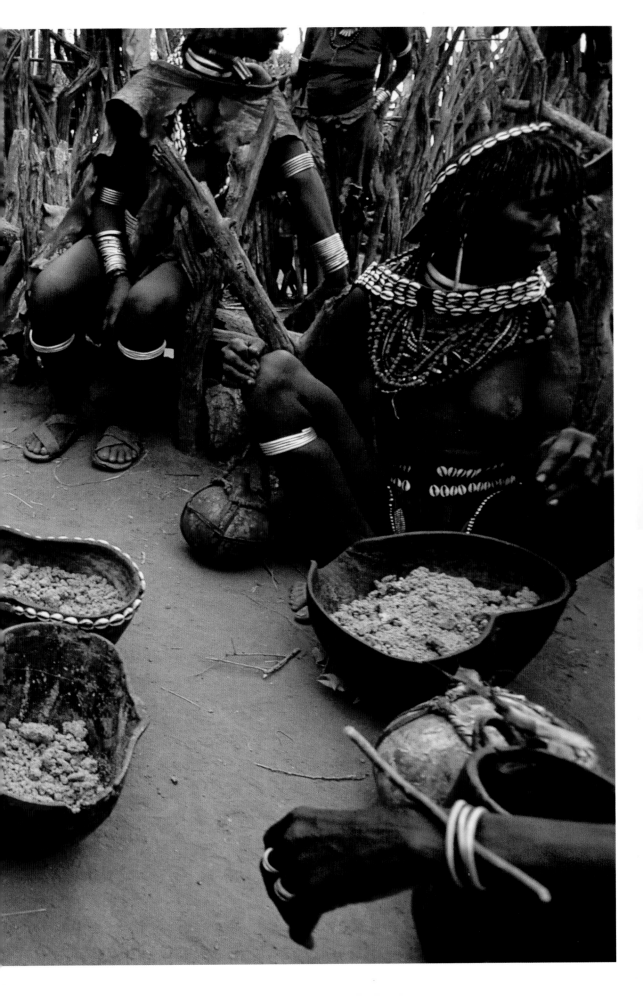

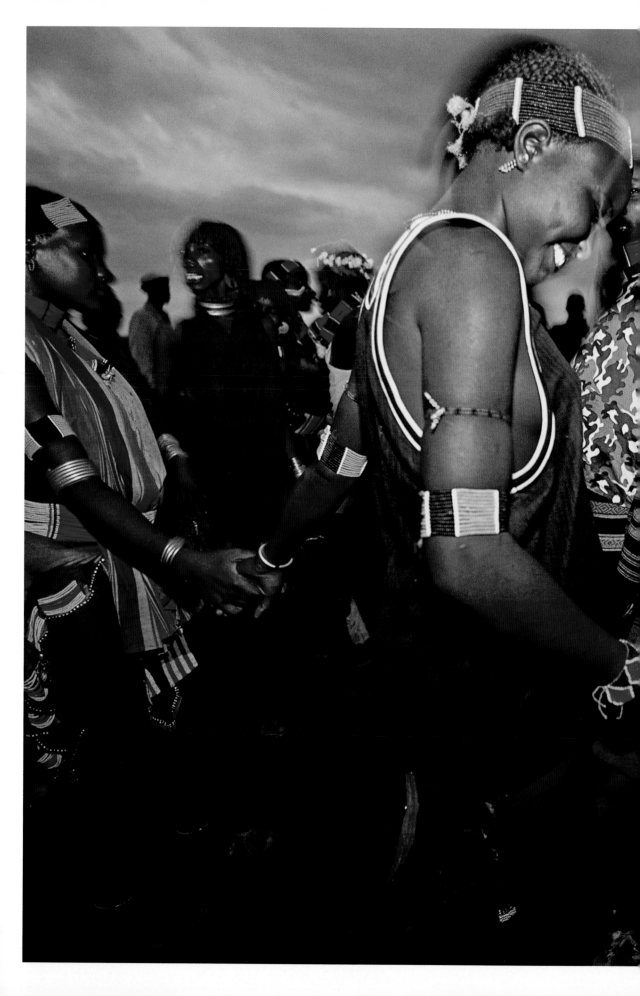

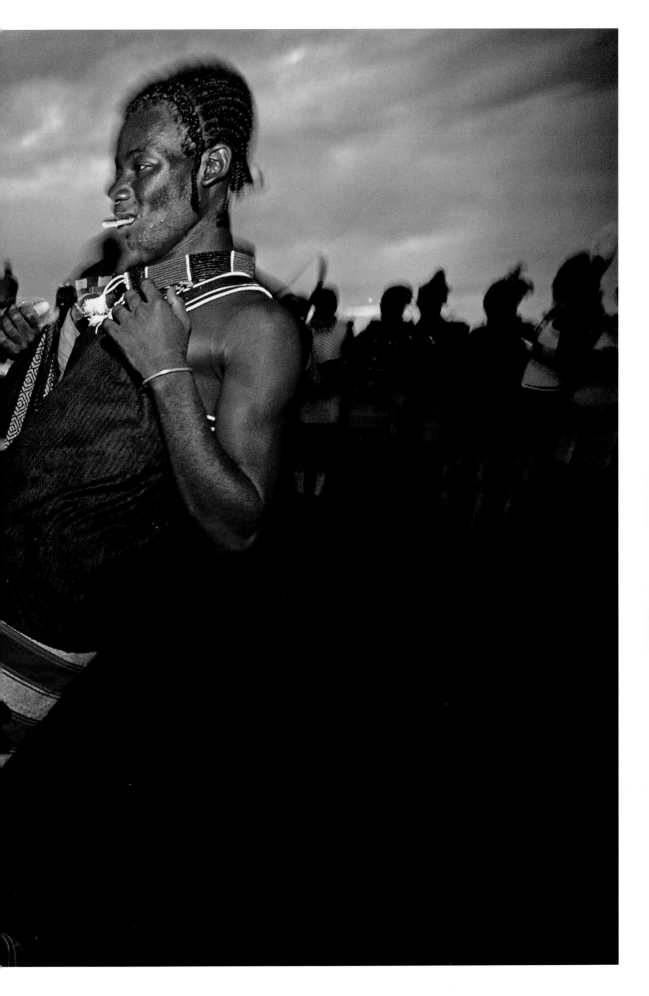

**Right:** When the initiate's family have concluded negotiations on his marriage, his bride visits his village for the betrothal ceremony.

**À droite :** Dès que la famille d'un *maz* a conclu des négociations de mariage, la promise se rend au village de son futur époux où auront lieu les fiançailles.

**Rechts:** Wenn die Familie des Initianden die Heiratsverhandlungen abgeschlossen hat, besucht die Braut sein Dorf, um die Verlobung zu feiern.

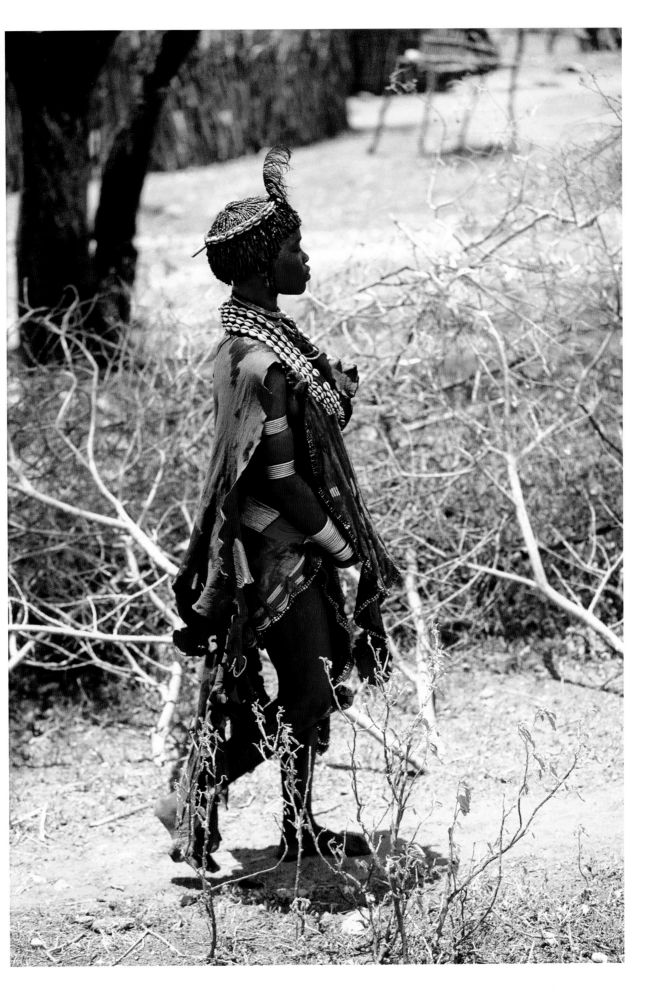

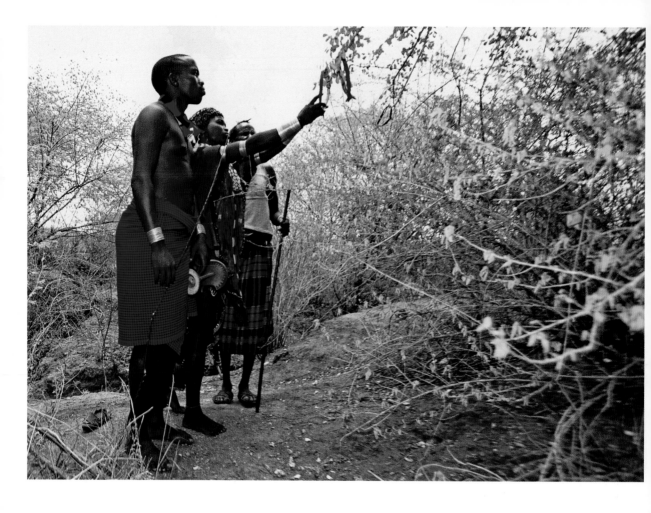

**Above and left:** The engagement rituals include the bride taking off the bark headband that her fiancé has worn since becoming a maz and hanging it in a tree. The tree, used by other locals for the same purpose, has amassed several headbands from previous ceremonies.

**Ci-dessus et à gauche :** Obéissant à un des nombreux rituels de la cérémonie de fiançailles, la jeune fille enlève à son futur époux le bandeau d'écorce qui ceint son crâne depuis qu'il est *maz* et le suspend à un arbre. Dans le feuillage de cet arbre, on peut voir toute une collection de bandeaux provenant de cérémonies antérieures.

**Oben und links:** Zum Verlobungsritual gehört, dass die Braut ihrem Verlobten das Rindenkopfband abnimmt, das er als Maz getragen hat, und es in einen Baum hängt, der von anderen Dorfbewohnern für den gleichen Zweck benutzt wird. So haben sich aus früheren Zeremonien einige Kopfbänder angesammelt.

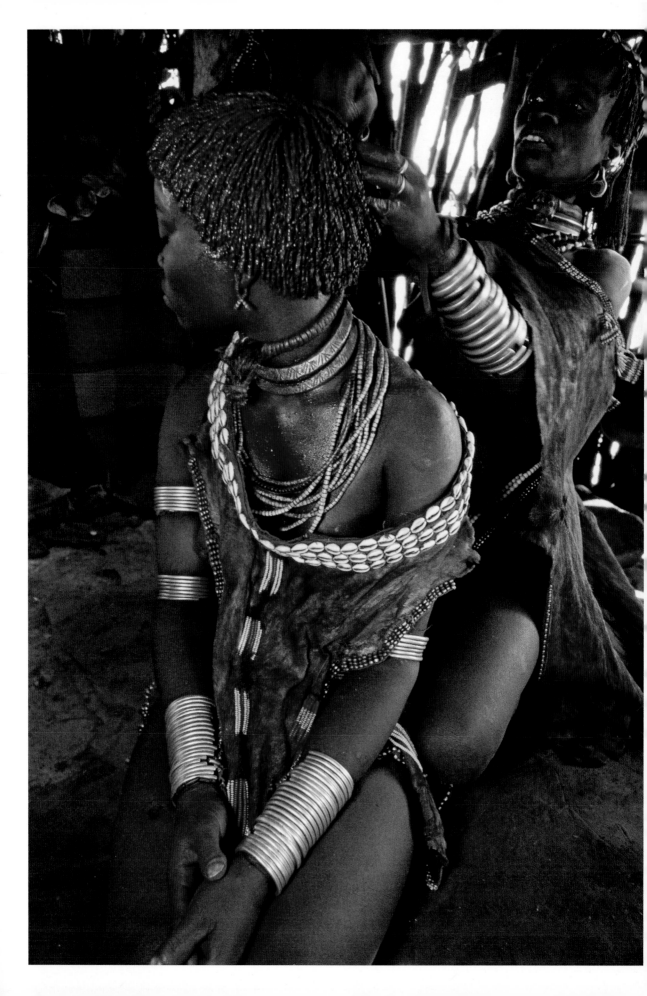

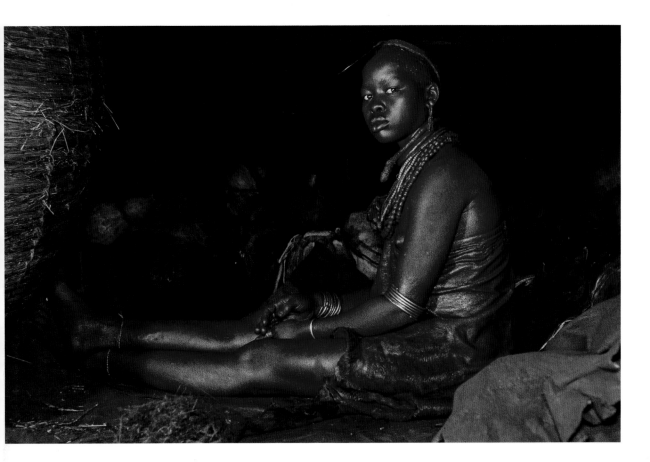

**Above:** It often takes a year or two between the betrothal and the bride-to-be moving in to her new home. She then spends the first three months of her new life living alone in the loft, where she receives daily treatments of butter and red ochre to ward off evil. Only after the three months are up can the marriage be consummated.

**Ci-dessus :** La période de fiançailles dure souvent une ou deux années. La promise passe ensuite les trois premiers mois de sa nouvelle vie seule dans le grenier, où elle a droit tous les jours au baume de beurre et d'ocre rouge censé éloigner les démons. C'est seulement après cette période que le mariage sera consommé.

**Oben:** Oft vergehen ein oder zwei Jahre zwischen der Verlobung und dem Umzug der jungen Braut in ihr neues Zuhause. Dann verbringt sie die ersten drei Monate ihres neuen Lebens allein auf dem Dachboden, wo sie täglich mit Butter und rotem Ocker eingerieben wird, um Böses von ihr fernzuhalten. Erst wenn die drei Monate um sind, kann die Ehe vollzogen werden.

**Left:** The initiate's aunt (his uncle's wife) is also related to the bride-to-be and participates in the ceremonies by applying butter and red ochre to her hair, shoulders and chest before the young woman returns to her own family.

**À gauche :** La tante du fiancé (femme du frère de son père) est également apparentée à la future épouse. C'est elle qui enduit les cheveux, les épaules et le buste de la jeune fille d'un mélange de beurre et d'ocre rouge avant qu'elle ne retourne dans sa famille.

**Links:** Die Tante des Initianden, die Frau seines Onkels, ist auch mit der zukünftigen Braut verwandt und nimmt an der Zeremonie teil, indem sie Butter und roten Ocker auf Haar, Schultern und Brust der jungen Frau verteilt, bevor diese zu ihrer eigenen Familie zurückkehrt.

# Weddings

At Kamigamo Jinja shrine in the Japanese city of Kyoto, Masanobu and Mari seal their marriage by drinking sake from three shared cups. The Shinto priest, in his high black hat, and the temple maid stand motionless close by. In Kautokeino in Arctic Norway, Mikkel Magnus and Karen Anne kneel in Saami costume to receive a blessing from the minister. And in the American state of New Jersey, Ilya and Elvira stand beneath a canopy drinking wine from a goblet that the Jewish rabbi hands them, after which Ilya crushes a glass with his shoe.

The formats vary, but virtually all cultures have ceremonies to mark the joining of a man and woman in marriage. They can range in length from Las Vegas-style drive-in weddings to drawn-out procedures such as those celebrated by members of some Brahmin castes in India, where the marriage begins in childhood but is not consummated until the girl has had her first menstrual period years later.

Across the world, weddings are often large, lavish events that involve many people. The union between man and woman is traditionally seen not just as a matter for the two individuals involved but for entire groups – relatives, villages, tribes – not to mention the children expected to be born as a result.

Mikkel Magnus and Karen Anne in Kautokeino have not skimped on their arrangements. They invited one thousand two hundred people to join them for their big day. Observing Saami custom, the happy couple spent the entire morning being carefully dressed by experts in traditional costume with ornate silver trimmings.

Both are anything but strangers to one another; they have lived together for twelve years and are the parents of three children. Cohabitation is fully accepted in Norwegian society today and they were under no pressure to marry. But the lure of tradition eventually became too strong to resist.

As it happens, getting married makes good financial sense for Mikkel Magnus and Karen Anne. For although the wedding will cost a small fortune, the gifts from all the guests will more than cover the expense.

**Right:** The ceremony is over at this Russian Orthodox wedding in St Petersburg's Transfiguration Cathedral. The bride and groom turn towards their families and friends, leaving the priest to return to the sanctuary.
**Page 326:** A Japanese bride and groom pose for photographs after their wedding at the Meiji shrine in Tokyo. The photographer has removed his shoes so he can tread on the carpet to help the bride adjust her kimono. The couple will later change into Western clothes for the reception.

**À droite :** La cérémonie de ce mariage orthodoxe russe dans la cathédrale de la Transfiguration à Saint-Pétersbourg est terminée. Les jeunes époux se tournent vers l'assemblée tandis que le prêtre regagne le sanctuaire.
**Page 326 :** Séance de photographies après une cérémonie nuptiale au temple Meiji à Tokyo. Le photographe a enlevé ses chaussures pour fouler le tapis et ajuster le kimono de la mariée. Le couple échangera ensuite les tenues traditionnelles pour des vêtements de noces occidentaux en vue de la réception.

**Rechts:** Die Zeremonie dieser russisch-orthodoxen Trauung in der Kirche Christi Verklärung in St. Petersburg ist zu Ende. Braut und Bräutigam wenden sich Freunden und Familien zu, während der Priester sich in das Allerheiligste zurückzieht.
**Seite 326:** In Tokio posieren Braut und Bräutigam nach der Hochzeit vor dem Meji-Schrein für das Foto. Der Fotograf hat seine Schuhe ausgezogen, damit er auf den Teppich treten und helfen kann, den Kimono der Braut zu richten. Beim Hochzeitsempfang wird das Brautpaar westliche Kleidung tragen.

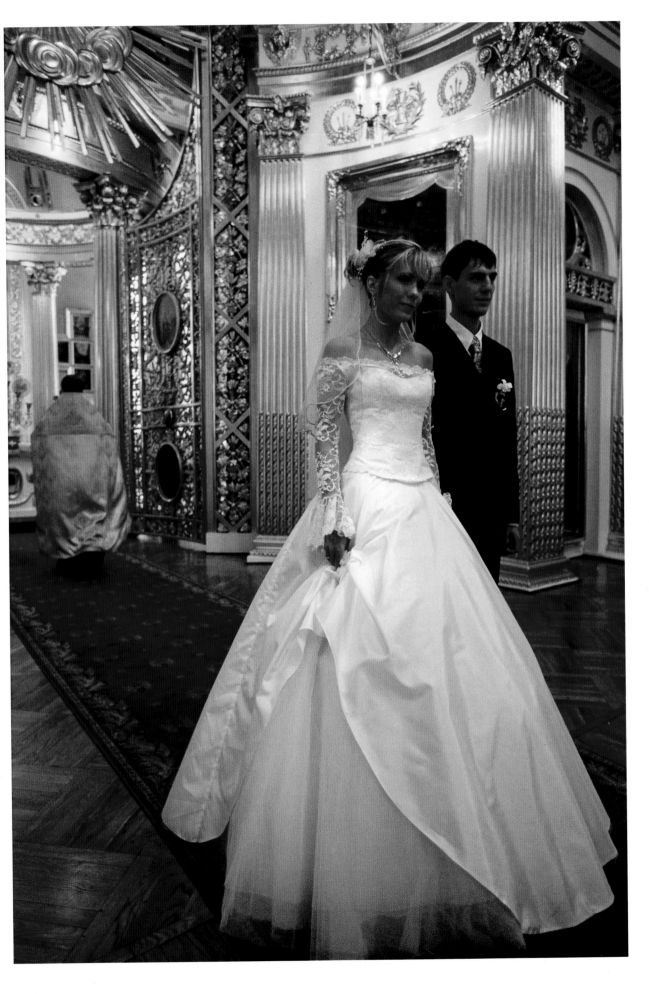

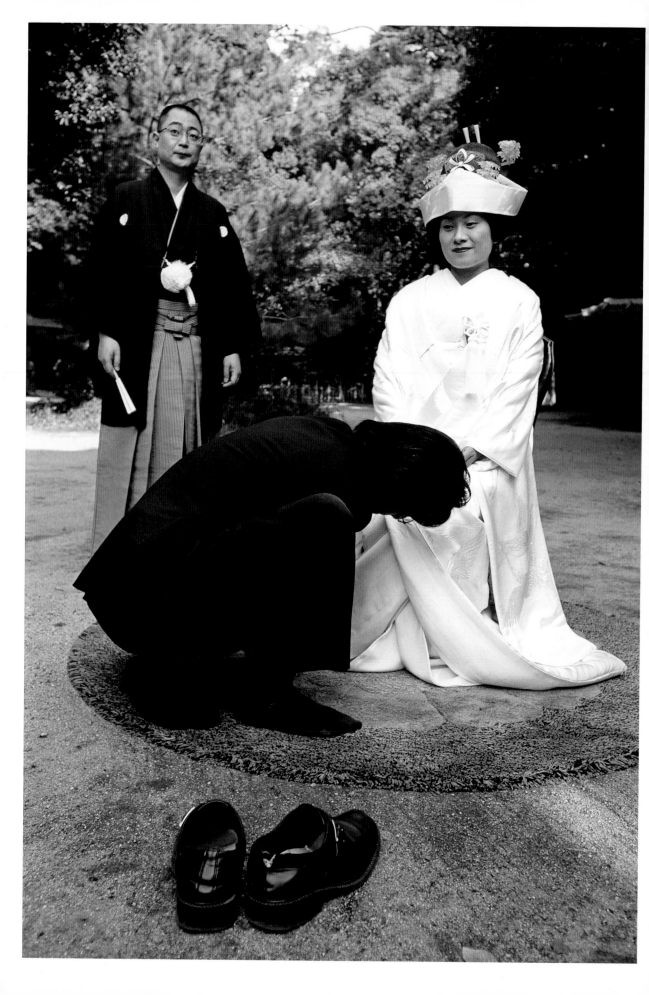

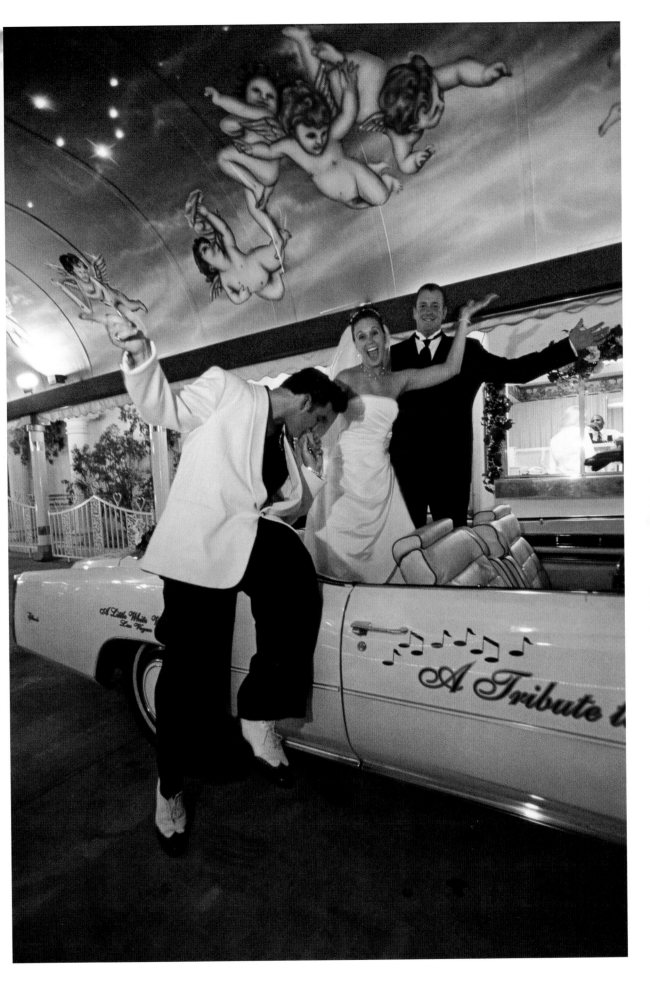

**Page 327:** Only two industries are bigger than weddings in Las Vegas – gambling and entertainment. There are no limits when it comes to choosing what you want for your nuptials. Easiest and cheapest is a drive-in ceremony; pay extra and you can be serenaded by an Elvis Presley look-alike.
**Right:** Wearing traditional Saami costume specially made for the occasion, the bride and groom emerge from Kautokeino Church in northern Norway to greet their friends and relatives. Only on her wedding day does a Saami woman wear such a glittering array of silver broaches.

**Page 327 :** Deux industries seulement sont plus importantes que celle des mariages à Las Vegas : le jeu et les spectacles. On a le choix entre mille et une façons de se marier. Le plus simple et le moins cher est une cérémonie drive-in, et en payant un supplément, les romantiques peuvent louer un imitateur d'Elvis Presley.
**À droite :** Revêtus du costume sami spécialement confectionné pour l'occasion, les nouveaux mariés reçoivent les félicitations de leurs parents et amis devant l'église de Kautokeino, dans le nord de la Norvège. Une femme Sami ne porte une telle brochette de bijoux en argent que le jour de son mariage.

**Seite 327:** Es gibt nur zwei Wirtschaftszweige in Las Vegas, in denen mehr verdient wird als mit Hochzeiten: Glücksspiel und Unterhaltung. Was die Wünsche für die Hochzeit betrifft, gibt es keine Grenzen. Am einfachsten und preiswertesten ist eine Drive-in-Zeremonie. Wenn man noch etwas drauf legt, kann man sich von einem Elvis-Presley-Imitator besingen lassen.
**Rechts:** Braut und Bräutigam kommen in eigens für diese Gelegenheit geschneiderten Samentrachten aus der Kirche in Kautokeino in Nordnorwegen, um Freunde und Verwandte zu begrüßen. Nur am Tag ihrer Hochzeit tragen samische Frauen so viele glänzende Silberbroschen.

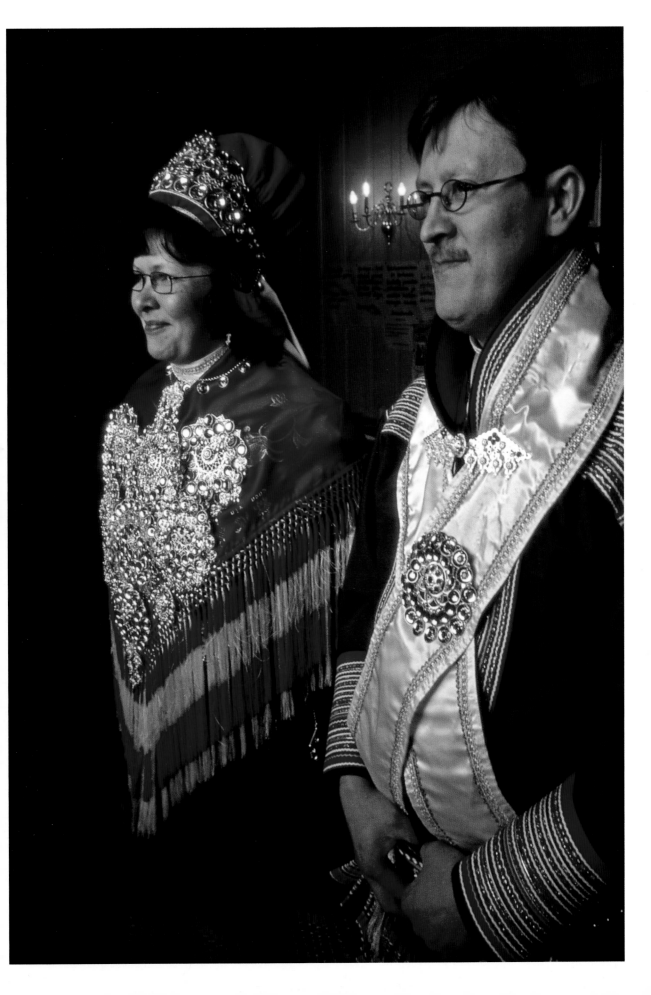

# Mariages

Au sanctuaire de Kamigamo Jinja, dans la ville japonaise de Kyoto, Masanobu et Mari scellent leur union en buvant du saké dans trois tasses partagées. Le prêtre shintoïste, sous son grand chapeau noir, se tient au côté de l'employée chargée de l'entretien du temple. À Kautokeino en Norvège arctique, Mikkel Magnus et Karen Anne s'agenouillent dans leur costume sami pour recevoir la bénédiction du pasteur. Dans l'État américain du New Jersey, Ilya et Elvira boivent du vin dans un gobelet que le rabbin leur tend ; Ilya écrasera ensuite un verre sous sa chaussure.

Les formes varient, mais pratiquement toutes les cultures organisent des cérémonies afin de marquer l'union d'un homme et d'une femme dans le mariage. Ces célébrations s'effectuent parfois à l'improviste, comme à Las Vegas, ou au contraire durent très longtemps, comme pour les cérémonies célébrées par les membres de certaines castes brahmanes en Inde où le mariage débute dès l'enfance, mais n'est pas consommé avant que la jeune fille ait atteint la puberté, quelques années plus tard.

À travers le monde, les mariages sont souvent de grands événements et représentent des occasions uniques de se rassembler. Traditionnellement, l'union entre un homme et une femme ne concerne pas uniquement deux individus, mais aussi des groupes entiers – familles, villages, tribus – sans mentionner les enfants, but ultime du mariage.

Mikkel Magnus et Karen Anne à Kautokeino n'ont pas lésiné sur les moyens. Ils ont invité mille deux cents personnes pour le grand jour. Selon la coutume sami, l'heureux couple passe la matinée à être habillé par des spécialistes en costumes traditionnels ornés d'argent. Tous deux ne sont absolument pas des étrangers l'un pour l'autre, puisqu'ils vivent ensemble depuis vingt ans et sont parents de trois enfants. De nos jours, la cohabitation est largement répandue dans la société norvégienne et ils n'étaient pas obligés de se marier. Mais la tradition reste plus forte malgré tout.

De plus, le mariage représente un avantage financier pour Mikkel Magnus et Karen Anne. Bien que cet événement leur ait coûté une petite fortune, les cadeaux de tous les invités offrent une fort belle compensation.

**Right:** A Bezanozano wedding in Madagascar. The groom's grandmother dips her hand in a cup of homemade rum, sprinkling the contents towards the north-eastern corner of the room as an offering to the ancestors, who have been invoked to bless the union. The young man beside the bride is not the groom but his brother and representative. Later that day the bride is brought to the groom's home, the dowry is paid and she is united with her new husband.

**À droite:** Noces bezanozano à Madagascar. La grand-mère du marié asperge du rhum fait maison vers le coin nord-est de la salle, une offrande faite aux ancêtres pour les implorer de bénir l'union. Le jeune homme assis à côté de la mariée n'est pas le fiancé, mais son frère qui a le rôle de subrogé. Plus tard dans la journée, la jeune épouse est amenée à la maison de son mari, la dot est payée et le couple enfin réuni.

**Rechts:** Eine Bezanozano-Hochzeit in Madagaskar. Die Großmutter des Bräutigams taucht ihre Hand in eine Tasse hausgemachten Rum, verspritzt den Inhalt in die nordöstliche Ecke des Raums und bringt so den Ahnen ein Opfer dar, damit diese die Ehe segnen. Der junge Mann neben der Braut ist nicht ihr zukünftiger Mann, sondern sein Bruder und Stellvertreter. Später an diesem Tag wird die Braut zum Haus des Bräutigams gebracht, die Mitgift wird gezahlt, und sie wird mit ihrem neuen Ehemann vereint.

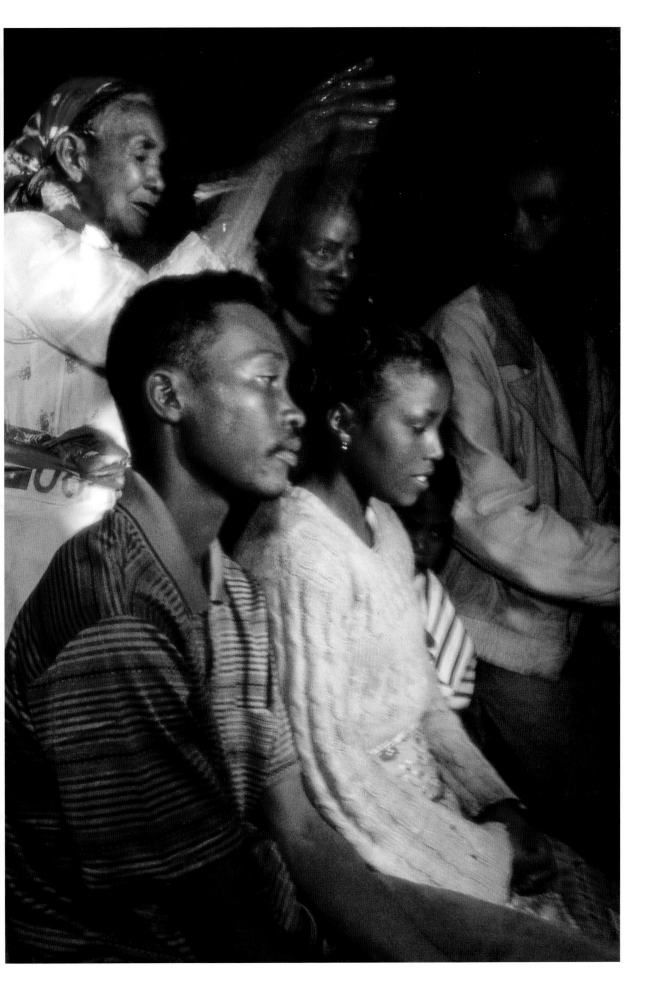

# Hochzeiten

Am Kamigamo-Jinja-Schrein in der japanischen Stadt Kioto besiegeln Masanobu und Mari ihre Eheschließung, indem sie gemeinsam aus drei verschiedenen Bechern Sake trinken. Der Shinto-Priester mit seiner hohen schwarzen Kopfbedeckung und seine Gehilfin, die Miko, stehen bewegungslos daneben. In Kautokeino im arktischen Norwegen knien Mikkel Magnus und Karen Anne in samischen Trachten vor dem Pastor, um seinen Segen zu empfangen. Und im US-Bundesstaat New Jersey stehen Ilya und Elvira unter einem Baldachin und trinken Wein aus einem Kelch, den der Rabbi ihnen reicht. Danach wird Ilya den gläsernen Kelch zertreten.

Die Art und Weise mag sich unterscheiden, aber so gut wie alle Kulturen kennen Zeremonien, die die Heirat eines Mannes und einer Frau besiegeln. Sie decken das ganze Spektrum ab, von Drive-in-Hochzeiten in Las Vegas bis zu langwierigen Prozeduren, wie sie die Mitglieder einiger Brahmanenkasten in Indien kennen, bei denen die Ehe schon in der Kindheit beginnt, aber nicht vollzogen wird, bis das Mädchen Jahre später seine erste Menstruation hatte.

Überall auf der Welt werden Hochzeiten als großzügige Feste gefeiert, an denen viele Menschen teilnehmen. Die Vereinigung von Mann und Frau wird gemeinhin nicht als eine Angelegenheit betrachtet, die nur die beiden Hochzeiter betrifft, sondern ganze Gruppen – Verwandte, Dörfer, Stämme –, von den Kindern, die der Ehe entstammen, ganz zu schweigen.

Mikkel Magnus und Karen Anne in Kautokeino haben sich nicht lumpen lassen. Sie haben 1200 Leute zu ihrem großen Tag eingeladen. Im Einklang mit dem Brauch der Samen haben die beiden den ganzen Morgen damit verbracht, sich von Leuten, die sich damit auskennen, sorgfältig in Trachten mit silbernen Verzierungen kleiden zu lassen.

Die beiden sind sich alles andere als fremd, denn sie leben schon seit zwölf Jahren unter einem Dach und haben drei gemeinsame Kinder. Unverheiratet zusammenzuleben ist in Norwegen vollkommen akzeptiert, und sie hätten nicht zu heiraten brauchen. Aber die Verlockungen der Tradition wurden irgendwann zu stark, um ihnen zu widerstehen.

Für Mikkel Magnus und Karen Anne ist es darüber hinaus auch finanziell ganz vernünftig, den Bund fürs Leben einzugehen. Obwohl die Hochzeit ein kleines Vermögen verschlingen wird, werden die Geschenke der Gäste diese Unkosten mehr als wettmachen.

**Right:** A Jewish wedding in the American state of New Jersey. The rabbi signs the wedding certificate before accompanying the couple to an outdoor canopy where he will marry them. Earlier the bride and groom wrote their signatures on a *ketubah*, a traditional Jewish marriage contract.

**À droite:** Noces juives dans le New Jersey, aux États-Unis. Le rabbin signe l'acte de mariage avant de célébrer la cérémonie dehors, sous le dais nuptial. Auparavant, le couple a signé la *ketubah*, contrat de mariage traditionnel.

**Rechts:** Eine jüdische Hochzeit in New Jersey, USA. Der Rabbi unterzeichnet die Heiratsurkunde, bevor er das Paar nach draußen unter den Baldachin begleitet, unter dem er es verheiraten wird. Schon zuvor haben Braut und Bräutigam ihre Unterschriften unter die Ketuba, einen traditionellen jüdischen Ehevertrag, gesetzt.

**Right:** The bride at this South African wedding in Soweto leads her family in a dance to a marquee outside the groom's home. The couple, both members of the Tswana people, have changed into African dress from the Western clothes they wore for the church service.

**À droite :** Soweto, Afrique du Sud ; en dansant, cette jeune mariée, membre du peuple tsawa, mène sa famille vers le chapiteau dressé devant la demeure de son nouvel époux. Elle a échangé la robe occidentale qu'elle portait à l'église pour la tenue traditionnelle tsawa.

**Rechts:** Bei dieser südafrikanischen Hochzeit in Soweto führt die Braut ihre Familie tanzend zu einem Zelt vor dem Haus des Bräutigams. Das Paar, beide sind Tswana, hat die westliche Kleidung, die sie für die kirchliche Trauung getragen haben, gegen afrikanische Kleidung eingetauscht.

**Right:** This Finnish couple dance a waltz after their wedding in the tiny chapel on Jurmo, an island off Finland's west coast. The couple are not from Jurmo, which has only ten inhabitants, but have sailed from Helsinki in their own yacht for the occasion.

**À droite :** Ces mariés finlandais danse une valse après s'être unis dans la minuscule église de Jurmo, île de la côte ouest. Le couple n'est pas de Jurmo qui ne compte que dix habitants, mais est venu d'Helsinki dans son yacht pour vivre un mariage romantique.

**Rechts:** Dieses finnische Paar tanzt nach der Trauung in der winzigen Kapelle auf Jurmo einen Walzer. Die beiden stammen nicht von Jurmo, einer Insel mit nur zehn Bewohnern vor der Küste Finnlands, sondern sie sind zu diesem Ereignis auf ihrer eigenen Yacht aus Helsinki angereist.

# Three nuptials of the Newar
## *Kathmandu, Nepal*

Ten-year-old Prerana is overjoyed. "I'm married now and can never be a widow," she says proudly, having just completed the grand *ihi* ritual in which she and a group of Newar girls have married the Hindu god Vishnu.

The Newar are the native inhabitants of the Kathmandu Valley in Nepal. Once they ruled themselves and had three divine kingdoms in the valley. But at the end of the eighteenth century they were invaded from the west by Hindu Gurkhas, whose ruling family assumed power and remain on the throne in Nepal to this day.

The Newar religion is a mixture of Hinduism and Buddhism. These two faiths have lived side by side in the Kathmandu Valley for centuries. But in the wake of the Gurkha invasion, the Newar came under strong pressure to submit to strict Hindu norms.

There is, however, one way in which Newar customs still differ from their more orthodox Hindu neighbours in India and other parts of Nepal. Newar women enjoy much more freedom and independence. Though it is rare, they are entitled to divorce and remarriage and they are not subject to the stigmatisation of orthodox Hindu widows, who must remain unmarried after their husband's death. Formerly, they were even expected to join him on the funeral pyre.

Newar women have managed to preserve this independence, despite more than two centuries of outside pressure, by having their daughters enter a symbolic marriage with Vishnu in the ihi ritual, when they are aged between five and ten. They are then seen as married forever and can never be divorced or widowed, irrespective of how many mortal men they marry later.

Before the onset of menstruation, Newar girls undergo a further ceremony in which they marry the sun god Surya. Marriage to a mortal, which for most women generally takes place during their twenties, is thus their third.

But it is the first marriage, that to Vishnu, which is the primary, eternal and indissoluble one, whereas that to a mortal is secondary and can be terminated if the woman is so unhappy with her situation that she can find no other solution.

# Trois noces chez les Newar
## Katmandou, Népal

Prerana, âgée de dix ans, est ravie : « Je suis mariée maintenant, et je ne serai jamais veuve », dit-elle fièrement, alors qu'elle vient d'achever le grand rituel *ihi*, lors duquel, elle et un groupe de fillettes Newar, se sont mariées au dieu hindou Vishnu. Les Newar sont originaires de la vallée de Katmandou au Népal. Autonomes, ils possédaient trois royaumes divins dans la vallée. Mais à la fin du XVIII$^e$ siècle, ils furent envahis par les indous gurkha venus de l'ouest, dont le clan dirigeant prit le pouvoir et occupe le trône du Népal jusqu'à aujourd'hui.

La religion newar est un mélange d'hindouisme et de bouddhisme. Ces deux croyances ont toujours cohabité dans la vallée de Katmandou. Mais depuis l'invasion Gurkha, le peuple Newar est fortement soumis à la pression exercée par les normes hindoues. Il persiste néanmoins dans les coutumes newar, qui diffèrent considérablement de celles de leurs voisins hindous plus orthodoxes en Inde et dans les autres régions du Népal. En effet, les femmes newar aiment profiter de leur liberté et de leur indépendance. Quoique ce soit rare, elles ont le droit de divorcer et de se remarier et ne sont pas soumises à la stigmatisation des veuves orthodoxes hindoues. Celles-ci doivent rester célibataires après la mort de leur mari. Jadis, elles étaient même brûlées sur le bûcher avec lui.

Les femmes newar ont réussi à préserver leur indépendance, malgré plus de deux siècles de pression extérieure, préférant marier symboliquement leurs filles à Vishnu, lors du rituel *ihi*, entre cinq et dix ans. Elles sont ainsi mariées pour l'éternité et n'auront pas à divorcer ni à être veuve, quel que soit le nombre d'hommes mortels qu'elles épouseront plus tard.

Avant le début de la puberté, les jeunes filles newar procèdent à une nouvelle cérémonie lors de laquelle elles se marient au dieu du soleil Surya. Leur mariage avec un mortel, généralement vers leur vingtième anniversaire, donne donc lieu à leur troisième mariage. Mais c'est le premier mariage à Vishnu qui demeure l'unique, l'éternel et l'indissoluble, tandis que celui avec un mortel peut parfaitement être remis en question si la femme est si malheureuse qu'elle ne voit pas d'autre solution.

# Drei Hochzeiten der Newar
## *Kathmandu, Nepal*

Die zehnjährige Prerana ist überglücklich: „Jetzt bin ich verheiratet und kann nie Witwe werden", sagt sie stolz. Sie hat gerade am großen Ihi-Ritual teilgenommen, bei dem sie und einige andere Newar-Mädchen den Hindugott Wischnu geheiratet haben.

Die Newar sind die Ureinwohner des Kathmandutals in Nepal. Früher waren sie unabhängig, es gab drei sakrale Königreiche im Tal. Doch Ende des 18. Jahrhunderts marschierten die aus Westen kommenden hinduistischen Gurkha ein, deren Herrscherfamilie die Macht an sich riss und bis 2008 auf dem nepalesischen Thron blieb.

Die Religion der Newar ist eine Mischung aus Hinduismus und Buddhismus, die lange Seite an Seite im Kathmandutal existierten. Im Zuge der Gurkah-Invasion mussten die Newar sich allerdings den strengen Hindunormen unterwerfen.

In einer Hinsicht unterscheiden sich die Newar aber immer noch von ihren orthodoxeren hinduistischen Nachbarn in Indien und anderen Teilen Nepals. Newar-Frauen genießen eine viel größere Freiheit und Unabhängigkeit. Obwohl das nur selten vorkommt, können sie sich scheiden lassen und erneut heiraten. Witwen werden anders als in hinduistischen Gemeinschaften üblich nicht stigmatisiert und dürfen nach dem Tod ihres Mannes eine neue Ehe eingehen. In frühren Zeiten wurde von einer hinduistischen Witwe sogar erwartet, dass sie sich mit dem Leichnam ihres Mannes verbrennen ließ.

Den Newar-Frauen ist es gelungen, diese Unabhängigkeit trotz des äußeren Drucks über mehr als zwei Jahrhunderte zu bewahren, indem sie ihre fünf- bis zehnjährigen Töchter im Ihi-Ritual eine symbolische Ehe mit Wischnu eingehen lassen. Danach gelten sie für immer als verheiratet, sie können nicht geschieden werden oder verwitwen, ganz gleich wie viele sterbliche Männer sie später heiraten.

Bevor ihre Menstruation beginnt, müssen sich die Newar-Mädchen einer weiteren Zeremonie unterziehen, in der sie den Sonnengott Surya heiraten. Ihre Ehe mit einem Sterblichen, die sie gewöhnlich eingehen, wenn sie in ihren 20ern sind, ist dann bereits ihre dritte. Aber die erste Ehe mit Wischnu ist die wichtigste, ewig und unauflösbar. Die Ehe mit einem Menschen dagegen kann beendet werden, wenn die Frauen so unglücklich sind, dass sie keinen anderen Ausweg sehen.

**Pages 344–345:** Durbar Square in Patan, one of three cities in the Kathmandu Valley that once served as seats of Newar monarchies.

**Pages 344–345 :** Durbar Square à Patan, une des trois villes de la vallée du Katmandou, jadis siège des monarchies newar.

**Seiten 344–345:** Der Durban Square in Patan, einer der drei Städte im Kathmandutal, die früher Sitz der Newar-Monarchien waren.

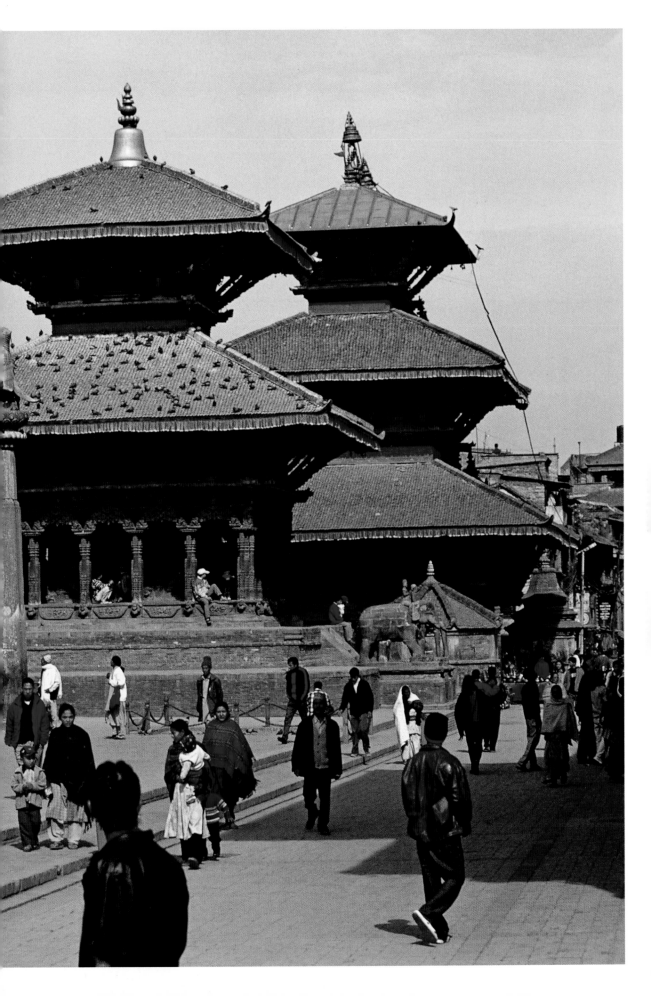

# Marrying Vishnu

It is a chilly January day in the Kathmandu Valley and a group of fathers sit in the courtyard of Patan's Kumbheswar Temple, each man holding a daughter in his lap.

Among the girls is ten-year-old Prerana, dressed in a red sari with a short red and yellow jacket and wearing trinkets – just like a bride at her wedding.

The moment that Prerana has been waiting for is at hand, and her father will shortly give her away in marriage – not to a boy or man but to the Hindu god Vishnu.

The origins of this tradition among the Newar people can be found in this story:

*The goddess Parvati was the daughter of Himavan, god of the Himalayas. On the eve of her marriage to Lord Shiva, Himavan gave her the Kathmandu Valley as a dowry. One day Parvati was walking in the valley when she heard an old woman weeping. Parvati asked her why she was crying. "My husband is dead. A woman needs a man. Without a man, a woman's life is dreadful." Parvati took pity on her and asked her husband Lord Shiva for help. "Please can you do something for the women in my homeland so they do not have to be widows?" Shiva replied: "Vishnu and I will make sure there are no more widows in the Kathmandu Valley from this day forth." The two gods gave the Newar the ihi ceremony, with Vishnu as the groom and Shiva the marriage witness.*

According to Newar mythology, this is the origin of the ihi ceremony in which Newar girls marry Vishnu in a lavish ceremony held in public and involving tens and even hundreds of girls at the same time.

As Prerana and twenty-six other girls sit expectantly in their fathers' laps, smoke from a holy fire drifts across the temple courtyard. Behind them stand their mothers, also dressed in red, the colour of marriage and fertility.

This is the second and last day of the ceremony, at which a Hindu Brahmin priest officiates. Prerana and her family participate traditionally in ihi ceremonies held by Hindu Brahmin priests, while other families may attend Buddhist services.

Both days start with purification rituals. One of them is when the barber's wife symbolically cuts the girls' toenails and paints their feet red. The girls also perform prayer and offertory rituals while sitting in two lines in the temple courtyard.

Their mothers are close by throughout, providing support and showing them how to perform the ritual movements correctly.

The first day's highlight comes when the girls have their height measured with a piece of twine made from six cotton threads, a process repeated eighteen times so that the measurement is equal to one hundred and eight times each girl's height. One hundred and eight is a lucky and holy number for Hindus and Buddhists alike.

The nuptial ceremony takes place on day two. A piece of cloth is tied to the girl's waist to imitate a sari, an item of clothing traditionally reserved for married women. The girl's forehead and hair parting are then daubed in vermilion paste, another mark worn by married women. Next, a piece of paper with religious motifs is pinned in the girl's hair in honour of Sri and Lakshmi, goddesses of wealth and fertility.

Now comes *kanya dana*, the defining moment in every Hindu wedding, when the fathers give away their daughters' hands in marriage. The fathers hold the daughters in their laps and a bowl containing a round fruit and a black stone is carried past

**Right:** A girl receives help from her paternal aunt to prepare for her marriage to Vishnu. It is considered important for the girls' paternal aunts to attend the ihi ceremony as representatives of her father's clan, since the event also marks the girl's elevation to full clan membership.

**À droite :** Une tante du côté paternel aide la fillette à se préparer à son union avec Vishnu. La présence des tantes paternelles est importante à la cérémonie *ihi*; elles représentent le clan du père lors de ce rituel par lequel la fillette devient membre à part entière de ce clan.

**Rechts:** Eine Schwester des Vaters hilft dem Mädchen, sich auf die Hochzeit mit Wischnu vorzubereiten. Es wird als wichtig erachtet, dass die Tanten väterlicherseits als Repräsentantinnen des Klans beim Ihi-Ritual anwesend sind, denn mit diesem Ereignis erlangt das Mädchen auch seine vollwertige Position im Klan.

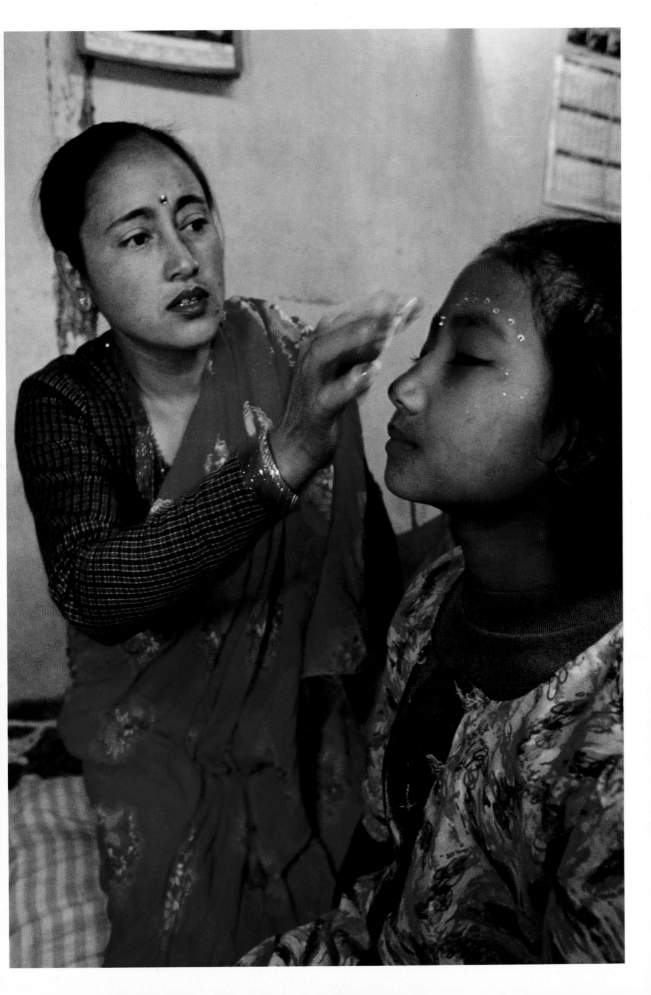

them. The stone represents Vishnu, the groom, and the fruit symbolises Shiva, the marriage witness.

When the bowl reaches Prerana her father gathers her hands in his along with flowers, leaves and a few banknotes for her mother to sprinkle with holy water. Her father then drops the leaves and notes into the water and moves Prerana's hands onto the black stone.

With Shiva as her witness, Prerana is now joined in eternal matrimony with Vishnu. There follow a few more rituals, which include the girls walking three times round the courtyard where the sacred fire burns, another typical feature of Hindu weddings. Then the families go home for an evening of celebrations with family and friends.

# Se marier à Vishnu

Par une froide journée de janvier dans la vallée de Katmandou, un groupe de pères est assis dans la cour du temple Kumbheswar de Patan. Chacun tient sa fille sur ses genoux.

Parmi les fillettes, Prerana, âgée de dix ans, est vêtue d'un sari rouge avec une veste courte rouge et jaune – telle une jeune mariée prête pour la cérémonie. Le moment tant attendu par Prerana est sur le point d'arriver, et bientôt son père l'amènera au mariage – pas avec un garçon ni un homme, mais avec le dieu hindou Vishnu. Les origines de cette tradition du peuple newar se situent peut-être au cœur de cette histoire :

*La déesse Parvati était la fille de Himavan, le dieu de l'Himalaya. La veille de son mariage avec le seigneur Shiva, Himavan lui donna la vallée de Katmandou en dot. Un jour où Parvati se promenait dans la vallée, elle entendit les pleurs d'une vieille dame. Parvati lui demanda pourquoi elle pleurait. « Mon mari est mort. Une femme a besoin d'un homme. Sans un homme, la vie d'une femme est épouvantable. » Parvati eut pitié d'elle et demanda à son mari, le seigneur Shiva, de l'aider. « S'il vous plaît, pouvez-vous faire quelque chose pour les femmes de ma vallée afin qu'elles ne soient plus jamais veuves ? » Shiva répondit alors : « Désormais, Vishnu et moi ferons en sorte qu'il n'y ait plus de veuves dans la vallée de Katmandou. » Les deux dieux donnèrent aux Newar la cérémonie ihi, Vishnu étant l'époux et Shiva le témoin du mariage.*

Selon la mythologie newar, il s'agit de l'origine de la cérémonie lors de laquelle les fillettes épousent Vishnu et où des dizaines, voire des centaines d'unions sont célébrées en même temps. Alors que Prerana et les vingt-six autres fillettes attendent patiemment assises sur les genoux de leures pères, la fumée issue du feu sacré dérive à travers la cour. Derrière eux se tiennent les mères, également vêtues de rouge, la couleur du mariage et de la fertilité.

Pour le deuxième et dernier jour de cérémonie, c'est un prêtre hindou brahmane qui officie. Prerana et sa famille participent traditionnellement aux cérémonies *ihi* où officient des prêtres hindous brahmanes, mais d'autres familles suivent également les offices bouddhistes. Les deux jours commencent par des rituels de purification. La femme du coiffeur coupe symboliquement les ongles des pieds des fillettes et leur peint les pieds en rouge. Les fillettes prient avec ferveur et effectuent des rituels d'offrandes, assises sur deux rangées dans la cour du temple. Leurs mères

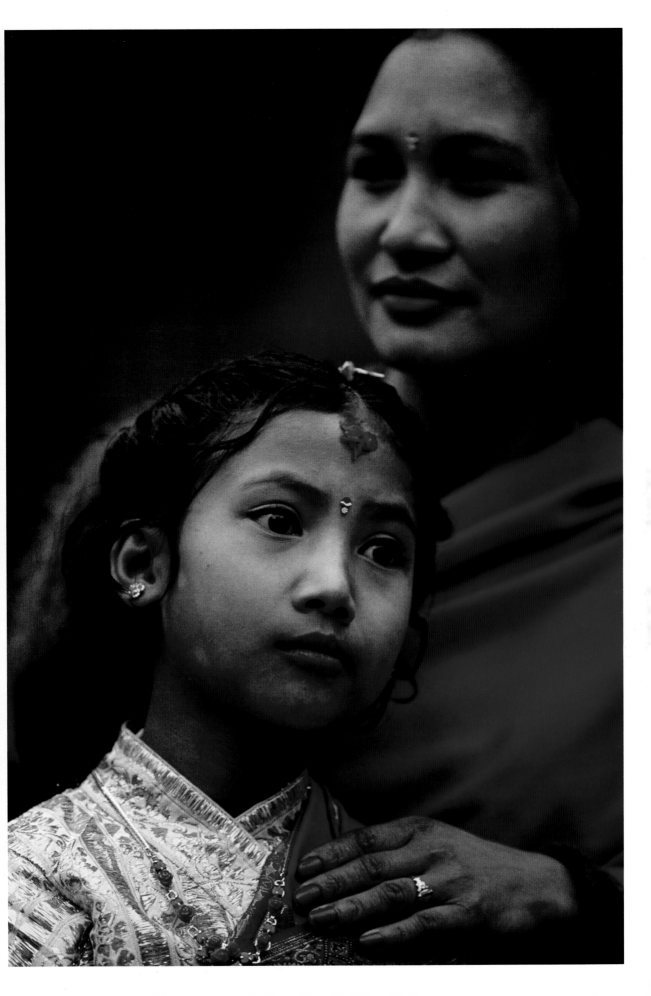

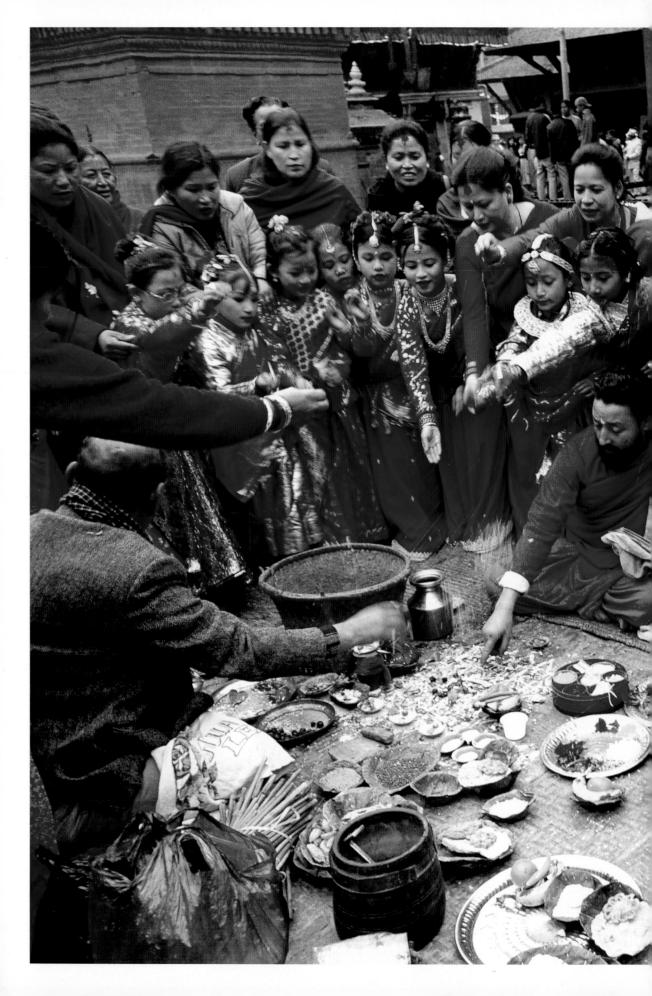

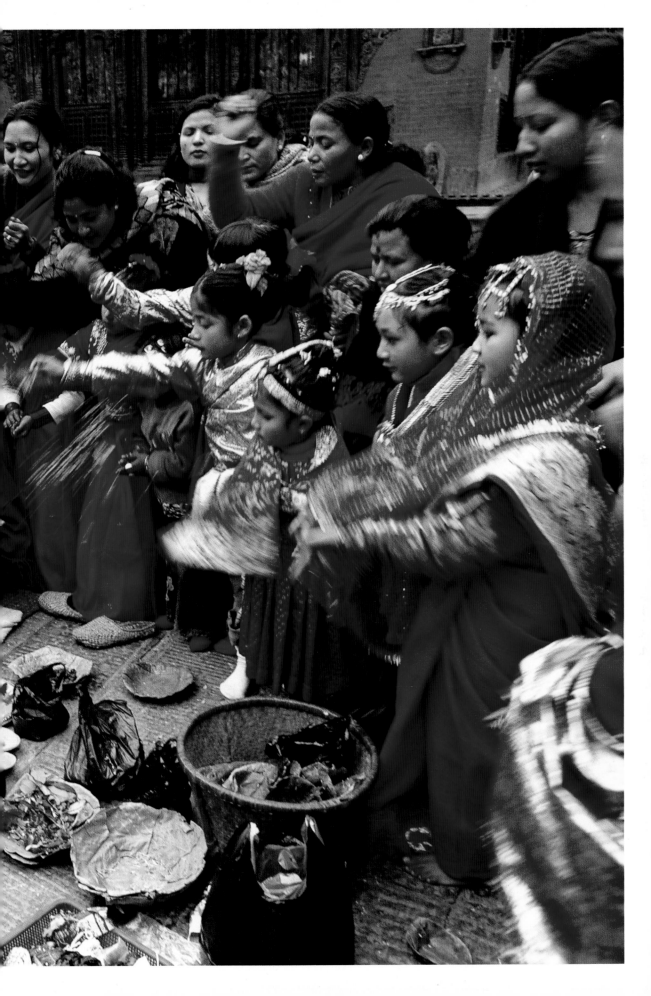

restent à leurs côtés afin de les encourager et de leur montrer comment procéder aux gestes rituels.

Le moment fort du premier jour se situe lorsque les fillettes se font mesurer avec un morceau de ficelle composé de six fils de coton, une mesure prise dix-huit fois de façon à ce qu'elle soit égale à cent huit fois la hauteur de chaque fillette. Cent huit est un nombre porte-bonheur et sacré, à la fois chez les hindous et chez les bouddhistes. La cérémonie nuptiale s'étend sur deux journées. Un tissu est noué à la taille des fillettes en guise de sari, le vêtement traditionnel réservé aux femmes mariées. Le front des fillettes et les racines de leurs cheveux sont enduits de pâte vermillon, autre signe typique des femmes mariées. Un morceau de papier orné de motifs religieux est épinglé dans leurs cheveux en l'honneur de Sri et Lakshmi, les déesses de la richesse et de la fertilité.

Commence alors *kanya dana*, le moment particulier lors de tous les mariages hindous où les pères offrent la main de leurs filles en mariage. Ils tiennent leurs filles sur leurs genoux, un bol contenant un fruit rond et une pierre noire est porté devant eux. La pierre représente Vishnu, le marié, et le fruit symbolise Shiva, le témoin du mariage. Lorsque le bol arrive devant Prerana, son père joint ses mains aux siennes pleines de fleurs, de feuilles et de quelques billets de banque, tandis que sa mère les aspergent d'eau sacrée. Son père lâche alors les feuilles et les billets dans l'eau et déplace les mains de Prerana sur la pierre noire. Avec Shiva comme témoin, Prerana est maintenant unie dans le mariage éternel à Vishnu. Quelques autres rituels suivent, dont celui qui veut que les fillettes fassent trois fois le tour de la cour où brûle le feu sacré, autre caractéristique des mariages hindous. Enfin, tout le monde rentre chez soi pour une soirée de célébration en famille et entre amis.

# Die Heirat mit Wischnu

Es ist ein kühler Januartag im Kathmandutal, und eine Gruppe von Vätern sitzt im Hof des Kumbheswar-Tempels in Patan, jeder mit einer Tochter auf dem Schoß.

Unter den Mädchen ist auch die zehnjährige Prerana, die einen roten Sari mit einer kurzen rotgelben Jacke und Schmuck trägt – wie eine Braut am Hochzeitstag.

Der Augenblick, auf den Prerana gewartet hat, steht unmittelbar bevor, und ihr Vater wird sie gleich ihrem Bräutigam übergeben – nicht einem Jungen oder Mann, sondern dem Hindugott Wischnu.

Die Ursprünge dieses Brauchs der Newar werden in dieser Geschichte erzählt:

*Die Göttin Parvati war die Tochter von Himawan, dem Gott des Himalajas. Am Abend vor ihrer Hochzeit mit dem Gott Schiwa gab ihr Himawan das Kathmandutal als Mitgift. Eine Tages ging Parvati durch das Tal und hörte eine Frau weinen. Parvati fragte sie, warum sie traurig sei. „Mein Mann ist tot. Eine Frau braucht einen Mann, ohne Mann ist ihr Leben furchtbar." Parvati hatte Mitleid mit ihr und bat ihren Mann Schiwa um Hilfe. „Kannst du etwas für die Frauen in meiner Heimat tun, damit sie nicht Witwen werden müssen?" Schiwa antwortete: „Wischnu und ich werden dafür sorgen, dass es im Kathmandutal von heute an keine Witwen mehr gibt." Die beiden Götter gaben den Newar die Ihi-Zeremonie, in der Wischnu der Bräutigam und Schiwa der Trauzeuge ist.*

Das ist der Ursprung der Ihi-Zeremonie, in der manchmal Hunderte Mädchen auf einmal in einer aufwendigen öffentlichen Zeremonie Wischnu heiraten.

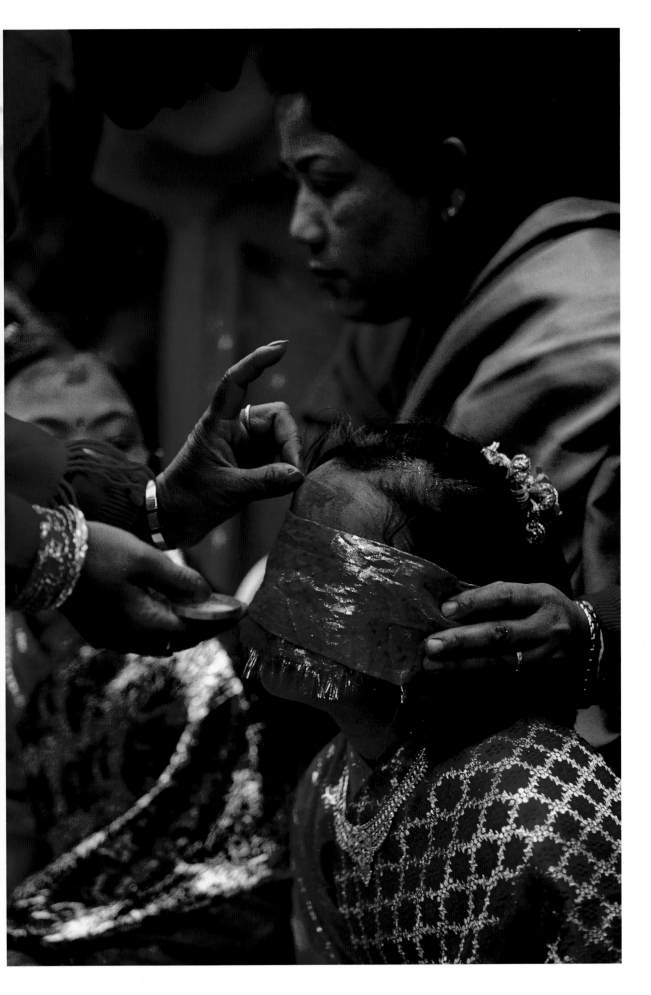

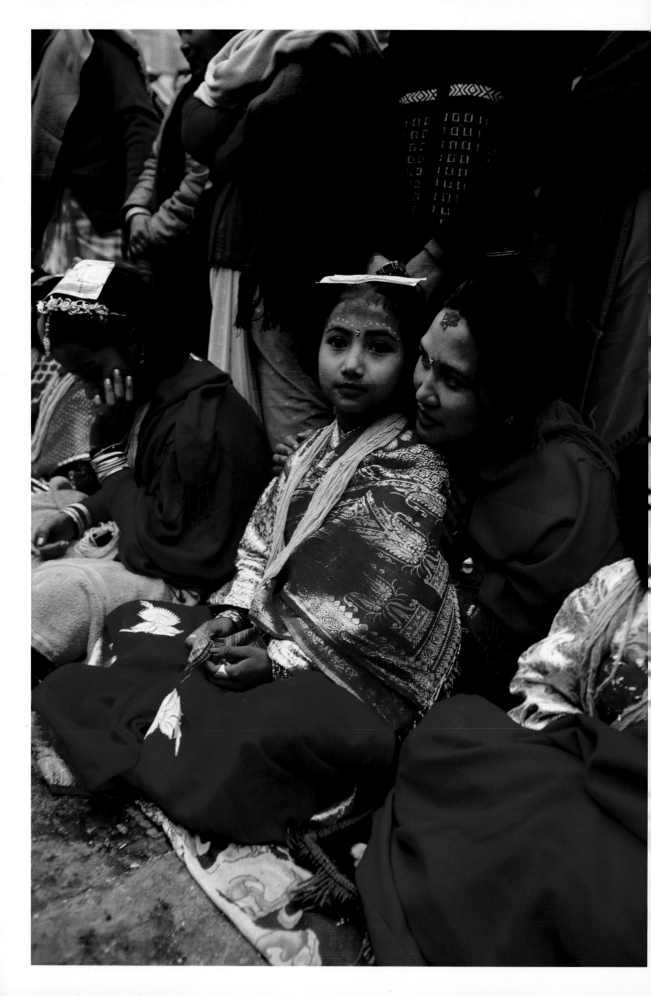

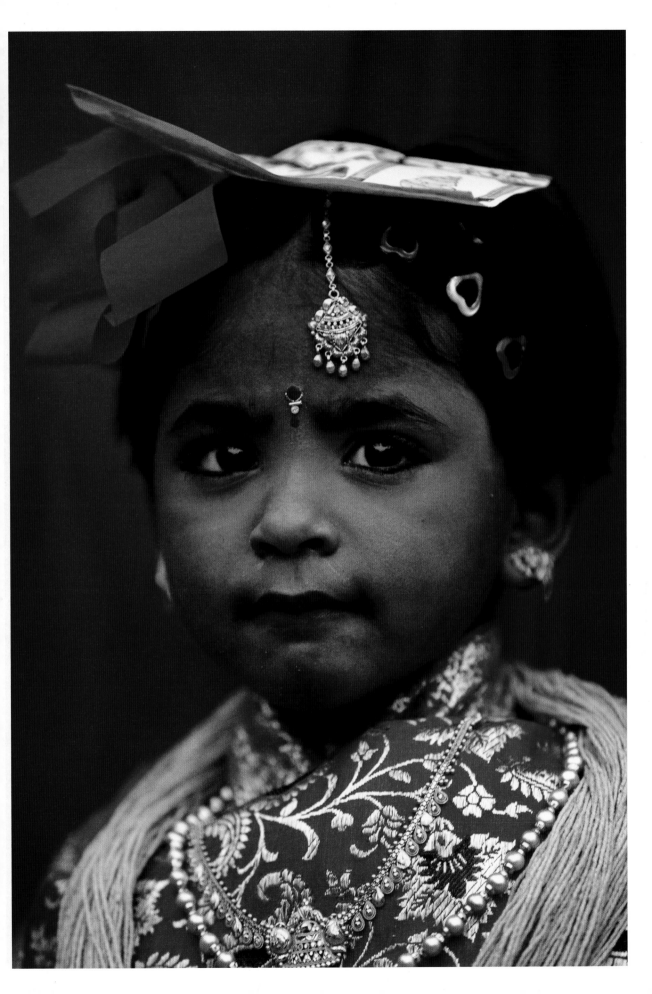

Während Prerana und 26 weitere Mädchen erwartungsvoll auf dem Schoß ihrer Väter sitzen, zieht Rauch vom heiligen Feuer über den Tempelhof. Hinter ihnen stehen ihre Mütter, die auch Rot, die Farbe von Ehe und Fruchtbarkeit, tragen.

Dies ist der zweite und letzte Tag der Zeremonie, die von brahmanischen Hindupriestern abgehalten wird. Prerana und ihre Familie nehmen traditionellerweise an diesen Ihi-Zeremonien teil. Andere Familie besuchen dagegen buddhistische Zeremonien.

Beide Tage beginnen mit Reinigungsritualen; so schneidet, zum Beispiel, die Frau des Barbiers den Mädchen symbolisch die Zehennägel und malt ihre Füße rot an. Außerdem beten die Mädchen, die in zwei Reihen im Tempelhof sitzen, und bringen Opfer dar.

Die ganze Zeit über sind ihre Mütter in der Nähe, um zu helfen und den Mädchen zu zeigen, wie man die rituellen Bewegungen richtig ausführt.

Der Höhepunkt des ersten Tages ist erreicht, als mit einer Schnur aus sechs Baumwollfäden gemessen wird, wie groß die Mädchen sind. Dieser Vorgang wird 18-mal wiederholt, sodass am Ende das 108-Fache ihrer wirklichen Größe dabei herauskommt. 108 ist eine Glückszahl und sowohl Hindus als auch Buddhisten gleichermaßen heilig.

Die Hochzeitszeremonie findet am zweiten Tag statt. Ein Stück Stoff wird dem Mädchen um die Taille geschlungen und soll einen Sari darstellen, ein Kleidungsstück, das traditionellerweise verheirateten Frauen vorbehalten ist. Seine Stirn und sein Scheitel werden mit Zinnoberpaste eingerieben, ein weiteres Zeichen verheirateter Frauen. Als Nächstes wird dem Mädchen zu Ehren von Sri und Lakschmi, den Göttinnen des Wohlstands und der Fruchtbarkeit, ein Stück Papier mit religiösen Motiven ins Haar gesteckt.

Nun kommt der bedeutendste Moment jeder hinduistischen Hochzeit, Kanya Dana: Der Vater gibt die Hand seiner Tochter dem Ehemann. Die Väter halten ihre Töchter auf dem Schoß, und eine Schale mit einer runden Frucht und einem schwarzen Stein werden vorbeigetragen. Der Stein repräsentiert Wischnu, den Bräutigam, die Frucht symbolisiert den Trauzeugen Schiwa.

Als die Schale Prerana erreicht, greift ihr Vater ihre Hände zusammen mit Blumen, Blättern und ein paar Geldscheinen, damit ihre Mutter sie mit geweihtem Wasser besprenkeln kann. Dann lässt der Vater die Blätter und das Geld ins Wasser fallen und führt Preranas Hände auf den schwarzen Stein.

Mit Schiwa als Trauzeugen ist Prerana nun auf ewig mit Wischnu verheiratet. Es folgen noch weitere Rituale, unter anderem umrunden die Mädchen dreimal den Hof, in dem das heilige Feuer brennt. Auch das ist ein typischer Bestandteil einer hinduistischen Hochzeit. Dann gehen die Familien nach Hause, um am Abend mit der Familie und Freunden zu feiern.

**Right:** Fathers hold their daughters in their laps when they give them away in marriage to Vishnu. In front of them are puja trays filled with food, flowers and leaves.
**Pages 358–359:** Tender moment: The ceremony is over and the priest moves among the girls to bless them with a spot of crimson dye on the brow.

**À droite :** Les fillettes sont assises sur les genoux de leurs pères qui les donnent en mariage à Vishnu. Devant eux sont disposés des plateaux *puja* remplis de nourritures, fleurs et feuilles.
**Pages 358–359 :** La cérémonie est terminée. Le prêtre bénit affectueusement chaque fillette en lui appliquant une touche de teinture rouge sur le front.

**Rechts:** Väter halten ihre Töchter bei deren Eheschließung mit Wischnu auf dem Schoß. Vor ihnen stehen Puja-Tabletts voller Speisen, Blumen und Blättern.
**Seiten 358–359:** Ein berührender Moment: Die Zeremonie ist vorüber, und der Priester segnet die Mädchen mit einem zinnoberroten Fleck auf der Stirn.

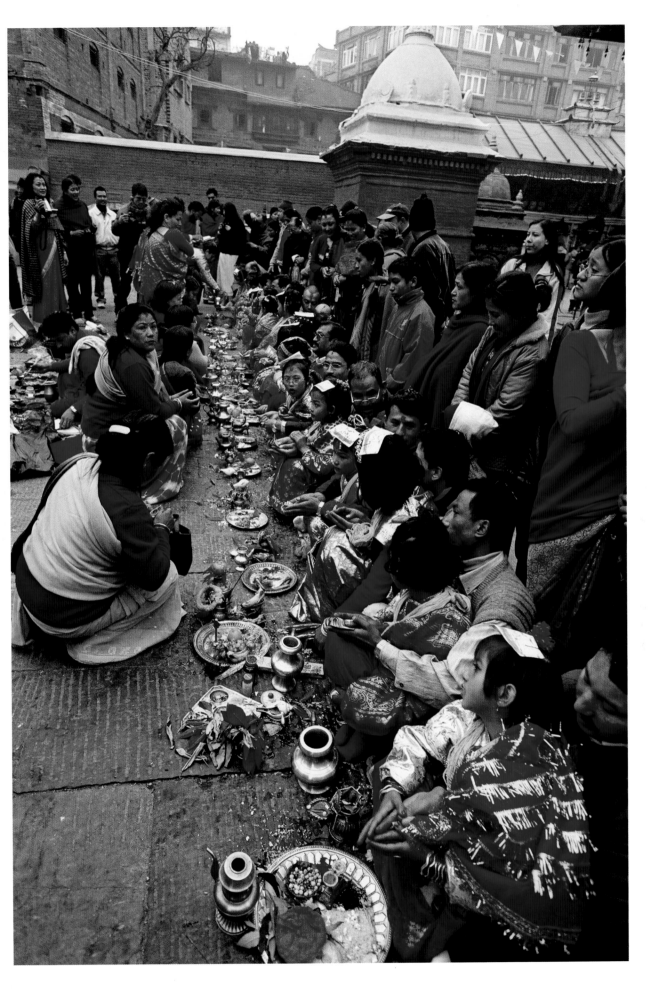

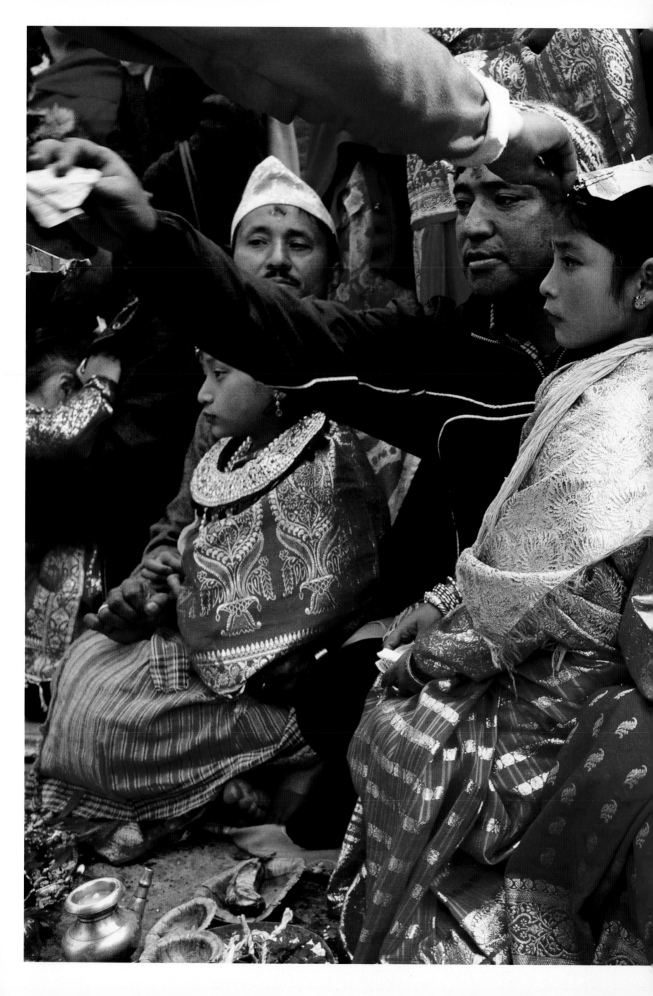

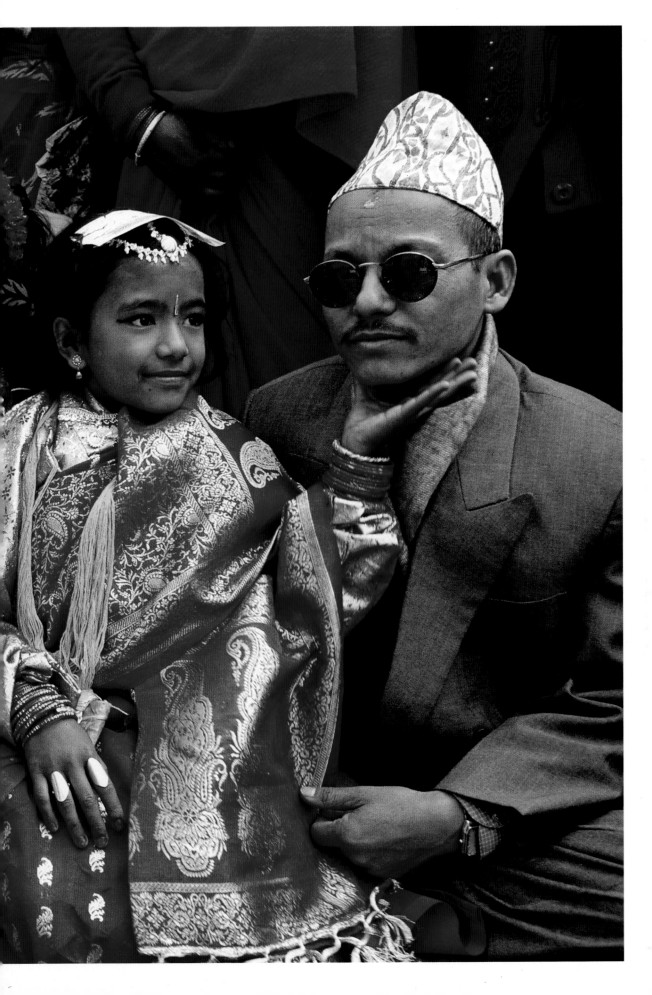

**Right:** The shiny black
stone symbolises Vishnu,
and the large round
fruit represents Shiva,
the marriage witness.

**À droite :** La pierre noire
brillante symbolise Vishnu ;
le fruit rond figure Shiva,
le témoin du mariage.

**Rechts:** Der glänzende
schwarze Stein symboli-
siert Wischnu, die große
runde Frucht Schiwa, den
Trauzeugen.

# Marrying Surya

In form but not content the ihi ceremony – in which girls marry the god Vishnu – resembles the child marriages traditionally favoured by some Hindu Brahmin castes. At such a marriage the girl is wed at a young age but remains at home until puberty. When she has her first menstrual period, she is brought to her husband's home to undergo a puberty rite during which she lives in seclusion. When the ceremony is complete, she and her husband consummate the marriage.

The Newar have an equivalent ritual, known as *bahra* and generally held after the girl performs ihi but before she reaches adolescence. This mock first-menstruation ritual culminates with her marrying another deity, in this case the sun god Surya. When the girl then has her first menstrual period, no ceremonies are held, nor is the girl placed under any restrictions keeping her from carrying on her life as normal.

However, should the girl have her first period before she has undergone bahra, the ceremony will be performed immediately.

Bahra takes place at home, in a twelve-day ceremony during which the windows of a secluded room are covered with drapes to keep out the sunlight. On the thirteenth day the girl is taken out of the room and up onto the roof of the house, where she reveals her face to Surya. Out of consideration for the sun god, she removes her hands from her face slowly and with care, reflecting the Newar belief that she possesses potentially destructive powers during bahra. When her face is fully exposed she becomes Surya's wife.

Men are not allowed to see the girl during her seclusion or to witness the marriage itself. For twelve successive mornings her face is anointed with cream to make her beautiful for Surya, and when the menfolk greet her on the roof at the end of the ceremony they are struck by how different she looks. She wears make-up and expensive robes of red, the colour of fertility and marriage, embroidered with gold.

The women and visiting girlfriends make sure the girl's seclusion is anything but dull. The lights in her room are kept on and the days filled with play, song and dance. "I want it to go on for a few more days!" exclaims Loonibha, a girl from Kathmandu at the end of her bahra.

**Right:** This girl from Kathmandu is about to commence her *bahra* and spend twelve days secluded from the outside world. No men may see her during this time and the windows are covered with drapes to conceal her from the sun god Surya.
**Pages 364–365:** School is over for the day and the girl sits on the doorsteps of her family's home in central Kathmandu while waiting for her bahra to begin. She will not go back to class again until the ceremony is over.

**À droite :** Cette fille de Katmandou commence son *bahra :* elle passera douze jours retirée du monde. Aucun homme n'a le droit de la voir durant cette période. Des tentures sont tirées devant les fenêtres pour dissimuler la jeune fille au regard du dieu du soleil Surya.
**Pages 364–365 :** Rentrée de l'école, l'adolescente attend, assise sur les marches de sa maison, que les préparations pour son bahra soient terminées. Elle ne retournera en classe qu'après les célébrations.

**Rechts:** Dieses Mädchen aus Kathmandu steht kurz vor seiner Bahra und wird zwölf Tage lang abgeschieden von der Außenwelt leben. Während dieser Zeit dürfen es Männer nicht sehen, und vor den Fenstern hängen Vorhänge, um es vor dem Sonnengott Surya zu verbergen.
**Seiten 364–365:** Für heute ist die Schule zu Ende, und dieses Mädchen sitzt auf den Stufen vor dem Haus seiner Eltern im Zentrum von Kathmandu. Es wartet darauf, dass seine Bahra beginnt. Bis die Zeremonie vorbei ist, wird es nicht mehr zur Schule gehen.

# Se marier à Surya

Les mariages traditionnels d'enfants effectués par certaines castes hindoues brahmanes ressemblent, dans leur forme mais pas dans leur contenu, aux cérémonies *ihi*. Pour de tels mariages, la fillette se marie au plus jeune âge, mais reste chez elle jusqu'à ce qu'elle atteigne la puberté. Après sa première menstruation, elle est conduite dans la maison de son mari pour participer à un rite de puberté lors duquel elle vit dans la solitude. Lorsque la cérémonie est achevée, elle et son mari consomment le mariage.

Les Newar pratiquent un rituel équivalent, connu sous le nom de *bahra*, qui a lieu généralement après le *ihi*, mais avant l'adolescence. Ce faux rituel de puberté s'achève par un mariage avec une autre divinité, ici le dieu du soleil Surya. Lorsque la fille a sa première menstruation, aucune cérémonie n'a lieu et aucune restriction ne lui est imposée, la laissant vivre une vie normale.

Cependant, si la fille a ses premières règles avant d'effectuer *bahra*, la cérémonie doit avoir lieu immédiatement. *Bahra* se tient à la maison, lors d'une cérémonie de douze jours pendant laquelle les fenêtres d'une chambre isolée sont couvertes avec des draps pour empêcher le soleil d'entrer. Au treizième jour, la jeune fille peut sortir et est emmenée sur le toit de la maison, où elle présente son visage à Surya. Par égard pour le dieu du soleil, elle retire très lentement les mains de son visage, telle que le veut la croyance newar prétendant qu'elle a des pouvoirs potentiellement destructeurs lors de *bahra*. Lorsque son visage est entièrement exposé, elle devient l'épouse de Surya.

Les hommes ne sont pas autorisés à voir la jeune fille lors de sa réclusion ou à être témoin du mariage. Pendant douze matinées consécutives, son visage est enduit de crème pour qu'elle soit belle devant Surya, et lorsque les gens la saluent sur le toit à la fin de la cérémonie, ils sont surpris par sa métamorphose physique. Elle est maquillée et porte des robes rouges luxueuses ornées d'or, couleur de la fertilité et du mariage.

Les femmes et les amies de la jeune fille font en sorte que le lieu de réclusion soit agréable. Les lumières dans la pièce restent toujours allumées et elles organisent des séances de jeu, de chant et de danse. « Je voudrais que ça continue plus longtemps ! » s'exclame Loonibha, une jeune fille de Katmandou arrivée au terme de son *bahra*.

# Die Heirat mit Surya

In ihrer Form, nicht aber in ihrer Auswirkung, gleicht die Ihi-Zeremonie, in der Mädchen den Gott Wischnu heiraten, den Kinderehen, die manche hinduistische Brahmanenkasten ihrer Tradition entsprechend bevorzugen. Bei diesen Eheschließungen wird das Mädchen sehr jung verheiratet, bleibt aber bis zur Pubertät zu Hause. Wenn es seine erste Menstruation hat, wird es zum Haus des Mannes gebracht, wo es sich in völliger Abgeschiedenheit einem Pubertätsritus unterzieht. Wenn diese Zeremonie abgeschlossen ist, vollziehen die beiden die Ehe.

Bei den Newar gibt es ein entsprechendes Ritual namens Bahra. Es wird üblicherweise nach dem Ihi-Ritual durchgeführt, aber bevor das Mädchen in die Pubertät kommt. Dieses Ritual zu seiner vorgeblichen ersten Menstruation gipfelt in einer weiteren Eheschließung mit einem Gott, in diesem Fall dem Sonnengott Surya. Wenn es dann seine erste Menstruation hat, wird keine weitere Zeremonie abgehalten, und es kann sein Leben ohne Einschränkungen weiterführen wie zuvor. Sollte das Mädchen seine erste Periode jedoch vor seiner Bahra-Zeremonie haben, wird diese sofort vollzogen.

Bahra wird in einer zwölftägigen Zeremonie zu Hause gefeiert. Die Fenster eines abgelegenen Raums werden dazu mit Vorhängen abgedunkelt, um das Sonnenlicht fernzuhalten. Am 13. Tag wird das Mädchen aus dem Zimmer auf das Dach des Hauses geführt, wo es Surya sein Gesicht zeigt. Mit Rücksicht auf den Sonnengott lässt es sein Gesicht nur langsam unter seinen Händen zum Vorschein kommen, denn die Newar glauben, dass es während der Bahra-Zeit über potenziell zerstörerische Kräfte verfügt. Ist sein Gesicht ganz zu sehen, wird es Suryas Ehefrau.

Männern ist es nicht erlaubt, das Mädchen anzuschauen, solange es sich zurückgezogen hat, oder gar der Eheschließung selbst beizuwohnen. An zwölf aufeinander folgenden Morgen wird sein Gesicht mit Creme eingerieben, um es für Surya schön aussehen zu lassen. Am Ende der Zeremonie sind die Männer darüber verblüfft, wie verändert das Mädchen erscheint. Es trägt Make-up und teure, mit Gold verzierte Kleider in Rot, der Farbe von Fruchtbarkeit und Ehe.

Die Frauen und Freundinnen, die zu Besuch kommen, sorgen dafür, dass die Zeit der Zurückgezogenheit alles andere als langweilig ist. Das Licht im Zimmer des Mädchens bleibt an, und die Tage sind mit Spielen, Liedern und Tanz ausgefüllt. „Das würde ich gerne noch ein paar Tage weitermachen", ruft Loonibha, ein Mädchen aus Kathmandu, am Ende seiner Bahra.

**Pages 368–369:** Twelve days have passed and the marriage to Surya has just taken place. The girl shows the men how she revealed her face to the sun. Only after this were they allowed to enter the roof.

**Pages 368–369:** Douze jours se sont écoulés; l'union avec Surya vient juste d'être célébrée. La fille montre aux hommes comment elle a révélé son visage au soleil. Ce n'est qu'après ce rite qu'ils ont pu la rejoindre sur le toit.

**Seiten 368–369:** Zwölf Tage sind vergangen, und die Hochzeit mit Surya hat gerade stattgefunden. Das Mädchen zeigt den Männern, wie es sein Gesicht der Sonne geöffnet hat. Erst danach durften die Männer das Dach betreten.

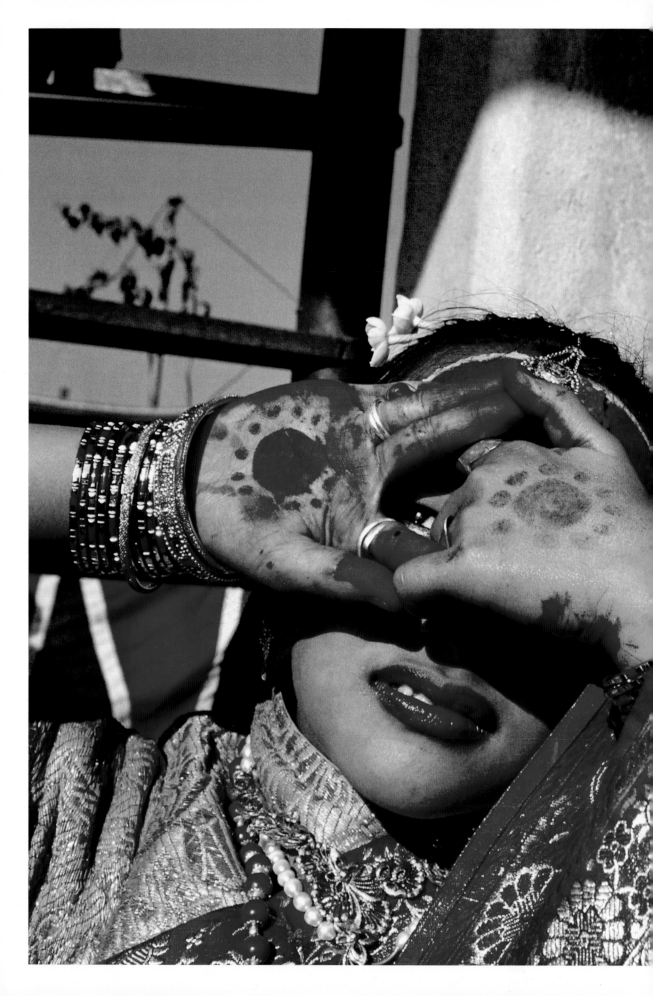

# Bride marries groom

At night, a dank mist hangs over the village of Panga. Sitting in an upstairs room, Mangal Kumari Maharjan is inconsolable. Her friends try to comfort her but to no avail, and the tears just flow and flow. Her fiancé's family has just arrived to take her with them. Before the day is over she will be married and living under a new roof. Mangal has met her husband-to-be and agreed to the family's marriage proposal but is still upset. No one is surprised. "What sort of girl doesn't cry when she has to leave her family?" say the Newar of brides who fail to show the emotions expected of them.

Only a few hours ago, Mangal was in good spirits at the party thrown by her family for relatives and friends, greeting the guests with smiles as they handed over their wedding presents and thanking them with gifts of betel nuts, a fertility symbol. Most of the presents were for her new home. The presents will be part of her dowry when she joins her husband, but they will always be hers to keep.

It is time to leave. A *puja* (prayer ceremony) is held and Mangal receives a blessing in the form of a red spot of dye on her forehead. Still sobbing, she is helped outside by a male relative. Her brother walks her twice round the car that will take her to her new home and then circles the vehicle carrying Mangal on his back. The engine revs, the headlights come on and the car drives off into the mist. Mangal's closest friends and the marriage broker accompany her on the journey.

The nuptial ceremony takes place at the home of Mangal's parents-in-law. Under the watchful guidance of a Buddhist priest, the groom daubs the parting of the bride's hair red to highlight her status as a married woman. The two then dine from a shared plate of food, a symbol of their unity as a couple.

But there is no kanya dana, when the father gives his daughter's hand in matrimony, nor is there any circling of a sacred fire, since these rituals have already been done during Mangal's ihi ceremony, when she was married to Vishnu.

# La mariée épouse le marié

Au milieu de la nuit, une brume humide s'accroche au village de Panga. Assise dans une chambre du premier étage, Mangal Kumari Maharjan est inconsolable. Ses amies tentent de la réconforter en vain, les larmes inondent son visage. La famille de son fiancé vient d'arriver pour l'emmener. Avant que le jour se lève, elle sera mariée et devra vivre sous un autre toit. Mangal a rencontré son futur mari et a accepté l'offre de mariage de la famille, mais elle demeure inquiète. « Quelle jeune fille ne pleurerait pas au moment de quitter sa famille ? » disent les Newar, si une fiancée ne montre pas les émotions attendues d'elle.

Il y a seulement quelques heures, Mangal était dans un tout autre état d'esprit lors de la fête donnée par sa famille pour ses proches et ses amis. Elle saluait ses invités en souriant lorsqu'ils lui tendaient leurs cadeaux de mariage, les remerciant avec de petits présents de noix de bétel, symbole de fertilité. La plupart des cadeaux étaient destinés à sa nouvelle maison. Sa famille lui a offert une armoire avec des portes vitrées, un réfrigérateur et un ensemble de trois canapés. Les cadeaux feront partie de sa dot lorsqu'elle rejoindra son mari, mais ils lui appartiendront toujours.

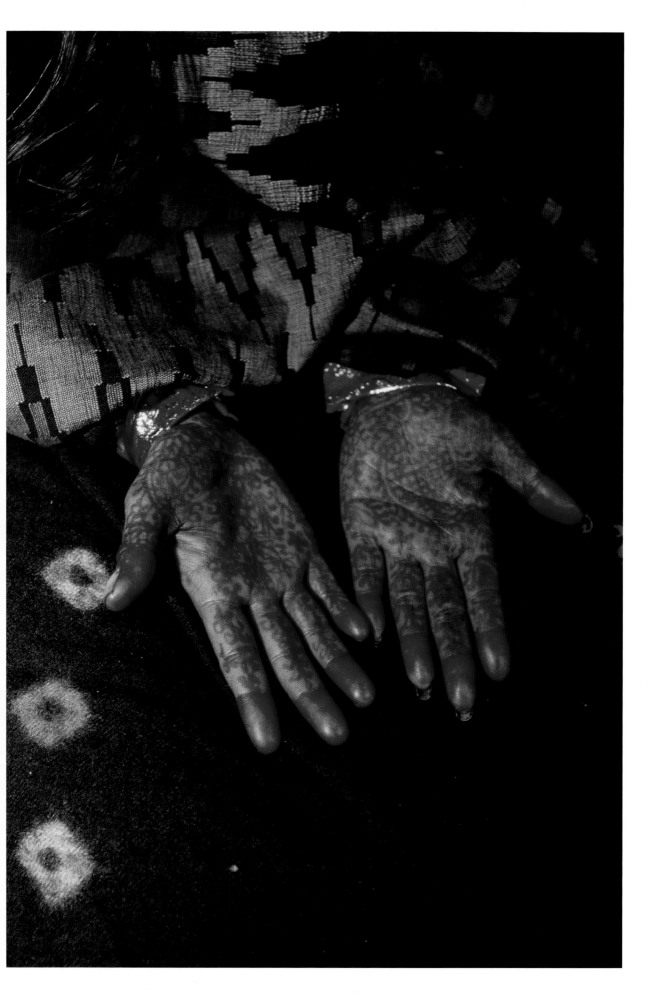

Il est temps de partir. Un *puja* (prêtre des cérémonies) est arrivé et Mangal reçoit une bénédiction par un point de teinture sur le front. Toujours sanglotante, elle est soutenue par un homme de sa famille. Son frère la fait marcher deux fois autour de la voiture qui la conduira vers sa nouvelle maison, puis en fait une fois le tour en portant Mangal sur son dos. Le moteur démarre, les phares s'allument et la voiture s'éloigne dans la brume. Les plus proches amis de Mangal, ainsi que l'intermédiaire matrimonial les accompagnent dans leur voyage.

La cérémonie nuptiale a lieu dans la maison des futurs beaux-parents de Mangal. Sous le regard d'un prêtre bouddhiste, le marié enduit de rouge les racines des cheveux de la mariée pour souligner son nouveau statut de femme mariée. Les époux dînent ensuite d'un plat de nourriture partagé, symbole de l'unité du couple.

Il n'y a pas de *kanya dana* lorsque le père offre sa fille en mariage, ni de rassemblement autour du feu sacré, ces rituels ayant été pratiqués durant la cérémonie *ihi* de Mangal, lorsqu'elle a épousé Vishnu.

# Braut heiratet Bräutigam

Es ist mitten in der Nacht und nasskalter Nebel hängt über dem Dorf Panga. In einem Zimmer oben im Haus sitzt die untröstliche Mangal Kumari Maharjan. Ihre Freundinnen versuchen, sie zu beruhigen, doch die Tränen kullern immer weiter.

Die Familie ihres Verlobten ist gerade angekommen, um sie abzuholen. Bevor der Tag um ist, wird sie verheiratet sein und unter einem neuen Dach leben. Mangal hat ihren zukünftigen Ehemann kennengelernt und dem Heiratsantrag der Familie zugestimmt. Trotzdem ist sie ganz aufgelöst. Keiner wundert sich darüber. „Was ist das für ein Mädchen, das nicht weint, wenn es seine Familie verlassen muss?", sagen die Newar über Bräute, die die erwarteten Gefühlsausbrüche schuldig bleiben.

Noch vor ein paar Stunden war Mangal bei einer Party, die ihre Familie für Freunde und Verwandte gegeben hat, guter Dinge. Sie begrüßte die Gäste mit einem Lächeln, während diese ihr die Hochzeitsgeschenke überreichten, und bedankte sich, indem sie ihnen Betelnüsse, ein Fruchtbarkeitssymbol, darreichte.

Die meisten Präsente sind für ihren neuen Hausstand bestimmt. Ihre Eltern haben ihr einen Kleiderschrank mit Glastüren, einen Kühlschrank und eine dreiteilige Couchgarnitur geschenkt. Die Geschenke sind Teil ihrer Mitgift, die sie mitnimmt, wenn sie zu ihrem Ehemann zieht, aber sie werden immer ihr gehören.

Es ist Zeit aufzubrechen. Eine Puja, eine Gebetszeremonie, wird abgehalten, und Mangal wird mit einem roten Farbpunkt auf ihrer Stirn gesegnet. Ihr Bruder umkreist zweimal mit ihr das Auto, das sie in ihr neues Zuhause bringen wird, und trägt Mangal dann noch einmal auf dem Rücken um das Auto. Der Motor heult auf, die Scheinwerfer gehen an, und das Auto verschwindet im Nebel. Mangals engste Freunde und die Heiratsvermittlerin begleiten sie auf ihrer Reise.

Die Hochzeitszeremonie findet im Haus von Mangals Schwiegereltern statt. Unter den aufmerksamen Augen eines buddhistischen Priesters färbt der Bräutigam den Scheitel der Braut rot, um ihren Status als verheiratete Frau deutlich zu machen. Danach essen die beiden von einem Teller, ein Symbol für ihre Einheit als Paar.

Hier gibt es weder ein Kanya-Dana-Ritual, bei dem der Vater die Braut an den Bräutigam übergibt, noch werden heilige Feuer umkreist, denn all das fand schon bei Mangals Ihi-Zeremonie statt.

**Right:** Helping hands: The bride's girlfriends and family assist her in putting on her wedding dress.
**Pages 376–377:** Friends and family offer the bride their congratulations and deposit wedding gifts in a large brass bowl.
**Pages 378–379:** As the time comes to bid her family goodbye the bride weeps uncontrollably. Friends and the marriage broker (left), who acts as intermediary between the two families, try in vain to console her.

**À droite :** Les amies et parentes de la fiancée l'aident à revêtir le costume de mariage traditionnel.
**Pages 376–377 :** Amis et parents félicitent la jeune mariée et déposent les cadeaux dans un vaste récipient en cuivre.
**Pages 378–379 :** La future mariée exprime sa douleur de quitter le toit paternel. Ses amies et la marieuse (à gauche), qui a fait l'intermédiaire entre les deux familles, tentent de la consoler.

**Rechts:** Unterstützung: Familienmitglieder und Freundinnen der Braut helfen ihr in ihr Brautkleid.
**Seiten 376–377:** Freunde und Verwandte gratulieren der Braut und legen ihre Hochzeitsgeschenke in eine große Messingschale.
**Seiten 378–379:** Als sich die Braut von ihrer Familie verabschieden muss, weint sie hemmungslos. Freundinnen und die Heiratsvermittlerin (links), die als Bindeglied zwischen den Familien dient, bemühen sich erfolglos, sie zu trösten.

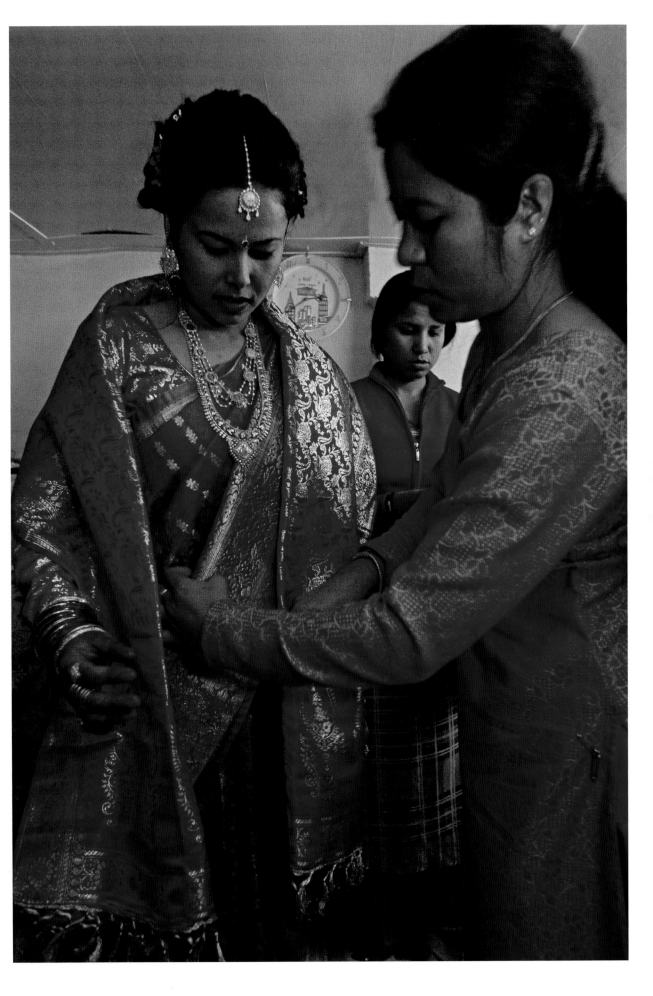

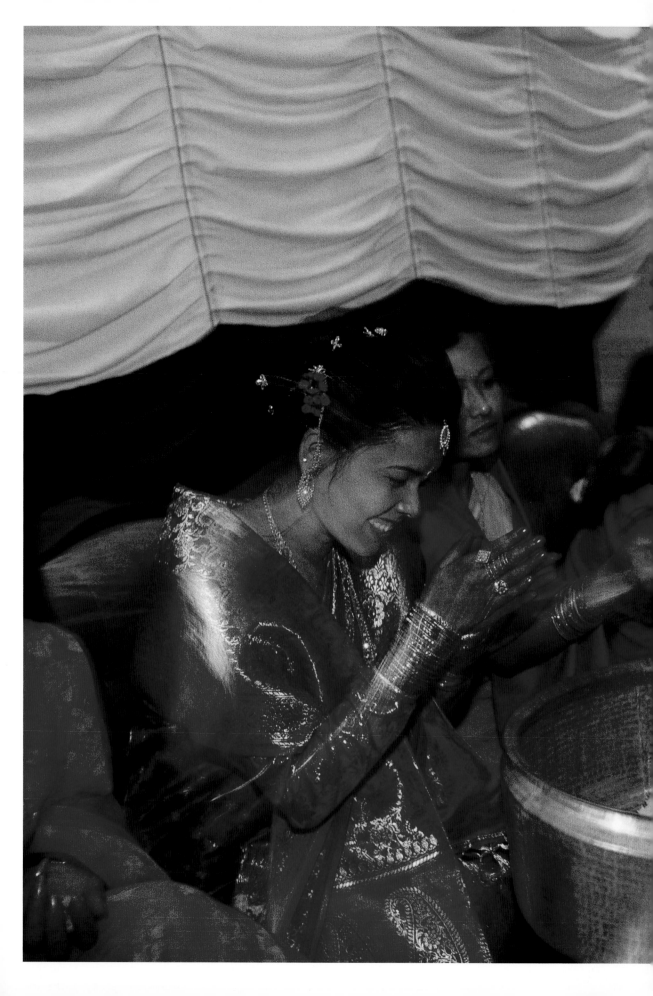

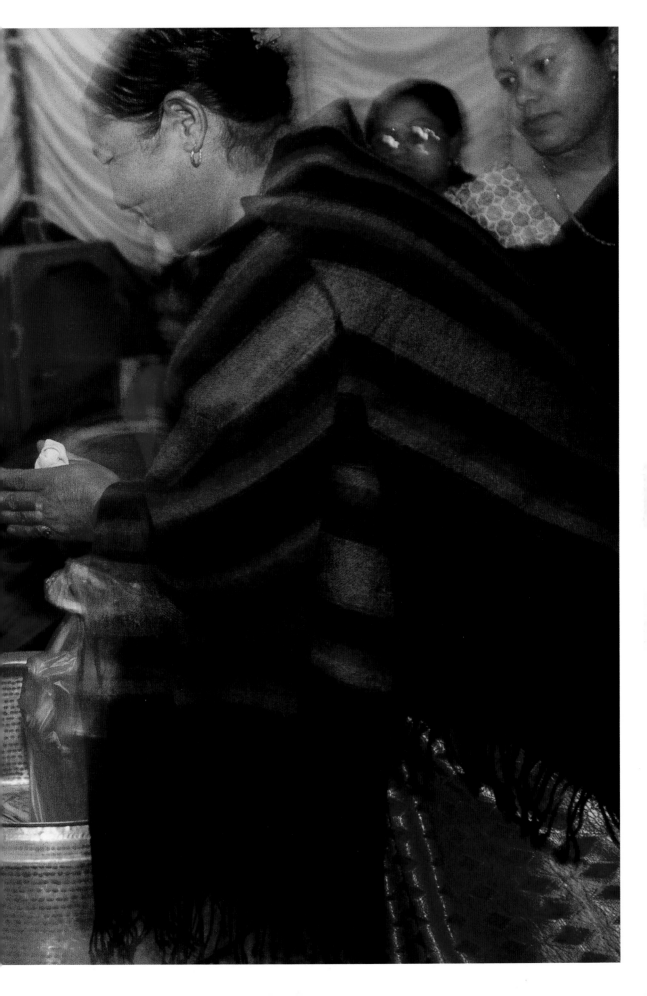

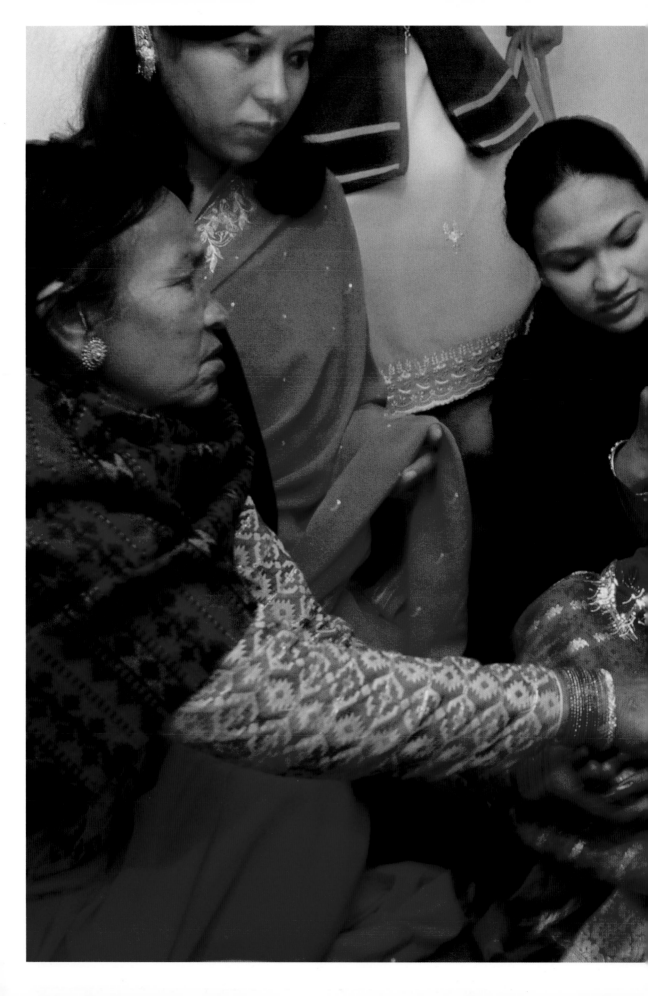

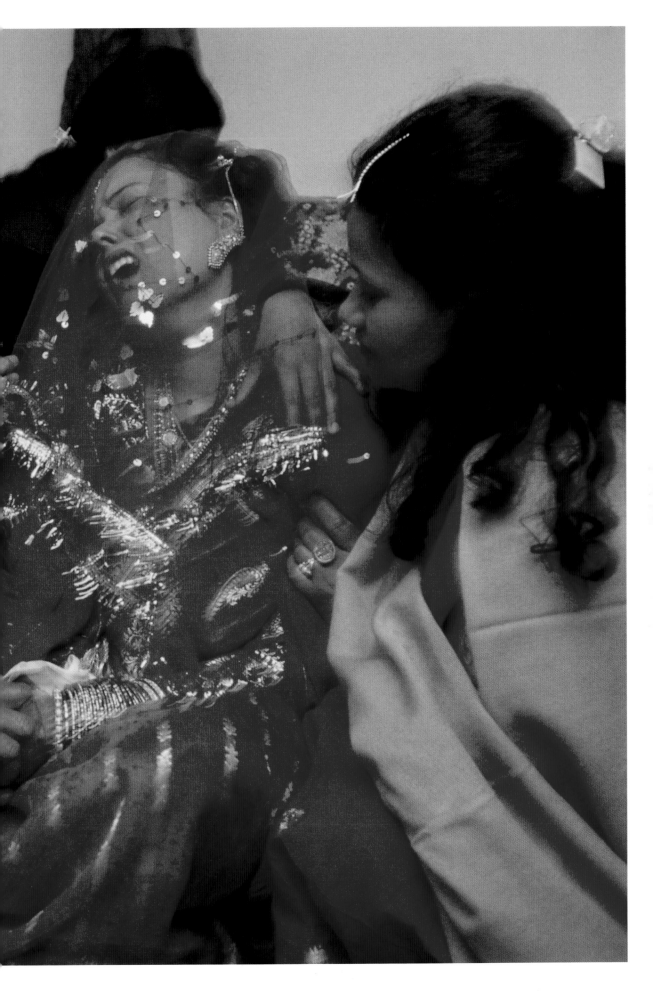

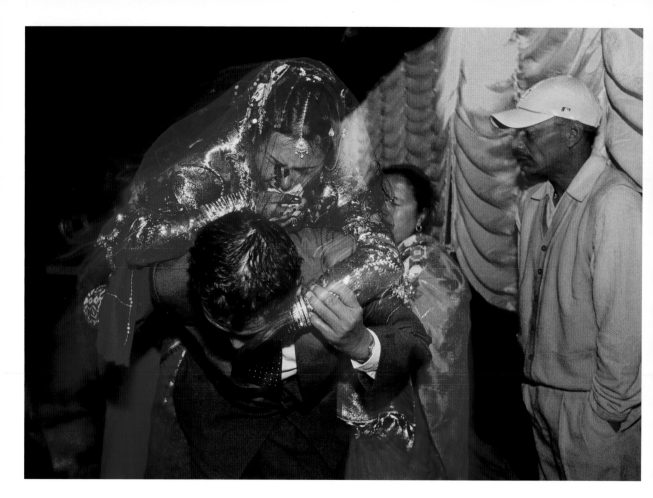

**Above:** The farewell ceremony tugs at everyone's heart strings. The sobbing bride is helped out of the house and her brother carries her round the car, which will drive her to her fiancé's family.

**Ci-dessus:** La cérémonie d'adieux est toujours émouvante. La fiancée en pleurs doit être soutenue lorsqu'elle quitte son foyer; un frère la porte jusqu'à la voiture qui la conduira à la maison de son fiancé.

**Oben:** Der Abschied geht allen zu Herzen. Man hilft der weinenden Braut aus dem Haus, und ihr Bruder trägt sie um das Auto, das sie zur Familie ihres Verlobten bringen wird.

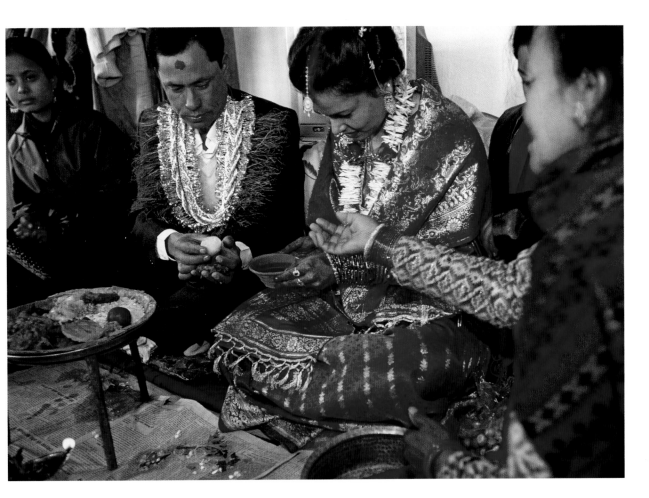

**Above:** The wedding ceremony is held later that day at the home of the groom's family. An important part of this consists of the couple eating from a shared plate of food. From this point on, the bride shows no outward signs of sorrow.

**Ci-dessus :** Plus tard, lors de la cérémonie de mariage dans la demeure du fiancé, le couple partage un plat de nourriture. Après ce rite important, la mariée ne doit plus montrer de signe extérieur de détresse.

**Oben:** Die Hochzeitszeremonie wird später an diesem Tag im Haus der Familie des Bräutigams abgehalten. Ein wichtiger Teil ist die gemeinsame Speise des Paars von einem Teller. Von nun an lässt die Braut kein Zeichen der Trauer mehr erkennen.

# Berber wedding
## *High Atlas Mountains, Morocco*

The music and dancing stop and two white plastic chairs are brought out and placed by the mud wall. The door of the house opens and the two newlywed brides emerge, no longer wearing the veils that until now have hidden their faces.

They take their seats and the festivities resume. With great curiosity the villagers study the faces of the two young women who have just married two local men and become their new neighbours.

Until 1985, every village in the Upper Assif Melloul Valley, home to the Berber Ait Haddidou people, held an annual mass wedding. This ancient custom still survives in parts of Morocco's High Atlas Mountains but is less common nowadays.

The Ait Haddidou have two branches: the Ait Brahim in the south and the Ait Azza in the north. Both live mainly from farming, growing crops such as barley, apples and almonds. Many are also herders and semi-nomads, spending part of the year in the village and the rest of the time with their animals on their wanderings in search of grazing pasture.

These desert-like mountain regions, through which the cultivations on either side of the Assif Melloul River run like green veins, are not among Morocco's richer areas. Living standards in the valley are higher than they once were but remain basic, and it has been suggested that the mass marriage tradition originated in response to poverty and the need to share the heavy costs that a marriage entails. By custom, the elders of the villages in the valley agreed a date every year on which weddings were to be held. Couples who wanted to marry gave the head of their village a *burnous* (woollen cloak) as a pledge that they would wed on the date in question.

Weddings took place after the annual fair in Imilchil, held in early September after the harvest. These were not arranged marriages: the Atlas Berbers allow free interaction between boys and girls. There are plenty of opportunities for young couples to meet, spend time together and fall in love while working in the fields or at village festivals and weddings – not to mention at the fair.

It is up to the couple to decide if they wish to marry, though family consent is required before the nuptials can take place.

**Pages 382–383:** Despite being at more than 2,000 metres, the High Atlas Mountains next to Imilchil once lay beneath the sea and their slopes still bear geological features from that era. **Right:** The Upper Assif Melloul Valley is home to the Berber Ait Haddidou tribe. Women from the southern branch, Ait Brahim, are recognised by their dark, striped woollen capes.

**Pages 382–383:** Si les montagnes du Haut Atlas près d'Imilchil dépassent aujourd'hui 2 000 mètres d'altitude, elles s'étendaient jadis au-dessous du niveau de la mer, ce que révèle le relief de leurs versants. **À droite:** La tribu berbère des Ait Haddidou habite la partie supérieure de la vallée d'Assif Melloul. On reconnaît les femmes Ait Brahim, la tribu berbère du sud, à leurs capes sombres à rayures.

**Seiten 382–383:** Obwohl das Atlasgebirge höher als 2000 Meter ist, lag die Region bei Imilchil einst unter dem Meer, und seine Hänge zeigen noch geologische Spuren aus dieser Zeit. **Rechts:** Das Obere Assif-Melloul-Tal ist die Heimat des Berbervolks Aït Haddidou. Frauen aus dem südlichen Zweig, Aït Brahim, tragen ein dunkles, gestreiftes Wollcape.

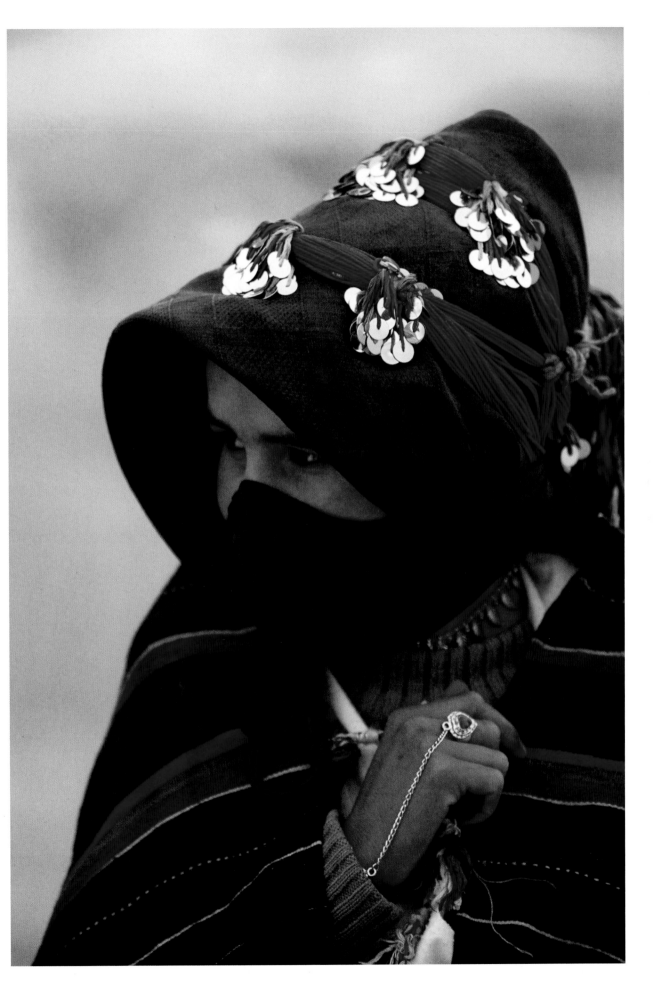

# Mariage berbère
## *Montagnes du Haut Atlas, Maroc*

La musique et la danse s'arrêtent quand deux chaises en plastique blanches sont amenées et placées contre le mur en terre. Les portes de la maison s'ouvrent et les deux jeunes mariées apparaissent, les voiles qu'elles portaient jusqu'à présent ayant disparu pour laisser place à leurs visages radieux. Elles prennent place sur les sièges et les festivités commencent. Les villageois regardent avec curiosité le visage des deux jeunes femmes qui viennent juste d'épouser deux hommes du village, devenant ainsi leurs nouvelles voisines.

Jusqu'en 1985, tous les villages du haut de la vallée de Assif Melloul, terre des Berbères Ait Haddidou, organisaient des mariages annuels en masse. Cette ancienne coutume survit encore dans les montagnes du Haut Atlas au Maroc, mais devient de plus en plus rare de nos jours. Les Ait Haddidou se répartissent en deux branches : les Ait Brahim dans le sud et les Ait Azza dans le nord. Les deux vivent principalement de l'agriculture, de la récolte de l'orge, de pommes et d'amandes. Beaucoup sont également bergers et semi-nomades, passant une partie de l'année dans le village et le reste du temps avec leurs animaux à la recherche de pâturages.

Ces régions montagneuses semblables aux déserts, dans lesquelles les cultures de chaque côté de la rivière Assif Melloul courent comme des veines vertes, ne sont pas les zones les plus riches du Maroc. Le niveau de vie dans la vallée est plus haut qu'il ne l'a été, mais reste peu élevé, et il n'est pas improbable que la tradition du mariage en masse ait, à l'origine, été pensée pour répondre à la pauvreté ou au besoin de partager les lourds coûts entraînés par un mariage. Par coutume, les personnes âgées du village de la vallée déterminent une date chaque année pour les mariages. Les couples qui souhaitent se marier donnent un burnous (manteau de laine) au chef de leur village en gage afin de confirmer leur intention de mariage à cette date.

Les mariages ont lieu après la foire annuelle d'Imilchil qui se tient début septembre, après les moissons. Il ne s'agit pas de mariages arrangés : les Berbères de l'Atlas autorisent une véritable interaction entre les garçons et les filles. Il existe de nombreuses opportunités pour les jeunes couples de se rencontrer, pour passer du temps ensemble et tomber amoureux lors des travaux dans les champs, dans les fêtes de villages ou les mariages – sans parler de la foire. Il appartient au couple de décider s'il souhaite se marier, bien que le consentement des familles soit requis avant que les noces soient annoncées.

# Berber-Hochzeit
## *Hoher Atlas, Marokko*

Musik und Tanz enden, und zwei weiße Plastikstühle werden herausgebracht und vor die Lehmwand gestellt. Die Haustür öffnet sich, und die beiden frisch verheirateten Frauen kommen heraus. Die Schleier, die bisher ihre Gesichter verborgen hatten, haben sie abgelegt.

Sie nehmen ihre Plätze ein, und das Fest geht weiter. Die Dorfbewohner studieren sehr neugierig die Gesichter der beiden jungen Frauen, die gerade zwei Männer aus dem Dorf geheiratet haben und nun ihre neuen Nachbarinnen sind.

Bis 1985 wurde in jedem Dorf im Oberen Assif-Melloul-Tal, der Heimat der Aït-Haddidou-Berber, jährlich eine Massenhochzeit abgehalten. Dieser alte Brauch hat in einigen Regionen des Hohen Atlas in Marokko bis heute überlebt, aber er ist selten geworden.

Die Aït Haddidou teilen sich in zwei Gruppen: die Aït Brahmin aus dem Süden und die Aït Azza aus dem Norden. Beide leben vorwiegend von der Landwirtschaft; sie bauen Gerste, Äpfel und Mandeln an. Viele von ihnen haben auch Vieh und sind Halbnomaden, die einen Teil des Jahres im Dorf und den anderen mit ihren Tieren unterwegs auf der Suche nach Weideland sind.

Diese wüstenartigen Bergregionen, durch die sich die Felder auf beiden Seiten des Flusses Assif Melloul wie grüne Adern ziehen, gehören nicht zu Marokkos wohlhabenderen Gebieten. Der Lebensstandard in den Tälern ist gestiegen, aber das Leben ist immer noch sehr einfach. Man hat vermutet, dass die Tradition der Massenhochzeiten sich aus der Armut der Region entwickelt hat, denn dadurch lassen sich die hohen Kosten einer Hochzeit auf viele Schultern verteilen. Dem Brauch zufolge einigten sich die Dorfältesten im Tal auf einen Termin im Jahr, an dem die Hochzeiten gefeiert werden sollten. Paare, die heiratswillig waren, gaben dem Dorfältesten einen Burnus, einen Wollumhang, als Pfand, mit dem sie versicherten, dass sie an dem entsprechenden Tag die Ehe eingehen würden.

Die Hochzeiten fanden im Anschluss an den jährlichen Markt von Imilchil statt, der immer nach der Ernte Anfang September abgehalten wird. Hier ging es nicht um arrangierte Ehen: Die Berber des Atlas erlauben den freien Umgang von Jungen und Mädchen. Für die jungen Leute gibt es reichlich Gelegenheit, sich kennenzulernen, Zeit miteinander zu verbringen und sich zu verlieben, etwa bei der gemeinsamen Feldarbeit oder den Dorffesten und Hochzeiten – vom Markt ganz zu schweigen.

Das Paar entscheidet selbst, ob es heiraten möchte, aber die Zustimmung der Familie muss doch eingeholt werden, bevor die Hochzeit stattfinden kann.

**Pages 388–389:** Imilchil's annual fair attracts Berbers from far and wide to trade cattle, sheep and numerous other commodities.

**Pages 388–389:** Venus de toute la région, les Berbères vendent et achètent bétail, moutons et maints produits divers à la foire annuelle d'Imilchil.

**Seiten 388–399:** Der jährlich stattfindende Markt von Imilchil zieht Berber von nah und fern an, die hier mit Rindern, Schafen und vielen anderen Waren handeln.

# The Imilchil fair

"He's got to be kind and not too poor, because I don't want to work too hard. And he's got to be a Berber of course."

Houda and her two girlfriends giggle and hug each other playfully as they reveal their marital preferences. Houda wears no veil and has the marks of her tribe tattooed on her chin. Her friend Saadja, here on a short visit, is also unveiled, while their friend Touda has her face covered.

It is the first day of the Imilchil fair. Here, marital prospects and potential suitors are a natural topic of conversation.

The fair is held at the shrine of a Muslim saint. The whitewashed mausoleum is open to Muslims only. Morocco is dotted with similar shrines and all host an annual religious festival, or *moussem*, which doubles as a fair. Imilchil is the most famous and often dubbed the "Brides' Fair" by foreigners because local people travel there not just to pray and trade but also to find wives and husbands.

This epithet conjures up images of women being traded, which is inaccurate. In fact it is the women who choose among the suitors rather than vice versa. The men wander round the fair in pairs, flirting with the women and eyeing them up. When a man and woman take a liking to each other they hold hands to express their sentiments and then typically take a walk, hand in hand, and spend the next few hours getting to know each other.

A man ascertains a woman's marital status by looking at her headwear. If her headscarf is wrapped tightly round her head she has never been married, but if her hair is tied in a bun beneath the headscarf she is either married, divorced or widowed.

Numerous divorced women attend the fair, many of them still teenagers. The Ait Haddidou regard divorce and remarriage as a normal part of life. After marriage, a woman retains her share of her family's possessions, making it easier for her to return to her parents' home in the event of a future separation.

Intensive marketing efforts by the Moroccan authorities have seen the Imilchil fair become an international tourist attraction in recent years, though the Berber themselves view this newfound popularity with mixed feelings. Many complain that inaccurate stories in the foreign media have misrepresented their customs to the outside world.

**Right:** Mule shoes and other iron items are among a wide assortment of goods traded at the Imilchil fair.
**Pages 392–393:** The mausoleum of Muslim saint Sidi Ahmed Oulmghani serves as a sanctuary for prayer and worship amid the hustle and bustle.

**À droite :** Des mules ouvragées aux outils en acier, on trouve un vaste assortiment de marchandises à la foire d'Imilchil.
**Pages 392–393 :** Le mausolée de Sidi Ahmed Oulmghan, un saint musulman, offre un lieu de prière et recueillement à l'écart de l'animation de la foire.

**Rechts:** Hufeisen für Maultiere und andere Dinge aus Eisen gehören zum großen Warensortiment auf dem Markt von Imilchil.
**Seiten 392–393:** Das Mausoleum des muslimischen Heiligen Sidi Ahmed Oulmghani dient inmitten des Trubels als Ort des Gebets und der Besinnung.

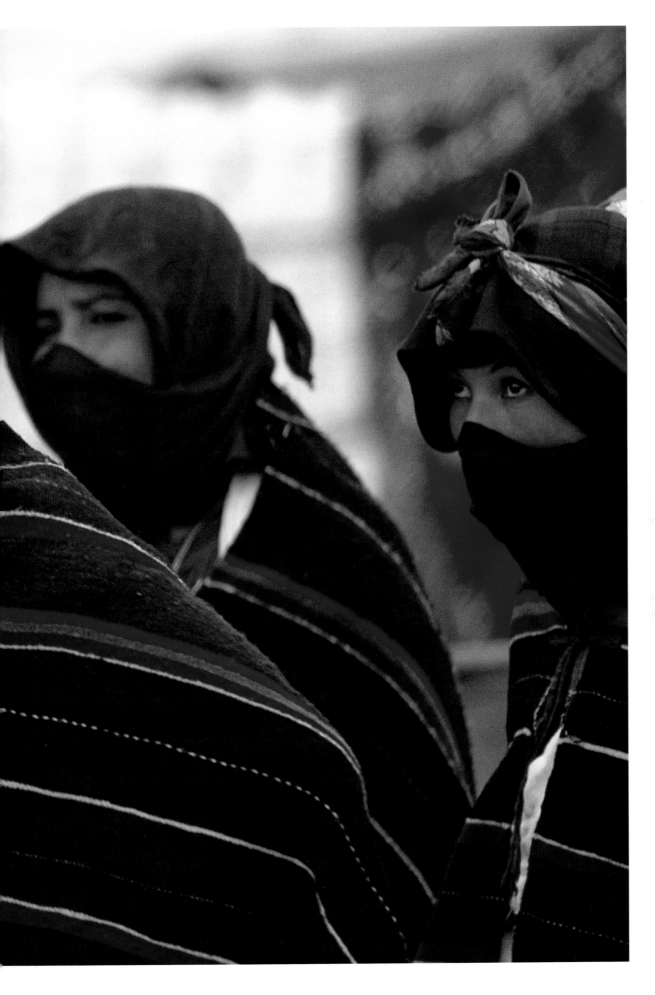

**Pages 394–395:** The Imilchil fair is a magnet for men and women seeking a marriage partner. A man looks at a woman's head apparel to check her marital status. If her hair is tied in a bun beneath her headscarf she either is or has been married. A close-fitting scarf signals that she has never been married.

**Right:** Imilchil's marriage tradition has brought it international fame. Eager to promote tourism, the authorities try to reinforce the nuptial theme by providing facilities like this goat-hair tent in the market place, where couples can sign their marriage contracts. Here, prospective brides and grooms, specially dressed for the occasion, wait for their turn to sign.

**Pages 394–395:** La foire d'Imilchil est aussi un marché matrimonial pour les deux sexes. Un homme reconnaît le statut d'une femme à sa coiffe. Si elle porte un chignon sous son foulard, elle est mariée ou l'a été. Un foulard enserrant la tête signale qu'elle est célibataire.

**À droite:** Désireux de promouvoir le tourisme, les autorités ont joué sur le thème du mariage en offrant diverses installations telles que cette tente en peau de chèvre dressée au milieu du marché, où les couples peuvent signer leurs actes de mariage. Ici, de futurs mariés, revêtus de leurs plus beaux atours, attendent leur tour pour signer. Cette tradition, unique à la foire d'Imilchil, lui a apporté une réputation internationale.

**Seiten 394–395:** Der Markt von Imilchil ist ein Magnet für Männer und Frauen, die einen Ehepartner suchen. Ein Mann betrachtet die Kopfbedeckung einer Frau, um sich über ihren Familienstand klar zu werden. Wenn das Haar unter dem Kopftuch zu einem Knoten gebunden ist, ist oder war sie verheiratet. Ein eng anliegendes Kopftuch signalisiert, dass diese Frau noch nie verheiratet war.

**Rechts:** Imilchils Hochzeitsbräuche haben es international berühmt gemacht. Mit Blick auf die Förderung des Tourismus versuchen die Behörden, den Hochzeitsaspekt zu betonen, indem sie Einrichtungen wie dieses Ziegenhaarzelt auf dem Marktplatz zur Verfügung stellen, in dem die Eheverträge unterschrieben werden können. Hier sitzen zukünftige Bräute und Bräutigame festlich angezogen und warten, bis sie an der Reihe sind.

# La foire d'Imilchil

« Il doit être gentil et pas trop pauvre, parce que je n'ai pas envie de travailler trop dur. Et, bien sûr, il doit être berbère. » Houda et ses deux amies rient et s'étreignent pour jouer tout en révélant leurs préférences matrimoniales. Houda ne porte pas de voile et présente les marques de sa tribu tatouées sur le menton. Son amie Saadja, en visite pour quelque temps, n'est pas non plus voilée, alors que son amie Touda a le visage couvert. Il s'agit du premier jour de la foire d'Imilchil. Ici, c'est le lieu idéal pour toutes les prospections et les conversations à ce sujet vont bon train.

La foire se tient sur un lieu musulman sacré. Le mausolée blanchi est ouvert uniquement aux musulmans. Le Maroc possède quelques lieux similaires et tous hébergent des festivals religieux annuels, ou *moussem*, qui sont couplés d'une foire. Celle d'Imilchil, la plus célèbre est connue sous le nom de « Foire aux mariées » par les étrangers, car la population locale n'y vient pas uniquement pour prier et négocier, mais également pour trouver une femme ou un mari.

Ce qualificatif qui évoque une image des femmes qui seraient achetées est loin d'être la réalité. En fait, ce sont les femmes qui choisissent parmi les prétendants, et non l'inverse. Les hommes arpentent la foire par deux, flirtant avec les femmes en les toisant du regard. Lorsqu'un homme et une femme se plaisent, ils se prennent par la main pour exprimer leurs sentiments et partent se promener pour apprendre à se connaître.

Un homme s'assure du statut marital de la femme en regardant son voile. Si son foulard est fermement noué autour de sa tête, c'est qu'elle n'a jamais été mariée, mais si ses cheveux sont liés dans un chignon sous le foulard, c'est qu'elle s'est déjà mariée, qu'elle est divorcée ou veuve. Beaucoup de femmes divorcées vont à la foire, certaines encore adolescentes. Les Ait Haddidou considèrent le divorce et le remariage comme faisant partie intégrante de la vie. Après le mariage, une femme conserve sa part d'héritage familial, ce qui facilite son retour chez ses parents en cas de séparation. Ces dernières années, les autorités marocaines ont réalisé un gros effort de marketing afin que la foire d'Imilchil devienne une attraction touristique internationale. Les Berbères expriment des sentiments mitigés face à cette récente popularité. En effet, beaucoup se plaignent des histoires fausses diffusées dans les médias étrangers qui ont tendance à déprécier leurs coutumes dans le monde entier.

**Right:** The father of the bride witnesses the marriage contract with a thumbprint after the couple have signed.
**Pages 400–401:** The wedding feasts are not held at the fair but at home in the villages some time later. But for the amusement of market visitors traditional wedding dances are performed during the fair. These musicians are using their drums to shield themselves from the sun between performances.

**À droite:** Le père de la mariée certifie l'authenticité de l'acte de mariage en y apposant l'empreinte de son pouce, après la signature des mariés.
**Pages 400–401:** Les célébrations des noces auront lieu plus tard, dans les villages. Mais des spectacles de danses nuptiales sont organisés à la foire pour divertir les visiteurs. Ces musiciens se protègent du soleil avec leurs tambours, entre deux représentations.

**Rechts:** Der Vater der Braut bestätigt den Ehevertrag mit dem Abdruck seines Daumens, nachdem das Paar unterschrieben hat.
**Seiten 400–401:** Die Hochzeitsfeiern werden nicht auf dem Markt, sondern etwas später in den Dörfern abgehalten, aber zur Unterhaltung der Marktbesucher werden traditionelle Hochzeitstänze vorgeführt. Diese Musiker benutzen ihre Trommeln, um sich zwischen den Aufführungen vor der Sonne zu schützen.

# Der Markt von Imilchil

„Er muss nett und nicht zu arm sein, denn ich will nicht zu hart arbeiten müssen. Und natürlich muss er ein Berber sein."

Houda und ihre beiden Freundinnen kichern und umarmen sich ausgelassen, als sie ihre Wünsche für die Hochzeit preisgeben. Houda trägt keinen Schleier; die Zeichen ihres Stammes sind auf ihrem Kinn eintätowiert. Ihre Freundin Saadja, die zu einem kurzen Besuch hier ist, ist ebenfalls unverschleiert, während Touda das Gesicht bedeckt hat. Es ist der erste Tag des Markts von Imilchil. Eheaussichten und potenzielle Verehrer sind hier ein ganz normales Gesprächsthema.

Der Markt wird am Grab eines muslimischen Heiligen abgehalten. Das weiß getünchte Mausoleum steht nur Gläubigen offen. Überall in Marokko gibt es ähnliche Schreine, die einmal im Jahr Schauplatz eines religiösen Festes oder Moussems sind, zugleich aber auch Märkte. Imilchil ist der berühmteste und wird von Ausländern oft Brautmarkt genannt, weil die Menschen aus der Region nicht nur hierherreisen, um zu beten und Handel zu treiben, sondern auch, um Ehefrauen oder -männer zu finden.

Diese Bezeichnung lässt Assoziationen an einen Markt aufkommen, auf dem Frauen verkauft werden. Das stimmt nicht. Tatsächlich sind es die Frauen, die unter den Verehrern wählen, und nicht umgekehrt. Die Männer ziehen zu zweit über den Markt, flirten mit den Frauen und mustern sie. Wenn ein Mann und eine Frau Gefallen aneinander finden, nehmen sie sich bei der Hand, um ihren Gefühlen Ausdruck zu verleihen, und verbringen ein paar Stunden miteinander, um sich kennenzulernen. Ein Mann kann den Familienstand der Frau an ihrer Kopfbedeckung ablesen. Ist ihr Schal eng um ihren Kopf gebunden, war sie noch nie verheiratet. Wenn aber ihr Haar unter dem Tuch zu einem Knoten gebunden ist, ist sie verheiratet, geschieden oder verwitwet.

Zahlreiche geschiedene Frauen besuchen den Markt, viele von ihnen sind noch Teenager. Die Aït Haddidou betrachten Scheidungen und erneute Eheschließungen als normalen Teil des Lebens. Nach der Hochzeit behält die Frau ihren Teil des Familienbesitzes. Das macht es ihr viel leichter, in ihr Elternhaus zurückzukehren, sollte es später zur Trennung kommen.

Dank intensiver Marketingbemühungen der marokkanischen Behörden ist der Markt von Imilchil in den vergangenen Jahren zu einer internationalen Touristenattraktion geworden. Die Berber selbst betrachten ihre plötzliche Beliebtheit mit gemischten Gefühlen. Viele beklagen sich darüber, dass unrichtige Darstellungen in den ausländischen Medien ihre Bräuche in einem falschen Licht erscheinen lassen.

**Pages 402–403:** Ait Haddidou men and women interact freely, which includes dancing together. Women wearing predominantly white cloaks are members of Ait Azza, the tribe's northern branch.
**Right:** A mock wedding is held for the benefit of curious visitors. The bride wears traditional silver and amber jewellery and is veiled to protect her from the evil eye.

**Pages 402–403:** Chez les Ait Haddidou, hommes et femmes ont des contacts libres et dansent ensemble. Les femmes portant des capes de couleurs claires appartiennent à la trivu Ait Azza, la branche berbère du nord.
**À droite:** Un simulacre de mariage à l'intention des touristes. L'épousée arbore les bijoux traditionnels d'argent et d'ambre. Le voile est censé la protéger du mauvais œil.

**Seiten 402–403:** Die Männer und Frauen der Aït Haddidou pflegen ein ungezwungenes Miteinander, was auch das Tanzen einschließt. Frauen, die vorwiegend weiße Umhänge tragen, gehören zu den Aït Azza, dem nördlichen Zweig des Stammes.
**Rechts:** Für die neugierigen Besucher wird eine Hochzeit inszeniert. Die Braut trägt den traditionellen Silber- und Bernsteinschmuck und ist zum Schutz vor dem bösen Blick verschleiert.

# The wedding day

As dusk falls on the flat roof, the two grooms Mbarch and Hassan stand in ankle-length white djellabas and red turbans gazing down at the open space below.

The brothers watch as their brides arrive on the backs of mules at the entrance. The women are about to be helped to dismount and taken into the house, where tonight they will spend their first night. The couples signed their nuptial contracts a few days ago in Rich, 150 kilometres or so east of Imilchil. Two days of festivities now await them before they can consummate their marriages.

This is a sensitive period for the women in the no-man's-land between married and unmarried status. Cocooned in heavy striped cloaks, their heads covered by red veils, they can neither see nor be seen. Inside these shells, designed to ward off the evil eye, they are preparing for their new lives as wives.

The day has been filled with the rituals involved in a local wedding. During the morning, Hassan and Mbarch's father baked traditional unleavened wedding bread. The womenfolk rubbed the brothers' hands and feet in henna, after which the grooms had to wait patiently while their relatives drove off in two trucks to collect the brides and their families.

After a journey across the treeless mountain landscape, the escorts arrive at their bride's village. With them they have gifts for the bride and her family – clothing, perfume and sugar, the latter a peace offering. Outside the home of the bride they dance carrying bags and boxes on their heads.

Once inside there is more singing and dancing. Then the important henna ceremony follows. The grooms' eldest brother and sister, who cannot be at two places at the same time, participate in one of the brides' ceremonies by smearing her hair with the greyish-green henna paste, which colours whatever it touches red.

Were the ceremony being hosted by the Ait Brahim, the southern branch of the Ait Haddidou, the escorts would have stayed overnight in the villages. But everybody involved belongs to the Ait Azza who have different customs and the visitors leave with the brides and their families after a few hours.

The bride is now swathed from head to toe in thick layers of clothing. To protect her from black magic and evil spirits, an aunt carries the bride from her home to the waiting truck. The two vehicles have a prearranged rendezvous to ensure they arrive at the grooms' village together. On reaching the village, the brides transfer to mules, the traditional form of bridal transport.

Each bride is joined on her mule by a young girl from the groom's family to symbolise the children expected to result from the nuptials. According to tradition, the brides should also carry a lamb with them as a symbol of prosperity, but Mbarch and Hassan's family were unable to get hold of any lambs for the occasion.

Virtually the entire village has turned out to witness the spectacle, and a large crowd follows the mules to the grooms' house. The brides must still not touch the ground, so the groom's sister and cousin carry them piggy-back style into the house. The threshold is considered a treacherous place where people are vulnerable to black magic, so before the brides enter, they dip their fingers into bowls of butter and milk, symbols of purity and life, and smear some on the doorframe. They then enter and the door closes behind them.

This is the cue for the festivities to start in the open space outside. Later, the guests will move indoors and celebrate through the night. Just as during all of the

**Right:** A father bakes traditional unleavened bread on hot stones outside his home for his two sons on their wedding morning. The bread will be given to the brides' families as a gift.

**À droite:** Au matin des noces de ses deux fils, un père cuit le traditionnel pain sans levain sur des pierres chaudes, devant sa maison. Ce pain sera offert aux familles des mariées.

**Rechts:** Am Morgen des Hochzeitstags seiner beiden Söhne backt ein Vater vor seinem Haus das traditionelle ungesäuerte Brot auf heißen Steinen. Das Brot ist als Geschenk für die Familien der Bräute gedacht.

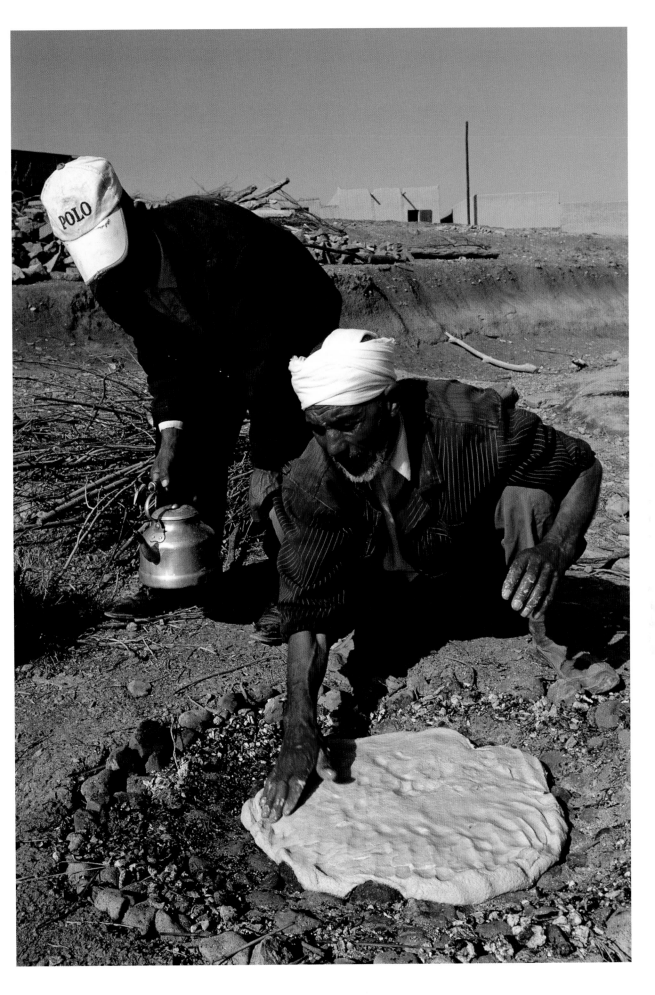

wedding ceremony, the guests are served plates of food and bread, and glass upon glass of sweet mint tea. The cushion-lined, whitewashed walls of the two guest rooms are soon brimming with wedding guests.

The brides, however, take no part in the partying. Still veiled, they remain secluded with their mothers. Not until late afternoon on the second day are their veils removed – and then only in the presence of female family members.

The music and dancing continue. When the night of the second day is drawing near, the guests return outside the house, where young women gyrate and swing their hips in time to the music. A highlight is the *ahidouss n'tislit*, a special dance to welcome the bride to the village. Two lines, men and women next to one another, dance shoulder to shoulder and hip to hip with those beside them. It is a slow event, with frequent stops during which the dancers, with knees slightly bent, prop themselves up against the person either side of them. Only women who are widows or divorcees but currently unmarried are permitted to take part.

Otherwise, the standard dance involves everyone facing each other in a large ring and slowly moving round in a circle. The young men on the drums set a fast beat, and even the children seem able to master the complicated rhythms that involve a simultaneous triple and quadruple beat. A shrill clarinet plays the tunes.

On the fringes, children play-wrestle and chase each other through the throng of grown-ups. At one point, one of the male guests falls into a trance and collapses in spasms on the ground.

Above the dancing area, the stars shine brightly in the chilly night air and the cube-like outlines of the houses are framed against the mountains.

Eventually the brides emerge to take their seats outside the house. Their woollen capes are gone, replaced by flowing white and gold-coloured robes. Their hair is tied up in the bun-like style of a married woman and covered with a dark scarf knotted with colourful ribbons.

Gone, too, are their veils. Saadea, eighteen, and Fatima, twenty-one, show their faces for the first time – a proud and emotional moment for the grooms' family. Their duty done, the brides do not linger long and soon return inside. Not until tomorrow will the marriage ceremonies be concluded, whereupon the brides will each move into their own room in the house and spend the first night with their new husbands.

# Le jour du mariage

Au moment où les lumières du crépuscule atteignent les toits plats des maisons, les deux mariés Mbarch et Hassan sortent vêtus de longues djellabas blanches et de turbans rouges. Le regard des deux frères se tourne alors vers les jeunes mariées montées sur des mules qui franchissent le seuil de la cour. Elles sont très attendues et sont immédiatement aidées, portées jusqu'à la maison où elles passeront leur première nuit. Les couples ont déjà signé les contrats nuptiaux quelques jours auparavant à Rich, situé à environ 150 kilomètres d'Imilchil. Deux jours de festivité les attendent maintenant avant qu'ils ne consomment leurs mariages.

Pour les femmes, il s'agit d'une période délicate où elles n'ont pas encore le statut d'épouses. Enroulées dans de lourdes capes rayées, la tête couverte par des voiles rouges, elles ne voient rien et ne doivent pas être vues. Sous ces couches de tissu, destinées à les protéger des esprits du mal, elles se préparent à leur nouvelle vie de femmes mariées.

La journée s'est déroulée selon les rituels communs à tous les mariages locaux. Le matin, le père d'Hassan et de Mbarch a confectionné le pain sans levain traditionnel des jours de noce. Les femmes ont recouvert de henné les mains et les pieds des frères. Les mariés ont ensuite patienté jusqu'à l'arrivée des deux camions conduits par des parents, qui amenaient les mariées accompagnées de leurs familles.

Après le voyage au cœur de la montagne aride, les escortes sont arrivées dans le village des futures mariées, les bras chargés de cadeaux – vêtements, parfums et sucre, symbole de paix. Dehors, les femmes dansent tout en portant de gros sacs ou des boîtes sur la tête.

Une fois à l'intérieur de la maison, les chants et la danse s'amplifient. Puis vient le moment de la grande cérémonie du henné. Le frère et la sœur aînés du marié, qui ne peuvent pas se trouver à deux endroits en même temps, participent à l'une ou l'autre des cérémonies ; ils enduisent les cheveux de la future épousée avec la pâte de henné gris-vert qui deviendra vite rouge.

Si la cérémonie avait été pratiquée par des Ait Brahim, la branche sud des Ait Haddidou, les escortes auraient passé la nuit dans les villages. Mais tout le monde ici appartient aux Ait Azza dont les coutumes diffèrent et, après quelques heures, les escortes repartent avec les jeunes épousées et leurs familles.

La mariée est maintenant enveloppée de la tête aux pieds de couches épaisses de vêtements. Afin de la protéger de la magie noire et des esprits malins, une de ses tantes la porte sur son dos pour parcourir la distance entre le camion et la maison. Les deux camions se sont organisés pour arriver en même temps au village des mariés. Une fois au village, les mariées sont déplacées sur des mules, le transport traditionnel lors des noces. Chacune d'elles est accompagnée d'une fillette issue de la famille des mariés, symbolisant ainsi l'enfant attendu du mariage. Selon la tradition, les mariées devraient également porter un agneau, symbole de prospérité, mais la famille de Mbarch et Hassan n'a pas réussi à trouver d'agneaux pour l'occasion.

Pratiquement tout le village s'est rassemblé pour assister au spectacle, et une foule de gens suit les mules en direction de la maison des époux. Les mariées ne sont toujours pas autorisées à toucher le sol, la sœur et le cousin des mariés se chargeant de les porter sur leur dos jusqu'à la maison. Le passage du seuil est délicat, car il s'agit d'un endroit où les personnes demeurent vulnérables à la magie noire. Aussi, avant que les mariées n'entrent, elles trempent leurs doigts dans des bols de beurre

**Pages 410–411:** Womenfolk rub the grooms' hands and feet with henna and sing to wish them luck and prosperity.
**Pages 412–413:** Two escort parties drive off to collect the brides and their families, playing music and singing as they go.
**Pages 414–415:** While being welcomed by the villagers the women in the escort dance in front of the bride's home, some carrying bags of presents on their heads.

**Pages 410–411:** Des femmes enduisent les mains et les pieds du marié de henné ; elles chantent pour lui souhaiter bonheur et prospérité.
**Pages 412–413:** Deux convois vont chercher les épousées et leurs familles dans leurs villages. Les participants chantent et dansent tout au long du chemin.
**Pages 414–415:** Accueillies par les villageois, les femmes du cortège dansent devant la demeure d'une épousée ; quelques-unes portent des sacs de cadeaux sur leurs têtes.

**Seiten 410–411:** Frauen reiben Hände und Füße der Bräutigame mit Henna ein und wünschen ihnen singend Glück und Wohlstand.
**Seiten 412–413:** Zwei Eskorten fahren musizierend und singend los, um die Bräute und ihre Familien abzuholen.
**Seiten 414–415:** Während sie von den Dorfbewohnern begrüßt werden, tanzen die Frauen aus der Eskorte vor dem Haus der Braut, einige tragen Taschen mit Geschenken auf dem Kopf.

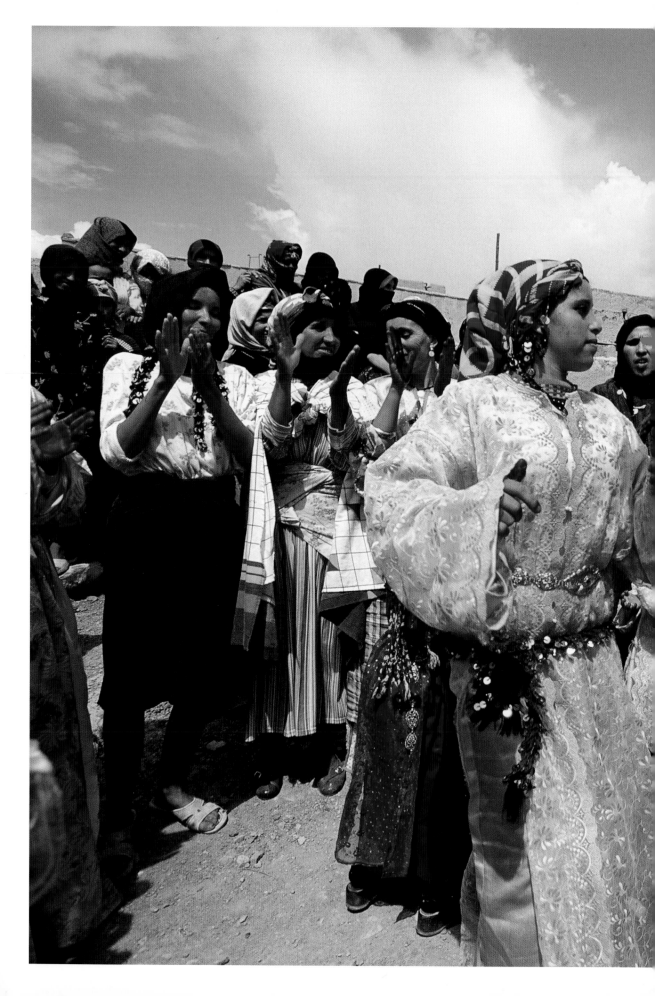

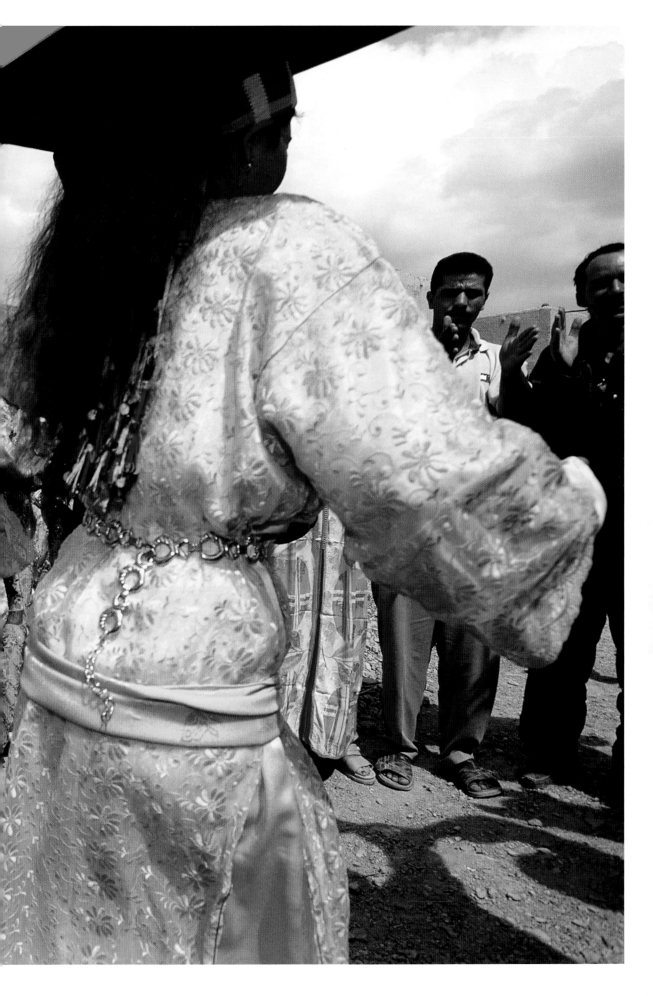

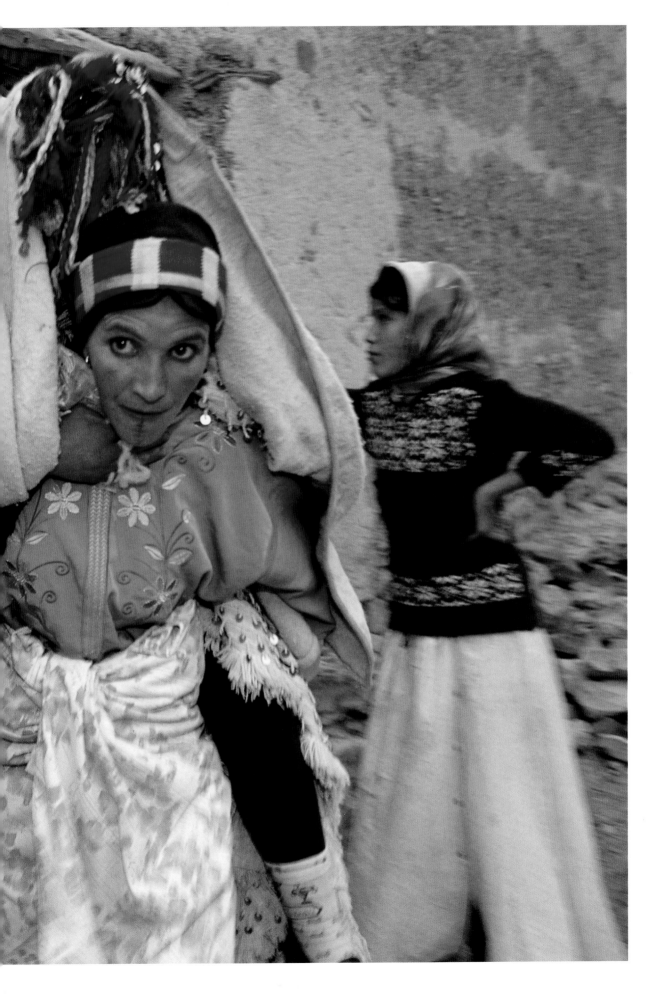

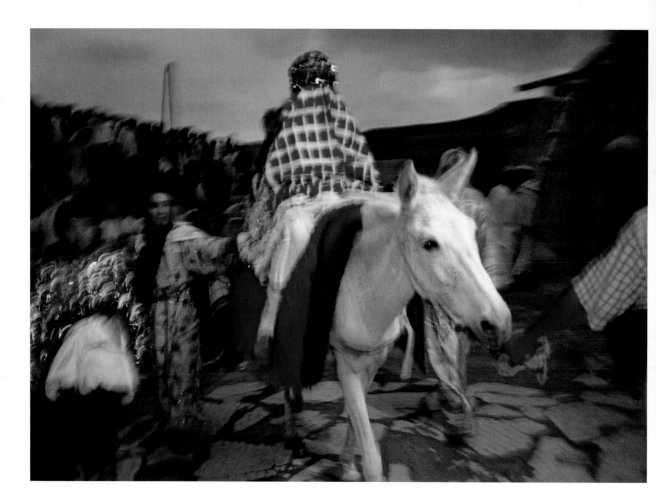

et de lait, symboles de pureté et de vie, avant de toucher le cadre de la porte d'entrée. Elles franchissent enfin le pas de la porte qui se referme derrière elles.

C'est le signal que les festivités peuvent commencer à l'extérieur. Plus tard, les invités rentreront et participeront à la cérémonie toute la nuit. Comme lors de toutes les cérémonies de mariage, des assiettes de nourriture et de pain sont servies aux invités, accompagnées d'innombrables tasses de thé à la menthe sucré. La maison aux murs blanchis s'emplit bientôt d'invités.

Les jeunes mariées ne prennent pas part à la fête. Toujours voilées, elles restent isolées avec leurs mères. Elles ne quitteront leurs voiles qu'en fin d'après-midi le deuxième jour, et seulement en présence des femmes de leurs familles. La musique et la danse persistent. La nuit suivant le deuxième jour, les invités quittent la maison, des femmes se dandinant au son de la musique. Le moment fort, *ahidouss n'tislit* est une danse spéciale de bienvenue au village adressée à la mariée. Deux rangs d'hommes et de femmes dansent alors épaules contre épaules, hanches contre hanches les uns à côté des autres, se livrant à des déplacements lents rythmés par de fréquents arrêts lors desquels les danseurs plient les genoux et se relèvent en se raccrochant à leurs voisins. Seules les veuves et les femmes divorcées, donc célibataires, sont autorisées à y participer.

Cette danse typique implique que tous s'unissent dans une grande ronde qui se déplace très lentement, créant de lancinantes ondulations. Les jeunes hommes guident la danse avec des percussions aux rythmes multiples et compliqués que les enfants suivent simultanément. Une clarinette entonne quelques airs.

Aux abords, des enfants jouent à se battre et à se poursuivre dans la foule d'adultes. À un certain moment, l'un des invités entre en transe et s'écroule à terre dans

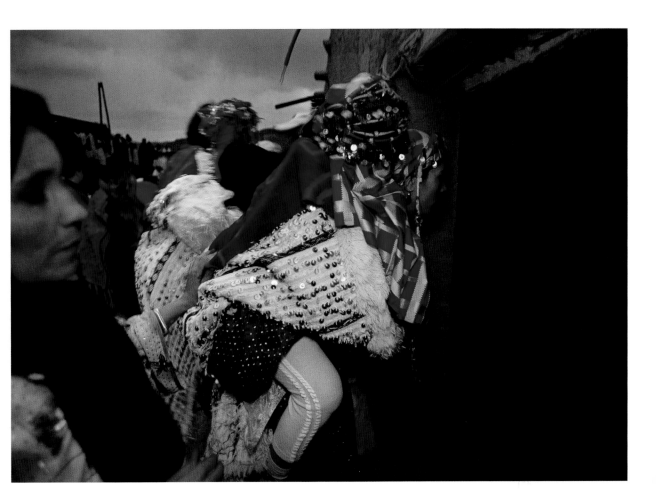

**Above and left:** Still fully veiled, the brides cover the final distance on mules. On arrival they are lifted off and carried over the threshold into the house.

**Ci-dessus et à gauche:** Entièrement voilées, les épousées parcourent les derniers mètres du chemin à dos de mule. À l'arrivée, elles sont soulevées et portées à l'intérieur des maisons des maris.

**Oben und links:** Immer noch vollständig bedeckt, legen die Bräute den letzten Teil der Strecke auf Maultieren zurück. Bei ihrer Ankunft werden sie von den Tieren gehoben und ins Haus getragen.

de longs spasmes. Les étoiles illuminent le ciel de la nuit fraîche, soulignant les contours des maisons en forme de cube, encadrées par les montagnes.

Les mariées sortent enfin pour prendre place sur les sièges placés à l'extérieur de la maison. Elles ont quitté leurs capes de laine et portent de vaporeuses robes blanches et or. Leurs cheveux sont tirés en chignons typiques des femmes mariées, couverts par une étole sombre nouée par des rubans colorés. Les voiles ont également disparu. Saadea, dix-huit ans, et Fatima, vingt et un ans, montrent leurs visages pour la première fois – un grand moment d'émotion teinté de fierté pour la famille des mariés. Leur devoir accompli, les mariées ne s'attardent pas et retournent aussitôt à l'intérieur. Lorsque les cérémonies du mariage seront achevées, les mariées se rendront chacune dans une pièce de la maison pour passer leur première nuit avec leurs nouveaux maris.

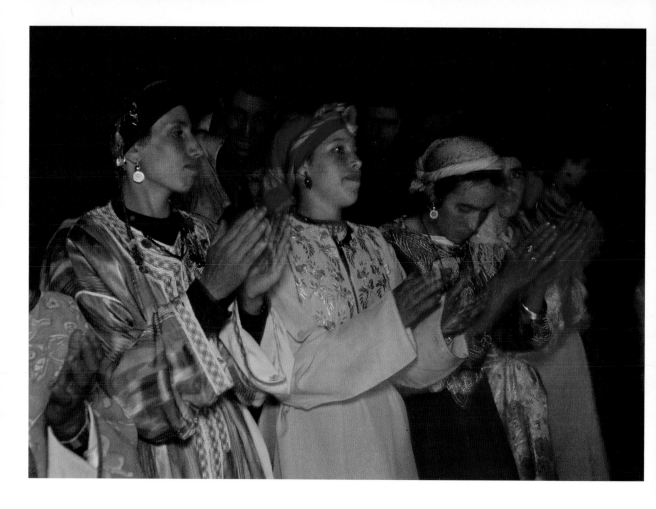

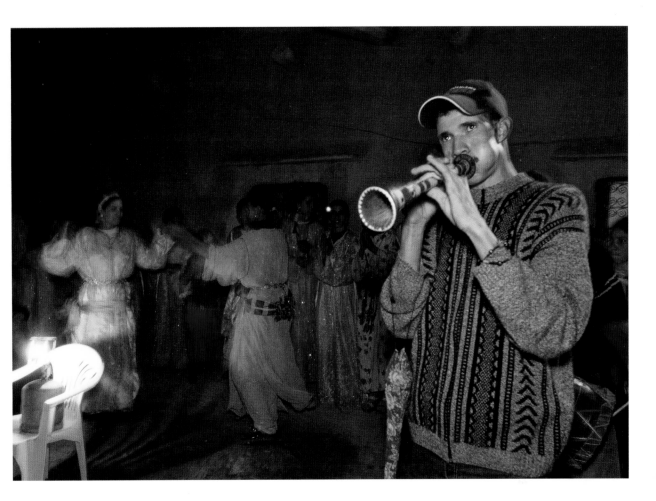

**Above, left and pages 422–423:** The singing and dancing gets under way outside while the brides are secluded in a special room inside the house. Later the wedding guests move indoors, where the party continues through the night and the next day. At dusk on day two the guests move back out into the open space outside the house.

**Ci-dessus, à gauche et pages 422–423 :** Pendant que les invités continuent de danser et chanter dehors, les épousées sont isolées dans une pièce spéciale de la maison. Plus tard, tout le monde rentrera à l'intérieur et la fête se poursuivra toute la nuit et le lendemain. Au soir du deuxième jour, les invités se rassemblent de nouveau à l'extérieur, devant la maison.

**Oben, links und Seiten 422–423:** Während die Bräute in einem besonderen Raum im Haus allein bleiben, beginnen draußen Gesang und Tanz. Später gehen die Gäste ins Haus, wo die Party bis spät in die Nacht und auch am nächsten Tag weitergeht.
In der Abenddämmerung des zweiten Tages begeben sich die Gäste wieder vor das Haus.

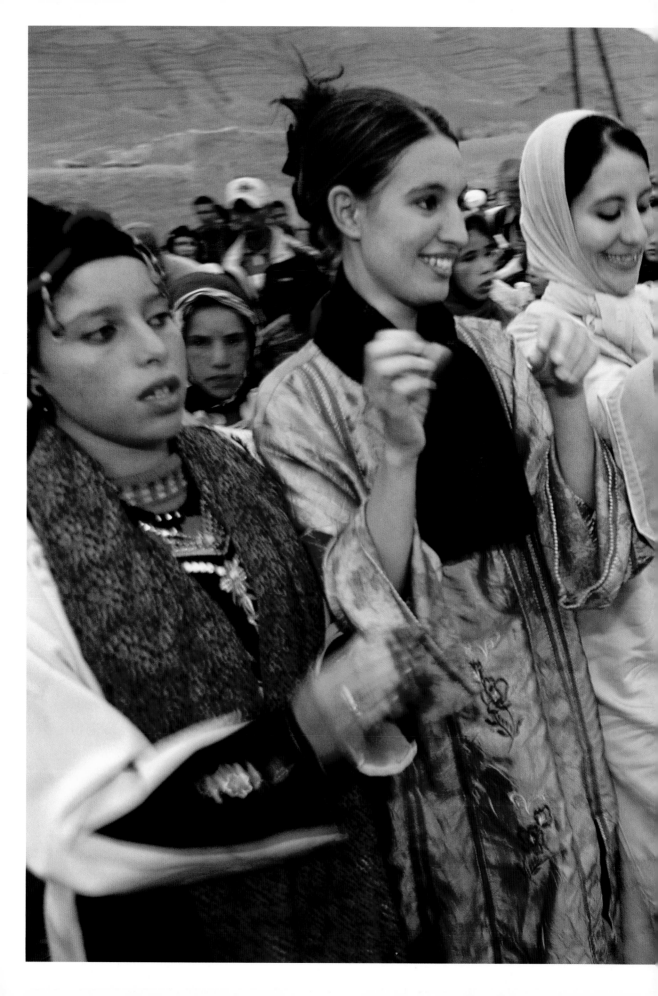

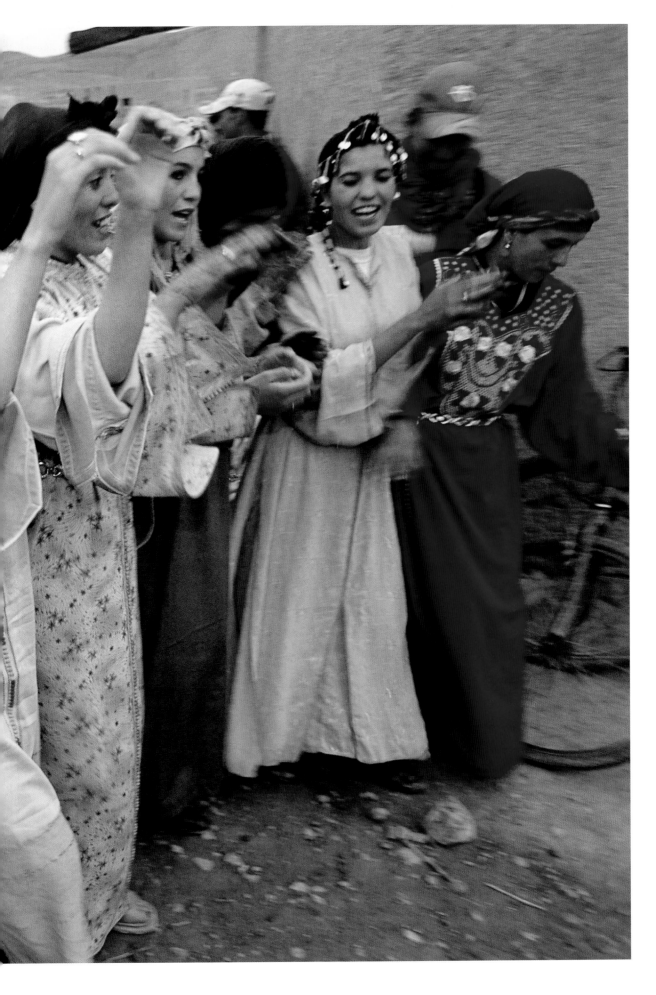

# Der Hochzeitstag

Bei Anbruch die Dämmerung blicken die beiden Bräutigame Mbarch und Hassan in knöchellangen Jellabas und roten Turbanen vom flachen Dach ihres Hauses hinunter in das offene Land.

Die Brüder sehen zu, wie ihre Bräute auf dem Rücken von Maultieren auf den Eingang zukommen. Gleich wird man ihnen beim Absteigen helfen und sie ins Haus bringen, wo sie heute ihre erste Nacht verbringen werden. Die Paare haben ihre Eheverträge vor ein paar Tagen in Rich, etwa 150 Kilometer östlich von Imilchil unterzeichnet. Jetzt warten zwei Tage mit nichts anderem als feiern auf sie, bevor sie ihre Ehen vollziehen können.

Für die Frauen ist diese Zeit im Niemandsland zwischen Vorehe- und Ehestand schwierig. Sie sind in schwere gestreifte Umhänge gewickelt, ihre Köpfe sind mit roten Schleiern bedeckt, sie können weder sehen noch gesehen werden. Innerhalb dieser Kokons, die den bösen Blick abwehren sollen, bereiten sie sich auf ihre Rollen als Ehefrauen vor.

Der Tag war angefüllt mit den Ritualen, die hier zu einer Hochzeit gehören. Am Morgen hatte Hassans und Mbarchs Vater das traditionelle ungesäuerte Hochzeitsbrot gebacken; unterdessen hatten die Frauen Hände und Füße der Brüder mit Henna eingerieben. Danach mussten die Bräutigame geduldig warten, nachdem die Verwandtschaft in Lastwagen losgefahren war, um die Bräute und ihre Familien abzuholen.

Nach der Reise durch die baumlose Berglandschaft kam die Eskorte im Dorf der Braut an. Sie haben Geschenke für die Braut und ihre Familie mitgebracht – Kleidung, Parfüm und Zucker, Letzteres ist eine Sühngabe. Vor dem Haus der Braut tanzten sie mit Taschen im Arm und Kartons auf dem Kopf.

Nachdem sie das Haus betreten hatten, wurde weiter gesungen und getanzt. Dann folgte die wichtige Hennazeremonie. Der älteste Bruder und die älteste Schwester des Bräutigams, die nicht an zwei Orten gleichzeitig sein können, nehmen jeweils nur an einer der Brautzeremonien teil und reiben das Haar der Braut mit einer gräulich-grünen Hennapaste ein, die alles, was sie berührt, rot färbt.

Hätten Aït Brahim, der südliche Zweig der Aït Haddidou, dieses Fest ausgerichtet, wären die Eskorten über Nacht im Dorf geblieben. Aber alle Betroffenen gehören zu den Aït Azza, die andere Bräuche haben. Und so sind die Besucher mit den Bräuten und ihren Familien schon ein paar Stunden später wieder aufgebrochen.

Die Braut wurde von Kopf bis Fuß in dicke Lagen von Kleidern gewickelt. Um sie vor schwarzer Magie und dem bösen Blick zu schützen, hat eine Tante sie vom Haus zu dem wartenden Lastwagen getragen. Die beiden Laster haben sich an einer festgelegten Stelle getroffen, um ganz sicher gleichzeitig im Dorf der Bräutigame anzukommen. Sobald sie das Dorf erreicht hatten, stiegen die Bräute auf Maultiere um, die traditionelle Art für eine Braut zu reisen.

Jede Baut wird auf ihrem Maultier von einem kleinen Mädchen aus der Familie des Bräutigams begleitet. Sie steht symbolisch für den Kindersegen, der aus der Ehe hervorgehen soll. Eigentlich will es die Tradition auch, dass die Bräute ein Lamm als Zeichen des Wohlstands mit sich führen, aber die Familie von Mbarch und Hassan konnte kein Lamm auftreiben.

Die Dorfgemeinschaft ist so gut wie vollständig erschienen, um bei dem Spektakel dabei zu sein, und eine große Menge folgt den Maultieren zum Haus der Bräu-

**Right:** The big moment arrives when the two brides emerge from the house minus their veils to show their faces to the villagers for the first time. The party then continues for a second night.

**À droite :** Apogée de la fête : les deux épousées dévoilées sortent de la maison et montrent pour la première fois leurs visages aux villageois. La deuxième nuit de fête ne s'achèvera qu'au petit matin.

**Rechts:** Der große Moment ist gekommen, als die beiden Bräute ohne Schleier aus dem Haus treten, um den Dorfbewohnern zum ersten Mal ihre Gesichter zu zeigen. Das Fest geht dann noch eine Nacht lang weiter.

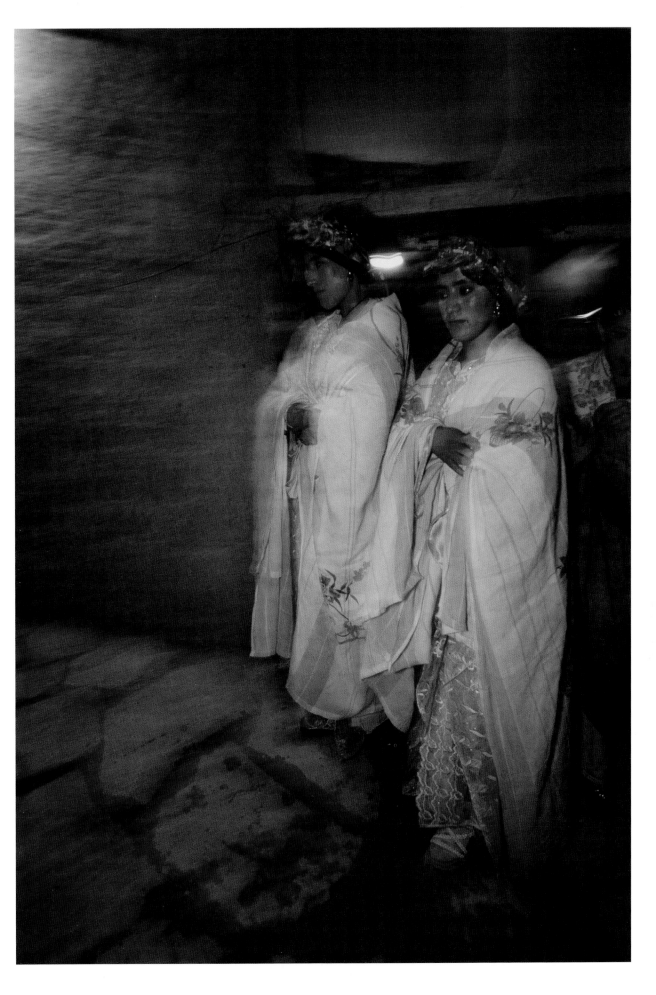

tigame. Die Bräute dürfen noch immer nicht den Boden berühren, deshalb werden sie von Schwester und Cousine der Bräutigame huckepack ins Haus getragen. Die Türschwelle wird als gefährlicher Ort für all jene betrachtet, die für schwarze Magie anfällig sind. Daher tauchen die Bräute ihre Finger in Schüsseln mit Butter und Milch, Symbolen der Reinheit und des Lebens, und streichen etwas davon auf den Türrahmen. Dann treten sie ein, und die Tür schließt sich hinter ihnen.

Das ist das Zeichen für den Beginn des Festes. Später werden die Gäste ins Haus gehen und die Nacht hindurch feiern. Die ganze Hochzeitszeremonie über werden sie mit Tellern voller Speisen und Brot und Glas auf Glas süßem Pfefferminztee bewirtet. Entlang der weiß getünchten Wände der beiden Gästezimmer liegen Kissen, und bald herrscht ein emsiges Treiben.

Die Bräute aber nehmen nicht am Fest teil. Sie sind noch immer verschleiert und bleiben mit ihren Müttern allein. Erst am späten Nachmittag des zweiten Tages legen sie ihre Schleier ab – und auch dann nur in Gegenwart der weiblichen Familienmitglieder.

Musik und Tanz gehen unterdessen weiter. Als der Abend des zweiten Tags naht, begeben sich die Gäste wieder nach draußen, wo junge Frauen ihre Hüften zur Musik wiegen und schwingen. Ein Höhepunkt ist der Ahidouss n'tislit, ein besonderer Tanz, der die Bräute im Dorf willkommen heißt. In zwei Reihen tanzen Männer und Frauen bunt gemischt, Schulter an Schulter und Hüfte an Hüfte. Es ist ein langsamer Tanz, bei dem die Tänzer oft mit leicht gebeugten Knien anhalten und sich an die Person neben ihnen lehnen. Nur Frauen, die verwitwet oder geschieden sind, dürfen an diesem Tanz teilnehmen.

Sonst stehen die Tänzer sich in einem großen Kreis gegenüber, der sich langsam in der Runde bewegt. Die jungen Trommler erhöhen das Tempo, und sogar die Kinder scheinen die komplizierten Rhythmen schon zu beherrschen, in denen gleichzeitig drei- und vierfache Schläge vorkommen. Eine schrille Klarinette spielt die Melodie.

Am Rand des Geschehens balgen und jagen sich die Kinder durch die Menge der Erwachsenen. Plötzlich fällt einer der Gäste in eine Trance und windet sich in Krämpfen am Boden.

Über dem Tanzbereich scheinen die Sterne hell in der kalten Nachtluft, und die würfelförmigen Umrisse der Häuser zeichnen sich gegen die Berge ab.

Schließlich erscheinen die Bräute, um vor dem Haus ihre Plätze einzunehmen. Sie haben ihre Wollcapes abgelegt und tragen nun fließende weiße und goldfarbene Kleider. Ihr Haar ist im Stil der verheirateten Frauen zu einem Knoten gebunden und wird von einem dunklen Schal mit bunten Bändern bedeckt.

Auch die Schleier sind fort. Saadea, 18, und Fatima, 21 Jahre alt, zeigen zum ersten Mal ihre Gesichter – ein stolzer und emotionaler Augenblick für die Familien der Bräutigame. Nachdem sie ihre Pflicht getan haben, halten sich die Bräute nicht lange draußen auf und kehren bald ins Haus zurück. Die Hochzeitszeremonien werden erst am folgenden Tag abgeschlossen sein. Dann ziehen die Bräute in ihre eigenen Zimmer und verbringen die erste Nacht mit ihrem neuen Ehemann.

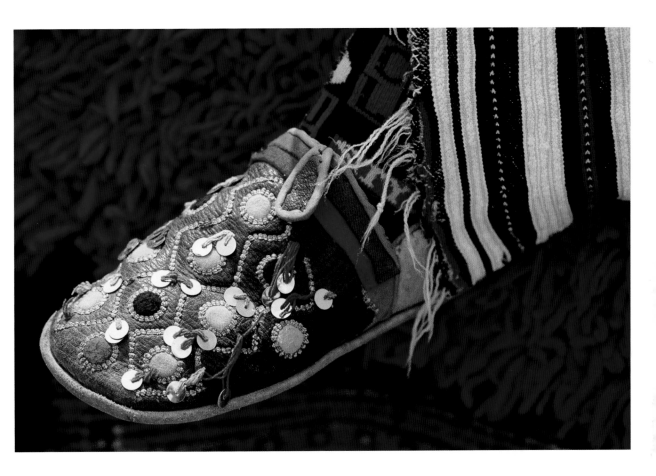

**Above:** Decorative bridal
shoe.

**Ci-dessus:** Mule de mariée
richement ornée.

**Oben:** Ein geschmückter
Brautschuh.

# Childbirth ceremony
## *Palau, Micronesia*

Flo, the medicine woman, fills the coconut shell with steaming hot water from the bucket on the bamboo floor and gives Edangel a good dousing. Drops spatter against the walls of the shack and Edangel, sitting naked on a mat of palm leaves, moans in discomfort. Edangel gave birth to her first child three and a half months ago and now she is undergoing the *ngasech*, a childbirth ritual that all first-time mothers in Palau must complete.

Her skin glistens with the yellowish sheen of coconut oil and turmeric and the room is filled with the sweet scent of water boiled with leaves from a wax apple tree.

It is the third and penultimate day of Edangel's hot-water cleansing ritual. On the fifth day she will take a steam bath and then dress in traditional costume before emerging to show herself and her infant child to her husband's family.

Edangel is staying at her uncle's house. In the old days, a mother-to-be would move to her maternal uncle's or parents' home four months before the birth, not returning to her husband for up to a year. But most births nowadays take place at the hospital in Koror, the biggest city in Palau, and Edangel does not need to visit her maternal family until it is time for her ngasech.

Palauans see the ritual as so important that new mothers living abroad in the United States, with which Palau has close ties, return home for it. It is considered to have health benefits and Palauans also attach great social significance to the event. The clothes worn by the mother when she "comes out" and the gifts exchanged by the families are regarded as important indicators of clan status and relations.

Flo continues her work, repeatedly throwing hot water at Edangel. Cleansing is always from the head down, starting with the eyes, then the neck, arms, chest, genitals, thighs and finally the woman's lower legs and feet, six times for each part of the body. Some parts are more sensitive to the steaming water than others and Edangel moans in pain when it hits her armpits and genitals.

Flo prepares a new bath, refilling the bucket with piping hot water and leaves from a wax apple tree. She washes Edangel four times with the leaves before rinsing her with the water. She then fills the bucket again and repeats the whole procedure twice more before the next round of dousing begins.

A "bath" thus consists of three sessions of washing plus a session of dousing. As if this was not enough, in Edangel's case she has sixteen such baths twice a day.

"It's hard for her," says Flo afterwards, shaking her head in sympathy as she makes herself a fresh betel chew. She crushes the nut with a cracker, wraps it in pepper vine leaf, adds a sliver of lime and pops the chew into her mouth with a red-coloured grin, revealing her dark, betel-stained teeth.

Edangel is now wrapped in a piece of cloth and sitting cross-legged on a bench breastfeeding her baby. Unpleasant as the baths may be, she makes no complaint and looks a picture of happiness as she feeds her infant.

The house is a hive of activity and the preparations for Edangel's "coming out" are in full swing. Relatives come and go, taro and manioc are peeled, a pig is slaughtered, a tortoise is butchered and packed in ice and a delivery truck arrives with crates of soft drinks and bottled water for the party.

Late in the afternoon of the day before the coming-out ceremony, a group of women travel in a pick-up truck across the bridge to the island of Babeldaob to pick the herbs

**Pages 428–429:** Protected by a large barrier reef, the Rock Islands of Palau rise like green mushrooms from the Pacific.
**Right:** A mother nurses her baby daughter during a break from one of the many hot baths required for her *ngasech*, the traditional ceremony that all women in Palau undergo after having given birth for the first time.

**Pages 428–429 :** Protégées par une large barrière de corail, les îles Palau émergent du Pacifique comme d'énormes champignons verts.
**À droite :** Une maman nourrit son bébé entre deux des nombreux bains bouillants qu'elle doit prendre pendant le *ngasech*, le rituel traditionnel que toutes les femmes de Palau accomplissent après un premier enfantement.

**Seiten 428–429:** Im Schutz eines großen Barriereriffs erheben sich die Felsinseln von Palau wie grüne Pilze aus dem Pazifik.
**Rechts:** Eine Mutter stillt ihre Tochter während einer Pause zwischen den vielen heißen Bädern des Ngasech, einer Zeremonie, der sich alle Frauen in Palau nach der Geburt ihres ersten Kindes unterziehen.

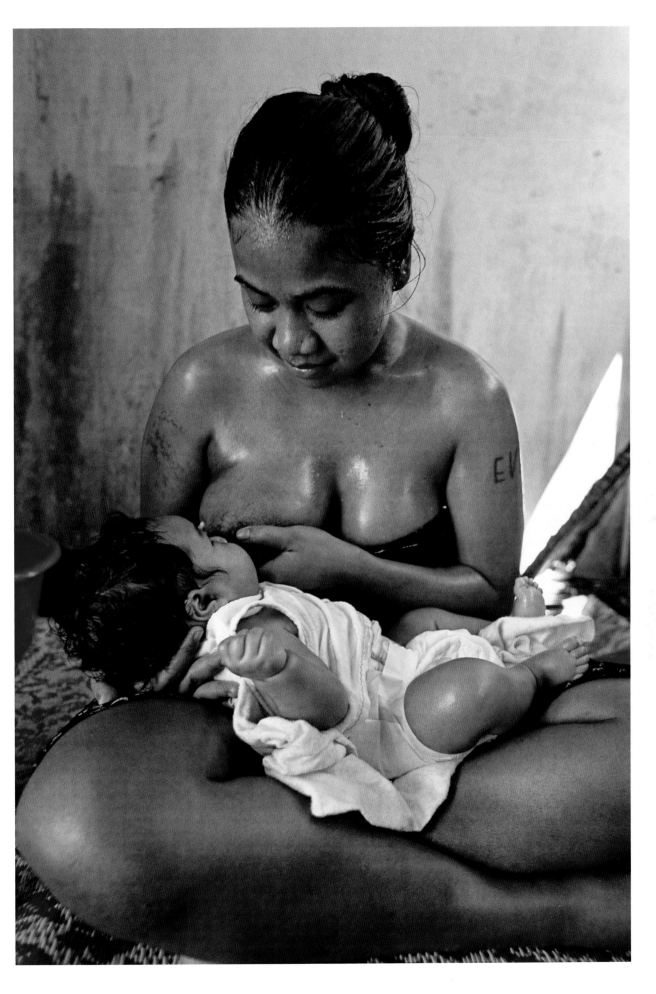

needed for the steam bath. They have to hurry to find all the different kinds of herbs before the sun goes down.

The following morning Flo then puts the herbs in a cauldron and boils them in water on the gas fire outside the bathing shack. She has turned it into a steam-hut by hanging blankets from steel wires. A more traditional way is to build a small cone-shaped hut of bamboo and cover it with blankets.

Flo puts out a stool with a hole in it for Edangel to sit on and places a bucket of boiling water underneath. She leaves Edangel alone in the steam bath, carefully arranging the blankets to make sure that no steam escapes.

As with the entire ritual, the steaming is intended to purify the body. Palauans say it removes old skin, smoothes out stretch marks and "cleanses the womb". Flo likens it to cleaning a room after a drunken party: "You wash away all the bad stuff."

However, *ngasech* is not considered sufficient to restore the mother's health. So, after the ritual women also take herbal medicines to counteract headaches, aid bodily healing and provide the stamina to spend long hours outside in the full glare of the sun – a vital ability in the old days, when women took care of the farming while the men were in charge of fishing.

It used to be customary for a new mother to remain with her maternal family for up to a year after the birth while she took her medicines and regained physical strength. When she eventually returned to the marital home she was deemed to be fully recovered from all the stresses and strains of pregnancy and childbirth. Today, however, women return to their husbands as soon as they complete ngasech.

Edangel emerges ten minutes later, dripping with sweat. Then some female relatives also have a bath, considered beneficial to their health as well. Two of them are younger cousins of Edangel who recently had their first menstruation, another milestone in a young woman's life when she should have a steam bath.

For the first time since the bathing ritual began five days ago Edangel is now allowed to wash with soap and shampoo, something she has longed for. Once washed and dry it is time to dress up for the presentation ceremony.

The womenfolk gather in the living room to help her. First, Edangel's hair is tied in a bun and decorated with a garland of red flowers. The women hang clusters of flowers from her earrings and help her into her "grass skirt", which is made of yellow and purple yarn. Around her waist Edangel wears a belt of tortoiseshell.

Later she will also wear long white tropicbird feathers in her hair. The costume and decorations reveal which clan she belongs to and its rank. Before going outside to show herself to her husband and his family, Edangel receives a final rub-down with oil and turmeric to make her skin glisten and shine.

Discussion then turns to whether she should be bare-breasted. The women try to encourage her. "Don't be ashamed, be proud! You're beautiful and sexy! This is Palau, it's our tradition!"

But the women's incitements are to no avail. Edangel is too shy and insists on putting on a bra of plaited pandanus leaves. Television and the island's close links with the United States have seen Western values gain ground in Palau, and it is increasingly uncommon that women appear topless during their ngasech.

Outside, Edangel's husband and his family sit in plastic chairs in a party tent with open sides waiting for her to appear. The sun beats down from the azure-blue sky and a gentle breeze rustles the palms. A band fronted by Lisa Sandei, one of the island's most popular singers, strikes up a rhythm on the driveway.

At last Edangel emerges. As is the custom, she holds her right arm under her

breasts and clasps a wax apple leaf in her left hand. Two short palm-leaf mats are laid out for her on which to place her oiled feet. She takes two steps on the first mat before stepping over to the second one. Then the first mat is moved to the front, and the procedure is repeated until she finally reaches the centre of the garden. Here she stands for everyone to admire: the new mother, fully recovered from childbirth.

Members of her husband's family dance towards her, clutching dollar notes as gifts. A couple of buckets of water from the steam bath are placed at her feet and the guests splash water from them onto Edangel's feet and under her skirt. The dance is risqué and rich in innuendo. Some of the dancers prance about wielding bananas. Lisa, gyrating her hips as she sings, fools around with a soursop fruit.

A few of the guests stick banknotes in Edangel's bra but most go into a plastic bag held out by her family. Later, the two families will exchange presents. In addition to the usual gifts of money and tortoiseshell to the wife's family, the husband's family also gives presents to the baby. As Edangel's child is a girl, she gets a grass skirt and items for women's work.

# La cérémonie des naissances
## Palau, Micronésie

Flo, la guérisseuse, remplit une noix de coco avec l'eau bouillante que contient le seau posé sur le sol en bambou et en asperge Edangel. Quelques gouttes éclaboussent les murs de la cabane tandis qu'Edangel, assise nue sur une natte en feuilles de palmier, gémit un peu. Edangel a donné naissance à son premier enfant il y a trois mois et s'apprête maintenant à vivre *ngasech*, un rituel des naissances que toutes les mères d'un premier enfant accomplissent à Palau.

Sa peau brille d'un éclat jaunâtre causé par le mélange d'huile de coco et de curcuma, la pièce profitant d'un parfum doux dû à l'eau bouillante où macèrent des feuilles de jamalac. C'est le troisième et pénultième jour à cause du nettoyage pour Edangel. Le cinquième jour, elle prendra un bain de vapeur et s'habillera d'un costume traditionnel avant de sortir pour se présenter, elle et son enfant, à la famille de son mari.

Edangel se trouve dans la maison de son oncle. Autrefois, toute future maman vivait dans la maison de son oncle maternel ou dans celle de ses parents quatre mois avant la naissance du bébé, sans retourner dans la maison de son mari avant une année. De nos jours, la plupart des naissances ont lieu à l'hôpital de Koror, et Edangel n'a pas besoin de se rendre chez sa famille maternelle avant *ngasech*.

Les habitants de l'île de Palau considèrent cet événement comme si important, que les mères qui vivent à l'étranger aux États-Unis, avec lesquels Palau entretient des relations fortes, retournent chez elles à cette occasion. Les habitants de l'île de Palau attachent une grande importance sociale à cet événement qu'ils considèrent également bénéfique pour la santé. Les vêtements portés par la femme lorsqu'elle « sort », ainsi que les cadeaux échangés par les familles, représentent des indicateurs forts en matière de statut et de relations sociales.

Flo s'attelle à sa tâche, jetant à plusieurs reprises l'eau chaude sur Edangel. Le nettoyage s'effectue toujours du haut vers le bas, en commençant par les yeux, puis le cou, les bras, la poitrine, les organes génitaux, les cuisses et finalement les jambes et les pieds. Ce rituel s'effectue à six reprises pour chaque partie de corps. Certaines

zones sont plus sensibles à l'eau brûlante et Edangel se plaint lorsque l'eau coule sur ses aisselles ou ses organes génitaux. Flo prépare un nouveau bain et remplit le seau d'eau bouillante et de feuilles. Elle lavera Edangel quatre fois avant de la rincer avec l'eau. Ensuite, elle remplira à nouveau le seau et répétera ses gestes deux fois de plus avant le prochain « bain ».

Un bain consiste ainsi en trois sessions de nettoyage. Et comme si ce n'était pas suffisant, Edangel aura droit à seize bains deux fois par jour. « C'est difficile pour elle », dit Flo en secouant la tête en signe de sympathie tandis qu'elle se prépare à mâcher du bétel frais. Elle écrase la noix avec un pilon, l'enveloppe dans une feuille de poivrier, ajoute un filet de citron vert et lance le bétel dans sa bouche affichant un sourire de ses dents teintées de rouge.

Edangel s'est enveloppée dans un morceau de tissu et s'assied en tailleur pour allaiter son bébé. Aussi déplaisants que puissent être les bains, elle ne se plaint pas et offre une vision de bonheur au moment de nourrir son enfant. La maison est en pleine activité et les préparatifs pour la « sortie » d'Edangel battent leur plein. Sa famille va et vient, taro et manioc sont pelés, un porc est tué, ainsi qu'une tortue empaquetée dans de la glace ; une camionnette délivre déjà des boissons pour la fête.

Tard dans l'après-midi de la veille de la cérémonie, un groupe de femmes part dans un pick-up vers l'île de Babeldaob pour ramasser les herbes nécessaires au bain de vapeur. Elles doivent se dépêcher de trouver les différentes variétés d'herbes avant le coucher du soleil. Au matin suivant, Flo plongera les herbes dans un chaudron et les fera bouillir à l'extérieur de la cabane. Elle accrochera ensuite des couvertures sur des fils de fer. Une méthode plus traditionnelle consiste à construire une petite hutte en bambou recouverte de couvertures.

Flo y place un tabouret troué pour Edangel, sous lequel elle dépose un seau d'eau bouillante. Elle laisse ensuite Edangel seule dans le bain de vapeur, après s'être assurée que la vapeur ne s'échappe pas à travers les couvertures. Lors du rituel *ngasech*, la vapeur est censée purifier le corps. Les habitants de l'île de Palau prétendent qu'elle décolle les peaux usées, efface les vergetures et les rides, et « nettoie l'utérus ». Flo le compare au grand nettoyage après une fête : « Il faut laver les lieux à grandes eaux. »

*Ngasech* n'est pas suffisant pour rétablir la bonne santé des mères. Après le rituel, les femmes ont recours à des herbes médicinales pour neutraliser leurs maux de tête, récupérer des forces et obtenir l'endurance nécessaire afin de rester plusieurs heures sous le soleil – une aide vitale autrefois, lorsque les femmes travaillaient dans les champs alors que les hommes étaient chargés de la pêche.

Il était d'usage pour une nouvelle mère de rester avec sa famille maternelle pendant une année après la naissance du bébé, le temps qu'elle reprenne des forces. Lorsqu'elle retournait enfin dans sa maison familiale, elle était censée être remise de toutes les tensions dues à sa grossesse et à son accouchement. De nos jours, les femmes retournent chez elles tout de suite après *ngasech*.

Edangel apparaît dix minutes plus tard, couverte de transpiration. D'autres femmes sautent alors sur l'occasion pour profiter du bain, si bénéfique pour la santé. Deux d'entre elles sont les cousines d'Edangel, récemment entrées dans la puberté, un autre repère important dans la vie des filles, les obligeant à prendre des bains de vapeur. Pour la première fois depuis le début du rituel, Edangel est autorisée à se laver avec du savon et du shampoing, ce qu'elle attendait avec impatience. Une fois lavée et séchée, elle s'habille pour la cérémonie.

Les femmes se réunissent alors dans la grande salle pour l'aider. Elles commen-

**Right:** The medicine woman sorts the herbs to be used as infusions for tomorrow's bath.
**Pages 436–437:** The young mother receives a steaming hot bath from the medicine woman. Coconut oil and turmeric are applied to the skin to protect her from scalding.
**Pages 438–439:** Before the woman is presented to her husband's family she is dressed in traditional costume and rubbed with oil.
**Pages 440–441:** Guests dance for the woman and present her with gifts when she emerges at the end of her childbirth ritual.

**À droite :** La guérisseuse trie les herbes à infuser pour le bain du lendemain.
**Pages 436–437 :** La guérisseuse lave la jeune mère à l'eau bouillante. L'application d'un mélange d'huile de noix de coco et de curcuma protège la peau des brûlures.
**Pages 438–439 :** Avant que la jeune mère ne se présente devant les parents de son mari, elle est revêtue du costume traditionnel et enduite d'huile de coco.
**Pages 440–441 :** Les invités offrent des danses et des cadeaux à la jeune mère quand elle les rejoint, une fois terminés les rituels de la première naissance.

**Rechts:** Die Medizinfrau sortiert die Kräuter, die als Zusatz für das morgige Bad dienen.
**Seiten 436–437:** Die junge Mutter wird von der Medizinfrau mit heißem Wasser gebadet. Kokosöl und Gelbwurz werden zum Schutz vor Verbrühungen auf die Haut aufgetragen.
**Seiten 438–439:** Bevor die Frau der Familie ihres Mannes präsentiert wird, zieht sie die traditionellen Gewänder über und wird mit Öl eingerieben.
**Seiten 440–441:** Gäste tanzen für die Frau und beschenken sie, als sie am Ende des Geburtsrituals aus dem Haus kommt.

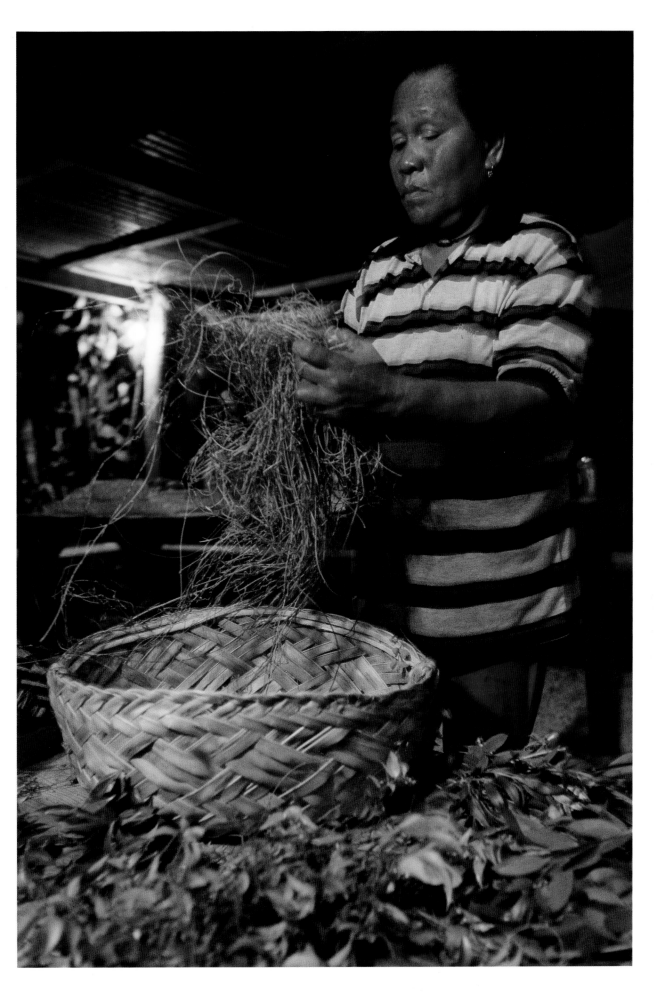

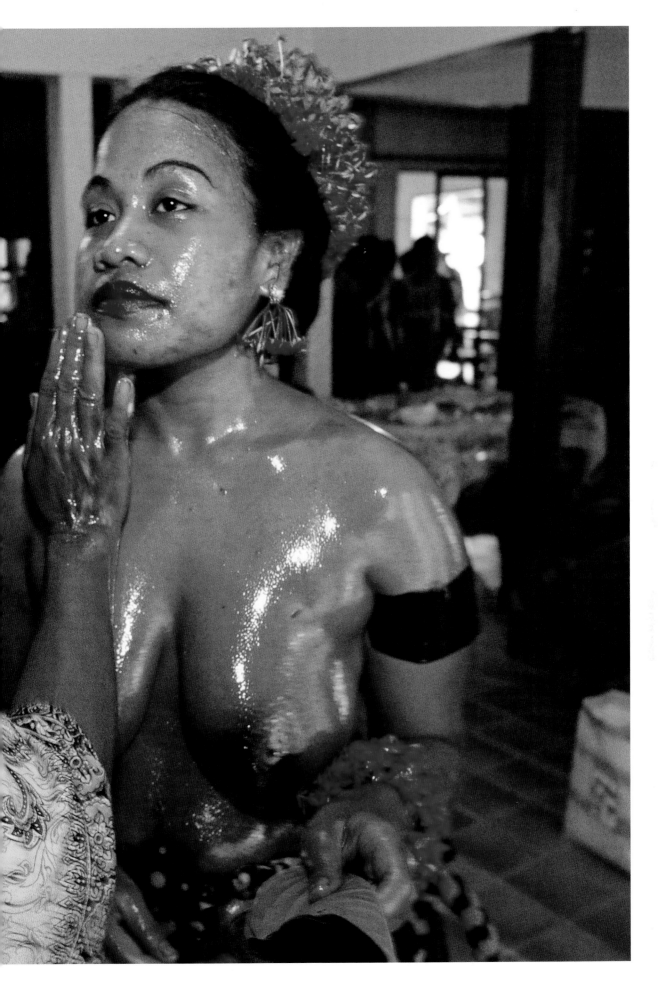

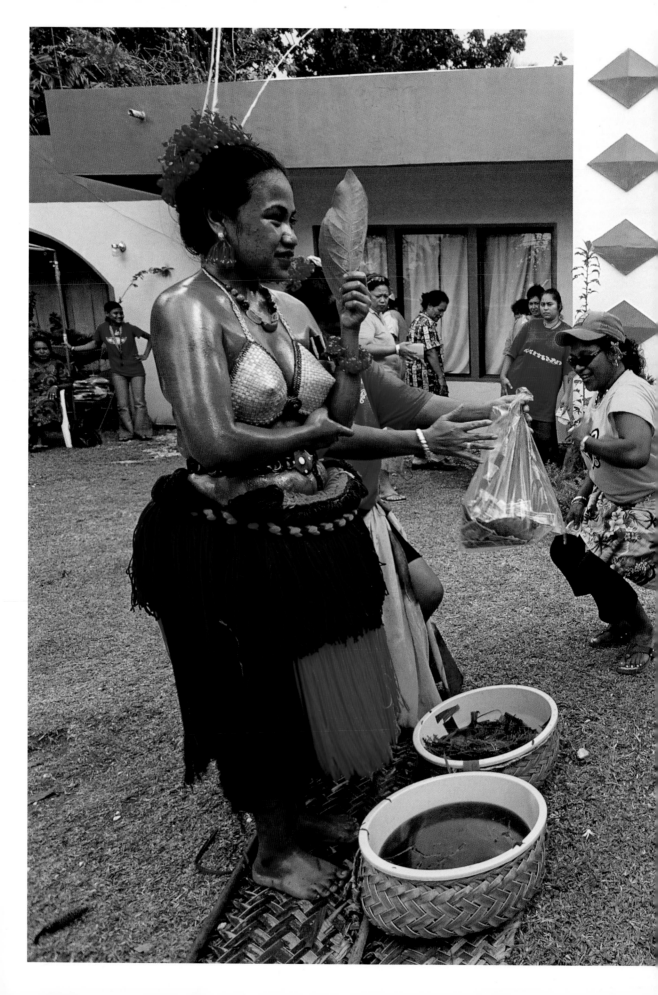

cent par tirer les cheveux d'Edangel en chignon, auquel elles ajoutent une guirlande de fleurs rouges. Elles accrochent quelques fleurs à ses boucles d'oreilles et l'aident à lui passer sa « jupe d'herbe » fabriquée avec des fils de coton jaunes et violets. Edangel porte également une ceinture en écailles de tortue.

Plus tard, elle se parera aussi de plumes d'oiseaux tropicaux blancs. Le costume et les ornements dépendent du clan auquel appartient la femme, ainsi que de son rang. Avant de sortir pour se présenter à son mari et à sa famille, Edangel est à nouveau badigeonnée d'huile et de curcuma pour que sa peau brille. La discussion en vient alors à savoir si elle doit rester seins nus. Les femmes l'encouragent : « N'aie pas honte, soit fière ! Tu es si belle et sexy ! C'est comme ça à Palau, c'est notre tradition ! »

Mais l'insistance des femmes restera vaine. Edangel est trop timide et insiste pour porter un soutien-gorge en feuilles de pandanus tressées. Les liens qu'entretient l'île avec les États-Unis et l'arrivée de la télévision ont permis aux valeurs occidentales de gagner du terrain à Palau, et il est de plus en plus rare que les femmes se montrent seins nus lors de *ngasech*. Dehors, le mari et la famille d'Edangel sont assis sur des chaises en plastique sous une tente ouverte et l'attendent avec impatience. Le soleil descend peu à peu dans l'azur du ciel, laissant place à une brise légère qui secoue les palmiers. Un groupe de musiciens menés par Lisa Sandei, une des chanteuses les plus connues de l'île, donne le rythme sur la chaussée.

Edangel sort en dernier. Comme le veut la coutume, son bras droit est replié sous sa poitrine, étreignant une feuille de jamalac dans la main gauche. Deux courtes nattes de feuilles de palmier sont disposées au sol pour qu'elle y pose ses pieds huilés. Elle fait deux pas sur la première natte avant de passer à la deuxième. La première natte est alors déplacée devant elle et l'opération est répétée ainsi jusqu'à ce qu'elle parvienne au centre du jardin. Elle signifie alors aux autres qu'ils peuvent l'admirer : elle, la nouvelle mère, parfaitement remise de son accouchement.

Des membres de la famille de son mari s'approchent d'elle en dansant et lui offrent quelques billets en guise de cadeau. Des seaux remplis avec l'eau issue du bain de vapeur sont placés à ses pieds pour que les invités éclaboussent Edangel. La danse est osée et riche d'insinuations. Les danseurs jouent avec des bananes, tandis que Lisa qui tourne des hanches en chantant, plaisante en montrant des guanabanas.

Quelques des billets finissent dans le soutien-gorge d'Edangel, mais la plupart sont collectés dans un sac en plastique. Puis, les deux familles échangeront des cadeaux. En plus de l'argent et des écailles de tortues pour la famille de l'épouse, la famille du mari offre des cadeaux au bébé. Le bébé d'Edangel étant une fille, elle aura une jupe d'herbe et des ustensiles destinés au travail des femmes.

# Geburtszeremonie
## *Palau, Mikronesien*

Flo, die Medizinfrau, füllt eine Kokosnussschale mit fast kochend heißem Wasser aus dem Eimer, der auf dem Bambusfußboden steht, und duscht Edangel ordentlich ab. Es spritzt auf die Wände, und Edangel, die nackt auf einer Matte aus Palmwedeln sitzt, stöhnt vor Unbehagen.

Vor dreieinhalb Monaten hat Edangel ihr erstes Kind bekommen, und nun unterzieht sie sich dem Ngasech, einem Ritual, das alle Frauen in Palau nach der Geburt ihres ersten Kindes durchlaufen müssen.

**Right:** The woman's hairstyle – a bun ringed with red flowers and topped by white tropicbird feathers – is specific to her clan and may not be worn by others without permission.
**Pages 444–445:** The colours and design of the grass skirt, nowadays often made of yarn, also signal which family the woman is from. The belt round her waist is made from tortoiseshell.
**Pages 446–447:** This fruit arrangement by the woman's relatives is in honour of the husband's family, who are served food and drinks when they arrive.

**À droite :** La coiffure de la femme – un chignon entouré de fleurs rouges et orné de plumes blanches – indique à quel clan elle appartient ; elle ne peut être portée par d'autres clans sans autorisation.
**Pages 444–445 :** Les couleurs et formes des jupes en crin végétal, ou en coton aujourd'hui, indiquent à quelle famille la femme appartient. La ceinture est confectionnée en écaille de tortue.
**Pages 446–447 :** Les parents de la jeune mère ont réalisé cet arrangement de fruits en l'honneur de la famille du mari. Mets délicats et boissons sont servis à la belle-famille lors de la réception.

**Rechts:** Die Frisur der Frau, ein Knoten, geschmückt mit Blumen und von Federn tropischer Vögel gekrönt, ist Zeichen ihres Klans – sie darf von anderen nicht unerlaubt getragen werden.
**Seiten 444–445:** Farben und Ausführung des Grasrocks zeigen ebenfalls an, aus welcher Familie die Frau kommt. Der Gürtel besteht aus Schildpatt.
**Seiten 446–447:** Mit dem Früchtearrangement ehren die Verwandten der Frau die Familie des Mannes, die mit Speisen und Getränken bewirtet wird, wenn sie zur Feier kommt.

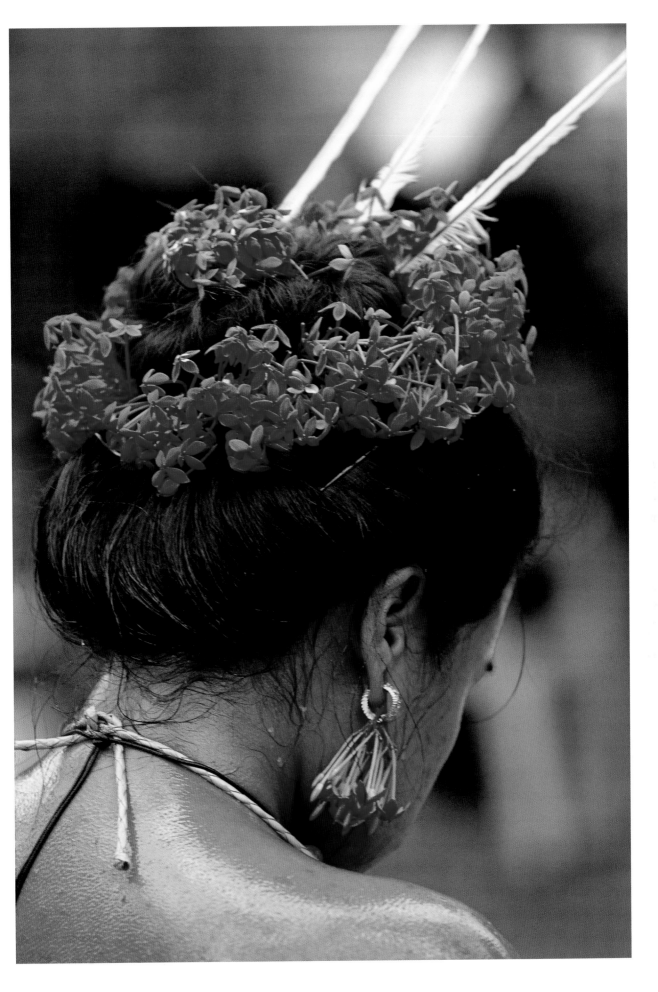

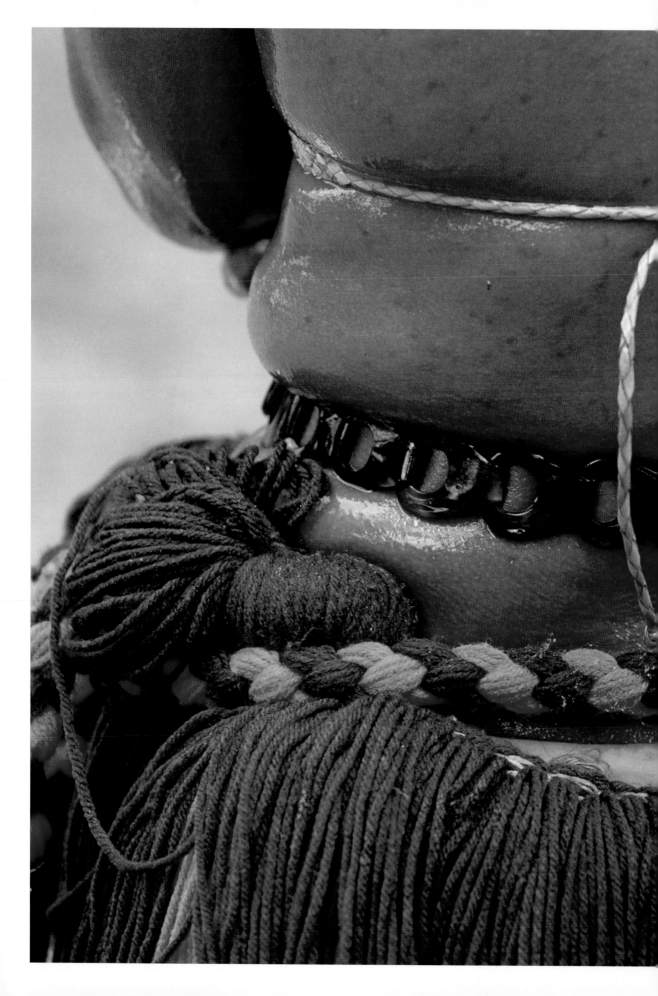

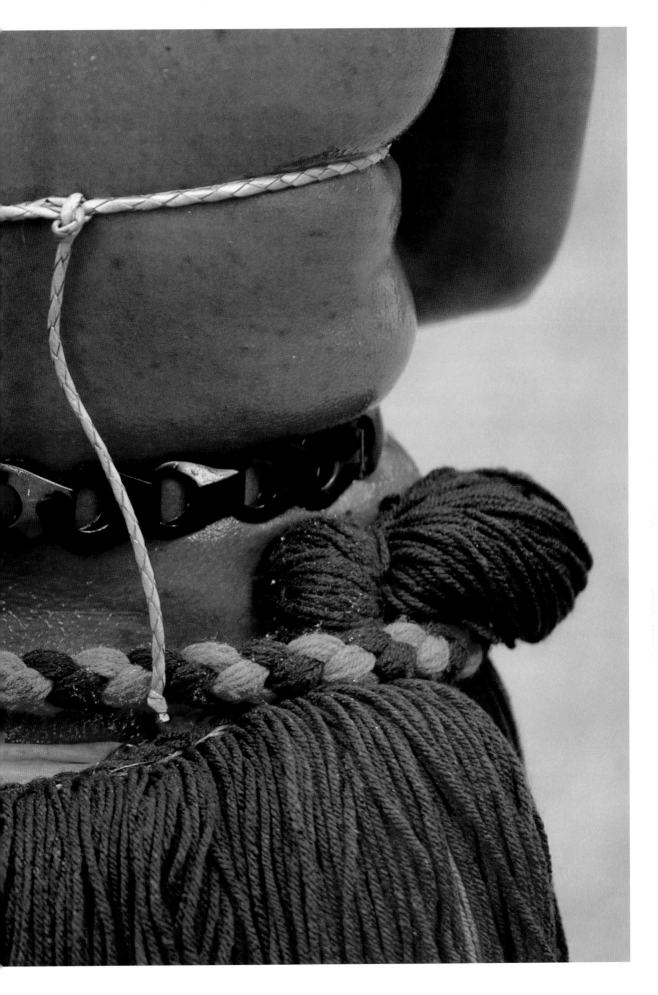

Ihre Haut hat den gelblichen Glanz von Kokosöl und Gelbwurz, und der Raum riecht süß nach den Blättern des Javaapfelbaums, die in dem Wasser aufgekocht wurden.

Es ist der dritte und vorletzte Tag von Edangels Reinigungsritual, an dem heißes Wasser zum Einsatz kommt. Am fünften Tag wird sie ein Dampfbad nehmen und die traditionelle Tracht anlegen, bevor sie sich und ihr Kind der Familie ihres Mannes zeigt.

Edangel wohnt zurzeit im Haus ihres Onkels. Früher zog eine werdende Mutter vier Monate vor der Geburt zu ihrem Onkel mütterlicherseits oder zu ihren Eltern. Aber heute werden die meisten Kinder im Krankenhaus von Koror, der größten Stadt Palaus, geboren, und Edangel musste die Familie mütterlicherseits erst besuchen, als es Zeit für ihr Ngasech war.

Für Palauer ist dieses Ritual so wichtig, dass Mütter, die in den USA leben, zu denen Palau enge Verbindungen unterhält, dafür nach Hause zurückkommen. Es gilt als der Gesundheit zuträglich, und für Palauer hat das Ereignis zudem eine große soziale Bedeutung. Die Kleider, die die Mutter trägt, wenn sie zu ihrem Mann zurückkehrt, und die Geschenke, die die Familien austauschen, werden als wichtige Symbole für den Status des Klans und seine Beziehungen betrachtet.

Flo setzt ihre Arbeit fort und übergießt Edangel wieder und wieder mit heißem Wasser. Die Reinigung erfolgt immer vom Kopf aus nach unten, zuerst die Augen, dann folgen Hals, Arme, Brust, Genitalien, Oberschenkel und schließlich die Unterschenkel und Füße, sechs Durchgänge für jeden Teil des Körpers. Einige Körperregionen reagieren auf das heiße Wasser empfindlicher als andere, und Edangel stöhnt vor Schmerzen, wenn das heiße Wasser auf ihre Achseln oder Genitalien trifft.

**Above:** When the new mother is presented to her husband and his family there are a variety of gifts for her family, including money and food, as "payment" for the child she has borne and the cost to her body of pregnancy and birth.

**Ci-dessus :** La famille du mari offre divers cadeaux à la famille de la jeune mère. Ces présents comprenant argent et aliments sont une sorte de « paiement » en remerciement de l'enfant qu'elle a mis au monde et des peines infligées à son corps durant la grossesse et l'accouchement.

**Oben:** Wenn eine junge Mutter ihrem Mann und seiner Familie präsentiert wird, erhält ihre Familie eine reiche Auswahl an Geschenken, u. a. Geld und Speisen. Das ist die „Bezahlung" dafür, dass sie ihren Körper eingesetzt und ein Kind geboren hat.

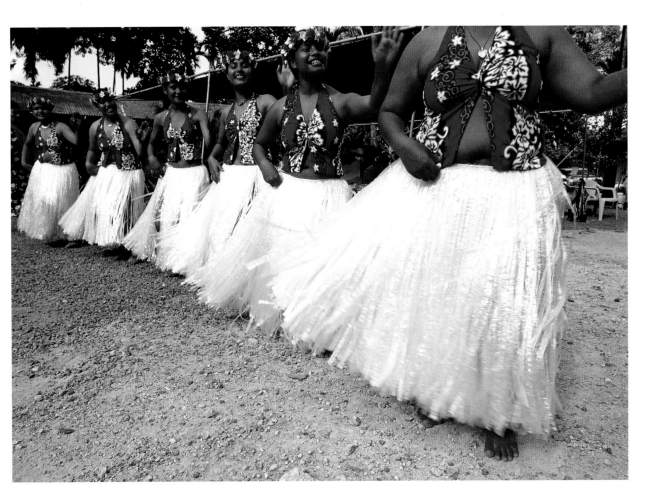

Flo bereitet das nächste Bad vor und füllt den Eimer wieder mit kochend heißem Wasser und den Blättern des Javaapfelbaums. Sie wäscht Edangel viermal mit den Blättern ab, bevor Flo sie mit dem Wasser abspült. Diese Prozedur wiederholt sie noch zweimal, bevor die nächste Runde mit Duschen beginnt.

Ein „Bad" besteht aus dreimaligem Waschen und einmaligem Abduschen. Als sei das nicht schon genug, werden in Edangels Fall 16 dieser Bäder zweimal am Tag verabreicht.

„Es ist schwer für sie", sagt Flo danach, und schüttelt mitleidig den Kopf, während sie sich eine neue Portion Betelnuss zubereitet. Sie knackt die Nuss, wickelt sie in ein Weinblatt, fügt eine Scheibe Limone hinzu und lässt das Ganze mit einem Grinsen im Mund verschwinden, der ganz von Betel verfärbte Zahnreihen zeigt.

Edangel ist nun in ein Stück Stoff gewickelt, sitzt im Schneidersitz auf einer Bank und stillt ihr Baby. So unangenehm die Bäder auch sein mögen, sie beklagt sich nicht und sieht glücklich aus, als sie ihr Kind an ihrer Brust liegen hat.

Im Haus Edangels herrscht reges Treiben. Verwandte kommen und gehen, Taro und Maniok werden geschält, ein Schwein wird geschlachtet und eine Schildkröte zerlegt und auf Eis gepackt. Ein Lieferwagen bringt Kästen mit alkoholfreien Getränken und Wasser für das Fest.

Am späten Nachmittag vor Edangels Rückkehrzeremonie am nächsten Tag fahren einige Frauen in einem Pick-up über die Brücke auf die Insel Babeldaob, um die Kräuter für das Dampfbad zu sammeln. Sie müssen sich beeilen, wenn sie all die verschiedenen Kräuter vor Sonnenuntergang finden wollen. Am nächsten Morgen legt Flo die Kräuter dann in einen Kessel und kocht sie auf dem Gasfeuer vor der Badehütte in Wasser. Sie hat die Bade- in eine Dampfhütte verwandelt, indem sie

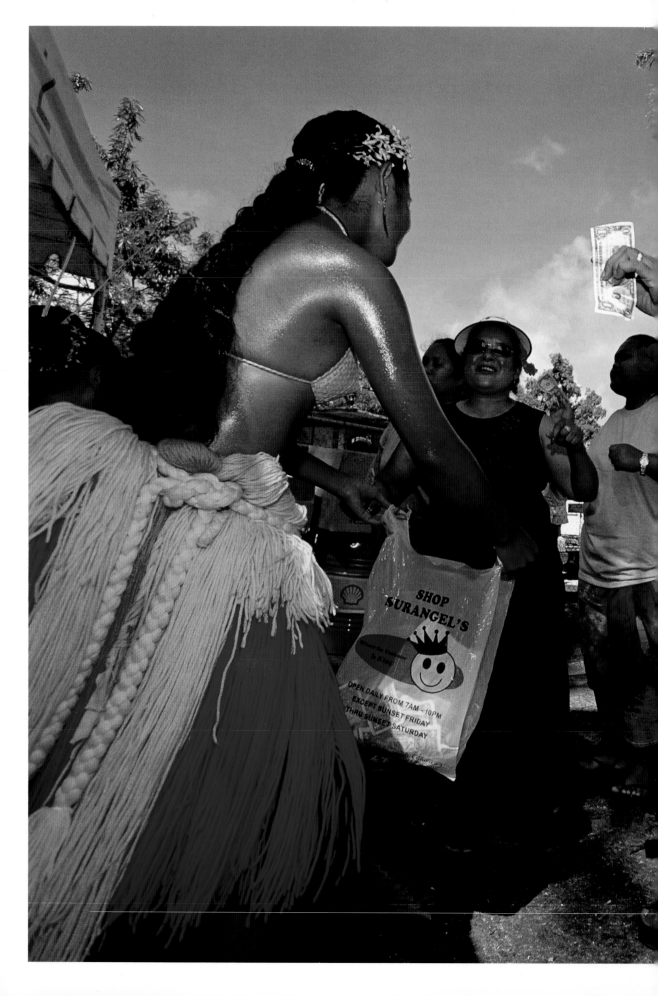

Decken an Stahlkabeln aufgehängt hat. Die traditionellere Art wäre es, aus Bambus eine kegelförmige Hütte zu bauen und diese mit Decken zu verhüllen.

Flo stellt einen Hocker mit einem Loch in der Mitte über einen Eimer kochenden Wassers, auf den sich Edangel setzt. Draußen richtet sie die Decken, um sicherzustellen, dass kein Dampf entweicht.

Wie das gesamte Ngasech-Ritual dient der Dampf der Reinigung des Körpers. Palauer sagen, das entferne alte Haut, lasse Schwangerschaftsstreifen und Falten verschwinden und „reinige den Mutterleib". Flo vergleicht es einem Raum nach einer Party mit viel Alkohol: „Man wäscht das schlechte Zeug weg."

Dennoch wird das Ritual als nicht ausreichend erachtet, um die Gesundheit der Mutter wieder herzustellen. Deshalb müssen die Frauen zusätzlich auch pflanzliche Medikamente einnehmen gegen Kopfschmerzen, zur Förderung des Heilprozesses und zum Aufbau der Kräfte, die notwendig sind, um lange Stunden in der heißen Sonne zuzubringen. Das war unumgänglich, als die Frauen Landwirtschaft betrieben, während die Männer zum Fischen hinausfuhren.

Es war früher üblich, dass eine junge Mutter bis zu einem Jahr nach der Geburt in der Familie ihrer Mutter lebte, um ihre Kraft wiederzugewinnen. Wenn sie dann wieder nach Hause kam, ging man davon aus, dass sie sich vollkommen von allen Schwangerschafts- und Geburtsstrapazen erholt hatte. Heute kehren die Frauen unmittelbar nach der Ngasech zu ihren Männern zurück.

Edangel kommt nach zehn Minuten schweißnass heraus. Einige weibliche Verwandte nutzen diese Gelegenheit, selbst ein Bad zu nehmen, denn auch für ihre Gesundheit gilt das als förderlich. Zwei von ihnen sind junge Cousinen Edangels, die vor Kurzem ihre erste Menstruation hatten. Auch anlässlich dieses Meilensteins im Leben einer jungen Frau ist ein Dampfbad angezeigt.

Zum ersten Mal seit fünf Tagen darf sich Edangel mit Seife und Shampoo waschen – etwas, wonach sie sich schon gesehnt hat. Ist sie gewaschen und abgetrocknet, wird es Zeit, sich für die Präsentationszeremonie in Schale zu werfen.

Die Frauen versammeln sich im Wohnzimmer, um ihr zur Hand zu gehen. Zunächst wird Edangels Haar zu einem Knoten gebunden und mit Girlanden aus roten Blumen geschmückt. Die Frauen hängen Blumen in ihre Ohrringe und helfen ihr in ihren „Grasrock", der aus gelbem und lila Garn besteht. Um ihre Taille trägt Edangel einen Schildpattgürtel.

Später wird sie auch lange weiße Federn von tropischen Vögeln im Haar tragen. Kleidung und Schmuck zeigen, zu welchem Klan sie gehört und welchen Rang dieser hat. Bevor sie hinausgeht, um sich ihrem Mann und seiner Familie zu zeigen, wird Edangel noch einmal mit Öl und Gelbwurz eingerieben, damit ihre Haut glänzt.

Dann beginnt eine Diskussion darüber, ob sie barbusig sein sollte. Die Frauen versuchen, ihr Mut zu machen: „Schäm dich nicht, sei stolz! Du bist schön und sexy! Wie sind hier in Palau, das ist unsere Tradition!"

Aber der Ansporn der Frauen nützt nichts. Edangel ist zu schüchtern und besteht darauf, einen BH aus geflochtenen Schraubenbaumblättern zu tragen. Durch das Fernsehen und die engen Verbindungen der Insel zu den USA haben sich in Palau westliche Werte verbreitet, und es wird immer seltener, dass Frauen mit unbedecktem Busen zu ihrem Ngasech erscheinen.

Draußen sitzen Edangels Ehemann und seine Familie in einem Partyzelt, das zu einer Seite geöffnet ist. Die Sonne strahlt vom azurblauen Himmel, und eine sanfte Brise spielt mit den Blättern der Palmen. Die Band von Lisa Sandei, einer der beliebtesten Sängerinnen der Insel, beginnt in der Auffahrt zu spielen.

Endlich kommt Edangel heraus. Wie es der Brauch vorschreibt, hält sie den rechten Arm unter ihrer Brust und präsentiert mit der linken Hand ein Blatt des Javaapfelbaums. Zwei kurze Matten aus Palmblättern liegen vor ihr, auf die sie ihre geölten Füße setzt. Sie macht zwei Schritte auf der ersten Matte, bevor sie die zweite betritt. Dann wird die erste Matte vor die zweite gelegt und diese Prozedur solange wiederholt, bis sie die Mitte des Gartens erreicht hat. Hier steht sie nun, und alle können sie bewundern: die junge Mutter, vollkommen wiederhergestellt und erholt von der Geburt.

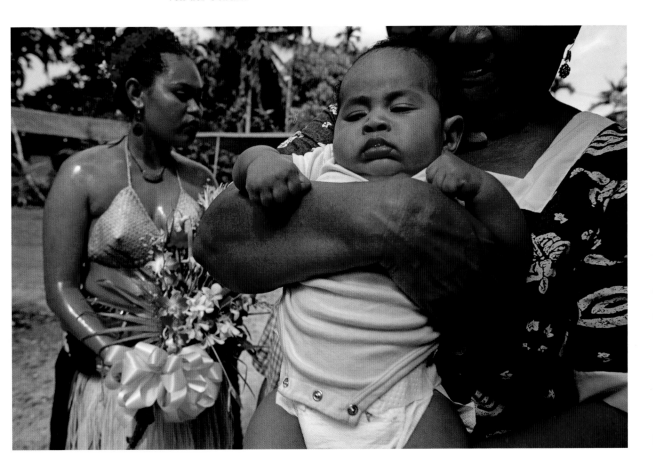

**Above:** The husband's family gets to meet the newborn child, though it is the mother who is at centre of the ceremony.

**Ci-dessus :** Le nouveau-né est présenté à la famille du mari, mais c'est la mère qui est l'héroïne des célébrations.

**Oben:** Die Familie des Ehemanns lernt das neugeborene Kind kennen. Im Mittelpunkt der Zeremonie steht aber die Mutter.

Verwandte aus der Familie ihres Mannes tanzen auf sie zu und halten Dollarnoten in den Händen. Ein paar Eimer Wasser aus dem Dampfbad werden ihr zu Füßen gestellt, und die Gäste spritzen Wasser aus ihnen auf ihre Füße und unter ihren Rock.

Der Tanz ist gewagt und voller sexueller Anspielungen. Einige Tänzer hantieren mit Bananen herum. Lisa lässt ihre Hüften kreisen und singt, während sie mit einer Annonenfrucht spielt.

Ein paar Gäste stecken Dollarnoten in Edangels Oberteil, aber die meisten wandern in die Plastiktüte, die ihre Familie aufhält. Später werden die beiden Familien Geschenke austauschen; neben den üblichen, wie Geld und Schildpatt für die Familie der Frau, erhält auch das Baby von der Familie des Mannes Geschenke. Weil Edangels Kind ein Mädchen ist, bekommt es einen Grasrock und Werkzeuge für die Frauenarbeit.

# Twilight years
## *Kathmandu, Nepal*

Tears of joy well up in Surja Maya Maharjan's eyes as one by one her sons, daughters-in-law and other family members bow solemnly in front of her. They bend down at her feet, immersed in a copper bowl filled with holy water, and take turns to dab their heads with the water as a blessing from the divine elderly sitting before them.

Surja Maya Maharjan has reached the venerable age of seventy-seven years, seven months, seven days, seven hours and seven steps and in so doing has reached the next phase of her long life.

For the Newar people of Nepal's Kathmandu Valley, old age is a time to retreat from the hurly-burly of everyday life and to enjoy one's rest. But it is also a time to prepare for death and the afterlife, to become a living deity, revered by loved ones. The old-age ceremony held to mark a person's entry into this contemplative, serene phase of life is known as *janko*.

Smoke fills the cold, spartan room. A Buddhist priest sits cross-legged in the middle of the floor, stoking a small sacred fire and performing the numerous janko rituals. In front of him is an assortment of plates, bowls and jars containing rice, flowers, incense and other ritual paraphernalia. Much of it is also kept in small plastic bags lying about on the floor.

Usually, other rites are held to coincide with janko. Surja Maya Maharjan's son has just returned from a nearby stream, where he has scattered rice in memory of the dead. Her two grandchildren Chirak, fourteen, and Sugat, five, are doing *kaeta puja*, an initiation rite that makes them full members of their father's clan.

Surja Maya Maharjan is the focal point. She is the only person in the room sitting in a chair, like a rajah on a throne, and when the ceremony is over she will have divine, magical powers to both bless and curse.

But this is not the last ritual for elderly Newar. Another ceremony is held for those who reach eighty-eight years, eight months, eight days, eight hours and eight steps – and a final one at the age of ninety-nine. With each of these the person becomes more divine and better prepared for his or her final step – into the afterlife.

**Pages 454–455:** Nyatapola Temple in Bhaktapur, which has the best-preserved Newar architecture of the three royal cities in the Kathmandu Valley.
**Right:** For her *janko* ritual, this elderly woman has had her forehead painted red and wears a card with religious decorations on her head. The motifs include a *purna kalash*, a vial of holy water symbolising perfection.
**Pages 458–459:** The woman's family line up to pay homage.

**Pages 454–455:** Le temple de Nyatapola à Bhaktapur, une des trois cités royales de la vallée de Katmandou ; elle abrite les plus belles architectures Newar conservées.
**À droite :** Pour sa cérémonie *janko*, la vieille dame porte une carte ornée de symboles religieux sur son front peint en rouge. Les motifs comprennent un *purna kalash*, une fiole d'eau sacrée, symbole de la perfection.
**Pages 458–459 :** La famille de la vieille dame fait la queue pour lui rendre hommage.

**Seiten 454–455:** Der Nyatapola-Tempel in Bhaktapur, wo sich die besterhaltenen Bauwerke der drei Königsstädte der Newar im Kathmandutal befinden.
**Rechts:** Für das Janko-Ritual lässt die alte Dame ihre Stirn rot bemalen und trägt eine Karte mit religiösen Motiven auf dem Kopf. Eines der Motive ist ein Purna Kalash, ein Gefäß mit geweihtem Wasser, das Perfektion symbolisiert.
**Seiten 458–459:** Die Familie der Dame stellt sich auf, um ihr die Ehre zu erweisen.

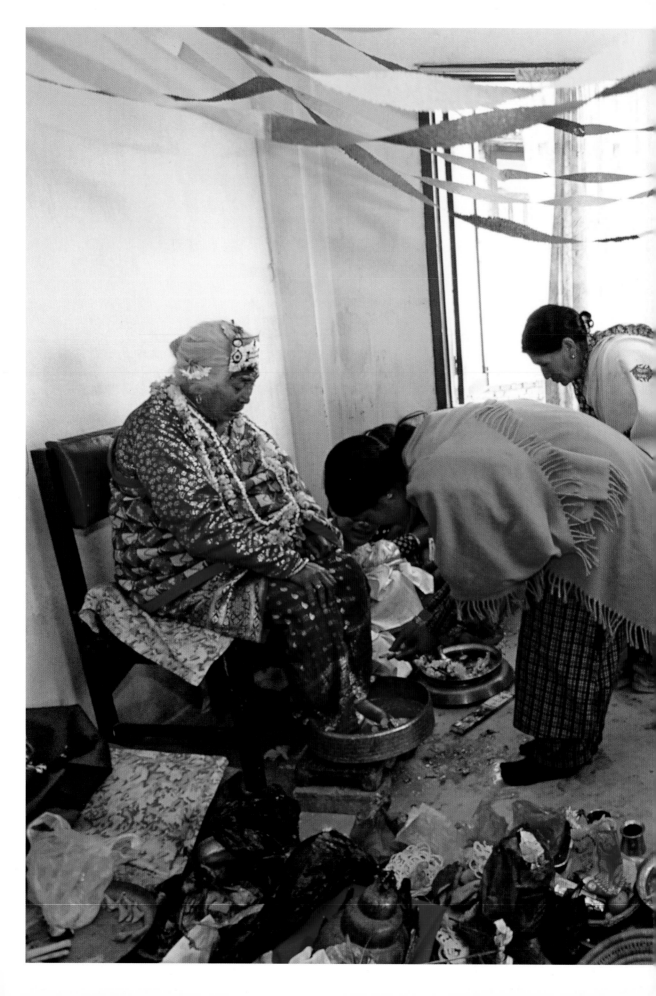

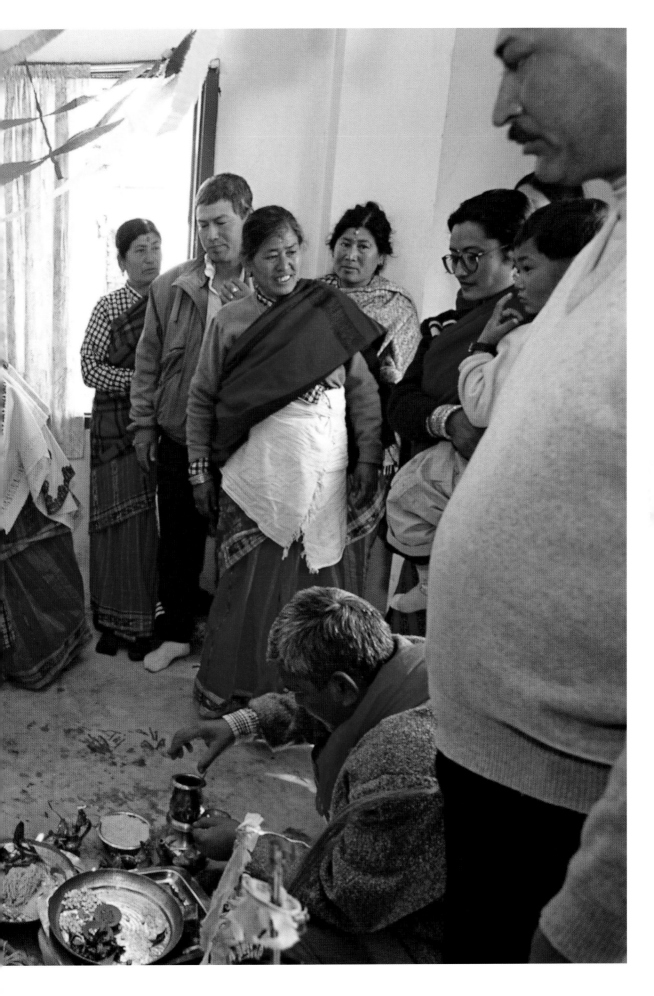

# Au crépuscule de la vie
## *Katmandou, Népal*

Des larmes de joie coulent des yeux de Surja Maya Maharjan lorsque, un par un, ses fils, belles-filles, et autres membres de sa famille, se placent devant elle pour un salut solennel. Courbés sur ses pieds immergés dans un bol en cuivre rempli d'eau sacrée, ils trempent leurs doigts dans l'eau avant de les porter à leur tête en signe de bénédiction reçue de la personne âgée assise devant eux. Surja Maya Maharjan a atteint le vénérable âge de soixante-dix-sept ans, sept mois, sept jours, sept heures et sept étapes et, par conséquent, elle franchit la prochaine phase de sa longue vie.

Pour les Newar de la vallée de Katmandou, la vieillesse signifie le retrait des labeurs de la vie quotidienne pour profiter du temps restant. Mais c'est également le moment de se préparer à la mort et à la réincarnation, et de devenir ainsi une déité vivante révérée par les êtres qui l'aiment. La cérémonie de la vieillesse marque l'entrée dans cette phase contemplative et sereine de vie, appelée *janko*. La fumée se répand dans la pièce spartiate et froide. Un prêtre bouddhiste est assis en tailleur sur le sol, attisant un petit feu sacré tout en exécutant les nombreux rituels *janko*. Devant lui se trouve un assortiment de plats, de bols et de jarres contenant du riz, des fleurs, de l'encens, ainsi qu'un petit attirail destiné au rituel. Des sachets en plastique remplis d'offrandes jonchent le sol.

Habituellement, d'autres rites coïncident avec *janko*. Le fils de Surja Maya Maharjan revient tout juste d'un ruisseau voisin où il a dispersé du riz en mémoire des morts. Ses deux petits-enfants, Chirak, quatorze ans, et Sugat, cinq ans, sont en plein *kaeta puja*, un rite d'initiation qui fait d'eux des membres à part entière du clan de leur père.

Surja Maya Maharjan reste le point de mire. Elle est la seule à être assise sur une chaise, comme un rajah sur son trône, et lorsque la cérémonie se termine, elle sera en possession de pouvoirs divins et magiques destinés à bénir ou maudire.

Il ne s'agit cependant pas du dernier rituel de vieillesse chez les Newar. Une autre cérémonie est prévue pour ceux qui atteignent quatre-vingt-huit ans, huit mois, huit jours, huit heures et huit étapes – ainsi qu'une dernière à l'âge de quatre-vingt-dix-neuf ans. Chaque fois la personne devient plus divine, mieux préparée à l'étape finale – la réincarnation.

**Right:** The eldest son scatters rice as an offering to the family's forebears. Wheat and rice balls at his feet commemorate deceased ancestors, among them his father, who died before his janko ceremony.
**Pages 462–463:** Initiation rites for two of the woman's grandsons are also held during the janko ceremony.

**À droite :** Le fils aîné jette du riz en offrande aux ancêtres de la famille. Le blé et le riz à ses pieds commémorent les aïeux disparus, dont son père, mort avant la célébration de son janko.
**Pages 462–463 :** Les rites d'initiation de deux des petits-fils de la dame sont également célébrés durant la cérémonie janko.

**Rechts:** Der älteste Sohn verstreut Reis als Opfer an die Ahnen. Weizen- und Reisbällchen zu seinen Füßen erinnern an die verstorbenen Vorfahren, darunter auch sein Vater, der vor seiner Janko-Zeremonie starb.
**Seiten 462–463:** Initiationsriten für zwei Enkel der Dame werden zusammen mit der Janko-Zeremonie gefeiert.

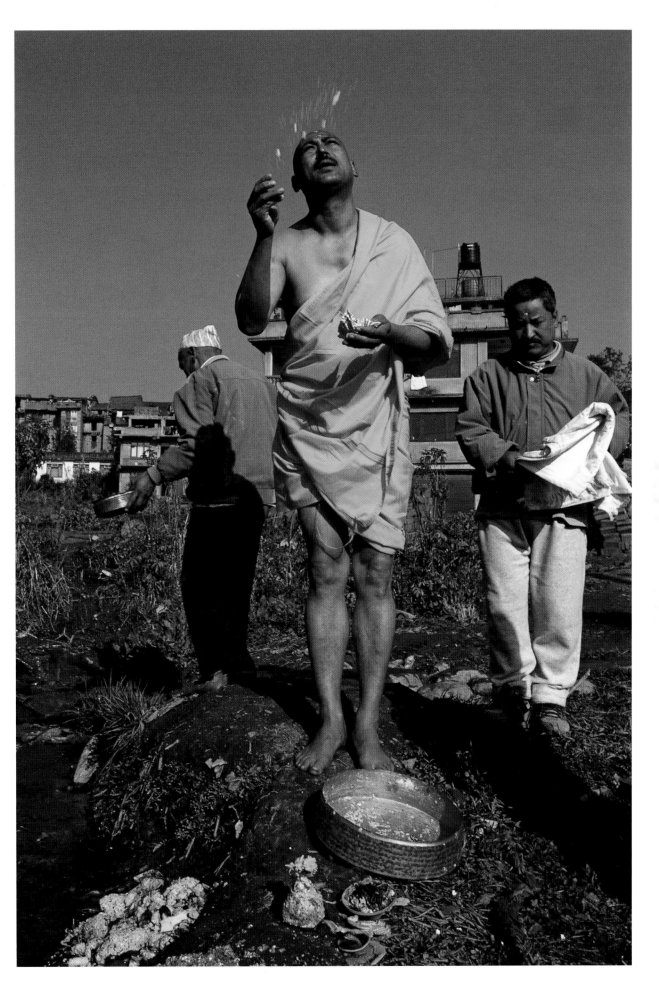

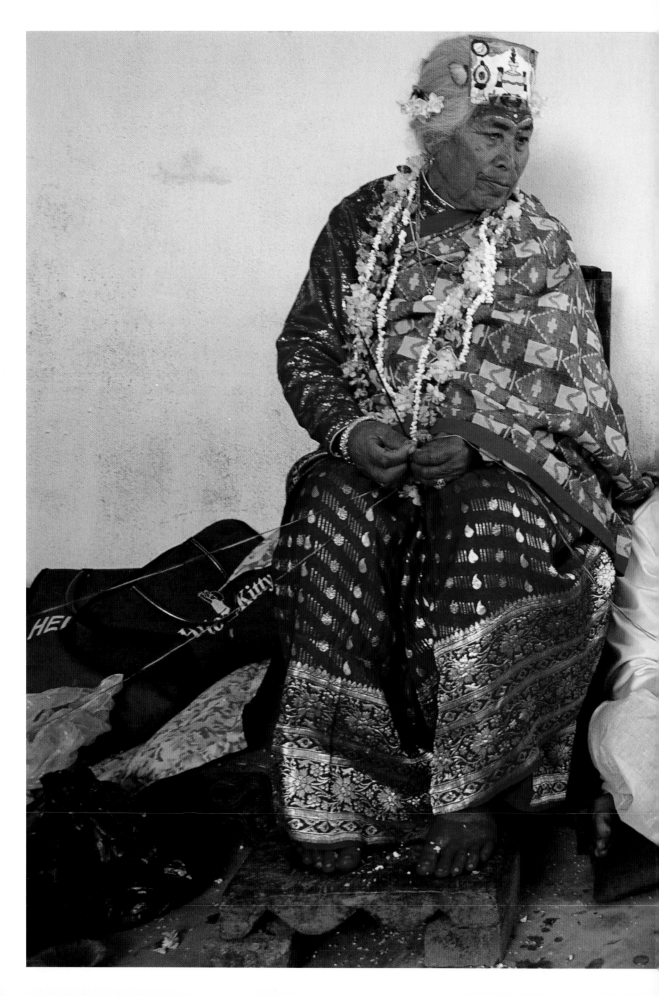

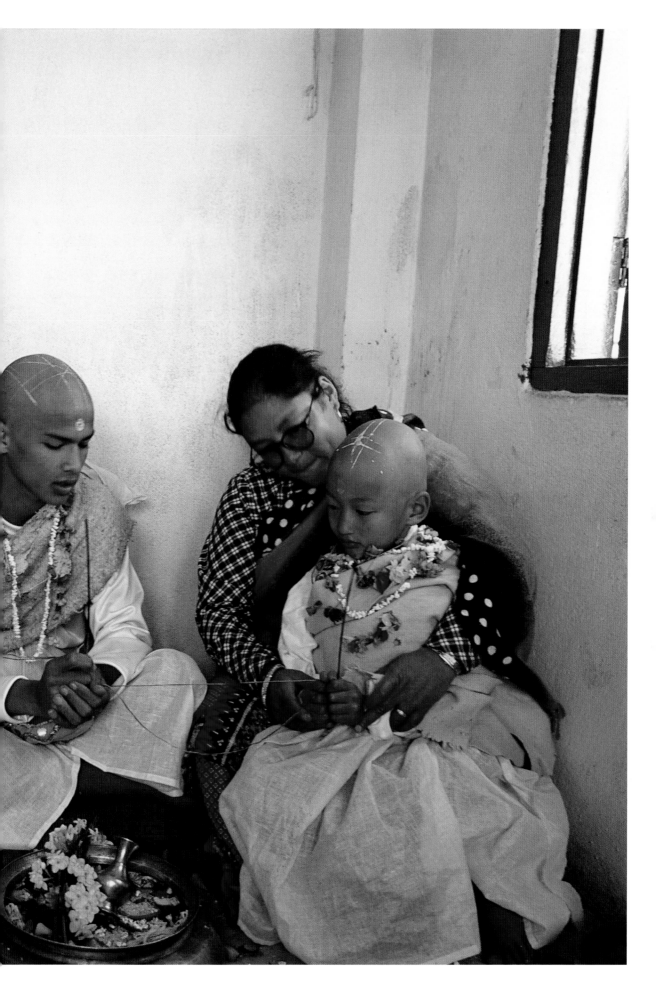

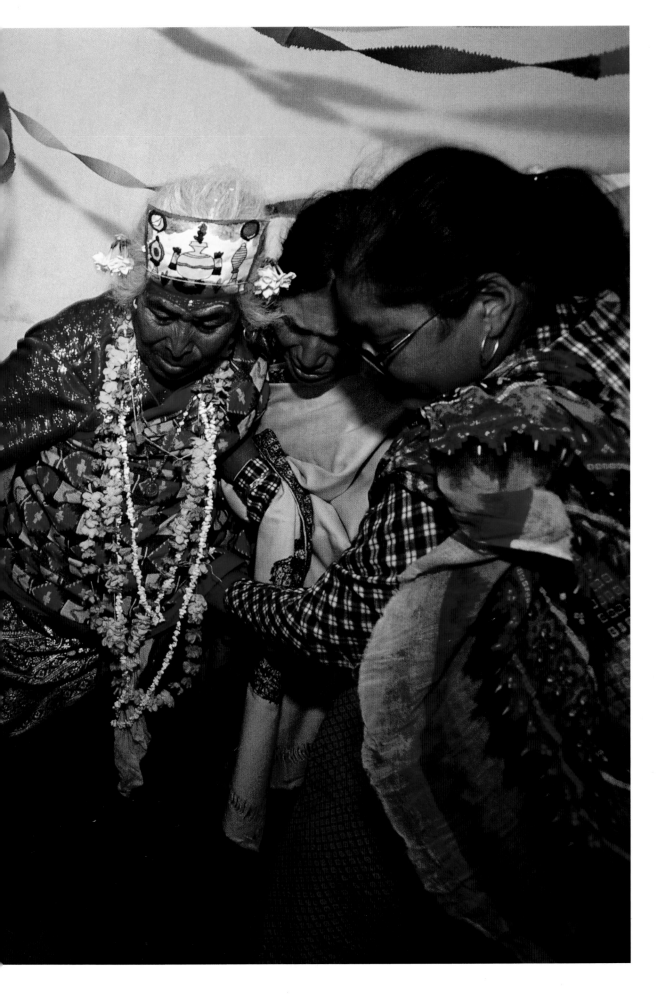

# Altersdämmerung
## *Kathmandu, Nepal*

Freudentränen schießen Surja Maya Maharjan ins Gesicht, als ihre Söhne, Schwiegertöchter und andere Familienmitglieder sich einer nach dem anderen feierlich vor ihr verneigen. Sie beugen sich zu ihren Füßen hinab, die in einem Kupferkessel mit geweihtem Wasser stehen, und jeder von ihnen betupft seinen Kopf mit dem Wasser und empfängt so die Segnung der frommen alten Dame, die vor ihnen sitzt.

Surja Maya Maharjan hat das ehrwürdige Alter von 77 Jahren, sieben Monaten, sieben Tagen, sieben Stunden und sieben Schritten erreicht, und damit beginnt die nächste Phase ihres langen Lebens.

Für die Newar im Kathmandutal ist das hohe Alter eine Zeit, in der man sich aus dem Alltagstrubel zurückzieht und sich Ruhe gönnt. Aber es ist auch eine Zeit, in der man sich auf den Tod und das Leben danach vorbereitet, darauf, eine lebende Gottheit zu werden, die von ihren Angehörigen verehrt wird. Die Alterszeremonie, die den Eintritt in diese kontemplative, abgeklärte Phase des Lebens markiert, heißt Janko.

Rauch füllt den kalten, spartanischen Raum. Ein buddhistischer Priester sitzt im Schneidersitz mitten auf dem Fußboden, facht ein kleines heiliges Feuer an und vollzieht die vielen Janko-Rituale. Vor ihm steht eine Ansammlung von Tellern, Schüsseln und Krügen mit Reis, Blumen, Weihrauch und anderen für das Ritual notwendigen Dingen – viele davon in Plastiktüten, die auf dem Boden liegen.

Normalerweise werden mit Janko zusammen noch andere Rituale vollzogen. So ist Surja Maya Maharjans Sohn soeben von einem Fluss zurückgekommen, an dem er zur Erinnerung an die Toten Reis verstreut hat. Ihre beiden Enkel, der 14-jährige Chirak und der fünfjährige Sugat, absolvieren gerade Kaeta Puja, einen Initiationsritus, der sie zu vollen Mitgliedern im Klan ihres Vaters macht.

Doch Surja Maya Maharjan steht im Mittelpunkt. Sie ist die einzige im Raum, die auf einem Stuhl sitzt, wie ein Radscha auf seinem Thron, und am Ende der Zeremonie wird sie über göttliche Kräfte verfügen, mit denen sie segnen und verfluchen kann.

Aber dies ist nicht das letzte Ritual für greise Newar. Weitere Zeremonien gibt es für diejenigen, die 88 Jahre, acht Monate, acht Tage, acht Stunden und acht Schritte oder 99 Jahre alt werden. Mit jeder Zeremonie rückt die Person näher an das Göttliche heran und ist besser auf den letzten Schritt vorbereitet – den in das Leben danach.

**Pages 464–465:** The old lady is helped to complete three clockwise circuits of the sacred fire towards the end of the ceremony. Behind her walks the Buddhist priest.
**Right:** The Buddhist priest and his son, who has assisted him during the service, are guests of honour at the rooftop meal afterwards.

**Pages 464–465:** La vieille dame soutenue fait trois fois le tour du feu sacré dans le sens des aiguilles d'une montre à la fin de la cérémonie. Un prêtre bouddhiste marche derrière elle.
**À droite :** La cérémonie s'achève par un festin servi sur la terrasse du toit. Le prêtre bouddhiste et son fils qui l'a assisté durant les rites en sont les invités d'honneur.

**Seiten 464–465:** Mit der Hilfe ihrer Verwandten umkreist die alte Dame am Ende der Zeremonie dreimal im Uhrzeigersinn das Feuer. Hinter ihr geht der buddhistische Priester.
**Rechts:** Der Priester und sein Sohn, der ihm während der Zeremonie assistiert hat, sind die Ehrengäste beim Essen auf dem Dach.

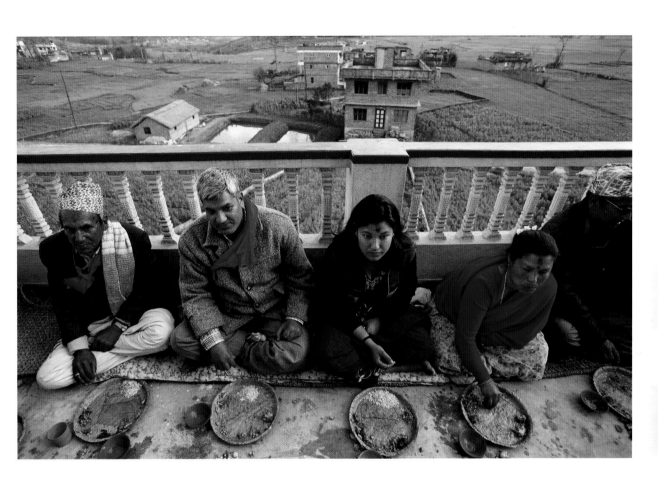

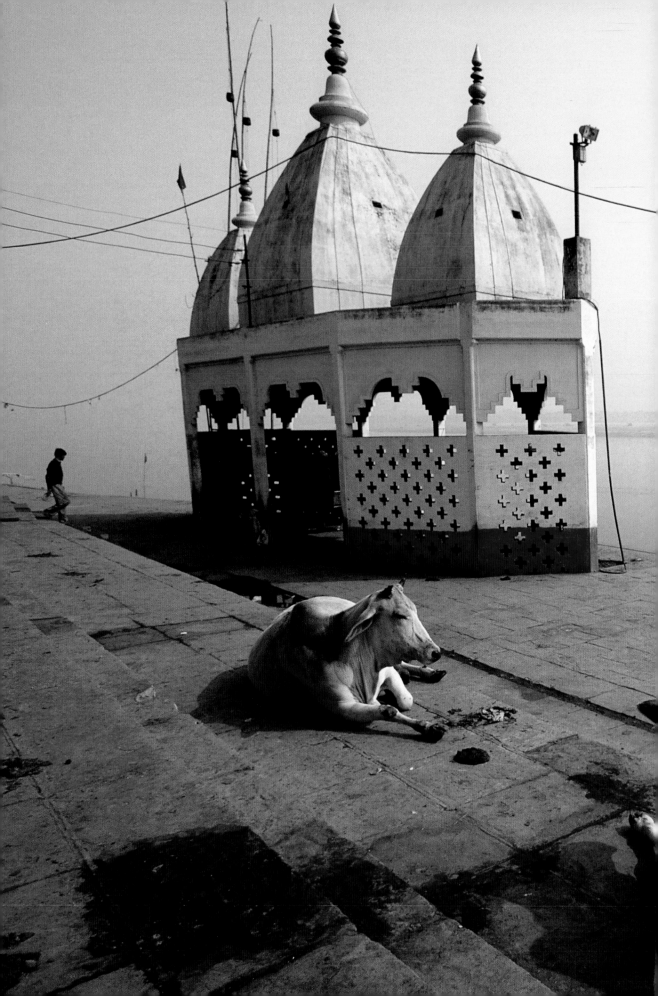

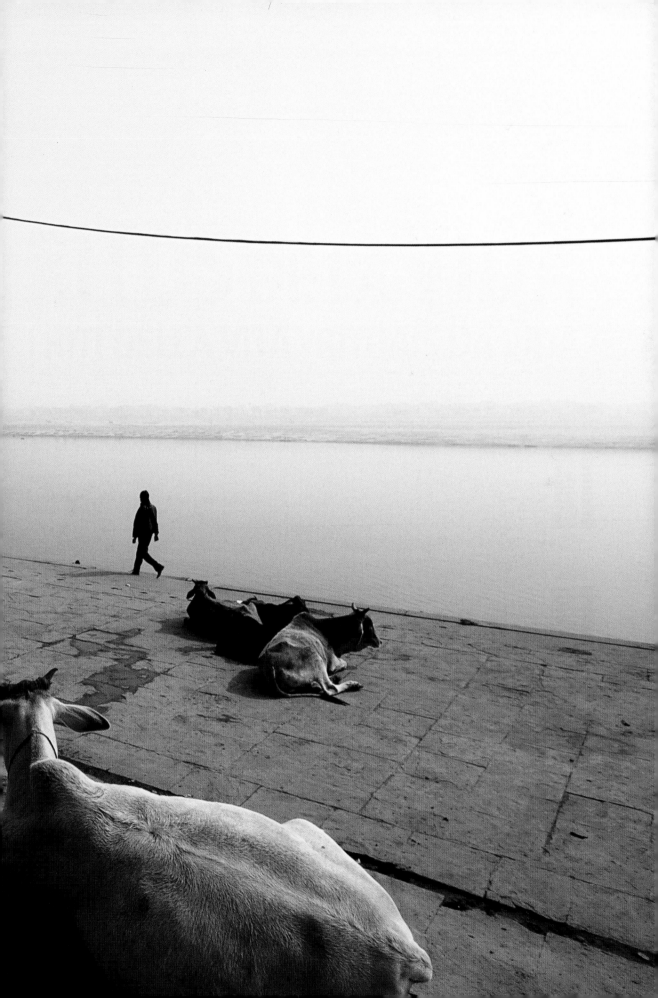

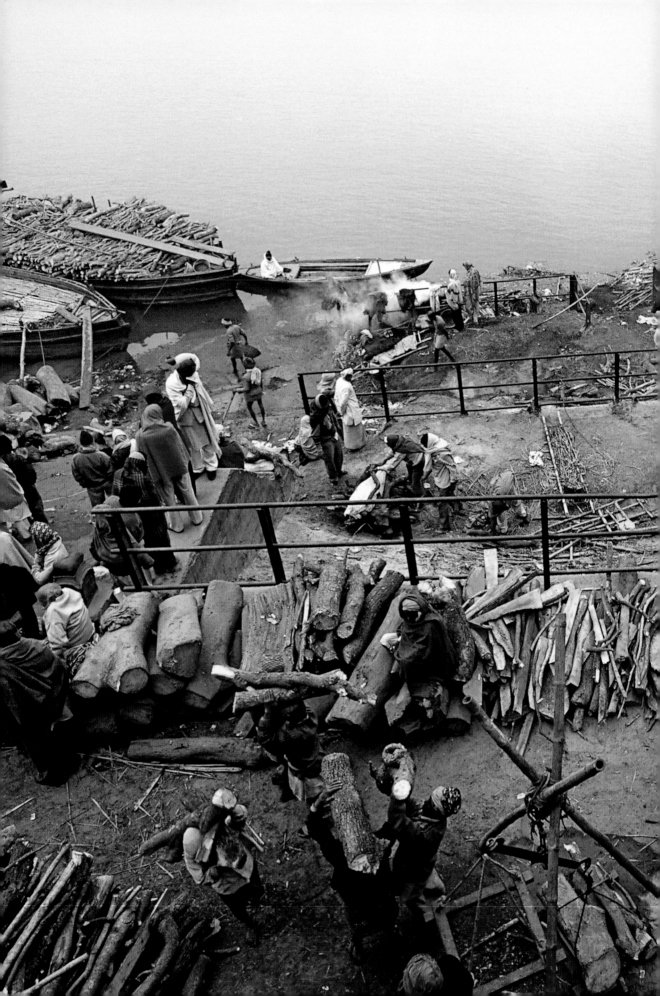

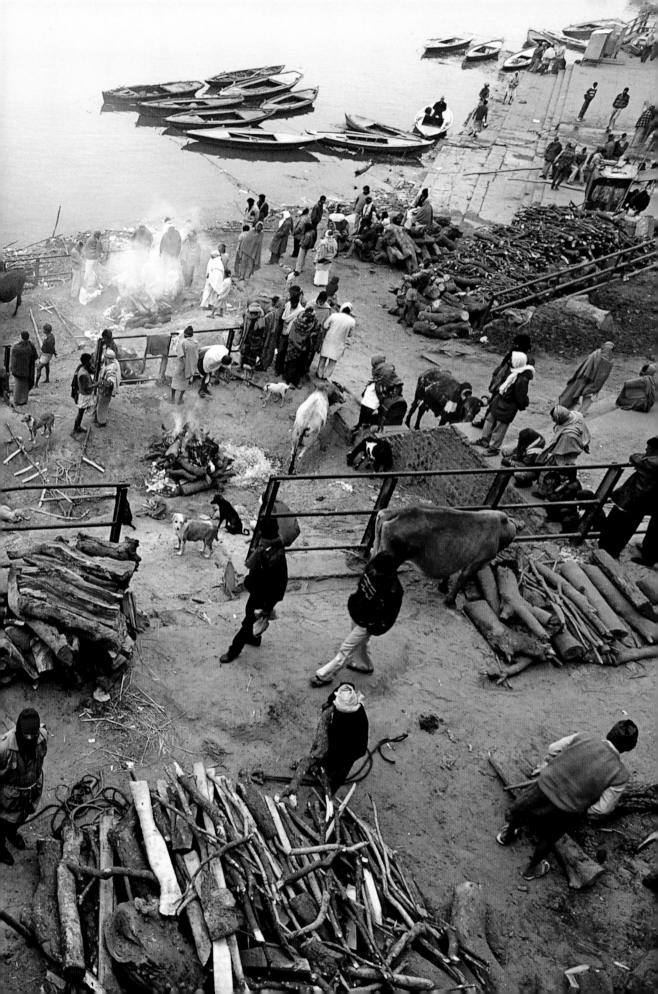

# Cremation
## *Varanasi, India*

Holiest of India's ancient cities and standing sentinel over the sacred waters of the River Ganges, Varanasi is one of Hinduism's most important sites.

More than one million pilgrims visit the city of light and Lord Shiva each year. Every day, the seven-kilometre stretch of river with its sixty-four ghats (bathing staircases) throngs with tens of thousands of devotees who have come to pray, bathe, wash and drink the holy water.

It is early morning in January and only a few degrees above freezing. A dank mist hangs over the Ganges, which at Varanasi snakes back northwards towards its Himalayan source before swinging round again to continue its journey to the Bay of Bengal.

As the morning wears on, the sun finally breaks through and bathes the temples, boats and worshippers, and all who live from their custom – priests, street peddlers, masseurs, guides, beggars – in a warm golden glow.

For some, the pilgrimage to Varanasi is a one-way ticket. People come here to wait to die and obtain *moksha* – liberation from the cycle of death and rebirth. Hindus believe that dying and being cremated at Varanasi guarantees they will enter heaven and be eternally united with the supreme cosmic spirit Brahman.

The funeral pyres burn day and night on the dirt terraces of Manikarnika Ghat. More than one hundred people are cremated here on average every day, a number which rises sharply during January's mid-winter chill. Anyone who dies within a fifty- or sixty-kilometre radius from the city centre is cremated within twenty-four hours either here or at Harishchandra Ghat, Varanasi's other cremation site.

Manikarnika, by far the larger of the two, typically has twenty or more pyres burning at any one time. Cremations are performed by specialists known as *Doms*, who hand their profession down from father to son. Despite being classed as Untouchables and looked down upon for their "unclean" work, the Doms are well paid. Their leader, Dom Raja, lives in a palatial residence at one of the ghats south of Manikarnika.

A never-ending stream of bodies enters Varanasi from the surrounding countryside, carried on carts, barrows, trucks, car roof-racks and auto rickshaws. For the last stretch, from the Chowk business district to the ghats, they are carried on foot through narrow streets passable only to pedestrians, moped riders and the occasional cow or water buffalo.

After death, bodies are anointed with ghee (clarified butter), placed in a white shroud and carried into the city on a bamboo bier covered with a golden cloth. Mourners chant *"Ram nam satya hai"* (The name of Lord Ram is truth), the meaning of which is that death is the only truth, as the body is borne to the cremation ground. Musicians and dancers may join the cortege but not women, as their tears would disturb the souls of the dead.

When the procession reaches Manikarnika, the bier is set down on the steps while all the cremation details are sorted out. The deceased's family must buy wood for the pyre. Three hundred and sixty kilograms are required to burn a single corpse.

Scented powders, sandalwood dust and ghee are then purchased from the shops surrounding the ghat, to be sprinkled on the corpse before the flames are lit. Here, too, sit the barbers, ready to shave the head of the person leading each procession, usually the deceased's eldest son. Once this tradition has been observed, the cor-

**Pages 468–469:** The steps of Scindia Ghat, one of Varanasi's many terraces leading down to the River Ganges.
**Pages 470–471:** Funeral pyres burn round the clock at Manikarnika Ghat. Being cremated here enables the deceased to achieve *moksha*, liberation from the cycle of birth and rebirth.
**Right:** Biers lie on the steps awaiting cremation. The *Doms* who tend the fires are classed as Untouchables because they handle corpses.

**Pages 468–469 :** Les escaliers de Scindia Ghat, un des nombreux quais de Varanasi (Bénarès) descendant vers le Gange.
**Pages 470–471 :** Jour et nuit, les bûchers brûlent à Manikarnika Ghat. L'incinération à cet endroit permet au mort d'atteindre le *moksha*, qui libère du cycle des naissances et renaissances.
**À droite :** Sur les escaliers, des corps sur les brancards attendent d'être incinérés. Les *doms* qui s'occupent des feux et des cadavres font partie de la caste des Intouchables.

**Seiten 468–469:** Die Stufen von Ghat Scindia, einer von Varanasis vielen Terrassen, die zum Ganges hinunterführen.
**Seiten 470–471:** Rund um die Uhr brennen die Scheiterhaufen am Ghat Manikarnika. Hier eingeäschert zu werden, verschafft dem Verstorbenen Mokscha, die Befreiung aus dem Kreislauf von Tod und Wiedergeburt.
**Rechts:** Bahren liegen auf den Stufen und warten auf die Verbrennung. Die Doms, die sich um die Feuer kümmern, gelten als unberührbar, weil sie mit Leichen umgehen.

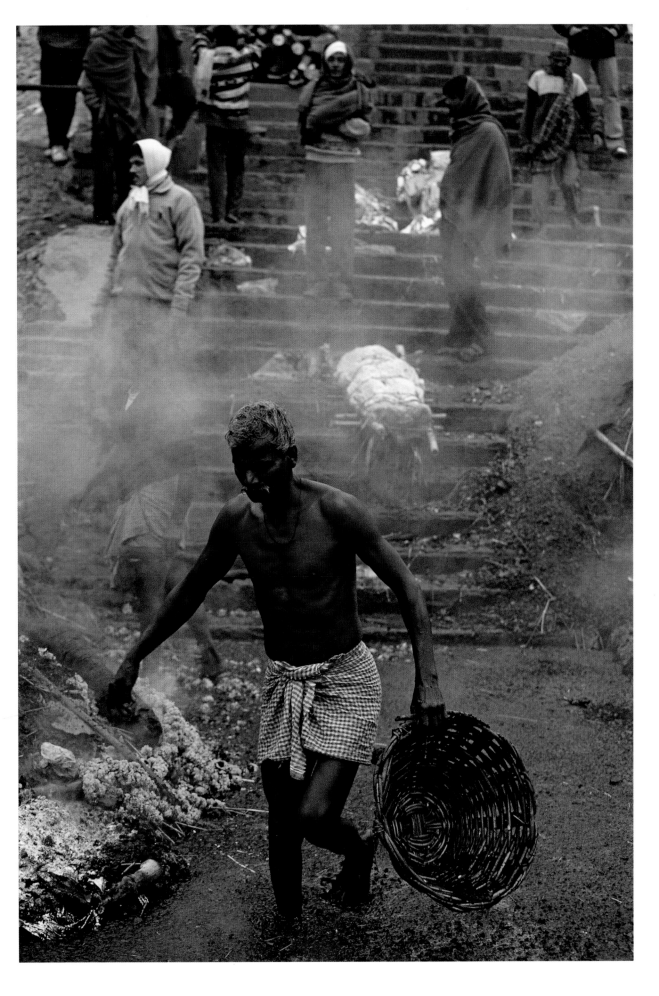

tege leader washes in the Ganges before putting on a white seamless gown which he keeps on for ten days.

Prior to cremation, the body is lowered into the holy waters of the Ganges. Water is then poured into the corpse's mouth five times to quench the deceased's thirst as the mourners chant *"Ram nam satya hai"*.

The corpse is laid on the pyre and the mourners circle it five times, led by the chief mourner, who on a piece of straw holds a glowing ember from the sacred fire that has burnt at Manikarnika since ancient times. No fire, no cremation. The Doms are the ones who control the sacred fire. It is from them it must be purchased before the ceremony can begin, and the richer you are the more you have to pay.

Ghee, scented powders and sandalwood dust are scattered on the body and once this is done the chief mourner lights the pyre – at the deceased's head if it is a man and at the feet if it is a woman. From here, the Doms take over to ensure the fire is properly stoked so the body burns properly. The mourners squat and watch in silence.

Other cremations are taking place all around, filling the air with smoke and the smell of burning flesh. Every now and then a stomach explodes with a bang.

The purpose of cremations is to liberate the deceased's soul. When the flames have burnt long enough to weaken the skeleton, the head mourner cracks the corpse's skull with a bamboo pole to release the soul, said to be the size of a thumb but invisible to the eye. Ceremonies will be held over the next few days to assist the soul in its journey into the abode of the ancestors and its transformation from spirit to ancestor.

The mourners bathe in the Ganges before returning home for a ten-day period of mourning, during which the chief mourner sleeps in a special room on a mat on the floor. During this time he is not permitted to use soap or shave, must cook on a separate hearth and when he eats he sits facing south, in the direction of the realm of Yama, the lord of death.

After ten days the party returns to the Ganges, where male mourners have their heads shaved before bathing in the holy water. On the thirteenth day a party is held, at which invited Brahmins are served the favourite food of the deceased.

The twelve preceding days represent the twelve months it takes for the deceased's soul to travel to the abode of the ancestors. On reaching its destination the soul is held to account for the person's actions during life. But the soul does not have to be reborn since it was cremated at Varanasi, or Kashi, the "city of light", as this holiest of cities is also called.

# Crémation
## *Varanasi, Inde*

Varanasi (Bénarès), une des villes antiques les plus sacrées, est célèbre pour ses berges longeant les eaux sacrées du Gange, demeurant ainsi le symbole de l'hindouisme. Chaque année, plus d'un million de pèlerins visitent la ville de lumière dédiée à Shiva. Tous les jours, sur les sept kilomètres qui longent le fleuve, ponctués par soixante-quatre ghats (berges dont les marches donnent accès au fleuve), des dizaines de milliers de dévots prient, pratiquent des ablutions, se lavent et boivent l'eau sacrée.

Il est tôt dans la matinée d'un jour de janvier et seuls quelques degrés nous protègent du gel. Une brume humide enveloppe le Gange qui, à Varanasi, décrit un méandre vers le nord, là où il prend sa source dans l'Himalaya, avant de poursuivre son cours qui l'amènera dans le golfe du Bengale.

Manikarnika, de loin le plus grand des deux, fournit plus d'une vingtaine de bûchers qui brûlent en même temps. Les crémations sont pratiquées de père en fils par des spécialistes connus sous le nom de *doms*. Bien qu'appartenant à la caste des Intouchables et méprisés pour leur « sale » travail, les *doms* sont bien payés. Leur chef, Dom Raja, vit dans un magnifique palais sur l'un des ghats au sud de Manikarnika. Un cortège perpétuel de corps venus des environs entre dans Varanasi, charrié dans des véhicules de fortune, des camions, des voitures ou des pousse-pousse. À la fin du trajet, du Chowk, le quartier des affaires, jusqu'aux ghats, les corps sont portés à pied dans les rues étroites uniquement accessibles aux cyclomoteurs, passants et vaches sacrées.

Après la mort, les corps sont enduits de beurre de ghee (beurre clarifié), placés dans un linceul blanc et transportés en ville sur une civière en bambou couverte de tissu doré. Les parents du défunt chantent « Ram nam satya hai » (La vérité réside dans le nom de Dieu), ce qui signifie que la mort est la seule vérité, justifiant que le corps soit incinéré. Musiciens et danseurs sont autorisés à rejoindre le cortège, mais pas les femmes, leurs larmes étant susceptibles de déranger l'âme des morts.

Lorsque le cortège atteint Manikarnika, la civière est déposée sur les marches pendant que la crémation s'organise. La famille du défunt doit acheter du bois pour le bûcher. Trois cent soixante kilogrammes sont nécessaires pour brûler un seul corps. Des poudres parfumées, du bois de santal et du ghee sont achetés dans des boutiques aux alentours, pour être répandus sur le corps avant que ne jaillissent les flammes. Des coiffeurs s'apprêtent à raser la tête du parent menant le cortège, souvent le fils aîné du défunt. Une fois la tradition observée, ce dernier se lave dans le Gange avant de s'habiller d'un costume blanc qu'il gardera dix jours. Avant l'incinération, le corps est plongé dans les eaux sacrées du Gange.

On verse alors de l'eau dans la bouche du défunt à cinq reprises pour assouvir sa soif, tandis que les parents scandent « Ram nam satya hai ». Le corps est ensuite déposé sur le bûcher et la famille l'encercle cinq fois, le chef du cortège tenant un charbon ardent, rayonnant du feu sacré qui brûle depuis la nuit des temps à Manikarnika. Sans feu sacré, pas de crémation. Ce sont les *doms* qui contrôlent le feu sacré et le procurent aux familles avant que ne commence la cérémonie. En outre, plus la famille est riche, plus elle paye cher. Le ghee, les poudres parfumées et le bois de santal sont dispersés sur le corps avant que le chef du cortège n'allume le bûcher – au niveau de la tête si le défunt est un homme, des pieds s'il s'agit d'une femme. Les *doms* s'assurent alors que le feu prend bien pour que le corps brûle rapidement. Assis par terre, les parents du défunt regardent en silence.

D'autres crémations ont lieu en même temps, remplissant l'air d'une odeur de chair calcinée. De temps en temps, un estomac éclate brusquement. Le but des crémations est de libérer l'âme du défunt. Lorsque les flammes ont brûlé assez longtemps pour laisser apparaître le squelette, le chef du cortège casse le crâne du cadavre avec un pieu en bambou pour laisser échapper l'âme qui, selon la croyance, aurait la taille d'un pouce. Des cérémonies auront lieu les prochains jours afin d'aider l'âme dans son voyage vers la demeure des ancêtres, et dans sa transformation d'esprit en ancêtre.

Les membres de la famille se baignent ensuite dans le Gange avant de retourner

**Pages 476–477:** Tonnes of firewood are delivered to Manikarnika every day and sold to mourners who have come to cremate their loved ones.
**Pages 478–479:** All cremation corteges follow a special route to Manikarnika through Varanasi's old town.

**Pages 476–477 :** Chaque jour, le bois à brûler est livré par tonnes à Manikarnika et vendu aux familles venues incinérer leurs proches.
**Pages 478–479 :** Tous les cortèges funéraires suivent un trajet particulier menant à Manikarnika, à travers les rues de la vieille ville de Varanasi.

**Seiten 476–477:** Jeden Tag werden Tonnen von Feuerholz nach Manikarnika geliefert und an die Trauernden verkauft, die gekommen sind, um ihre Angehörigen einzuäschern.
**Seiten 478–479:** Alle Leichenzüge nach Manikarnika folgen einer bestimmten Route durch Varanasis Altstadt.

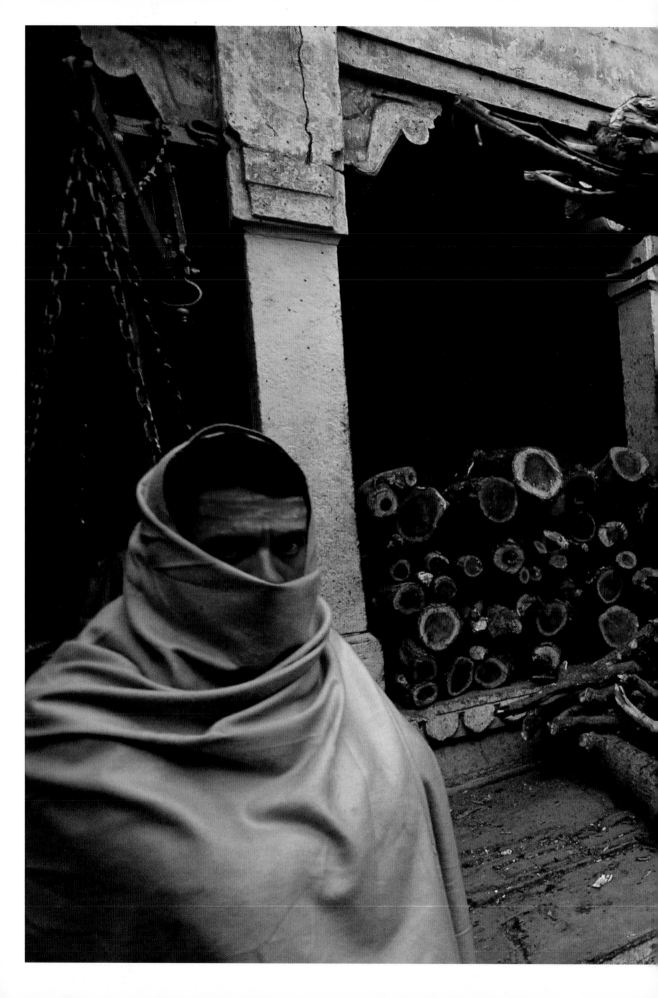

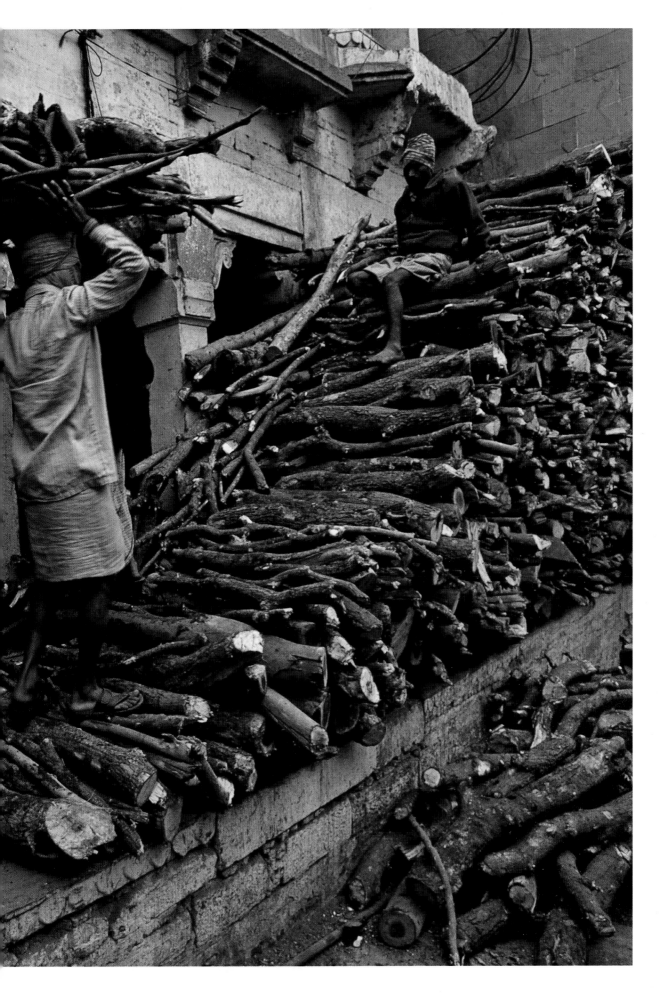

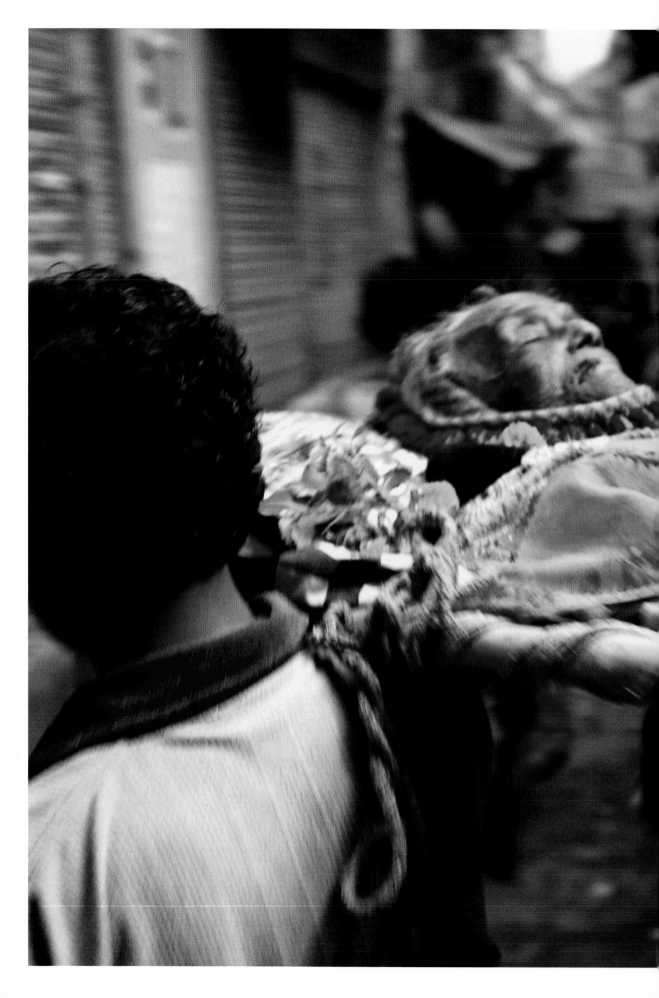

chez eux pour une période de deuil de dix jours. Durant cette période, le chef du cortège dormira dans une pièce spéciale sur une natte au sol. Il ne sera pas autorisé à utiliser du savon ni à se raser : il devra cuisiner sur un foyer séparé et manger assis face au sud, dans la direction du royaume d'Yama, le dieu de la mort. Après dix jours, le cortège retourne au Gange, les hommes devant se raser la tête avant de se baigner dans les eaux sacrées. Le treizième jour, une fête est organisée à laquelle sont conviés les prêtres brahmanes à qui l'on sert les plats préférés du défunt.

Les douze jours précédents symbolisent les douze mois nécessaires pour que l'âme du défunt voyage vers la demeure des ancêtres. Une fois à destination, l'âme est tenue de rendre compte des actions accomplies par la personne lors de sa vie. Mais l'âme n'est pas réincarnée tant que le corps n'a pas été incinéré à Varanasi, aussi appelée Kashi ou Bénarès, la ville sacrée.

# Einäscherung
## *Varanasi, Indien*

Die heiligste von Indiens alten Städten und Hüterin der heiligen Wasser des Flusses Ganges ist Varanasi, einer der wichtigsten Orte des Hinduismus.

Jedes Jahr besuchen mehr als eine Million Pilger die Stadt des Lichts und des Gottes Schiwa. Tag für Tag drängen sich auf den 64 Ghats, den Stufen zum Wasser des Ganges entlang dem sieben Kilometer langen Ufer, Zehntausende Gläubige. Sie sind gekommen, um zu beten, zu baden, sich zu waschen und das heilige Wasser zu trinken.

Es ist früh am Morgen im Januar und nur wenige Grad über dem Gefrierpunkt. Ein feuchter Nebel hängt über dem Ganges, der sich bei Varanasi wieder nach Norden zu seiner im Himalaja liegenden Quelle wendet, bevor er erneut die Richtung wechselt und seine Reise zum Golf von Bengalen fortsetzt.

Im Verlauf des Morgens bricht die Sonne endlich durch und taucht Tempel, Boote und Betende sowie alle, die von den Pilgern leben – Priester, Straßenhändler, Masseure, Führer, Bettler – in ein warmes, goldenes Licht.

Für einige ist die Pilgerfahrt nach Varanasi eine Reise ohne Wiederkehr. Die Leute kommen hierher, um zu sterben und Mokscha zu erlangen, die Befreiung aus dem Kreislauf von Tod und Wiedergeburt. Hindus glauben, dass derjenige, der in Varanasi stirbt und eingeäschert wird, sofort in den Himmel eingeht und auf ewig mit dem über allem thronenden kosmischen Geist, Brahman, vereint sein wird.

Die Scheiterhaufen brennen Tag und Nacht auf den schmutzigen Terrassen des Ghats Manikarnika. Im Durchschnitt werden hier täglich mehr als 100 Leichen verbrannt, eine Zahl, die in der mittwinterlichen Kälte des Januars dramatisch ansteigt. Jeder, der in einem 50- bis 60-Kilometer-Radius um die Stadt herum stirbt, wird innerhalb von 24 Stunden hier oder am Ghat Harishchandra, Varanasis anderem Ort für Feuerbestattungen, verbrannt.

Manikarnika ist die bei Weitem größere der beiden Stätten. Normalerweise brennen hier immer zwanzig oder mehr Scheiterhaufen gleichzeitig. Einäscherungen werden von Spezialisten, den Doms, durchgeführt, die ihren Beruf vom Vater auf den Sohn weitergeben. Obwohl sie als Unberührbare gelten und wegen ihrer „unreinen" Tätigkeit verachtet werden, verdienen Doms gut. Ihr Anführer, Dom Raja, lebt in einer palastartigen Residenz an einem der Ghats südlich von Manikarnika.

**Right:** As chief mourner, the eldest son of the deceased has his head shaved before the cremation.
**Pages 482–483:** Mourners look on as the eldest son lights the funeral pyre with embers from Manikarnika's eternal sacred fire.
**Pages 484–485:** After the cremation the Doms sift the ashes for jewellery and dental gold.

**À droite :** Menant le deuil, le fils aîné du défunt doit se faire raser le crâne avant la cérémonie de l'incinération.
**Pages 482–483 :** Le fils aîné allume le bûcher funéraire avec des tisons du feu sacré éternel de Manikarnika sous les yeux de la famille éplorée.
**Pages 484–485 :** Après l'incinération, les *doms* tamisent les cendres pour en recueillir bijoux et dents en or.

**Rechts:** Als Haupttrauernder lässt sich der Sohn des Verstorbenen vor der Einäscherung den Kopf rasieren.
**Seiten 482–483:** Die Trauernden sehen zu, wie der älteste Sohn den Scheiterhaufen mit Glut von Manikarnikas ewigem heiligem Feuer anzündet.
**Seiten 484–485:** Nach der Verbrennung sieben die Doms die Asche nach Schmuck oder Zahngold durch.

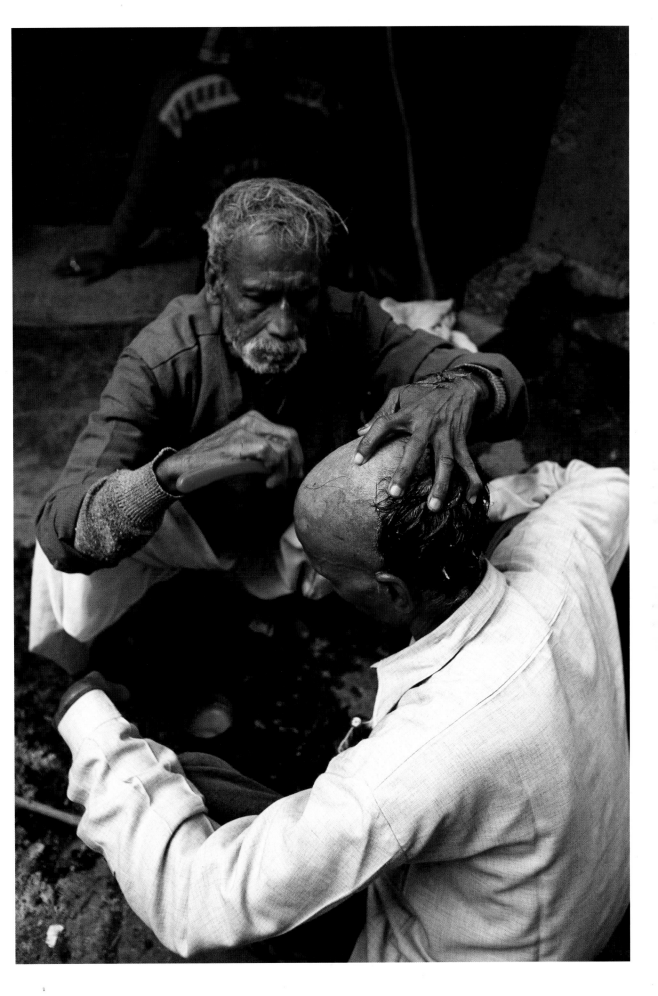

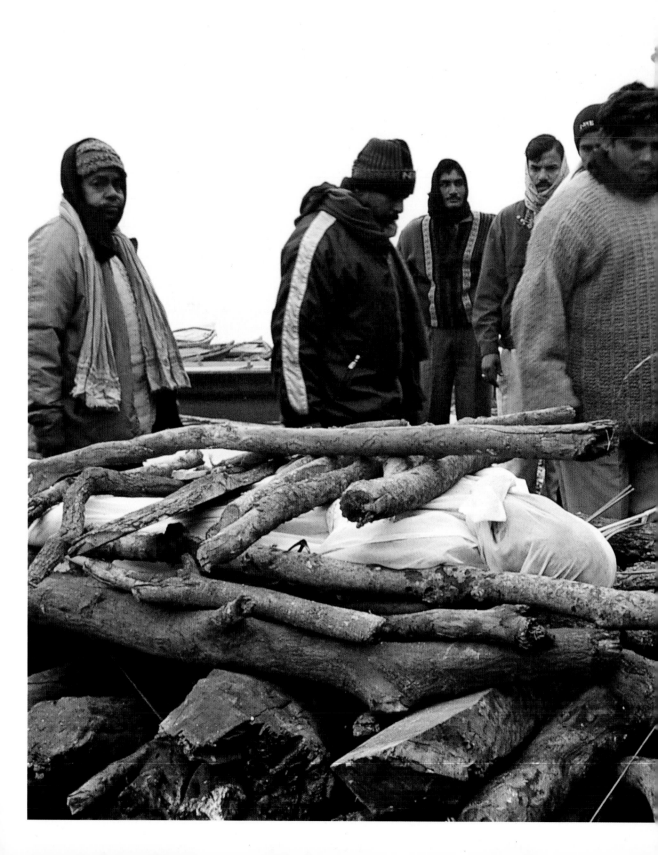

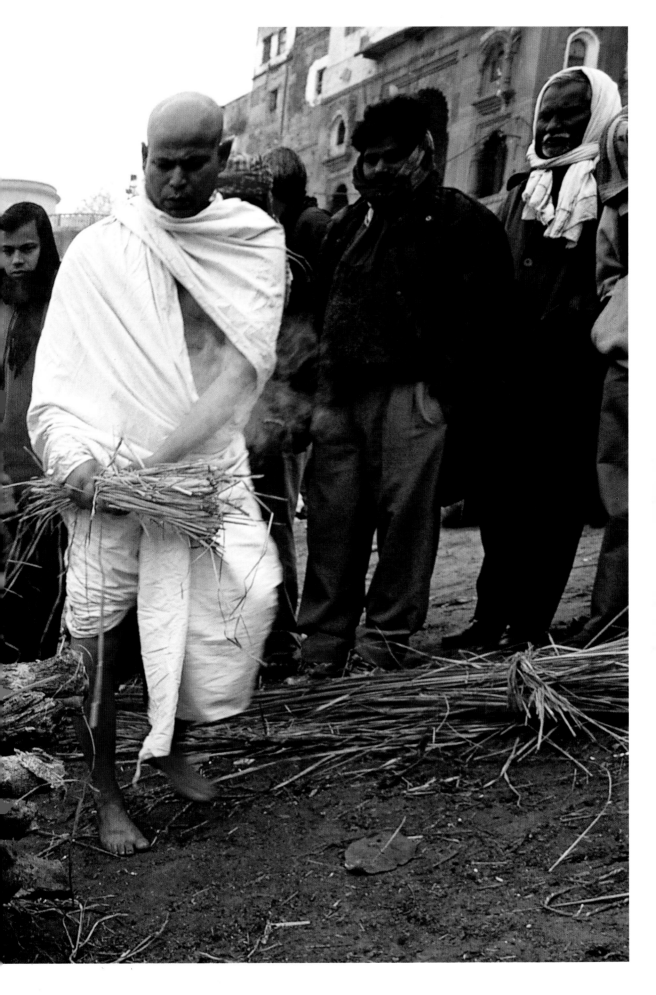

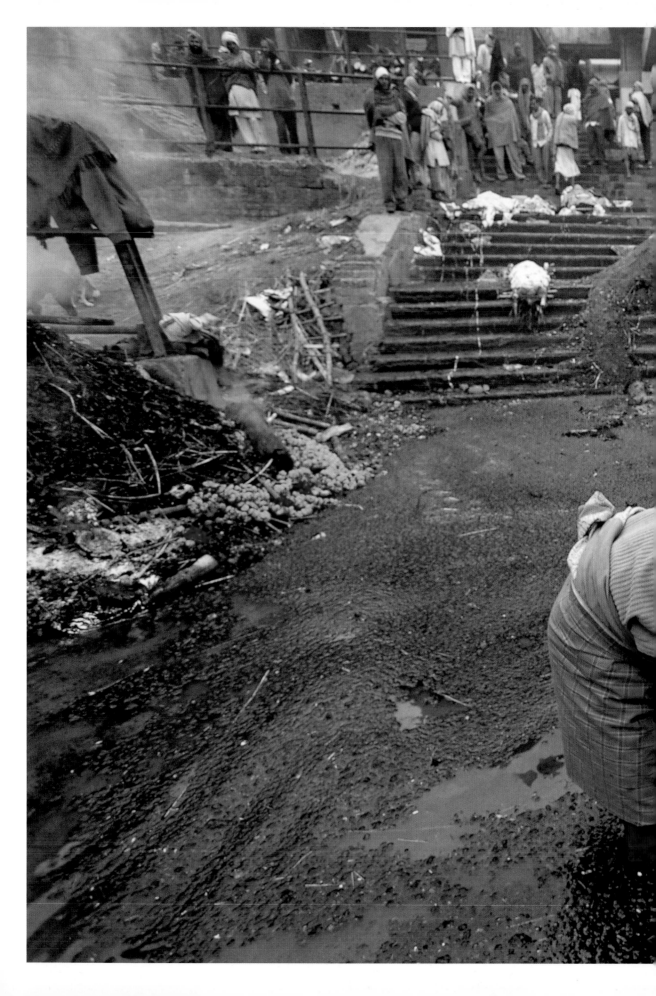

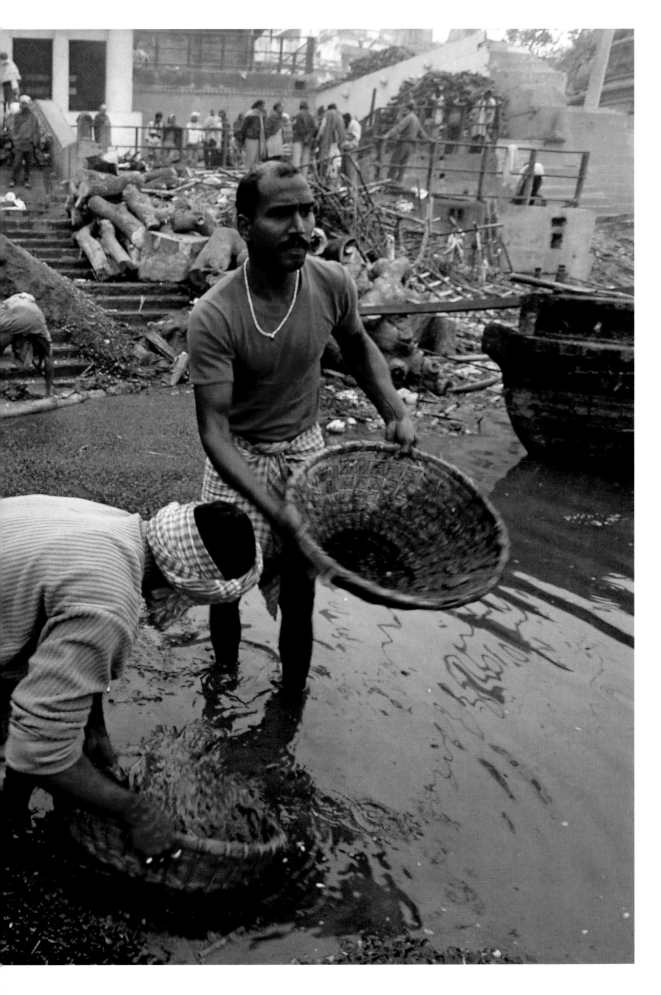

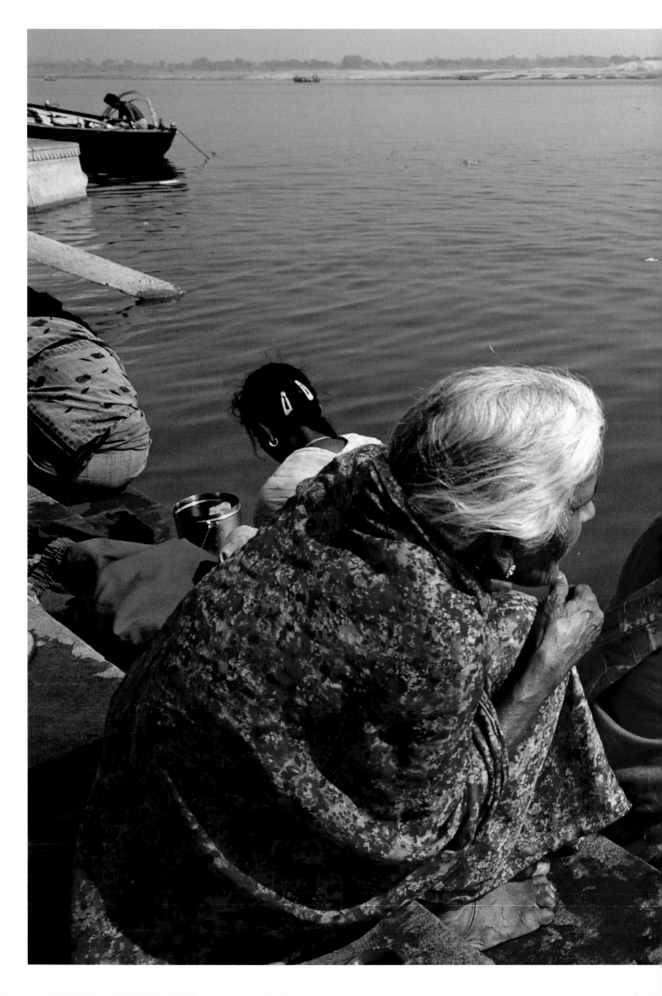

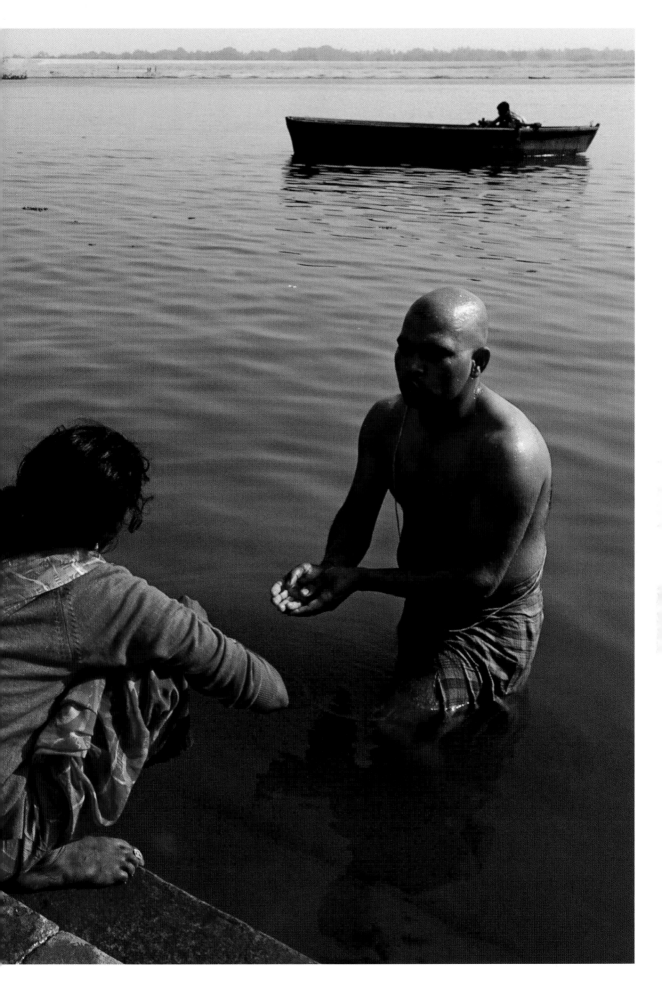

Ein nie endender Strom von Leichnamen kommt per Karren, Schubkarren, Lastwagen oder Motorriksha aus dem Umland nach Varanasi. Das letzte Stück vom Chowk-Geschäftsviertel bis zu den Ghats müssen sie durch die engen, nur für Fußgänger, Mopedfahrer und die gelegentlich auftauchenden Kühe oder Wasserbüffel passierbaren Straßen getragen werden. Nachdem der Tod eingetreten ist, wird der Körper mit Ghee, geläuterter Butter, gesalbt, in ein weißes Leichentuch gewickelt und auf einer Bambusbahre mit einem goldenen Tuch in die Stadt gebracht. Während sie den Leichnam zum Verbrennungsplatz bringen, singen die Trauernden „Ram nam satya hai" (Der Name des Gottes Ram ist Wahrheit). Das bedeutet, dass die einzige Wahrheit der Tod ist. Bisweilen begleiten Musiker und Tänzer den Trauerzug, Frauen sind jedoch nicht dabei, denn ihre Tränen könnten die Seelen der Verstorbenen stören.

Wenn die Prozession Manikarnika erreicht, wird die Bahre auf den Stufen abgesenkt, und die Details der Einäscherung werden geklärt. Die Familie des Verstorbenen muss das Holz für den Scheiterhaufen kaufen. 360 Kilogramm sind erforderlich, um einen einzigen Leichnam zu verbrennen.

Anschließend besorgen die Trauernden in den Geschäften am Ghat parfümierte Puder, Sandelholzstaub und Ghee, die über der Leiche zerstäubt werden, bevor das Feuer angezündet wird. Hier sitzen auch die Barbiere, die den Kopf desjenigen rasieren, der die Prozession anführt; in der Regel ist das der älteste Sohn des Verstorbenen. Ist diesem Brauch Genüge getan, wäscht sich der Anführer des Leichenzugs im Ganges, bevor er ein weißes nahtloses Gewand anzieht, das er zehn Tage lang tragen wird. Auch der Leichnam wird vor der Einäscherung in den Ganges getaucht.

Dann wird fünfmal Wasser in den Mund des Verstorbenen gegossen, um seinen Durst zu löschen; dabei singen die Trauernden wieder: „Ram nam satya hai." Der Leichnam wird auf den Scheiterhaufen gelegt, den die Trauergemeinde fünfmal umkreist. Ihr voran geht der Führer des Trauerzugs, der auf einem Bündel Stroh etwas Glut von den heiligen Feuern hält, die seit ewigen Zeiten am Manikarnika brennen. Denn ohne Feuer keine Einäscherung. Die Doms sind diejenigen, die das heilige Feuer beaufsichtigen. Von ihnen muss man es kaufen, bevor die Zeremonie beginnen kann. Und je reicher man ist, desto mehr muss man zahlen.

Ghee, parfümierte Puder und der Sandelholzstaub sind über den Leichnam verteilt, und nun zündet der Haupttrauernde den Scheiterhaufen an – am Kopf des Leichnams, wenn ein Mann verbrannt wird, an den Füßen, wenn es eine Frau ist. Von nun an kümmern sich die Doms darum, dass das Feuer richtig angefacht wird, sodass die Leiche vollständig verbrennt. Die Trauernden hocken sich hin und sehen schweigend zu.

Rundherum finden andere Einäscherungen statt, Rauch und der Geruch von verbrennendem Fleisch erfüllen die Luft. Ab und zu explodiert ein Magen mit einem Knall.

Die Einäscherung findet statt, um die Seele des Verstorbenen zu befreien. Wenn das Feuer so lange gebrannt hat, bis das Skelett brüchig wird, schlägt der Haupttrauernde mit einem Bambusstock den Schädel auf, um der Seele den Weg frei zu machen. Sie soll so groß wie ein Daumen, aber unsichtbar sein. An den kommenden Tagen werden Zeremonien abgehalten, die der Seele den Weg in das Reich der Ahnen und den Übergang vom Geist zum Ahnen erleichtern sollen.

Die Trauernden baden im Ganges, bevor sie zu einer zehntägigen Trauerzeit nach Hause zurückkehren. In dieser Zeit schläft der Haupttrauernde in einem speziellen Raum auf einer auf dem Boden ausgebreiteten Matte, darf weder Seife benutzen

**Pages 486–487:** Mourners return to the Ganges for a purification ceremony ten days after the cremation.
**Right:** The holy city of Varanasi is a pilgrimage site and the place where every Hindu would wish to be cremated.

**Pages 486–487 :** Dix jours après l'incinération, les familles des défunts retournent au Gange pour une cérémonie de purification.
**À droite :** La ville sainte de Varanasi (Bénarès) est lieu de pèlerinage et l'endroit où tous les Hindous voudraient être incinérés.

**Seiten 486–487:** Die Trauernden kehren zehn Tage nach der Einäscherung zu einer Reinigungszeremonie an den Ganges zurück.
**Rechts:** Die heilige Stadt Varanasi ist ein Pilgerort und der Platz, an dem jeder Hindu nach seinem Tod eingeäschert werden möchte.

noch sich rasieren, muss auf einer eigenen Feuerstelle kochen und beim Essen nach Süden blicken, in die Richtung, in der das Reich Yamas, des Herrschers über den Tod, liegt. Nach zehn Tagen kehrt die Trauergemeinde an den Ganges zurück, wo die männlichen Trauernden sich den Kopf rasieren lassen, bevor sie im heiligen Wasser baden. Am 13. Tag wird ein Fest gefeiert, zu dem Brahmanen eingeladen werden, denen das Lieblingsessen des Verstorbenen serviert wird.

Die zwölf Tage davor stehen für die zwölf Monate, die die Seele bis zum Sitz der Ahnen braucht. Ist sie dort angekommen, muss sie Rechenschaft über das ablegen,

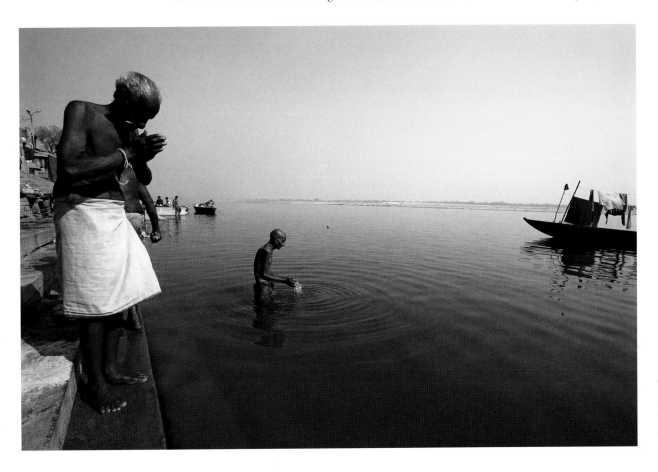

was sie als Mensch im Lauf des Lebens getan hat. Aber die Seele muss nicht wiedergeboren werden, denn ihr Körper wurde in Varanasi oder Kashi, der Stadt des Lichts, wie die heiligste Stadt auch genannt wird, verbrannt.

# Reburying the dead
## *Madagascar*

"When someone dies young it makes us sad, but when an old person dies it makes us happy. Because, you see, in Madagascar we don't want to stay when we get old, we want to return to our village, home to those who have died before us."

Death is an ever-present companion in the Madagascan highlands, both physically and psychologically. The practice of exhuming the dead and reburying them in another, final resting place is a phenomenon known to many cultures. But in Madagascar the Merina, Betsileo, Bezanozano and Sihanaka people bring the dead out of the grave and then put them back. And not just once after their death, but repeatedly until the deceased finally joins his or her ancestors.

*Famadihana*, the Madagascan reburial ritual, is practically unique among world cultures, although the ideas behind it are more or less universal.

After fifteen minutes or so of digging, the stone doors are fully exposed and swing open with a dull creak. Barefoot but wearing a white shirt and long trousers, Rakotoarivelo is the first to disappear down the steps into the underground tomb where the remains of his father, mother, two brothers and other ancestors lie on two-storey shelves.

Along the west-south-west wall there are no shelves; just a doorway. This makes the rays of sunshine sneak around the corner to the front of the grave and shine obliquely into it when the sun sets.

Rakotoarivelo is the reburial organiser. A couple of male relatives are helping him and follow him down the steps into the tomb. They carry torches, though some natural light enters the crypt through a skylight in the roof. The air is dry and odourless, somewhat unexpectedly since the corpse of Rakotoarivelo's older brother was buried here only a year ago and has yet to dry out fully. The general rule is to wait at least one and a half years after a funeral before opening the tomb for a reburial.

The sides of the shelves are in stone and painted in red and green floral patterns. Rakotoarivelo steps onto one to climb up to the bodies of his mother and father on the upper shelf. The dead will now be removed, sprayed with perfume and given alcohol while family members talk to them and tell them the latest news. The old, stained shrouds from their last reburial will also be covered with new spotless white ones.

Rakotoarivelo and his helpers first wrap the bodies in fresh sheets to make sure they look presentable when brought above ground. Waiting for them is the entire family, along with relatives, friends and neighbours. A group of young men play flutes and drums as the bodies emerge.

Far from being an ancient rite, famadihana is a relatively new custom in most of the areas where it is now performed. It developed in the nineteenth century among the Merina, the island's largest ethnic group. In former times, Merina kings and queens were the link between people and their ancestors, giving blessings without which it was not possible to have a good life. But when Madagascar came under foreign influence the monarchy adopted Western ways and the link was broken. People instead turned straight to their ancestors for spiritual blessings.

Famadihana gradually spread across the Madagascan highlands and was adopted by the Bezanozano people, to which Rakotoarivelo belongs, as recently as the 1940s. As the ritual has grown, so the tombs have become increasingly grandiose,

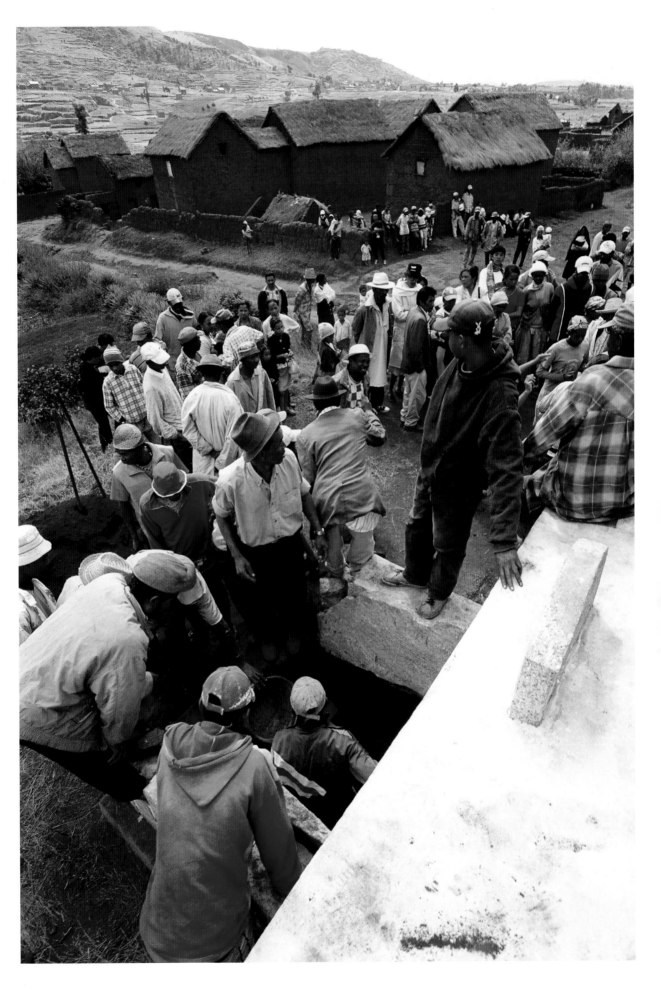

and these days are often topped by a stone building above ground. These small whitewashed structures are a common feature of the highland landscape, standing inside or at the edges of rural villages.

There are three types of reburial ceremony. The first involves the deceased being temporarily buried in a tomb somewhere else prior to exhumation and removal to the family grave. The second involves consecrating a new grave by moving one or several ancestors from an old family crypt to a new one. The third, as practised by Rakotoarivelo and his family, involves exhumation and reburial in the same tomb.

The bodies are laid carefully on pandanus mats on the ground on the northern side of the tomb. It is an emotional moment for Rakotoarivelo's sister-in-law, nephews and nieces as this is the first time they have been reunited with their husband and father since he died one year ago. The other bodies have been dead for years and Rakotoarivelo's mother and father have been reburied before. All that remains of them is bones.

The relatives sway gently as they stand beside the bodies, moving their hands in unison with the music and holding up photographs of the deceased during life.

For hygienic reasons, reburials are legally permitted only during the dry season. This is the coolest time of year and the dead are said to lie freezing in their graves. New shrouds are applied in layers to keep the bodies warm.

By tending to their dead, close relatives secure blessings that will benefit the harvest and their health and fertility. Women who touch the dead bodies are believed to become fertile, and after reburials it is not unusual for them to fight over who gets to keep the mats on which the bodies have lain. Placing a piece of a mat under her bed is a potent means for a woman to become pregnant.

Once the dead have been wrapped in new shrouds the dancing begins. The bodies are rolled in the mats and hoisted onto their descendants' shoulders. In tune to the music, the dancers move clockwise round the tomb. Gradually the dance gains intensity as the sombre mood gives way to a more festive air. The fear of the dead has ebbed away and the dancers laugh and smile as they cavort with the bodies, sometimes almost throwing them into the air.

Later that evening, when the ritual is over and the dead have been returned to their shelves inside the tomb, the family sit around reminiscing. Rakotoarivelo talks about his younger brother, who died when still a young man and left behind young children. "When an old person dies we're happy, you know. But when someone dies young it makes us very sad."

# La réinhumation des morts
## *Madagascar*

« Quand quelqu'un meurt jeune, nous sommes tristes, mais lorsqu'il s'agit d'une personne âgée, ça nous rend heureux. Parce qu'en fait, vous voyez, à Madagascar, on ne veut pas rester quand nous devenons vieux, nous préférons retourner dans notre village, avec ceux qui sont morts avant nous. »

La mort est un compagnon constant dans les régions montagneuses de Madagascar, tant physiquement que psychologiquement. La pratique consistant à exhumer les morts et à les enterrer de nouveau dans un autre lieu de repos est un phénomène connu dans d'autres cultures. Mais à Madagascar les Merina, les Betsiléo, les Bezanozano et les Sihanaka sortent les morts de leur tombeau avant de les inhumer de nouveau. Et ils agissent ainsi à plusieurs reprises, jusqu'à ce que le défunt ait finalement retrouvé ses ancêtres.

*Famadihana*, le rituel de réinhumation, s'avère pratiquement unique au monde, bien que les motivations de ce phénomène soient plus ou moins universelles. Après quinze minutes de travail dans la terre, les portes en pierre apparaissent et s'ouvrent dans un grincement lourd. Pieds nus, mais vêtu d'une chemise blanche et d'un pantalon long, Rakotoarivelo est le premier à s'engouffrer par les marches dans le tombeau souterrain où gisent les restes de son père, sa mère, ses deux frères ainsi que ses ancêtres couchés dans des niches superposées. Le long du mur orienté ouest-sud-ouest, il n'y a rien ; juste une embrasure. Les rayons du soleil passent ainsi dans le coin devant le tombeau et tombent obliquement lorsque le soleil se couche. Rakotoarivelo est l'organisateur de la réinhumation. Deux ou trois hommes l'aident et le suivent dans le tombeau. Ils tiennent des torches, bien qu'un peu de lumière filtre dans la crypte par une lucarne sur le toit. L'air est sec et inodore, ce qui est inattendu puisque le corps du frère aîné de Rakotoarivelo a été enterré il y a seulement un an, et n'a donc pas encore séché entièrement. En général, il est d'usage d'attendre au moins un an et demi après les obsèques avant d'ouvrir le tombeau pour la réinhumation.

Les côtés des niches sont en pierres peintes ornées de motifs floraux rouges et verts. Rakotoarivelo grimpe sur une niche pour accéder aux corps de sa mère et de son père à l'étage supérieur. Dehors, les corps seront parfumés et les membres de la famille leur donneront de l'alcool, leur parleront et leur raconteront les dernières nouvelles. Les vieux linceuls souillés de la dernière réinhumation seront également recouverts de linceuls neufs d'un blanc immaculé.

Rakotoarivelo et ses compagnons enveloppent d'abord les corps dans des draps frais de façon à s'assurer qu'ils seront présentables une fois remontés à la surface. Toute la famille attend, ainsi que des proches et des voisins. Un groupe de jeunes hommes joue de la flûte et des percussions au moment où les corps apparaissent. Loin d'être un rituel antique, Famadihana est une coutume relativement récente dans la plupart des secteurs où elle est pratiquée. Elle fut développée au XIXe siècle par les Merina, le plus important groupe ethnique de l'île.

Autrefois, les rois et reines merina assuraient les liens entre le peuple et leurs ancêtres, offrant des bénédictions sans lesquelles il n'était pas possible de bénéficier d'une belle vie. Mais lorsque Madagascar tomba sous influence étrangère, la monarchie adopta les règles occidentales et la liaison fut rompue. Le peuple s'est alors tourné vers ses ancêtres pour des bénédictions spirituelles.

**Pages 496–497:** Relatives and friends arrive for a reburial. They bring contributions of firewood, food and money with them.

**Pages 496–497 :** Parents et amis se retrouvent pour l'exhumation. Ils contribuent à la cérémonie en apportant bois de chauffage, nourriture et dons d'argent.

**Seiten 494–495:** Verwandte und Freunde kommen zum Totenumwendungsfest und steuern Feuerholz, Essen und Geld bei.

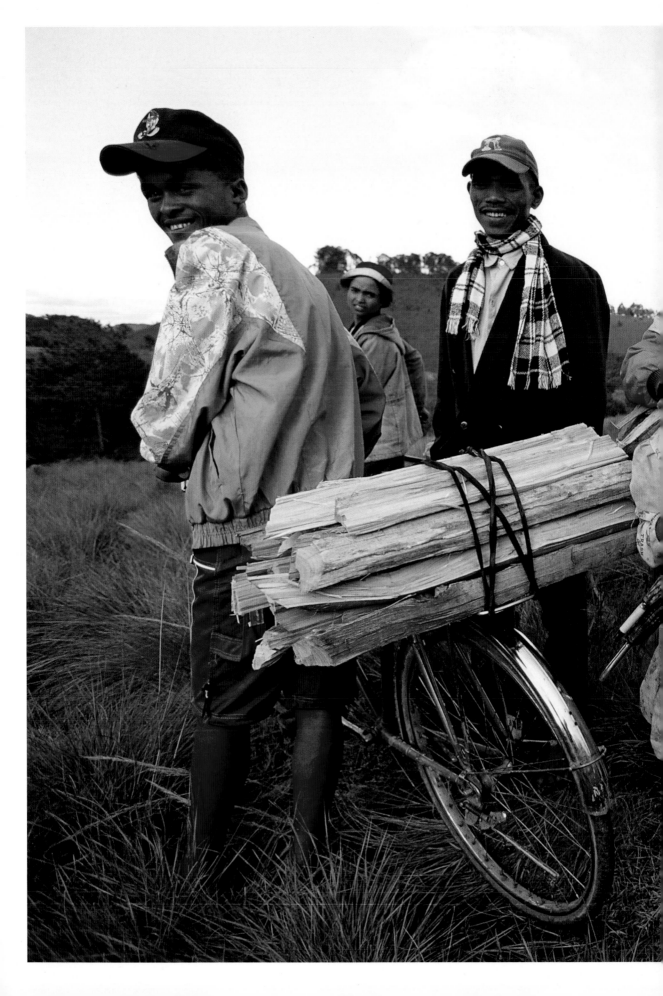

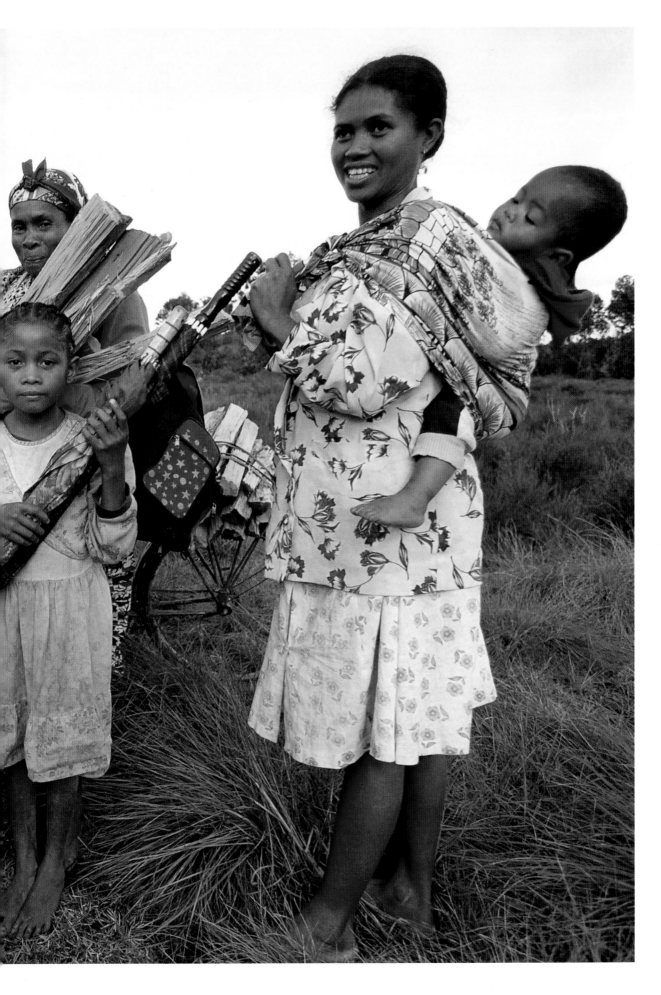

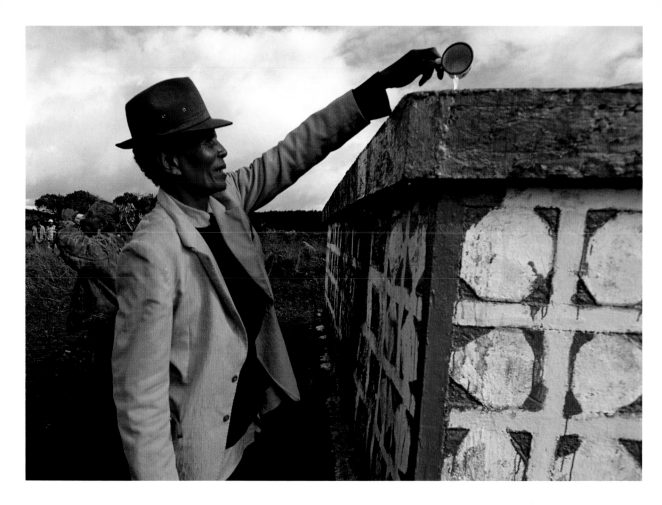

Famadihana s'est progressivement étendue à travers la région montagneuse malgache et a été adoptée depuis les années 1940 par les Bezanozano, auquel appartient Rakotoarivelo. La pratique du rituel se développant, les tombeaux sont devenus de plus en plus impressionnants et, de nos jours, ils se distinguent par une construction en pierre érigée au-dessus du sol. Ces petits édifices blanchis sont typiques des paysages montagneux, plantés ça et là à l'intérieur ou aux abords des villages.

Il existe trois natures de cérémonies de réinhumation. La première implique que le défunt soit temporairement enterré dans un tombeau à part avant d'être exhumé et déplacé dans le tombeau familial. La deuxième suppose la création d'un nouveau tombeau et sous-entend de déplacer un ou plusieurs ancêtres de la crypte familiale vers le nouvel emplacement. La troisième, telle que la pratique Rakotoarivelo et sa famille, implique l'exhumation et la réinhumation dans le même tombeau.

Les corps sont étendus avec précaution sur des nattes en pandanus à même le sol, au nord du tombeau. Il s'agit d'un grand moment d'émotion pour la belle-soeur de Rakotoarivelo, pour ses neveux et nièces qui sont réunis ici pour la première fois avec l'époux et le père, mort il y a un an. Les autres corps sont ici depuis longtemps, la mère et le père de Rakotoarivelo ayant déjà été déplacés et il ne reste d'eux que des os.

Les membres de la famille se balancent doucement à côté des corps, bougeant leurs mains à l'unisson avec la musique, brandissant des photographies des défunts lors de leur vie. Pour des raisons d'hygiène, les réinhumations ne sont autorisées que lors de la saison sèche. Il s'agit de la saison la plus fraîche et on dit que les morts sont frigorifiés dans leur tombeau. C'est pourquoi de nouveaux linceuls sont appliqués en couches successives pour garder les corps au chaud. En s'occupant de leurs morts,

**Above:** A pre-reburial ceremony is held the day before to inform the deceased to be ready. Rum is poured on the tomb as an offering.
**Right and pages 500–501:** One of the two bulls slaughtered to feed the guests who attend the ceremony.

**Ci-dessus:** La veille de l'exhumation, un premier rite consiste à informer les morts et à asperger la tombe de rhum en offrande.
**À droite et pages 500–501:** Un bœuf est tué pour le repas qui sera servi aux invités de la cérémonie.

**Oben:** Am Tag zuvor werden die Toten in einer Zeremonie über das Fest informiert, damit sie bereit sind. Als Opfergabe wird Rum über das Grab gegossen.
**Rechts und Seiten 500–501:** Einer der beiden Bullen, die für die Gäste des Festes geschlachtet werden.

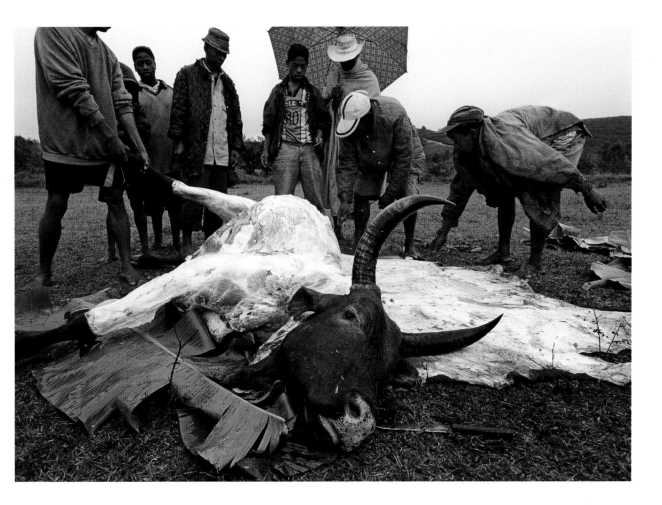

les parents de la famille s'assurent de bénédictions qui profiteront aux moissons, à la santé et à la fertilité. Les femmes qui touchent les corps sont en effet censées gagner en fertilité, et après la réinhumation il n'est pas rare de les voir se disputer les nattes sur lesquelles étaient étendus les corps. Placer un morceau de natte sous son lit représente un excellent moyen de tomber enceinte.

Une fois que les morts ont été enveloppés dans de nouveaux linceuls, la danse commence. Les corps sont roulés dans les nattes et hissés sur les épaules de leurs descendants. Sous l'emprise de la musique, les danseurs tournent en rond autour du tombeau dans les sens des aiguilles d'une montre. La danse s'intensifie progressivement tandis que l'humeur sombre cède la place à un air de fête. La crainte de la mort s'est éloignée et les danseurs rient de bon cœur tout en s'agitant dans des cabrioles et projetant presque les corps dans l'air.

Plus tard dans la soirée, lorsque le rituel s'est achevé et que les morts ont été replacés dans les niches de leur tombeau, la famille évoque le passé. Rakotoarivelo parle de son plus jeune frère, mort en laissant des enfants en bas âge. « Quand une personne âgée meurt, nous sommes heureux, vous savez. Mais lorsqu'elle est jeune, ça nous rend très tristes. »

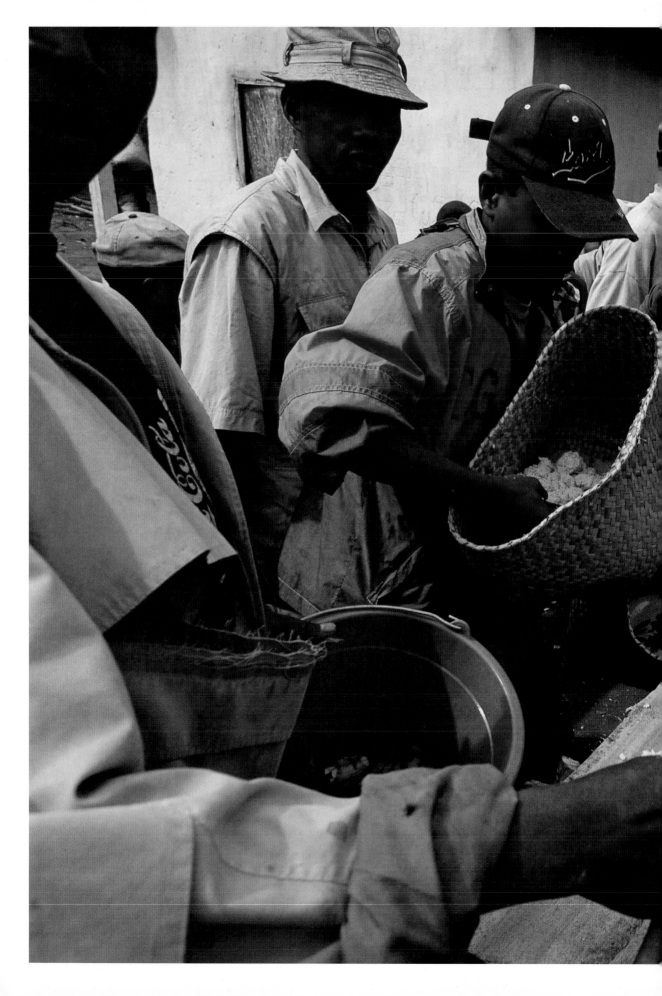

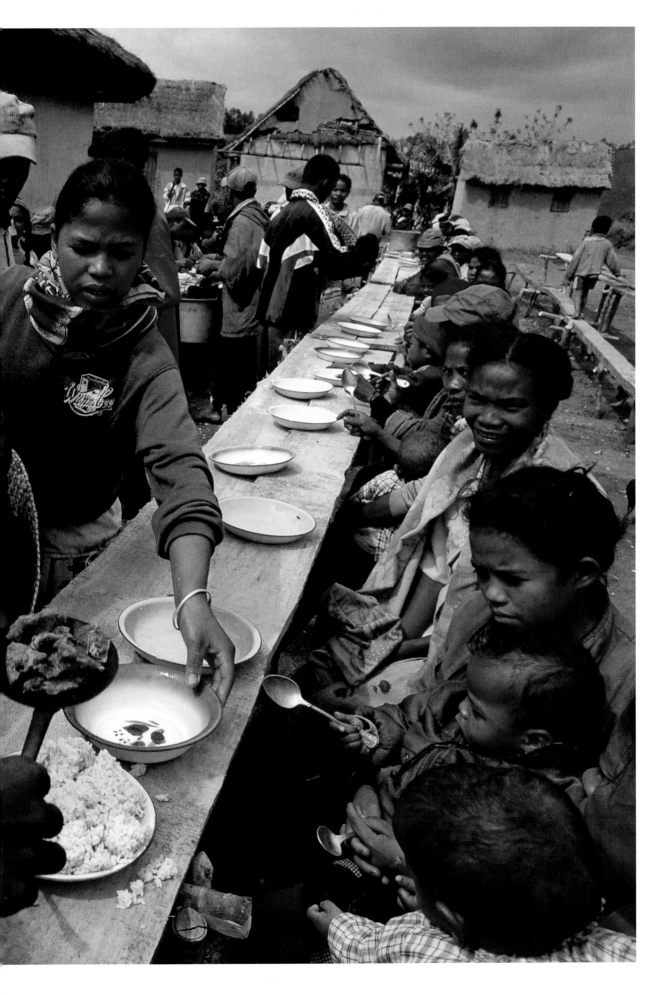

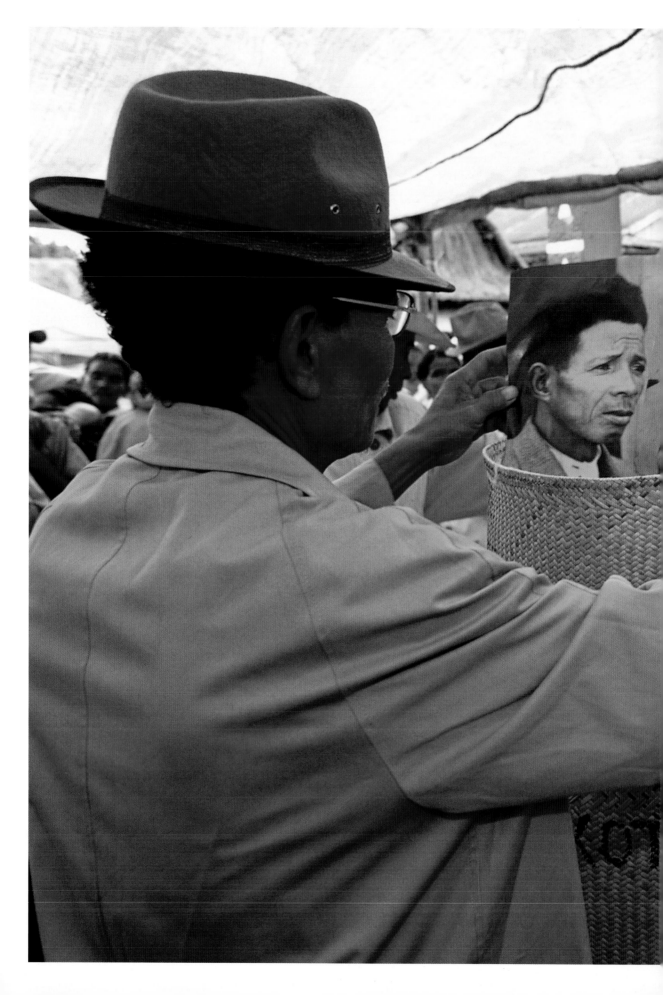

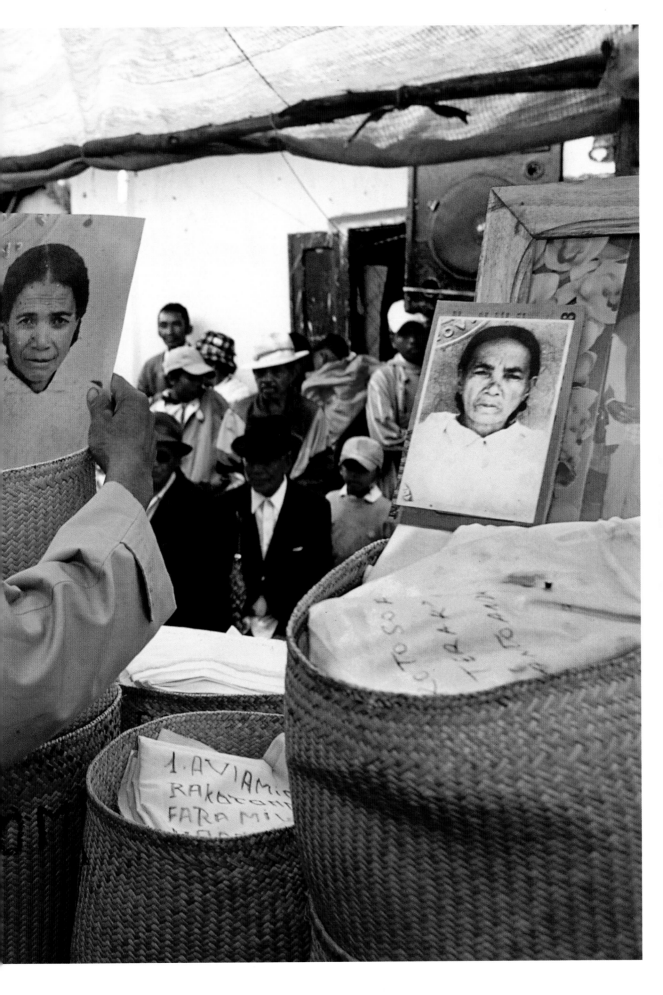

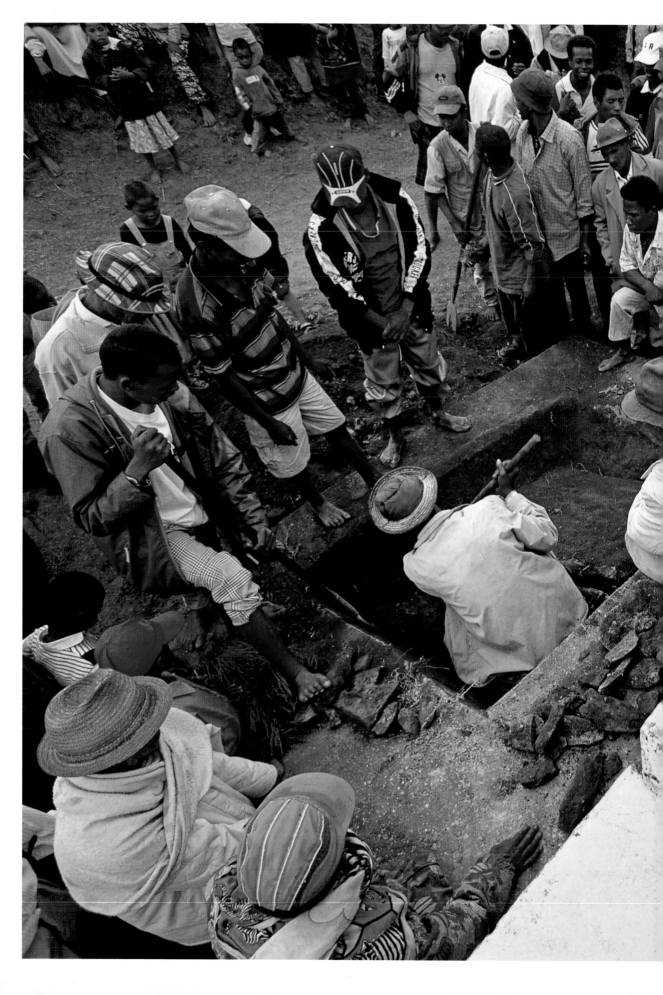

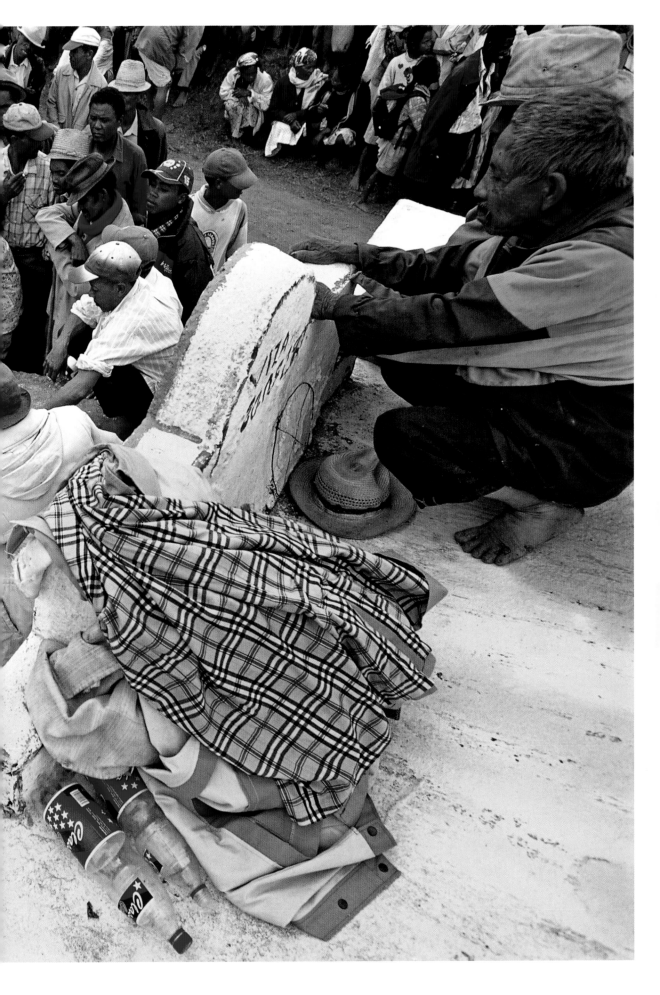

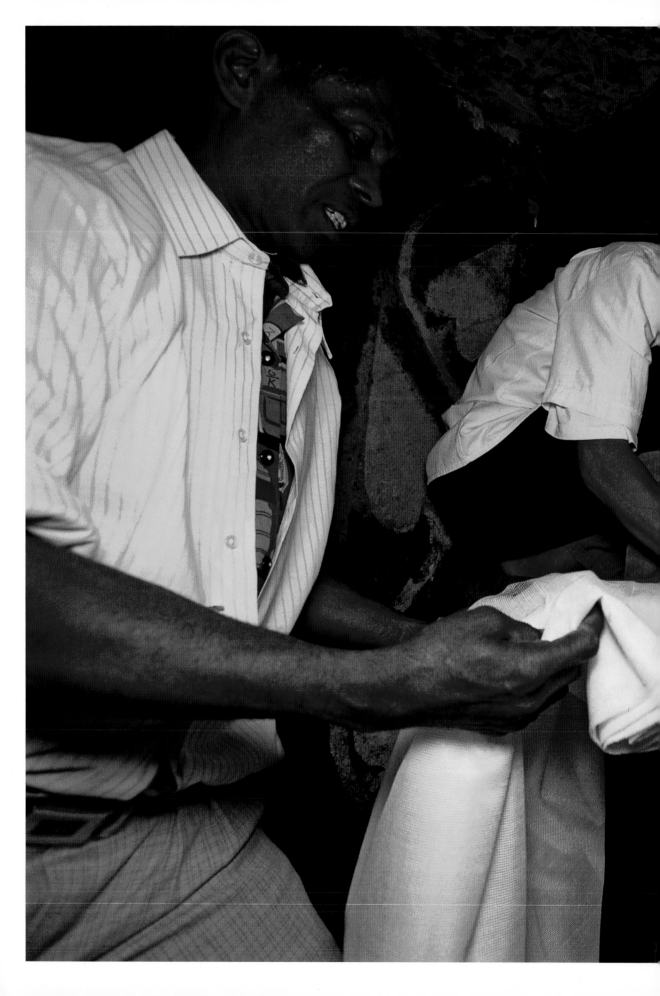

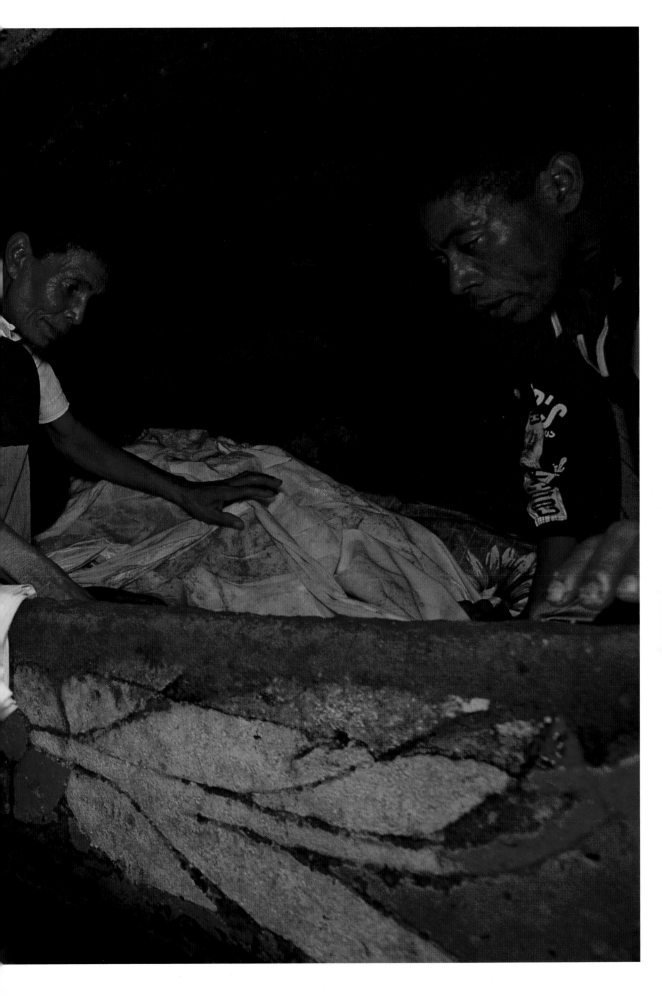

# Totenumwendungsfest
## *Madagaskar*

„Wenn jemand jung stirbt, macht uns das traurig, aber wenn ein alter Mensch stirbt, sind wir darüber glücklich. Denn wissen Sie, in Madagaskar wollen wir nicht bleiben, wenn wir alt sind. Wir wollen in unser Dorf zurückkehren, die Heimat derer, die vor uns gestorben sind."

Der Tod ist im Hochland von Madagaskar ein ständiger Begleiter, sowohl physisch als auch psychologisch. Es ist auch in anderen Kulturen üblich, Verstorbene zu exhumieren und an einem endgültigen Ort noch einmal zu bestatten. Aber in Madagaskar holen die Merina, Betsileo, Bezanozano und Sihanaka ihre Toten aus den Gräbern, nur um sie dort gleich wieder zu beerdigen. Und nicht nur einmal, sondern wiederholt, bis der Verstorbene schließlich bei seinen Ahnen ist.

Famadihana, das madagassische Ritual der Totenumwendung, ist einzigartig in allen Kulturen der Welt, obwohl die Idee, die dahinter steht, mehr oder weniger universell ist.

Nach etwa 15 Minuten sind die Steintüren vollkommen freigeschaufelt und öffnen sich mit einem gedämpften Quietschen. Barfuß, aber in einem weißen Hemd und langer Hose, verschwindet Rakotoarivelo als Erster die Stufen hinunter in das unterirdische Grab, wo die sterblichen Überreste seines Vaters, seiner Mutter, zweier Brüder und anderer Vorfahren in zweigeschossigen Nischen liegen.

Entlang der westsüdwestlichen Wand gibt es keine Nischen, nur eine Tür. Durch sie fallen die Strahlen der untergehenden Sonne schräg vorn ins Grab.

Rakotoarivelo organisiert die Totenumwendung. Ein paar männliche Verwandte helfen ihm und folgen ihm die Stufen hinunter in das Grab. Sie tragen Fackeln, obwohl durch ein Oberlicht in der Decke der Krypta etwas Licht fällt. Die Luft ist trocken und geruchslos. Das ist ein bisschen überraschend, denn Rakotoarivelos Bruder wurde hier erst vor einem Jahr bestattet und sein Leichnam ist noch nicht ganz ausgetrocknet. Im Allgemeinen wird nach der Beerdigung eineinhalb Jahre gewartet, bevor man das Grab für eine Totenumwendung öffnet.

Die Wände der Nischen bestehen aus mit roten und grünen Pflanzenmustern bemalten Steinen. Rakotoarivelo stellt sich in eine Nische, um von da aus auf die obere Etage zu klettern, wo die Überreste seines Vaters und seiner Mutter liegen. Die Toten werden nun herausgenommen und mit Parfüm besprüht. Man gibt ihnen Alkohol, und währenddessen erzählen die Familienmitglieder ihnen, was in letzter Zeit passiert ist. Die alten fleckigen Leichentücher von der letzten Beerdigung werden mit neuen, makellos weißen Tüchern bedeckt.

Rakotoarivelo und seine Helfer wickeln die Leichname zuerst in die neuen Tücher, damit sie ordentlich aussehen, wenn sie nach oben gebracht werden. Die ganze Familie wartet auf sie, gemeinsam mit Verwandten, Freunden und Nachbarn. Eine Gruppe junger Männer spielt Flöte und Trommeln, als die Leichname herauskommen.

Die Famadihana ist ein alles andere als alter Brauch, vielmehr ist sie eine relativ neue Sitte in den meisten Regionen, in denen sie heute befolgt wird. Sie entstand im 19. Jahrhundert bei den Merina, der ältesten Ethnie der Insel. In vergangenen Zeiten stellten die Könige und Königinnen der Merina die Verbindung zwischen den Menschen und ihren Ahnen dar. Sie erteilten den Segen, ohne den ein gutes Leben nicht möglich war. Als Madagaskar aber unter ausländischen Einfluß geriet,

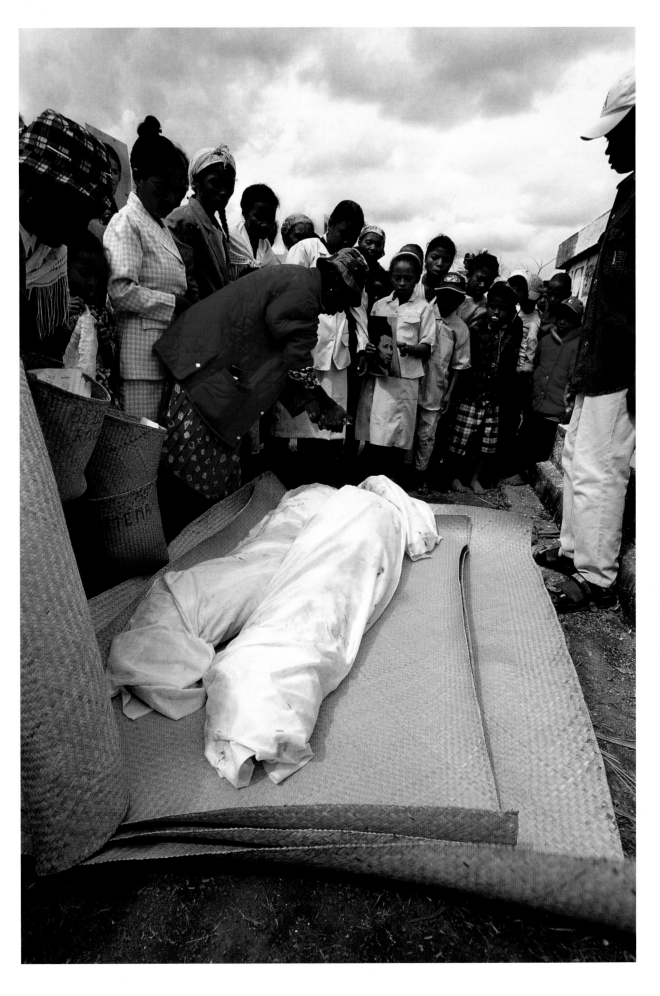

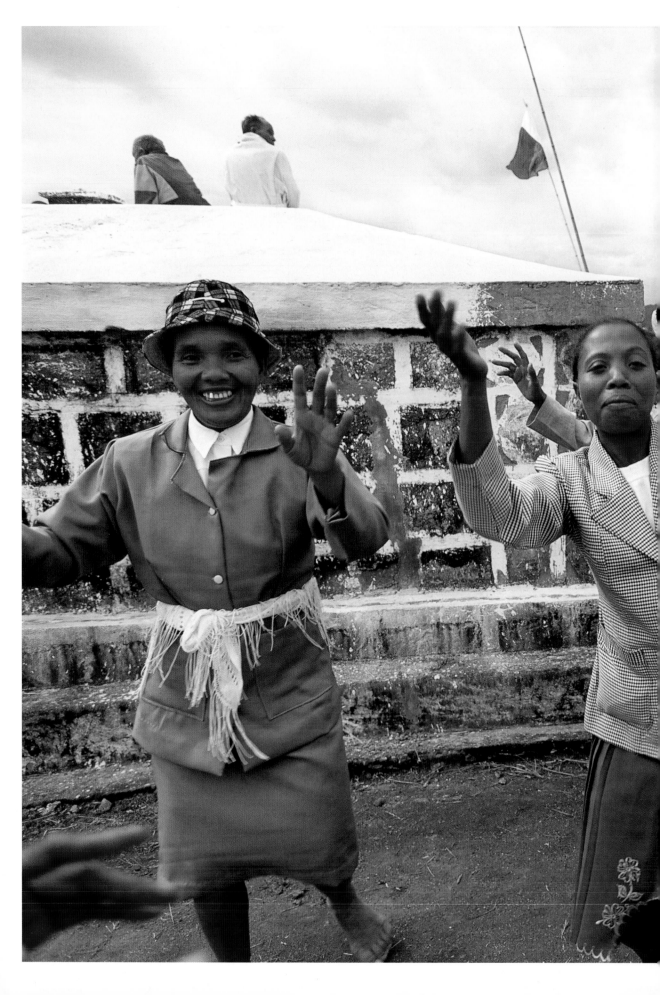

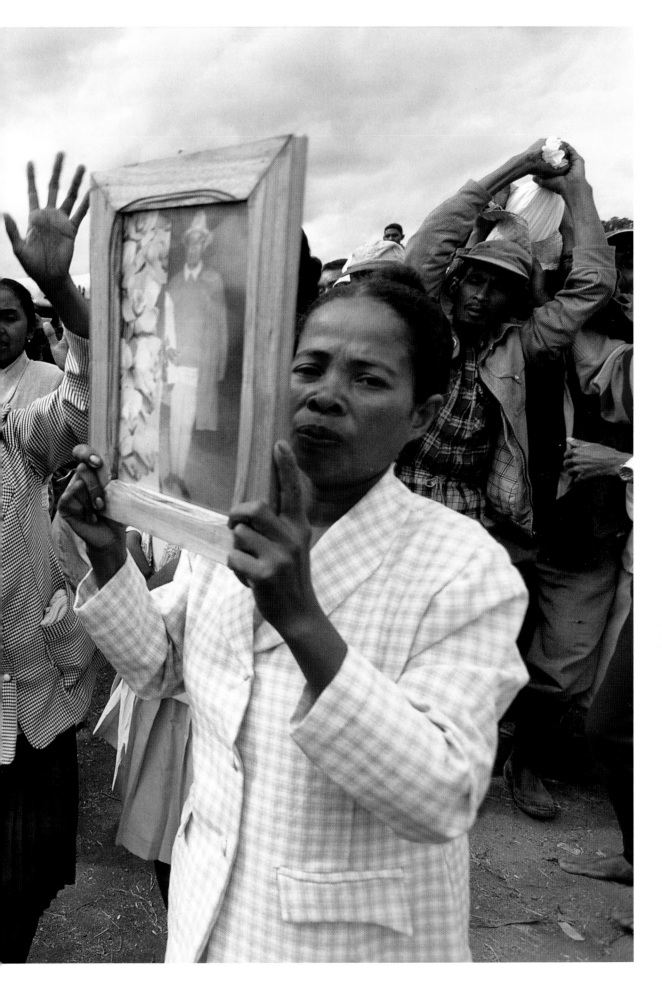

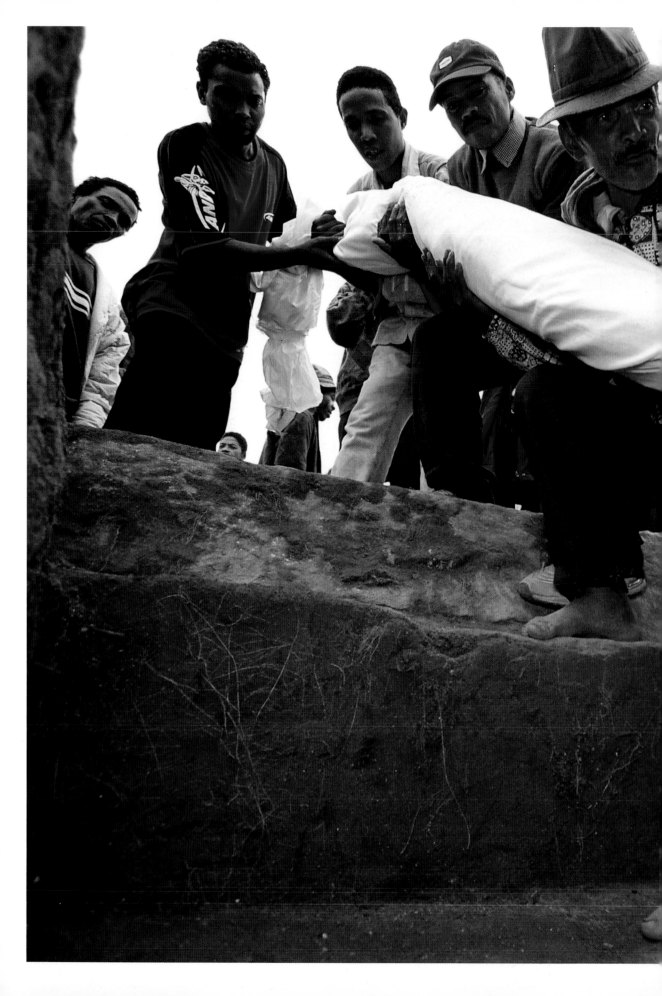

passte sich die Monarchie westlichen Gepflogenheiten an, und die Verbindung zu den Ahnen war unterbrochen. Von nun wandten sich die Leute direkt an die Ahnen, um deren Segen zu erhalten.

Die Famadihana verbreitete sich allmählich über das ganze madagassische Hochland. Erst in den 1940er-Jahren wurde sie auch von den Bezanozano übernommen, zu denen Rakotoarivelo gehört. Mit der wachsenden Bedeutung des Rituals sind auch die Gräber immer großartiger geworden, und heute steht oft ein Gebäude aus Stein auf ihnen. Diese kleinen, weiß getünchten Häuser sind im Hochland ein wiederkehrender Anblick. Sie befinden sich entweder im oder am Rand eines Dorfes auf dem Land.

Es gibt drei Arten von Totenumwendungsritualen. Beim ersten werden die Verstorbenen zunächst zeitweise in einem Grab bestattet, bevor sie wieder exhumiert und im Familiengrab beigesetzt werden. Das zweite betrifft die Weihung einer neuen Grabstätte, wenn ein oder mehrere Familienmitglieder aus einem alten in ein neues Grab überführt werden. Beim dritten Ritual, wie Rakotoarivelo und seine Familie es feiern, geht es darum, die Toten zu exhumieren und erneut im gleichen Grab zu bestatten.

Die Leichname werden sorgfältig auf Matten aus Blättern der Schraubenbäume auf der Nordseite des Grabs auf den Boden gelegt. Für Rakotoarivelos Schwägerin, Neffen und Nichten ist das ein berührender Moment, denn dies ist das erste Mal, dass sie mit ihrem Ehemann und Vater wieder zusammen sind, seit er vor einem Jahr gestorben ist. Die anderen Leichname sind seit Jahren tot und Rakotoarivelos Eltern sind bereits mehrfach beerdigt worden.

Die Verwandten wiegen sich leicht im Rhythmus der Musik, während sie neben den Leichnamen stehen und Fotos von ihnen aus Lebzeiten in den Händen halten.

Aus hygienischen Gründen sind Totenumwendungsfeiern offiziell nur während der Trockenzeit erlaubt. Das ist die kühlste Zeit des Jahres und man sagt, die Toten lägen nun frierend in ihren Gräbern. Sie werden in mehrere Lagen neuer Leichentücher gewickelt, damit sie es warm haben.

Indem sie sich um ihre Toten kümmern, versichern sich nahe Verwandte ihres Segens, der ihnen im Hinblick auf Ernte, Gesundheit und Fruchtbarkeit von Nutzen sein wird. Von Frauen, die die Leichname berühren, sagt man, dass sie fruchtbar werden, und es kommt nicht selten vor, dass sie sich am Ende einer Totenumwendungsfeier um die Matten streiten, auf denen die Leichname gelegen haben. Ein Stück solch einer Matte unter das Bett einer Frau zu legen, ist ein wirksames Mittel für eine Schwangerschaft.

Nachdem die Toten in neue Tücher gewickelt sind, beginnt der Tanz. Die Leichname werden in die Matten gerollt und ihren Nachkommen auf die Schultern gehoben. Im Rhythmus der Musik bewegen sich die Tänzer im Uhrzeigersinn um das Grab. Allmählich wird der Tanz intensiver, und Ausgelassenheit tritt an die Stelle der eher gedrückten Stimmung. Die Angst vor den Toten hat sich gelegt, und die Tänzer lachen und grinsen, wenn sie mit den Leichnamen herumspringen und sie manchmal fast in die Luft hochwerfen.

Später am Abend, wenn das Ritual beendet ist und die Toten wieder in ihre Grabnischen gelegt worden sind, sitzen die Familien zusammen und reden über alte Zeiten. Rakotoarivelo spricht über seinen jüngeren Bruder, der jung gestorben ist und kleine Kinder hinterlassen hat. „Wissen Sie, wenn ein alter Mensch stirbt, sind wir glücklich. Aber wenn ein junger Mensch stirbt, macht uns das sehr traurig."

**Pages 510–511:** Dancing with the dead: The family roll the bodies in straw mats and then carry them aloft in a dance round the tomb. The sombre mood gradually lifts and a more festive atmosphere takes hold.
**Pages 512–513:** Returning the dead to the tomb.
**Right:** When the dead have been restored to their resting place their closest relatives go down to talk to them and bid a final farewell. Then they are covered in a new shroud and the tomb is sealed.

**Pages 510–511:** La danse avec les morts; la famille enroule les corps dans des nattes de paille et les porte en l'air en dansant autour de la tombe. Peu à peu, une ambiance festive remplace l'atmosphère de tristesse.
**Pages 512–513:** Les morts sont replacés dans la tombe.
**À droite:** Les parents proches descendent dans la tombe pour parler une dernière fois à leurs chers disparus et leur adresser un dernier adieu. Ils les recouvrent ensuite d'un nouveau suaire et referment la tombe.

**Seiten 510–511:** Tanz mit den Toten: Die Familie rollt die Leichname in Strohmatten und trägt sie tanzend um das Grab. Die gedrückte Atmosphäre legt sich allmählich und Partystimmung macht sich breit.
**Seiten 512–513:** Die Toten werden wieder in ihr Grab gelegt.
**Rechts:** Nachdem sich die Verstorbenen wieder in ihrer Ruhestätte befinden, nehmen die engsten Verwandten im Grab Abschied von ihnen. Dann werden die Leichname nochmals in ein neues Tuch gewickelt und das Grab wieder versiegelt.

# Todos Santos
## *Oruro, Bolivia*

Marco Antonio Velasco Montoya was only thirty when he died. One and a half years later, his family has never found out why. His wife Muriel blames the hospital and the surgeons who operated but failed to save him.

Today she kneels at a newly built altar, wafting smoke at a photograph of her late husband as an invitation to his spirit to visit the family and spend the next two days with them.

It is 30 October and the night before All Saints' Day, or Todos Santos as it is known in the Bolivian Andes.

Muriel hands the tray of glowing charcoal and incense to her father kneeling on the earth floor beside her. He purses his lips and puffs the grey smoke towards the altar while beseeching Marco Antonio's spirit with the words "Give us a good life". Here, as in many parts of the world, the dead play an active role in the lives of the living. Wearing warm jumpers and coats, relatives and neighbours sit on the benches lining the walls of the bare, unheated room. Smoke and incense fill the air.

Though Todos Santos is a Roman Catholic feast, it reflects traditions that Bolivia's native Indian population have observed since ancient times. November was the month of the dead in Inca times and the altar decorations include an assortment of Inca symbols, such as bread figurines shaped as the sun and the moon. In Inca mythology, the sun god Inti was father of the Inca and husband of the moon.

"The sun and the moon light up the path for daddy when he comes to visit us," explains Leydi, Muriel's eleven-year-old daughter.

Leydi speaks Spanish and can also understand Aymara, her grandmother's language. Her grandfather speaks Quechua, the ancient language of the Incas and the mother tongue for more than eighteen million people living in the Andes today.

Todos Santos is a time for welcoming the spirits of deceased relatives, especially those who have died within the last three years. Families build an altar at home and then invite the spirits of their loved ones to visit them. After revisiting their families for three successive years the spirits can then rest in peace.

In Oruro, the mining town where Muriel and her family live, the market stalls brim with all the items needed for communing with the dead: flowers, fruit, candy and bread to decorate the altar; crucifixes and wreaths for the graves; and beer, liquor, cigarettes and coca leaves.

The fire bowl is taken out of the room and prayers are said before the religious ritual concludes with the family members making the sign of the cross in front of the altar. Small glasses of liquor are passed round. Everyone then takes a small glass, pouring a few drops on the floor in a toast to Pachamama (the Earth Mother) before gulping down the fiery liquid.

My ploy for remaining sober enough to continue taking photographs is to do things the other way round, giving Pachamama most of the liquor and leaving just a few drops for myself. The ruse works well until my pouring becomes a bit too obvious and my hosts immediately oblige me to drink an entire glass.

Out come the cigarettes and coca leaves. The leaves are chewed with potash into a ball placed inside the cheek. Cheeks bulging, people light their cigarettes and the room fills with smoke once more.

**Pages 516–517:** In the mining town of Oruro in the Bolivian Andes houses climb hills cut through by an extensive network of mine shafts now abandoned by the mining companies and worked exclusively by cooperative miners.
**Right:** Families who have recently lost a loved one build an altar at home for *Todos Santos* (All Saints' Day), covering it with food and drink for the deceased's returning spirit.

**Pages 516–517:** Les maisons grimpent à flanc de montagne à Oruro, ville minière des Andes boliviennes. Abandonné par les grandes compagnies minières, le vaste réseau de galeries est désormais exclusivement exploité par des coopératives de mineurs.
**À droite:** À la Toussaint, *Todos Santos*, les familles qui ont récemment perdu un proche, construisent un autel familial sur lequel sont disposés des mets et boissons pour les esprits des défunts qui reviennent les visiter.

**Seiten 516–517:** In der Bergbaustadt Oruro in den bolivianischen Anden ziehen sich die Häuser an Hängen hoch, die von einem ausgedehnten Stollensystem durchzogen sind. Die Minen werden nicht mehr von Bergbaugesellschaften, sondern von Bergarbeiterkooperativen ausgebeutet.
**Rechts:** Familien, die erst kürzlich einen Angehörigen verloren haben, bauen zu Hause an Todos Santos (Allerheiligen) einen Altar auf, den sie mit Essen und Getränken für den Geist des Verstorbenen decken.

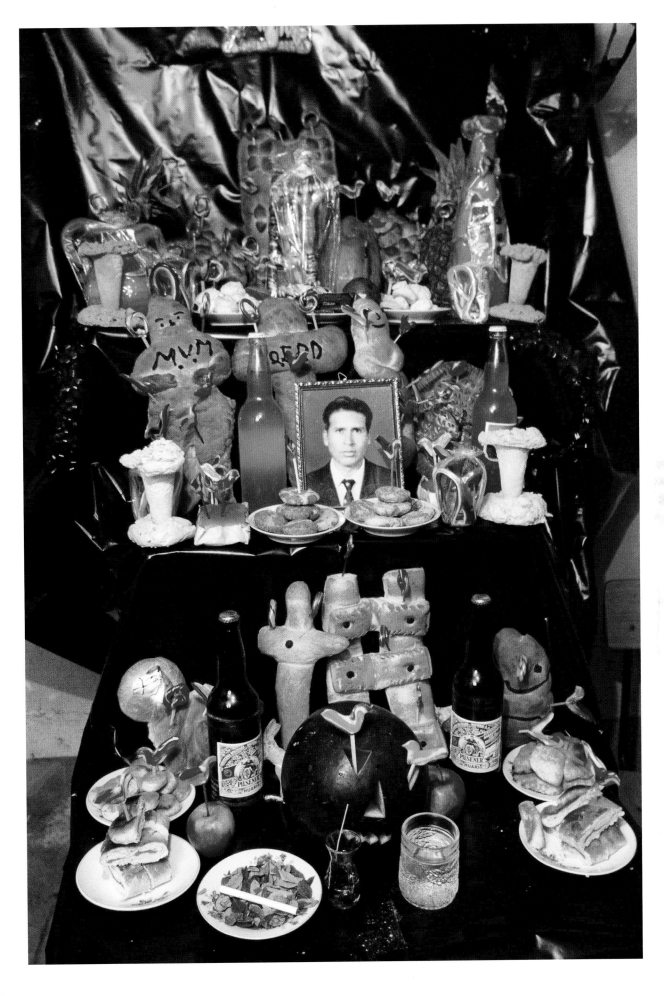

Draped in black plastic, the altar is festooned with food, drink and decorations. The bread and pastries come in all sorts of shapes and sizes, including a human-like figurine representing the deceased, a crucifix, a ladder for the deceased to climb down from heaven and a horse to carry back his gifts from the living. Stalks of sugar cane tied to the front corners of the altar represent the staff that the deceased uses during his journey. Similarly, onion stalks tied together with sugarcane symbolise straws through which the deceased drinks chicha, a fermented maize beverage.

Drinks are an important part of the ritual. It is the end of the dry season and the bones of the dead lie parched in the ground. The deceased will be thirsty when he arrives, and glasses of water, cinnamon brandy, chicha, sweet wine and Pepsi (Marco Antonio's favourite) stand ready for him on the altar. After Todos Santos comes the rainy season and the earth springs to life again.

The people in the room have different thoughts on when Marco Antonio's spirit joins them. Some say he arrives at midnight, but his father-in-law insists he is already there. There are signs. A moth lands on his wife Muriel's neck. His daughter Leydi feels something touch her shoulder when she goes out to the toilet. And the dogs start barking.

At all times at least one of the adults remains awake in the room with the altar to ensure that his spirit is not left alone. They smoke, chew coca leaves, drink and feel Marco Antonio's presence.

The visitation continues the next day. A plate of the deceased's favourite food is placed on the altar. During the day a steady stream of boys and underprivileged people visit the house to pray and sing hymns. The more prayers are said, the more content the deceased's soul becomes. In return the family give the visitors bread, with a glass of sweet wine for the adults. The guests then move on to the next house where a visitation is in progress.

On the second day of Todos Santos the family bid the visiting spirit farewell with incense burning and prayers. The altar is taken down and the fruit and sweets given to the children.

A collective celebration with the dead follows. The cemeteries are filled with people and the graves are decorated with flowers and wreaths. Musicians play and people dance and enjoy alcoholic refreshments and coca leaves.

In rural areas, the custom is to leave the cemetery for the village square, where the festivities continue with traditional dancing. However, in Marco Antonio's family they prefer to amuse themselves with relatives and friends in the room where the altar used to be.

Marco Antonio's soul has now departed, though, like all the dead who visit the living during Todos Santos, he is considered to remain on earth until the end of the rainy season. It is thanks to them and the efforts of people playing special tunes on wooden flutes that the rains arrive.

Not until the February carnival do the souls of the deceased finally leave the earth and return to the spirit world. Then it is harvest time. For Todos Santos is not just a memorial to the dead, but a celebration of fertility and rebirth, a point in time when life starts all over again.

# Todos Santos
## *Oruro, Bolivie*

Marco Antonio Velasco Montoya n'était âgé que de trente ans quand il est mort. Un an et demi plus tard, sa famille n'a toujours pas compris pourquoi. Sa femme Muriel accuse l'hôpital et les chirurgiens qui l'ont opéré de n'avoir pas tenté de le sauver. Aujourd'hui, elle est à genoux devant un autel récemment construit, repoussant la fumée vers une photographie de son mari, invitant son esprit à rendre visite à sa famille et à passer ainsi les deux prochains jours avec eux.

Nous sommes le 30 octobre, la nuit précédant la Toussaint, ou Todos Santos pour les habitants des Andes boliviennes. Muriel tend un plateau de charbon de bois et d'encens à son père agenouillé sur le sol à côté d'elle. Il gonfle les lèvres et souffle sur la fumée grise en direction de l'autel tout en priant l'esprit de Marco Antonio de ces mots : « Offre-nous une belle vie. » Ici, comme dans beaucoup d'endroits dans le monde, la mort joue un rôle actif dans la vie quotidienne. Vêtus de lainages et manteaux épais, la famille et les proches sont assis sur les bancs alignés au mur de la pièce froide et nue. La fumée et l'encens alourdissent l'air.

Bien que Todos Santos soit une fête catholique, elle reflète les traditions que la population indienne native de Bolivie observe depuis toujours. Novembre était le mois de la mort au temps des Incas et les décorations des autels présentent toujours toutes sortes de symboles incas, dont les figurines de pain en forme de soleil et de lune. Dans la mythologie inca, le dieu du soleil Inti était le père des Incas et le mari de la lune. « Le soleil et la lumière de la lune éclairent le chemin de mon père lorsqu'il vient nous rendre visite », explique Leydi, la fille de Muriel, âgée de onze ans. Leydi parle l'espagnol et comprend également l'aymara, le langage de sa grand-mère. Son grand-père parle le quechua, l'ancienne langue des Incas, la langue maternelle de plus de dix-huit millions de personnes vivant dans les Andes aujourd'hui.

Todos Santos représente la période lors de laquelle les esprits des défunts sont accueillis, et tout particulièrement de ceux morts les trois dernières années. Les familles fabriquent un autel dans leur maison et invitent les esprits des êtres aimés à leur rendre visite. Après trois visites annuelles successives, les esprits peuvent reposer en paix.

À Oruro, la ville minière où vivent Muriel et sa famille, les stands du marché sont couverts d'articles utiles pour communiquer avec les morts : fleurs, fruits, sucreries et pains pour décorer l'autel ; crucifix et couronnes pour les tombes ; bières, liqueurs, cigarettes et feuilles de coca.

Le bol provoquant la fumée est sorti de la pièce, puis la famille prononce des prières avant d'achever le rituel religieux par un dernier signe de croix devant l'autel. De petits verres d'alcool tournent ; chacun en verse quelques gouttes sur le plancher en l'honneur de *Pachamama* (Terre-Mère) avant de boire d'un trait la liqueur forte.

Mon stratagème afin de rester sobre pour continuer à prendre des photographies consiste à faire le contraire : ne boire que quelques gouttes d'alcool et offrir le reste à *Pachamama*. La ruse fonctionne assez bien jusqu'à ce que mon petit manège s'avère trop évident pour mes hôtes qui m'obligent alors à avaler un verre entier. Voilà qu'arrivent les cigarettes et les feuilles de coca. Les feuilles sont mâchées en une boule à l'intérieur de la bouche. Les joues bombées, tout le monde allume une

cigarette et la pièce se remplit à nouveau d'une épaisse fumée. Drapé de plastique noir, l'autel est orné d'aliments, de boissons et décoré de mille choses. Le pain et les pâtisseries sont de toutes tailles et de toutes formes, dont une figurine représentant le défunt, un crucifix, une échelle lui permettant de descendre des cieux et un cheval pour remporter tous ses cadeaux. Les tiges de canne à sucre accrochées aux coins de l'autel symbolisent tout ce que le défunt utilise lors de son voyage.

De même, des tiges d'oignons sont liées avec les tiges de canne à sucre pour symboliser les pailles avec lesquelles le défunt boit la *chicha*, une boisson à base de maïs fermenté. C'est la fin de la saison sèche et les os du défunt s'assèchent dans la terre. Aussi, comme il aura soif en arrivant, des verres d'eau, de liqueur à la cannelle, de *chicha*, de vin doux et de Pepsi (la boisson préférée de Marco Antonio) sont disposés sur l'autel. Après Todos Santos vient la saison des pluies et du renouveau de la nature.

Les avis des personnes présentes dans la pièce divergent quant au moment où l'esprit de Marco Antonio les rejoindra. Certains imaginent qu'il arrivera plutôt vers minuit, mais son beau-père reste persuadé qu'il est certainement déjà parmi eux. Les signes sont probants. Une mite a atterri sur le cou de sa femme Muriel. Sa fille Leydi a senti quelque chose la toucher à l'épaule lorsqu'elle est sortie tout à l'heure. Et même les chiens commencent à aboyer. Un adulte reste en permanence éveillé dans la pièce où se trouve l'autel afin de ne pas laisser l'esprit seul. Ils fument, mâchent des feuilles de coca, boivent et ressentent la présence de Marco Antonio. La visite se poursuit jusqu'au lendemain. Une assiette contenant le plat favori du défunt est placée sur l'autel. Pendant la journée, un flux permanent de jeunes garçons et de gens défavorisés visite la maison pour prier et chanter des hymnes.

**Above:** *Tablillos*, small pieces of incense embossed with a skull and crossbones, are burned to invite the dead.
**Right:** Bread figurines are placed on the altar as symbolic offerings to the returning spirit. The girl holds a shape of the sun, an ancient Inca motif.

**Ci dessus :** Les *tablillos*, carrés d'encens décorés d'un crâne et de deux os sont brûlés pour attirer les défunts.
**À droite :** Les figurines symboliques en pâte de pain sont des offrandes aux esprits qui reviennent. Une fillette regarde un ancien motif inca, figurant le soleil.

**Oben:** Tablillos, kleine Stücke Weihrauch mit einem Totenkopf, werden verbrannt, um die Toten einzuladen.
**Rechts:** Brotfiguren werden als Opfergaben an den zurückkehrenden Geist auf den Altar gestellt. Das Mädchen hält eine in Form der Sonne in der Hand.

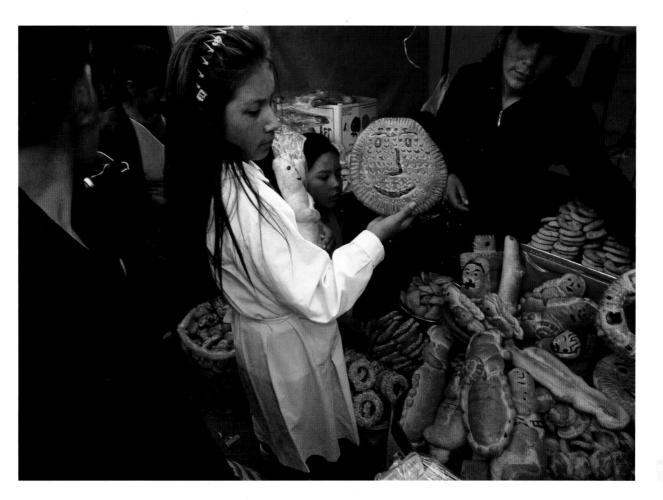

**Pages 526–527:** On the evening of 30 October the family members gather to invite the spirit of the deceased to visit them.
**Pages 528–529:** By midday on 2 November the deceased's spirit has left and the family go to the cemetery to tend his grave.

**Pages 526–527:** Le soir du 30 octobre, la famille se rassemble devant l'autel et invite l'esprit des morts à se joindre à elle.
**Pages 528–529:** Les esprits des morts quittent la maison le 2 novembre. L'après-midi, les familles se rendent au cimetière pour prendre soin de leurs tombes.

**Seiten 526–527:** Am Abend des 30. Oktober kommen die Familienmitglieder zusammen, um den Geist des Verstorbenen einzuladen.
**Seiten 528–529:** Am 2. November ist der Geist des Toten wieder fort. Die Familie geht auf den Friedhof, um sein Grab zu schmücken.

Plus nombreuses sont les prières, plus l'âme du défunt est contentée. En retour, la famille offre du pain aux visiteurs, avec un verre de vin doux pour les adultes. Ensuite, les visiteurs se rendent dans d'autres maisons où ont lieu la cérémonie.

Le deuxième jour de Todos Santos, la famille fait ses adieux à l'esprit en brûlant de l'encens et en priant. L'autel est démonté tandis que les fruits et les sucreries sont distribués aux enfants. Vient alors une célébration collective pour les morts. Les cimetières se remplissent de toutes parts et les tombes sont décorées de fleurs et de couronnes. Des musiciens jouent tandis que les gens dansent et se délectent de boissons alcoolisées et feuilles de coca. Dans les zones rurales, la coutume consiste à quitter le cimetière pour se rendre sur la place du village où les festivités se poursuivent avec des danses traditionnelles. La famille de Marco Antonio préfère rester en petit comité et se divertir avec leurs amis dans la pièce où se trouvait l'autel. L'âme de Marco Antonio les a maintenant quittés mais, comme tous les morts qui rendent visite aux vivants lors de Todos Santos, elle est censée demeurer sur terre jusqu'à la fin de la saison pluvieuse. C'est grâce aux morts et aux airs spécifiques joués par les musiciens sur leurs flûtes en bois que les pluies surviennent. Les âmes des défunts ne quittent donc pas la Terre avant le carnaval de février, pour enfin retourner dans le monde des esprits. Vient ensuite le temps des moissons. En fait, Todos Santos n'est pas simplement une fête en mémoire des morts, mais bien une célébration de la fertilité et de la renaissance, au moment précis où la vie recommence une nouvelle fois.

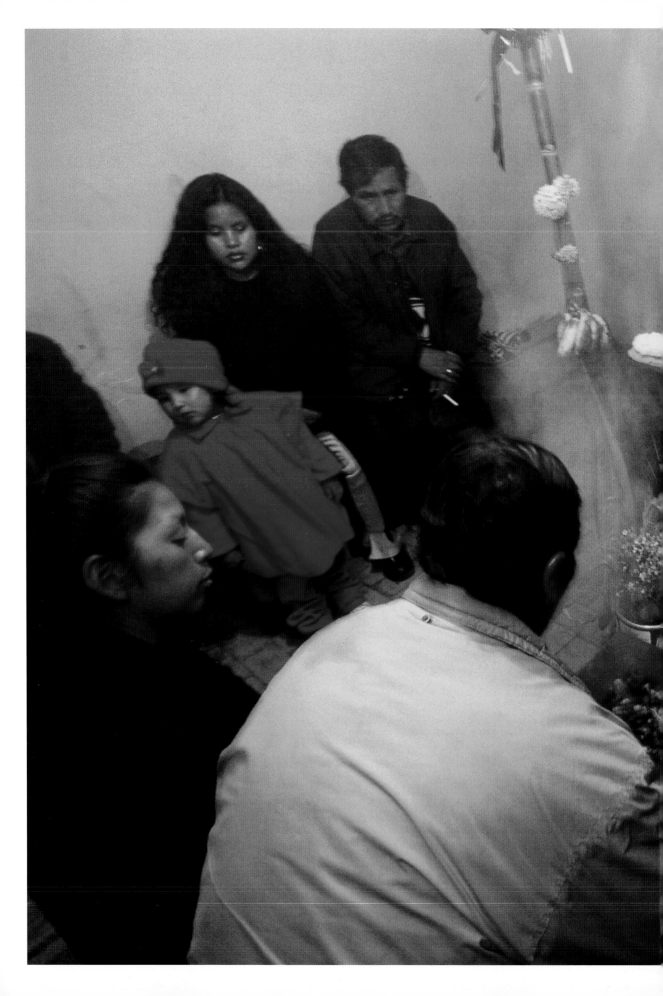

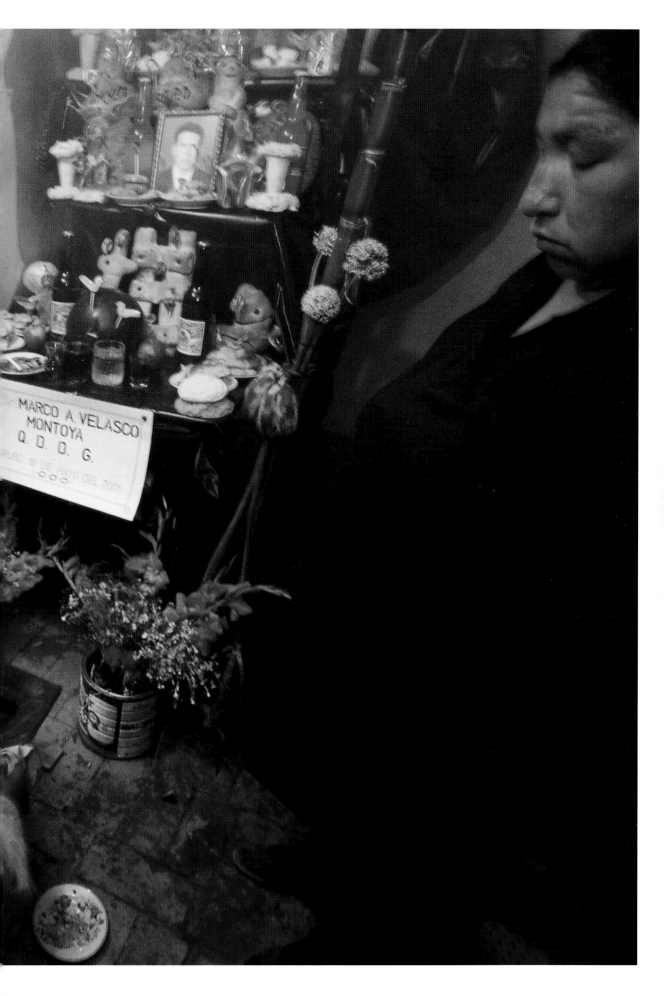

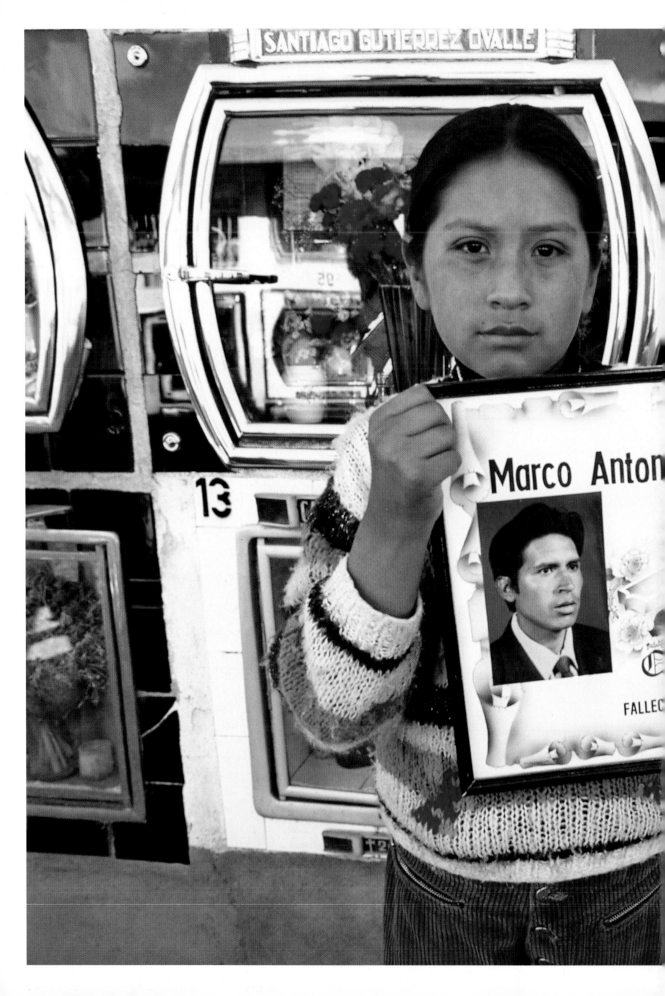

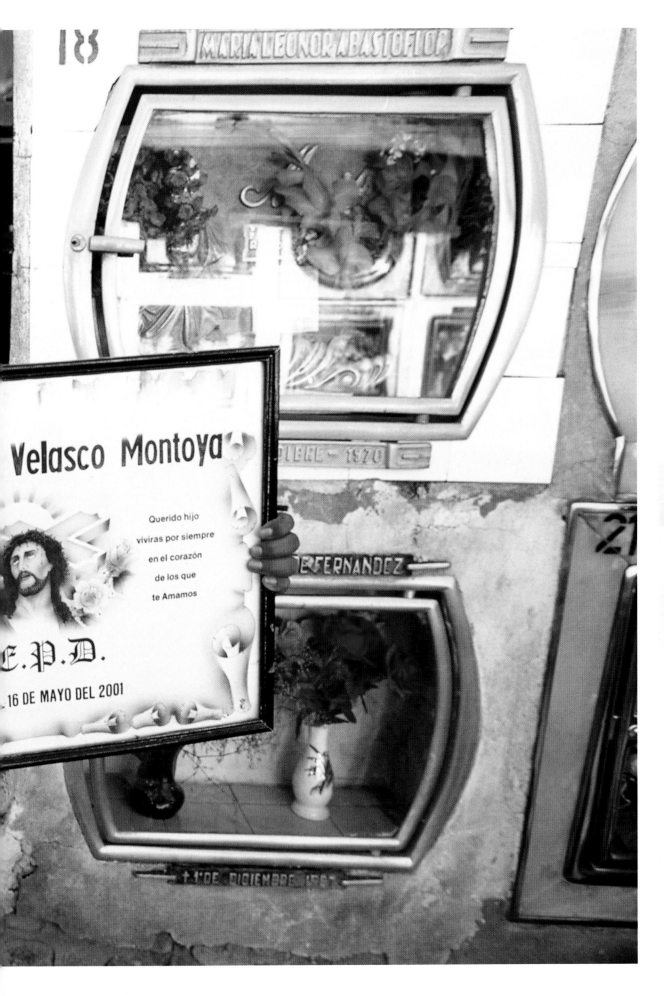

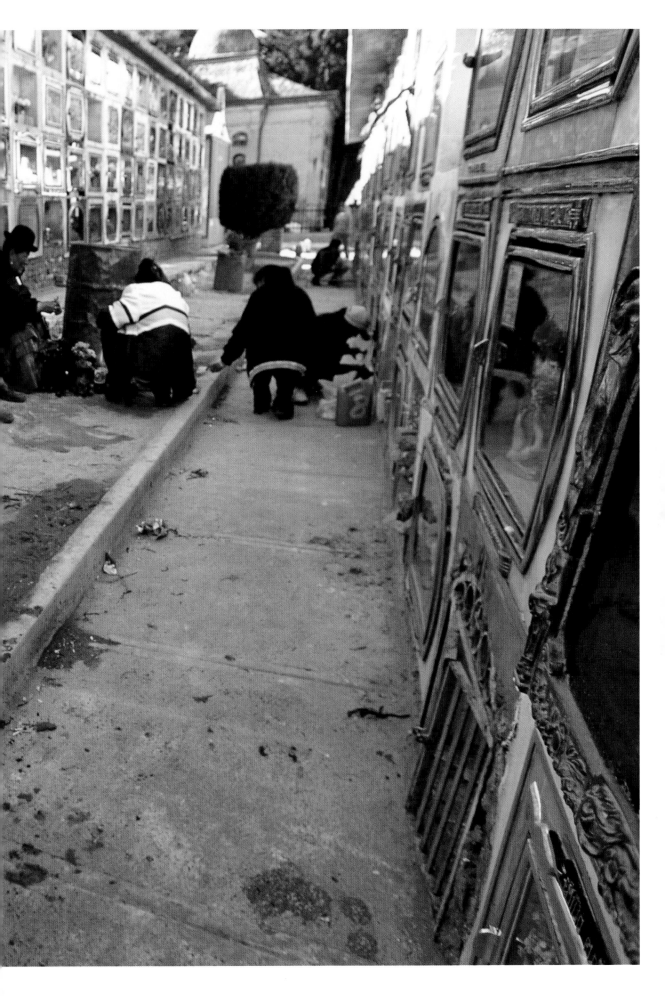

# Todos Santos – Allerheiligen
## Oruro, Bolivien

Marco Antonio Velasco Montoya war erst 30, als er starb. Und auch eineinhalb Jahre später weiß seine Familie noch nicht, warum. Seine Frau Muriel gibt dem Krankenhaus und den Ärzten die Schuld, die ihn operierten, ihn aber nicht retten konnten.

Heute kniet sie vor einem neu errichteten Altar, wedelt Rauch auf die Fotografie ihres verstorbenen Mannes, um so seinen Geist einzuladen, seine Familie zu besuchen und die folgenden zwei Tage mit ihr zu verbringen.

Es ist der 30. Oktober und der Abend vor Allerheiligen oder Todos Santos, wie es in den bolivianischen Anden heißt.

Muriel reicht das Tablett mit glühender Holzkohle und Weihrauch an ihren Vater weiter, der neben ihr auf dem Boden kniet. Er spitzt die Lippen und bläst den grauen Rauch zum Altar, während er Marco Antonios Geist mit den Worten „Gib uns ein gutes Leben" beschwört. Wie in vielen anderen Teilen der Welt spielen die Toten auch hier eine wichtige Rolle für die Lebenden.

Verwandte und Nachbarn in dicken Pullovern und Mänteln, die sie warm halten sollen, sitzen auf Bänken entlang der Wände des kahlen, ungeheizten Raums. Qualm und Weihrauch erfüllen die Luft.

Obwohl Todos Santos ein römisch-katholisches Fest ist, greift es Traditionen auf, die die indianische Urbevölkerung Boliviens von alters her bewahrt hat. Für die Inka war der November die Zeit der Toten, und so finden sich auf dem Altar eine Reihe von Inkasymbolen, darunter Brotfiguren, die wie Sonne und Mond geformt sind. In der Mythologie der Inka war der Sonnengott Inti der Vater der Inka und Ehemann des Mondes.

„Sonne und Mond erhellen den Weg für Papa, wenn er uns besuchen kommt", erklärt Leydi, Muriels elfjährige Tochter.

Leydi spricht Spanisch und kann Aymara, die Sprache ihrer Großmutter, verstehen. Ihr Großvater spricht Quechua, die alte Sprache der Inka und Muttersprache von mehr als 18 Millionen Menschen, die heute in den Anden leben.

Todos Santos ist die Zeit, in der die Geister verstorbener Verwandter empfangen werden, vor allem derer, die in den drei Jahren zuvor gestorben sind. Die Familien bauen zu Hause einen Altar auf und laden dann die Geister ihrer Angehörigen zu einem Besuch ein. Hat ein Geist seine Familie in drei aufeinanderfolgenden Jahren besucht, kann er in Frieden ruhen.

In Oruro, der Bergbaustadt, in der Muriel und ihre Familie leben, sind die Marktstände voll von Dingen, die man braucht, um mit den Toten zu kommunizieren: Blumen, Obst, Kerzen und Brot als Schmuck für den Altar, Kreuze und Kränze für die Gräber sowie Bier, Schnaps, Zigaretten und Kokablätter.

Die Feuerschale wird aus dem Zimmer getragen, und es wird gebetet, bevor das religiöse Ritual damit endet, dass die Familienmitglieder sich vor dem Altar bekreuzigen. Kleine Gläser mit Schnaps werden herumgereicht. Jeder nimmt ein Glas, schüttet zu Ehren Pachamamas, Mutter Erde, ein paar Tropfen auf den Boden und stürzt dann das scharfe Getränk hinunter.

Meine Strategie, um nüchtern zu bleiben und weiter Fotos schießen zu können, ist es, Pachamama den Großteil meines Schnapses zu überlassen und selbst nur ein paar Tropfen zu nippen. Das funktioniert ganz gut, bis auffällt, wie viel ich verschütte, und mich meine Gastgeber anhalten, gleich ein ganzes Glas zu trinken.

**Pages 530–531:** Boys and elderly poor people visit the cemeteries to offer their prayers.
**Right:** Families take some of the bread and sweets from the altar to the cemetery for those who pray for the deceased.
**Pages 534–535:** Space is at a premium at the cemetery and people find whatever room they can, which includes standing and sitting on the graves.
**Pages 536–537:** People drink, dance and chew coca leaves as they spend time with their loved ones.

**Pages 530–531:** De jeunes garçons et des personnes âgées pauvres se rendent dans les cimetières pour offrir leurs prières.
**À droite:** Les familles emportent des pains et des douceurs de l'autel qui seront donnés à ceux qui prient pour leurs morts dans les cimetières.
**Pages 534–535:** La place est restreinte dans les cimetières; la foule est si dense que les gens doivent grimper ou s'asseoir sur les pierres tombales.
**Pages 536–537:** Les gens mangent, boivent et mâchent des feuilles de coca en tenant compagnie à leurs chers disparus.

**Seiten 530–531:** Junge und arme, alte Leute besuchen die Friedhöfe, um ihre Gebete anzubieten.
**Rechts:** Die Familien nehmen etwas Brot und einige Süßigkeiten vom Altar mit auf den Friedhof und verschenken sie an die, die für die Toten beten.
**Seiten 534–535:** Der Platz auf dem Friedhof ist knapp, und so sitzen oder stehen notgedrungen viele auch auf den Gräbern.
**Seiten 536–537:** Die Menschen trinken, tanzen und kauen Kokablätter, während sie ihre Toten besuchen.

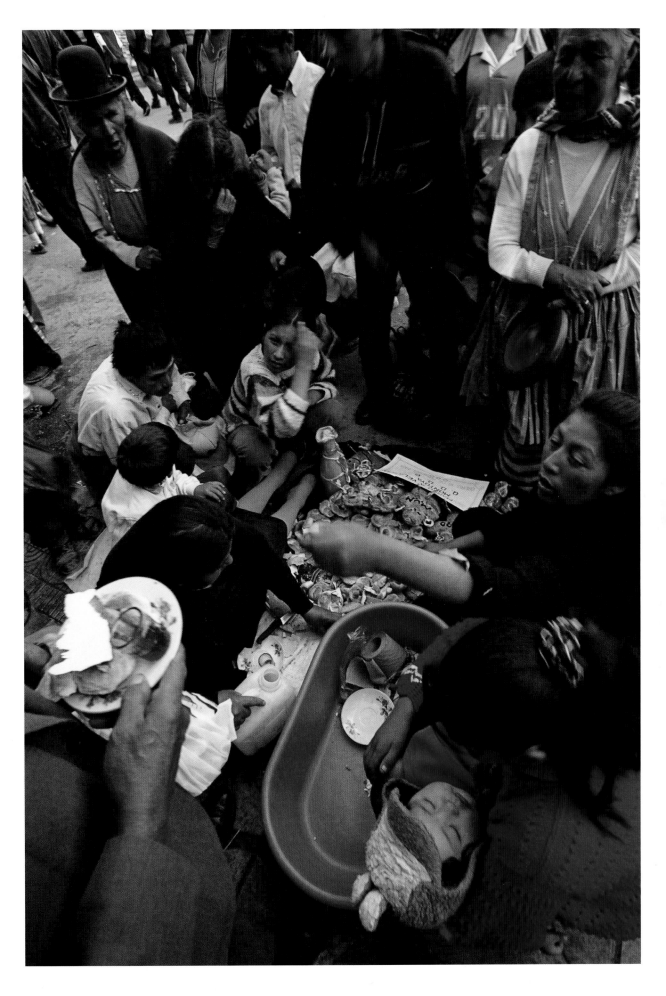

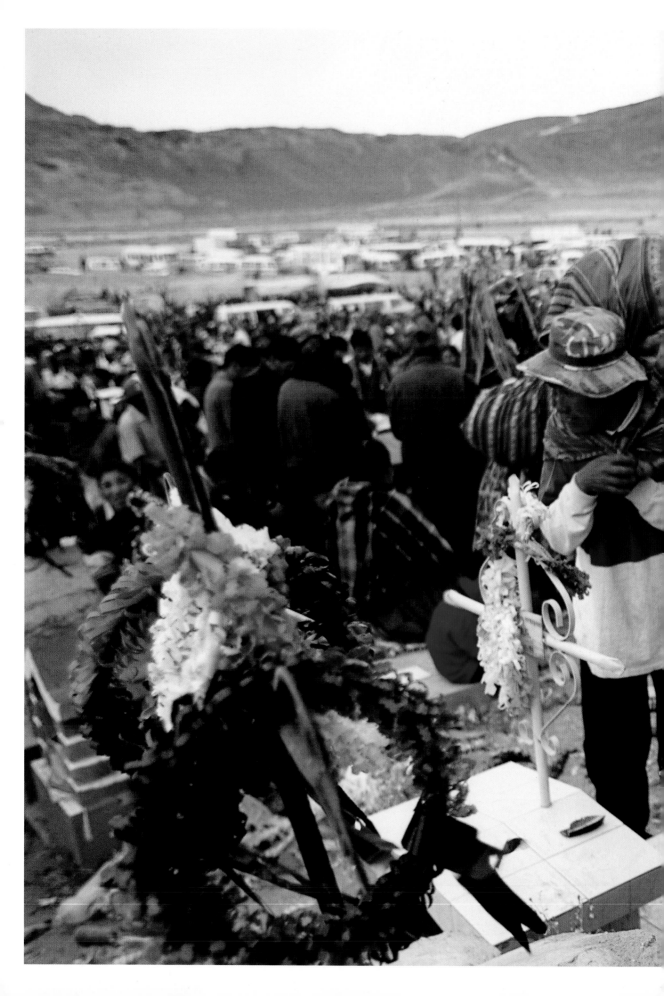

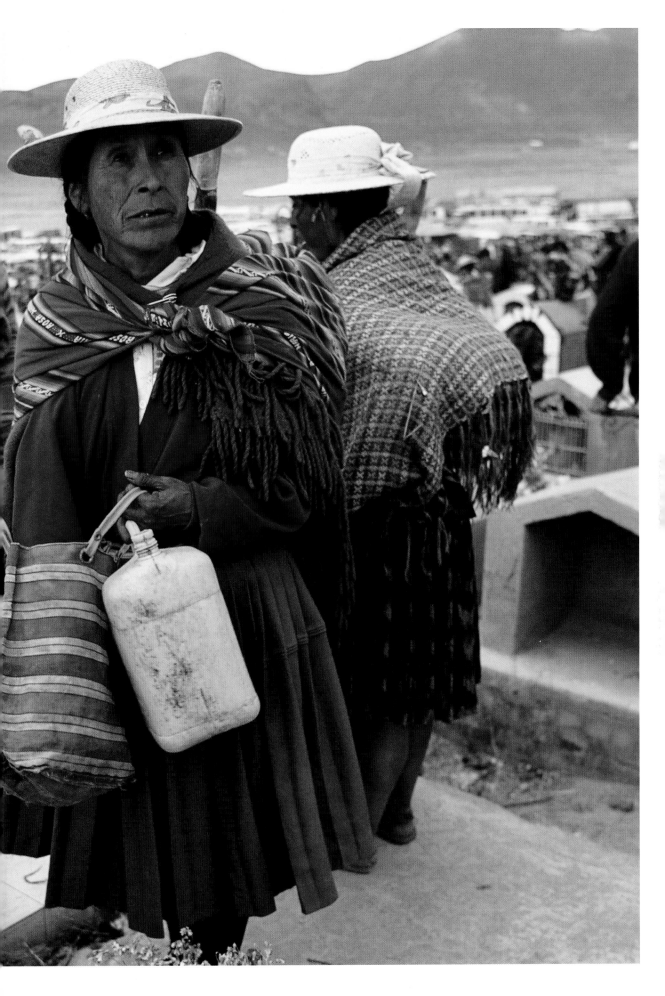

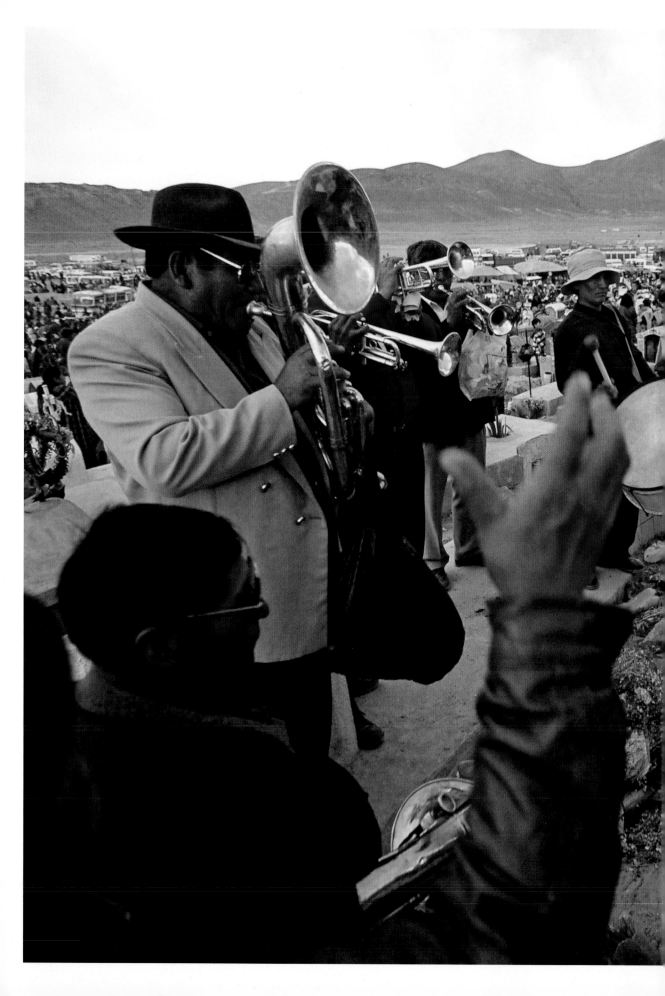

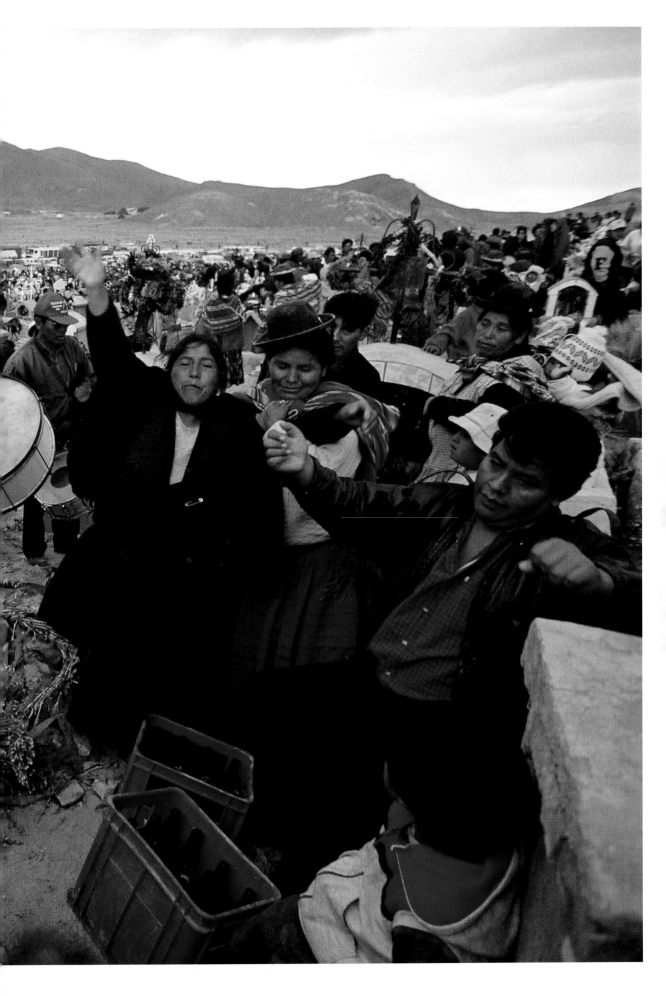

Nun werden die Zigaretten und die Kokablätter herausgeholt. Die Blätter werden mit Pottasche zu einem Ball gekaut, der in die Backe geschoben wird. Mit dicken Backen zünden sich alle Zigaretten an, und der Raum ist wieder voller Rauch.

Der Altar ist mit schwarzem Plastik verkleidet und geschmückt mit Speisen, Getränken und Dekorationen. Brot und Kuchen gibt es in allen Formen und Größen: als menschliche Figur, die den Verstorbenen repräsentiert, als Kreuz, als Leiter, auf der der Geist des Toten vom Himmel herunterklettern kann, sowie als Pferd, das die Geschenke der Lebenden trägt. Zuckerrohrstangen sind an die Ecken des Altars gebunden. Sie symbolisieren den Wanderstab, den der Verstorbene auf seiner Reise benutzt. Zwiebelpflanzen, die an Zuckerrohr gebunden sind, stellen die Strohhalme dar, durch die der Verstorbene Chicha, ein fermentiertes Maisgetränk, trinkt.

Getränke sind ein wichtiger Teil des Rituals. Die Trockenzeit ist vorbei und die Gebeine der Toten liegen ausgetrocknet im Boden. Der Verstorbene wird Durst haben, wenn er ankommt, und Gläser mit Wasser, Zimtbrandy, Chicha, süßem Wein und Pepsi (Marco Antonios Lieblingsgetränk) stehen für ihn auf dem Altar bereit. Nach Todos Santos beginnt die Regenzeit, und die Erde erwacht wieder zum Leben.

Die Anwesenden im Raum sind unterschiedlicher Ansicht darüber, wann Marco Antonios Geist zu ihnen stoßen wird. Manche sagen, er werde um Mitternacht kommen, aber sein Schwiegervater besteht darauf, dass er schon da ist. Es gibt entsprechende Anzeichen: eine Motte landet auf dem Hals seiner Frau Muriel, seine Tochter Leydi spürt, wie etwas ihre Schulter berührt, und die Hunde fangen an zu bellen.

Es ist immer wenigstens ein Erwachsener in dem Raum mit dem Altar wach, damit der Geist nicht allein ist. Sie rauchen, kauen Kokablätter, trinken und spüren Marco Antonios Anwesenheit.

Der Besuch zieht sich auch über den nächsten Tag hin. Ein Teller mit den Lieblingsspeisen des Verstorbenen wird auf den Altar gestellt. Im Verlauf des Tages besucht ein steter Strom von armen Leuten und Jungen das Haus, um zu beten und Kirchenlieder zu singen. Je mehr Gebete gesprochen werden, desto zufriedener wird die Seele des Verstorbenen. Dafür gibt die Familie den Besuchern Brot und den Erwachsenen auch ein Glas süßen Wein. Die Gäste ziehen dann zum nächsten Haus weiter.

Am zweiten Tag von Todos Santos verabschiedet sich die Familie mit Weihrauch und Gebeten von dem Geist, der sie besucht hat. Der Altar wird abgebaut und das Obst und die Süßigkeiten an die Kinder verteilt.

Darauf folgt eine kollektive Feier mit den Toten. Die Friedhöfe sind voller Menschen, und die Gräber sind mit Blumen und Kränzen geschmückt. Musiker spielen auf, und die Leute tanzen, trinken und kauen Kokablätter.

In ländlichen Gegenden ist es üblich, vom Friedhof auf den Dorfplatz weiterzuziehen, wo das Fest mit traditionellen Tänzen fortgesetzt wird. Marco Antonios Familie dagegen geht mit Verwandten und Freunden zurück in den Raum, in dem der Altar gestanden hat.

Marco Antonios Seele hat sich nun entfernt, obwohl man davon ausgeht, dass er, wie alle Toten, die zu Todos Santos zu Besuch gekommen sind, bis zum Ende der Regenzeit auf der Erde bleiben wird. Es ist ihnen und den Holzflötenspielern mit ihren speziellen Melodien, zu verdanken, dass der Regen einsetzt.

Die Seelen der Verstorbenen bleiben bis zum Karneval im Februar auf der Erde und kehren erst dann in die Geisterwelt zurück. Dann ist Erntezeit. Denn Todos Santos ist nicht nur eine Erinnerung an die Toten, sondern auch ein Fest der Fruchtbarkeit und der Wiedergeburt, ein Augenblick, in dem das Leben von Neuem beginnt.

**Right and pages 540–541:** At Cochabamba, east of Oruro, Todos Santos concludes with the *wayunkha* ceremony. Young women hoping for marriage swing high as they try to grab a decorated basket with their feet. To succeed they have to spread their legs in front of the watching men, a highly erotic manoeuvre since they wear nothing beneath their skirts. The fertility rite celebrates the return to life after the death rituals of last two days.

**À droite et pages 540–541:** À Cochabamba, située à l'est d'Oruro, la Toussaint s'achève par le rite de *wayunkha*. Les jeunes filles en quête d'époux se balancent en essayant d'attraper un panier décoré avec leurs pieds. Pour y parvenir, elles doivent écarter les jambes devant un public d'hommes, une manœuvre très érotique puisqu'elles ne portent rien sous leurs jupes. Ce rite de la fertilité célèbre le retour à la vie après les cérémonies consacrées aux morts des deux jours précédents.

**Rechts und Seiten 540–541:** In Cochabamba, östlich von Oruro, endet Todos Santos mit der Wayunkha-Zeremonie. Junge Frauen, die heiraten möchten, schaukeln ganz hoch und versuchen, einen geschmückten Korb mit den Füßen zu greifen. Damit das gelingt, müssen sie ihre Beine vor den zuschauenden Männern spreizen – ein hocherotisches Unterfangen, denn sie haben unter ihren Röcken nichts an. Das Fruchtbarkeitsritual feiert die Rückkehr des Lebens nach den Totenritualen der letzten zwei Tage.

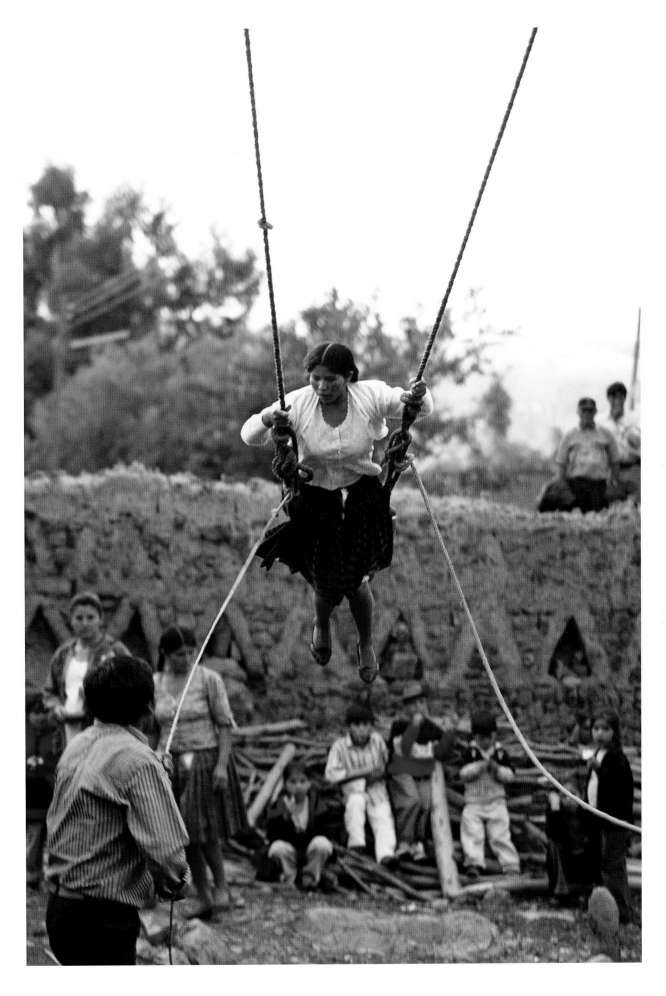

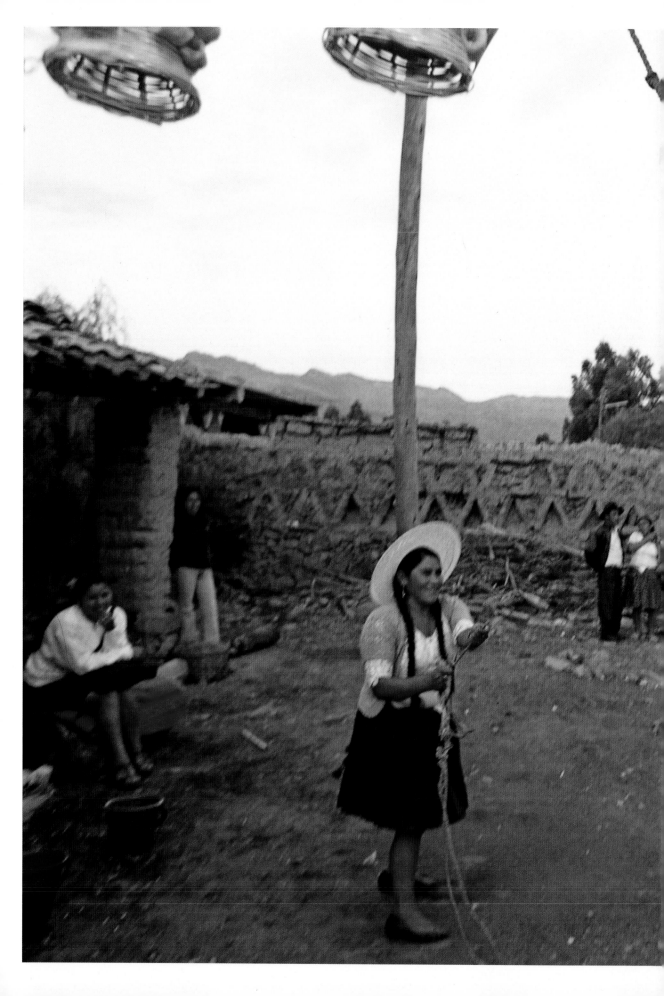

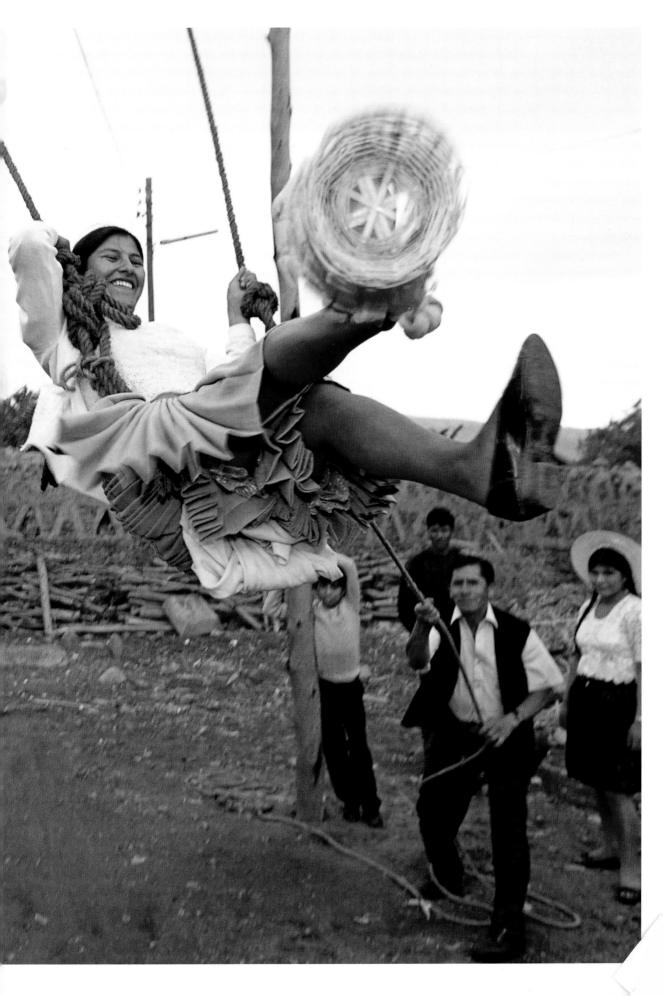

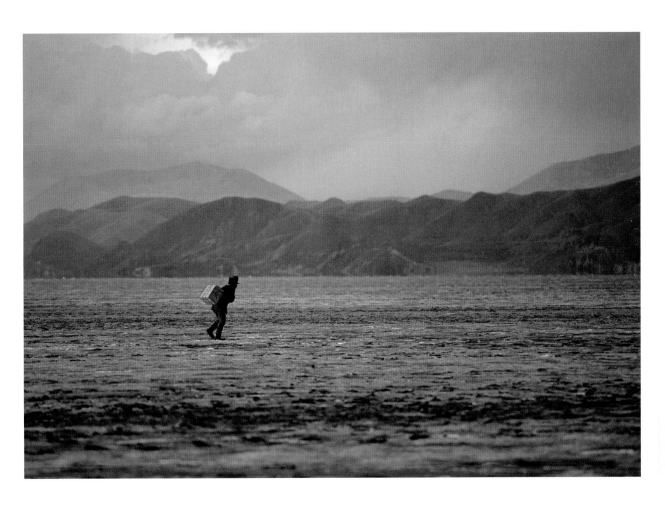

**Above:** A fisherman walks home with his day's catch across the former bottom of the partially dried-up Lago Poopo.

**Ci-dessus :** Un pêcheur rentre chez lui, le soir, avec son butin ; il traverse l'ancien lit du lac Poopo, partiellement asséché.

**Oben:** Ein Fischer geht mit seinem Tagesfang über den ehemaligen Grund des teilweise ausgetrockneten Lago Poopo nach Hause.

# Epilogue

As a photographer who meets and interacts with people with a camera in hand, I have to consider what attitudes I bring to the field. But before any photographs are taken I must first find the right subjects and settings. Then I have to work my way to the point at which the shutter clicks.

Planning for this book was like assembling a huge jigsaw. I not only wanted to capture all the transitions of life, but also to present a broad spectrum of rituals spanning all inhabited continents and all the major religions, as well as lesser-known beliefs and practices.

The key was often to find a contact with knowledge of local people and their cultures – an "ambassador" who could explain what I wanted and encourage people to open their homes and sacrosanct places to me. Usually this was a person from the local community, someone who could speak one of my languages and understood what I was looking for.

Many such local people played a crucial role in helping me to bring this book to fruition. And many others – scholars, photographers, journalists – contributed by putting me in contact with them.

Though things were occasionally left to chance, I generally planned the journeys in detail. I like to be *in situ* ahead of time so I can get to know the people and show respect for them and their customs. It is also helpful to know roughly what to expect before the ceremonials begin. At every step of the way I was clear and open about why I was there – to take pictures. I never hid my cameras.

Photographing people in private settings or during sacred religious rites is a balancing act. I have to be careful not to cross the line. Equally, if I am over-cautious I won't get any decent pictures.

In reality, I like to get up close. Emotional intimacy in the photographic process also demands spatial intimacy. Carrying cameras with big lenses and the fact that I'm often wearing different clothes from my subjects mean I tend to stick out, even more so when my flash goes off, as it does fairly often. But I keep a low profile and, when necessary, try to be unobtrusive in my movements. And almost without exception those magical moments happen when people become totally absorbed in what they are doing without appearing to be aware of my presence.

Throughout the book I used analogue slide film, as I was concerned that switching to new digital technology during the project would affect how I expressed myself through photography. The digital revolution in this field was not yet in full swing when I started work on the book.

Looking back at the project and all the journeys to different cultures around the world I must say it has been a tremendously enriching experience. Naturally, a few difficulties and setbacks arose along the way, but far outweighing these were the goodwill, hospitality and pride I encountered everywhere I went.

I have often been amazed by this openness. It has made me wonder why people let me into their lives and allow me to take pictures of their most sacred ceremonies. There are doubtless many reasons. But I believe that one of the foremost is the empathy that we all share and that impels us to help our neighbour, even a visiting Swedish photographer.

# Épilogue

En tant que photographe qui va à la rencontre des gens, mon appareil à la main, je dois faire très attention à ma façon d'être et d'agir sur le terrain. Mais avant de prendre n'importe quelle photographie, il me faut d'abord trouver les sujets et les décors adéquats. Je dois ensuite saisir le moment opportun pour appuyer sur le déclencheur. En réalisant ce livre, j'ai eu l'impression d'assembler un énorme puzzle. Je ne voulais pas seulement capter tous les rites de passage, mais aussi présenter un vaste spectre de coutumes embrassant toutes les régions habitées de la Terre, toutes les grandes religions, de même que des croyances et pratiques moins connues.

J'y suis le plus souvent parvenu en liant des contacts avec une personne qui connaissait les autochtones et leurs cultures, un « ambassadeur » qui pouvait expliquer mes desiderata et inciter les gens à m'ouvrir les portes de leurs demeures et de leurs sites sacrés. La plupart du temps, ces gens appartenaient à la communauté que je voulais rencontrer, parlaient une des langues que je connais et comprenaient ce que je recherchais. Ils ont joué un rôle capital dans la réussite de mon projet. D'autres – universitaires, photographes, journalistes – y ont aussi contribué en établissant ces contacts inestimables.

Dans l'ensemble, j'ai minutieusement planifié mes voyages, tout en laissant parfois une marge au hasard. Je préfère arriver en avance sur les lieux, pour avoir le loisir de connaître les gens, de montrer mon respect envers eux et leurs coutumes, et d'avoir une idée du déroulement des cérémonies. À aucun moment, je n'ai caché quels étaient mes objectifs : prendre des photos. Mon équipement était toujours bien en vue. Photographier des gens dans leurs sphères privées ou lors de rites religieux relève de la gageure. Il y a des limites à ne pas franchir, mais on n'obtient pas de bonnes photos en étant trop timoré. En vérité, j'aime prendre des gros plans. En photographie, capter des émotions intimes exige une intimité spatiale. Or, avec mes gros appareils photo et vêtu différemment de mes « motifs », je ne passe jamais inaperçu, surtout quand j'utilise mon flash, ce qui est fréquent. Mais j'adopte toujours un profil bas et, si nécessaire, me déplace aussi discrètement que possible. Presque toujours, j'ai capté les instants magiques quand ceux que je photographiais étaient entièrement absorbés par ce qu'ils faisaient, sans paraître conscients de ma présence.

Pour ce livre, j'ai utilisé des diapos analogiques, craignant qu'une reconversion dans la photographie numérique en cours de projet ne modifie ce que je cherchais à exprimer. Par ailleurs, quand j'ai commencé ce travail, les nouvelles technologies numériques dans la branche ne connaissaient pas encore le boom d'aujourd'hui. Revenant sur le projet et tous ces voyages autour du monde dans des cultures différentes, je dois dire que j'ai vécu une expérience incroyablement riche. J'ai bien sûr rencontré des difficultés et des revers en route mais, bien plus encore, partout où je suis allé, j'ai rencontré des gens de bonne volonté, fiers d'offrir leur hospitalité.

J'ai souvent été stupéfié par l'accueil des gens. Je me suis demandé pourquoi il m'ouvraient les portes de leurs vies et m'autorisaient à photographier leurs cérémonies les plus sacrées. On pourrait sans doute trouver bien des raisons, mais je crois qu'une des plus importantes est l'empathie, sentiment universel, qui nous incite à aider notre prochain, serait-il un photographe suédois en visite.

# Epilog

Als Fotograf, der viele Leute kennenlernt, muss ich mir darüber im Klaren sein, mit welcher Einstellung ich an die Sache herangehe. Aber bevor ich überhaupt anfange zu fotografieren, muss ich die richtigen Motive und Umgebungen finden. Von da aus arbeite ich mich zu dem Punkt vor, an dem ich auf den Auslöser drücke.

Die Planung für dieses Buch war wie ein riesiges Puzzle. Ich wollte nicht nur alle Übergänge im Leben einfangen, sondern auch das breite Spektrum der Rituale auf allen bewohnten Kontinenten der Welt und in den großen Religionen zeigen, ebenso wie die der weniger bekannten Glaubensrichtungen und Praktiken.

Die Lösung war oft, eine Person vor Ort zu finden, die die Menschen der Region und ihre Kulturen kannte – einen „Botschafter", der erklären konnte, was ich wollte, und die Leute ermutigte, mir die Türen zu ihren Häusern und heiligen Stätten zu öffnen. Das war gewöhnlich jemand aus der örtlichen Gemeinschaft, jemand, der eine meiner Sprachen sprach und verstand, wonach ich suchte.

Viele dieser Leute spielten eine entscheidende Rolle dabei, dass dieses Buch überhaupt zustande kam. Und viele andere – Wissenschaftler, Fotografen, Journalisten – haben dazu beigetragen, indem sie den Kontakt zu ihnen herstellten.

Obwohl gelegentlich Dinge dem Zufall überlassen werden mussten, habe ich die Reisen im Allgemeinen detailliert geplant. Ich bin gern schon ein bisschen früher vor Ort, damit ich die Leute näher kennenlernen und ihnen und ihren Bräuchen Respekt erweisen kann. Es ist außerdem hilfreich, schon im Voraus zu wissen, was einen bei den Zeremonien erwartet. Während der ganzen Zeit machte ich keinen Hehl daraus, was ich wollte: fotografieren. Ich habe meine Kameras nie versteckt.

Leute in ihrer Privatsphäre oder bei heiligen, religiösen Riten zu fotografieren, ist ein Balanceakt. Ich muss darauf achten, nicht zu weit zu gehen. Gleichzeitig bekomme ich aber auch keine guten Fotos, wenn ich übervorsichtig bin.

In Wahrheit möchte ich nah rangehen können. Emotionale Nähe beim Fotografieren erfordert auch räumliche Nähe. Dass ich Kameras mit großen Objektiven bei mir habe, lässt mich auffallen, ganz besonders, wenn dann auch noch geblitzt wird, was ziemlich häufig vorkommt. Aber ich versuche, unauffällig zu bleiben und, wenn nötig, mich mit äußerstem Bedacht zu bewegen. Und fast immer ist es so, dass die magischen Momente passieren, wenn die Menschen ganz von dem eingenommen sind, was sie gerade tun, scheinbar ohne sich meiner Anwesenheit bewusst zu sein.

Für das ganze Buch habe ich Diafilme benutzt, denn ich fürchtete, dass ein Wechsel zur neuen digitalen Technologie Einfluss darauf haben könnte, wie ich mich durch Fotografie ausdrücke. Die digitale Revolution hatte in diesem Bereich noch nicht richtig um sich gegriffen, als ich mit der Arbeit an diesem Buch begann. Wenn ich auf das Projekt und all die Reisen zu den unterschiedlichen Kulturen in aller Welt zurückblicke, muss ich sagen, dass es eine ungemein bereichernde Erfahrung war. Natürlich gab es unterwegs ein paar Schwierigkeiten und Rückschläge, aber der gute Wille, die Gastfreundschaft und der Stolz, denen ich überall, wo ich war, begegnete, hatten doch ein viel größeres Gewicht.

Ich war oft fasziniert von dieser Offenheit. Ich frage mich, warum mich Leute in ihr Leben gelassen und mir erlaubt haben, Fotos von ihren heiligsten Zeremonien zu machen. Dafür gibt es zweifellos viele Gründe. Aber ich glaube, der wichtigste ist die Empathie, die wir alle empfinden und die uns unseren Nächsten helfen lässt, sogar einem schwedischen Fotografen auf Besuch.

# Background

## BLESSINGS FOR THE NEWBORN

Virtually every village in Spain holds an annual fiesta. The vast majority of the country's 45 million inhabitants are Roman Catholic, and religious ceremonies such as Masses and processions are a common fiesta theme. Fiestas also celebrate local culture and are a way for people to enjoy themselves through food, drink and dance. The figure of El Colacho is thought to have Arabic roots and his name is believed to refer to his mask and burlesque antics. Many of the villages around Castrillo de Murcia used to have El Colacho-type figures, but these days you have to travel farther afield, to places like Ciudad Real, where he is known as Zagarrón. El Colacho's jump over the babies is supposed to protect primarily against hernias and epilepsy, thought in former times to be the Devil's work.

## SHICHI-GO-SAN
Japan has 127 million people, though there are no accurate figures on how many practise Shinto, the country's native religion. However, Shinto values are deeply ingrained in Japanese culture and most people, at one time or another, take part in festivals, ceremonies and other rituals that are Shinto. At the same time many are also Buddhists and usually ask Buddhist priests to officiate at burials and other death rites, since Shinto regard contact with the dead as unclean. But for life's other transitions, such as the blessing of the newborn, shichi-go-san and weddings, people generally turn to one of the tens of thousands of Shinto shrines, where Shinto priests lead the rituals. Western-style Christian weddings, often held in special wedding chapels, have also become popular.

## CIRCUMCISION
No less than 97 per cent of Turkey's 74 million inhabitants are Muslim. The two main ethnic groups are Turks (around 80 per cent of the population) and Kurds. Secular Muslims also hold circumcision ceremonies for their sons, a tradition that is not only done for religious reasons but also because it is considered to have health benefits.

## IN THE FOOTSTEPS OF BUDDHA

The Shan people, who come mainly from Burma but also live in neighbouring parts of Thailand, Laos and China, number around six million. They grow wet rice and have close cultural and linguistic ties with the Thai and Lao ethnic groups. Their religion is Theravada Buddhism. For decades, Shan territory in Burma has been a seat of rebellion against the Burmese government and many of the Shan living in Thailand are refugees from fighting between Shan guerrillas and the Burmese army.

## BAR AND BAT MITZVAH
Estimates suggest there are 12–14 million Jews worldwide. More than 40 per cent live in the United States and, of these, around 80 per cent practise Judaism in some form and 48 per cent belong to a synagogue. Apart from Orthodox Jews, who adhere strictly to Jewish law and believe God dictated the Torah to Moses on Mount Sinai, there are two other major Jewish branches in the United States: Reform Judaism and Conservative Judaism. The former are not literal believers and do not regard themselves as bound by Jewish law, focusing instead on moral interpretation of the Torah. Conservative Jews are somewhere in between, following traditional Jewish rules, for instance, on observance of the Sabbath and Kosher dietary laws, but taking a more liberal approach to interpreting the Torah. They are also more positively disposed to modern society and gender equality. The bar mitzvah dates back to medieval times but the first public bat mitzvah for a girl was not held until 1922.

**THE SUNRISE DANCE OF THE APACHE** Aside from three small Apache reservations in central Arizona, there are four main Apache reservations in the south-west United States: Jicarilla and Mescalero in New Mexico and Fort Apache and San Carlos in eastern Arizona. Almost 10,000 Apache live on the San Carlos reservation. The origins of the name Apache are uncertain. In their own language, the Apache call themselves Ndee ("the people"). When Westerners arrived, the Apache lived in what is now the south-west United States and north-west Mexico. They are thought to have arrived there sometime after the year 1000, though some anthropologists believe it might have been as late as 1400 or 1500. The Apache belong to the Athabascan language group and have their closest relatives in western Canada and Alaska. The Navajo are also Athabascans and are thought likely to have come to the south-west United States at roughly the same time. Unlike the Pueblo Indians, who arrived before them and lived as farmers in per-manent villages, the Apache were nomadic hunter-gatherers. They found most of their game in the mountainous areas of south-west United States and north-west Mexico, which they made their home.

**SAAMI CONFIRMATION** Sápmi, the region traditionally inhabited by the Saami people, covers a wide expanse of northern Scandinavia and Russia's Kola Penin-sula. There are around 80,000 Saami, of whom 50,000 live in Norway, 20,000 in Sweden, 8,000 in Finland and 2,000 in Russia. In Kautokeino, 90 per cent of the 3,000-strong population are Saami. Reindeer herding is deeply rooted in Saami culture and many of Kautokeino's Saami are reindeer herders. They tend their herds on the Finnmark Plateau during winter and then follow their herds on the spring mi-gration to summer grazing grounds by the Atlantic coast. Historically, the Saami were nomads who followed their herds through-out the year. These days, snowmobiles and

other modern advances have revolutionised the way of life and family members who are not directly involved with the herds can remain at home. Nevertheless, most reindeer-herding families own two houses: one in Kautokeino and one on the coast. Reindeer herding now occupies around a third of Kautokeino's Saami. Even in the past not all Saami were reindeer herders. Some were hunters and fishermen. And in Kautokeino many were sedentary farmers.

**XHOSA MALE INITIATION** Africa's eight million Xhosa have their ancestral lands in South Africa's Eastern Cape Province between the Fish and umThamvuna rivers. They are Africa's southernmost Bantu-speaking group and are known to have settled in the Eastern Cape at least by the end of the sixteenth century after arriving as part of a major Bantu migration. Before the Bantu arrival, South Africa was populated by hunter-gatherer San (also known as Bushmen) and the closely related Khoi, who were nomadic cattle herders. Xhosa traditions are in cattle farming and agriculture, and cattle continue to play a prominent role in Xhosa culture. Cattle are slaughtered at circumcision rituals, and men often make speeches from cattle pens during important ceremonies. Many Xhosa have moved from Eastern Cape Province to places like Cape Town, Port Elizabeth and Johannes-burg in search of work and education. They are prominent among South Africa's political and intellectual elite and include well-known names such as former president Nelson Mandela, Thabo Mbeki and Archbishop Desmond Tutu.

**HIGH-SCHOOL GRADUATION** Uppsala, Sweden's fourth largest city, has a population of 130,000 and is home to Scandinavia's oldest university, founded in 1477. High-school graduation ceremonies are a tradition throughout Sweden but are particularly strong in this seat of learning. Until the 1950s, the white caps first worn on graduation day were everyday attire for

students at Uppsala University from 30 April to 30 September. Now they are seen only on graduation day itself and on special occasions like Walpurgis Night, a festival on 30 April to celebrate the arrival of spring.

**A DANI GIRL COMES OF AGE** The Dani are one of New Guinea's largest and best-known ethnic groups. Their home in the island's Baliem Valley was unknown to the outside world until it was spotted from an aeroplane in 1938. At 1,500 metres above sea level, the valley is home to more than 100,000 Dani. The main economic activity is sweet-potato farming. The Dani live in the western, Indonesian half of New Guinea, which used to be known as Irian Jaya but became Papua in 2000 and was later divided into two provinces: Western Papua and Papua.

**TOOTH FILING** The volcanic island of Bali is an Indonesian province with around three million inhabitants. Its highest peak, Gunung Agung, rises 1,324 metres above sea level and the island's natural beauty and vibrant culture attracts hundreds of thousands of tourists every year. The cultural diversity is partly explained by a mass exodus of the intelligentsia from neighbouring Java in the late fifteenth century following the collapse of the Hindu Majapahit kingdom. To this day, the Balinese remain overwhelmingly Hindu while most Javanese, like the majority of Indonesians, observe Islam.

**HAMAR BULL JUMPING** The 40,000-strong Hamar are among the largest of the twenty or so ethnic groups which inhabit South Omo in south-west Ethiopia, an area through which the Lower Omo River flows en route to Lake Turkana on the Kenyan border. Though relativ-ely small in area, South Omo is a unique heritage area that is home to numerous ethnic groups with strong cultural identities. The Hamar are cattle herders and farmers whose main crop is sorghum. Because their land is arid and covered by acacia

many men spend the dry season with their herds in special cattle camps on the savannah by the Omo River, where grazing conditions are superior.

## THREE NUPTIALS OF THE NEWAR
and **TWILIGHT YEARS** The Newar are Nepal's sixth-largest ethnic group, numbering around 1.3 million, and are native to the Kathmandu Valley. Known as traders and craftsmen, they live mainly in urban communities. The valley was historically divided into three Newar kingdoms – Kathmandu, Bhakta-pur and Patan – each ruled by a divine monarch. But the conquest of the valley by Gurkhas in 1768 brought an end to their sovereignty and saw the Newars assimilated into the Kingdom of Nepal.

**BERBER WEDDING** The Berber are the indigenous inhabitants of North Africa west of the Nile Valley. Numbering around 25 million in the region, most of them live in Morocco, where they make up the majority of the population. Despite widespread Arabisation in large areas of the Moroccan lowlands, the Berber language Tamazight still predominates in urban centres like Marrakech and Agadir, and the Berber culture remains strong in the Rift Mountains and the Middle, High and Anti Atlas Mountains. After centuries of disadvantage, the Berber culture has experienced a revival in recent years. Tamazight is now recognised as an official language and has been added to the national curriculum. A royal institute for Berber culture has been set up and many radio and television channels broadcast Berber-language programmes. Today, around half of Moroccans speak Tamazight.

**CHILDBIRTH CEREMONY** Palau is a tiny island nation about 800 kilometres east of the Philippines in a sub-region of Oceania known as Micronesia. After decades as a United Nations trust territory under American administration, Palau's 20,000 islanders attained independence in 1994. Historically, they lived mainly from farming and fishing, with men traditionally working at sea and women farming the land. Nowadays the islands rely heavily on tourism as well as aid from the United States. In spite of strong Western influences, traditional clan structures continue to play an important role in society.

**CREMATION** Varanasi – also known as Kashi and Benares – is one of the world's oldest living cities. With a population of 1.5 million, it is situated on the River Ganges in the northern Indian state of Uttar Pradesh and is one of the most sacred pilgrimage sites for all Hindus. Its numerous Hindu shrines include the Vishwanath Temple, dedicated to Lord Shiva as the ruler of the universe. In addition to its religious significance, Varanasi is also known for its silk industry.

**REBURIAL** Madagascar is the world's fourth-largest island and has a population of 18 million drawn from eighteen ethnic groups. The first settlers arrived 2,000 years ago from present-day Indonesia, possibly via southern India and East Africa. Madagascans have both Indonesian and African traits, though the national language, Malagasy, is of Malayo-Polynesian origin and related to Indonesian, Philippine and Polynesian tongues. People living in the Madagascan Highlands closely resemble ethnic Indonesians and grow rice on irrigated terraces, a form of agriculture that originates from South-East Asia. The outrigger canoes favoured by coastal fishermen provide another link with that part of the world.

**TODOS SANTOS** At 3,710 metres above sea level, Oruro is a Bolivian mining town on the Altiplano, the high plateau of the central Andes. Bolivia has a higher ratio of indigenous Amerindians than any other South American country, and the proportion is highest in Andean districts, where around 70 per cent of people have Amerindian roots. The two largest ethnic groups are the Quechuas, descendants of the Incas, and the Aymaras. Both groups number more than two million. The great majority of Bolivians are Roman Catholics, though beliefs with roots in the pre-Columbus era still remain strong.

# Divers horizons

**BÉNÉDICTION DES NOUVEAU-NÉS**
Presque tous les villages en Espagne ont au moins une fête annuelle. La majorité des quelque 45 millions d'habitants étant catholique, les cérémonies religieuses telles que les processions dominent. Cependant, les fêtes célèbrent aussi les traditions locales ; on s'y amuse, on y mange, on y boit et on y danse. Le personnage d'El Colacho aurait des racines maures et devrait son nom à son masque et ses bouffonneries. De nombreux villages voisins de Castrillo de Murcia avaient autrefois leur El Colacho mais, aujourd'hui, il faut se rendre plus loin, à Ciudad Real par exemple, pour trouver un bouffon nommé Zagarrón. Le saut d'El Colacho au-dessus des bébés est censé les protéger d'abord des hernies et de l'épilepsie, maladies apportées par le Malin, selon les croyances anciennes.

**SHICHI-GO-SAN** Le Japon a 127 millions d'habitants, mais il n'existe aucun relevé précis quant au nombre d'entre eux pratiquant le shintoïsme, la religion nationale. Toutefois, les valeurs shintoïstes sont profondément ancrées dans la civilisation japonaise et la plupart des gens participent à des festivals, cérémonies et rituels shintoïstes en diverses occasions de leur vie. Dans un même temps, ils pratiquent aussi le bouddhisme. Des prêtres bouddhistes officient lors des enterrements et autres rites funéraires puisque le contact avec les morts est considéré comme impur par le shintoïsme. Les autres rites de passage, tels que naissance, shichi-go-san et mariage, sont célébrés dans les dizaines de milliers de temples shintoïstes. En parallèle, les noces à l'occidentale, qui ont lieu dans des « chapelles de mariage », ont gagné en popularité.

**LA CIRCONCISION** Pas moins de 97 pour cent des 74 millions d'habitants de Turquie sont musulmans. Les deux principales ethnies sont les Turcs (80 % environ) et les Kurdes. Même les Turcs laïcs font circoncire leurs fils et célèbrent l'événement. En effet, cette tradition ne repose pas seulement sur des raisons religieuses, mais aussi d'hygiène et de santé.

**SUR LES TRACES DU BOUDDHA** Le peuple chan, principalement basé au Myanmar (Birmanie), mais qui vit aussi dans des régions voisines de Thaïlande, du Laos et de la Chine, compte environ six millions d'âmes. Les Chan pratiquent la culture du riz et ont des liens culturels et linguistiques étroits avec les groupes ethniques thaïlandais et laotiens. Leur religion est le bouddhisme theravada. Depuis des décennies, le territoire chan de Birmanie est la scène de révoltes contre le régime du pays. Un grand nombre de Chan en Thaïlande sont des réfugiés qui ont fui la guérilla entre leur peuple et l'armée de la junte.

**BAR ET BAT MITZVAH** Selon les estimations, il y aurait 12 à 14 millions de Juifs dans le monde. Plus de 40 % habitent les États-Unis. Quelque 80 % des Juifs américains sont plus ou moins pratiquants et 48 % sont membres d'une synagogue. Outre les Juifs orthodoxes qui suivent strictement la Loi, la Torah dictée par Dieu à Moïse sur le Mont Sinaï, on trouve deux autres branches majeures du judaïsme aux États-Unis : le mouvement réformé et le mouvement conservateur. Les Juifs réformés n'appliquent pas à la lettre les lois et se focalisent plutôt sur une interprétation morale de la Torah. Les Juifs conservateurs ont aussi une approche plus libérale de la Torah, mais observent certaines règles traditionnelles juives telles que le sabbat et les préceptes d'alimentation casher. Ils sont également plus ouverts à la société moderne et à l'égalité de sexes que les orthodoxes. La

bar mitzvah remonte aux temps médié-vaux ; la première bat mitzvah publique pour une fille ne fut célébrée qu'en 1922.

### LA DANSE DU SOLEIL LEVANT DES APACHES
Trois petites réserves apaches se trouvent au centre de l'Arizona ; les quatre réserves principales s'étendent dans le sud-ouest des États-Unis : Jicarilla et Mescalero au Nouveau-Mexique, Fort Apache et San Carlos dans l'est de l'Arizona. Près de 10 000 Apaches vivent dans la réserve de San Carlos. L'origine du nom apache est incertaine ; dans leur langue, les Apaches se nomment « Ndee » (le peuple). À l'arrivée des Occidentaux, les Apaches occupaient la région qui constitue aujourd'hui le sud-ouest des États-Unis et le nord-ouest du Mexique. Ils y auraient émigré après l'an 1000, bien que certains chercheurs fixent plutôt leur venue vers 1400 ou 1500. Les Apaches appartiennent à la famille linguistique Athabascan, dont la plus proche parenté se situe dans l'ouest canadien et en Alaska. Également de langue athabascane, le peuple Navajo est apparu dans le sud-ouest des États-Unis à environ la même époque. Contrairement aux Indiens Pueblo, agriculteurs sédentarisés, installés dans ces régions avant eux, les Apaches étaient un peuple nomade vivant de la chasse et la cueillette. Les montagnes giboyeuses du sud-ouest américain et du nord-est mexicain devinrent leurs territoires.

### LA CONFIRMATION CHEZ LES SAMI
Sápmi, région traditionnellement habitée par le peuple Sami, englobe une vaste étendue du nord de la Scandinavie et la péninsule russe de Kola. Des quelque 80 000 Samis constituant ce peuple, 50 000 vivent en Norvège, 20 000 en Suède, 8 000 en Finlande et 2 000 en Rus-sie. À Kautokeino, 90 % de la population de 3 000 habitants sont Sami. L'élevage des rennes est une tradition profondément ancrée dans la civilisation sami. Beaucoup de Sami de Kautokeino possèdent des troupeaux de rennes qu'ils gardent sur

le plateau du Finnmark durant l'hiver. Au printemps, ils transhument vers les pâtu-rages de la côte Atlantique où ils passeront l'été. Les Sami ont longtemps été un peuple nomade qui suivaient leurs troupeaux toute l'année, mais les scooters de neige et autres inventions modernes ont révolu-tionné leur mode de vie. Aujourd'hui, seuls les gardiens vivent avec les troupeaux, le reste de la famille ne quitte pas la maison. Toutefois, la plupart des familles possédant des troupeaux ont deux demeures, l'une à Kautokeino, l'autre sur la côte. Environ un tiers des Sami de Kautokeino vit de l'éleva-ge du renne. Comme par le passé, d'autres vivent de la chasse ou la pêche, et certains sont même agriculteurs sédentaires.

### L'INITIATION DES JEUNES XHOSA
Le pays ancestral des huit millions de Xhosa s'étend dans la province du Cap-Est en Afrique du Sud, entre les rivières Fish et Thamvuna. Ils sont le peuple de langue bantoue le plus au sud de l'Afrique, arrivé vers la fin du XVIe siècle lors d'une grande migration bantoue. Avant l'apparition des Bantou, le sud de l'Afrique était peuplé par les San, chasseurs-cueilleurs, également nommés Bushmen, et par les Khoi, tribu proche d'éleveurs de bétail nomades. Les Xhosa sont traditionnellement éleveurs de bétail et agriculteurs. Le bétail joue encore un rôle crucial dans la civilisa-tion xhosa. L'abattage d'un bœuf est un rituel de circoncision ; les discours lors des cérémonies importantes se tiennent souvent depuis les enclos des troupeaux. De nombreux Xhosa ont quitté la province du Cap-Est pour des villes telles que Cape Town, Port Elizabeth et Johannesbourg, pour y étudier ou travailler. L'élite politique et intellectuelle d'Afrique du Sud compte beaucoup de Xhosa, citons entre autres des personnalités telles que l'ancien président Nelson Mandela, Thabo Mbeki et l'archevêque Desmond Tutu.

### REMISE DES DIPLÔMES
Uppsala, la quatrième ville de Suède avec une popu-lation de 130 000 habitants, abrite la plus

ancienne université du pays, fondée en 1477. La fête célébrant la fin des études secondaires est une tradition dans toute la Suède, mais elle est surtout très vivace dans le berceau de l'érudition. Jusque dans les années 1950, les étudiants de l'univer-sité d'Uppsala portaient quotidiennement, du 30 avril au 30 septembre, la casquette blanche reçue à la cérémonie du « bac-calauréat ». Aujourd'hui, ils ne l'arborent plus que le jour même de la remise du diplôme et lors d'événements spéciaux comme la Nuit de Walpurgis, le 30 avril, festival célébrant l'arrivée du printemps.

### UNE JEUNE FILLE DANI ATTEINT LA MAJORITÉ
Les Dani constituent un des groupes ethniques majeurs de Nouvelle-Guinée. Leur territoire dans la vallée de Baliem était inconnu du monde jusqu'à sa découverte en 1938, depuis un avion. Située à 1 500 mètres au-dessus du niveau de la mer, cette vallée est l'habitat de plus de 100 000 Dani, dont la ressource principale est la culture de la patate douce. Les Dani vivent dans la partie occidentale indonésienne de la Nouvelle-Guinée, région connue sous le nom d'Irian Jaya jusqu'à ce qu'elle devienne la Papouasie en 2000, et soit ensuite divisée en deux provinces : Papouasie occidentale et Papouasie.

### LIMAGE DES DENTS
Bali est une province indonésienne comptant environ 3 millions d'habitants. Gunung Agung, le plus haut sommet de l'île volcanique s'élève à 1 324 mètres au-dessus du niveau de la mer. Les beautés naturel-les et la civilisation fascinante de Bali attirent annuellement des centaines de milliers de visiteurs. La diversité cultu-relle s'explique en partie par l'exode en masse de l'intelligentsia qui quitta l'île voisine de Java à la fin du XVe siècle après la chute du royaume hindou de Maja-pahit. Jusqu'à aujourd'hui, la plupart des Balinais pratiquent l'hindouisme, tandis que les Javanais sont musulmans, comme la majorité des Indonésiens.

## LE SAUT DE BŒUFS CHEZ LES
## HAMAR
Comptant environ 40000 âmes, le peuple hamar est l'un des plus importants des quelque 20 groupes ethniques habitant le Sud-Omo, région du sud-ouest de l'Éthiopie traversée par le cours inférieur de la rivière Omo qui se jette dans le lac Turkana sur la frontière du Kenya. D'une étendue assez modeste, le Sud-Omo est un véritable patrimoine national, berceau de nombreux groupes ethniques aux profondes identités culturelles. Les Hamar sont éleveurs de bétail et agriculteurs, cultivant notamment le sorgho. Quand les terres deviennent arides et se couvrent d'acacias à la saison sèche, les hommes transhument vers les savanes herbeuses de la rivière Omo qui offrent de meilleures pâtures à leurs troupeaux.

## TROIS NOCES CHEZ LES NEWAR
## et AU CRÉPUSCULE DE LA VIE
Les quelque 1, 3 million de Newar constituent le sixième groupe ethnique du Népal, originaire de la vallée du Katmandou. Commerçants et artisans, ils vivent pour la plupart en communautés urbaines. Jadis, la vallée était partagée en trois royaumes – Kathmandou, Bhaktapur et Patan – chacun gouverné par un monarque divin. Mais après la conquête de la vallée par les Gurkhas en 1768, les souverains newar furent déchus, et leurs peuples et territoires intégrés dans le royaume du Népal.

## MARIAGE BERBÈRE
Les Berbères sont un groupe d'ethnies autochtones à l'ouest de la vallée du Nil. Au nombre de 25 millions, ils habitent surtout au Maroc où ils constituent la majorité de la population. Malgré l'arabisation extensive des régions de plaines du Maroc, la langue berbère tamazight reste prédominante dans des centres urbains tels que Marrakech et Agadir. De même, la culture berbère est toujours aussi vivace dans les montagnes du Rift et dans le Moyen-Atlas, le Haut-Atlas et l'Anti-Atlas. Après des siècles d'exclusion, la culture berbère connaît un renouveau depuis quelques décennies. Le tamazight est désormais reconnu comme langue nationale. L'Institut royal de la culture amazigh a été fondé au Maroc et plusieurs chaînes de radio-télévision diffusent en langue berbère. Près de la moitié des Marocains parlent les tamazight.

## LA CÉRÉMONIE DES NAISSANCES
Archipel minuscule de la Micronésie, Palau s'étend à environ 800 kilomètres à l'est des Philippines. Après avoir été sous tutelle des Nations unies et de l'administration américaine, les 26000 habitants de ces îlots d'Océanie ont obtenu leur indépendance en 1994. Auparavant, les insulaires vivaient de la culture et de la pêche ; les hommes partaient en mer et les femmes cultivaient les champs. Aujourd'hui, outre les subventions des États-Unis, Palau tire principalement ses ressources du tourisme. Malgré les influences occidentales, les structures claniques traditionnelles ont conservé un rôle important dans la communauté.

## CRÉMATION
Varanasi – aussi appelée Bénarès ou Kashi – est une des plus anciennes villes du monde. Comptant 1,5 million d'habitants, Bénarès, un des grands sites sacrés de pèlerinage chez les Hindous, s'étend sur une rive du Gange dans l'État d'Uttar Pradesh, au nord de l'Inde. Vishwanath est un des nombreux temples liés au culte du dieu Shiva, maître de l'univers. Outre son importance religieuse, Bénarès est également connue pour son industrie de la soie.

## LA RÉINHUMATION DES MORTS
Madagascar, la quatrième île du monde par sa superficie, a 18 millions d'habitants répartis dans 18 groupes ethniques. Les premiers colons arrivèrent d'Indonésie, il y a 2000 ans, sans doute via le sud de l'Inde et l'est de l'Afrique. La culture malgache réunit des éléments indonésiens et africains, mais le malagasy, langue nationale, est d'origine malayo-polynésienne, proche des langues indonésienne, philippine et polynésienne. Les habitants des hauts plateaux descendent des immigrants indonésiens et cultivent le riz sur des terrasses irriguées, comme dans le Sud-Est asiatique. Les bateaux munis d'outriggers des pêcheurs de la côte rappellent également les racines asiatiques.

## TODOS SANTOS
Située à 3710 mètres d'altitude, Oruro est une ville minière de l'Altiplano, haut plateau au cœur des Andes boliviennes. La population d'origine amérindienne est plus élevée en Bolivie que dans les autres pays d'Amérique du Sud. Environ 70 % des habitants des régions andines de Bolivie ont des racines amérindiennes. Les Quechuas, descendants des Incas et les Aymaras autochtones constituent les deux groupes ethniques principaux, qui rassemblent plus de deux millions de personnes.

# Hintergrund

## SEGEN FÜR DAS NEUGEBORENE

So gut wie jedes Dorf in Spanien veranstaltet jährlich ein Fest. Die große Mehrheit der 45 Millionen Einwohner des Landes ist römisch-katholisch, und religiöse Zeremonien wie Messen und Prozessionen sind ein häufiger Anlass für Feste. Diese feiern auch die Kultur der Region und sind eine Gelegenheit, sich zu amüsieren, zu essen, zu trinken und zu tanzen. Was die Figur El Colachos anbelangt, wird vermutet, dass sie arabische Wurzeln hat, sein Name soll sich auf die Maske und seine Possen beziehen. In vielen Dörfern um Castrillo de Murcia gab es ähnliche Figuren, aber heute muss man weit reisen, um eine zu finden, zum Beispiel nach Ciudad Real, wo er Zagarrón heißt. El Colachos Sprung über die Babys soll die Kinder vor allem vor Leistenbrüchen und Epilepsie schützen, die man früher für das Werk des Teufels hielt.

## SHICHI-GO-SAN

Japan hat 127 Millionen Einwohner, aber genaue Angaben darüber, wie viele von ihnen Schintoismus, die ursprüngliche Religion des Landes, praktizieren, fehlen. Die Werte des Schintoismus sind jedoch tief mit der Kultur Japans verwoben, und die meisten Menschen nehmen im Lauf ihres Lebens irgendwann einmal an Festen, Zeremonien oder Ritualen teil, die zum Schintoismus gehören. Gleichzeitig sind viele Menschen Buddhisten und bitten normalerweise buddhistische Priester, Beerdigungen oder andere Totenriten zu zelebrieren, denn im Schintoismus wird der Kontakt zu Toten als unrein betrachtet. Für die anderen Meilensteine des Lebens wie die Segnung von Neugeborenen, Shichi-go-san und Hochzeiten, wenden sich die Leute meist an einen der Zehntausenden schintoistischen Schreine, in denen Schintopriester die Rituale durchführen. Daneben sind Hochzeiten im westlichen Stil, die oft in besonderen Hochzeitskapellen gefeiert werden, in Mode gekommen.

## BESCHNEIDUNG

Nicht weniger als 97 Prozent der 74 Millionen Einwohner der Türkei sind Muslime. Die beiden großen ethnischen Gruppen bilden die Türken (etwa 80 Prozent der Bevölkerung) und die Kurden. Auch nichtreligiöse Türken lassen ihre Söhne beschneiden, eine Tradition, die nicht nur aus religiösen Gründen befolgt wird, sondern auch der Gesundheit dienen soll.

## IN BUDDHAS FUSSSTAPFEN

Es gibt etwa sechs Millionen Shan, die vorwiegend aus Birma stammen, aber auch in den Nachbarländern Thailand, Laos und China leben. Sie bauen Reis im Nassanbau an und haben enge kulturelle und sprachliche Verbindungen zu den ethnischen Gruppen der Thai und Lao. Sie sind Theravada-Buddhisten. Seit Jahrzehnten ist das Gebiet der Shan ein Hort der Rebellion gegen die birmanische Regierung, und viele Shan sind vor den Kämpfen zwischen den Shan-Rebellen und der birmanischen Armee nach Thailand geflohen.

## BAR- UND BAT-MIZWA

Schätzungen zufolge gibt es weltweit 12 bis 14 Millionen Juden. Davon leben mehr als 40 Prozent in den USA. Von diesen wiederum praktizieren etwa 80 Prozent ihren Glauben in irgendeiner Form, und 48 Prozent gehören einer Synagoge an. Abgesehen von orthodoxen Juden, die sich streng an die jüdischen Gesetze halten und glauben, dass Gott Moses die Thora auf dem Berg Sinai diktiert hat, gibt es noch zwei weitere Hauptrichtungen des Judentums: das Reformjudentum und das konservative Judentum. Erstere glauben nicht wörtlich an die Thora und betrachten sich als nicht an das jüdische Gesetz gebunden. Sie konzentrieren sich eher auf die moralische In-

terpretation der Thora. Konservative Juden sind irgendwo in der Mitte positioniert. Sie folgen den jüdischen Regeln und beachten beispielsweise den Sabbat und die koscheren Essensvorschriften, interpretieren die Thora aber freier. Sie stehen auch der modernen Gesellschaft und der Gleichstellung der Geschlechter positiver gegenüber. Die Zeremonie der Bar-Mizwa stammt aus dem Mittelalter, aber die erste öffentliche Bat-Mizwa wurde erst 1922 gefeiert.

### DER SUNRISE DANCE DER APACHEN

Neben drei kleinen Apachenreservaten in Zentralarizona gibt es noch vier weitere, größere Reservate im Südwesten der USA: Jicarilla und Mescalero in New Mexico und Fort Apache und San Carlos in Ostarizona. In San Carlos leben fast 10000 Apachen. Der Ursprung des Namens Apache ist ungewiss. In ihrer eigenen Sprache nennen sie sich Ndee (Menschen, Volk). Als die Europäer ankamen, lebten sie im Gebiet des heutigen Südwestens der USA und des Nordwestens von Mexiko. Man nimmt an, dass sie dort etwa seit dem Jahr 1000 siedeln, aber einige Forscher glauben auch, dass sie erst um 1400 oder 1500 dorthin kamen. Die Apachen gehören zu athapaskischen Sprachfamilie, die am nächsten verwandten Völker leben in Kanada und Alaska. Die Navajo gehören ebenfalls zur athapaskischen Sprachgruppe und sind vermutlich um die gleiche Zeit in den amerikanischen Südwesten gezogen. Anders als die Pueblo-Indianer, die sich schon vor ihnen in festen Dörfern in der Region niedergelassen hatten und Landwirtschaft betrieben, waren die Apachen nomadische Sammler und Jäger. Sie fanden ihre Beute zumeist in den bergigen Regionen des Südwestens der heutigen USA und des Nordwestens Mexikos, und so blieben sie dort.

### KONFIRMATION BEI DEN SAMEN

Sápmi, die Region, die traditionell von den Samen bewohnt wird, reicht über weite Gebiete Nordskandinaviens bis zur russischen Halbinsel Kola. Es gibt etwa 80000 Samen, von denen 50000 in Norwegen,

20000 in Schweden, 8000 in Finnland und 2000 in Russland leben. In Kautokeino sind 90 Prozent der 3000 Einwohner Samen. Die Rentierwirtschaft hat tiefe Wurzeln in der samischen Kultur, und viele Samen in Kautokeino sind Rentierzüchter. Sie weiden ihre Herden im Winter auf der Hochebene der Finnmark und folgen ihnen dann auf ihrer Frühjahrswanderung zu den Sommerweidegründen an der Atlantikküste. In früheren Zeiten waren die Samen Nomaden, die ihren Herden das ganze Jahr über folgten. Heute haben Schneemobile und andere moderne Errungenschaften diese Lebensweise revolutioniert, und Familienmitglieder, die sich nicht um die Herden kümmern müssen, können zu Hause bleiben. Trotzdem besitzen die meisten Rentierzüchterfamilien zwei Häuser: eins in Kautokeino und eins an der Küste. Zurzeit sind etwa ein Drittel der Samen in Kautokeino in der Rentierzucht beschäftigt. Selbst in vergangenen Zeiten haben in diesem Bereich nicht alle Samen gearbeitet. Es gab auch Jäger und Fischer. Und in Kautokeino waren viele Menschen sesshafte Bauern.

### INITIATION DER XHOSA-JUNGEN

Die acht Millionen Xhosa in Afrika kommen ursprünglich aus der Region zwischen den Flüssen Fish und umThamvuna in der heutigen südafrikanischen Provinz Ostkap. Sie sind die am weitesten im Süden lebende, bantusprachige Bevölkerungsgruppe in Afrika, und sie haben das Ostkap spätestens Ende des 16. Jahrhunderts im Zuge einer großen Bantuwanderung besiedelt. Bevor die Bantu kamen, lebten die San, die auch als Buschmänner bekannt sind und als Sammler und Jäger lebten, in Südafrika. Sie sind eng mit den Khoi verwandt, nomadischen Viehzüchtern. Die Xhosa sind traditionell Bauern und Rinderzüchter, und bis heute haben Rinder eine große kulturelle Bedeutung für die Xhosa. Zu Beschneidungszeremonien werden Rinder geschlachtet, und die Männer halten bei wichtigen Zeremonien oft Reden in den Viehpferchen. Zahlreiche

Xhosa sind auf der Suche nach Arbeit und Bildung aus der Provinz Ostkap nach Kapstadt, Port Elizabeth und Johannesburg gezogen. Viele von ihnen gehören zur politischen und intellektuellen Elite Südafrikas, darunter so bekannte Persönlichkeiten wie Nelson Mandela, Thabo Mbeki und Erzbischof Desmond Tutu.

### ABITUR

Uppsala, Schwedens viertgrößte Stadt, hat 130000 Einwohner und die älteste Universität des Landes, die 1477 gegründet wurde. Abiturzeremonien haben in ganz Schweden Tradition, sind an diesem Ort der Bildung aber besonders ausgeprägt. Bis in die 1950er-Jahre gehörten die weißen Mützen, die zum ersten Mal am Tag des Abiturs getragen wurden, vom 30. April bis zum 30. September zur Alltagskleidung der Universitätsstudenten in Uppsala. Heute werden sie nur anlässlich des Abiturs oder zu besonderen Gelegenheiten wie der Walpurgisnacht getragen, ein Fest, mit dem am 30. April die Ankunft des Frühlings gefeiert wird.

### EIN DANI-MÄDCHEN WIRD VOLLJÄHRIG

Die Dani sind die größte und bekannteste ethnische Gruppe in Neuguinea. Ihre Heimat im Baliemtal war der Außenwelt unbekannt, bis sie 1938 von einem Flugzeug aus entdeckt wurde. 1500 Meter über dem Meeresspiegel gelegen, ist das Tal die Heimat von 100000 Dani. Hauptwirtschaftszweig ist der Anbau von Süßkartoffeln. Die Dani leben auf der westlichen, zu Indonesien gehörenden Hälfte der Insel Neuguinea, die früher Irian Jaya hieß, dann aber 2000 in Papua umbenannt und in zwei Provinzen aufgeteilt wurde, Westpapua und Papua.

### ZÄHNEFEILEN

Die vulkanische Insel Bali ist eine indonesische Provinz mit etwa 3 Millionen Einwohnern. Ihr höchster Gipfel, Gunung Agung, erhebt sich 1324 Meter über den Meeresspiegel, und die Schönheit der Natur sowie die lebendige Kultur ziehen jedes Jahr Hunderttausende Touristen an. Die kulturelle Vielfalt

erklärt sich zum Teil aus dem Exodus der Intellektuellen aus Java im späten 15. Jahrhundert, nachdem das Hindukönigreich Majapahit zusammengebrochen war. Bis heute sind die meisten Balinesen Hindus, während auf Java wie im übrigen Indonesien vorwiegend Muslime leben.

**SPRUNG ÜBER DIE RINDER** In Süd-Omo im Südwesten Äthiopiens leben 40000 Hamar, die größte von etwa 20 ethnischen Gruppen in der Region, durch die der Unterlauf des Omo auf seinem Weg zum Turkanasee an der Grenze zu Kenia fließt. Obwohl Süd-Omo relativ klein ist, ist es die Heimat von zahlreichen ethnischen Gruppen mit ausgeprägtem kulturellem Erbe. Die Hamar sind Rinderzüchter und Bauern, die vorwiegend Sorghumhirse anbauen. Weil das Land sehr trocken und von Akazien bewachsen ist, verbringen viele Männer die Trockenzeit mit den Viehherden in speziellen Rindercamps am Omo in der Savanne, wo die Weidebedingungen besser sind.

**DREI HOCHZEITEN DER NEWAR** und **ALTERSDÄMMERUNG** Die Newar bilden mit 1,3 Millionen Menschen die sechstgrößte Bevölkerungsgruppe Nepals. Sie stammen aus dem Kathmandutal und sind als Händler und Handwerker bekannt. Sie leben in kleinen städtischen Gemeinden. Das Tal war früher in drei Newar-Königreiche aufgeteilt – Kathmandu, Bhaktapur und Patan –, von denen jedes von einem als Gott verehrten König regiert wurde. Aber die Eroberung des Tals durch die Ghurka 1768 beendete ihre Regierungszeit und assimilierte die Newar in das Königreich Nepal.

**BERBER-HOCHZEIT** Die Berber sind die Ureinwohner Nordafrikas westlich des Niltals. In der Region leben etwa 25 Millionen Berber, die meisten in Marokko, wo sie die Bevölkerungsmehrheit stellen. Trotz der weit verbreiteten Arabisierung in großen Teilen des marokkanischen Tieflands dominiert die Berbersprache

Tamazight noch immer in den städtischen Regionen wie Marrakesch und Agadir. Die Berberkultur ist in den Rifbergen sowie im Mittleren, Hohen und Antiatlas immer noch stark. Nach Jahrhunderten der Benachteiligung hat die Berberkultur in den vergangenen Jahren eine Wiederbelebung erfahren. Tamazight ist nun als offizielle Sprache anerkannt und wurde in den nationalen Lehrplan aufgenommen. Ein königliches Institut für Berberkultur wurde eröffnet, und viele Radio- und Fernsehsender senden Programme in der Sprache der Berber. Heute spricht etwa die Hälfte der Marokkaner Tamazight.

**GEBURTSZEREMONIE** Palau ist ein winziger Inselstaat ungefähr 800 Kilometer östlich der Philippinen in der pazifischen Region Mikronesien. Nachdem Palau jahrzehntelang unter treuhänderischer Verwaltung der UNO gestanden hatte, erlangten die 20000 Einwohner 1994 ihre Unabhängigkeit. Traditionellerweise leben sie von Landwirtschaft und Fischerei, wobei Erstere von den Frauen und Letztere von den Männern betrieben wurde. Heute leben die Inseln großenteils vom Tourismus sowie von Unterstützungen der USA. Trotz starker westlicher Einflüsse haben traditionelle Klanstrukturen immer noch großen gesellschaftlichen Einfluss.

**EINÄSCHERUNG** Varanasi – auch als Kashi oder Benares bekannt – ist eine der ältesten bewohnten Städte der Welt. Mit 1,5 Millionen Einwohnern liegt sie am Ufer des Ganges in dem nordindischen Bundesstaat Uttar Pradesh und ist einer der heiligsten Pilgerorte für Hindus. Zu seinen zahlreichen Hinduschreinen gehört auch der Vishwanath-Tempel, der dem Gott Schiwa als Herrscher über das Universum geweiht ist. Neben seiner Bedeutung als religiöser Ort ist Varanasi auch für seine Seidenindustrie bekannt.

**TOTENUMWENDUNGSFEST** Madagaskar ist die viertgrößte Insel der Welt und hat 18 Millionen Einwohner, die 18 ethnischen

Gruppen angehören. Die ersten Siedler kamen vor etwa 2000 Jahren aus dem heutigen Indonesien, vermutlich über Südindien und Ostafrika. Madagassen haben sowohl indonesische als auch afrikanische Züge, obwohl die Landessprache, Malagasy, malayo-polynesischen Ursprungs und mit indonesischen, philippinischen und polynesischen Sprachen verwandt ist. Menschen, die auf dem madagassischen Hochland leben, ähneln sehr Indonesiern und bauen Reis auf bewässerten Terrassen an, eine Landwirtschaftstechnik, die aus Südostasien stammt. Die Auslegerkanus, die die Madagassen an der Küste bevorzugen, stellen eine weitere Verbindung zu diesem Teil der Welt her.

**TODOS SANTOS – ALLERHEILIGEN** Auf dem Altiplano, dem Hochplateau der mittleren Anden, liegt auf 3710 Metern über dem Meeresspiegel Oruro, eine bolivianische Bergbaustadt. Bolivien hat einen höheren Anteil von indianischen Ureinwohnern in der Bevölkerung als jedes andere südamerikanische Land. Ihr Anteil ist in den Andenregionen am höchsten, wo etwa 70 Prozent der Bevölkerung indianische Wurzeln haben. Die beiden größten Gruppen sind die Quechua, Nachfahren der Inka, und die Aymara, zu denen jeweils zwei Millionen Menschen gehören. Der überwiegende Teil der Bolivianer ist römisch-katholisch, obwohl auch Glauben mit präkolumbischen Wurzeln noch immer stark sind.

# Bibliography  Bibliographie  Bibliografie

**Allen, Michael**, 1996, *The Cult of Kumari: Virgin Worship in Nepal*. Kathmandu: Mandala Book Point.

**Alvarsson, Jan-Åke**, 1997, 'Anderna'. Jan-Åke Alvarsson (ed.), *Amerikas Indiankulturer*, pp. 151–157. Uppsala: Institutionen för kulturantropologi och etnologi, Uppsala universitet.

**Basso, Keith H.**, 1986, *The Cibecue Apache*. Prospect Heights: Waveland Press.

**Becker, Peter**, 1975, *Trails and Tribes in Southern Africa*. London: Hart-Davis, MacGibbon.

**Bloch, Maurice**, 1971, *Placing the Dead: Tombs, Ancestral Villages, and Kinship Organization in Madagascar*. London: Seminar Press.

---, 1983a, 'Madagaskars befolkning'. Bloch, Maurice (ed.), *Jordens folk – Sydafrika, Madagaskar*, pp. 66–67. Stockholm: BonnierFakta.

---, 1983b, 'Merina – Madagaskar'. Bloch, Maurice (ed.), *Jordens folk – Sydafrika, Madagaskar*, pp. 86–93. Stockholm: BonnierFakta.

---, 1986, 'Death, Women and Power'. Bloch, Maurice & Jonathan Parry (eds.), *Death and the Regeneration of Life*, pp. 211–230. Cambridge: Cambridge University Press.

**Brett, Michael & Elizabeth Fentress**, 1996, *The Berbers*. Oxford: Blackwell.

**Buechler, Hans C.**, 1980, *The Masked Media: Aymara Fiestas and Social Interaction in the Bolivian Highlands*. The Hague: Mouton Publishers.

**Buechler, Hans C. & Judith Maria Buechler**, 1971, *The Bolivian Aymara*. New York: Holt, Reinhart and Winston.

**Calvo, Enrnesto Pérez**, 1985, *Fiesta del Colacho: una farsa castellana*. Burgos: Imprenta Monte Carmelo.

**Cohn-Sherbok, Dan**, 1999, *Judaism*. London: Routledge.

**Conway, Susan**, 2006, *The Shan: Culture, Arts and Crafts*. Bangkok: River Books.

**Courtney-Clarke**, Margaret & Geraldine Brooks, 1996, *Imazighen: The Vanishing Traditions of Berber Women*. London: Thames & Hudson.

**Covarrubias, Miguel**, 1988, *Island of Bali*. Oxford: Oxford University Press.

**Eck, Diana L.**, 1983, *Banaras: City of Light*. London: Routledge & Kegan Paul.

**Edkvist, Ingela**, 1997, *The Performance of Tradition: An Ethnography of Hira Gasy Popular Theatre in Madagascar*. Uppsala: Department of Cultural Anthropology and Ethnology, Uppsala University.

**Elliott, Aubrey**, 1989, *The Xhosa: and their Traditional Way of Life*. Cape Town: Struik.

*Encyclopaedia Judaica*, Vol 4 (1971–72) pp. 243–247. Jerusalem: Keter Publishing House.

**Gellner, Ernest & Charles Micaud**, 1973, *Arabs and Berbers: From Tribe to Nation in North Africa*. London: Duckworth.

**Goddard, Pliny E.**, 1918, 'Myths and Tales from the San Carlos Apache'. *Anthropological Papers of the American Museum of Natural History*, Vol 24, Part 1.

---, 1919, 'Myths and Tales from the White Mountain Apache'. *Anthropological Papers of the American Museum of Natural History*, Vol 24, Part 2.

**Goseyun, Anna Early**, 1991, 'Carla's Sunrise'. *Native Peoples*, Vol 4, No. 4, pp. 8–16.

**Groth, Bente**, 2002, *Judendomen: kultur, historia, tradition*. Stockholm: Natur och kultur.

**Hætta, Odd Mathis**, 2003, *Samiske påskeradisjoner i Kautokeino*. Alta: Høgskolen i Finnmark.

**Haley, James L.**, 1997, *Apaches: A History and Culture Portrait*. Norman: University of Oklahoma Press.

**Hampton, O.W.**, 1999, *Culture of Stone*. College Station: Texas A&M University Press.

**Harnesk, Helena & Ulla Oscarsson**, 1995, *Uppsala från liten medeltidsstad till Sveriges fjärde stad*. Uppsala: Upplands fornminnesförening och hembygdsförbund: Upplandsmuseet.

**Harris, Olivia**, 1986, 'The Dead and the Devils among the Bolivian Laymi'. Bloch, Maurice & Jonathan Parry (eds.), *Death and the Regeneration of Life*, pp. 45–73. Cambridge: Cambridge University Press.

**Heider, Karl G.**, 1970, *The Dugum Dani: A Papuan Culture in the Highlands of West New Guinea*. Chicago: Viking Funds Publications in Anthropology.

**Inokuchi, Shoji**, 1983, *Kodansha Encyclopedia of Japan*, Vol 7, p. 87. Tokyo: Kodansha.

**Kjellström, Rolf**, 2000, *Samernas liv*. Stockholm: Carlssons.

**Kraus, Wolfgang**, 1991, *Die Ayt Hdiddu: Wirtschaft und Gesellschaft im zentralen Hohen Atlas*. Vienna: Österreichische Akad. der Wissenschaften.

**Kulonen, Ulla-Maija & Irja Seurujärvi-Kari & Risto Pulkkinen** (eds.), 2005, *The Saami: A Cultural Encyclopaedia*. Helsinki: Kirjallisuuden Seuran toimituksia.

**Laubscher, B.J.J.**, 1937, *Sex, Custom and Psychopathology: A Study of South African Pagan Natives*. London: Routledge & Kegan Paul.

**Lehtola, Veli-Pekka**, 2004, *The Sámi People: traditions in transition*. Fairbanks: University of Alaska Press.

**Levy, Robert I.**, 1992, *Mesocosm: Hinduism and the Organization of a Traditional Newar City in Nepal*. Delhi: Motilal Banarsidass Publishers.

**Littleton, C. Scott**, 2002, *Shinto: Origins, Rituals, Festivals, Spirits, Sacred Places*. Oxford: Oxford University Press.

**Löwdin, Per**, 1998, *Food, Ritual and Society: A Study of Social Structure and Food Symbolism among the Newars*. Kathmandu: Mandala Book Point.

Lueras, Leonard & R. Ian Loyd, 1987, *Bali: The Ultimate Island*. Singapore: Times Editions.

Lydall, Jean & Ivo Strecker, 1979, *The Hamar of Southern Ethiopia II: Baldambe Explains*. Hohenschäftlarn: Klaus Renner Verlag.

Magubane, Peter, 1998, *Vanishing Cultures of South Africa: Changing Customs in a Changing World*. London: New Holland.

Mandela, Nelson, 1994, *Long Walk to Freedom: The Autobiography of Nelson Mandela*. London: Little Brown.

Matthiessen, Peter, 1962, *Under the Mountain Wall: A Chronicle of Two Seasons in the Stone Age*. New York: Viking Press.

Meintjes, Graeme, 1998, *Manhood at a Price: Socio-Medical Perspectives on Xhosa Traditional Circumcision*. Grahamstown: Institute of Social and Economic Research, Rhodes University.

Ono, Sokyo, 1962, *Shinto: The Kami Way*. Rutland: Tuttle.

Parry, Jonathan P., 1985, 'Death and Digestion: The Symbolism of Food and Eating in North Indian Mortuary Rites'. *Man*, Vol 20, No. 4, pp. 612–630.
---, 1994, *Death in Banaras*. Cambridge: Cambridge University Press.

Peters, H.L., 1975, 'Some Observations of the Social and Religious Life of a Dani-group'. *Bulletin of Irian Jaya Development*, 4(2).

Picken, Stuart D.B., 1980, Shinto: Japan's Spiritual Roots. Tokyo: Kodansha.

Quintero, Nita, 1980, 'Coming of Age the Apache Way'. *National Geographic Magazine*, Vol 157, No. 2, pp. 262–271.

Ramseyer, Urs, 1986, *The Art and Culture of Bali*. Oxford: Oxford University Press.

Rydén, Bengt-Erik, 1992, *Studenten, Staden och Sanningen*. Uppsala: Upplands Nation.

Smith, DeVerne R., 1983, *Palauan Social Structure*. New Brunswick: Rutgers University Press.

Strecker, Ivo, 1988, *The Social Practice of Symbolization: An Anthropological Analysis*. London: Athlone Press.

Sugimoto, Yoshio, 2003, *An Introduction to Japanese Society*. Cambridge: Cambridge University Press.

Svanberg, Ingvar & David Westerlund (eds.), 1999, *Blågul islam? muslimer i Sverige*. Nora: Nya Doxa.

Swearer, Donald K., 1995, *The Buddhist World of Southeast Asia*. Albany: State University of New York Press.

Tayler, Jeffrey & Alexandra Boulat, 2005, 'Among the Berbers'. *National Geographic Magazine*, January 2005, pp. 78–97.

Terzioglu, Derin, 1995, 'The Imperial Circumcision Festival of 1582: An Interpretation'. *Muqarnas*, Vol 12, pp. 84–100.

Thyssen, Mandy, 1988, *The Palau Islands*. Koror: Neco Tours.

*Traditions of Pregnancy and Birth*, 1998. Koror: Division of Cultural Affairs.

Van Gennep, Arnold, 1960, *The Rites of Passage*. Chicago: The University of Chicago Press.

Vergati, Anne, 2002, *Gods, Men and Territory: Society and Culture in Kathmandu Valley*. New Delhi: Manohar Publishers and Distributors.

Wensinck, A.J., 1979, 'Khitan'. *Encyclopaedia of Islam*, Vol V, pp. 20–22. Leiden: E.J. Brill.

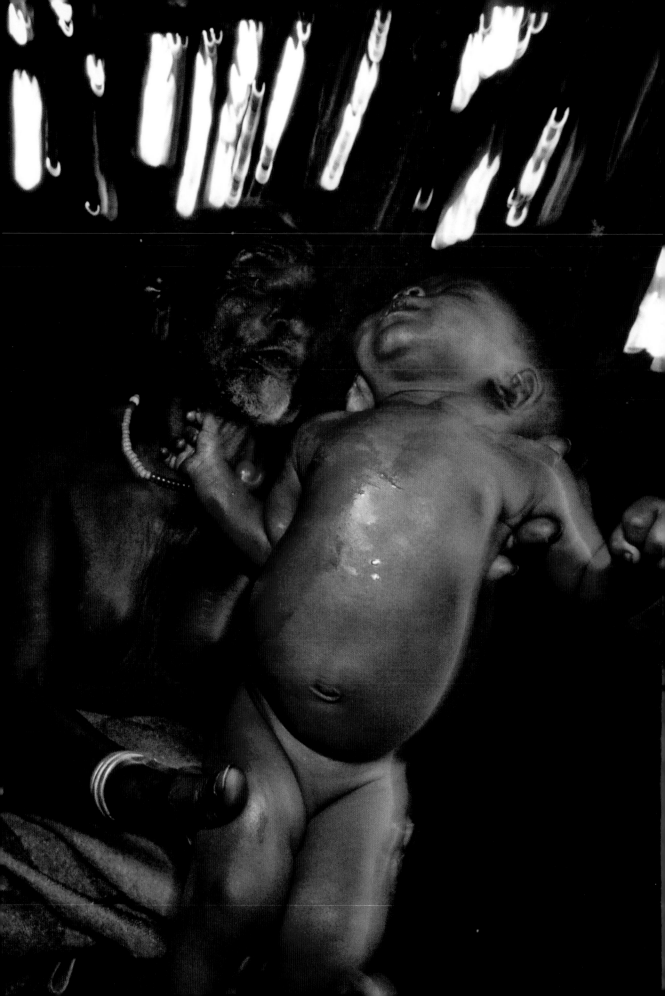

# Acknowledgements
# Remerciements
# Danksagungen

When the journeys are over, the book has been written and it is time for me to express my gratitude, it is clearer to me than ever how dependent I am on the goodwill of other people in my work. The list of people who, in one way or another, contributed to making this book possible is very long. Below I have listed those I can name and want to thank especially. There is no order of precedence. Some have contributed with tip-offs and contacts, something very important to work of this kind, others have had a decisive importance for the realisation of the project.

*I thank you all!*

**THE BOOK TEAM:** Petra Ahston Inkapööl, Charlotta Broady, Mark Holborn, Patric Leo, Martin Peterson, Susanne Reali, Marika Stolpe, Jeppe Wikström

**FACT CHECKERS:** Jan-Åke Alvarsson, Axel-Ivar Berglund, Éva Ágnes Csató Johanson, Erik af Edholm, Ingela Edkvist, Marianne Laanatza, Göran Larsson, Göran Lennartsson, Håkan Liby, Christer Lindberg, Gunnar Jinmei Linder, Per Löwdin, Enid Nelson, Lena Roos, Håkan Rydving, Ing-Britt Trankell, Charlotta Widmark

**ASSISTANTS, ON THE ROAD AND IN THE STUDIO:** Per Enar Andersson, Tord Carlsson, Tobias Grahn, David Holmström, Jesper Persson, Samuel Svensäter

**OTHER INDIVIDUALS:** Christer Alvarsson, Magnus Andersson, Sebastian Andersson, Els-Marie Anbäcken, Roberta Aplin Roos, Lena Backlund, Hugh Beach, Pawel Berens, Monica Braw, Staffan Brunius, Katarina Båth, Berit Eidner, Magnus Elander, Thomas Elmqvist, Jörgen Fredriksson, Marika Griehsel, Ahmed Hamdouchi, Peter Hanneberg, Bernth Johansson, Christian Jutvik, Hans-Åke Lerin, Göran Låås, Gunilla and Emerson Medina, Inger Nilsson, Lisa Norén, Hans Odöö, Jan Pedersen, Mikael Persson, Håkan Pohlstrand, Seidi Ryman, Liesbeth Schouten, Simon Stanford, Olof Sundqvist, Torleif Svensson, Staffan Widstrand, Michel Östlund

**FOUNDATIONS/SCHOLARSHIPS/PRIVATE SUPPORT:** The Catarina and Sven Hagströmer Foundation, the Helge Ax:son Johnson Foundation, the Uppsala county council cultural scholarship, the Längman Cultural Foundation, Eva Redhe Ridderstad

**COMPANIES:** Canon, Diabolaget, Hera, Skandia, Yggdrasil

**EMBASSIES:** The Ethiopian embassy in Stockholm, the Indonesian embassy in Stockholm

**HELP IN ARIZONA, USA:** San Carlos Tribal Council, Ophelia James and family, Karen Kitcheyan, Kayla Kitcheyan and family, Robertson Preston

**BOLIVIA:** Leydi Giovanna Velasco and family, Victor Sepúlveda

**ETHIOPIA:** Ethiopian Airlines, Brook Kassa, Geltiy Zubo Muko

**FINLAND:** Aliisa and Juri-Pekka Kainulainen, Esa Killström

**INDIA:** Munna Bhaiya, Avinash Gupa, Sunil Sharma

**INDONESIA:** Air Garuda, Gunilla Larsson, Marie-Louise Olsson and family, I Ketut Sudarsana, Ida Bagus Ngurah Wijaya

**JAPAN:** Noe Aiba, Anna Hamakoji, Itokuji Hideki, Hideyuki Masuda, Mio Noriuchi, Akio Noshi, Tasuhiro Yagyu, the Furuyado, Hashimoto, Hori, Tani and Okazawa families

**LAS VEGAS, USA:** Litte White Wedding Chapel, Viva Las Vegas Wedding Chapel, Charolette Richards

**MADAGASCAR:** Rakotoarivelo Martin, Ramilisonina and family, Rasamison Albert, Rasoamanalinarivo Louise

**MOROCCO:** The Moroccan National Tourist Office, Fatima Bouabdelli, Abderrahmane Boudrouz, Zahra Idali, Mustapha Jebbor, Said Mouddou, Lahcen Ouabou, Silvio Zanoni

**NEPAL:** Santa Ratna Bajracharya, Prerana Baidhya and family, Madhab Lal Maharjan, Mangali Kumari Maharjan, Surja Maya Maharjan, Loonibha Manandhar and family, Susanne Mikhail, Sanak Raj Shrestha, Nirmal Man Tuladhar

**Left:** During the *galekana* ceremony, an elderly Hamar man blesses an infant by spraying it with a mouthful of coffee, Omo, south-west Ethiopia. After this ceremony the parents can resume their sexual relation and bring more children into the world.

**À gauche :** Pendant la cérémonie *galekana,* un vieil homme hamar bénit un nouveau-né en l'aspergeant d'une gorgée de café, Omo, sud-ouest de l'Éthiopie. Après cette cérémonie, les parents peuvent reprendre leurs relations sexuelles et avoir d'autre enfants.

**Links:** Während der Galekana-Zeremonie in Omo, Südwestäthiopien, segnet ein älterer Hamar ein Kind, indem er es mit einem Mundvoll Kaffee besprüht. Nach dieser Zeremonie können die Eltern ihre sexuelle Beziehung wieder aufnehmen und weitere Kinder zeugen.

**NEW JERSEY, USA:** Fair Lawn Jewish Center, Tempel Avoda, Ilya Kiselyuk, Elvira Thinkas, Eric Wasser, Jonathan Woll, the Avraham and Swain families

**NORWAY:** Inga Anne Marit Hætta Juuso and family, Karen Anne Sara, Karen Utsi, Mikkel Magnus Persen Utsi

**PALAU:** Palau Visitors Authority, Everlyn Adelbai, Koreen August, Edangel Kenally, Michelle Mengidab, Malahi Mista, Florence Sokau

**RUSSIA:** Lidia Kalinnikova

**SOUTH AFRICA:** Patrick Blaai, Charles Vusi Kunene, Annika F. Langa, Zolani Nkohla, Allan and Maria Seatlholo, Janet Stanford, John and Josephine Stanford, John Stanwix

**SPAIN:** La Cofradia del Santisimo Sacramento, Patronato de Turismo de la Provincia de Burgos, Laura Villaverde, the Larrubia Trujillo and Oviedo Carrera families

**THAILAND:** Thai Air, Tour Merng Tai, the Tourism Authority of Thailand, Wasan Banleng, Panot Pakongsup, Achan Prawet

**TURKEY:** Ilkay Akca, Gökçe Kaçmaz, Kemal Özkan, Levent Özkan, the Aksu, Ar and Bostançi families

Finally my thoughts go to all those other kind souls along the road, whose names I do not know but whose welcoming attitude and great helpfulness have reinforced rather than frustrated my fundamentally positive view on man, without which this project would never have been conceived!